MANNERISM

The Crisis of the Renaissance
& the Origin of Modern Art

ARNOLD HAUSER

MANNERISM

The Crisis of the Renaissance
& the Origin of Modern Art

TRANSLATED IN COLLABORATION WITH THE AUTHOR

BY ERIC MOSBACHER

Volume I: TEXT

ALFRED · A · KNOPF

NEW YORK · 1965

Contents

Contents

Contents

Late mannerism: the Zuccari and their circle—Barocci —the last mannerists—mannerism, baroque, and classicism

PART THREE: MODERN

Plates

(In volume II)

245. BARTHOLOMEUS SPRANGER: Hermaphroditus and the Nymph. Vienna, Gallery
246. CORNELIS CORNELISZ VAN HAARLEM: Massacre of the Innocents. Haarlem, Frans Hals Museum
247. ABRAHAM BLOEMAERT: Judith showing the Head of Holofernes. Vienna, Gallery
248. J. DE GHEYN (after BLOEMAERT): Miracle of the Loaves. Utrecht, Centraal–Museum
249. ABRAHAM BLOEMAERT: Birth of Christ. Göttingen, University
250. ABRAHAM BLOEMAERT: John the Baptist preaching. Amsterdam, Rijksmuseum
251. ABRAHAM BLOEMAERT: Theagenes and Chariclea. Utrecht, Centraal-Museum
252. JOACHIM WTEWAEL: Adoration of the Shepherds. Oxford, Ashmolean Museum
253. JOACHIM WTEWAEL: Joseph and his Brethren. Utrecht, Centraal-Museum
254. HANS VON AACHEN: Bacchus, Ceres, and Cupid. Vienna, Gallery
255. JOSEF HEINTZ: Adonis taking Leave of Venus. Vienna, Gallery
256. GAUDENZIO FERRARI: Crucifixion. Detail. Varallo, Sacro Monte
257. WOLF HUBER: Christ taken Captive. Munich, Alte Pinakothek
258. LODOVICO MAZZOLINO: Massacre of the Innocents. Rome, Galleria Doria
259. ALBRECHT ALTDORFER: Martyrdom of St. Florian. Florence, Uffizi
260. HANS BALDUNG GRIEN: Adam and Eve. Lugano-Castagnola, Thyssen-Bornemisza Collection
261. LUCAS CRANACH: Venus. Rome, Galleria Borghese
262. MATTHIAS GRÜNEWALD: Resurrection. Part of the Isenheim altarpiece. Colmar, Museum
263. MATTHIAS GRÜNEWALD: Margarete Prellwitz. Drawing. Paris, Louvre
264. HANS MIELICH: Wilhelm IV on his Death-bed. Munich, Bayerisches Nationalmuseum
265. HOLBEIN: Charles de Solier, Sieur de Morette. Dresden, Gallery
266. HOLBEIN: Simon George de Cornwell. Frankfurt, Städel
267. HOLBEIN: William Warham, Archbishop of Canterbury. Windsor Castle
268. HOLBEIN: Sir Thomas Elyot. Windsor Castle
269. HOLBEIN: William Fitzwilliam, Earl of Southampton. Windsor Castle
270. HOLBEIN: William Parr, Marquess of Northampton. Windsor Castle
271. CHRISTOPH AMBERGER: Christoph Fugger. Munich, Alte Pinakothek
272. ADRIAEN DE VRIES: Mercury and Psyche. Paris, Louvre
273. BENVENUTO CELLINI: Perseus. Florence, Loggia dei Lanzi
274. BENVENUTO CELLINI: Cosimo I de' Medici. Florence, Bargello
275. BENVENUTO CELLINI: Narcissus. Florence, Bargello
276. VINCENZO DANTI: Honour vanquishing Deceit. Florence, Bargello
277. BACCIO BANDINELLI: Adam and Eve. Florence, Bargello
278. GIOVANNI BOLOGNA: Virtue vanquishing Vice. Florence, Bargello
279. GIOVANNI BOLOGNA: Samson and the Philistine. London, Victoria and Albert Museum

Preface

I HAVE been repeatedly reminded since the appearance of my *Philosophy of Art History* in 1959 that that work did not deal thoroughly enough, as I myself was the first to point out, with one of the main problems raised in it, that of convention in art, and that it would be desirable to return to the theme and if possible give it more comprehensive treatment. I should like now to remedy this shortcoming to the best of my ability, only I am afraid I shall still be unable completely to fulfil expectations on this score.

The period of mannerism which is the subject of this study was certainly marked by the most impersonal, inflexible, mechanical conventions. That, however, is only one aspect of it, for side by side with the most uniform products it presents us with some of the most original, unique, and boldest creations of the human spirit. The period was far from being restricted to conventionalism, and consequently the work that follows is far from dealing exclusively with that phenomenon; and, as its chief concern is the solution of a historical problem, the systematic discussion of such a constantly recurring trend as that of convention is to an extent irrelevant to it.

The subject and aim of the present work permit, indeed require, me to revert from the philosophical problems that I attempted to answer in my last published work to the descriptive method of its predecessor, *The Social History of Art* (1951), and have led me rather to be driven by the stream of historical development. The sociological and psychological conditions that resulted in conventions, the immobilisation of the spirit and the separation of its forms from the creative self, the depersonalisation and reification of human relations and man's alienation from himself, are for the most part only incidentally discussed in this volume, in which attention is focused on the historical process and the development that led to the production of works which, in spite of their conventional nature, are among the greatest of mankind. Their value far surpasses the boundaries of the formulas on which they are based. The artists of the age had no need to shake off the stereotyped artistic means and current formal language; in their hands the conventions themselves became

productive. The same language was shared by genius and bungler, originality felt free and moved unhampered within the limits of the established means of communication.

I hope that the nature of the conventions at work in mannerism appears plainly enough in the work that follows, but the nature of the method used perhaps calls for some comment. It is historical, but not purely art historical; the task I set myself could not have been tackled with the methods of art history alone. In reality, none of the more complex and comprehensive problems concerning the history of art as part of the general cultural process can be solved exclusively on the basis of the given art historical material, or by a method cut to the measure of that material; such problems can be meaningfully stated and satisfactorily answered only in the framework of a history of ideas, and with the aid of a much broader methodological approach than that of pure art history. The formulation and solution of the problems connected with mannerism, however, call for special concentration on historical synthesis and tracing back to their origin the components of a historical complex. Mannerism does certainly not differ so fundamentally from other artistic trends that its manifestations call for a special method of investigation, but the phenomena outside the field of art with which it is associated have such complicated, involved, and widespread ramifications, and the change of style that it represents was so deeply rooted in the general change of outlook and the historical, social, economic, and technological innovations of the age, that a study of its products purely in terms of the history of form, or iconography in the narrower sense of the term, turns out to be even less fruitful than in other cases.

In a work devoted to the history of ideas such as this, the establishment of art historical connections is of course only a means, not an end. It is in no way more significant than the description and interpretation of literary development, or of the path taken by philosophy or scientific thought, or of the history of social organisation. There are, however, good reasons why the section of the present work devoted to the history of painting is longer than the others, though there are no axiomatic reasons for it. The disproportion is primarily the result of the circumstance that there is no field in which the historically relevant processes can be so immediately and vividly displayed as in the visual arts. In literature the place of an illustration can often be taken only by a long quotation, and even that has to be torn out of a context that is left insufficiently clear. Summarising a complicated philosophical train of thought often involves neglecting important details, and in other fields there is no alternative to a tedious *précis* that inevitably fails to achieve the totality and intensity of impression produced by an appropriately selected if not fully analysed illustration. An even more important factor that led to the preferential

treatment of painting was the circumstance that it was the concept of style established by art history that made it possible to isolate trends of spiritual development from their personal representatives, and to take a collective view of individual endeavours and purposes.

Yet another circumstance that justified the more detailed treatment of painting and, out of regard for the already substantial length of the work, led among other things to the omission of any reference to music, was that nowhere did mannerism appear so early and so distinctly as in the visual arts, though this does not mean that the real origin of the mannerist outlook and sense of life is to be sought in them. The origin of mannerism is connected with factors far more complex and involved than any phenomena restricted to the visual field. The determining factor, however, in the allotment of the space available was that quite definitely mannerist and qualitatively outstanding works were being produced in painting while no trace of the style was yet apparent in the other arts, and that for a long time it was possible to conceive of a 'mannerist' outlook in other fields only by analogy, that is to say, only on the basis of ideas drawn from the visual arts.

To remain within the limits indicated, not only did certain fields, such as music, have to be omitted and a more thorough discussion of the special problems of modern art renounced, but also no adequate account could be given of the history of some forms of mannerist art in the narrower sense. More specifically, treatment of the architecture and sculpture of the age on a scale proportionate to their importance in relation to painting was sacrificed in this operation, as was that of the whole of German mannerism, apart from its final phase. Such sacrifices were made, however, only where the text seemed to throw light on the principles involved in the matters omitted. Also an attempt has been made to offer the reader a substitute for the missing chapters by providing him with appropriate illustrations which, it is hoped, will facilitate his forming an idea of the mannerist movement as a whole. True, practical considerations necessitated sacrifices here too; it has been possible to use only part of the available material, and the remainder, notwithstanding its attractiveness, had to be renounced. Nevertheless, this may still be the most compact and comprehensive book of illustrations of its subject yet published. In accordance with the text, in which mannerism is not regarded as merely a bizarre and abstruse vogue, the works chosen for reproduction are not the most strange and piquant that could have been found, but rather such as seemed to elucidate most fully the artistic movement under discussion.

As for the bibliography, it should be noted that failure to mention a relevant work does not mean that it has been considered unworthy, but only that it did not serve as an immediate source for the present work. The bibliographical references have obviously and deliberately been left

incomplete. The expert knows where to find the literature, and the references he will find here will be sufficient for the general reader.

I cannot say good-bye to my manuscript without expressing my thanks to those who have helped me. What I owe to my teachers and friends cannot be even hinted at here. For material assistance I am deeply grateful to the Bollingen Foundation in New York, which enabled me to devote more time to the preparation of this book than would otherwise have been possible. The learned institutions and art collections that assisted me in the obtaining of photographs and facilitated my undisturbed study of the works of art I was concerned with are too numerous for me to be able to thank them individually, and I ask them to accept my thanks in this form.

ARNOLD HAUSER

London

PART ONE

General

I

The Concept of Mannerism

1. REDISCOVERY AND REVALUATION

THE rehabilitation of a misunderstood or neglected style does not take place without good reason, and there was nothing haphazard or arbitrary about the rehabilitation of mannerism, the latest artistic period to have been rediscovered and fundamentally reappraised in our time. Its language in the visual arts and in literature had been largely forgotten and had to be relearnt, and the way to a better understanding did not lie open until we had learnt to take a more unbiased view of the baroque. The first step towards this was taken by impressionism, the formal relationship of which to the baroque brought the latter back into favour, thereby undermining the authority of the whole system of classical aesthetics which had hitherto barred the way. Impressionism, however, still bore deep traces of the rationalism and realism of classical art, for it remained within the broad lines of the development that had begun with the Renaissance; and, as the baroque was directly connected with the Renaissance, it was perfectly possible for its rediscovery and reappraisal to take place partly on the basis of a system of aesthetics derived from ancient and Renaissance models, though full appreciation of this fundamentally anti-classical style implied a certain relaxation of the rules of classical aesthetics. But mannerism was a much more radical departure from the classical ideal, and its acceptance and approval involved the ruthless dethronement of aesthetic doctrines based on the principles of order, proportion, balance, of economy of means, and of rationalism and naturalism in the rendering of reality.

The development of mannerism marked one of the deepest breaks in the history of art, and its rediscovery implies a similar break in our own day. Indeed, the crisis that led to our acceptance of it was deeper than the crisis of the Renaissance which gave it birth. Mannerism marked a revolution

3

in the history of art and created entirely new stylistic standards; and the revolution lay in the fact that for the first time art deliberately diverged from nature. True, non-naturalistic and anti-naturalistic art had previously existed, but its makers had been hardly conscious of deviation from nature, which they certainly had no intention of defying. The path that led to the revaluation of mannerism was laid by modern expressionism, surrealism, and abstract art, without which its spirit would have remained basically unintelligible; and at the same time these modern developments repeated the mannerist revolution by bringing to an end a preceding growth of naturalism which in both cases had lasted for several centuries. A revaluation of mannerism was feasible only for a generation which had experienced a shock like that associated with the origin of modern art. In other words, there would have been no such revaluation but for the state of mind which made possible the emergence and development of modern art. The latter is not, however, a mere repetition of the mannerist revolution; it is more radical than mannerism, in that it not only discards natural reality, not only distorts it, but to an extent replaces it by completely imaginary or abstract forms. Instead of copying objects of real experience, interpreting them or describing and analysing their impact, it seeks to create new objects and to enrich the world of experience by autonomous artifacts. However novel and unprecedented this may seem to be, there are many parallels between the age of mannerism and our own, and the significance that the works of that age have acquired in the eyes of our generation seems to be increasing rather than diminishing.

2. THE TRANSIENCE OF CLASSICAL STYLES

Periods of classical art, characterised by the absolute discipline of form, the complete permeation of reality by the principles of order, and the total subjection of self-expression to harmony and beauty, are of relatively brief duration. In comparison with the geometrical and archaic periods, or that of Hellenism, even the classical period of Greek art did not last for long, and the classicism of the Renaissance was a fleeting phenomenon which was over almost as soon as it began. The classicism of imperial Rome or of the turn of the eighteenth century which, in contrast to true classical art, was in each case purely derivative and degenerated into rigid formalism, was more enduring, but neither, in spite of its one-sidedness and the rigour of its principles, produced such purity of form as did classical art itself. Because of their derivative nature and the temptations of romanticism and anarchy which had to be fought off, they never attained the single-mindedness and immediacy of the classics. Perhaps classicism is contrary to human nature and requires a self-discipline to which men are

not able to submit for long. Art may be altogether less an expression of inner peace, strength, and self-confidence, and of a direct, unproblematic relationship with life such as we meet in the fleeting moments of classical art, than a spontaneous, often wild and desperate, and sometimes barely articulate cry, the expression of an ungovernable urge to master reality, or of the feeling of being hopelessly and helplessly at its mercy.

At the beginning of the sixteenth century a generation of artists grew up in Italy who were at one with themselves and apparently in complete harmony with the outside world. Because of its inner harmony and finality, we call their style, which lasted for barely more than twenty years, classical *par excellence*. But, even within that brief period of time and those restricted geographical limits, it was only in the visual arts that it prevailed undisputed and undiminished, and neither in literature nor in music did it produce works which rivalled in influence on future stylistic developments, let alone aesthetic merit, the creations of Leonardo, Raphael, or Michelangelo. Thus it is only in a limited sense that the Renaissance can be said to have been classical, and the question remains of the degree to which true classicism was possible in an age as dynamic as that of the Renaissance, which contained within itself all the ferments of the disintegrating Middle Ages and of the imminent crisis caused by the breakdown of the newly-acquired equilibrium.

The classical period of the Renaissance is generally considered to have ended with the death of Raphael; and, though it is not quite correct to say with Heinrich Wölfflin[1] that no purely classical work was done after 1520, that year by no means marked the beginning of its disintegration, signs of which had become perceptible long beforehand. There is practically no master of the High Renaissance in whom anti-classical trends did not manifest themselves earlier. Leonardo, who was responsible for the purest example of classical art in Italy, was in the last resort a romantic. In Raphael and Michelangelo truly classical values and aims were increasingly superseded by baroque or mannerist trends from their youth onwards. Because of his Venetian manner, apart from anything else, the description of 'classical' applies to Titian only with certain reservations. In the art of Andrea del Sarto the premonitions of mannerism are unmistakable, as are those of the baroque in that of Correggio. Thus the change of style did not first set in with the death of Raphael and the establishment of his school as an independent body, or with Michelangelo's late style and the development of Michelangelism. Not all the masters of the High Renaissance became mannerists, but nearly all were affected by the mannerist stylistic crisis. Gaudenzio Ferrari and Lorenzo Lotto had their share in the disintegration of the classical style, as Dosso Dossi and Correggio had; and Titian also went through a mannerist phase, though a shorter one, and one of less consequence than the break in the

development of Jacopo Bassano, for instance. The only masters who remained unrelenting classicists were the more or less conservatively-minded, such as Fra Bartolommeo and Albertinelli. Thus, though the classical tradition for a long time survived side by side with the new trends which proclaimed the advent either of mannerism or the baroque, and though in artists such as Andrea del Sarto, Correggio, Lorenzo Lotto, and Titian it continued to inspire work which was thoroughly creative and progressive, the breach with the past is unmistakable. The stylistically consistent, continuous advance of the Renaissance could no longer be taken for granted, but was tied up with certain conditions. Beauty and discipline of form no longer sufficed, and to the new, conflict-torn generation the repose, balance, and order of the Renaissance seemed cheap, if not actually mendacious. Harmony seemed hollow and dead, unambiguousness seemed over-simplification, unconditional acceptance of the rules seemed like self-betrayal.

Something terrible must have happened to that generation, something which shook it to its core and made it doubt its highest values. However, the crisis must have been in part rooted in the nature of Renaissance classicism itself, for symptoms of the breach with classical principles appeared even before the destructive forces to which that crisis could be attributed made themselves felt. In spite of the masterpieces produced by the Renaissance, the sense of harmony, the eternal values attributed to its creations and its absolute standards seem from the first to have been a dream, a hope, a Utopia, rather than a certain possession which could be passed on without question to succeeding generations. Apart from brief episodes, the complete harmony between subject and object, form and content, characteristic of antiquity and the Middle Ages, was never reached again. Works such as Leonardo's *Last Supper*, Raphael's *Disputà*, or Michelangelo's first *Pietà* were wish-dreams of a life in which body and soul were but different aspects, each as precious as the other, of the same ultimate purpose. They were products of a great Utopian art, not of a harmonious world. Sooner or later the fiction was bound to collapse, and before it collapsed cracks appeared in the edifice, signs of doubt and uneasiness and declining power, evidence, in short, that, in spite of the apparent effortlessness of its creations, classicism was in reality a tremendous *tour de force*, an achievement wrung from the age by force and not plucked like a naturally grown fruit.

3. THE CRISIS OF THE RENAISSANCE

Since the end of the Middle Ages the history of the west has been a history of crises, the short intervals between which have always contained the

6

germs of subsequent disintegration; they were intervals of euphoria between periods of misery and suffering, man's suffering because of the world and because of himself. The Renaissance was such an interval, but its foundations were never secure, and thus the tormented art of the mannerists, impregnated with the mentality of crisis and so much denounced and decried for insincerity and artificiality, is a much truer reflection of the age than the ostentatious peace, harmony, and beauty of the classics.

Periods of crisis are generally described as periods of transition. All historical periods, however, are periods of transition, for change is characteristic of them all. None has fixed boundaries, the legacy of the past is never absent, and there are always anticipations and promises of the future, including promises that remain unfulfilled. But the period of the crisis of the Renaissance which is known as mannerism was even more transitional in character than most in history. It came in between two relatively uniform phases of western civilisation, the static, Christian Middle Ages and the dynamic, scientific new age. It looked back, sometimes condescendingly, sometimes nostalgically, to medieval times, and drew again on a number of religious, scholastic, and stylistic sources which the Renaissance had dropped; on the other hand, it also anticipated much of the scientific outlook of the centuries ahead.

What we mean by the crisis of the Renaissance appears most clearly in the crisis of humanism, the questioning of the validity of the whole philosophical synthesis which, taking its stand on man and his spiritual needs, tried to reconcile the legacy of antiquity with that of the Middle Ages, and to reconcile both with the present. The ideals of humanism were formulated in their purest form in the works of Erasmus, who spoke simultaneously as a good Christian and a loyal pupil of the classics but, like most humanists, felt more drawn towards the wisdom of the stoics than to Christian ethics. In the classics they prized most highly the sense of the inherent worth of man; and they continually went back to them to reinforce that sense, which Christianity had so violently depreciated. They believed their true goal to be the restoration of confidence in the fundamentally moral character of man; but what they had in mind was something very different from Rousseau's 'natural goodness'. Their human ideal was that of the stoics; it was the product of training and education, the fruit of self-discipline and self-control. For them 'being human' was not a free gift of nature's, but an ideal to be striven for. Seneca summed it up for them in the phrase: 'How contemptible is man if he does not rise above the human.' In this sense Goethe was a humanist when he said: 'Every man must think in his own way. . . . Only, he must never let himself go, he must control himself; mere instinct is not becoming to man.' (*Wihelm Meisters Wanderjahre.*)

This faith in man collapsed again, and out of the ruins there arose the anti-humanist spirit of the Reformation, of Machiavellism, and of the mannerist sense of life. Once more man was no more than a fallen sinner, fallen even though he had not sinned. The optimism of the humanists had been based on belief in the harmony of the divine and human orders, the harmony of religion and justice, faith and morals. But now it was suddenly proclaimed that the divine will was not bound by these considerations. God arbitrarily and inscrutably decreed grace or damnation without regard to human standards of right or wrong, good or evil, reason or unreason. The validity of ethics, artistic standards of value, and scientific certainty went into the melting-pot together with human criteria for salvation. The riddle of predestination in religion had as its counterparts scepticism in philosophy, relativism in science, the 'double standard' in politics, and the spirit of *je ne sais quoi* in aesthetics.

The quintessence of humanism lay in the *sequere naturam* of the stoics. Luther, Calvin, Montaigne, Machiavelli, Copernicus, Marlowe, and Shakespeare all had their share in the destruction of the ideal of nature. However remote from each other these men's aims and interests may have been, they coincided in their views of the nature of man and society, their determined nominalism and pragmatism, their relativism, and the sense of reality they thereby expressed. This was something that neither the Middle Ages nor the Renaissance had possessed, and was an outcome of the same anti-humanist spirit. The crisis and partial disintegration of humanism in Italy set in with the Reformation in progress in distant Germany, and at home the Roman Catholic reform movement, foreign invasion, the sack of Rome and the ensuing chaos, the preparation and progress of the Council of Trent, the reorientation of trade routes and economic revolution throughout Europe, and economic crisis in the Mediterranean area. The good relations between the Church and the humanists were permanently shattered. The ideas that they spread became more anti-dogmatic and anti-authoritarian, and an increasing rationalism and a strong anti-intellectual bias existed side by side.

The crisis of humanism and the Renaissance was full of contradictions. Montaigne, Machiavelli, Telesio, Luis Vives, Vesalius, Cardano, Jean Bodin, etc., all shared the same kind of naturalism and empiricism, and directly or indirectly expressed the same spirit of scepticism. They all fought the same battle against dogma, scholasticism, abstract formal logic, and rigid tradition, and did so in the name of the same principle of reason. In that paradoxical age rationalism and irrationalism, intellectualism and anti-intellectualism, enlightenment and mysticism appeared together. Montaigne and Machiavelli were stern rationalists, while Giordano Bruno and Agrippa von Nettesheim were incalculable irrationalists.

The anti-intellectual trends assumed the most varied forms. A by-

product of the Reformation was the new religious spirit, inclined to mysticism and rapture. This was as much a reaction against the intellectualism of the humanists as was the relatively modest but unmistakable revival of medieval philosophy that cropped up occasionally. At the same time there arose a certain impatience with the humanist flood of words and ink, which was felt to be alien to life. From this point of view *Don Quixote*, as has been pointed out,[2] may be regarded as an indictment of the paper world of the humanists. The anti-intellectualism was above all a revolt against the predominance of reason in philosophy, science, and morals; but it also expressed opposition to the principles of order, proportion, and subservience to rules, and emerged as such in the anti-classical aesthetics of mannerism.

Also anti-humanist in character was the abolition of the balance between body and soul, mind and matter. The precept *sequere naturam* amounted to the principle of *mens sana in corpore sano*, that is to say, equilibrium between mind and body; aesthetically it implied the perfect equilibrium of form and content, the total absorption of content in form. In the new art that broke with the principles of the Renaissance and of humanism the content bursts through, shatters, and distorts. If, however, it is desired to draw attention to physical beauty and order, form becomes an independent entity on its own account, and it is content which is violated and laid in chains and, being thus abused, leads to formalism. With all this, the whole formal language of the Renaissance remains in force; its methods of composition, linear rhythm, monumental structure, powerful sense of movement, its grandiose human types, and impressive settings. But the whole huge apparatus has lost the meaning it had in the classical period. The forms remain unchanged, but are in conflict with the impulses that move the new generation, and in consequence they are compromised, become an empty shell, and finally disintegrate. Thus the new generation indirectly brought about what had been its real aim from the outset—the break-up of the classical style; and what it had already in part achieved directly by the deformation and distortion of classical forms it completed indirectly by means of this detour. The two paths met. In a stylistic revolution of this magnitude no other outcome was conceivable.

The formal perfection of the classical Renaissance had been attained with the aid of an over-simplification; completeness of expression and perfect harmony of form had to be paid for by shrivelling of spiritual content. The limitations of this art did not have to wait to be demonstrated by its inability to meet the needs of the new generation. The works of Raphael, Fra Bartolommeo, or Andrea del Sarto, composed within the boundaries of the ideal of formal beauty, did not, even at the time when they were conceived, square completely with the problems that were harassing the

9

mind of western man. Their untroubled harmony, their unperturbed detachment from events, their impassive objectivity, the complete poise and balance of their form, were anachronistic from the beginning and never had any real connection with reality. The ancient classics were born of a comparatively simple scheme of things, when the other-worldliness, subjectivism and symbolism of Christianity, the conflict between realism and nominalism, and the dualism between perishable body and immortal soul had not yet been heard of. The Renaissance of the classical period believed in the possibility of returning to the objectivity of the ancients, to the Greek cult of the body, and to Roman stoicism, thus completely adjusting themselves to this world while remaining spiritual beings directed towards the life beyond. This proved illusory.

One of the fictions of the Renaissance was that mind and body, man's moral demands and the demands of his senses, formed a harmonious unity, or were at any rate reconcilable as such without any grave conflict. In this there was a relic of the Greek ideal of *kalos k'agathos* and of the stoic belief in the controllability by reason of the passions, the senses, the body. The crisis of the Renaissance began with the doubt whether it were possible to reconcile the spiritual with the physical, the pursuit of salvation with the pursuit of terrestrial happiness. Hence mannerist art—and this is probably its most unique and characteristic feature—never confronts the spiritual as something that can be completely expressed in material form. Instead it considers it so irreducible to material form that it can be only hinted at (it is never anything but hinted at) by the distortion of form and the disruption of boundaries.

Golden ages are the wish-dreams of mankind. There are happy moments, but no happy periods in history. Insecurity and fear generally turn out to have prevailed in periods held to have been harmonious and free of conflict, and those who lived in them were not merely dissatisfied with them, but had no reason to be anything else. If the Renaissance is compared with earlier or later periods, however, there is no mistaking the signs of serenity, acceptance of life and self-confidence, though negative aspects are not lacking either. A freer, more cheerful outlook had succeeded medieval discipline and Christian restriction of the enjoyment of life, and enabled the individual, now relatively independent and free of the shackles of clerical tutelage, to become aware of his potentialities. The crisis of humanism and the Renaissance was a reaction against this relative freedom and frivolity. The *joie-de-vivre* and the sense of harmony were undermined by doubt, which was always lurking somewhere underneath the never completely solid and secure optimism of the Renaissance. We do not have to wait for the ageing Michelangelo's dramatic revolt against Renaissance worldliness, or for the gloom of Tasso, in whom Galileo so sadly missed Ariosto's gaiety, self-assurance,

and reasonableness,[3] or for outbursts of anguish such as that in the beautiful stanza in the *Gerusalemme Liberata* made famous by Rousseau:

Temerò me medesmo, e, da me stesso
Sempre fuggendo, avrò me sempre a presso.

Even the light-hearted and temperate Ronsard has lines such as:

Ah, et en lieu de vivre entre Dieux,
Je deviens homme à moi-même odieux.
(Élégie à Belot)

The Renaissance dream of a divine idyll on earth was over. Western humanity went through a 'tremendous upheaval',[4] and the picture of the world built up by classical antiquity, the Middle Ages and the Renaissance was in a state of collapse.

4. ATTEMPT AT A DEFINITION

Anti-humanism, as a philosophy of life and history, had its counterpart in art, the anti-Renaissance trends of which are so preponderant that the movement might well be called a 'Counter-Renaissance' were it not desired to emphasise its independent and positive character, and were the label of 'mannerism' not too firmly established to be superseded. The chief objection to the term 'mannerism' is the suggestion of disparagement that still clings to it, the consequence of which is that its application to the works of great masters still causes a certain shock. Another objection is that the concept of the manneristic can easily be, and indeed often is, confounded with that of the mannered, which may be, but is not necessarily, associated with mannerism. The two things are distinct. Mannerism belongs to the terminology of the art historian and defines a type; the mannered is a matter of aesthetic judgment, *i.e.*, is part of the terminology of the critic. Admittedly there is a considerable area of overlap, but there is no necessary connection between the two. There is certainly a tendency in mannerist artists towards a mannered way of expression, but there is no compulsion in them to sacrifice their individuality to a formula and to appear forced and bizarre.

Easy though it may be to draw up a list of more or less striking characteristics of mannerism, or to produce an impressive partial description of the phenomenon without laying claim to completeness or penetrating to the heart of the matter, arriving at a definition of mannerism that is both exhaustive and captures its essence is very difficult indeed. In spite of the continually growing literature on the subject, nothing of the sort exists. Even the most useful contributions have fastened only on isolated, though

sometimes remarkable, aspects, while others are more interesting and stimulating than convincing; some take insufficient account of the given conditions, or are based on historically untenable assumptions, *e.g.*, on incorrect ideas of the time needed for religious developments to make their impact in the prevailing circumstances.

Of the attempts which have been made to grapple with the problem, the most important is Walter Friedländer's. For him mannerism is basically 'anti-classical',[5] that is to say, emancipated from norms, irrational and unnaturalistic, as opposed to the art of the High Renaissance, the characteristics of which are taken to be objectivity, regularity, and normativity, based on timeless and universally valid standards and the shunning of everything merely accidental and arbitrary. Valuable as this may be as a starting-point for an analysis of mannerism, it is inadequate if its one-sidedness is maintained and if it is applied without qualification. For merely stating that mannerism is anti-classical without stating that it is classical at the same time does not tell us very much, and restricts and distorts the truth. Similarly, it is only a half-truth to describe mannerism as unnaturalistic and formalistic, or irrational and bizarre, for it possesses as many naturalistic as unnaturalistic features, and its rational are no less important than its irrational elements. A proper understanding of mannerism can be obtained only if it is regarded as the product of tension between classicism and anti-classicism, naturalism and formalism, rationalism and irrationalism, sensualism and spiritualism, traditionalism and innovation, conventionalism and revolt against conformism; for its essence lies in this tension, this union of apparently irreconcilable opposites.

Moreover, Friedländer's 'anti-classicism', apart from its one-sidedness and particularity, is confined to a single, negative characteristic of mannerism. A completely satisfactory description of the style would, however, make a positive statement about it, pointing out what it is rather than what it is not. Above all, it would emphasise the tension between conflicting stylistic elements which finds its purest and most striking expression in paradox. In any case, the idea of paradox could provide the basis of a definition that attempted to cover most of the phenomena in question and at the same time do justice to their positive and original stylistic traits instead of merely contrasting them with other artistic styles. At first sight, it is an eccentric and piquant quality, never absent in any mannerist work, however profound and serious it may be, that expresses itself in paradox. A certain piquancy, a predilection for the subtle, the strange, the over-strained, the abstruse and yet stimulating, the pungent, the bold, and the challenging, are characteristic of mannerist art in all its phases, and are the hall-mark of the most diverse of its representatives. They are to be seen in the precursors, such as Lorenzo Lotto, Gaudenzio Ferrari, and Pordenone, in the pupils of Raphael and the successors of

Michelangelo, and they are characteristic of early mannerists, such as Pontormo, Rosso, and Beccafumi, as well as of later ones, such as Primaticcio and Tibaldi. They are present in the great masters, such as Tintoretto and El Greco, and in the last representatives of the movement, such as Bloemaert and Wtewael, they are more pronounced than ever. It is often this piquancy—a playful or compulsive deviation from the normal, an affected, frisky quality, or a tormented grimace—that first betrays the mannerist nature of a work. The virtuosity that is always displayed contributes greatly to that piquancy. A mannerist work of art is always a piece of bravura, a triumphant conjuring trick, a firework display with flying sparks and colours. The effect depends on the defiance of the instinctual, the naïvely natural and rational, and the emphasis laid on the obscure, the problematical, and the ambiguous, the incomplete nature of the manifest which points to its opposite, the latent, the missing link in the chain. Beauty too beautiful becomes unreal, strength too strong becomes acrobatics, too much content loses all meaning, form independent of content becomes an empty shell.

Paradox in general implies a linking of irreconcilables, and *discordia concors*, the label often applied to mannerism, undoubtedly reflects an essential element in it. It would, however, be superficial to regard the conflicting elements that make up a work of mannerist art as mere play with form. The conflict expresses the conflict of life itself and the ambivalence of all human attitudes; in short, it expresses the dialectical principle that underlies the whole of the mannerist outlook. This is based, not merely on the conflicting nature of occasional experience, but on the permanent ambiguity of all things, great and small, and on the impossibility of attaining certainty about anything. All the products of the mind must therefore show that we live in a world of irreducible tensions and mutually exclusive and yet inter-connected opposites. For nothing in this world exists absolutely, the opposite of every reality is also real and true. Everything is expressed in extremes opposed to other extremes, and it is only by this paradoxical pairing of opposites that meaningful statement is possible. This paradoxical approach does not signify, however, that each statement is the retraction of the last, but that truth inherently has two sides, that reality is Janus-faced, and that adherence to truth and reality involves the avoidance of all over-simplification and comprehending things in their complexity.

Paradoxical ideas, feelings, and statements are always possible, of course, and are to be found in the art and literature of all periods. What makes mannerism remarkable in this respect is that it is unable to state its problems except in paradoxical form. Thus paradox ceases to be mere play with words and ideas, a rhetorical device or a display of wit, even though often it may amount to not much more than that.

The paradoxical roots of the spirit of the age are most vividly illustrated in the Protestant doctrine of predestination. Being chosen without merit is the moral-religious paradox *par excellence*. Luther's saying: 'Faith must learn to rely on nothing' is only another version of *credo quia absurdum*, which is the basic formula of faith—certainly without certain knowledge, the supreme paradox. This idea dominated the thought of all the great religious philosophers, from the fathers of the church to Pascal and Kierkegaard. The doctrine of predestination was only the most extreme statement of the belief that salvation, grace, justification, and righteousness, were unfathomable and beyond the range of human reason. Faith itself is paradoxical to the core, and the more differentiated and critical an age, the more paradoxical does it become—paradoxical not only in Kierkegaard's meaning of the word, namely that it is absurd, that is to say, inconceivable to reason, that the absolute should manifest itself in time, that the eternal and timeless should intervene in time and history, and that mankind should partake of grace; paradoxical not only in the sense of the doctrine of predestination, according to which there were, and must be, those to whom grace was predestined; but also in Tolstoy's and Dostoevsky's sense, that is to say, that not only was there no moral criterion for grace, there was also actually a conflict between grace and morals; for in the Dostoevsky mythology after Myshkin and Alyosha, it is the great sinners Mitya Karamazov, Rogozhin, Stavrogin, and Raskolnikov, who are the most certain of salvation. To see how close these paradoxes of faith are to the ideas of the mannerist world it is sufficient to recall a phrase of Luther's in a letter to Melancthon: 'Be a sinner and sin valiantly . . . we are bound to sin so long as we are here.' He becomes completely paradoxical when he adds: 'Beware of being so pure that you are not affected by anything . . . [for] the greatest evil has at all times come from the best.' Faith denies not only logic, but also morality; it abolishes the idea of sin.

However, in the age of mannerism it was not only Protestantism that created paradoxes with its doctrine of the irrational choice of the elect. Paradoxes abounded in the field of economics, with the worker's alienation from his work; in that of politics, with its 'double standard' of morality, one for the prince and the other for his subjects; in literature, with the leading role allotted to tragedy, which created a counterpart to the 'predestination of the elect' with the idea of guilt without sin, and with the discovery of humour, which enabled a man to be looked at and judged simultaneously from two different and contradictory aspects. In the cultural framework of this time nothing can be reduced to a simple and straightforward formula; every attitude is associated with its opposite. But its most remarkable feature is not the simultaneous presence and proliferation of contradictions, but the frequent lack of differentiation

between them, and their interchangeability. There is a saying of Kierkegaard's that illustrates this kind of paradox. 'One man prays to God in truth,' he says, 'though it is an idol that he worships, and another prays to the true God in untruth, and hence in reality worships an idol.'[6]

Kierkegaard's idea, which became the foundation and starting-point of existentialism, namely that abstract, systematic thought, as seen in its purest form in Hegel, has nothing whatever to do with the real business of living, and in particular with the difficulties and logically insoluble problems of our real lives, to an extent provides a clue to the intellectual climate of mannerism. When we tackle our daily tasks, difficulties, and problems, we do so completely unsystematically and alogically. The process is a continuous bearing in mind of the difficulties, a skirting of the rocks of life rather than steering clear of them altogether. The artists and writers of the mannerist period were not only aware of the insoluble contradictions of life, they actually emphasised and intensified them; they preferred reiterating and drawing attention to them to screening or concealing them. The fascination that the paradoxical nature and ambiguity of everything exercised over their minds was so strong that they singled out the contradictory quality of things, cultivated it as artists, and tried to perpetuate it and make it the basic formula of their art.

On the one hand, they took fully into account the inadequacy of rational thought and appreciated that reality, ordinary, everyday reality, was inexhaustible and defied rational synthesis. On the other, in spite of their fundamental irrationalism and scepticism, they could not give up the arts of reason, playing with problems, throwing them up and catching them again. They despaired of speculative thought, and at the same time clung to it; they had no high hopes of reason, but remained passionate reasoners, just as they continually questioned the legitimacy of their sensual appetites and were continually flung back on them. They felt themselves to be most truly themselves now in the mental, now in the physical manifestations of their nature, now in their rational, now in their instinctual aspirations; and they ended by finding the truest self-expression in the contradictory disposition of their natures and the irreconcilability of their impulses. They used paradox, however questionable a method it might be, as the only possible way of expressing the otherwise barely expressible. They may have known or felt that it was a tricky and losing game, stamped with the mark of tragic inadequacy, and that as a philosophy it did not take them very far, but in spite of that they went on being fascinated by it.

What is one to make of the temper of an age whose creations were for the most part born under the sign of this uncommonly fascinating but coquettish and complacent way of thinking? Irrationalism, which in philosophy and science leads to the 'destruction of reason'[7] and intellectual

bankruptcy, does not of course prevent the creation of significant works of art, a fact which is often overlooked by those critics who acutely point out its dangers in the field of theory. Left wing art criticism, correctly recognising that there is a causal connection between philosophy of life, political ideas, and social attitude on the one hand and artistic creation on the other, frequently succumbs to the error of concluding that indisputably high standards in the former must inevitably lead to similarly high standards in the latter. However, the phenomenon by which a good man may be a bad musician, or *vice-versa*, is by no means unknown on the social level. The artistic is quite different from the theoretical intelligence, and paradox, like irrationalism in general, means something quite different to the artist and to the philosopher. Nevertheless it is the minor mannerists who most frequently succumb to stereotyped, hackneyed, and mechanical paradox. But both the greatest artists of this school, to whom it is an additional source of strength, and the less great, to whom it is a danger, use it with evident satisfaction. Rosso, Parmigianino, Tintoretto, and El Greco make as lavish use of paradoxical forms as do Spranger or Bloemaert or Callot and Bellange; and the works of Tasso, Shakespeare, and Cervantes are as deeply rooted in paradoxical ideas and images as are those of Marino, Góngora, or John Donne.

5. THE UNITY OF MANNERISM

While in Walter Friedländer's view, the essence of mannerism lies in its anti-classicism, for Max Dvořák it lies in its spirituality, its other-worldly, metaphysical, and essentially religious outlook as opposed to the empiricism of the new scientific age. Dvořák somewhat exaggerates its immaterialism, but does not overlook another impulse that existed side by side with its urge to spiritualise and sublimate. In the distinction that he draws between its 'inductive' and 'deductive' aspects he recognises the essential part played in it by the direct, sensuous experience of nature. He is well aware that other-worldliness is not the whole of mannerism, that it is not a mere return to the Middle Ages, and that besides a Tintoretto and an El Greco it produced a Bruegel and a Bassano, and that Tasso and Cervantes moved within the same framework. Nevertheless, he assumes an overriding spiritual trend in mannerism, and in this he is wrong only to the extent that its spiritualism was not so specifically religious, as he claims, as generally intellectual. The vision with which mannerism is continually at grips is obviously of a supersensible nature, it is never completely absorbed in form, never completely mastered, but is always hinted at, and it produces the tension that Dvořák, under the influence of the anti-positivism and the anti-materialism of his generation,

calls 'spiritual' and is unable to explain except as an essentially religious unrest. In reality, however, this tension is not invariably directed to other-worldliness and is not always of a religious or mystical origin. It appears not only in artists such as Tintoretto and El Greco, but, behind the 'armour of reserve'[8] which is so characteristic of the courtly form of mannerism, also in artists as worldly as Bronzino and Parmigianino; and it is no less discernible in the intellectually apparently undemanding naturalism of Bruegel and Bassano than in the academic intellectualism of Vasari and Salviati. The art of the mannerist 'peasant painters' is certainly more spiritual, less naïve, because it is less homogeneous and more deeply affected by an unmistakable, if only indirectly perceptible, immaterial principle than that of the great idealists of the High Renaissance. The immaterialism of mannerist art does not necessarily imply ascetic renunciation of the world, a Platonic or Christian sense of transcendentalism, but merely a state of mind that is unable to find rest in any objective form of reality and apprehends the world and the self, the senses and the spirit, as inextricably interwoven and relative to each other. The world must therefore bear the mark of the spirit, the formative and simultaneously distorting element; it could not and should not be made to seem free of the opposition of the spirit.

In a discussion of Dvořák's theory of mannerism Rudolf Kautzsch[9] asks what there really is in common between the two trends of mannerism called 'inductive' and 'deductive', represented on the one hand by Bruegel and the definite naturalists of the school and on the other by El Greco or even a Bronzino. He asks whether there is really any stylistic connection between them; he doubts whether artists such as Bruegel and El Greco, not to speak of Shakespeare and Cervantes, should be classified as mannerists, and he would like to restrict the term to those who 'in some way really display "manner"'. In his view the term 'mannerism' should certainly not be applied to the art of the whole period which is claimed for it. He praises Dvořák's penetration in discerning that the spirituality of Michelangelo and Tintoretto led them into opposition to the Renaissance, but criticises him for treating this spiritualism, and the naturalism or, as the case may be, the formalism of the *maniera*, as equally important trends of the style in question. He also claims that the contrasting trends that Dvořák calls 'deductive' and 'inductive' have always existed, and says that, if in mannerism they are more sharply differentiated than elsewhere, he owes us an explanation of why this happened. However, it is not correct to say with Kautzsch that this contrast has always existed, and that in mannerism we are confronted only with a more accentuated form of a phenomenon familiar through the ages. The conflict of stylistic elements in mannerism is of a quite special kind; sensuousness and transcendentalism, naturalism and formalism, had never previously been so closely associated in the

same period—and it is Dvořák's merit to have discerned and emphasised this. Kautzsch is right only to the extent that the mere statement of the antithesis that Dvořák discovered in the simultaneous devotion to the world of mannerism and its turning away from it is no explanation. The question, however, is not answerable by the art historical method used in criticism of him.

The most important of the questions raised by Kautzsch which can be dealt with in pure art historical terms concerns the unity of mannerism throughout the century. Is it an essentially uniform style peculiar to the whole age covered by Dvořák and characteristic of a whole period of development? Is it, one may ask, in a spirit of loyalty to Dvořák's viewpoint greater than his own, a style that in the visual arts includes the period from the second decade of the Cinquecento until the end of the century and in literature from the appearance of Tasso to the decline of conceptualism and preciosity? Should all the artists affected by mannerism be known as mannerists? Can great artists in whose development mannerism was only one among a number of factors and whose work obviously extended beyond the bounds of mannerism be regarded as representatives of the style? Can the whole period in which manneristic art existed and flourished, though it certainly did not prevail without competition, be described as mannerist? Is it possible to speak meaningfully and unambiguously of mannerism in view of the development of different mannerist trends? In short, is mannerism a meaningful conception focusing on the essence of an age, or a mere summary description of a number of not strictly related artistic phenomena between the Renaissance and the baroque?

It can rightly be complained that there is no such thing as a clear and exhaustive definition of mannerism, but the same complaint can be made of every other style, for there is and can be no such thing. There is always a centrifugal tendency in the nature of any style, which includes a variety of not strictly adjustable phenomena. Every style manifests itself in varying degrees of clarity in different works, few, if any, of which completely fulfil the stylistic ideal. But the very circumstance that the pattern can be detected only in varying degrees of approximation in individual works makes stylistic concepts essential, because without them there would be no associating of different works with each other, nor should we have any criterion by which to assess their significance in the history of development, which is by no means the same thing as their artistic quality. The historical importance of a work of art lies in its relationship to the stylistic ideal it seems to be striving to achieve, and that provides the standard by which its original or derivative, progressive or retrograde, nature can be judged. Style has no existence other than in the various degrees of approximation towards its realisation. All that exist in fact are

individual works of art, different artistic phenomena differing in purpose. Style is always a figment, an image, an ideal type.

When the variety of the factors concerned is taken into account, the baroque, or the Quattrocento, or even the concept of the gothic or of romanticism, seem just as inconsistent and hard to reduce to a common denominator as mannerism. Nevertheless, it can hardly be doubted that it is sensible and useful to apply these concepts in connection with the artistic phenomena to which they refer. Mannerism as a movement is actually more uniform, continuous, and coherent than the baroque, and incomparably more homogeneous than romanticism, with all its national and local variations. Caravaggio, the Carracci, Bernini, Rubens, Rembrandt, Poussin, and Velazquez are no more the same kind of 'baroque' artists than Pontormo, Vasari, Tintoretto, Bruegel, El Greco, and Spranger are the same kind of 'mannerist' artists. Refusal to seek for what is common to the various trends and personalities, whether of the baroque or of mannerism, would leave one with a vague nominalism which made the concept of an artistic style impossible and put out of court the writing of art history in any real sense of the term. We should be left with no foundations on which to build, and no principle with which to differentiate between a sound synthesis and an arbitrary one.

The usefulness of the concept of style is that it establishes a unity where there is apparently no unity, but the artistic coherence of the works concerned is greater than their divergence from each other. The worst confusion in the historical treatment of mannerism was a result of its overlapping in certain phases of development with the Renaissance and the baroque. Artists readily identifiable as mannerists have been claimed now for one, now for the other of these styles, which for a time existed side by side and encroached on each other. But closer inspection reveals greater differences between them and the real representatives of the Renaissance or of the baroque than between them and other mannerists, with whom they are linked, not only by external contacts, but by a common purpose.

Mannerism remained the prevailing style in art for seventy or eighty years after the death of Raphael. During this period there are artistic phenomena that have little or nothing to do with mannerism, but they are few; and there is the more justification for speaking of mannerism as the predominant style of the period as hardly any important or progressive artist was uninfluenced by the movement, its cultural problems, and the revolution in taste associated with it. The individual artists were of course mannerist in varying degree, just as since the end of the Middle Ages and the Renaissance they had been participants in other styles in varying degree, and were to be classicists, romantics, or naturalists in varying degree in the future. Michelangelo, to quote the most disputed example, can undoubtedly be described as a mannerist in certain phases of his

development, though at no time of his life was he a mannerist exclusively and the non-mannerist characteristics of his art were certainly more remarkable than those which can be called mannerist; and this view remains unaffected though in other artists, such as Tintoretto or El Greco, the same mannerist characteristics are among the most significant. It is only with reservation that any great artist, like any average or only minor artist, can be classified under any particular style, whether it be mannerist, baroque, or Renaissance. Michelangelo burst through the framework of mannerism, not because he was an incomparable and unique genius, and not because mannerism, considered to be a derivative and decadent style, was inappropriate to him, but because no individual, whether important or unimportant, complicated or simple, can be fitted into an abstract category, such as every artistic style is, and still retain his identity as a spontaneous, creative personality. But the question of the relationship between a style and the artist's personality belongs to the field of the psychology of art rather than to that of the history of style. What we are concerned with here is the fact that from the third decade of the Cinquecento onwards stylistic peculiarities prevail which are common to the works of the most varied artists, and these justify the concept of an individual style clearly distinguishable from the Renaissance and the baroque. In view of this it is immaterial whether one or other of Michelangelo's or any other master's works displays more or less of these mannerist characteristics, or whether the master concerned followed the mannerist trend during a longer or shorter phase of his development.

The age of mannerism begins with a remarkable lack of stylistic uniformity. Trends deriving directly from the High Renaissance are often indissolubly entangled with others which proclaim the advent of mannerism on the one hand or of the baroque on the other. At the beginning of the period mannerist and baroque trends are just as closely intertwined as they are at the end. In the later works of Raphael and Michelangelo the two are scarcely distinguishable from each other, and even at this early stage the passionate expressionism of the baroque competes with the intellectual refinement of mannerism. The two post-classical styles begin with the intellectual crisis of the first decades of the century—mannerism as the expression of the conflict between the spiritual and sensual impulses of the age, the baroque as the resolution of that conflict on the basis of spontaneous emotion. The latter was for the time being unacceptable, but finally prevailed after the seventy- or eighty-year-long predominance of mannerism. Some critics explain mannerism as a reaction against the early baroque, and the high baroque as a counter-movement which then superseded mannerism again. [10] In that case the history of sixteenth-century art would turn on a repeated clash between the baroque and mannerism, with initial success going to the latter and final victory to the former. But

20

then the early baroque would have had to precede mannerism, which it did not, and mannerism would have been no more than a passing phase.[11]

Nothing parallel to the sixteenth-century coexistence of styles—the Renaissance, mannerism, and the beginnings of the baroque—had previously existed. There had, of course, been stylistic differences, corresponding to trends and schools of varying degrees of progressiveness and sections of the public of differing degrees of education. There was the really creative art of the intellectual *élite*, and a qualitatively inferior and backward art of the semi-educated, but clear-cut differences of style unaccompanied by qualitative differences had not previously coexisted. Such stylistic divergencies imply an awareness of style which became evident when artists first consciously deviated from nature and assumed a critical attitude to tradition—in other words, with the arrival of mannerism. Previously artists had not been conscious of the stylistic trend of their own period, which they took for granted, as a matter requiring no explanation or reflection, for they were not aware of having any choice. But with mannerism style became a programme, and therefore problematical. The art of earlier periods, and in particular that of the immediately preceding generation, that of High Renaissance classicism, became a matter of deliberation, on which artists had to take their stand; and with that the phenomenon of historicism made its appearance in the field of art. Men became aware of history, and of being conditioned by the historical circumstances of their time, and this was to become a vital factor in artistic development. Earlier stylistic periods had also stood in a relationship of dependence or opposition to the art of preceding periods, but in mannerism there is a deliberate reaching back to an earlier style, which is either regarded as a model, or is accompanied by an intentional and often ostentatious deviation from it. With that art lost its unproblematic nature, and henceforward its spontaneous, naïve relationship to earlier forms becomes rarer and rarer. Thus to mannerism the art of its time appeared to be bound up with a particular historical situation, and the art of the past seemed to it to have been the product of historical forces in the same way. It is therefore highly intelligible that the period of mannerism should have seen the origin of art history as a literary form, and that its first distinguished representatives, Vasari and Karel van Mander, should have been mannerists.

Another question arises in this connection. Even if the concept of mannerism as a homogeneous style is accepted, the question remains open whether and to what extent it is possible to talk of its contemporaneity in the various arts and, if such contemporaneity cannot be seen to exist, whether the whole assumption of a general historical basis of artistic development should not be abandoned. Stylistic development in the various arts never takes place simultaneously, however, even if a lag of

fifty years such as that between the end of mannerism in the visual arts and in literature is an exception, and the interval of a century, such as that between the end of baroque painting and that of baroque music, is a quite special case. But even divergencies as great as these do not imply anarchy; on the contrary, there are good reasons for them, and the principle of stylistic uniformity and of the overriding historical definition of artistic development are not abolished by them, but merely modified. In any case, even when there is a parallelism in stylistic development between the various arts, it is not to be expected that an idea, a feeling, or vision will be rendered in each with the same completeness, directness, and intensity, for rendering the same content in words, colours, or tones is an entirely different thing. Every art form, apart from following the trend and tempo of stylistic development in general, follows its own course, determined by its own technique, past history, and social function. All the arts take part in the general historical and social process on the basis of their own premises. The individual stages of stylistic development will therefore diverge in each case, and the 'impressionism' discernible in Velazquez, Frans Hals, and Rembrandt, for instance, will be sought in vain in baroque literature and music. And thus a phenomenon such as the complexity of mannerism and its entanglement with the Renaissance and the baroque will be found in the various arts in various degrees and expressed in different ways.

II

The Disintegration of the Renaissance

1. ANTI-CLASSICISM

THE history of art has always alternated between pursuit of tradition and revolt against it. For thousands of years this process took place in complete spontaneity, that is, with the feeling that in the given situation there was no alternative to the direction being followed. The problem of whether and to what extent the existing artistic tradition should be continued first arose with the disintegration of the Renaissance. Artists suddenly found themselves faced with the choice between trodden and untrodden paths, and out of this the cultural problem of the Renaissance arose. Might not swimming all too easily with the stream of tradition involve abandoning the best in oneself? On the other hand, if all models and precepts were repudiated, how avoid the abyss of one's own internal chaos? Men began to see that tradition could be a dead hand, but also that it could be a defence against all too unruly innovation—for innovation was now suddenly felt to be the basic principle of life and at the same time the most dangerous threat to it. This complex dilemma provides a clue to mannerism. Its imitation of classical patterns served as a refuge from the chaos of creativity in which men feared to lose themselves. Its exaggeration of the subjective, its ostentatious arbitrariness, the inexhaustible devices of its interpretation of reality, expressed the fear that form might fail in the face of the dynamism of life and become ossified in humdrum beauty.

Conscious artistic creation is always associated with problems related to the choice of means which best accord with the specific artistic purpose. But the cultural problem in art arises only when the artistic purpose to be pursued is itself in question, when not merely artistic methods but artistic

23

aims have become problematical. The question that mannerism sought above all to answer was whether artistic aims such as those of the Renaissance were worth pursuing, and whether attaining them meant attaining a higher level of humanity, a fuller possession of life, a more sublimated form of the human spirit. The attitude of the new generation to these aspirations was full of doubt and mistrust, and was essentially negative.

The anti-classicism of mannerist art basically implied the repudiation of the universal human validity of the art of the High Renaissance, its validity as representing the ideal and supreme pattern to be followed. It implied abandonment of its principles of objectivity and reason, regularity and order, and the loss of the harmony and clarity characteristic of its slightest creations. The most striking feature of mannerist anti-classicism, however, was its abandonment of the fiction that a work of art is an organic, indivisible, and unalterable whole, made all of a piece. The characteristic anti-classical work of art is composed of the most varied and heterogeneous elements, all more or less independent of each other. It is a dogma of text-book aesthetics that it is impossible to add to or subtract from the individual components of a work of art without endangering the artistic value and effect of the whole; this applies only to a relatively small number of works created in accordance with the purest classical principles. To the work of artists as important as Shakespeare, Cervantes, or Bruegel, for instance, it cannot be applied at all. Indeed, in the history of art the 'inorganic' structure characteristic of mannerist works seems to be the rule rather than the exception, and the few typical creations of classicism provide no justification for concluding that the essential aim of art is to abolish the luxuriant creativity and the unrestrained anarchy of life. On the contrary, throughout long periods of its history art has been directed to preserving as much as possible of the chaotic and inexhaustible riches which classicism, by its crystalline forms, tries to conjure out of existence; and one of the strongest impulses behind mannerism must have been the consciousness of the loss to art implied by classical rules and restraints felt by the generation growing to maturity at the time of Raphael's death.

A classical work of art is a synthesis. It is directed towards the rendering of things regarded as the quintessence of life. The objective is to leave out nothing essential, and to dismiss from the picture of reality everything inessential, accidental, and marginal, everything in fact which might seem disturbing, bewildering, or irrelevant. A classical work of art seizes on what is assumed to be the core and centre of life, round which all its components pivot. Properly, it does not consist of various parts or of separable details, but unfolds a vision of life regarded as unitary, revolving round a centre. Rich as it may be in individual features, it remains essentially uniform, and, however sparing in subject-matter it may be, it is always complete. All the marks of the adventitious, the improvised, and the pro-

visional have been eliminated from its formal structure. In contrast to this synthesis, the objective of an anti-classical mannerist work of art is the analysis of reality. Its aim is not the seizure of any essence, or the condensation of the separate aspects of reality into a compact whole; instead it aspires to riches, multiplicity, variety, and exquisiteness in the things to be rendered. It moves for preference on the periphery of the area of life with which it is concerned, and not only in order to include as many original elements as possible, but also to indicate that the life that it renders has no centre anywhere. A mannerist work is not so much a picture of reality as a collection of contributions to such a picture. The more original, the stranger, the more sophisticated, the more puzzling, the more demanding these are to the discriminating mind, the greater is their value—their non-classical value. It is this, and not universal validity, that is the test.

Nothing better illustrates the synthetic nature of a classical work of art than its microcosmic quality. The threads connecting it with external reality seem to have been broken; all those that run through its texture are connected with each other and form a self-contained unity complete in itself. Nothing in it points to anything outside it, and there is no indication of anything that is missing or needs to be added. In contrast to this, a non-classical work always seems like an open, incompleted system, no matter whether the incompleteness is attributable to an unmastered abundance of experience or to an intellectual conception the breadth and depth of which have burst the classical bonds. Consciously or unconsciously, non-classical art abandons the fiction that artistic creation constitutes a self-contained world with impassable boundaries, a precinct which, once having been entered, cannot be left again. Mannerism permits—and often actually calls for—occasional interruption of the illusion of art and return to it at pleasure. Play with different aspects and attitudes, with fictitious feelings and 'deliberate self-deception'[1] is in mannerism so closely associated with artistic appreciation as to seem to be totally irreconcilable with the conceptions of classical aesthetics. A mannerist work of art, in short, is no holy of holies you enter in solemn awe and reverence, leaving all mundane and trivial things outside; rather, to use the well-known mannerist image, it is a labyrinth you lose yourself in and do not seek to escape from.

The mannerist revolt against Renaissance classicism was directed chiefly against the over-simplification it imposed on the variety of phenomena. In every mannerist work the artist seems to be trying to demonstrate that artistic values do not have to be, or actually cannot be, simple. For if, as has been said, the truth is never simple, art is rarely simple. Mannerism rejects the fiction of necessity in art just as firmly as it rejects simplicity. In the artistic creation of a mannerist nothing can be assumed in advance, his work grows from the outside as well as from the inside, and much

25

more from the former than the latter, and the frontiers are never rigidly and unalterably drawn. Here and there the work is broken and torn, and it bleeds, it bleeds wherever the skin is broken, but does not bleed to death, because each part has its own vital nerve and its own cellular life. The clue to this structure lies in what Paul Valéry wrote of Marcel Proust:

> L'intérêt de ses ouvrages réside dans chaque fragment. On peut ouvrir le livre où l'on veut; sa vitalité ne dépend pas de ce qui précède . . . elle tient à ce que l'on pourrait nommer *l'activité* propre du tissu même de son texte.[2]

At first sight this sounds like a commonplace. How often has one heard the phrase: 'No matter where one opens the book. . . .' In reality, however, nothing is rarer than a work of art so overflowing with life that it bleeds wherever it is pricked. Loosely constructed works consisting of more or less independent parts occur, of course, much more frequently than those made all of a piece, but in relatively few does the 'blood flow' everywhere; few abound with the same energy and vitality at every point. But that is how the great works of mannerism are made. Their overwhelming effect has nothing to do with classical aloofness, or with impeccability of form, unity, homogeneity, and subordination. In the formal respect many much more insignificant classical works are often incomparably more successful, more balanced, and more independent, more self-reliant, in relation to external reality.

The basic principle of classical art is correctly described as mastery of form, in contrast to the formal anarchy of mere expressionism or the proliferation of content in naturalism, but abstract formalism is just as anti-classical as is lack of form. Both represent a disturbance of the equilibrium between form and content that is always preserved in the classics. In mannerism, idea and experience, the imitative and expressive, often take completely second place to compositional and ornamental arrangement; and the decorative form does not arise from the nature of the objects rendered and their real relations to each other, but is imposed and forced on them in such a way that it remains alien, arbitrary, and playful. In painting, this formalism appears in the tendency to make the ornamental pattern the basis for the construction of the whole picture, in architecture in the independent life and purpose given to certain structural elements, and in literature in the play made with associations of ideas and the accumulation of images and metaphors for their own sake. In each case the form is no longer a means of mere representation, and the formal devices assume an independence of their own, that is to say, a function is transformed into an end in itself, permitting the observer to forget the content and to be absorbed in the manner of its rendering. The only meaning and justification of a form consists, however, in its serving as a means of expression, its communicating a message, a sense and philosophy of life; in itself it is

no more than an obsession, a game of make-believe, with fictitious problems and difficulties. In formalism the methods employed cease to serve any ulterior purpose; they tell us nothing about the nature of the objects rendered; the composition articulates nothing, the light illuminates nothing, the colour models nothing. The formalism of mannerist art indicates no desire to impose order, and no belief in the predominance of form over matter; it expresses no spontaneous sense of discipline, but is purely a compensation, or rather an over-compensation, for the lack of any such desire, belief, or sense. The form, order, and system of decorative relationships do not arise out of the work of art as its central principle, but are imposed on it, out of fear that it might collapse and dissolve in anarchy.

There is, however, yet another respect in which mannerism is unclassical *par excellence*. Apart from the value of its artistic products, it is unauthoritative and unbinding on the nation, the culture and the language of its origin; it is not exemplary and representative, in the sense that 'classical' art is. T. S. Eliot must have felt this when he said that, in spite of his greatness, Shakespeare was no 'classic'.[3] Mannerism is not normative, and Shakespeare is not a continuable poet; he is a genius who soars above his nation, but is not its preceptor; also he embodies the paradoxical nature of mannerism in the sense that he states absolute artistic values in enigmatic terms, and that, in spite of the joy that is in him, there is always a sense of unease as well.

The style developed in their old age by great masters such as Titian, Velazquez, Frans Hals, and Rembrandt has been described as 'impressionist', but the looser, freer, in a certain sense more improvised, style at which they finally arrived could also be called 'mannerist'. A departure from classicism is common to them all; and a similar departure in personalities such as Goethe and Beethoven, who had deeper roots in classicism, is even more striking and significant. In their late works they abandoned not only classical equilibrium of form, but also pleasing and flattering harmony; their manner of presentation became more abrupt and their tone harsher. They built atectonically, expressed themselves in sharp contradictions and—this applies particularly to Beethoven—made free use of fantasy and quasi-improvisation. Neither Beethoven nor Goethe were of course anything resembling mannerists in any phase of their lives, and mannerism helps in no way to explain their art. But the style of their old age undoubtedly throws a sharper light on certain characteristics of mannerism.

2. ANTI-NATURALISM

Friedländer's summing-up of mannerism as anti-classical also implied its anti-naturalism. For the classicism of the Renaissance, like that of

antiquity, was essentially naturalistic. It idealised, stressed, and elevated the significance, beauty, and range of natural phenomena, but also remained within the boundaries of the natural and the plausible. Its ideal of beauty implied a certain departure from ordinary reality, a selection of the features to be exploited; but its rationalism and objectivity permitted nothing that conflicted with reality. Its formal rigour, its sense of order and proportion, involved a certain tension in relation to reality, but within the bounds of classical art there was no breach with it. It may have renounced certain elements and aspects of experience, but it never denied or falsified them. Instead it strove at all costs to preserve the fiction of fidelity to nature.

In mannerism we are for the first time confronted with a conscious and deliberate deviation from nature; that is to say, with an abandonment of fidelity to it that is based neither on lack or limitation of artistic ability, nor on purely ideological, non-artistic considerations arising essentially from the historical situation or the prevailing philosophy of life. It arose instead from an urge for expression that, in order to validate itself, deliberately renounced the known and familiar picture of things. In previous ages, even when art was unnaturalistic, artists always believed themselves to be rendering what they really saw with their physical or spiritual eyes and, often in spite of the boldest stylisation, did not doubt that they were pursuing objective reality. Now the fundamental difference between art and reality began to be perceived for the first time, and divergence from nature was made the basis both of artistic practice and theory. With that, however, art entered a phase of development that can be called critical in more ways than one. For, if spontaneity is regarded as a 'natural' quality of the artistic attitude, the mere circumstance that mannerism was associated with a conscious purpose, and that not only the choice of means but also that of ends had become a matter of deliberation, can be regarded as a critical symptom. In this sense mannerism was a totally new and unprecedented phenomenon, the first sophisticated, deliberately adopted, artistic style of the western world, the first in which one has the feeling of conscious choice rather than of necessity, of driving rather than of being driven, of the spontaneous impulse being subjected to control.

But the question of spontaneity in art is just as difficult as that of sincerity. Apart from the fact that the value of sincerity is itself problematical in this context, there is no criterion for differentiating between the sincere and insincere in a work of art, between that which derives from feeling that is genuine and that which is fictitious;[4] and it is just as hard to draw a line between so-called spontaneous artistic production and that which is stylistically self-conscious, that is to say, is no longer based on a naïve relationship with nature. Who can say when and where non-spontaneous, sophisticated artistic production began, or whether such a thing as com-

pletely naïve, 'instinctive' artistic production ever existed? However that may be, with mannerism a revolution in sensibility enters the history of art, and the breach between art and nature, spontaneous reaction and critical reflection, unintentional and deliberate divergence from nature, becomes strikingly deeper.

To the mannerists the meaning and object of art was to make something of reality that it is not and cannot be. In contrast to the stylistic ideal of the Renaissance or the baroque, however, they did not wish to elevate it to a higher human, or even superhuman plane, but tried rather to create a world between the natural and the supernatural, a world of pure illusion, in which everything that seemed to them to be unacceptable in ordinary reality was put right, or at any rate altered, distorted, and subjected to an artificial order. To them artistic form was primarily neither a means of imitating nature nor a means of self-expression, nor was it a method of idealisation and stylisation; rather was it a vehicle for escaping from a world that seemed to them to be alien and often very questionable, of ridding themselves of it in one way or another, either denying it or ignoring it in dream-like sublimation or high-spirited play.

The mannerists must have been well aware that even the naturalism of the Renaissance did not represent a completely pure and unbiased approach to nature, but in any case they set out to widen the distance between nature and art. In their eyes the very fascination of art lay in the tension between its wilfulness and reality, the abolition of the objective laws of experience and their replacement by rules of the game imposed by themselves. Their purpose was, not so much to concentrate on internal rather than external reality and to subject the world to their inner needs, as to cast doubt on the validity of any objectivity. The age had lost confidence in the unambiguity of facts, had lost the sense of actuality altogether. The boundaries between being and appearance, experience and illusion, objective statement and subjective fantasy, had grown blurred, and it began to be suspected that even the most objective picture of reality was a product of the mind, and was therefore partly fiction and illusion, not separated by an abyss from the world of fantasy and dream, masquerading and acting. All this led, not merely to the individual's sense of his subjective potentialities and an attitude of mere indifference to objective facts, but also to resentment of the latter, a reluctance to following them and reconciling oneself with them.

The unnaturalistic peculiarity of mannerism also appears in the fact that the origin of artistic creation is not nature, but something already fashioned out of it. In other words, the mannerists were inspired less by nature than by works of art, and as artists they were not so much under the influence of natural phenomena as of artistic creations. Wölfflin's remark that a picture owes more to other pictures than to the painter's

observation of nature is nowhere better justified than by them.[5] They also provide corroboration for Malraux's dictum that the painter is in love, not with landscape, but with pictures, that the poet cares nothing for the beauty of the sunset, but so much the more for the beauty of verse, and that the musician is interested, not in the nightingale, but in music.[6] Marino explicitly confesses to plagiarism when he says: 'I do not deny having sometimes merely imitated, either giving new form to old things or clothing new things in an old manner.'[7] There should be no hesitation in admitting that mannerism is derivative and draws its inspiration, not from nature, but from other styles. That, however, in no way detracts from its value. Works of art always intervene between the mannerist and his natural experience, but that does not mean that anything intervenes between him and his own works. However indirect his relationship to the world is, his relationship to his own art is immediate and direct.

And, however devious his experience of nature may be, he is never completely cut off from it. For all the unnaturalistic features of his style and the vagueness of the very conception of naturalism in his eyes, there is no denying that mannerism is rooted in a naturalistic tradition which its representatives can never entirely shake off. They remain attracted by the immediate experience of reality just as often as they are put off by it. Not only is the dream a favourite subject of mannerism, whose sense of life it perfectly epitomises with its fusion of semblance and reality, but also it represents one of its fundamental stylistic principles by reason of the abstract connections it establishes between concrete facts. In its bold, unreal, fantastic framework details are often rendered with uncommon sharpness and extreme realism, thus maintaining close similarity to the structure of dreams.

The mixture of stylistic trends characteristic of mannerism manifests itself, not only in the presence side by side of naturalistic and completely unnaturalistic tendencies, schools, and works, but also in the different levels of reality that appear in one and the same work; for even different parts and layers of the same work may deviate from reality in different degrees. The dissimilar quality of stylistic elements in mannerist works is, however, inadequately described by stating only that some parts are completely true to reality while others are stylised and actually distort or deform reality. Not only are there different degrees of realism in different areas of the same picture and different degrees of deviation from the norm in the inconsistent proportions, but yet another characteristic of this stylistic diversity is the differing degrees of substantiality given to the different groups of figures in the picture. Works of the masters of later mannerism, such as Tintoretto, El Greco, Wtewael, and Bellange, and sometimes also of earlier artists such as Pontormo and Parmigianino, display completely substantial, plastically conceived figures side by side with others that are

phantom-like, dematerialised, shadowy, and transparent, as if sketched in with chalk. This often gives the whole picture a weird or visionary quality, sometimes creating the impression that unreal, dream-like figures are taking part in a real event, or that we are faced with a super-natural vision some parts of which have been seen in sharper outline than others.

It is often hard to tell whether this diversity of style is mere play with various manners or is intended to imply that a work of art is not a unified, completely integrated and articulated formal structure conveying a picture of reality in accordance with the concepts of classicism, in short, that mannerism has aims other than that of stylistic logic. Generally, the mannerist variety of style is both playful and serious, a juggling with different techniques, and an indication that the artist's aim is not the creation of a total illusion or the undistorted reproduction of a section of reality.

3. THE BIRTH OF MODERN MAN

The subject of this study is the period in the history of ideas that saw the birth of modern man, and its object is to work out the implications of that event. The sixteenth century has been labelled before as the beginning of the modern era, and still is generally so described, but the mistake made is that precisely those things that are usually held to have constituted its modernity[8] had to be overcome before the way was open for the appearance of modern man and his new and radically transformed attitude to life. It was the break-up of the Renaissance and not, as is nearly always assumed, the Renaissance itself that created the conditions for the modern age. The man of the classical phase of the Renaissance was still the man of the past, the heir of antiquity and the Middle Ages, on the whole unaffected by the spiritual crisis of modern times and their conflicting aims and values. The Renaissance still thought and felt practically in terms of traditionalism and Christian dogma and was governed by the cultural authoritarianism and the economic forces of the Middle Ages. In fact, it still belonged to the Middle Ages, or at any rate belonged to them more closely than to later times. The term 'modernity' can correctly be applied only to the post-classical phase of the sixteenth century. The modern world was built on, though partly out of, the ruins of the Middle Ages and the Renaissance; and, if the achievements of the Renaissance were not lost in the new age, the spiritual heritage of the Middle Ages was partly preserved too.

In over-estimating the significance of the Renaissance for the present day we are in many respects the victims of an optical illusion. We are still

too close to the period that rediscovered, revalued, and rehabilitated it after the period of indifference that resulted from the general disillusion of the nineteenth-century counter-revolutionary period. The Renaissance, as we regard it today, was not only rediscovered but was also in part re-invented by the philosophy of history that ensued from the political and social development of that time. The Renaissance discovery of nature was an invention of nineteenth-century liberalism, which played up the natural and nature-enjoying Renaissance against 'medieval alienation from nature' in order to use it as a weapon against reactionary romanticism. For the emotional origin of Michelet's and Burckhardt's thesis of the Renaissance 'discovery of the world and of man' was partly a defence against the use made by romanticism of the Middle Ages as a means of propaganda against the spirit of the revolution. The theory that naturalism originated in the Renaissance derives from the same impulse as do the theories that the struggle against the spirit of authority and hierarchy, the idea of the free-dom of thought and of conscience, the emancipation of the individual, and the principle of democracy are all Renaissance achievements. In this his-torical picture the light of the new age is in every instance contrasted with medieval darkness. In Michelet, the coiner of the phrase *découverte du monde et de l'homme*, the link between the concept of the Renaissance and the ideology of liberalism is even more striking than it is with Burckhardt. It is sufficient to run one's eye down his list of representative figures of the Renaissance, which includes the names of Rabelais, Montaigne, Shake-speare, and Cervantes side by side with those of Columbus, Copernicus, Luther, and Calvin, and includes that of Brunelleschi, for instance, as the destroyer of the gothic, to convince oneself that in his mind they con-stituted above all the family-tree of liberalism. As in the eighteenth cen-tury, the enemy was still clericalism, only the struggle for enlightenment was now aggravated by the bitter experiences of 1848 and the conse-quences of yet another unsuccessful revolution.

Attention has frequently been drawn to the errors and omissions in Burckhardt's classical picture of the Renaissance, but it is seldom recog-nised that we are still under the influence of his misinterpretation—which incidentally was that of his whole generation—in that we misconceive the relationship to each other of the Middle Ages, the Renaissance, and the new age. If there is a watershed in the history of the west marking the boundary between the modern world and that of the Middle Ages, a much more striking one than the Quattrocento is the end of the twelfth century, which saw the reconstruction of the cities, the beginnings of bourgeois culture and of the new money economy, the premonitory signs of the break-up of feudalism, the rudimentary beginnings of lay education, and the naturalism of the gothic. If one overlooks how many of the achieve-ments claimed for the fifteenth century were of medieval origin, one can-

not help both over-estimating the importance of the Renaissance and under-estimating the importance of its crisis and disintegration for the origin of the modern world.

The spirit of modern times, like that of the Renaissance, is, in contrast to that of the Middle Ages, basically rationalist, empirical, anti-traditionalist, and individualist, but also, in contrast to the Renaissance, it tends irresistibly towards irrationalism, anti-naturalism, traditionalism, and anti-individualism; and, because of this conflict, it has been involved in continual crises ever since its origin. The *querelle des anciens et des modernes* in French seventeenth-century literature, the struggle for enlightenment of the eighteenth century, the romantic revolution in the nineteenth, and the relativism of the present day are only repetitions of the crisis of the Renaissance, which was the first cultural crisis of general European significance since the decline of antiquity, and it is with it that the history of the modern western world in reality begins. It is only since the standards of rationalism, naturalism, objectivism, and individualism which were partly created and partly developed by the Renaissance became problematical, and not since their discovery and adoption, that it is possible to speak of modern man.

Nothing better illustrates the cultural transformation that took place in the course of the Renaissance than the change that came over the concept of individualism. Individualism is, of course, a phenomenon of a kind to which no historical beginning can be attributed. There have always been individuals who were distinguishable and distinguished themselves from others, and ever since man lived in a state of nature there have obviously been those willing and able to lead others, and a similar state of affairs exists even in the animal world. But being an individual, or even a strong personality, is one thing, and believing in individualism another. Ever since human history began there have been leading personalities, that is to say, individuals in the truest sense of the word, but it is only since the Renaissance that there have been individuals who were not just aware of their individuality, but deliberately cultivated or sought to cultivate it. Previously there had merely been individuals; henceforward there was individualism. The latter can be said to exist only where there is reflective awareness and cultivation of the self, and not merely individual reaction to impressions and stimuli. Self-awareness began with the Renaissance, though the Renaissance, in the sense of individual self-expression, did not begin with individual self-awareness. The expression of personality in art was pursued and appreciated long before it was realised that the standard being applied was a subjective 'how' and not an objective 'what'. In other words, the objective truth of a work of art went on being talked about long after art had established itself as subjective self-expression.

The great revelation of the Renaissance was the spiritual energy and

33

spontaneity of the individual, and its great discovery the idea of the genius and that of the work of art as his creation. To the Middle Ages, which saw no inherent value in originality, were hardly touched by the idea of intellectual competition, and regarded imitation, or even plagiarism, as perfectly acceptable, the idea of the genius was completely alien, though it is a romantic exaggeration to describe medieval art as fundamentally anonymous. In the field of book illumination there are many works dating from every period of the Middle Ages, the producers of which are known by name. There was nothing inherently attractive about anonymity in medieval times; it was accepted, but not pursued. On the contrary, men liked having their names mentioned; it was a valued distinction, which the clergy, in their capacity both as patrons and chroniclers, generally granted only to their fellow clerics. However that may be, it would be pure blindness to say that, as a consequence of the dominance of tradition, school, the prevalent historical or local style, the rules of the masons' lodge and the workshop, or church doctrine and the scholastic cult of authority, individual differences in medieval art did not exist. Nevertheless, if there is one way in which the approach of the Renaissance is unmistakable, it is in relation to individualism. Not only does the individual artist become aware of his individuality and insist on the rights deriving from it, but on the part of the public there is a shift of attention from the work of art to the artist's person, and everywhere the concept of the creative personality comes to the fore.

Burckhardt's view of the Renaissance as an age of individualism requires to be corrected and supplemented in two respects, however. In the first place, as we have seen, the idea of individualism was not completely alien to the Middle Ages, though the individual did not attach any particular importance to his individuality, and still less had any idea of emphasising or cultivating it. In the second place, the medieval idea of art as a form of activity based on tradition and craftsmanship survived for a long time, and even after the end of the Middle Ages the subjective view of artistic creation established itself only slowly. But, as soon as the individualist outlook came fully to prevail, a critical phase set in. Renaissance individualism reached its culmination in the concept of the genius, which implied the possibility of conflict between the creative personality and rules, teaching, and tradition, and made the artist more important than his work. Thus the seed of crisis and dissolution was already contained in it. The concept of genius represented a decisive step in the history of individualism because it involved the transfer of all the emphasis from the artifact to the artist and his personality, from the artist's achievement to his ability, from the success of the work of art to its creator's purpose. This step could have been taken only in an age which had developed an absorbing interest in self-expression for its own sake, an interest that far

exceeded that in the objective content of the artifact. But this brought it very near to losing its great gains. Individualism, which should have brought about equilibrium between the personality and the work of art, led to a fateful tension between them, and finally to the suppression of one by the other.

Michelangelo claimed to paint *col cervello* and not *colla mano*, and would have liked best to have been able to conjure forth his figures from the marble block by the sheer magic of his vision. This was more than mere artist's pride or awareness of superiority to the ordinary artisan or guild craftsman, more than a sense of being different from others and possessing the ability to create works the spiritual quality of which was more real than their material shape and had deeper roots in his own mind than in any spiritual heritage in which others too might share. For here there proclaimed itself a fear of contact with ordinary reality, a fear of being contaminated by the world and taken possession of and misused by ordinary men. With this a degree of sovereignty was proclaimed in comparison with which all previous claims to liberty and individualism seemed empty and insubstantial. This was the complete emancipation of the artist, and he was now indeed the genius he had been held to be since the beginning of the Renaissance. The last step had been taken in his ascent, and the object of worship was no longer art, or the artist's work, but the artist himself.

Michelangelo was the first modern, lonely artist driven by his inner daemon, not only because of his obsession with his art and because nothing existed for him apart from his 'idea'; not only because he felt himself to be under a deep obligation to his talent, and recognised in it a power higher than himself, his will, knowledge, and judgment, but also because with him individualism attained its really modern, problematical form, bursting the bounds of the Renaissance concept of equilibrium between work and personality, performance and potentiality, aim and success. When the burden of the conflict between the Christian and pagan elements in Renaissance art grew too much for him and he took refuge 'in the arms of Christ', he did not feel this to be an act of desertion; he felt he was being true to himself, or rather that it was the only course open to him if he were to remain true to himself. In earlier times, not only in the Middle Ages, but also in the Renaissance, an artist who abandoned his calling would simply have ceased to be anything at all, but Michelangelo could do so and remain the same formidable, 'divine' figure he had been while still practising his art. In the Middle Ages it would have been hardly conceivable that an artist could serve God other than through his art, and even in the earlier phases of the Renaissance, when religious and social ties had begun to relax, it would have been hardly possible for a man to maintain himself outside and apart from his calling. Not till the Renaissance cult of genius established itself did it become possible for an artist to accumulate a fortune, as

Michelangelo did, or to find lavish patrons, as did Parmigianino, or to put up with failure after failure and lead a doubtful and hazardous life outside the social order for the sake of loyalty to his ideas, as did Pontormo.

The artists of the mannerist period sacrificed practically everything that had given security to the artist-craftsmen of the Middle Ages, and in many respects also to the Renaissance artists who were still not yet completely emancipated from the artisan status; that is to say, their assured position in society, the protection of their guild, their unambiguous relationship with the church, their unproblematical attitude to the rules of faith and artistic tradition. Individualism provided them with innumerable possibilities not open to the artists of earlier times, but their newly acquired liberty was also a void in which they often came close to losing themselves. The spiritual upheaval of the sixteenth century, which forced artists to abandon their Renaissance ideals and reorient their vision of life, made it impossible for them to place implicit trust in outside guidance, and they were unable simply to fall back on their own impulses. They were torn between coercion and anarchy, and were often defenceless in the face of the chaos which seemed to be threatening the spiritual world. In them we meet for the first time the modern artist, divided between his ties with the past and his rebelliousness, his subjective exhibitionism and his ultimate, insuperable reserve.

With that the third and last phase was reached in the history of the individual's relationship to himself, the phase in which individualism itself became questionable, having been driven to absurd extremes, its characteristic representative being the individual alienated from himself. The crisis expressed itself in two ways—either by the exaggeration or by the suppression of individualism; mannerism provides innumerable examples of both. Most mannerists either over-strained their individual peculiarities and succumbed to extravagances of a purely personal kind or, denying their own nature, submitted to outside influence. But both their individualism and their flight from it meant the collapse of the Renaissance ideal of the artist's personal liberty, originality, and self-assertion.

Modern individualism, with its problematical nature, continually oscillating between revolt and conformism, now rebelling against ties, now putting itself in fetters, is a creation of mannerism. Since the mannerist age western culture has never fully recovered from the crisis in the relationship between the individual and his spiritual allegiances, whether of the past or the present. Mannerism became its doom, though it was also a source of renewal and new depth. Tintoretto, Bruegel, El Greco are the first modern artists; Shakespeare, Cervantes, John Donne the first modern poets; Montaigne, Machiavelli, Galileo the first modern thinkers; they are all typical representatives of mannerism. With them there begins the history of modern art, which combines spiritualism and naturalism, expres-

sionism and formalism, intellectualism and irrationalism; and the history of modern literature, with the first modern tragedies, the first great examples of humour, the first modern novel. Modern anthropology and psychology begin their triumphal march with the creation of figures such as Don Juan, Don Quixote, Faustus, and Hamlet, who, embodying as they do the human problem of the time, have become the most impressive symbols of modern western man. Scepticism makes its first appearance as an epoch-making intellectual force, and as the basic principle of modern epistemology; and Machiavelli's psychological and moral relativism, his discovery of the phenomenon of ideology and 'rationalisation' in the psychological sense, become the methodological foundation of critical thought. With all this there also emerge a previously unknown intimacy and sensibility, a nervous tension and susceptibility that is as full of promise as it is of danger, and an incomparably more personal, though more obtrusive and challenging, mode of expression. The result is a way of thinking, feeling, and writing that make Renaissance individualism seem completely out of date and all the subjective elements in the art and literature of earlier times frigid and remote.

4. MANNERISM OR MANNERISMS?

Anti-classicism is such a prominent feature of mannerism that it is easy to fall into the error of regarding it as a mere epilogue to classical periods and thus a regularly recurrent phenomenon in the history of styles. Wölfflin described the baroque as a typically recurring trend, and accordingly developed the theory that in every comprehensive period in the history of art a classical is necessarily followed by a baroque phase; and in the same way mannerism is regarded today as a general stylistic tendency, not bound to any specific historical conditions, but as invariably appearing in similar circumstances. More or less identical formal principles are assumed to have been followed in late antiquity, the late gothic, and the late Renaissance, and it is held that they are coming to the fore again in our own day for the same reasons of periodicity.

In literature in particular it has been claimed that every age has its 'excrescences' similar to mannerism;[9] that an ornamental, pointed, forced style is a perpetually recurring phenomenon in European literature in devaluing classical standards;[10] that mannerism is the manifestation of a permanent element in the western spirit;[11] and, in short, that it is a 'timeless possibility'.[12] Thus mannerism is given the character attributed by Wölfflin to the baroque, and it has been expressly described as a 'normal stage in the development of every style'.[13] Not content with contrasting it with the specific classicism of the High Renaissance, as was done by

Walter Friedländer, mannerism has been regarded as a 'complementary phenomenon' of any classicism.[14]

There can be no such thing, however, as a periodicity of this kind, that is to say, a regular recurrence of styles in the history of art, as every artistic style is to an extent the result of preceding developments, and every development takes place at a different phase of the total historical process. The end of one phase is the starting-point of the next, and every phase uses as its raw material the work of its predecessor. This is taken possession of, worked up, and transformed into new material.[15]

The mannerism of the sixteenth century differs essentially from what is described as that of the late gothic if only because the latter had still to produce the artistic forms used as raw material by the former. Pontormo, Rosso, Beccafumi, and Parmigianino may have taken up certain gothicisms from the Quattrocento and, if one insists, it is therefore possible to speak of a gothic or Quattrocento mannerism. But these early forms are no more anticipations of later mannerism than the High Renaissance is a repetition of the Carolingian Renaissance. Artistic styles cannot be repeated in their original form. Since their first appearance they have never ceased existing and influencing, taking part in the process of development, and thus continually changing in character. Pontormo could not look at the world with the eyes of a Fra Angelico, a Piero di Cosimo, an Andrea del Sarto, or even an Albrecht Dürer, because their way of seeing was just one single element, just one changing coefficient, in the totality of factors out of which his vision of the world was made up. If Pontormo's style is to be called mannerism, none of his predecessors can be so called. The recurrence of a style is conceivable—only very theoretically conceivable —in two completely different and totally unrelated cultures, for within the same culture there can be only further development or variation of a style, but no such thing as its simple recurrence or literal transference. But, if that is the case, there is not much sense in talking of different versions of mannerism, and it seems more reasonable to abandon the idea of a multiplicity of mannerisms and to restrict the term to the artistic trend which came into being with the crisis of the High Renaissance and the specific stylistic development which took place between the latter and the baroque. It was only in this period that all the formal principles which provide the criteria of mannerism were fully developed; in other periods we meet them at most in rudimentary, modified, or hybrid forms.

E. R. Curtius goes furthest in regarding mannerism as a style of practically no historical definition, recurring with the regularity of a natural law and always resulting in the same formal structure.[16] This can be done only if the distinction between *mannerist* and *mannered* is ignored. Curtius, and others who succumb to the same error, are led astray by the fact that a mannered element always occurs in mannerism, however slight it

may be. A conventional, formal, artificial, deliberately sophisticated, and exquisite element is invariably associated with it. Correct assessment of the stylistic character of the phenomena with which we are dealing is also made more difficult by the fact that most artistic periods of any length go through a late, tired, declining phase bearing at least some resemblance to mannerism, and end in a more or less derivative, unspontaneous and precious phase. It is this manner, met with so frequently, which is confused with mannerism. In reality, however, we are confronted with two completely different phenomena, and consequently with two completely different meanings associated with the word 'manner'. One refers to a specific phenomenon in the history of art and the other to a category of art theory. Mannerism, indicating a unique historical style, is a kind of proper noun; it refers to a phenomenon that in all its completeness and detail can never recur. The 'mannered', on the other hand, is a generic name, under which innumerable examples can be filed. If the term 'mannerism' is used to refer to the latter, it is of course possible to talk of its occurrence in the most different historical periods, but only in a very general and abstract way, that has less to do with history than with psychology and art criticism; and 'mannerism' thus becomes an artistic possibility that is practically always open, and the 'mannerist' a psychological type who is much more the victim of his nerves than a child of his time.

The basic concept is that of mannerism as a specific and unique historical phenomenon; the generic notion of the mannered as a recurrent phenomenon arose from consideration of the analogies that occur in different periods. Once again, the broad generalisation turns out to be poorer in content than the individual instance, for the abstract is always poorer than the concrete. There is, of course, room for dispute about which should be called the period of 'true' and 'original' mannerism. One could, if one chose, use the term to describe the art and literature of late antiquity or the late gothic, for instance; in the last resort it would be merely a question of general consent. The essential, however, is to use the term for one period only. For if we assume that the real mannerism was that of the sixteenth century, that is to say, that it was in that period that the stylistic principles in question reached fruition in their purest and most complete form, it is only in a loose and analogical sense that we can talk of 'mannerism' in ancient or medieval times. The validity of this principle is not affected by the existence of historical connections between the different kinds of manner which can be placed typologically together. The fact that sixteenth-century mannerism took over certain characteristics of medieval art, that it seems to be heralded in some respects by the Latin literature of the Silver Age, and that it survives in the art of the present day, means only that there is a certain affinity between the periods in question for which the most varied explanations may be found. It

does not mean that all these periods are mannerist in the true sense of the word.

Max Dvořák, who always refused to regard artistic styles as recurrent, did not regard mannerism as an isolated historical phenomenon, but rather as a trend which has not ceased to exert influence since the sixteenth century.[17] Mannerism, in spite of its actuality as an unambiguous style at one period, has indeed remained a lasting factor in the history of modern art, and, as Dvořák points out, had 'a lasting importance for the whole of the modern age'. Not only did it influence the baroque and play a considerable part in the early works of artists such as Rubens and Poussin, but it also remained an important factor in the rococo, survived in certain features of classicism, as is shown by the work of Fuseli, reappeared with increased strength during the romantic movement, and manifests itself with astonishing vitality in the artistic movements of the present day.

5. MANNERISM AND ITS CRITICS

Criticism of mannerism is generally based on standards taken over from Renaissance classicism, and it is mostly denounced for offences against naturalism, spontaneity, and regularity. The art thus condemned remains undistinguished from the mannered, the affected, and repetitive, whose artificiality, exaggeration, coquettish virtuosity, and obstinate clinging to the same formulas are not seldom associated with an almost manic striving for originality which had to compensate for a lack of real originality. But all these faults do not prevent the appearance of very attractive works even by minor artists, and in the case of the real masters they belong to the peculiarities of accent of which one rapidly grows fond. Condemning mannerism root and branch involves ignoring the principle of judging an artist's work by the standard of his aims. An art that is deliberately non-spontaneous, sophisticated, and unnaturalistic cannot be judged by the principles of directness, spontaneity, and naturalness, for it obviously originated from the feeling that these things had had their day and had grown meaningless, shallow, and mendacious. In a period of highly developed social forms and exaggerated refinement, naïveté and apparent spontaneity seem much more forced and unnatural than the utmost sophistication. How can simplicity and directness be expected of the art of a period, one of the representative poets of which—Góngora—declared: 'Naturalness—what poverty of spirit. Clarity—what thoughtlessness.' The taste for disguise, artificiality, make-believe, went so far that it was not these things which it was felt necessary to defend, but the simple pleasure in the natural and the genuine.

Who says that fictions only and false hair
Become a verse? Is there in truth no beauty?
Is all good structure in a winding stair?
 (George Herbert, *Jordan.*)

The severest and most frequent criticisms of mannerism have been directed against the excessive conventionality and rigidity of its methods. In taking this line it is generally overlooked that the form in which art, like any form of communication which is not purely private, expresses itself has to be more or less 'conventional' and that the most original, unique, and creative genius has no alternative but to make use of tacitly accepted forms if he is to make himself understood.[18] But if all art is to an extent conventional, the question arises whether certain traces of manner are not always associated with it. Is not manner one of the permanent dangers and limitations of art, just like externalisation of subjective experience on the one hand, or the artist's exhibitionism and virtuosity on the other? But it is only up to a point that artistic effectiveness is reconcilable with convention and manner, though the boundaries are exceedingly fluid and expand or shrink according to the nature of the artistic taste, the demands made on the artist by the public of his time, and the artist's own gifts. The firmer the foundations of an artistic culture, the deeper its roots, the more uniform its public and the more self-assured its artists, the more convention will it be able to absorb and the longer will it survive, in spite of the progressive sclerosis of its forms. That is why a style like the rococo survived for so long. Mannerist conventionalism, however, was inherently vulnerable because it was the product of a dynamic society which, with a bad conscience, as it were, and feeling ill at ease, continued with conventions which had grown problematical.

Nearly as frequent as the criticisms of mannerism for its lack of naturalness, regularity, and originality are those charging it with lack of simplicity, directness, and naïveté. But what exactly is meant by 'naïve' in this context? Generally a spontaneous, instinctual, creative urge, independent not only of any deliberately adopted purpose, but if possible also of any deliberation or conscious choice between various methods or of regard to any particular public. But artistic production of this kind simply does not exist; and, though there are varying degrees of consciousness, reflection, purpose, and self-criticism in artistic production, the value of the product is neither positively nor negatively related to these cognitive functions. Knowledge, theory, critical reflection do not prevent the production of important works of art; indeed, they are often the source from which great works come. Leonardo, Rubens, Delacroix, and Cézanne— to mention a few only—were certainly not 'naïve' artists; their work was the product of completely conscious mental processes, without their being anything like mannerists.

41

What, then, could a critic of the rank of Wölfflin have had in mind when he said of mannerism that it showed 'no trace whatever of naïve vision'? The statement is in fact correct, though it is not so condemnatory as he obviously meant it to be. For he goes on to say: 'It ceased to be a popular art',[19] thus disclosing the romantic background behind his approach. What 'popular' art was there in the Cinquecento that could have had anything to do with mannerism or the High Renaissance? And what great art has ever been popular? When it has been popular—as in Shakespeare's case, for instance—this was in spite, and not because of, its greatness. The best in Leonardo, Raphael, Michelangelo, or Titian certainly did not consist of the elements that gave them their greatest popular appeal, and the least popular elements in their work were certainly not the worst.

Another criticism of mannerism deriving from the romantic outlook is directed at its intellectualism, that is to say, once again its lack of naïveté. Mannerism is intrinsically intellectual, not merely because such an important part was played in the production of its works by the feeling for artistic quality and critical discrimination, but also because of the preference shown for the representation of intellectual experiences. Mannerism demonstrates, not only that such experiences can be just as genuinely and immediately stimulating as emotional experiences, but that the interaction between intellect and affect, reason and passion, reflection and spontaneity, which seems to have played the biggest part in averting the drying-up of the artistic culture of the sixteenth century, can be one of the most fruitful sources of artistic inspiration.

So strong was the mannerist trend to intellectualism that interest came to be centred on philosophical difficulties, theoretical complications, speculative edifices. Thinking became a highly personal activity pursued by the poet with dramatic passion. Not content with falling eagerly on the philosophical problems or speculative conundrums that came his way, he enterprisingly sought them out or invented them for himself. The mannerists would have applauded Friedrich Schlegel when he said: 'You really would be sorry if your wishes came true and you were able to say that the whole world had become completely intelligible.'[20] But, for all its display of intellectualism, mannerism turns out on closer inspection to contain more wit than depth, more sparkle and glitter than genuine intellectual challenge. It is more apt to cause unrest in the mind than to open up new perspectives and provide firm ground beneath one's feet. It has been pointed out that John Donne's intellectualism does not go very deep, that his complexity moves very near the surface, and that his poetry, in spite of its apparent wealth of ideas, is too undifferentiated to be satisfying in the long run;[21] and Donne is undoubtedly not only one of the most characteristic poets of his age, but also intellectually one of the liveliest representatives

of mannerism, though certainly not one of those with whom the whole movement's claim to intellectual significance must stand or fall.

To quote another example, a sense of incomplete satisfaction, similar to that left behind by this overstrained and often so superficial intellectualism, is provided by the generally over-exuberant use of images, metaphors, conceits, and other formal devices in mannerist poetry. They are captivating and stimulating at first, but this gives way to a sense of surfeit and weariness.

Nevertheless, the part played by mannerism in the history of artistic sensibility must not be overlooked. The visions realised by Tintoretto and El Greco make the products of the Renaissance, for all their magnificence, seem no more than bold over-simplifications in comparison, and not only did Shakespeare and Cervantes write works that make the whole of Renaissance literature look like a modest prelude, but much less important and earlier representatives of mannerism point the way to artistic achievements of which the preceding generation did not even dream. They create the elements of a language appropriate to the expression of a completely new sensibility combined with a totally unprecedented grace and elegance. Pontormo and Rosso reacted to their impressions with more delicate nerves, and Parmigianino and Bronzino used their brushes with a more exquisite touch, than did the masters of the Renaissance. Marino and Góngora may have made too much play with the new and often excessively superficial virtuosity, and Maurice Scève and Donne may sometimes seem too sophisticated and playful. But Tintoretto and El Greco, Shakespeare and Cervantes, have more in common with the nervous, eccentric, and often abstruse pioneers and representatives of anti-classicism than with classicism itself.

III

The Origin of the Scientific Outlook

To the men of the Renaissance every aspect of life and thought—theology, philosophy, and astronomy as well as economics and politics—seemed to be dominated by a system of concentric circles revolving round a fixed and motionless centre. The universe was thought of as being organised on the same hierarchical pattern as feudal society. Just as the feudal pyramid was centred on the Emperor, so was the universe centred on the seat of God, and the pattern was repeated in every sphere, divine, human, and natural. Even the central perspective of Renaissance painting was merely one more instance of the same orientation towards a single focal point. The seat of God was the centre round which the heavenly spheres revolved, the earth was the centre of the material universe, and man himself a self-contained microcosm round which, as it were, there revolved the whole of nature, just as the celestial bodies revolved round that fixed star, the earth. This whole picture of the universe was still that of the Middle Ages. All that was required to enable such a vision to endure was the bolstering up of the individual's threatened self-confidence. Hitherto man had been reconciled to his modest position on earth by his belief that, in spite of his nullity in relation to God and the ultimate, he was the real summit and purpose of creation. The Renaissance reinforced his belief in his importance among the creations of God, and his increased sense of individualism compensated for the diminished certainty of his faith.

When the feudal social order and the doctrines of the church lost their undisputed authority, the concentric medieval pattern of the uni-

44

verse was maintained by the Ptolemaic system, and when this collapsed it brought down the whole edifice which had seemed to give humanity confidence and security in the world. When Copernicus dismissed the earth from the centre to a peripheral position in the universe, he deprived men of their sense of occupying a central position in the world of creation; the lord of creation was relegated to being a wretched outsider on a mere planet. The heavenly bodies no longer circled round the earth; the earth now circled round the sun, reduced to being one of the innumerable little stars that filled the wide and alien sky, and its light, warmth, and strength all depended on the sun. The distinction between a sub-lunar and a trans-lunar world drawn by Aristotelian–Ptolemaic astronomy lost its meaning and validity. 'The moon belongs to the earth's sky, just as the earth belongs to the moon's', as Giordano Bruno put it. With this discovery the whole idea of a rigidly concentric, stable, world order following one and the same pattern collapsed in ruins. The old hierarchy of the various parts of creation, which had been sanctioned socially, theologically, and scientifically, collapsed too. Henceforth heaven and earth, the sun and the stars, the moon and the sub-lunar world, formed a homogeneous system, though split up into a number of solar systems. This heralded the idea of the homogeneity and equivalence of all things, and paved the way for a philosophy of universal relativism. For the relegation of man and his earth from the centre to the periphery of the universe shattered anthropocentricity together with geocentricity. As John Donne lamented:

> 'Tis all in pieces, all coherence gone;
> All just supply, and all relation:
> Prince, subject, father, son, are things forgot. . . .
> *(The First Anniversary)*

However, the importance of Copernicus's discovery in the history of ideas goes beyond the destruction of the anthropocentric picture of the universe and the dehumanisation of the sciences associated with it. Of even greater importance for the future was that it was the first step towards the recognition of the perspective nature of thought, and hence of the relativity of truth, which hitherto had been held to be absolute and completely objective. After Copernicus practically every scientific advance begins with a questioning of previous assumptions, and the suspicion that a source of error may be concealed in the very premises of inquiry. For the theory of the relationship of the heavenly bodies itself underwent a much less fundamental change than did the aspect upon which that theory was based. One effect of the Copernican theory was that all the events in the universe that took place before the astronomers' eyes assumed a meaning only if previous notions were reversed.

It was not for nothing that the 'Copernican revolution' became a catchword in the history of philosophy and science, for it was the first methodical reorientation in which error was shown to have been due, not to inadequacy of observation or means of knowledge, but to the observer's false assumptions. Kant notoriously described the change he introduced into philosophy as a 'Copernican' revolution, and his whole epistemology is based on the conception of ideology in the sense indicated above, that is to say, on the proposition that knowledge is itself conditioned by the cognitive apparatus. Kant was able to leave unaltered the mathematical and physical theories of his time; what he criticised was the assumption that human cognition was a completely passive faculty in relation to objective impressions, and that it presented a true and neutral picture of objective reality. He regarded objects and the forms of cognition as revolving round the observer, just as Copernicus regarded the earth and the other planets as revolving round the sun; and Marx's theory of ideology, which represents the culmination of the method of disclosing intellectual assumptions and the perspective nature of certain truths, deserves even more to be called 'Copernican'. Though it was only the last step on a well-trodden path, it gave it its real meaning. Meanwhile nothing can diminish the significance of Copernicus's own achievement, and nothing better illustrates the importance of the seed sown in that age of crisis than the path that finally led to the theory of ideology.

2. KEPLER'S EIGHT MINUTES

The Renaissance is generally credited with the revival, not only of the arts, but also of learning and, above all, science. The origin of the scientific outlook is usually ascribed to it, that is to say, the spirit of empiricism, systematic observation, and the first attempts to reduce qualitative differences in sense impressions to quantitative terms. It is held, in short, to have laid the foundations on which the whole edifice of modern science was built, and to have excluded from the outset all mystificatory, theological, or scholastic explanations of natural phenomena. In reality, however, the idea of exact scientific method was totally alien to the Renaissance. It is a falsification of the picture to regard its aspiration to free itself of medieval prejudices as a scientific revolution and, with the impatience of historians ever on the look-out for portents of the future, to antedate thereby advances which took place from fifty to a hundred years later. Copernicus, Galileo, and Kepler, the real founders of the scientific method, belong, not to the Renaissance, but to a generation that saw the collapse of the Renaissance conception of the world. The Copernican theory was published in 1543, but it was not until the seventeenth century

that its influence spread through Kepler and Galileo; and, in spite of their enormous importance in the history of ideas, Copernicus and even Kepler cannot be regarded as typical representatives of the new, unbiased scientific spirit that based itself purely on observation. In the development of their ideas and the description of their systems they allow themselves to be guided by all sorts of mystical, metaphysical, and aesthetic fancies; all sorts of fascinating geometrical and ornamental patterns hover luringly before their mind's eye, and they continually imagine themselves to be hearing the music of the spheres. Indeed, it is in this that their true mentality seems to lie, and they create the impression that their great discoveries were due to chance and sudden inspiration. But perhaps the impression is too superficial.

The real borderline between the humanist and scientific period of the Renaissance was, it has been vigorously argued,[1] the year 1600, but the foundations of the scientific outlook were laid by Copernicus and his contemporaries during the crisis of the Renaissance, and the shift to it originated in the spiritual upheaval that shook the west in the middle of the sixteenth century. Copernicus and Kepler, who were the products of this period, were thus not phantasts who hit on scientific discoveries by chance, but enthusiastic scholars whose unbridled metaphysical and artistic imagination often got the better of their rational thought.

Wilhelm Dilthey's acute observations on the part played by artistic imagination in the scientific thought of the Renaissance are well known;[2] and the part played by the scientific imagination in Renaissance art seems obvious enough.[3] But this picture needs rectifying by pointing out that, while the scientific spirit appears very early in the art of the Renaissance, that is to say, at the beginning of the Quattrocento, artistic imagination in science makes itself felt relatively late, actually not within the classical period of the Renaissance at all. Also the incursion into science of artistic concepts, such as the idea of a world plan, for instance, or that of the arrangement of the constellations in regular and aesthetically pleasing patterns, can be regarded as a questionable symptom, while art, even in its purest stylistic periods, always contains scientific or quasi-scientific components. Science had to shake off its aesthetic prejudices if it was to progress, but only the most short-sighted advocates of art for art's sake would reject all links between art and science.

Copernicus combined in the crudest fashion the essentially speculative outlook of medieval philosophy and Renaissance Neo-Platonism with the inductive scientific reasoning of the later sixteenth and the seventeenth centuries, and in this he is one of the most typically mannerist men of learning of his age. The part played by the teleological element in his thought, which is otherwise dominated by the principle of causality, is especially characteristic of him. An example of this is his answer to

critics who maintained that, if the earth really revolved, as he said it did, centrifugal force would cause it to disintegrate and fly apart. He replied that, as rotation was a *natural* movement of the earth, it could not possibly have the evil consequence of destroying the object of which it was a property.

Kepler had less naïve ideas about the providential character of natural phenomena and the teleological background of natural laws, but is his 'heavenly machine' really so fundamentally different from Copernicus's celestial system? Are they not both mechanisms which keep themselves in motion by a force that is simple and material, it is true, but nevertheless expresses itself in pleasing forms and harmonious relationships? Just before the end of his principal work, the *Astronomia Nova*, Kepler describes his object as follows:

> My aim is to show that the heavenly machine is not a kind of divine, animated being (and he who believes that a clock has a soul ascribes to it the properties of its maker), in so far as all its complicated movements are caused by a simple, magnetic and material force, just as the movements of a clock are caused by a simple weight. And also to show how these physical causes find arithmetical and geometrical expression.

In spite of his partially antiquated ideas, the history of the exact sciences begins with Kepler. He was the first to have a due regard for facts and to refuse to ignore any real aspect of a phenomenon. That sounds much too sober and dry to do justice to the heroism that lay behind his great discovery. After he had established his first two laws, it turned out that the motion of Mars diverged by eight minutes of arc from what was required by his theory. That might have been sufficient to drive a man to suicide unless, like Copernicus, he was capable of ignoring the discrepancy and going his way unmoved. Kepler says himself that he might have ignored the eight minutes and patched up his theory in one way or another. But that was something he could not bring himself to; and those eight minutes led to a new astronomy. It was to them that an important part of his work was due. (*Astronomia Nova.*, II, 19.)

3. THE FLUID SELF

Nowhere is the crisis of the Renaissance and the concomitant process of disintegration better illustrated than in the philosophy of Montaigne. His scepticism is one of the earliest and most unmistakable manifestations of the spirit of the Counter-Renaissance, and one of the most vivid demonstrations of the collapse of the system of values which the Renaissance had taken over from the Middle Ages and still believed in. Indeed,

faith in absolute values in general began to break down; doubt began to spread, not merely about single and specific values that could be isolated from life as a whole, but about all general truths, unconditional moral commandments, and abstract maxims. Montaigne's was a 'methodical' doubt; though unlimited, it was only provisional, that is to say it was 'tentatively' applied to all values (which provides a clue to the choice of the title he gave his work), but does not imply a final repudiation of all values. In Montaigne's philosophy there are values, actually a whole series of them, which survive the test of critical, sceptical reason and give meaning to life, but there are none that are applicable to everyone at all times and in all circumstances, or are even always valid in all circumstances for the same person. The relativity of values, the conditional nature of truth, the impermanence of moral standards and the variability of fashions, customs, and habits is the point round which Montaigne's mind continually revolves.

The most revolutionary feature of his thought, however, which brings him into sharpest conflict with the Middle Ages and the Renaissance, is his view that, whatever validity may be attributed to values and principles, they are not of superhuman or supernatural origin, but are based on human foundations. Nothing is either good or bad in itself; it is we who give them these properties, they are what we make of them. But Montaigne's relativism goes further. Even the values that man creates for himself are not everlasting, immutable, and unequivocal, for such things are beyond his capacity, human nature being infirm and inconstant, in a state of perpetual flux, hovering between different states, inclinations, moods, for it is in continual transition from one level to another, and its true nature lies not in permanence but in change. 'Je ne peints pas l'estre. Je peints le passage,' he writes, 'non un passage d'aage en autre, ou, comme dict le peuple, de sept en sept ans, mais de jour en jour, de minute en minute.'[4] Elsewhere he says even more plainly: 'Certes, c'est un sujet merveilleusement vain, divers, et ondoyant, que l'homme. Il est malaisé d'y fonder jugement constant et uniforme.'[5] And yet again, in deeper and more philosophical terms: 'Il n'y a aucune constante existence, ny de nostre estre, ny de celui des objects. Et nous, et nostre jugement, et toutes choses mortelles, vont coulant et roulant sans cesse. Ainsi il ne se peut establir rien de certain de l'un à l'autre, et le jugeant et le jugé estans en continuelle mutation et branle.'[6] What sort of good is it, he asks in the same essay, that yesterday enjoyed high repute and tomorrow will do so no longer? And what sort of truth is it that is true on this side of the hill but is a lie on the other? Not only is there no single property that is always characteristic of man and is always and invariably good, but all his characteristics and actions can always be judged in very different ways, and ignoble motives can always be found for his apparently

finest and most selfless deeds. There is no motive of human behaviour of which the opposite cannot also be assumed.

Not only does the nature of external, objective reality change according to the subjective viewpoint, not only is everything we perceive 'altered and falsified by our senses', but also the self changes so greatly from case to case that there is no pinning down its true nature. The fact that there is no escape from the subjectivity of the observer's impressions and experiences does not in itself affect the reliability of the observing self. What does affect it is the continually changing aspects of the self towards the same object, by which doubt is cast on the very nature and permanence of the self. This was the shattering blow at faith in the identity of the self from which the culture of the Renaissance was never to recover; without it there can be no explanation of mannerism, either as vision of life or artistic style. The distortion in the visual arts, the strained and restless use of metaphor in literature, the frequency with which characters in drama masquerade as others and question their own identity, are only ways of expressing the fact that, while the objective world had grown unintelligible, the identity of the self had been shattered, had grown vague and fluid. Nothing was what it seemed, and everything was different from what it purported to be. Life was disguise and dissimulation, and art itself helped to disguise life as well as to penetrate its masks.

How vague and uncertain the relationship between the self and the world had become is illustrated by Montaigne's feeling that his book, which interpreted the world in such a personal and sovereign manner, was a reality that had formed him. 'Je n'ai plus faict mon livre que mon livre m'a faict,' he writes. Profoundly true and universal though this statement may be, indisputable though it is that every artist—and every creative human being—is to an extent only what his work makes of him, and that his work is his life-story, just as his life-story is his work, the mannerist nature of Montaigne's statement is unmistakable. The feeling that mannerism always awakens is that there is no firm ground anywhere beneath one's feet.

4. THE TOPSYTURVY UNIVERSE

In spite of the increasingly scientific and rationalist outlook of the mannerist period, Neo-Platonism had by no means lost its influence. On the contrary, after reaching a peak in the Quattrocento and suffering a decline at the beginning of the classical period of the Renaissance, it can be said to have taken on a new lease of life. The philosophy of the period, like all its other intellectual manifestations, was characterised by

completely opposite trends. Side by side with the empiricism of the scientists and the scepticism of philosophers such as Montaigne and Sanchez there was the spiritualism of Giordano Bruno which, coloured as it was with pantheism and pan-psychism, was just as characteristic of the age as were the contrary trends. Dilthey actually regards pantheism as having been its most important philosophical doctrine; in his view it was not merely the result of three centuries of development, but constituted the real spiritual link between the medieval and modern worlds. In some respects it is true that Giordano Bruno with his new cosmological ideas represents the most momentous step in philosophical and scientific thought during this period of transition. The older philosophy and science, and even the doctrines of the Neo-Platonists and the Copernican system itself, were still dominated by the concept of the finiteness of the universe; Giordano Bruno was the first to think of it as infinite, and the importance of this concept for the outlook of the age is immeasurable and incalculable. In art its full influence was not felt until the baroque, but mannerism paved the way for it. The problem of rendering infinite space in painting remained unsolved until Claude Lorrain and the Dutch landscape painters of the seventeenth century, but the mannerists wrestled with it, and were on the way to a solution. At all events, Tintoretto's and Bruegel's sense of cosmic space burst the bonds of the category of space in classical painting and, though this had nothing to do with Giordano Bruno's philosophy it was obviously a concomitant phenomenon, and played a part in the development of the idea of infinity and the concept of infinite space.

Montaigne and Giordano Bruno are unquestionably the two most important and representative philosophers of mannerism. In spite of their contrasting visions of life, the sober rationalism of the one and the ecstatic mysticism of the other, the strength and rejuvenation that the reader derives from the former and the nervous strain (though accompanied by a strange sense of stimulation) produced in him by the latter, the two belong together; and they must be mentioned together just because of the differences between them, for only so is an adequate idea of the divided spirit of the age obtainable. Supplementing and offsetting each other, they paved the way for the subsequent development of western philosophy. Montaigne's scepticism was the precursor of Cartesian doubt and the freedom from assumptions postulated by Kant's epistemology; and, in bringing the problem of philosophy down from the realm of the boundless and baffling universe to the tangible, immediate sphere of the individual, he became the founder of modern psychological relativism. Giordano Bruno went the opposite way, from microcosm to macrocosm. He expanded the Copernican system to infinity and made the human mind a mirror of the infinite, thus regaining the absolute,

which since the Middle Ages mankind had lost. The self became the source of the idea of the absolute, the link with the infinite, the eternal, and the all.

Mingled with Giordano Bruno's philosophical ideas are the boldest literary flights and the wildest fantasies; his ideas are often more like visions or hallucinations, but sometimes, lent wings by his scientific imagination, he achieves theoretical insights of which more cautious minds would be incapable. Thus he takes the Copernican theory of the earth's movement round the sun, and the consequent recasting of assumptions about what is in motion and what is at rest, and develops it into a general theory of relativity. He extends the principle of relativity to space, time, and gravity, finally arriving at his theory of the *indifferenza della natura*, according to which everything depends on the observer's standpoint, nothing is more substantial or significant or divine than anything else, and the all is one and identical in all its parts. In his view of the relativity of space he is completely Copernican, in that he states that the moon belongs to the earth's sky just as the earth belongs to the sun's; and, though he adds nothing new to the Copernican theory, he gives it such an epigrammatic, essentially 'mannerist' twist that it suddenly seems to open up new perspectives. Just as the horizon moves with the observer, and every other point in space is relative to the observer's position, so does the universe look different, depending on whether it is observed from the earth, the moon, or any other heavenly body. When Giordano Bruno remarks that the same point can be either the zenith or the nadir, according to the observer's point of view, again he is saying nothing new, but is giving the truth discovered by Copernicus a new turn characteristic of his age. Once more he is expressing the fundamental mannerist feeling that there is no firm ground anywhere under one's feet, and that when one believes one is standing on one's feet one may really be standing on one's head.

IV

The Economic and Social Revolution

THE pronouncements made in the age of mannerism by the spiritual authorities, that is to say the church, provided artists with no substitute for the sense of security and purpose that had been given to their life and work by the all-embracing Christian system of the Middle Ages. For these pronouncements, in so far as they were not concerned merely with the subjects of artistic representation, were more negative than positive and, except in the field of ecclesiastical art, had no sanctions behind them, perhaps because the representatives of the church, even if only moderately expert in such matters, were aware of the risks that might have been involved in too drastic interference in art, which had now reached an all too advanced stage of development. In conditions as they were now, plain and straightforward ecclesiastical direction of artistic production such as had been taken for granted in the Middle Ages had become unthinkable. However good Christians they might be, artists could not simply ignore the mundane and pagan elements in classical art, and the inner conflict between the different factors in artistic tradition had to be accepted as unsolved and apparently insoluble. For many the tension was too great. Some, like Michelangelo, sought consolation 'in the arms of Christ', while others took refuge either in a more or less superficial and playful artiness or in neurosis. The number of eccentrics and psychopaths increased from day to day. Pontormo suffered from severe depressions from his youth onwards, and grew more anti-social as his life went on. Parmigianino in his last years devoted himself to obscure forms of alchemy, and completely neglected his personal appearance.

53

Others besides Pontormo who suffered from manic depressions were Salviati, Francesco Bassano the younger, and Goltzius. Rosso Fiorentino committed suicide; Tasso, Góngora, and Orlando di Lasso died insane; and El Greco sat through the hours of daylight with his curtains drawn, which caused him to be thought insane, and still seems odd. The visions he was able to see only in his darkened room might certainly have been seen by a medieval artist in broad daylight. To a Renaissance artist, however, they would not have been visible at all.

The sudden appearance of so much neurosis among intellectuals, and artists in particular, and the fact that scepticism became a feature of the age and melancholy a fashionable complaint, of which Elizabethan drama provides so many examples, can be understood only as a symptom of the development that was in train. The break-up of the old bonds, the old groupings, the members of which shared common interests and outlook, was accompanied by the collapse of the old sense of security, and the new world of universal, though relative, liberty, into which they were plunged was also a world of fierce and unrestricted competition. The result was a state of anxiety from which every conceivable way of escape was sought. For the first time the driving force was the necessity of achieving personal success. In the old days the lash of the slave-driver or feudal lord had threatened men's shoulders only intermittently, but now they were left with no peace at all.

Psychoanalysis attributes this pathological condition, which is the subject of Freud's *Civilisation and its Discontents*, to the restriction of instinctual life, *i.e.*, of the erotic impulse, but leaves out of account the part played in its causation by economic insecurity, social upheaval, and political disturbance. These factors cannot be ignored, however, if the aetiology of the state of mind we are examining is to be understood. The striving for personal success, the remorseless drive of competition, which first appeared in practical and then in intellectual life, is a typical symptom of capitalist development and if, as seems impossible to doubt, the neurosis of the age is connected with it, the beginnings of mannerism are hardly to be explained without linking them with the origins of modern capitalism.

This brings us to the question of when capitalism first appeared in the modern sense, that is, as a force capable of producing the state of mind we have been discussing. The beginnings of capitalism do not, of course, date from the sixteenth century, for capitalism can be said to have existed in the Middle Ages, and in a certain sense also in ancient times. If by capitalism we mean merely the weakening of the guilds and corporations by the new forces of production, accompanied by diminution of the security that the corporations provided, that is to say, production and trade carried on by the individual on his own account and at his own risk,

with the idea of competition and the profit motive becoming increasingly evident, the High Middle Ages must be included in the capitalist era. But if these things are considered insufficient, and the criterion of capitalism is held to be the entrepreneur's exploitation of the labour of others and his take-over and control of the labour market by possession of the means of production—in short, the transformation of labour from a form of service, as it was in the times of slavery and serfdom, into a commodity, as it became with the liberation of the serfs from the soil—the beginnings of the capitalist economy will be attributed to the turn of the fourteenth century. At that time, however, there was no question yet of any real accumulation of capital, the presence of which, according to Werner Sombart, for instance, constitutes an essential feature of modern capitalism. This accumulation first becomes perceptible in the sixteenth century, and there are other reasons as well why capitalism in the real sense of the word cannot be held to have come into existence earlier.

Capital accumulation, accompanied by the breakdown of the medieval corporative organisation of the economy, the shift in the essential activity of the entrepreneur from manufacture to trade and from trade to finance, together with the intensification of competition and the gradual absorption of smaller enterprises by larger, still belong to the rather superficial and more or less automatic development of capitalism. The most essential characteristic of the modern capitalist economy, the first appearance of which is associated with a completely new outlook, and cannot be regarded merely as a further development of an already existing trend, is economic rationalism. This too first reached full development in the sixteenth century, though it had been making continual progress since the fourteenth. Careful, calculated, systematic planning took the place of primitive, medieval acquisitiveness. The enterprising spirit of the pioneers gradually lost its original romantic, adventurous, free-booting characteristics; the venturer and the pirate turned into an organiser and a calculator, a careful and a cautious business man; and rationalisation was applied with a view to the elimination of chance from the supply of raw materials and the distribution of finished products as well as of improvisation and waste in the use of labour, while traditional methods of production and finance were simultaneously superseded. The real novelty in all this was not the principle of expediency or the readiness to give up a traditional method of production when a better one came into sight, though in the Middle Ages the dropping of a tradition in itself would have been regarded as undesirable. The new element in the situation was the consistency with which henceforward tradition was sacrificed to rationalisation, and every factor in the process of production was considered on material grounds alone, quite independently of its human, personal, or emotional aspects. But this stage was not reached until the

growth of trade in the sixteenth century made the complete rationalisation of the economy inevitable. The resulting increase in production required a more intensive use of labour, and hence a mechanisation that was not confined to the introduction of machinery but consisted above all in the depersonalisation of human labour and its valuation solely by results. Nothing more plainly illustrates the economic spirit, and to an extent the whole way of feeling, of the age than the dehumanising matter-of-factness that equates the worker with his output and his output with his money-value—his pay; in other words, the realism that turns the worker into a mere entry in the calculation of investment and yield, profit and loss, assets and liabilities.

The economic rationalism of the age is expressed not so much in the change that came about in the character of the economy of the towns—that is to say, the economic centres in Italy and the Netherlands—in which commerce took over the lead from manufacturing, or that calculating and speculative factors gained the upper hand in the activity of the entrepreneurs, as in the recognition of the principle, which was the result of the change in practice, that it was not essential for the entrepreneur to produce new goods to create new values. It was highly characteristic of the new economic outlook, which in this respect was only one aspect of the general trend of the age towards complication and abstraction, that it developed an unprecedented understanding of the fictitious, fluctuating nature of market value and its complete dependence on juncture, and eventually came to see that the value of a commodity depended, not on the good or bad will of the supplier, but on a constellation of circumstances completely independent of him. In the Middle Ages, as is shown by the concept of the 'just price' and the hostility to the charging of interest, the value of a commodity was regarded as a quality permanently inherent in it. Concepts of this kind are given up only very slowly and reluctantly. It was the new practice that paved the way to the new outlook and the new morality, and not the other way about. The true criteria of market value, its relativity and its moral indifference, were discovered only in connection with the new commercialised economy.

2. FINANCE CAPITAL AS A WORLD POWER

Meanwhile finance capital was still taking shape and investment was making further advances. This put an increasing distance between the entrepreneur and the processes of production, not only because henceforward he might well have no direct contact with labour and was not necessarily concerned with the exploitation of its products, but also because, as a result of the growth of finance into an independent form of

business activity, the time taken by capital turnover was so drastically reduced that it lost all connection with the tempo of production. Acceleration of turnover increased the chances of profit, but bigger profits meant bigger risks, and in finance the reasons for success or failure were not by a long way so easy to understand as they were in trade or in the production and sale of consumer goods. The vicissitudes in the careers of the great financiers had consequences for the smallest producers, though to these, as to most people, the really vital factors in the economic process grew more and more inscrutable and mysterious and more impossible to influence from their own position. In their eyes economic chance became a reality hanging over their heads like a higher and ineluctable power, the more inexorable for its very mystery.

With the loss of their influence in the guilds and their former by no means unimportant role at least on the local market, the lower and middle ranks lost their sense of security, but even the capitalists were far from feeling secure; and they suffered from the neurosis of the age more severely than the smaller men, not only because of their greater commitments, but because of the greater involvement of their prestige. But for them there could be no standing still, no making sure of their gains, and as they grew bigger they necessarily entered ever more dangerous territory. The second half of the century was marked by one financial crisis after another; there were three state bankruptcies which shook the leading European banks to their foundations. The most attractive big business of the day was the flotation of state loans but, in view of the heavy indebtedness of the ruling houses, it was at the same time the most dangerous. Apart from the bankers and the professional or habitual speculators, the middle ranks were also involved in the great game of fortune by reason of their bank deposits and their commitments on the exchanges that had then not long come into existence. When the capital needs of princes outran the resources of the banks, public loans were floated on the Antwerp and Lyons exchanges. All Europe was seized with a fever of speculation, which was further increased when English and Dutch overseas trading companies offered the public opportunities of participating in their fantastic profits.

The consequences of this development for the various sections of society were the more disastrous the more subordinate their position, though, in accordance with their lower social status, they reacted less neurotically to events. Unemployment as a consequence of the progressive transfer of population from agricultural to industrial production, overcrowding and inhuman living conditions in the cities resulting from the increasing flight of serfs from the land, rising prices and falling wages as a natural consequence of war and the import of precious metals from the American continent on the one hand, and inexorable class rule and

rationalisation of production on the other, made themselves felt every-where. Discontent rose to its climax in Germany, where at the time the greatest accumulation of capital had taken place, and reached sparking-point in the class that had suffered most severely, that is, the peasantry. The outbreak linked up immediately with the religious mass movement, partly because this was itself determined by the social dynamics of the age, partly because nonconformist, revolutionary forces and trends still gathered most easily under a religious banner.

However, the main reason why the sixteenth century marks the begin-ning of modern capitalism is that it was then that finance capital became a world power to which the ruling houses themselves were subject. Political control became a function of capital. No matter what happened to individual capitalists, whatever their personal fate might be, the ideology of capitalism reigned supreme.

Charles V conquered Italy with the aid of German and Italian capital, after the election of the Emperor had itself become more or less a question of money, which was resolved by a consortium of bankers under the leadership of the Fuggers. Henceforward the logic and interests of finance capital dictated the conditions in which it best could thrive. The armies with which Charles conquered his enemies and founded his empire were the creation of that power. The wars that he and his successors conducted ruined the greatest capitalists of their time, it is true, but they assured the world domination of capitalism. Maximilian I had not yet been in a position to impose regular taxes and thus keep a standing army, and real power remained in the hands of the territorial lords; his grandson was the first monarch able to introduce state budgeting on strict business principles and thus lay the foundations of an efficient, uniform, and con-centrated bureaucracy and a standing army. As the crown revenues were to a great extent derived from taxation of the non-noble and non-privileged population, it was in the state's interest to do more to promote the economic prosperity of these sections of society than had been done in the past. Nevertheless, in every critical situation regard for the ordinary tax-payer had to take second place to the interests of the big capitalists, with whose aid the princes, in spite of their regular revenues, were unable to dispense.

Thus, whatever losses individual capitalists might suffer, the capitalist class as such and the capitalist system gained incalculably from their con-nection with the princes. They acquired lasting influence on foreign policy, economic measures in general, and the distribution of privileges and monopolies, and finally, in the rationalisation of state budgeting, saw the victory of the principles on which their prosperity, repute, and power depended over the continually revived medieval prejudices against their activities, acquisitiveness, and style of life.

3. THE ECONOMIC CRISIS IN ITALY

At the time of Charles V's conquest of Italy the axis of world trade had shifted from the Mediterranean to the west as a result of the Turkish danger, the interruption of trade with the east through the Mediterranean, the discovery of the new sea routes, and the appearance of the so-called oceanic nations as economic powers. There were also other factors that contributed to the weakening of the Italian economic potential —political events and the social crisis, the Spanish and French invasions and the occupation of the country by foreign troops, the sack of Rome and its temporary elimination as a cultural centre, the religious struggles and the consequent regrouping of forces, the collapse of the productive middle class and the process of aristocratisation that was in progress; and, simultaneously with the economic crisis in Italy and the process that resulted in the displacement in the world economy of the Italian city states, with their relatively small business concerns, by centrally administered nation states, in control of incomparably greater territories and with far richer resources at their command, the age of early capitalism came finally to an end, and the period of modern, large-scale capitalism began.

The economic crisis of the sixteenth century made itself felt more powerfully and earlier in Italy than in most of the rest of the west, though manifestations of the class struggle were less acute there. Elsewhere in western Europe, and particularly in Germany, an embittered anti-capitalist movement set in, associated with continual outbreaks against usurers, exorbitant prices, the monopolies, the big trading companies and their privileges, the driving of the peasants from the land, and the artisans' loss of influence through their guilds. In contrast to this, after the violent clashes that took place in the course of the fourteenth and fifteenth centuries, the class struggle in Italy came to a relative standstill. Capitalism had such a firm grip of the society and the economy that any anti-capitalist movement was inevitably predestined to failure, and nothing was left for the oppressed and exploited sections of the population but resignation. Later, however, when general economic decline set in under the Spaniards, strong anti-capitalist feeling manifested itself in Italy too.[1]

Until the sack of Rome in 1527, Florence was the greatest financial power in Italy, holding sway in Rome and Naples too, and Florentine bankers set the pace internationally as well, in spite of the competition of the Fuggers and the Welsers. But, after the sack of Rome, Genoa took the lead in Italy, and consolidated her position internationally by going over to the imperial party, while the Florentines, after giving up their republican privileges, under the absolute rule of the Medici put their

financial resources at the disposal of France and made common cause with Francis I. When the Emperor and the House of Habsburg gained complete victory over the French in the struggle for the domination of Italy, the result was a further exodus of Florentine capital to France. Political events accelerated the already existing trend from trade to finance and transferred the economic power of the Florentines abroad, that is to say, eliminated it at home.

However, with the understanding between the Pope and Charles V in 1530, Florentine economic power began to decline, and thus the economic as well as the political crisis broke out earlier and with greater violence in Florence than elsewhere in Italy. In discussing the origins of the 'tremendous upheaval' concomitant with the mannerist crisis, this is a fact that must not be overlooked. Whether the simple answer is that the upper bourgeoisie, threatened by the shift of world trade to the west and the economic crisis associated with it, was driven into the arms of the church, and that this led to the mannerist reaction[2], may well be doubted; in any case, connecting events in such simple, direct, and undiscriminating fashion seems unsatisfactory, and it is certainly inappropriate to attribute the origin of mannerism purely to Florentine local conditions. The fact that mannerism originated in Florence is not without significance, but it would not have become so universal had the changes in Florence not been part of much wider trends.

The Medici governed Florence with the blessing of the Pope. Their rule meant not only the end of the republican constitution, but also the introduction of Spanish customs and tastes. Though for chronological reasons alone the new Spanish vogue cannot be regarded as the explanation and origin of the mannerist stylistic crisis, it certainly can be regarded as a factor which reinforced trends already in existence. Since the beginning of the Cinquecento a tendency to aristocratisation had manifested itself in the courtly forms of life of the upper bourgeoisie and in the formalism of classical art, and the Spanish fashion only gave additional momentum to this. A fact the importance of which must not be underestimated is that the Italian culture of this period was following an inner impulse of its own, even when it seemed to be submitting to foreign influence.

At the time when its leaders were beginning to transform themselves into a courtly aristocracy, the Florentine bourgeoisie was at the end of a long process of development that resulted in a complete change in its economic outlook, moral ideas, and style of life. The capitalist spirit of the Renaissance originally consisted of a combination of acquisitiveness with the so-called bourgeois virtues, that is to say industry, honesty, and frugality. These principles were inspired by the rationalism which governs the whole life of the oven-fresh bourgeois, whose aims are utili-

tarian even when he is apparently concerned only with prestige, for in his language honesty and reliability mean credit-worthiness. However, in the second half of the Quattrocento these honourable and rational bourgeois or petty bourgeois principles gave way to a different ideal, that of the man of independent means, and more distinguished and often actually seigniorial features invaded the bourgeois style of life. These were to be further cultivated and developed, and the bourgeois ideal changed accordingly.

The process was completed in three phases. In the first, that of the 'heroic' age of capitalism, we see the entrepreneur as a bold, aggressive, self-confident adventurer who has outgrown the relative security of the Middle Ages. In this phase he still fights with real weapons in his hand against the jealous nobility, rival city communes, and unfriendly seaports. After social struggles and trade wars have been brought more or less to an end, trade, now conducted into safer channels, requires and makes possible more efficient organisation and bigger production. The military and romantic features rapidly vanish from the portrait of the acquisitive bourgeois, who arranges his whole life on a tidier, more reasonable, more systematic and orderly basis. But, as soon as he feels a sense of economic security, he relaxes the discipline to which he has previously submitted, and devotes himself with increasing satisfaction to the pleasures of ease and beautiful living. He adopts a more carefree, hedonistic style of life, apeing the nobility just at the time when the princes have begun to adopt the business principles of a solid, reliable, trustworthy merchant. Thus the courtly and the bourgeois met half way, as both were moving in a direction opposite to that of their earlier impulses. While the princes became more sensible, practical, and sober, the bourgeoisie, or at any rate the highest level of the bourgeoisie, became more conservative, irrational, and romantic.

But for the decline of bourgeois democracy, the consolidation of princely absolutism, and the new courtly culture of the west, the revival and widespread fashion of the chivalrous romance, to which, among other things, we owe *Don Quixote*, would have been as inconceivable as the whole elegant, exquisite, precious art of mannerism, whose sophistication, refinement, and affected way of expression, like everything else about it, points to the presence of a public which, whatever else it appreciated in and expected from art, enjoyed the social pleasure of initiation into a secret language. The chivalrous ideals that Cervantes, with an ambivalence of feeling characteristic of him, his hero, and his whole period, simultaneously ridicules and admires represent much more than a fashionable game. They were the form in which the new nobility partly risen from below and the princes heading for absolutism clothed their ideology. A rational, realistic, industrious bourgeoisie would have

found little to enjoy either in the chivalrous romances themselves or in satirising them, and little to appreciate in a hero of the type of Don Quixote, who would have struck them as neither tragic nor comic, but at most stupid. For the features of the Knight of the Doleful Countenance are as twisted, distorted, and exaggerated as are the figures of the most bizarre mannerist painter; they too are the elements of a not easily understood language.

V

The Religious Movement

I. THE DOCTRINE OF PREDESTINATION

THE Renaissance and the Reformation are generally regarded as parallel phenomena, but the Reformation should be associated with the crisis and break-up of the Renaissance rather than with its development and full flower. The Renaissance on the whole remained loyal to the medieval church; it was the Reformation which, in spite of its return to certain forms of medieval religiosity, broke with the ecclesiastical organisation of the Middle Ages as well as with that of the Renaissance. It differed as sharply from the humanist view of the church as it did from that of the orthodox theologians.

The Reformation has been called the 'Copernican revolution in religion', in the sense that it is 'no longer the church, but the individual who becomes the principal factor in religious life'.[1] For, just as Copernicus demonstrated that it was not the sun that revolved round the earth but the earth that revolved round the sun, so did Luther teach that it was not the church but the individual who was the centre-point of faith, and that the individual stood in a direct filial relationship to God and required no intermediary for his salvation. Luther's fiercest denunciations were reserved for 'mechanism in religion'.[2] His onslaught on the Roman Catholic church was concentrated on the soulless and impersonal elements in it; the point of supreme importance to him was that no institution must be allowed to interfere in the direct relationship between man and his Creator. Ernst Troeltsch[3] maintains that Luther was not opposed on principle to the idea of a church, and that it was never his intention to displace it by a 'churchless mysticism and lay religion'.[4] However that may be, he certainly saw danger in rigid church organisation, and in this, as in so many other matters, his attitude was unquestionably ambivalent. At all events, at first, though he did not reject the idea of a church

63

outright, he insisted that it must be not a hierarchical organisation, but the community of all the faithful. He seems to have hoped that his teachings would lead to a change of heart that would make a church superfluous, but this aspiration was totally disappointed. In so far, however, as he accepted the idea of a church, it was to be a universal church reformed on the basis of the Bible, and the separate regional churches such as arose in Germany involved the failure of his efforts here too. Ultimately he had to use the force and violence that he had above all wished to avoid in matters of faith and conscience.

The Lutheran revolution, which is comparable in importance only with the Copernican, was not confined to the elimination of the church as the institution of salvation, the abolition of the sacraments and the sacramental priesthood, and the idea of religion independent of the church, *i.e.*, of the direct connection between salvation and faith. Salvation was no longer a miraculous medicine one could pour down one's throat, in the words of Melancthon, but a grace, a *favor*, connected with faith which, however, no longer depended on individual good works, but on the totality of the individual's disposition. Luther's real Copernican revolution in religion lay in statements such as: 'Good works do not make a good man, but a good man performs good works.' In other words, one can no more assume knowledge of what good works are than one can ascertain, explain, or justify by human standards the granting of divine grace in any particular instance. The good man performs good works, but good works are not sufficient to prove that he who performs them is good. The just man has a prospect of grace, but the granting of it does not assume merit, nor has the meritorious any claim to it. He has no more claim to it than he had, for instance, to be created a human being instead of an animal.[5]

The core of Protestant dogma is the doctrine of predestination, which contains the fundamental ideas on which Protestantism rests as a religion of pure faith expressed in the concept of grace. It, and it alone, implies the belief that the rule of God, His decisions, His granting of salvation, are completely beyond the range of human understanding or judgment. It makes the ways of God so inscrutable that even the concepts of morality, justice, and piety are all too human in comparison, and are not binding on Him. The real meaning of predestination is that, measured by human standards, the judgment of God is bound to seem absurd; the only appropriate human attitude in relation to God's wisdom is the sacrifice of the intellect. Divine grace has nothing to do with merit and deserts, right or justice. God grants one man salvation without his deserving it, and denies it to another without any special guilt on his part. Arbitrariness, or even injustice, belong to His nature. 'The assumption that God is unjust has a great deal to be said for it,' Luther wrote. 'It is so well

founded that it is not to be resisted by reason.' If moral standards were binding on God, He would be their creature, they would not derive their validity from Him. And if it were possible to ensure salvation by merit, there would be no such thing as grace, for one would be lord over God.[6]

The doctrine of predestination gives Protestantism an aristocratic aspect, in spite of its origin in economic distress and social injustice and its beginnings as a popular religious movement. Grace granted independently of any personal merit, solely by God's eternal, unmotivated, and unalterable choice, implies human inequality. It is surely no accident that the finest literary parables on the subject of predestination were written by an aristocrat—strangely enough, not a Protestant—that is to say, Tolstoy. One of them, in his *Folk Tales*, is a version of the old legend of three fishermen who land one day on a lonely island near the hut of a holy hermit. One of the three, an old man, is so simple that he can hardly express himself properly, let alone pray. The hermit is greatly dismayed at his ignorance, and eventually manages with a great deal of difficulty to teach him the Lord's Prayer. The old man thanks him, and leaves the island with his companions. No sooner has their boat vanished into the distance than the hermit sees a human form walking over the water towards the island. It is the aged fisherman, and when he approaches the shore the hermit advances to meet him in silent awe. The old man confesses that he has forgotten the prayer he has been taught. '*You* need no prayer,' the hermit tells him, and leaves him to walk back over the water towards his boat. The moral of this story is the same as that of the doctrine of predestination—salvation is not associated with any moral conditions or other criteria of personal merit. In another story, written towards the end of his life, Tolstoy looks at predestination from the opposite, negative point of view. The grace that is granted the simple old man without effort and apparently without desert on his part is refused to the highly intellectual and moral hero of *Father Sergius*, in spite of his great sacrifices, heroic self-mastery, and superhuman renunciation.

The grace of God, which results in salvation but implies no personal value, and the social selection which gives value to an individual though personally it is undeserved, are of course not quite the same thing. Hereditary nobility turns on family and descent, while to the Protestant there is no merit for which grace is granted as a reward. It is not without significance for Tolstoy's 'Protestantism' that the old man to whom the divine grace is granted in his story is a humble fisherman, while the hero to whom it is denied is a nobleman; in this he seems to express the ambivalence of the Protestant attitude towards the social order. Luther dismissed the whole religious aristocracy of Roman Catholicism, exemplified not only in the many levels of the ecclesiastical hierarchy with

the Pope and the princes of the church at their head, but also in the long family-tree of religious heroes—martyrs and saints, fathers of the church and founders of orders—and replaced it by the democratic principle of a universal priesthood, an invisible church and a direct filial relationship between the believer and God. Nevertheless the aristocratic tinge that clings to the doctrine of predestination is unmistakable. The democratic principle is the same chance for everyone, but where an irrational choice prevails, no matter what sort of choice may be involved, this principle is denied. The ambivalence inherent in the doctrine of predestination runs through the whole of Luther's social teaching. His attitude to the Peasants' War is ambivalent, and his attitude to the princes and the industrious and prosperous bourgeoisie is the same.

2. THE PEASANTS' WAR

The most significant sociological fact about the Reformation is that it arose from the corruption of the church and that the immediate occasion of the outbreak of the storm was provided by the manipulations of the clergy, the trade in indulgences and church offices. The oppressed and exploited, most of whom at first probably had no very clear idea what it was all about, soon realised that in fighting the Pope they were fighting their landlord, and in fighting the landlord they were fighting the Pope. But the members of the middle class, who joined enthusiastically in the struggle of the lower orders against the privileges and extortions of the church from which they suffered themselves, not only withdrew from the revolutionary movement as soon as they had attained their aims, but resisted with might and main any further advance which would have damaged their own interests by favouring the lower classes; and the Reformation, which had begun as a popular movement on the broadest possible basis, now fell back on the favour of the landlords and the loyalty of these conservative bourgeois elements. Luther, with true political insight, assessed the prospects of the revolutionary classes so unfavourably, and drew the consequences with such truly Machiavellian realism and pitiless logic, that he came gradually to side completely with those sections of society whose interests lay in the maintenance of order and the preservation of authority. Perhaps he went too far in this direction, and used excessive zeal in inciting the princes against the 'predatory and murderous bands of peasants', but at all events he considered it necessary, if he were to save the Reformation, to avoid the appearance of having anything to do with the social revolution.[7]

Luther's role in the Peasants' War has been condemned in the severest terms from his own time down to the present day. His brother-in-law,

Johann Rühel, wrote to him on May 26, 1525, among other things: 'However that may be, to many who are well disposed towards you it seems strange that you tolerate the pitiless suppression by the tyrants. And it is said openly at Leipzig that because the Elector is dead you fear the house and flatter Duke George.' He has been blamed for the failure of the only broadly based revolutionary movement in German history, charged with responsibility for the massacre of tens of thousands of peasants, accused of betrayal of the Reformation, the 'destruction of the Lutheran left', and the 'defeat of the youthful impulses that sprang from his own bosom and were often the best forces in Lutheranism'. It has also been maintained that, after he took his stand on the side of the princes, the cities and the universities, 'spiritual life and activity in Germany never again attained a legitimacy and authority publicly sanctioned by the intelligentsia itself'.[8]

Many of his severest critics admit, however, that, as the defeat of the peasants was inevitable, the Reformation would have been crushed too if Luther had not dissociated his cause from theirs. He was certainly no mere tool of the princes; his admonitions to them to meet the people's just demands and treat them with leniency do not, however, prove that he was opposed to the princes. He may have only concealed and compensated for his conformism by his threats and warnings. Like the whole of his attitude to established authority, his attitude to the princes was ambiguous. For all his rebelliousness, he preserved a petty bourgeois awe of attacking authority; and his doctrine that evil can never be averted by brute force and violence was obviously only a rationalisation of his readiness to compromise. The ambivalence of his attitude to temporal power is most strikingly illustrated by the inconsistency of his statements on the matter between 1525 and 1531; only after this long period of inner struggle did he finally surrender.[9]

At all events, his influence and reputation reached their climax with the Peasants' War, after which they noticeably diminished. The popularity of his works, which before the war was extremely high, provides a good yardstick. Between 1518 and 1523 he was the author of one third of all the publications printed in Germany.[10] In 1520, 4,000 copies of his *Address to the Nobility of the German Nation* were sold in three weeks. *On the Liberty of a Christian Man*, also published in 1520, went through eighteen editions in six years. His famous pamphlet *Against the Predatory and Murderous Bands of Peasants* went through twenty editions. After this, interest in his works declined, and there is no doubt that his attitude in the Peasants' War played an important part in the change of public opinion about him.[11] What has been called his betrayal, whatever may be thought of it today, must have had a devastating effect. The direct evidence is scanty; except among the Anabaptists, there were no real

spokesmen for the betrayed. But the gloom and scepticism of the age, the general neurosis, the sickness of the whole society, which is full of pathological signs, weigh heavily enough as evidence of the disillusionment which must have been left behind, partly by the course taken by the Reformation itself. Luther's caution was a terrifying example of political realism, no less terrifying than Machiavelli's. This was not the first compromise between religious ideals and practical life—from one aspect the whole history of the Christian church can be regarded as a compromise between what was God's and what was the Emperor's—but concessions to the secular power had taken place slowly, gradually, and almost imperceptibly, spread over long periods of transition, moreover at a time when the whole background of politics was generally hidden from the public view. But the degradation of Protestantism took place in full daylight, after the invention of the printing press, in a period of political pamphleteering, when there was a large public interested in politics and capable of political judgment. To a great extent the intelligentsia may have been uninterested in or actually opposed to the peasants' cause but, even if they were not well disposed to the Reformation, the spectacle of the corruption of a great ideal cannot have left them unmoved. For Luther's attitude to the peasant question was only a symptom of what was bound to happen to any revolutionary idea at that time of incipient absolutism and the progressive advance of capitalism.

3. PROTESTANTISM AND CAPITALISM

Luther's attitude in the Peasants' War has been vindicated [12] on the ground that he was of petty bourgeois-peasant origin and remained loyal to his class to the end, and that he allied himself with the princes in order to save the Reformation and his class. This does not imply that the Reformation originated in the interests of a social class, or that the acquisitive spirit of the bourgeoisie was the product of Protestant doctrine. The Reformation was a religious movement, and as such had religious roots, though it unquestionably provided an outlet for the economic dissatisfaction and social unrest of the time. One may grant the point that without this dissatisfaction and unrest there would have been no religious upheaval while still maintaining that the Reformation movement was not simply the outcome of the contemporary social struggle and that the Protestant ethic of calling (*Berufsethik*) was not simply a direct consequence of the principles of the capitalist economy. One may even concede that social revolt merely assumed a religious guise in the Reformation, and nevertheless attach the greatest importance to the fact that the form it took was religious rather than anything else. A fact of economic

or social life can no more be directly translated into religious experience, or capacity for religious experience, than an economic or social system can be deduced from a religious outlook. Even Max Weber, who was inclined to an idealist approach of this kind, admitted that an exclusively spiritual explanation of the historical process was just as inadequate and unsatisfactory as a purely material explanation. But recognition that the materialist explanation, though inadequate in this instance, was at any rate not unreasonable and entirely devoid of foundation, as is the opposite view, lay outside the limits of his theoretical approach.

Protestantism was certainly the ideological expression of a social upheaval, though to most of those involved in it it meant a great deal else besides. It united those sections of the population who were more interested in religious than in social change with others who were far more, if not exclusively, interested in the latter. However these different elements were combined, men's outlook was still so deeply coloured by religion that all ideas of reform or betterment clothed themselves most naturally in religious disguise. Hence the obscure sense of imminent salvation, in which religious and social ideas intermingled. At all events, it was under a religious standard that revolutionary ideas had the best chance of making an impact, rallying supporters, and setting them in motion. Indignation at ecclesiastical corruption certainly focused most attention and was the rallying-point round which dissatisfaction gathered.

The question whether the Protestant ethic of calling was the ideology of this new acquisitive and competitive capitalist society from the outset, or arose only gradually, as a justification of the principles of conduct that served the interests of that society, can be decided only from case to case, and is hardly the most important issue in this context. Far more important seems to be the fact that the clamour for freedom of conscience tallied with that for economic freedom, and was not essentially distinguishable from the cry for political freedom. When one has grasped this fact, the high place given to industry in the Protestant ethic of calling—that of 'worldly asceticism' (*innerweltliche Askese*) in Max Weber's well-known phrase—turns out to be one of the most revealing instances of ideology formation. For the giving of an ethical and religious cloak to a social-economic attitude of completely profane origin and aim, an attitude that from the religious aspect is at best neutral if not actually reprehensible, and the doctrine that work sanctifies and that commercial success is a sign of divine grace, can be explained only as an ideological superstructure the object of which is to provide a moral justification for capitalist acquisitiveness. When poverty is explained away as a sign of the denial of grace to its victims, as demonstrating that for reasons inscrutable to man they have been found unworthy of the divine blessing, the ideological origin of this morality is even more manifest.

Max Weber's work on the links between Protestantism and capitalism is important for the light it throws on the *psychological* factors underlying both, but is vitiated by the mistake of assuming the spontaneity and autonomy of the Protestant ethic of calling and trying to deduce the principles of the capitalist economy from it, instead of postulating the ideological nature of that ethic. Protestantism may have prompted and encouraged capitalist aspirations, and given them confidence and assurance, but it did not originate them. Similarly, economic conditions may have accelerated the Reformation, or even provided the circumstances without which it would not have taken place, and certainly contributed to the ideological substructure of the new doctrines, but could not possibly have produced the religious experience itself. The crucial point to be made in criticism of Weber's theory is that the development of the capitalist system was primarily due to material, technical, and political conditions, for without these there could have been no mental preparedness for capitalism, or even preparedness to move towards it. Religious, moral, and psychological impulses react on economic practice; indeed, they are partly determined by economic and social conditions, or share a common origin with them which is indefinable and hard to trace. In any case, the most primary and fundamental basis of civilisation cannot be defined otherwise than in material terms.

Besides the material conditions for the accumulation of capital, there must of course be present a readiness and ability to take advantage of the opportunities presented, but what is generally called the spirit of capitalism is not one of the conditions and causes of capitalism, but rather its product and part of its ideology. Nothing better illustrates that Max Weber was in the main trying to change back an ideological superstructure into a historical substructure than the fact that his examples are taken from the seventeenth and eighteenth centuries instead of from the sixteenth.

Since there was exploitation of labour and an aspiration to cloak the interests of the ruling social class, there was an ideological disguising and varnishing of the truth. The doctrines of the medieval church, let alone more ancient examples, are a gold-mine of factual distortions and concealments of this nature. But never was the ideological function of moral and religious doctrines so transparent as it was with Protestantism, its sanctification of work, its worship of material success, its stigmatisation of poverty, and its condemnation of sympathy with the poor as an encouragement to sin. With this the Reformation aggravated the spiritual conflict of the age, and deepened the crisis that threatened its culture. For what is ideology if not duplicity, double-dealing and in the last resort, self-deception? Did not this departure from truth involve the danger of paralysis and self-annihilation? At all events, that was the risk taken with

mannerism, its juggling with reality and its deformations and distortion. Yet it also provided the dynamic element that gives its works their tension and makes even its less successful products provocative and often compelling.

4. REFORMATION AND COUNTER-REFORMATION

None of the ideas of the Reformation made so deep an impact on the mannerists as the denial of the freedom of the will; or at any rate there was none with which they seemed more fully in agreement. The compulsive, mechanical, puppet-like view of man, so characteristic of mannerism, expresses the feeling of unfreedom, inhibition, confinement in the frail body and in this earthly life, that underlies Luther's anthropology. Moreover, in mannerism the sense of coercion and discomfort extends far beyond the boundaries of human life and appears in wider fields than the rendering of the human form, its connection with space, and the compulsiveness of its movements. In this sense Wilhelm Pinder speaks rightly not only of the 'armour of reserve' by which man is restricted, but of an 'imposed form' which often cause mannerist artistic composition to degenerate into a rigid and unbending formula.[13] This obviously derives from the same sense of impotence and guilt, the same anxiety, that led to Protestantism, its surrender of the freedom of the will and its renunciation of the claim to deserve God's grace. It is readily intelligible that for a liberal humanist like Erasmus Luther's determinism was the greatest obstacle to his associating himself with Protestantism which, he felt, would involve him in giving up the whole tradition of classical and Christian culture; and it was to this tradition that he appealed in defending the freedom of the will and of man, for he could not agree that man was as evil and contemptible as Luther maintained, or that there could be either grace or free will for him, but not both.

On the one hand, Luther's Copernican revolution consisted of his spiritualising religion, his transforming Christianity from Catholic legalism into a religion of grace, his displacing of the sacramentally ordained clergy (at any rate theoretically) by a universal, unofficial priesthood, his substitution of the miraculous substances, the pneuma, by the pure word, the spirit, the conscience. It represented the final step in the gradual process described by Max Weber as 'disenchantment' (*Entzauberung*), the elimination of magic for the attainment of salvation. On the other hand, it threw man back entirely on himself, with the knowledge that his fate was fixed for all eternity and that nothing and nobody could change it. This necessarily made him feel utterly abandoned and alone. He had grown out of the tutelage of the church. There

was no priest to damn him, but neither was there anyone to absolve and save him. He was left alone with himself, his sinfulness, and his God, Who granted grace, it is true, but was inaccessible, deaf, and inexorable.

It was from a sense of life and anguish of this kind that mannerism grew. It cannot of course be regarded as having originated in Protestantism, as both Protestants and Catholics, on the whole independently of each other, were often filled with the same sense of gloomy foreboding and anxiety. Only rarely did Italian artists come under the direct influence of the German Reformation, and, when this did occur, it was relatively late. This question, however, does not seem to be of primary importance, as the Reformation was only one of the various ways in which the spiritual crisis of the age expressed itself. It was a secondary form of the latter, running parallel with the form it took in art, and it did not precede it or, if so, did so only exceptionally.

In discussing the relationship of mannerism to religious developments, whether the Reformation or the Counter-Reformation, the beginnings of the stylistic change are generally put too late. It has long since been recognised, though it is seldom taken into account, that, as a result, attention is paid to the effects rather than the causes of the changes in mental outlook.[14] As a possible starting-point of mannerism, the Reformation can be discarded on chronological grounds alone. The new style began before the repercussions of the Reformation reached Italy. At most the young Pontormo, Rosso, and Beccafumi anticipated a trend which was reinforced by the spread of Luther's ideas in Italy, but they themselves were hardly influenced by the Reformation. The often-mentioned influence of Dürer on Pontormo was unconnected with the Reformation and, as is well known, the German master's influence on Andrea del Sarto can be traced back to 1515. Moreover, in the case of an artist like Pontormo, who occupies a key position in the early history of mannerism, religious factors can hardly be regarded as having played a vital part in view of the fact that he seems to have been totally irreligious. He scorned this earthly life without believing in a life beyond and, according to Vasari, was so terrified of death that no one was allowed to mention it in his presence. This had obviously little to do with a Christian's preparation for death.

It is very doubtful whether the religious movements of the age had any *direct* bearing on the origin of mannerism. It seems to be much more probable, as is so often the case in historical development, that we are here confronted with a parallelism rather than a causal connection. The early mannerists may have been impelled by the unrest of their time and may have aspired to an art more spiritualised than that of the High Renaissance, but in general the impulse behind them can hardly have

been genuinely and specifically religious, as it was with Michelangelo, for instance, and it should not necessarily be assumed that it was the religious and other-worldly aspect of Michelangelo's art that made the deepest impact on them. There was so much about him to enthral an age of spiritual crisis that in considering his influence, at any rate on the first generation of mannerists, the religious factor can be ignored, however important it was to him. It was on the later mannerists, that is to say, artists of the type of Tintoretto and El Greco, on whom religious ideas and impulses, now connected with the Counter-Reformation, came to exercise a deeper influence.

For a critic like Max Dvořák, who identifies mannerism mainly, though not exclusively, with the trend followed by Tintoretto and El Greco, an attempt to derive it from the Counter-Reformation would be intelligible —though incidentally he never showed any inclination to undertake such an enterprise. But when the attempt is made by authors who grant mannerism its true historical extent, that is to say, date it from Raphael's death, and still claim to trace it to the Counter-Reformation, it is disconcerting and unintelligible.[15]

To dispose of the theory that mannerism originated from the spirit of the Counter-Reformation, it is sufficient to point to the fact that, when the first signs of mannerism appeared, and even after a whole series of its most important works had been produced, there was no sign of any Counter-Reformation yet. Leaving aside the mannerist tendencies that appear in the masters of the High Renaissance, at the time when the first definitely mannerist works were being painted by Pontormo nobody in Italy outside a relatively small circle really knew what to make of the Lutheran movement; and Luther himself had not heard of any Counter-Reformation.

Mannerism became a distinct and well-established style before the religious struggles in Italy began. Werner Weisbach's argument against deriving it from the Counter-Reformation approaches the question from the correct standpoint, but his presentation of the case is weak and defective.[16] It does not tell us very much to say that the Counter-Reformation did not end with the end of mannerism and the beginning of the baroque. The points that should be made are that works of high value in a definite and unmistakable mannerist style were being produced before the Counter-Reformation began, and that the Counter-Reformation itself frequently changed its character in relation to art. The militant Counter-Reformation, which exercised a certain influence on the late phase of mannerism, was essentially different from the victorious Counter-Reformation which had a decisive influence on the baroque; and this later, artistically more productive, Counter-Reformation manifested itself in the baroque, not, as Weisbach says, just because it takes a relatively long

time for 'ideas and social changes' to exercise their influence on art, but because at the time when mannerism originated there were no Counter-Reformation ideas yet which could have exercised any influence.

However, chronology, conclusive though it is in relation to tangible facts, is not always conclusive in the history of ideas. Artistic development often anticipates ideas that have not yet been formulated, but are 'in the air'. Thus in tracing the history of ideas we are confronted just as often with correlations as with causal connections, if not more often. In considering the relationship of mannerism to the reform movement we are certainly faced with such a correlation. It can be assumed that the same spiritual excitement, the same sense of crisis, that in Germany led to the Reformation led in Italy to corresponding phenomena in philosophy, science, art, and literature without Luther's exercising any direct influence there. But an assumption as bold as this must not be strained so far as to talk of ideas anticipating the Counter-Reformation before the Reformation itself had yet been heard of.

Weisbach is right in describing the baroque and not mannerism as the artistic style of the Counter-Reformation, but he is totally wrong in dismissing mannerism as a 'soulless' and 'mechanised' art 'essentially marked by a lack of religious feeling'.[17] Such is the dual nature of mannerism that, in addition to its other contradictions, it includes both religiousness and scepticism, worldliness and other-worldliness, spiritualism and sensualism. But a description of it that ignores what Dvořák regards as the most important element in the art of Tintoretto and El Greco is based on a much more serious misunderstanding than the reverse would be. Mannerism may have adopted religious impulses without these necessarily being in the line of the Counter-Reformation, and some of its later representatives, such as Tintoretto and El Greco, were influenced by the Counter-Reformation without turning into baroque artists. The Counter-Reformation frame of mind coincides completely neither with the mannerist nor with the baroque, though it expresses itself far more easily in the latter.

The discrepancy between mannerism and the Counter-Reformation is not confined to chronology. Both stylistically and in fundamental outlook they represent two opposite principles. Mannerism is essentially formalistic, unrealistic, irrational, intellectual, difficult, complicated, and sophisticated, while the outlook of the Counter-Reformation is realistic and rational, its artistic bent is governed by instincts and sentiments, its statements are intellectually levelled, aimed at simplicity, clarity, and ease of understanding. Mannerist forms of expressions are affected, distanced, intended for an *élite*, while those of the Counter-Reformation are emotional, direct, and generally popular in tone. The Counter-Reformation rejected the wit, piquancy, ambiguity, and obscurity of mannerism chiefly

because its way of expressing itself in veiled allusions, abstruse conceits, far-fetched associations and esoteric metaphors was unsuited to its objective of propagating the faith. It turned against the exclusiveness of mannerist taste because its primary aim in art was the winning back to orthodoxy of broad sections of the population.

5. THE COUNCIL OF TRENT

The anti-mannerist tendency of the Counter-Reformation and the incompatibility of its canons of taste and standards of value with mannerist objectives appear most plainly in the decisions of the Council of Trent, the spirit of its deliberations, and the views expressed by the writers about art who wrote under its influence. The guiding principles laid down for art and art criticism developed gradually during the years the council spent in session. The Roman church was battling for survival, and consequently an atmosphere of grave danger prevailed and the necessity for firm measures was clearly felt. Nevertheless there was also a growing sense of strength and confidence.

Most of those who took part in it certainly did not know a great deal about art, and their artistic judgment was certainly not particularly reliable, but their minds were perfectly clear about the fundamental function of art within the church. Apart from their obvious insistence that works of art must be dogmatically unobjectionable and decent in tone, they saw that what they needed was relatively simple, undemanding, and readily intelligible artistic representations that appealed primarily to emotions and feelings instead of to intellect and expertise. They must be aimed at the great mass of church-goers, not at an *élite* of connoisseurs.

The strongest objections to the kind of art that seemed unsuitable for church purposes concerned the subject-matter of representation. In the first place, works of art inspired or influenced by heresy must not be accommodated in churches. Artists must adhere strictly to the canonical form of the Biblical stories, and in cases of dogmatic controversy must abide by the official interpretation. The other important decision affecting content condemned the representation of nudity and obscene or indecent allusions in works of art intended for churches. The campaign against indecency in art was of course much older than the Council of Trent. In 1559, before any decisions had yet been reached at Trent, this led Pope Paul IV to order the covering up by Daniele da Volterra of those nude figures in Michelangelo's *Last Judgment* which seemed particularly provocative. Later, in 1566, after the council had pronounced on the matter, Pius V had further objectionable parts removed; and finally

Clement VIII wanted to have the whole fresco destroyed, and was deterred only by a plea from the Academy of St. Luke.

The famous decree containing regulations referring to the subjects and motives of works of art was drafted at the last session of the council on December 3 and 4, 1563. Its most important passage reads:

> . . . in the invocation of the saints, the veneration of relics, and the sacred use of images, all superstition shall be removed, all filthy quest for gain eliminated, and all lasciviousness avoided, so that images shall not be painted or adorned with a seductive charm . . . it shall not be permitted to display in a church or elsewhere an unusual picture (*insolitam imaginem*) without the approval of the bishop.

Nothing in this is new, except for the placing of responsibility for the supervision of ecclesiastical art in the hands of the bishops, but this was the most important and far-reaching of the council's rulings on this matter.[18] The prescriptions were rather vague and general in nature, and many loop-holes were left wide open. The danger lay in the power given to bishops to ban works of art from churches and to decide what works were to be accommodated in them. This imposed on the artist a whole series of mechanical regulations to which his spontaneous creativity was eventually bound to succumb.[19] It was the first great blow suffered by art with the transition from mannerism to the baroque, whatever else may have come out of it. Religious art assumed an official character and lost its intimacy, subjectivity, and directness. It came to be more and more dictated by liturgical considerations and less and less by personal faith, and thus led to modern 'church art', the modern 'devotional picture' in the worst and most insipid sense of the word. The art of a Rubens or a Bernini do not alter the fact that in the baroque this kind of church art was the rule, and that the end of mannerism and the beginning of the baroque thus involved a tremendous loss in spite of all that was gained thereby.

The Council of Trent was as anti-mannerist in regard to style as it was in regard to subject-matter and its dogmatic interpretation, though the question of style was not specifically mentioned in any of its decrees. Its attitude was made plain in the general spirit of the deliberations, and more particularly in the discussion of church music, though much less attention was paid to this, and the rules that were laid down were much less specific, than was supposed until recently.[20] The spirit in which style in general and mannerism in particular were discussed can best be deduced from the wealth of literature on art that appeared soon after the council ended and directly under its influence, as this became the basis of the whole art policy of the Counter-Reformation.

The main weight of the council's stylistic objections to mannerism was

evidently directed at its playful, virtuoso formalism and its soulless sensualism, for these were the two points on which the criticism inspired by it concentrated. Sensualism did not mean merely suggestiveness, and formalism did not mean merely ornamentalism or play with complicated and overloaded patterns. In music the council condemned as sensualism the subjection of the text to musical structure, and called for the elimination from church music of hedonism, which sacrificed the expression of religious feelings to the pleasures of the senses.

What the council meant by formalism is most clearly stated in Giovanni Andrea Gilio's *Due Dialoghi degli errori de' pittori* (1564), the first literary expression of its anti-mannerist bias. He complains that painters no longer trouble about the content of their paintings, but are concerned only to make a display of their virtuosity; and this must certainly have been one of the principal themes in the council's deliberations on the subject. As has recently been pointed out,[21] Gilio initiated a new trend in art criticism, as in his work, and a whole series of others that derive from him, only practical, functional questions connected with subject-matter are discussed, while purely formal problems are ignored. Ecclesiastical art having assumed an official function, works of art are henceforward assessed primarily for their value as devotional objects. This attitude, and the condemnation of the representation of the nude, are shared by nearly all the art critics of the time, notably Raffaele Borghini, the author of the *Riposo* (1584), and Carlo Borromeo who, as is well known, caused pictures which seemed to him to be indecent to be removed from all the churches in his sphere of influence.

That the aestheticians of the time of the Council of Trent and the Counter-Reformation were not just anti-mannerist but were tending towards the baroque, thus lending support to the view that the latter was the artistic fulfilment of the Counter-Reformation, is illustrated by this passage from Gabriele Paleotti's *Discorso intorno le immagini sacre* (1582):

> If we see the martyrdom of a saint rendered in lively colours without being shattered by it, if we see Christ being fastened to the cross with dreadful nails, we must be of marble or wood if we do not feel deeply moved, if our piety is not stimulated afresh and our inner being is not deeply affected by remorse and devotion.

This emotionalism and sentimentalism, this wallowing in pain and suffering, wounds and tears, is baroque, and has nothing to do with the intellectualism, spiritual aloofness, and emotional remoteness of mannerism. In his call for a more expressive artistic language charged with greater affect, Gilio specifically mentions the coldness of the earlier artistic style. He takes the view that from the casual allusions to the

wounds of the saints and martyrs in the art before his day nobody would conclude how great were their sufferings and torments; and in the same way Possevino and Borromeo insist that affect in church art should be rendered with greater directness.[22]

The liberalism of the church in relation to art now ceased all along the line. Ecclesiastical art was produced under the strict supervision of theologians, and in all important works artists had to follow the instructions of their spiritual advisers. Giovanni Paolo Lomazzo, the greatest authority of his time in matters of art, specifically calls for such adaptation.[23] Taddeo Zuccari at Caprarola actually had to obey instructions in the choice of colours, and Vasari not only had no objection to the directions he received while working in the Sala Regia from the Dominican art expert Vincenzo Borghini, but actually felt uncomfortable when Borghini was not about.

The situation now was that the church rejected mannerism in principle but, as it was the only art available, made use of it with certain reservations. Its primary aim was to enlist art as an ally in its struggle with the Reformation, and it therefore behaved as a friend of the arts, in contrast to the Reformation, which was hostile to them. Nevertheless it nourished a certain mistrust of art, and never rid itself of its fear of the idolatrous practices to which holy pictures might give rise. St. John of the Cross, who as a poet was himself a mannerist, adopted the characteristic ecclesiastical reserve towards art when he said that the devout needed no pictures, and that the churches that had least decoration to distract the senses were the best for praying in. In contrast to this attitude, however, the seventeenth-century saints and founders of orders regarded art as one of the most valuable means of missionary propaganda. While mannerism had often been severe, ascetic, and unworldly, the baroque was once more able to be liberal and pleasing to the senses. In accordance with the Counter-Reformation spirit of the baroque, churches became, not so much places of remorse and repentance, as inviting, welcoming, friendly homes for the faithful. Once more they could be adorned and resplendent, flattering to the flocks of whom Rome now felt sure again. It was even possible to revert to the practice of tickling their senses.

Even in its earliest phases the Counter-Reformation was by no means hostile to art; it merely revived the medieval doctrine that pictures were 'the Bible of the poor' and art, rather like philosophy, the handmaiden of theology. But Luther strictly speaking regarded only literature as such, and he could see no merit in the Catholic cult of painting, having in mind, not only the 'religious' art of the Renaissance, which indeed had little to do with faith, but the expression, *i.e.*, externalisation, of religious feeling through art in general. This was the 'idolatry' which the mere adornment of churches with pictures meant to him. But he was not more

radical in his rejection of art than were the heretical movements of the Middle Ages, all of which were fundamentally iconoclastic, and condemned the profanation of faith by the all too worldly brilliance of art. Luther's comparatively mild disapproval of painting was nothing, however, compared to that of later reformers, such as Karlstadt, who in 1521 made a bonfire of the holy pictures at Wittenberg, or Zwingli, who in 1524 ordered the removal of works of art from the churches and their destruction, or Calvin, in whose eyes taking pleasure in a picture amounted to idolatry, or finally the Anabaptists, who regarded art with loathing and contempt, as part of the corrupt culture of their time. With these men opposition to art amounted to iconophobia. They were much more intolerant and consistent in the matter, not only than Savonarola, for instance, whose aim was rather to purify art than completely to repudiate it, but also than the Byzantines, who, as is well known, did not so much object to painting as to those who exploited the cult of holy pictures.

6. THE CATHOLIC REFORM MOVEMENT

While there was no direct, genetic connection between mannerism and either the Reformation or the Counter-Reformation, such a connection certainly existed between the beginnings of mannerism and the Catholic reform movement. The latter was able to influence artistic development before knowledge of the Reformation became widespread in Italy and presented circles wider than a small clerical and humanist *élite* with an acute religious problem. There are scholars who believe that the Italian reform movement began before the Reformation in Germany and that, but for the subsequent external influence, it would have developed more rapidly and consistently.[24] This would support the assumption that mannerism, though religious factors played a part in its origin, did not have to await the influence of the Reformation before making its appearance.

Even apart from the chronological factor, the intellectual and emotional atmosphere of the Catholic reform movement can be regarded as the closest religious equivalent of mannerism, which conflicted alike with the sober, rigorist, and anti-sensualist spirit of the Reformation and with the emotionalism and popular appeal of the art of the Counter-Reformation. On the other hand, with its fits of nervous sensibility and religious fervour, it is close to the sophisticated, spiritually exclusive and divided mind of the Catholic reformers. This link recalls Dvořák's suggestion that the inwardness produced by Protestantism had a greater effect on art in Catholic countries, that is to say, by way of Catholicism, than it had in the countries of the Reformation. In the latter mannerism certainly

never produced works as deeply spiritual as those of Tintoretto and El Greco.

The importance of the Reformation to the west is underrated if it is regarded merely as a matter of denomination. Immensely large though this loomed in the lives of men of that time, it meant much more. It should be regarded rather as a vital issue of the time, from which it was impossible for anyone with a sense of moral responsibility to stand totally aloof, rather like that of the teachings of the sophists in the time of Plato, or of the Enlightenment in the period preceding the French Revolution, or of socialism in the age of capitalism. In countries which remained completely Catholic, like Italy and Spain, it led to a religious revival, and everywhere it was like a clarion call to men to awaken from a long sleep and search their hearts. No good Catholic was left unaware of the corruption of his church and of the need of reform. The impact of the ideas from Germany went even deeper than that; men became aware of how much of its original content the Christian faith had lost. Even those with the least thought of disloyalty to the religion of their upbringing underwent a kind of reformation. They began examining the assumptions of their faith, acquired a better knowledge of it, grew better able to distinguish its genuine essence from the false superstructure, rediscovered the freshness and spontaneity of a religion that had degenerated into routine, and were thus strengthened and fortified in it. Faith ceased to be an insipid formality, and glowed in the blaze kindled by Luther. What most impressed good Christians everywhere, and particularly in Italy, was the anti-materialism of Protestantism, the doctrine of justification by faith, the idea of man's direct relationship with God, and the universal priesthood. The impact of this on the Italian intelligentsia was more far-reaching and revolutionary than any direct borrowing from the Lutheran doctrine could have been; and, so far as art was concerned, the complete acceptance of Protestantism could hardly have affected it more profoundly than its echo, the Catholic reform movement, seems to have done.

The need for a spiritualisation of religious life was nowhere felt more deeply than in Rome. The leaders of the reform movement were mostly respected members of the Roman clergy and enlightened humanists who were under no illusions about the failings of the church and the need of drastic measures to put them right, but their radicalism stopped short of questioning the justification of the papacy. They wanted reform of the church at all costs, but reform from within. The first phase of the movement came to an end with the sack of Rome; later, when its scattered members began to gather again, Vittoria Colonna and her friends, of whom Michelangelo had been one since 1538, were among its most enthusiastic supporters. It was from this circle, and above all from Juan Valdès, who was one of the leading figures of the movement, that Michel-

angelo received the vital stimulus that led to his religious rebirth and the spiritual style of his old age, though the path taken by him and his art had to an extent been marked out in advance since his youth and the influence of Savonarola. But without the reform movement his spiritual development might have taken a different course, and it can be assumed that but for this movement a different course would have been taken by Italian mannerism as a whole.

VI

The Autonomy of Politics

MACHIAVELLI was the first modern thinker. *The Prince* set in motion the final breakdown of the integrated and self-contained spiritual world in which the Middle Ages and the Renaissance moved. The idea of the autonomy of political thought and action provided the first impulse that led to the atomisation of the various fields of knowledge and experience and led to the break-up of the homogeneous and harmonious, though still undifferentiated, vision of life of the preceding centuries. With it there begins the history of our modern, specialised fields of study, each with its own methods and clearly defined territory. This revolutionary development resulted in the loss of the 'whole man' who still possessed a uniform and harmonious vision of life, but also in a gain which is generally overlooked when that loss is deplored. The gain was the ability to discriminate between different approaches to and interpretations of reality, and to retain the specific aspect of the different approaches. This revolution is most closely associated with Machiavelli. No other representative of the age so clearly illustrates the crisis connected with the collapse of the uniform vision of life, and no one else seized so swiftly and acutely on the advantage derived from the differentiation of thought and its adaptation to distinct and divergent aims.

The great discovery with which he set the intellectual history of the west on a new course—the discovery of the autonomy of political thought, the difference between the morality of political action and the moral categories which provide the framework of ordinary life, the transformation of the state from a planet into a sun that takes place when the political sphere is entered—can again be compared only with that of Copernicus. The third Copernican revolution, standing side by side with the supersession of the geocentric by the heliocentric system and the Protestant

82

substitution of the sacramental priesthood by the believer's direct relationship with God, was that of Machiavelli, whose share in the recasting of western culture was no less than that of Luther or Copernicus himself.

His revolution can be called Copernican, not only because of the discovery of a system in which morality was a mere planet in the sky of the state, displacing the older system in which the state had been no more than a planet in the sky of morals, but also because, like Copernicus's discovery, it is closely linked with the concept of ideology, that is to say, understanding of the perspective nature of thought; and in Machiavelli's case the ideological aspect is the more striking in that his field is not that of natural science, like Copernicus's, but history, and he was a far more rigorous thinker than Copernicus, far more aware of his assumptions.

Machiavelli defines politics as an activity having its own objectives, principles, and standards, an activity, that is to say, that can and should be conducted totally independently of non-political considerations. In politics means must be chosen to meet the ends, and the best means are those that lead most surely to those ends. This principle, which implies the autonomy and self-sufficiency of politics, is the whole basis of his thought. The autonomy he discovered in politics also appeared in other fields, and became one of the leading ideas of modern scientific inquiry. The autonomy of economic life, and that of capitalism in particular, began making itself felt before anyone was capable of recognising and stating the fact. Recognition of the autonomy of natural laws was on the way; the autonomy of artistic creation came gradually to be accepted and, in the art criticism of later mannerism, art is no longer regarded as imitation of nature, but as a creative activity of the mind.

The autonomy of politics discovered by Machiavelli, and all the other autonomies that came into being in other fields of theory and practice as they gradually threw off the unifying yoke of ecclesiastical dogma and scholasticism and the feudal economic and social order, meant independence—as did the emancipation of Protestantism from the Roman Church —but independence without freedom, in other words, loneliness and isolation. With each new step in this development yet another territory isolated itself from the uniform, wholly spiritualised medieval cosmos, and the atomised view of life of modern civilisation, having no central truth to link all the various partial truths, drew nearer.

2. THE DOUBLE STANDARD OF MORALITY

Of the ideas associated with the name of Machiavelli, that which made the greatest and most far-reaching impact was the double standard of morality. This is expressed in the celebrated proposition that the rules of Christian

morality binding on men in general are in certain circumstances not applicable to princes, with the result that there is one morality for subjects and another for their rulers, and that the private morality of the subject has nothing to do with the public morality of the ruler responsible for the survival of the state. The most important passage relating to this in *The Prince* is:

> A man who wishes to make a profession of goodness in everything must necessarily come to grief among so many who are not good. Therefore it is necessary for a prince, who wishes to maintain himself, to learn how not to be good, and to use this knowledge and not use it, according to the necessity of the case.[1]

The other important passage in this connection tells the famous parable of the fox and the lion.

> A prince being thus obliged to know well how to act as a beast must imitate the fox and the lion, for the lion cannot protect himself from traps and the fox cannot protect himself from wolves. He must therefore be a fox to detect the traps and a lion to frighten off the wolves. Those that wish to be only lions do not understand their business. Therefore, a prudent ruler ought not to keep faith, when by doing so it would be against his interest, and when the reasons which made him bind himself no longer exist.[2]

The two standards of morality, one for the rulers and the other for the ruled, have always existed, ever since there were conquerors and conquered, masters and servants, exploiters and exploited. But Machiavelli was the first who made men aware of this ancient dualism and had the courage to state openly that in politics, when the safety of the state and the position of its masters were at stake, the principles of action that applied were different from those that applied to the lives of ordinary mortals; in others words, the Christian moral principles of good faith and honesty were not binding on princes in all circumstances.

There had been an analogy to the Machiavellian 'double standard' in the earlier history of western culture, the doctrine of the 'duality of truth', which was similarly associated with a grave cultural crisis and was a symptom of the controversy between universalism and nominalism that for centuries divided the Middle Ages and played such an important part in their break-up. It is significant that Machiavelli's contemporary, the philosopher Pietro Pomponazzi, revived the medieval theory of the duality of truth, and argued that a proposition could be true in theology, yet not true in philosophy. But Machiavelli's dualism was in the moral and not the intellectual sphere, and its impact was the more shattering because of the far more vital issues involved.

So revolutionary was its effect that anyone familiar with the literature of

the period can almost infallibly detect whether one of its products was written before or after the author had come across Machiavelli's ideas. It was not necessary actually to have read him, and no doubt by many he remained unread for, rather like Marx and Freud, he was one of the minds whose ideas become common property, though most of those who feel their influence never make direct contact with their author. The idea of the double standard, like that of political realism and rationalism, spread by innumerable and unverifiable channels, and nobody could tell for certain how it first came his way. Machiavelli was taken up everywhere, and a ubiquity was ascribed to him that could have been possessed only by the devil, with whom he was indeed identified. In the end every liar seemed to speak his language, and every sharp practice was suspected of being a product of his devil's kitchen.

No doubt the reason why he made such an enormous impact on his contemporaries was that they recognised their own conflicts in his dualism. He touched them on the raw, and for all the wrath, condemnation, and scorn that they poured on his head, he spoke to them out of their own hearts. True, only a few were able to lead the double life of a prince, but many were involved in the moral inconsistency on which the prince's life was based.

The same conflict of values that lies at the base of Machiavelli's double standard also appears in the doctrines of Luther and the methods of the Jesuits, in the ambiguous life of Don Quixote, and in the borderland between dream and reality in which so many of Shakespeare's and Calderón's plays move. Luther's confession that the world could not be governed 'according to the Gospel' and his willingness to recognise the established power bring him very close to Machiavelli.[3] Moreover, the gradual development of church organisation and of a more objective, material outlook in the Reformation movement, which was originally intended to be completely subjective, resulted in a kind of 'double standard' in him too. The relations of Ignatius of Loyola's views and Machiavelli's is obvious. The catch-phrase about the end's justifying the means commonly used to sum up the basic principle of Jesuitism also states Machiavelli's principles in a nutshell. Even Montaigne was at heart as much a Machiavellian as Luther or Loyola. The passage in the *Essays* in which he excuses a prince's breach of faith on the ground that in certain circumstances he may have to listen to 'reasons more important and more widely valid than his own',[4] and recommends honesty to princes only as the best policy, is well known. But his kinship with Machiavelli goes deeper than one would conclude from parallelisms of this kind. Machiavelli derives his view of ideology from the relativity of standpoints and values, and so does Montaigne. It is this relativism which is the turning-point in the history of the Renaissance and is the basic cause of the spiritual crisis of the age.

Cervantes is evidently no stranger to the idea. 'What seems to you to be a barber's basin,' Don Quixote says to Sancho Panza, 'seems to me to be Mambrino's helmet, and to someone else it may again seem something quite different' (I. 25). And no one, not even Machiavelli, expresses the idea of relativism associated with the double standard of morality more vividly than Gracián. 'Let human means be applied as if there were no divine means, and divine means as if there were no human means,' he writes (*El Oráculo Manual*, No. 251).

3. THE THEORY OF POLITICAL REALISM

Machiavelli was the first to develop the theory of political realism; he was not the inventor of 'Machiavellism', which dissociates political practice from Christian ideals and moral standards, for every Renaissance princeling was a consummate Machiavellian. But he formulated the doctrine of political realism and rationalism, and he was the first to think out to the end the consequences of deliberate and systematic realism.

For all his originality, he was only the spokesman of the generation whose breath he took away by his daring. If his ideas had been merely those of a brilliant and eccentric philosopher, they would hardly have made an impact that re-echoed through the whole literature of the west. If his work had been relevant merely to the political methods of the Italian petty tyrants, he would not have moved minds more deeply than did the horror stories that circulated about the use they made of poison and dagger. But he was not alone in his disillusioned realism, and the number of those who shared it was not restricted to the uninhibited *condottieri* princelings of Italy. For what was Charles V, the defender of the Catholic Church, who physically threatened the Holy Father and turned the capital of Christianity into a barracks and a brothel, but an unscrupulous realist? Or Luther, the founder of the modern popular religion *par excellence*, who betrayed the people to the princes and allowed the religion of inwardness to degenerate into the creed of the most mundane and practical section of society? Or any of the princes who were ready at any time to sacrifice their poor subjects to the interests of the capitalists? And, finally, what was the whole of capitalist society but an illustration of Machiavelli's doctrine? Was it not plain enough that reality followed its own inexorable logic, in face of which all ideas were helpless, and that the choice was between adapting oneself to reality or going under?

But what horrified the world was not reality, or the crimes of the despots, or the fawning of court poets and chroniclers. What shocked it and roused its indignation was the justification of their methods by a man who counselled mercy as well as violence, nobility as well as cunning, the

morality of the fox as well as that of the lion. What was new was not the implications of political realism, but the fact that they were publicly stated and advocated.[5] The revolutionary feature was that here practice was turned into principle. When the dualism more or less implicit in any political attitude was made manifest in this way, and a degree of justification and legitimacy was granted to moral iniquity, an abyss opened up beneath the world of order and threatened to swallow it. The key to the new outlook and the resultant spiritual crisis was that Machiavelli saw no anomaly in political realism and rationalism, but accepted them as entirely normal, regarded the mechanism of the reason of state as completely natural, and considered the fact that the state was bound to practise power politics and was therefore 'bound to sin'[6] as necessary and inevitable.

The influence of Machiavellian realism was immeasurable; its extent was comparable only to that of the great religious teachers or, say, the ideas of Rousseau or Marx. Montaigne, Luther, Ignatius of Loyola, are only the most striking of the names that occur in this connection. The Council of Trent was a high school of political realism. With sober and ruthless objectivity, it took the steps most appropriate to adapt the church to the requirements of the day, and to save what could be saved in the circumstances. No severity was excessive if it promised to attain the goal, and no indulgence too great if it led in the same direction.

Posterity now praised Machiavelli, now condemned him; its judgment followed historical developments with a fidelity corresponding to changes in social and political conditions. But sometimes diametrically opposite attitudes were adapted towards him, and fascinated admiration was lavished on him at the same time as loathing and contempt. However, at a relatively early stage a general revulsion against him is discernible. While Marlowe was enthusiastic, and Shakespeare deeply impressed, though rather aloof, the later Elizabethans were alarmed, terrified, indignant. But his influence on those whom he angered by his objectivity and scared and enraged by his anticipation of Marx, Nietzsche, and Freud—their psychology of exposure—was no less than that which he exercised on his admirers. Its extent can be judged from the frequency of references to him in Elizabethan drama; it has been shown that he is either specifically mentioned or directly referred to 395 times.[7] He became a symbol of double-tongued hypocrisy, cunning, and intrigue, his surname, spelt with a small m, came to stand for a type, and he himself became a bogyman.

In that age of crisis, when all values were becoming problematical and all the old props were collapsing, so great was the fear of slipping into a void that bogies were seen everywhere, and the true nature of Machiavelli's moral principles was misunderstood. The independence from Christian and bourgeois moral standards that he called for in judging

87

political decisions did not imply the immorality that it was believed to imply, but an amorality, a freedom from moral judgments, an indifference to moral considerations, a beyond-good-and-evil attitude in the political sphere. He never tried to excuse or cover up evil; he nowhere maintains that evil can in any circumstances be good, or that it is morally justified by success. All he says is that political success is the only relevant criterion of political action. If anyone has to take political action and is determined to act politically, political success must be his aim and, with that in mind, moral considerations do not come within his purview, for he, his thought, and his will must move in a sphere outside the categories of morality.

The real misunderstanding of Machiavelli arose from sheer inability to see what was seen at once by Francis Bacon, for instance. Machiavelli's object was not to show how men should behave, but how they did behave.[8] Instead of following up this very revealing hint, and taking as their starting-point his dispassionate, unprejudiced, objective approach, the innumerable interpreters of Machiavelli in the course of the centuries wasted their time demonstrating either the admirable nature of his doctrines or their moral iniquity.

Apart from Machiavelli's political bombshell, the principle of abstention from moral judgment in studying a phenomenon first came to the fore in the field of economics. The abolition of the ban on lending money at interest, the abandonment of the conception of the 'just price', the spread of the principle of free competition, the gradual elimination of guild protectionism, the growth of an impersonal money economy, the slow transformation of labour from skilled artisanship to more or less mechanical machine-minding, are all symptoms of the same development—practice resting on the principle of the independence of economic activity from moral criteria and leading to the autonomy of the capitalist economy, its independence of tradition, personal considerations, and emotional ties. Machiavellism, with its rationalism and its justification by success, is itself obviously in part a product of the circumstances that brought capitalism into being, but it must in turn have exercised a strong influence on economic development and contributed to the origin of the system of aims, methods, and institutions which we call modern capitalism.

Machiavelli is fundamentally a rationalist; he is rightly regarded as the founder of the theory of the reason of state, and 'political rationalism' describes his philosophy just as accurately as does 'political realism'. But he is also a typical representative or pioneer of mannerism, in that his partly conscious and partly unconscious affinities are divided between rationalism and irrationalism. In all matters affecting man as a political and moral being, his whole unprejudiced, resolute, liberal standpoint, uninhibited and untouched by ecclesiastic doctrine, traditional morality, and social conventions, is rational, and so is his unmistakable dislike of

obscurantism, and his instinctive sympathy with commonsense and the spirit of enlightenment and progress. So far all is plain sailing, but then one comes up against Machiavelli the irrationalist. It is hard to reconcile the admirer and panegyrist of Cesare Borgia, gangster prince, poisoner, murderer, perjuror, and intriguer, who plotted and laid traps, robbed and killed whenever 'reasons of state' required, with the picture of him as a friend of enlightenment and progress. The justification of crime might perhaps be acceptable as the logical consequence of the doctrine of rationalism in the service of political necessity driven to extremes; but Machiavelli could hardly have picked on a Cesare Borgia as his political ideal, or even as an example of a competent prince, unless he had felt a certain sympathy for him. The choice betrays a romantic, irrational trend, a dark, obscure bond, a weakness and naïveté inexplicable on rational or normal psychological grounds, in a thinker as sturdy, masculine, and fearless as Machiavelli. This is yet another instance of the combination of opposites which is so frequent in mannerism. Moreover, his admiration for Cesare Borgia is not the only instance of Machiavelli's paradoxical irrationalism. A similar conflict of principles occurs in his philosophy of history.

In Machiavelli's view human nature is unalterable; man is always dominated by the same selfish instincts, the same cowardly and crafty aggressiveness. Completely evil men are as rare as completely good men, but men in general are weak, mean, and greedy for gain. In his often quoted phrase, they find it easier to forgive the murder of their father than the loss of their property. But, if that is the permanent nature of man, it follows that his thoughts, reactions, and deeds are predictable, and thus universally valid generalisations about society and politics are possible. Nevertheless, political events could not be predicted with any confidence, as Machiavelli felt, and therefore his method, however closely it approached that of the exact sciences, could not be strictly scientific. So he had to correct, or rather supplement, his very unhistorical view of human nature. This, being a constant and unalterable entity, as he described it, could not be subject to historical change, and to explain the irrational and incalculable element in the historical process he had to introduce the idea of *Fortuna*. To this he ascribes all the factors in history which are generally referred to as chance, destiny, or the ineluctable combination of circumstances. The tone of the passage with which he concludes his chapter on *Fortuna*, though it is appropriate to its subject, is surprisingly playful, temperamental, high-spirited and, one might almost say, boisterous.

> For fortune is a woman [he says], and it is necessary, if you wish to master her, to conquer her by force; and it can be seen that she lets herself be overcome by the bold rather than by those who proceed coldly. And therefore, like a woman, she is always a friend to the young, because they are less cautious, fiercer, and master her with greater audacity.[9]

4. THE THEORY OF IDEOLOGY

Nowhere does the crisis of the Renaissance come closer to the spirit of our own age than in relation to the question of ideology, the notion of which was first clearly stated by Machiavelli, who thus set in train a process the continuity of which has since suffered no sensible or lasting break. Marx was only the last and certainly the most radical of the minds that developed the notion, and it was he who gave it its most specific and concrete meaning. But at the same time he gave it a limited and restricted application, with the result that ideology, the warping of views resulting from perspective, for which there may be the most varied reasons, came to refer to a special distortion of outlook brought about by economic interests and a corresponding falsification of truth. If it is realised that one of the most important turning-points in the history of the concept of ideology was the discovery of the subjectivity of the categories of thought, it will be granted that Kant played just as important a part in this development as those with whose name the theory of ideology is most closely connected. The spiritual father of both Marx and Kant, and all the others who played a part in the development of the notion, was, however, Machiavelli, not merely because he discovered the existence of more than one order of moral standards, but because he recognised that standards depended on the special situation, the social position, and the political objectives of those who held them.

In deriving the idea of right and good from expediency he came very close to the modern notion of ideology. He did not of course attribute a class character to these things, though he quotes a saying current in his time that the man in the street (*in piazza*) thought in one way and the man in the palace another,[10] so he cannot have been entirely unsuspecting in the matter. But his awareness of the ideological character of thought is best illustrated by his explanation of the origin of moral standards. In the early phases of their history, he states, men sought to protect themselves against being harmed and threatened by others by imposing punishments on evil-doers in the name of justice, and the concept of right and honourable conduct on the one hand and of wicked and ignoble conduct on the other arose from this. But men forgot the origin and real purpose of the standards that they originally set up purely in the interests of their security, and formed the idea of unconditional and timeless good and evil. Such ideas are obviously only fictions. The good is the expedient, the conduct one expects from one's fellow-men, and the things one does oneself only under the pressure of laws and penalties.[11]

Machiavelli only indirectly paved the way to the turn that the concept of ideology took with Kant. Its immediate predecessors were other repre-

sentatives of the mannerist intellectual revolution. No one before Kant
was aware of participating in a reorientation of thought comparable with
that initiated by Copernicus; he was the first to realise the epoch-
making nature of the upheaval brought about in epistemology by a trans-
fer of primacy from object to subject, which he himself described as a
'Copernican' revolution. By this new emphasis he did not of course imply
that the subject created his world in a completely autonomous way, but
only that he produced it out of the inchoate and inarticulate raw material
of the sense impressions. As before, all cognition began with experience,
though it could no longer claim to arise exclusively out of experience. The
proposition that connects Kant's discovery so closely with the theory of
ideology and makes it possible to regard him as something in the nature
of a predecessor of Marx forms the very core of his philosophy; it states
that cognition does not provide us with a copy of reality, but with a dis-
torted, or at any rate transformed, picture of what may be really at hand.

Apart from the fact that mannerism is essentially an art of deformation,
and that the whole outlook of the age revolves round the idea of distort-
ing, concealing, and obscuring reality and putting substitute forms in its
place, its whole aesthetics, with the concept of spontaneity as a basic prin-
ciple, show a quite astonishing resemblance to the philosophy of Kant.
All the statements and precepts of Renaissance art theory were based on
two fundamentals—the *imitation* of nature and the overcoming of it by
the *selection* from it of those features that were regarded as 'beautiful'. The
assumption behind this theory, and the connecting link between the two
fundamentals, was that the artist found ready to hand, objectively present
in the world, both what he was to imitate and what he was to select. From
the Kantian point of view, this assumption was 'naïve'; it assumed an
attitude of pure receptivity in relation to artistic creation, and still accorded
with the medieval notion that the artist's talent or genius was rooted in
craftsmanship and imitative ability. The notion of spontaneity, as familiar
from Kant's epistemology, makes its first appearance in the art theory of
mannerism. Moreover, it does not do so in the form of a vague and un-
defined idea of spontaneous creation, merely saying that the artist can
neither borrow the beautiful from nature nor that it is innate in him nor
that he is inspired with it. Instead it appears as a genuine Kantian concept,
declaring that artistic spontaneity originates *with* but not *from* experience
of nature.

The later mannerist aestheticians, that is to say Giovanni Paolo
Lomazzo[12] and Federico Zuccari,[13] are well aware that the 'idea' or *con-
cetto* or *disegno interno*, or whatever they may call the aesthetically creative
category, is neither purely subjective nor objectively present in nature,
and therefore, as Erwin Panofsky rightly saw, there arose for the first
time the question of how it is possible for the mind to form an idea which

cannot simply be derived from nature and yet cannot originate in man—
which amounts in the last resort to the question of how artistic creation is
altogether possible.[14] The problem of Renaissance aesthetics was: How
does the artist truly render a thing, and how does he render the beautiful?
The problem now was: How is artistic creation as a form of mental activity
possible? In other words, in contrast to Renaissance naturalism, or 'naïve
dogmatism', as it would be called in philosophical terms, mannerism for the
first time posed Kant's 'critical' question in relation to art. Harmony with
nature was no longer regarded as a self-evident proposition. Instead it
presented a problem; and men felt called upon to ask how it came about
and was warranted. The aesthetics of mannerism dropped the theory of
imitation in the relation between subject and object, just as astronomy
dropped geocentricism, Protestantism the objective means of salvation,
and Machiavelli the absolute validity of moral standards. In accordance
with the new doctrine, the artist created, not *after* nature, but *like* her.

Both Lomazzo and Federico Zuccari regard art as having a spontane-
ous mental origin. Lomazzo states that genius in art works like God in
nature, and Zuccari says that an artistic idea is the manifestation of the
divine in the artist's mind. Their thought still moves partly in Platonic,
partly in medieval grooves, and in particular Zuccari's conception of the
artist's vision comes very close to that of innate ideas, though he is well
aware that in the absence of sense experience the mind has nothing objec-
tive to work on, and clings fast to the great discovery of his time, the
twin roots of the objective contents of consciousness.

The newly acquired knowledge of the self is expressed in the aesthetics
of mannerism, as indeed it is in its whole philosophy. It occupies a more
and more prominent place, and emphasis is laid on it even when the con-
tents of consciousness are negative, as in the case of scepticism. For what
matters is not the content but the functions of consciousness, and not so
much the functions as reflection upon them. That is what Sanchez meant
when he said: 'True, we know nothing, but we know that we know
nothing.'

5. DUAL MORALITY AND TRAGEDY

In his book on *The Idea of the Reason of State*, Friedrich Meinecke re-
marks that, without departing from his basic train of thought, Machiavelli
might have called on his prince not to accept the moral duplicity involved
in compromise between Christian ideals and political realism, but to take
upon himself the conflict between private morality and the interests of the
state and accept the tragic consequences for himself. But, he goes on to
say, in Machiavelli's time no such way out was possible, for it assumes a

mental attitude that was first expressed in the plays of Shakespeare.[15] Meinecke was probably unaware what a wealth of spiritual connections he was here touching on, and what still occluded perspectives in the history of ideas he opened up by this passing and apparently casual remark. The path from the tension underlying the 'double standard of morality' led to a conflict that indeed found its outlet and resolution in tragedy. Modern tragedy, as created by Marlowe, Shakespeare, and their contemporaries, internalises conflicts and transfers fate from without to within, and was thus in a sense merely a way of escape from the intolerable situation created by the double standard. It was the poet's answer to the question of how life could be lived meaningfully and, if possible, unequivocally in an age of insoluble contradictions by men torn by ambivalent urges and irreconcilable aspirations. The tragic hero prefers coming to grief to inner contradictions, divided loyalties, a life of humiliating compromise; and his example became a crying reproach, not merely to the prince, but to men in general. For they, though on a much more trivial scale and in a manner far less harmful to their fellows, practised the very thing that roused their indignation in Machiavelli, namely his attribution to the prince of a moral standard different from that of other mortals. They themselves, in so far as their actions had any moral implications, daily and hourly followed different and conflicting moral principles. They willingly reconciled themselves to their inner contradictions, and were far from perishing of the conflict between reason and passion, duty and love, blood ties and loyalty to their convictions, that causes the tragic hero to come to grief. Actually they never allowed the conflict to appear, but avoided it by a compromise between their contradictory impulses.

The concept of 'symbolic forms' has been badly misused. A form like tragedy can, however, rightly be spoken of as 'symbolic' so far as its emergence and productivity are concerned. The circumstance that early mannerism had no tragedy in the sense in which it developed later gains a special significance from the fact that the question posed by Machiavelli was first answered by Shakespeare. That the age had a poet like Shakespeare may have been chance and accident, but the fact that it produced Shakespearean tragedy was symbolically significant, that is to say, was historically meaningful, and to an extent inevitable.

VII

Alienation as the Key to Mannerism

1. THE CONCEPT OF ALIENATION

NOTHING better expresses the nature and origin of the cultural crisis of our own time than the concept of alienation. From Rousseau's answer to the celebrated question of the Dijon academy to Freud's *Civilisation and its Discontents* the same notion, if not always the same word, was associated with the threatening or already present danger. The first to use the term alienation, or self-estrangement, in the sense of a criticism of modern culture was Hegel, and in the main it has preserved its original meaning even under the name of reification it received from Marx and that of the sublimation of instincts that it was given by Freud, who took a much more positive view of the outcome of the process of alienation than his predecessors, but nevertheless regarded repression of instinctual urges as an exorbitant price to pay for the protection that civilisation provides for us.

The concept of alienation is so much used and misused in modern works on the philosophy of history and culture that its meaning has been somewhat obscured, and special care is needed in disentangling the various levels of meaning that have become confused, and sorting out the essentials in the various aspects of the idea. The individual's sense of uprootedness, aimlessness, and loss of substance is and remains basic to the idea of alienation—the sense of having lost contact with society and having no engagement in one's work, the hopelessness of ever harmonising one's aspirations, standards, and ambitions.

Its discovery as a cultural phenomenon, as the destiny of civilised man, may date back to Rousseau, and its first authoritative and more or less still

94

valid definition may be due to Hegel, but alienation certainly did not begin with its discovery, naming, or definition, even if it is not actually timeless and does not appear as soon as and whenever contact is made with the objective world, as Hegel believed. It has existed since man ceased to live in a natural condition and civilisation began, since he began to subject himself to conventions and traditions, to adapt himself to institutions and to think in objective terms; in short, ever since he emerged from the state of nature and became the subject of history. However, in the narrower sense of the term in which we are interested in the present context, it originated in the age when the organic unity of the spiritual world began gradually to disintegrate into a multiplicity of aspects, interests, and ties. This too is of course a very ancient process, for it began in about the sixth century B.C., and is only loosely connected with the alienation of our own cultural period. In the broadly uninterrupted process of development that has since taken place, there have been some pauses offering rest and relief, as in the Middle Ages, for instance, as well as a number of sudden, revolutionary leaps, of which the most striking was that which took place in the sixteenth century. Western man experienced another such abrupt leap in the nineteenth century, with the development of modern high capitalism. These two periods are of especial significance, because of the contemporary awareness of the processes in train, which not only added a new dimension to the changes objectively taking place, but also gave them a new meaning.

In conscious form alienation appeared for the first time as the crisis of the Renaissance, and its effect was so revolutionary and all-embracing that the concept of alienation is the only possible common denominator for the various forms of the 'upheaval' that affected every field of culture. Whichever way one looks, one sees the same phenomenon, of men suddenly feeling themselves cut off, as it were, from the familiar things that previously gave meaning and purpose to their lives. They may have been at the mercy of tyrannical lords before, but now they found themselves at the mercy of forces from which they were estranged. They had grown estranged from their own work as a consequence of the application of mechanical methods of production, the replacement of the old patriarchal relationship with their masters by the impersonal forces of the market and the inscrutable play of economic forces, the turning of state and administration, economy and society, justice and the military system, into ruthless automata functioning with inhuman objectivity. The reification of life had gone so far that Georg Simmel's 'tragedy of culture' became a tangible fact. Man created objects, forms, and values, and became their slave and servant instead of their master. The works of his hand and mind assumed an autonomy of their own, and became independent of him while he became dependent on them, in that he recognised their meaning, worth,

and validity, or strove to possess them without ever being able to acquire them, as Marx complains. In the classical meaning of the term, from which both Hegel and Marx as well as Kierkegaard and the modern existentialists start out, alienation means divestiture of the self, the loss of subjectivity; a turning inside out of the personality, exteriorising and driving out what ought to remain within, with the result that what is ejected in this way assumes a nature completely different from the self, becomes alien and hostile to it, and threatens to diminish and destroy it. Meanwhile the self loses itself in its objectifications, faces an alienated form of itself in them.

But, above all, alienation means the loss of the wholeness or, as Marx called it, the 'universal nature' of man. Men whose world is still homogeneous and undivided are not yet alienated and are still whole, but those who have lost that universality and are confronted by independent and autonomous cultural phenomena isolated from the unity of life, like the state, the economy, the sciences, and art, themselves possess no concrete reality, have become 'abstractions' in the sense of the word used by Marx, to whom it is a synonym for alienation and loss of universality. In discussing alienation the cultural philosophers, both the followers of Kierkegaard and those of Marx, that is to say, the irrationalists as well as the rationalists, lay increasing emphasis on the loss of contact with reality. In this sense the whole trend is away from Hegel, who regarded alienation rather as an acceptance of concrete reality than as a departure from it.

Hegel understands by objectification an act of alienation from the self and by alienation a process of turning a subject into an object. He anticipates the basic theme of Simmel's cultural philosophy in that he recognises that meaningful mental structures or, as he calls them, the forms of the 'objective spirit', make themselves independent of their creator and thereby become alienated from him. He expresses this by saying that man loses himself in his own creations, works of art, philosophies, religions, sciences, etc., and lives in an alien, spiritually unreal and imaginary world. A work of art, philosophy, or science belongs both to its creator and does not; every such work contains an element of alienation, without which the mind would continue in a state of passivity, a form of being for itself alone. Just as God created the world by an act of self-alienation, so is the human mind confronted by an alien element in his own creations. In this way Hegel derives a positive value from alienation; not only does it lead to everything that is objective to man, but it also represents a necessary and indispensable stage in the mind's journey to itself. Only through alienation does the mind attain awareness of itself; for, in accordance with the laws of dialectics, it is superseded in objectification only to re-establish and realise itself again. The mind constructs a second world for itself by rising above and opposing alienated reality. But this higher world of self-aware-

ness can come into being only in conflict with the alienated world. Thus alienation is the prerequisite, so to speak, the price, of the mind's ultimate self-realisation. For 'the self is only real after having been superseded'.[1]

How close mannerism is to us, not only with its sense of alienation, but also with its theory of it, is shown most clearly by Campanella, who quite literally anticipates Hegel's use of the term as an epistemological principle. When he states that all cognition consists in undergoing external impressions he is still faithful to the imitation theory of the Middle Ages and the Renaissance. But he is original and revolutionary when he states that in the process of cognition the subject becomes alienated from itself, that it conceives things in being seized by them, and that in this process it loses its own true nature and assumes an alien nature in exchange. In his epistemology Campanella goes so far as to deny all difference between knowledge and madness, cognition and distortion. 'Knowing is becoming alienated from one's self,' he writes, 'becoming alienated from one's self is going mad, losing one's own being, and assuming an alien being.'[2]

2. MARX'S CONCEPT OF ALIENATION

Both Marx and Hegel mean by alienation the loss of that universality without which, in their view, man is not man. Nevertheless they differ in the important respect that with Hegel alienation is a super-historical process which takes place at every contact between subject and objective reality and is repeated with every such contact, while with Marx it is historically conditioned, that is to say, it first arises with private property, and in the narrower sense of the word originates in modern capitalism or, strictly speaking, the division of labour. The great advance made by Marx in the history of the idea lies chiefly in his stripping the Hegelian concept of its abstract, metaphysical, timeless generality and his defining it historically, that is to say, giving it limits in time. He brings the process of alienation down from the vacuum of logic and epistemology into the reality of history by attempting to derive the whole phenomenon from the worker's separation from the products of his labour, which are no longer his in any real sense of the word and have no real meaning for him. He transforms alienation from a kind of original sin attached to the human spirit from which it has yet to be redeemed, in Hegel's view, into a process with historical limits and dependent on historical conditions. He regards it as having originated with the mechanisation of production associated with the division of labour—or, as we should rather say today, tending towards the division of labour—and believed that it would disappear again with it.

Inadequate though Marx's theory of alienation may be in one way or

97

another, it is based on the correct assumption that the fundamental pattern of the alienated world is set by the commodity character of the products of labour. This is nowhere more evident than in the field of art. Works of art were formerly produced for specific purposes arising out of specific personal relationships for specific patrons known personally to the artist. Now they became the object of commercial transactions, a commodity with a market value, expressing thereby the problematic relationship between the artist and his public that so unmistakably differentiates him from the artist of earlier times.

The essence of a 'commodity' in this sense is the circumstance that as a result of neglecting the unequal quality of labour input—its reduction to an abstract common denominator, to mere 'labour', in fact—it is an article of trade having an exchange value.[3] Marx shows how as a consequence of his alienation from the product of his labour, which becomes a commodity, and his alienation from his work, which is performed solely in the service of others, the worker externalises and objectifies all that is human in himself, gradually loses all his personal qualities in his relationship with others as well as in relation to himself, acquires an exchange value like everything around him, and becomes a function of money.

The more he gives of himself, the harder he works and produces, the more strength accrues to the alien, objective world that he erects over and against himself, the poorer he becomes, and the less he retains for himself. He puts his life into his work; his life, however, is no longer his own, but belongs to the object that he produces. 'The worker feels himself at home when he is not working, and when he is working he is not at home. . . . His labour is forced labour.'[4] His alienation from the product of his hands thus means, not only that his work has been transformed into an alien object, has a life of its own apart from and independent of him, but also that it has become a hostile force in relation to him.

If Marx's alienation of the worker meant merely that labour was a social activity done for others, and that the product of labour received its deplored commodity character from the social relationships in which the labour was involved, it would be no more than a commonplace. For, ever since man emerged from the state of nature in which he produced solely for his own needs, *i.e.*, left behind him the idyllic conditions of life *à la* Robinson Crusoe, labour has had a social character, that is to say, has been labour for others. The difference between earlier conditions and those described and criticised by Marx is that in the latter the products of labour are and remain solely the property of others; the worker has no more share in their possession than he has in the raw material and the machinery, which are the property of the employer. At no stage do they belong to the worker, who produces them from beginning to end in the knowledge that there is no bond between him and them. His alienation

from the product of his labour is greatly enhanced by a new characteristic of production that makes its first appearance with the beginnings of modern capitalism, namely the division of labour, which Marx regards as a decisive factor in modern economic development. It is impossible to feel any solidarity with work of which one is responsible only for a part, and often only a very unimportant and insignificant part, and in which one is not always able even to identify one's share. In these circumstances one is bound to feel like the slave of one's work.

In the sixteenth century there was of course not yet any division of labour in Adam Smith's sense, and his celebrated example, the manufacture of pins, lay in the future. But since the end of the fifteenth century there had been an increasing mechanisation of labour resulting from the introduction of machinery. At all events, the Cinquecento can be regarded as the beginning of the technical age, and of the tendency for skilled to be replaced by unskilled labour, though it should not be overlooked that industrial labour was still far from being reduced to simple, mechanical, repetitive tasks.[5] But to bring about the alienation of the worker from his work there was no need for division of labour in the strict sense of the word, in the form in which it first appeared in the eighteenth century; the mechanisation of production and the devaluation of skilled craftsmanship were quite sufficient. The importance of the mechanisation of labour cannot be over-estimated, even if it is qualified by the consideration that machinery was not invented until it was needed and opportunities for it existed. However that may be, there is no doubt that the rapid growth of capitalism in the sixteenth century was closely connected with technological progress. This advanced at such speed and on so broad a front that the process might well be described as an early industrial revolution. Some time after machinery, and with it a more or less modern and rationalised organisation of labour, had been introduced into textile manufacture, it also came to be used in mining, printing, and glass and paper manufacture, leading to the concentration of production in relatively few hands as well as to the more intensive use of labour and the gradual elimination of the small producer.

In his description of the process of alienation Marx, in spite of the basic rationalism of his methods and approach, cannot resist romanticising the past, obviously in order to bring into sharper relief the intolerable nature of modern conditions. For all the epoch-making impact of the beginnings of mechanisation and the division of labour, he should not have overlooked or passed over in silence the fact that for most men labour cannot have been associated with any pleasure even in earlier ages. It is and always has been possible to identify oneself with work only if it is individual and to some extent creative. The failure of the inner impulse to work certainly did not first begin with modern capitalist production; and alienation from

work can take place whenever it is done solely to make a living, and production is not for personal consumption but to acquire means of exchange. The slave, the serf, and the servant also worked only because they had to and no more than they had to; not only the serf, but the often so thoughtlessly romanticised medieval craftsman no doubt generally identified himself with his work no more than an industrial worker on a conveyor belt. Nevertheless the development of modern capitalism and the mechanisation of production brought about a deep change in this respect. For in different historical periods similar situations do not always have the same results. The patience with which labour is endured depends on the historical situation. In the age of serfdom, when lack of freedom was more or less taken for granted by the whole of feudal society, labour, though it was often far more strenuous and soulless than in later ages, was not by a long way felt to be as oppressive and humiliating as it came to be felt after the liberation of the peasants, the spread of ideas about the rights of the human personality, and the new fluidity of the barriers between the social classes. A beast of burden tolerates more physical labour than man, and primitive man tolerates more than civilised man; there is a relativity about what is felt to be tolerable in any period. What men are willing and able to put up with depends on what they are able to look forward to. Just as the urge to rise in the social scale arises only after the boundaries between the classes have begun to wobble, and social revolutions do not break out when conditions for the oppressed classes are at their worst, but only when their situation becomes comparable to those of the higher classes, so does the sense, if not the fact, of alienation from work hardly become really oppressive until the worker's liberty of movement brings the improvement of his position within the realm of possibility. Thus it was mainly in the subjective respect that conditions deteriorated for the worker with the rise of modern capitalism. In earlier historical periods he was objectively and materially no better off, but he was less aware of the wretchedness of his lot.

Marx was also guilty of romanticising the past in his assumption that mechanisation and mere machine-minding led and was bound to lead to the worker's intellectual frustration. In reality, however, work on a machine was mentally more demanding than ploughing a field, and called for more intelligence than handling a hoe or shovel, or doing the work of many artisans on feudal estates or in small village communities. But the more skilled the worker becomes in the course of time, the more deadening the necessarily monotonous and repetitive processes connected with the use of machinery are felt to be, though these certainly require intelligence and make higher demands on it with the increasing complication of machinery. Leaving modern electric devices entirely aside, a simple mechanical loom such as was used in the early stages of the textile industry

was far more complicated and certainly much more absorbing than the tools which he had to handle on a feudal estate in the old days of serfdom. But in the last resort the worker's alienation from his work is not affected by this. The vital factor is that with the change to modern mechanical production, in spite of the more demanding nature of his work, he is robbed of all initiative and all possibility of innovation and change. In considering whether and to what extent an increased degree of alienation is present in any historical period, the decisive factor is the distance that exists between the worker and his work; and this depends, not so much on the nature of his work, as on the totality of his situation, that is to say, the relationship between his economic resources, his chances on the labour market, his social rights, his self-awareness, and his level of intelligence on the one hand, and the actual work he is called on to do on the other. Thus Marx is ultimately correct in his indictment of the mechanisation of labour, in spite of his mistake in underestimating the demand made by mechanical production on the worker's capacities.

Though Marx recognises as the most important symptom of alienation the 'ghost-like objectivity' assumed by products of labour transformed into commodities as a consequence of the mechanisation and division of labour of the capitalist age, he is of course very well aware that trade in commodities is much older than modern capitalism. Nevertheless he talks correctly of a hitherto unknown commodity fetishism, that is to say, of a new domination of life by the concept of commodities, a channelling of thought into commodity categories, a revolutionising of human relationships, now governed by the production and sale of commodities. What was new in the period we are discussing was not so much the fact that both the products of labour and their producers' working-time became saleable commodities, for even in its most exaggerated form this could not have had the revolutionary effect that Marx ascribed to what he understood by 'reification'; the epoch-making upheaval consisted in the fact that the concept of commodities became the fundamental category of social life and reshaped and refashioned every field of human endeavour. Every element in human social relations assumed the quality of a commodity, and not merely in the sense that it became purchasable or saleable like any other commodity, or that the worker's time became a neutral article of commerce measurable by a common standard and comparable with any other worker's time, with the result that the worker himself came to think of his strength and working capacity simply as a saleable object. The essence of the matter, as Marx pointed out, lay in the fact that 'one hour of one man's time equals one hour of any other man's time', and that 'one man working for one hour was worth as much as any other man working for one hour'.[6] Here we are confronted with something much more fundamental than the sale of working time and the products of labour; we are

face to face, not just with loss of work and time, but with loss of personality and individual identity. Not only life and labour were dehumanised and became objectified; the worker himself was dehumanised and became a 'thing' in the same way. It is this that enables one to appreciate the extent to which the commodity concept invaded the whole of life and gives a clue to the depth of the spiritual crisis in which it resulted. For conditions that led to such human degradation in an age of social emancipation must have made an impact in fields far wider than the industrial worker's personality, and the pleasure he took in his work; indeed, its revolutionary influence extended to all forms of life and thought, all levels of society, and all areas of culture. The way of thinking of the whole of society was based on the ideology of commodities. There was no form of human relations or human activity that it left untouched or unthreatened.

This, it is true, was also the period when the artist most strikingly differentiated himself from the craftsman, and was increasingly being granted the privileges of individual treatment. Nevertheless his products ceased to be 'bespoke', and became a commodity, produced for stock or for offer on the open market. Though the greatest works of the age were more strongly marked by individuality than those of any previous age, this was bound to lead to a depersonalisation of artistic production in general. Works of art had of course been bought and sold in earlier periods, but the fact that the middle of the sixteenth century saw the real birth of the art trade is highly symptomatic and significant for the future. This was the birth hour, not only of the art dealer and art collector in the modern sense, but also of the modern artist. The latter had to pay for his greater independence with a higher degree of insecurity, and his value was assessed in figures as never before.

3. ALIENATION FROM SOCIETY

Nothing illustrates the process of alienation in economic and social life more strikingly and significantly than the part played by money in modern capitalism. It is so important and so all-embracing that the whole system could be described as a money economy. Money became the instrument of reification, the means of reducing all values to an impersonal common denominator. It dehumanises, neutralises, and quantifies qualitative differences.

Money deprives concrete human relations of their personal character, and turns those engaged in economic activity into strangers to each other. The worker becomes a mere employee, and his master an employer. One sells his work, which the other buys. To the seller the buyer becomes an entity from whom he receives money, to the buyer the seller is a slot-

machine from whom he gets labour power in return for the coins inserted.

But money not only depersonalises economic relationships and the exchange of property; it also depersonalises possession itself. One banknote is like another. Money has no face, is not reminiscent of anything, *non olet.* Nothing of its origin clings to the hands of those who inherit it, or even of those who earn it; and the possession of shares is just as impersonal as is the possession of currency. The financier who puts capital into an enterprise has no direct involvement in it, shares pass from hand to hand without affecting the business concerned, and are bought and sold without the buyers or sellers having the slightest real interest in the business.

There is another respect in which money is impersonal, a mere abstraction, quantity without quality. Besides disguising the thing it pays for and the possession that assumes its form, it also disguises the individual who possesses it. In a world ruled by money, in which it has become the universal standard, everyone is valued by the amount of it he possesses. Not only does it make objective values comparable, exchangeable, transferable from one person to another—in other words, make them abstract; it also makes it possible to relate and compare with each other personal values that are qualitatively unique and, as Georg Simmel, Max Weber, and Ernst Troeltsch have shown, accustoms people to an abstract, rational way of thinking in which no account is taken of the individual and the individual case. It encourages, for instance, work in the interests of the 'firm', which is thought of as existing independently of the employer as an individual; and it plays its part in the building up of an objective, impersonal legal system, an independently functioning bureaucracy, and an army in which irrational feudal principles have been done away with; that is to say, in the multiplication of institutions which alienate themselves from the individual and share the characteristic of freeing themselves from personal influences and considerations.

Money is the very symbol and quintessence of relativism; it expresses the relative value of things by stamping them all as saleable and transforming their utility value into exchange value, thus depriving them of their substance and making them mere bearers of functions, which have their price. Whatever is obtainable for money—and in a society which is organised in capitalist fashion and thinks in capitalist terms most things are obtainable for money—goes to those willing and able to pay the best price for it, without respect to persons or merit or ability. When property, labour, services, become purchasable, they pass out of the sphere of personal relations and enter another sphere in which relations lose their subjective, emotional, and spiritual features. Money serves as a substitute for everything and reduces everything to equality but, however greatly it may succeed in this function, it fails to eliminate the feeling that many

things are unique, irreplaceable, and inexchangeable. Nothing could have a more devastating effect on human relations than the fact that nevertheless everything had its price, that one got nothing for nothing, and that one's value in the eyes of others depended on the iron law of inhuman competition. In the old days it had been possible to rely on humane considerations, patriarchal customs, traditional favours. But now all exceptions, concessions, grants of grace and favour, looked like indolence and indulgence. Everything had to be paid for in full, and a full day's work had to be given for a full day's pay, and there was no disposition to be satisfied with less. The laws of the market governed the whole of life.

In recent times the humanitarian element in the treatment of the serfs and the relative security enjoyed even by the lowest sections of society in the Middle Ages, compared with the precarious position of the modern proletariat, has been perhaps somewhat excessively emphasised, obviously to correct the earlier exaggeration of their inhuman treatment. Exploitation is a permanent characteristic of any class society, though often its maintenance imposes certain more or less closely defined limits. On the other hand, when exploitation seems to increase or diminish, it sometimes merely means that methods of exploitation have changed. Since the end of the Middle Ages the lower classes have had to pay for the advantages of freedom of movement with an increased inflexibility and depersonalisation of relations with their employers. True, the worker receives more adequate pay, but no bread if there is no work for him. Nobody can force him to work if he does not want to, but there is no law, practice, or custom that obliges or occasions anyone to use services he does not need. Since the end of the feudal system the town labourer has had to accept, in exchange for his sense of a more or less nominal liberty, greater insecurity and a lot that in a number of respects has been much harder than it was in the days of serfdom. He had been freed from the soil, but not from fear, thus resembling the Protestant, who had shaken off the clerical yoke, but was thrown back completely on himself, full of anxiety and suspicion, feeling threatened from everywhere, protected by no one, surrounded by an alienated world, condemned to stand alone.

The medieval forms of loyalty, patriarchal solicitude, corporative solidarity, and Christian and comradely charity gradually disappeared. Not only did the bonds of the manor, the guilds, and other corporations which offered some protection in emergency begin to weaken, but most forms of association lost their human directness. Corporations became rigid institutions, and charitable institutions were motivated less and less by humane and more and more by practical and unemotional considerations. The Protestant ethos of work and the view that poverty was either a sin or the consequence of sloth, negligence, or incompetence, played a part in this, just as did capitalism with its class struggle and ruthless com-

petition. For alienation, a dehumanisation of relations, appeared, not only between members of different social classes, but also between members of the same group. Not only did alien, antagonistic, or actually hostile relations—at any rate legal relations from which all trace of patriarchal attachment had vanished—establish themselves between landlord and peasant, master and man, employer and worker, but the employers themselves fought each other and were united only in their struggle against the workers or small craftsmen; and in the more or less homogeneous trade associations and church communities human relations gave way to rigid, impersonal, administrative regulations.

The whole age was dominated by individualism, the discovery, emphasis, and acceptance in principle of the rights of the individual. But, in spite of this principle, the ordinary, anonymous individual counted much less as a person, friend, or brother, than before. No one had legal control over anyone else's life and liberty, but no one was expected to do more for his fellow-men than the law or his contractual obligations required. Human relations were between legal persons and parties to legal contracts, and had all the coldness and distance of contractual relations, and man suffered the more from this the greater his sense of individuality and the greater emphasis he was able to lay on his individual rights. Sensitiveness grew with the sense of vulnerability, and emancipation led to greater susceptibility and a greater readiness to take offence than had ever previously seemed conceivable. There was the more reason and opportunity for grievance as the development of individualism was automatically accompanied by a multiplication of institutions. For the more definitely members of society came forward or claimed to come forward as individuals, the more necessary it became to form new institutions and expand their influence in order to ensure the survival of society.

4. THE PROCESS OF INSTITUTIONALISATION

Even if nothing were known about the age of mannerism except that it saw the origin of most of the important institutions that prevail in the public life of the present day, it would have to be counted among the most notable and significant periods of history, as one of those which have most profoundly influenced the structure of modern civilisation. In the fields of government, military organisation, and the administration of justice, private enterprise and social and church organisation, as well as that of artistic education, the principle of meeting the problems involved by institutionalisation definitely established itself. Modern bureaucracy, the standing army, the new reformed churches as well as the reformed Roman church, exchanges, cartels, academies, and their associated art schools, are

all the creations of that time. The social institutions that now arose are so numerous and affected so vitally the subsequent development of western culture that it is tempting to describe mannerism, if not as a new beginning, at any rate as the deepest break and the most important turning-point in the history of institutions. The institutionalisation of human relations is of course a continuous process, liable to disturbances and sudden accelerations, but it never comes to a complete standstill, and there is never a new beginning for which the ground has not previously been prepared. The history of institutions is indeed as old as that of civilisation itself, and it can certainly be claimed that the latter began when institutions developed out of improvisation.

With the birth of institutions man emerged from the state of nature and history began. They ensured the continuity and survival of his cultural attainments. Every habit, every custom, every tradition, is part of the bulwark that he erects against the threat of chaos, the intervention of blind chance; they are defensive arrangements, as Émile Durkheim says, that ensure the objectivity of social action against individual motivation. To complain of dependence on institutions is usually pure romanticism; they often provide a far more reliable guarantee of social security than the most tender conscience. But, in spite of the identity of the history of institutions with that of civilisation, and notwithstanding the continuity in the formation of institutions, there are turning-points in their development that give them a new significance, when a quantitative change, that is to say, a multiplication of them, becomes a qualitative change. It was the discovery of such a turning-point that enabled Marx to describe the sixteenth century as the beginning of a new epoch in the history of industrial labour, capitalism, and alienation, and the same insight enables us today to see that a significant transformation in the function of institutions took place in that century.

In spite of the rapid advance of institutionalisation in the Cinquecento, not all the institutions of the age were as novel as they seemed to be, though many appeared then for the first time. The Reformation was originally a reaction against the institutional rigidity of the church. But nothing is more indicative of the prevailing trend than the fact that the Reformation itself became rigidly institutionalised, and that the reformed churches developed into the most pedantic and petty-minded institutions of the age. Soulless and inflexible though the older institutions might have been, they were incomparably fewer in number, and exercised far less influence on the individual's life. There were no institutions in the past corresponding to the new bureaucracy and standing armies, the state administration of justice and the princes' fiscal systems, the international banking and credit machinery, the financial operations and exchanges, the academies and schools of art, the art market, and the systematic art col-

lecting; for even the old city administrations, corporations, and guilds, though they ended by functioning almost as mechanically as the new institutions, had originally permitted the individual member to identify himself far more closely with them than was later the case.

The borderline between identification with an institution and alienation from it is as vague and fluctuating as that between 'culture' and 'civilisation' or 'community' (*Gemeinschaft*) and 'society' (*Gesellschaft*). Even institutions with which the individual is still able to identify himself contain alienating features, and even the most soulless institutions came into existence to meet a real psychological need. Typologically the same phenomenon continually recurs. The most utilitarian civilisation is capable of enriching mental life, and the loftiest culture contains trends leading to formalisation, and thus depersonalisation and neutralisation, of the cultural picture. Similarly, 'social' forms of organisation are at work in every form of community, just as something of the original idea of community survives even in the most impersonal forms of social organisation. It is nevertheless sensible and useful to distinguish between living and fossilised cultural products, between spontaneous expressions of the human spirit and practically oriented attitudes, between sense of community and social cooperation. For these phenomena mingle with and are relative to each other, and at times one or other of them gains the upper hand, with the result that a period such as that of mannerism can legitimately be described as a period of alienation and the institutionalisation of social forms *par excellence*.

It has always been felt that it is in connection with institutions that depersonalisation and dehumanisation make themselves felt in their most sensitive and wounding way. When one has to adapt oneself to the rules of an institution, one ceases to be oneself, an individual, a person, one is deprived of one's human identity, and often also of one's human dignity. The first thing to be sacrificed to an institution is spontaneity, not merely in those who administer it, but also in most of those who come into contact with it from the outside. It leads a life of its own, as if driven by an internal mechanism. Every mannerist style, and every mannerist vision of life, either bears marks of this deadening of spontaneity and mechanisation of reactions, or shows signs of struggle against it by the development of exaggerated forms of individualism, sensibility, and arbitrariness. Simultaneously with their neglect of the individual and the individual case and their loss of direct relationship with concrete actuality, institutions lead to an inherently dangerous but in practice often very useful formalism. Mannerism adopts a similar formalism alienated from reality, but has to pay for the much smaller advantages of ready-made formulas with the much greater disadvantages involved in formalisation of artistic expression.

Institutions change very slowly; inertia and inflexibility are among their most characteristic features. They generally outlive their original aim, survive after the conditions which called them into being have completely changed, and their continued existence often harms instead of helping their original cause. There is no cultural formation that more strikingly and tangibly illustrates the process by which a creation of the human spirit assumes independence and becomes a self-governing automaton. In relation to it, whether he is confronted by it in the form of state, church, justice, the economy, society, etc., the individual feels like a puppet moved by invisible and anonymous guiding strings without having the feeling that they are in good hands. Not only does the institution become more and more resourceless and paralysed in relation to the increasingly complex and heterogeneous reality with which it is faced, but it outgrows its own creators and administrators. Irresistibly and sluggishly it goes on its own uncanny way. But the worst thing about it is its transformation of means into ends, a phenomenon well known to anyone familiar with institutions dating from earlier times in history. Its real and original purpose is neglected and retreats into the background, until administration seems to be carried out for the benefit of the administrators and the office seems to be there for the benefit of the official who sits in it. Exactly the same substitution of means for ends is to be seen in mannerist art. The lack of any directly evident functionalism of detail, the apparently senseless and purposeless play with purely decorative forms, the demonstrative virtuosity in the rendering of the human figure, its postures and movements, the absence of relationship between these forms and the spiritual content of the work, the emphasis laid on individual elements in its structure, *e.g.*, in the treatment of space and the organisation of the picture plane or of colour and light values, are all examples of the lack of relation between means and ends that is so characteristic of institutions and the way of thinking brought about by them. The question of how far this correspondence depends on direct or indirect influence, and the extent to which mere equivocation may be at the back of it, cannot be answered out of hand; the hazards of making such sweeping transferences from one order of phenomena to another suggest caution, however.

The greatest danger with which institutions are faced is that of bureaucratisation, that is to say, lies in the control exercised by officials who do not always use it to the best purpose. Every public institution inclines naturally towards bureaucracy, and all bureaucracies are inclined to misuse their powers. In the age of mannerism, when so many new institutions came into being and bureaucracy in our sense of the word was a new phenomenon, men must have suffered very severely under their pressure. Complaint at the progressive bureaucratisation still re-echoes in the Shakespearean phrase 'the insolence of office', though one has to wait for

Franz Kafka for a picture of the full horror of what a bureaucratised world might be. Though Shakespeare and his contemporaries knew nothing of the mythical proportions to be assumed by bureaucracy and officials, courts and authorities in the works of Kafka, that most unmistakable modern counterpart of a mannerist, they were certainly on the way to visualising the great image in which he sees human life as subject to the preposterous requirements and inscrutable regulations of an unapproachable officialdom, involving the absurdest formalities, following them up through endless and senseless official channels, all the time remaining in complete perplexity about which course of action might harm and which might help. The image culminates in the idea of total alienation in the jungle of institutions, in which private and personal life is overshadowed, obscured, paralysed, or crushed by unknown, nameless or inadequately named powers that appear in the most absurd disguise.

The age of mannerism was the first to be threatened by a rising tide of institutionalisation similar to our own. It struggled against it, but scored only minor successes in stemming it, and that only in the most personal creations of art, literature, philosophy, and science. Even in fields in which the strongest resistance was put up, in Protestantism, it was swept away by the prevailing trend. For, though there was nothing to which Protestantism was more violently opposed than to the depersonalisation and institutionalisation of religion, the destiny and tragedy of the age lay in the fact that it itself became an instrument of materialisation and alienation.

That the Reformation ended by being totally transformed into the reformed churches there can be no doubt. The early history of the movement, and the question of what the church meant in the eyes of the young Luther, are more controversial, however. Luther's well-known shift towards conservatism during and after the Peasants' War, and the inconsistency of his pronouncements about the meaning and function of the church, incline one to the assumption that he moved gradually to the right in this matter too. As has already been mentioned, however, a different view is taken, among others by Ernst Troeltsch, who maintains that Luther, in spite of his religious individualism, his sympathy with lay religion, and his conviction of the subjectivity of the road to salvation, never displayed the slightest inclination towards sectarianism and regarded the community of the church as the only real and true form of religion. Troeltsch argues that, for all the subjectivity and spirituality of his conception of the church, his aspiration was always for an objective, supraindividual institution resting on supernatural foundations.[7] Other scholars still maintain that the institutionalisation of Protestantism was a gradual process, and many of them regard its transformation into a system of state churches as a disastrous development which had as little basis in Luther's

beginnings as had his final attitude towards the peasants. In his sermon *de virtute excommunicationis* (1518), for instance, he specifically states that the church is no mere institution, but the community of all the faithful; and Karl Holl regards his 'invisible church', in spite of the various meanings that came to be associated with the term, as having meant the exact opposite of the Catholic church.[8] Troeltsch himself was ultimately forced to admit that 'the objectivity of the institution increasingly prevailed over the original subjectivity' of Luther's conception.[9] But to show that Protestantism shared the historical destiny of institutionalisation with the other spiritual movements of the age it is not necessary to appeal to the original meaning of Luther's 'invisible church', or his much less problematic 'direct filial relationship to God'. The fact that Luther's chief aim, and the mainspring of the Reformation, was the liberation of Christianity from the rigid mechanism of the Roman church is indisputable and not in need of any special proof. In any case, mere quotations do not get one very far in this respect. Luther's statements in relation to the church, as in so many other respects, are contradictory; he speaks now for it and now against it, and often what he says is ambiguous. In this he reflects not only his own doubt-tormented mind, but also his whole generation which, like him, thought in antitheses and was torn by ambivalent impulses.

Moreover, the process of institutionalisation and the transition from liberty to coercion that Protestantism underwent corresponded exactly to that by which mannerism, rooted in opposition to the classicism of the High Renaissance, degenerated into dogmatic academicism, or that by which the place of the guilds, from whose ties the artists gradually liberated themselves, was taken by academies which were just as narrow-minded.

A word remains to be said about the closeness of the connection between ideology and alienation. Human thinking has been ideologically determined ever since it represented antagonistic class interests. Apart from serving the purpose of philosophical or scientific orientation, it simultaneously fulfilled the more or less concealed function of serving the economic and social interests of the ruling classes. But, to the extent that men thought and acted in a fashion the motivation of which remained unknown and inscrutable to them, they became alienated from themselves. They did not know what they did, and did not do what they consciously would have liked to have done. But never was ideology more obscured, and alienation consequently deeper, than at the time of the crisis of the Renaissance, the origins of modern capitalism, the religious struggles of Protestantism, and the transition from feudalism to centrally administered national states. Never were men less aware of what lay behind their efforts and actions than the Protestants, who believed themselves to be battling solely for freedom of conscience, the artists, who believed them-

selves to be struggling to liberate themselves from the guilds solely in the name of free and unfettered creativity, or the thinkers and scientists, who believed their war on dogma and superstition to be based purely on rational grounds. They did not know that their aims, though unobjectionable in themselves, were the ideological cloak for economic interests and social aspirations. However, the true face of the ideals for which they fought was finally revealed. The liberation of the economy chiefly served the interests of the employers, and to them it of course represented progress. The Reformation led to the establishment of churches as intolerant as the old. The successful artists barricaded themselves in their academies instead of the old guilds, and science produced its own shackles and blinkers, for it was no more free of prejudices than were the doctrines of the church or of scholasticism.

5. ART IN AN ALIENATED WORLD

Mannerism is not so much a symptom and product of alienation, that is to say, an art that has become soulless, extroverted, and shallow, as an expression of the unrest, anxiety, and bewilderment generated by the process of alienation of the individual from society and the reification of the whole cultural process. The alienation of the individual does not in this case exclude the creation of true works of art; on the contrary, it leads to the most profoundly self-revelatory creations. The sense of alienation is the artists' raw material, not a formal element in his work. He expresses his concern, dismay, and despair at a world in which the spirit of alienation, depersonalisation, and soullessness prevail, but his work, as an expression of protest against this world or a way of escape from it, in the artistic respect need bear no marks of alienation. This of course does not mean that a large number of works did not simultaneously appear which were a direct manifestation of alienation, that is to say, themselves were soulless, impersonal, conventional, mannered, and not merely mannerist.

One of the contradictory features of mannerism is that it not only represents a struggle against formalism and what might be called 'fetishism' in art, but is also itself a precious and fetishistic form of art that alienates itself from the creativity of the individual. Of particular significance in this respect is the circumstance that these conflicting principles, this polarity and tension, are not only characteristic of the style as a whole, that is to say, that the signs of stylistic conflict are not only present in different groups of works, different trends, schools, or artists, but also often appear in one and the same work. The greatest, the most vital, the spiritually most significant mannerist works often include devices used with a conventionality and thoughtlessness that are otherwise rarely to be found

even in works of the second and third rank. It is precisely this that makes it so difficult to define the stylistic concept and qualitative character of mannerism, which was a desperate attempt to preserve life from alienation and soullessness, mechanisation and schematisation, but itself partially succumbed to soullessness and materialisation.

Its attempt to stem the growing flood of alienation in spite of its own vulnerability, its struggle against the reification and schematisation of life, had no real continuation in western culture. With the Counter-Reformation and the baroque it began fading away; the classicism of the seventeenth and eighteenth centuries, the rationalism of the age of enlightenment and the scientific outlook of the nineteenth century, led finally to its extinction. The romantic movement made the embers glow again, but it remained an episode, though the traces it left behind are ineradicable. The consequences of the present revival of mannerism are not foreseeable, but it again seems to be no more than a kind of romanticism.

Whether mannerism presents itself as a positive or negative reaction to alienation, its connection with the social process is unmistakable. In examining its historical and sociological origins it is impossible not to be struck by the parallelism between the loss of personality suffered by the manual worker as a consequence of the mechanisation of production and that of the intellectual worker as a consequence of specialisation on the one hand, and on the other of the sense of estrangement and loss of self, the doubt about the reality and identity of the self, that are among the principal themes of the literature of the age. Shakespeare's characters, to quote the best known and most striking example, feel lost in this respect; they are continually wondering what they are, whether they really are what they seem to be, and they talk continually of their sense of going about in changed, distorted, unreal form. In most of the plays of which they are the heroes, it is the feeling that they have grown false and untrue to themselves that creates the dramatic crisis, and they set themselves the task of realising their true nature. 'I am not what I am,' says Iago, and Viola says the same of herself in *Twelfth Night*. 'My Lord is not my Lord,' Desdemona says of Othello, and 'Thou are not thyself,' is the phrase round which the whole drama of *Measure for Measure* seems to revolve. 'This she? . . . No . . . If beauty have soul, this is not she. . . . This is, and is not Cressida,' says Troilus; and, after succumbing to Cleopatra's spell, Antony no longer knows himself, and likens himself to a cloud continually changing in shape. From this idea of man's problematical identity, his failure to appear what he is, partly because he must not and partly because he dare not be what he should be, Shakespeare, Cervantes, Calderón, and most of the writers of the age, developed the theme that it was his nature and destiny to conceal and disguise himself, to be always playing a part, hiding behind a fictitious identity, living an illusion, and that it was part

of the tragi-comedy of his life that there might be spectators who were amused at, or even actually took malicious pleasure in, watching him play his role in dreadful earnest.

Man himself could not tell what part of him was true and real and what was illusion and self-deception. The core of Shakespearean and the whole of modern tragedy is the process of man's achieving clarity about himself, and the moral value of the tragic self-interrogation lies in the remorselessness with which illusion is shattered and the hero's real nature is revealed, above all to himself. The reward of the great moment of the fulfilment of tragic destiny is self-consciousness and self-realisation; so long as these are not attained, or even aspired to, man remains in doubt about his own nature and the world he lives in. 'Thou art not certain' says the Duke in *Measure for Measure* and 'nothing that is so, is so' says the fool in *Twelfth Night*, and these two phrases express the sense of life of the whole age. Everything is uncertain, questionable, different from what it seems, and all certitude and bedrock has to be fought for.

Like the novel of the nineteenth century, *Don Quixote*, the novel of mannerism *par excellence*, the greatest novel of the age and to an extent the unattained ideal of all subsequent novel writing, is a novel of disillusion, a quality characteristic of the whole literature of the age. *Desengaño* is not, as is generally assumed, the dominant note only of Spanish literature, of the works of Cervantes, Góngora, Gracián, and Calderón, but is also that of Tasso and Marino, John Donne and, broadly speaking, Shakespeare too. Don Quixote, Segismondo, Faustus, Hamlet, and Troilus are all ultimately disillusioned, as if on awakening from a dream, facing an alien and alienated world, a tremendous, disastrous incongruity. The world, however evil it might otherwise have been, had once seemed uniform and in harmony with itself and with man, but now it had been irretrievably split—into a world of illusion and another of dreadful reality. The generation of mannerism that underwent this bewildering and shattering experience hit on one of the greatest literary themes of all time.

All that Max Weber understands by 'disenchantment', or everything that can be connected with it, that is to say, the progressive rationalisation of life, the elimination of magic, mysticism, and metaphysics from the explanation of natural phenomena, the freeing of the economy and society from the bonds of tradition, and in particular the relentless domination of empiricism, can be regarded as a source of alienation. The deep disillusion and dismay at the outcome of the advances in the natural sciences felt at the end of the nineteenth century by many who deplored their exclusively quantitative criteria and their materialism, in spite of the pride felt in their achievements, is a reminder of the shock that must have been caused at the outset of the new age by the beginnings of modern science. Men were alarmed instead of reassured at finding themselves in a disenchanted world,

deprived of witches and wizards and spirits, both good and bad. The world had grown empty and barren, and once more the result was a sense of solitude, not a sense of release. There were no more devils to be afraid of, but also there were no more angels and saints to come to man's aid. The desolate, empty space into which Protestantism turned the thickly-populated heavens—the infinite, empty space that still terrified Pascal—yawned everywhere.

One of the most moving things about the adventures and mishaps of Don Quixote, who talks constantly of the enchantments, snares, and deceptions prepared for him by wizards and sorcerers, is that they take place in a completely disenchanted, sober, and sceptical world, in which there are no more sorcerers and no one is left who still believes in them. His monomania and spiritual isolation—the main theme of this novel of alienation—are unaffected by the fact that the arch-realist Sancho Panza ends by becoming infected with his master's madness and begins imagining things himself; Don Quixote remains as mad and solitary as ever. But what gives the novel its universal perspective is the fact that in this disenchanted, sober, and rational world the chivalry and valour which were once men's highest ideal have degenerated into mere folly and madness. So we see the hero of the novel, the personification of that chivalry and valour, now as a sheer madman, now as the symbol of courage and innocence.

From whatever angle such a figure is looked at, like most of the great figures of mannerist literature it preserves its enigmatic character. Not only is it full of paradoxes, not only does it move on different planes of reality, but also it keeps the reader in suspense and guards its secret even more jealously than other artistic figures. This preservation of mystery, which is one of the fundamental characteristics of mannerist art, appears most strikingly in the genre in which alienation presents itself in its most unmistakable form—in portraiture. The cool, rigid, glassy expressions, the lifeless, 'armour-like' masks of the portraits of Bronzino, Salviati, or Coello, the unconcern with which character is treated in contrast to the care lavished on the incidentals, the architecture, costume, weapons, or jewels, demonstrates a complete withdrawal from the world. The mind, the character is there, but it is concealed behind a mask of indifference. The nerves vibrate, the affects are alive, but they scorn to reveal themselves; nobody must know what goes on behind the mask.

Feeling alienated in this world, men are not resigned to remaining so; they wish to have an alienating and startling effect on others. Therefore the artist not only chooses strange and startling subjects, but also tries to render the most ordinary things in a startling way. The purpose is not merely to surprise and unsettle, but also to state that it is impossible to feel at home among the things of this world or make friends with them.

VIII

Narcissism as the Psychology of Alienation

I. SOCIOLOGY AND PSYCHOLOGY

ALIENATION is an essentially sociological concept, the real meaning of which is lost, or restricted and falsified, when it is simply transferred to the psychological plane. It has scientific value only as long as it means a crisis in human relations and loss of roots in the social soil. The psychological phenomena accompanying alienation are most striking and impressive, which makes it tempting to be led astray into describing them for their own sake, but they offer too wide a field for purely impressionistic, literary descriptions, and objectively they are as a rule not particularly revealing. In this inappropriately used psychological aspect of the word, alienation becomes a mere synonym for a sense of unrest and discomfort. A more genuinely psychological concomitant of alienation, and one better adapted to scientific investigation, is a phenomenon *sui generis* that is closely connected but by no means identical with it. It is the more or less pathological condition which Freud calls by the borrowed term of narcissism [1] and is an illness of the individual mind, just as alienation is an illness of the social body.

A narcissistic character in Freud's sense of the term has withdrawn his libido—his love and affect-charged interest—from the outer or objective world, from persons and things, and has concentrated it on the self. He is able to love no one but himself, and in reality not even himself, for anyone able to love only himself would be bound to despise and hate himself. The psychoanalytic description of this dialectical process is that the narcissist identifies himself with the object from which he has withdrawn his love, and develops a hate–love of himself (sometimes associated with

suicidal impulses) which bears all the marks of the attitude known as ambivalence. Being in love with oneself is no happy love.

By the withdrawal of his libido and interest from objects, the narcissist loses direct contact with reality and the sense of what is real; he entrenches and hides himself under the wings of his own ego, and is finally incapable of emerging from his place of refuge. For reality he has substituted a fiction, the centre of which is himself, and he moves in his fictitious world untroubled by the truth and undisturbed by doubt, because he has neither the desire nor the ability to test the reliability of the path he has chosen. Thus narcissism is in the last resort a crisis of the sense of reality, and the loss of object-love involves the loss of the whole of the external world. However, the 'self-sufficient ego', as Freud describes it, cannot be really self-sufficient, and eventually has to declare itself bankrupt. Narcissism may provide comfort and compensation to an individual disappointed in his love or hopes and expectations by throwing him back on himself, and in this role it plays an important part in restoring mental equilibrium. But it can perform this function only occasionally and temporarily; as a permanent condition compensating the ego for the lost love-object by fixation on the self it is pathological, and is always associated with the paralysing effect of an illness.

Looked at historically, narcissism is an expression of the same spiritual crisis, the same sense of helplessness and abandonment, of being thrown back on oneself, as is alienation. Here the psychological condition is produced and made possible by the social situation, and not the other way about. For all the light that the psychological structure of narcissism may throw on the culture of an age dominated by alienation, and for all the understanding of the psychological mechanism of the latter that analysis has made possible, it is a pathological condition which occurs only in an alienated society. The psychological phenomenon presupposes social-historical conditions, that is to say, there can be alienation without narcissism, but no narcissism—at any rate in the pathological sense—without alienation. Generally there is a reciprocal relationship between sociology and psychology, that is to say, on the one hand, only what is psychologically viable and possible can be realised sociologically, while on the other, in the psychological—and thus not merely vegetative —field processes appear only when they are social in character, that is to say, do not take place exclusively within the limits of the organism, but are determined by the law of adaptation, imitation, and resistance. But no such reciprocal relationship exists between alienation and narcissism; alienation precedes narcissism and determines it unilaterally; narcissistic tendencies may reinforce it, but add nothing new to it. When a period is described as 'narcissistic', and it is not merely the prevailing type of character that is meant, the psychology thus engaged in is nothing but

disguised, unclarified sociology that has not been thought out properly.

A narcissist is an individual with asocial inclinations. In concentrating all his interest on himself he loses all direct interest in others, increasingly withdraws from them, and generally ends by being not only alienated from, but actually hostile to, them. He admires only himself, and all he wants of others is their admiration. For that purpose he needs them, and consequently he is not by a long way so independent of them as he would like to be and believes himself to be; in reality he is much more like their slave. The narcissistic ego-image that purports to be so satisfactory is a compensation for failure, a substitute for the fulfilment that the individual is either denied or denies himself. But in this process not only are there historical and social reasons for the external circumstances which frustrate the fulfilment of libidinous or similar desires, but also the inner motivation that leads to pathologically consistent self-denial of the fulfilment of such desires may have quite definite historical and social causes, such as those that appeared in the age of mannerism and to a certain extent are repeated in our own day.

The choice of the term 'narcissism' from Greek mythology seems, however, to be intended to indicate that the phenomenon referred to has always existed and can occur at any time. In fact it has existed only since alienation in the modern sense of the term made itself felt. To the Greeks the legend of Narcissus was simply an allegory of self-love and, though they could not have regarded it as an entirely harmless phenomenon, to them it did not imply the breach with the world and the self, the loss of reality and the sense of loneliness and desolation, that it has for us. The feeling of being isolated from one's fellow-men and of being thrown back on oneself in the modern sense has existed only since the age of mannerism. It was then that men felt for the first time that they were cut off from all sense of community, or at any rate were living in an age in which all community both with the past and present and all past traditions and existing conventions had grown questionable. Such circumstances must have contributed to the transformation of narcissism from an innocuous or useful defence mechanism into a neurotic symptom of the age.

Biology and medicine have accustomed us to looking at man ahistorically and, in so far as he is the object of biological or medical study, to regarding him more or less as unchanging. Short though the known history of mankind is in relation to the age of the species, it is nevertheless possible, particularly in the field of psychological anomalies and illness, to speak of changing historical trends and the greater or lesser prevalence of different infirmities and failings at different times. Human instincts, the psycho-physiological disposition and constitutional tendencies to the abnormal, do not, in spite of the overriding conservatism

of the organism, seem always to have been the same. In some historical periods men show a particular susceptibility, a more than normal receptivity, to some illness or other. To the historically trained and sociologically practised eye, the physical constitution of man also seems less constant than it does to the natural scientist. However, there is no need to postulate changes in the psycho-physiological constitution, the nervous system, or the instincts—which in any case are hardly conceivable in the short periods of time that are in question here—if illnesses, and more particularly psychological illnesses, are assumed to have a historical trend, and we speak in the present context, now of a tendency to narcissism, now of resistance to it; just as there is no need of any such postulation in speaking of the varying prevalence of the Oedipus complex, which depends on changes in economic, social, and family relationships, but involves no change in the nervous system or the instinctual apparatus.

2. SELF-LOVE AND SELF-OBSERVATION

The legend of Narcissus, as interpreted in the light of his mannerist inclinations by Paul Valéry, for instance, combines the theme of self-love with that of self-observation, in the sense of self-examination and the acquisition of self-awareness. Interpreting it in this way makes it clear why the age of mannerism became an age of narcissism, and why it took such great pleasure in the legend. The mannerist was inclined towards narcissism as a consequence, not only of the emphasis on the self with which he compensated for his shaken sense of tradition and convention in every field, but also of his discovery of the spontaneity, that is to say, the creative power, of mind and, above all, his acute sense of that spontaneity, an attitude the introduction of which into aesthetics is due above all to mannerism. The shift of attitude inherent in this was a turning-point in the history of thought, not only because artistic creation, which had hitherto been regarded as a gift, was henceforward regarded as an activity of the spirit, but also because it heralded the completely new and revolutionary idea that the mind could watch itself at work, and in philosophic thinking actually continually did so.

With Paul Valéry, one of the modern writers who come so close to mannerism, above all because of the consciousness of their own artistic being, holding the mirror up to himself, the compulsion to examine his own image from ever new and changing aspects, becomes a main theme of literary creation. After *Monsieur Teste*, the early work that already contains his whole philosophy in a nutshell—'je suis étant, et me voyant; me voyant me voir, et ainsi de suite'—the theme of the observer's observing himself runs through the whole of his work. Thinking is thought

thinking itself; art exists only in awareness of itself; the poet is a poet by reason of his self-observation. Writing, thinking, mirroring oneself, loving, loving oneself, are all essentially one and the same thing. For 'qui donc peut aimer autre chose que soi-même?'[2]

The legend of Narcissus was very popular with the symbolists, and Valéry's interpretation of it bears a great deal of resemblance to André Gide's in the *Traité du Narcisse* (1891), though his speculative attitude is closer to Mallarmé's than to the artistic-decorative interests of the young Gide and the other symbolists.[3] Valéry makes the emotional theme a philosophical one, turns love of the self into thought about the self, and makes the inability to love, see, or think about anything outside the self a problem of sterility, on the lines of Mallarmé. Gide's interpretation of the ancient legend is purely aesthetic. Narcissus is in love with his own image in the spring, and dies of his sterile love. His bending over the water becomes the symbol of the artist, who hopes to attain deeper and truer self-knowledge from his work, but finds himself left with an unsubstantial reflection that perpetually eludes his grasp while he remains the perpetual passive spectator of himself; and he ends by smashing the mirror in despair.

La Jeune Parque is the poem of Valéry's in which he tackles the theme of narcissism most subtly. Though here he appears in female form, the hero is still Narcissus. The change of sex serves only to distance the figure from the writer who, with his prejudice in favour of the *impassibilité* of 'pure poetry', wishes to appear emotionally detached and to give the figure a fascination which would otherwise be inappropriate. The chief theme is the agonising process taking place in the poet's mind—his wrestling with the outer world, which he now sees only in the form of his own image, his wrestling with the world and for possession of the world, with which he believes himself to be alone—but it remains mute, does not answer him, is not with *him*. He has lost it, and is left only with images, or rather his own image. The *Leitmotif* is solitude, being not with the world, not with nature, not even with the spring that reflects one's image, but only with oneself.

> *Je suis seul, si les Dieux, les échos et les ondes*
> *Et si tant de soupirs permettent qu'on le soit!*
> *Seul! . . .*

Solitude was the blessing for which Narcissus longed, and it becomes his curse, as it is also of the poet, who ends by identifying himself completely with the legendary self-lover, who could see nothing but himself and perceived reality only as a reflection of himself. The same curse lies on the poet as lay on the self-admiring Narcissus. This is something that the Greeks would never have felt, though the mannerists certainly did.

The frequency with which the theme recurs must certainly be due to their special attitude to art and to the analogy that must have been clear to them between Narcissus admiring himself in the spring and the artist's self-satisfied contemplation of himself in his work. The legend is in fact a staple theme of mannerist art and literary metaphor. Apart from the disguises in which Narcissus appears in such forms as Don Juan and Don Quixote, he often appears in person in art and literature, and most frequently in Marino.[4] Góngora also makes use of the theme.[5] In the visual arts there are works by Tintoretto (Galleria Colonna, Rome) and Cellini (Bargello, Florence), another which is generally acknowledged as a work by Caravaggio but is very suggestive of mannerism (Palazzo Barberini, Rome), and one by Daniele de Volterra which bears the title *John the Baptist*, but might just as well be called 'Narcissus'.

To the mannerists metaphor was the most important means of literary expression and represented the quintessence of the poetic apprehension of reality, and the legend of Narcissus must have had a special meaning for them for that reason alone. With its ever-changing iridescence and deceptiveness to the senses, there is a striking analogy between the reflection that Narcissus saw in the water, which showed him himself as he loved to see himself, and the metaphor as developed by mannerism. The point of mannerist metaphor is of course not the similarity between the things compared; they are not so much compared with one another as brought into relationship with the writer, and the metaphor reflects nothing so truly as the writer himself. Moreover, the mirror itself is a mannerist requisite, just like the mask, costume, and the stage, in short, anything that shows reality indirectly. One has only to recall the strange use made of the convex mirror in Parmigianino's early self-portrait and compare it with the relatively simple use that Van Eyck makes of the mirror a century earlier or Velazquez about a century later. The mirror both lies and tells the truth. It is crystal clear, hard and smooth, and is also delicate and fragile; and, if one reflects oneself in water, a breath is sufficient to shatter the image and turn both mirror and image into sheer illusion. What, indeed, could symbolise better than a mirror the mannerist idea of art, its inherent paradox, unreality, brilliance, and magic?

3. THE NARCISSISTIC TYPE

The most important achievement of mannerist literature undoubtedly lies in the creation of a whole gallery of narcissistic types that are not only the most impressive of their kind but also exceed in number and variety the products of any other age. It is sufficient to recall Don Quixote, Don Juan, Faustus, and Hamlet, and the many related characters in the

literature of the time, to demonstrate that mannerism not only created the type, but practically exhausted it. Indeed, there is hardly a period in the history of literature that has shown comparable power in the creation and development of types. Yet its real importance lies, not in the great number of variations on the new types or in the almost legendary proportions of many of their embodiments, but in the fact that it created the modern literary character itself. Before the age of mannerism there were no 'modern', 'problematical' characters in literature, for the rift between the self and the world, and the conflicting impulses of the self, which are so characteristic in the narcissistic type first came into existence with the alienation of the mannerist age.

Three different methods can be distinguished in the psychological representation of character. The most primitive consists of a simple enumeration and combination of traits with no special regard for their unity and conformity, and the resulting picture is generally neither consistent nor coherent. The individual traits are on different levels of reality—some are better observed than others—and might well be the result of the observation of different persons. But often the outcome is not a uniform, homogeneous character, even if the source of observation is one and the same. The artistic effect depends on the liveliness of the picture and the sheer contrast of the various traits. Generally the psychology of pre-classical literature is at this level of development, while that of the classics is based on the idea of unity. The psychologically convincing portrayal of a character derives from its logical consistency of attitude; the more consistent the behaviour, the more natural and plausible the impact. This was the stage reached in classical antiquity and hardly surpassed by the Renaissance. Mannerism then created the third and modern method of characterisation depending, not on the logical consistency of character, but on its opposite, its inconsistency. Instead of laying all the emphasis on the sharply defined major outlines that define and delimit character, it concentrates, on the one hand, on the irrational and conflicting traits that are always present and, on the other, on the barely perceptible shades and nuances that make it difficult and often impossible to pin it down. A character is now the more convincing the less complete is the writer's picture of him and the more complex and the richer in surprises is his behaviour. The main difference between the characters of earlier and those of modern literature beginning with mannerism lies in their rhapsodic and conflicting, illogical and incalculable nature. Narcissistic characters are, from the point of view of literary history, most noticeably 'modern' in this sense. Their complexity lies in the often extraordinarily involved and elaborate technique by which they maintain their identity, their infinite resourcefulness in devising fictions and stratagems, like Don Quixote, to evade reality and truth. The inner conflict of their

nature lies in the fact that, while they have completely withdrawn their love and sympathy from the world of men, they still need them as their partners, public, or victims.

The fact that mannerism found its way to modern characterisation does not of course mean that earlier methods were superseded. The integrating classical method continued to be used, and the relatively primitive, atomising technique was not by a long way finally discarded. Among the reasons why French seventeenth-century literature, noticeably the drama of Corneille and Racine, is to be considered 'classical' is the fact that the criterion of psychological plausibility is once more the logical consistency of the characters' behaviour and the logical coherence of their attitude; and how little the pre-classical methods, which neglected the conformity of character traits either out of lack of skill or lack of interest in it, were abandoned in the time of mannerism is shown by the fact that even the greatest writers, among them Shakespeare, were deeply caught up in its inadequacies. Shakespeare actually uses two different psychological methods, both of which are based on the atomisation of character, though each has a different meaning. He allows the crudest inner contradictions to remain unmotivated and unmitigated, chiefly because he has in mind nothing but the play of conflicting forces and their dramatic effect. Instead of trying to make the conflicting elements in his characters psychologically credible, he concentrates on their curiosity. What interests him is the turbulence of a great passion, the power of a violent personality, and outbursts of temperament that rage and destroy like natural forces; and also the paradoxical mixture of disparate traits and the strange situation created by their simultaneous presence. But justice is not done to Shakespeare's characterisation if it is judged exclusively from this aspect of curiosity, whether in the service of sheer elemental impact or of striking stage effect. Psychological motivation, the presentation, explanation, and reconciliation of mental conflicts, always plays a relatively minor role with him, while the conflicts themselves fulfil very varied functions. They may serve the purpose of producing immediate dramatic effect and thus, strictly speaking, serve no psychological purpose. But also, and in this they perform a far more important function artistically and in the history of ideas, they may express a psychological antagonism that was unknown in earlier drama but now manifests itself in the narcissistic conflicts of characters such as Hamlet or Othello.

Hamlet, in spite of the apparent originality and uniqueness that Shakespeare gives him, and leaving aside the qualities he shares with the fashionable melancholia of the time, belongs to the same category as the other narcissistic characters of the age. Fundamentally he is yet another variation of the type represented by Don Quixote, Don Juan, Dr. Faustus, and so many other less striking figures of the literature of the

age. Common to them all is their detachment from reality, their imprisonment in themselves, the fictitious nature of their lives. Their self is so constituted that it spares them all direct contact with reality and contains within itself, or imagines that it contains within itself, a substitute for the whole of reality. The playing off against each other of the self and objective reality, and the vengeance that the latter ultimately takes on those who scorn it, provides a practically inexhaustible source of literary invention. There is no limit to the adventures and vicissitudes that result from the struggle with reality and the attempt to outwit it, and a shattering fate awaits those who abandon it. They fight with windmills instead of real enemies; they conquer one woman after another, without loving any of them; they sell their souls to the devil, in exchange for youth and magic powers which they have no idea how to use; they think of success, victory, revenge, not of justice or love. Apparently they need no one but themselves, nothing but their own ego, but their ego is unreal, fictitious, barren. It exists only in the impression they make on others, in ostensible success, or in the suffering they cause to others; and they are not even real or at any rate successful egoists, for they torment themselves as much as they torment others.

In this respect, however, Don Quixote is an exception, for he torments himself only. What has been called his author's cruelty to him, the pitilessness with which he hands him over to ridicule and maltreatment, preserves him from being able to cause suffering to others. Actually he does harm to others now and then, but his kindness of heart always reconciles one again to his madness. His childish naïveté is associated with a sophist's cunning, but he uses his intellectual gifts only to preserve himself from contact with reality and to maintain the fiction that everything in the world that does not fit in with his crazy ideas is the result of the machinations of evil sorcerers, in other words, is really unreal. His narcissism protects him from all female blandishments; his professed love of Dulcinea serves only as a cover for this. Nothing better illustrates how his narcissistic defence mechanism works unfailingly to preserve him from contact with reality than the inexhaustible resourcefulness and fertility of his imagination that prevents him from meeting the young woman of his dreams and, when her coarseness and ugliness can no longer be denied, the same sorcery that turned giants into windmills turns her into a commonplace peasant girl. If Don Quixote is not a knight without fear and blemish, he is either an innocent child or a madman. The question has left the critics no rest since the time of the romantic movement. He has been regarded now as the personification of valour and innocence, now as a childishly comic eccentric, and Cervantes's novel has been held alternately to be a great work of the imagination and a mere piece of persiflage, a parody of chivalrous romances with a number of amusing

but not very momentous anecdotes. That no general agreement was reached on the matter in spite of all the often uncommonly intelligent interpretations is to be attributed to the fact that, if Don Quixote's narcissism is left out of account, both the hero and the novel are bound to remain fundamentally unintelligible, and that both psychoanalytic knowledge and a sense of history, that is to say, qualifications that seldom coincide, are required for the solution of the problem. It is all the more necessary to bear in mind Don Quixote's narcissism, and thus his pathological condition, as only by so doing can one prevent justified admiration of this masterpiece from resulting in a transfiguration of the phoney knight and allowing free course to the romantic irrationalism that makes of disease a virtue, of the unconscious a source of wisdom, and of ignorance of the ways of the world being dazzled by the stars.

Don Juan seduces all the women he meets but, like Don Quixote, loves none of them. That he has to seduce them because he cannot really love any of them has become a commonplace of criticism. The idea that he is perpetually searching for the one woman whom he cannot find is, however, unfounded; so far from searching for her, he has no desire to find her. It has been pointed out that his interest in women is exclusively 'erotic', and that the real 'artist of love' was not he, but Casanova.[6] It has also been shown that, unlike the real lover, with him love does not grow with time, for as soon as he has possessed a woman he loses interest in her.[7]

Don Juan was not an invention of the age of mannerism, but belonged to the stock-in-trade of medieval legend, which owed its wide dissemination to the internationalism of Christian civilisation. The story of the 'stone guest', which obviously forms the core of the Don Juan legend, is characteristic of the mystery and morality plays; the stereotyped sinner of Christian drama had to pay for his life of dissipation by being sent to hell, and his infernal sufferings provided a popular stage spectacle.[8] The main theme of the oldest version was certainly not libertinism, which cannot have been part of Don Juan's original character. The seducer whose 'supreme pleasure is bringing about a woman's downfall and dishonourably abandoning her',[9] the evil-doer whose unassuageable passion makes him a daemonic force, was the invention of Tirso de Molina and his age, which produced a whole series of works with a libertine as protagonist, including Lope de Vega's *La Fianza satisfecha* and Cueva's *Infamador*. Thus a commonplace blasphemer and mocker was turned into a man obsessed with his passions who plunged wildly and indiscriminately from one affair into another, and as a result of his monomania became a gigantic figure.

It is tempting to connect Don Juan with Faustus, not so much because, as has been pointed out, both aspire to 'unlimited happiness from pleasure',[10] but rather because both do so with so little success. Faustus

too suffers from Don Juan's narcissism. He is in love merely with his dearly bought, prolonged youth, not with what he might have used it for; with his magic power, that is to say, the sense of possessing it, but not the satisfactions that he might have obtained by means of it. In characters such as Faustus and Don Juan Nietzsche and his followers have seen personifications of the Renaissance sense of power and enjoyment of life. It is true that there is a connection between the two figures, and that there is a close relationship between them and the pattern of Machiavelli's prince. But these critics could not have been further from the mark than in regarding them as paragons of virility, exuberant health, and un-crippled instincts. They failed to see what sickly, decadent figures they were, and how far they departed from the Renaissance ideal of a balanced mind and wholehearted enjoyment of life. If the Renaissance meant a mind open to the world, receptivity to its beauty and meaning, and love of the things that mirrored its beauty and meaning, the narcissism of Faustus or Don Juan represented the spirit of the Counter-Renaissance.

The 'Faustian' nature of Hamlet has also long since been discerned, and Goethe made of him a problematic character of the type of his own Faust, marked by the 'pale cast of thought', disabled by his over-sensitivity, and incapable of bearing the heavy burden placed on his shoulders by fate.[11] But in reality Hamlet is as strong as an ox, stronger than the king and his whole court, stronger than all those with whom he has to deal. Ultimately he destroys them all without exception—mother and bride, friend and foe. All he cares about is remaining as he is—with his resentment. His narcissism shows itself in hatred of the outside world, and he hates in order not to love. The need to avenge his father's death is a welcome pretext with which to rationalise his desire to part company with men, go his own way, withdraw from them completely and remain alone with his hate.

Hamlet is not the greatest of Shakespeare's works, but its hero is one of the most overwhelming figures in literature. That is what admirers of the play have always felt though, like Goethe, they sought to justify their conviction with unsound arguments. It is only in connection with Hamlet that the historical importance of Don Quixote, Don Juan, and Faustus can be appreciated in full. With Hamlet the narcissist first discloses himself as one of the most important types in modern literature, if not the most important, or the modern literary type *par excellence.* His advent does not merely supplement the older types; to an extent he makes them all out-of-date, for in the course of time they had grown rigid and stale. In contrast to the new types, their psychological constitution seems too simple and straightforward. Rich though the choice that they offer the writer may be, there is nothing problematical about them, nothing that opens up new perspectives. There are heroes of

physical prowess, like Achilles, or of mental adroitness, like Odysseus; there is the innocent victim of fate, like Oedipus, or of conflicting duties and impulses, like Antigone; there are knights-errant in love with their mistresses, like the heroes of the chivalrous romances; pilgrims in search of salvation (the Dante of the *Divina Commedia* and the prototypes of Bunyan's hero); the pair of young lovers (as in Hellenistic romances); the rogue, the villain, the sly-boots, the miser, the elderly rake, the calculating and non-understanding parents (characters from ancient comedy, medieval drama, the Renaissance *novella* and the picaresque novel). Seneca and his followers extend the cast by the introduction of a series of wild and desperate characters, tyrants and despots, brutes and monsters, who still preserved their fascination for the Elizabethans and even the French classics. But none of these types is so constituted as to interest a writer after the end of the Renaissance and the beginning of mannerism to the extent of inspiring him to make any one of them an embodiment of a new vision of life. This, of course, by no means implies that these now rather fossilised types vanish from the scene; in one form or another they all reappear.

Hamlet, in spite of Marlowe's *Dr. Faustus*, is the first fully-fledged representative in dramatic literature of the enigmatic modern character. He is the first and purest example of the type of modern man, with his inner conflict, his alienation from the world, his resentment of humanity which throws him back on himself. Though he may find the most varied rationalisations, the psychological root of his renunciation of outside reality is always narcissism. Hamlet is no doubt the most pronouncedly narcissistic of Shakespeare's characters, but is far from being the only one; indeed, narcissistic traits appear in all his psychologically most interesting figures. Othello's narcissism leaps to the eye. It is evident from the outset that unlike, say, Romeo or Troilus, he is no real and genuine lover. Though he admires Desdemona's beauty and desires her, what she really is to him is a symbol of success, demonstrating in his own eyes that, though a stranger and an outsider among the exclusive Venetians, he is fully accepted by them.[12] In his marriage he mirrors himself and his success, and in his relations with Desdemona he is always thinking only or primarily of himself, his rights, and his so vulnerable honour; he thinks of her and others with the suspiciousness of an outsider who never feels quite sure of himself, and finally he kills the woman he loves in order to remain alone with himself, his suspicion, his jealousy, and his egoism.

Shakespeare also has a female variation on the narcissistic theme, though feminine narcissism is much rarer in dramatic literature. At first sight the position of women in a masculine and patriarchal society would seem to predestine them to narcissism. Because of what Freud calls their 'socially impoverished liberty in respect of choice of love-object'[13] they are at a

disadvantage in many ways, exposed to aggressions of all sorts, and often helpless and defenceless. A woman is compelled to think above all of herself instead of her love-object, as her feminine attractiveness is generally her only possession and her most effective weapon, and often remains so only as long as she does not surrender to her lover. On the other hand, when one considers that calculation and coquettishness play the most negligible role in narcissism and that the male draws back from the love-object, not to save himself for another, but to be and remain alone with himself, and that this withdrawal into himself is his weakness and not his strength, his curse and not his blessing, it will be seen that caution is called for in discussing female narcissism as a dramatic theme. Nevertheless, some of Shakespeare's women, and notably Cleopatra, have unmistakable and dramatically vital narcissistic traits. Cleopatra rises to the loftiest heights reached by any of Shakespeare's characters and ultimately achieves real moral greatness, though she is no less narcissistic than Hamlet or Othello and is a strumpet like Cressida. Yet, in every fibre of her being she is more than that, not only because, in accordance with her narcissistic nature, she is not so happily in love with herself as Cressida, but because—and this is where the drama and tragedy of her character appears—she, like Othello, must in her own way kill what she loves and thus destroy herself. This tragic feature is always lacking in the picture of the strumpet, however 'pure' and 'noble' she may be according to the romantic image.

Narcissistic characters, however, generally do not make ideal heroes because, in Freudian terms, they are dominated by their actual ego instead of by an ego-ideal. The tragic hero sets himself a moral ideal and, though he is not always able to attain it, he is uncompromising in his struggle to do so. He is not prepared to reconcile himself with his ephemeral ego or with its inadequacies. The distance that usually separates the narcissistic character from the tragic hero can perhaps best be judged on the basis of Freud's 'libidinal types', according to which characters vary depending on whether they are dominated by the id, the ego, and the super-ego. The 'erotic' type, so-called by Freud, devotes the greatest part of his libido to his love-life, but it is not loving but being loved that is most important to him, and all the levels of the mind are adapted to the instinctual demands of the id. The second type, which Freud calls the compulsive, is characterised by predominance of the super-ego achieved in strong conflict with the ego. The third is the narcissistic type and, as Freud says, its characteristics are negative. There is no tension between the ego and the super-ego, and there is no predominance of erotic needs and no primacy of the ego-ideal over the ego.[14] This typology has been objected to on the grounds that it uses static instead of dynamic terms, and that the three types are too rigidly differentiated.[15] But that only corresponds

to their pathological nature; the more they are mingled, the more nearly they approach the normal, and Freud himself remarks that a mixture of all three would represent 'the absolute norm, the ideal harmony'.[16] At any rate, it is clear that of the three it is the so-called compulsive type, dominated by the super-ego, that comes closest to the idea of the tragic hero, and that the narcissistic type is able to rise to the tragic sphere only by the negation of itself. That is a point of particular consequence in the present context.

The idea of negation is associated with the narcissistic type in more ways than one. Sancho Panza, Leporello (who in Tirso de Molina is still called Catalinón), and Iago have been called the negative heroes of the works in which they occur.[17] The combination of positive and negative heroes in this sense, that is to say, master and servant, knight and squire, hero and confidant, unsuspecting victim and evil plotter, have belonged to the stock-in-trade of literature from the earliest times. There are few stories without situations in which such a pair are not involved in one way or another. But it is characteristic of mannerism, and is an inherent part of its dialectical structure, its antithetical approach, its ambivalence in practically every critical situation, not only that the thoughts, feelings, and actions of its literary heroes are never completely unambiguous, but also that the implicit psychological conflict often appears in the form of two independent characters. Sancho Panza is more than merely the squire and counterpart of Don Quixote, Catalinón-Leporello more than the companion and shadow of Don Juan, Mephistopheles more than the aider and abetter and tempter of Faustus, and Iago more than the confidant and betrayer of Othello. In all these subsidiary figures a secret tendency, a suppressed characteristic, a repressed drive of the hero is objectified, made autonomous, worked out more clearly, and contrasted with another side of the character, with the result that the associated pair of figures are essentially one single figure taken apart and represented by two. Actually we have here an anticipation of the modern idea of the *Doppelgänger*; and the description of squire, servant, or companion as 'negative hero' in connection with a narcissistic character is wrong to the extent that these figures are not merely the hero's obverse, negative side, but the objectification of a part or potentiality of his character, which is precisely what is meant by a 'double'.

In one sense, however, Don Quixote, Don Juan, Faustus, and Hamlet are themselves 'negative' heroes, that is to say, characters in which negative, questionable, or morally not quite unobjectionable qualities predominate over or restrict the influence of the positive qualities. Incidentally, it is but another aspect of the turning-point in literary psychology represented by mannerism that henceforward completely 'positive' heroes, that is to say, completely virtuous and ideal characters,

lose their credit. From now on, the criterion of psychological plausibility is lack of wholeness and integrity and a sense of inadequacy. The romantic movement, which otherwise has so many points of contact with mannerism, represents the only relapse in this respect; in its characterisation it reverts to the black-and-white technique, and it creates one single type that contributes to the further development of the narcissistic character discovered by mannerism, that is to say, the Byronic hero. Childe Harold is the original of the type of eternal stranger among men, which is continued, with variations and modifications, in the long series that stretches from Werther, René, Obermann, Adolphe, Onegin, to Hans Castorp and Swann, who belongs to it in spite of his sociability. Byron's hero, with his inner loneliness, his secret which is never revealed because it is ineffable, his childish and animal-like 'self-sufficiency and unapproachability'—traits described by Freud as especially characteristic of female narcissism[18]—is the 'interesting man' *par excellence*. The narcissistic figures of nineteenth-century literature, all of whom stem either directly or indirectly from Childe Harold, are 'interesting' in a way quite different from the characters of Elizabethan drama, but the emphasis in the characterisation in both cases is on their being 'interesting'; the point, in other words, lies in the piquancy and paradox of the qualities associated with each other, which was never a vital factor in the classics.

Until the nineteenth century, or more specifically until the triumphal march of the naturalistic novel, literature produces no types that can compare in importance or numbers with the great figures of the literature of mannerism; and even then the most important of the new types are to an extent only derivatives and varieties of the narcissistic characters of the mannerist age. The three most important variations come from Stendhal, Balzac, and Dostoevsky. Stendhal's 'angry plebeian' is at war with the whole of bourgeois society; his strongest weapon is his hypocrisy, his lovelessness, the withdrawal of his libido from humanity. He transforms his innate romanticism into sober logic, his youthful idealism into a system of Machiavellian rules, and turns all the things that life offers him into counters in the gamble for success. Julien Sorel is the chief representative of the type, but Fabrice del Dongo and Lucien Leuwen are also mere variations on the theme of the gifted young man disappointed by the post-revolutionary bourgeois order and driven into narcissism by his alienation from society. Balzac's Lucien de Rubempré, Eugène de Rastignac, Henry de Marsay, and the rest of them, are not plebeians, and have no need to be plebeians to rebel against the prevailing society, to feel alienated from humanity in spite of their temporary successes and to develop the most obdurate narcissism though they make ample use of their love-objects. Alienation and narcissism reach their climax in nineteenth-century literature in characters such as Dostoevsky's Ivan Kara-

mazov and Stavrogin. With these, egocentricity, in the sense that everything is seen as a personal, individual, problem, and that the individual believes himself obliged and able to tackle everything alone, achieves a wholly diabolical power. Dostoevsky's novels seem to take place on the eve of the Last Judgment; tension and chaos prevail, and everything is waiting for clarification and release. Ivan Karamazov and Stavrogin expect salvation from reason, the fearless, dispassionate, untrammelled intellect, but it is that, so Dostoevsky believes, that leads them to destruction and ruin; and his irrationalism and mysticism makes him preach salvation by the sacrifice of reason, in other words, intellectual suicide. What concerns us here, however, is Dostoevsky's correct diagnosis of, not his questionable cure for, the disease which has afflicted western man since the crisis of the Renaissance and undoubtedly attains its highest artistic expression in his work.

The characters created by Stendhal, Balzac, and Dostoevsky are not restricted to the narcissistic type, as is shown by Mathilde de la Mole, Baron Hulot, Dimitri Karamazov, Rogozhin, Prince Myshkin, Natasya Philippovna, Katherina Ivanovna, and so many others, but nineteenth-century literature has to its credit one single characterological discovery of universal significance, that is to say, Mme. Bovary, the modern feminine variety of the narcissistic type. Her continual love affairs, that is to say, the fact that she is never at a loss for a love-object, seem to point to the opposite of a narcissistic constitution. But in reality she loves none of her men; what she loves is their love, and that is the romantic and narcissistic element in her. She is never really in love, but is always playing a part, and there is only one real protagonist in her drama and that is herself—Mme. Bovary in love, Mme. Bovary the beloved.

Even a brief sketch of the development of psychological types in modern literature such as this cannot be concluded without mentioning Tolstoy, the author of the greatest modern novel. Though he is perhaps not to be counted among the supreme psychologists of the century, there is one quite unusual psychological achievement to his credit that is worthy of his greatness. The only completely positive and at the same time naturalistically described figures in the modern novel—unadorned, *i.e.,* unheightened by the mystificatory or fabulously idealistic light thrown upon such figures by other authors—are Pierre Bezukhov and Levin. These have nothing to do with narcissism, but break with the assumption that psychological credibility is irreconcilable with complete moral rectitude. They fail to shatter the predominance of narcissistic psychology, and enigmatic types have been characteristic of modern literature both before and since. But Tolstoy's work provides the first and so far the only single great instance of artistic creation basically free of the influence of narcissism and mannerism.

IX

Tragedy and Humour

1. THE ANCIENT AND MODERN CONCEPT OF TRAGEDY

IN discussing narcissism the question arose whether narcissistic char-
acters were able to reach the level of tragedy because of their usual
incapacity to rise above themselves or, in psychoanalytic terms,
because of the lack of tension between their ego and super-ego. There
could be, of course, no question of tragedy in connection with sick
persons completely imprisoned in their narcissism. On the other hand, we
have seen that characters with a narcissistic disposition, such as Cleopatra,
are able to rise to the highest flights of tragic transfiguration. On closer
inspection it appears that there is actually a direct connection between
narcissism and tragedy. Just as Machiavellism cries aloud for tragedy as a
way out of the dilemma of the 'dual morality', and to an extent prepares the
way for it, so does narcissism, with its sociological counterpart, alienation,
provide the prerequisite for modern tragedy. Loneliness is not only an
inherent characteristic of figures such as Hamlet, Othello, or Coriolanus,
but also plays a vital part in their tragedy, and in modern tragedy in
general. When disaster overtook the hero of ancient tragedy, he was
able to feel the bond between himself and his fellow-men and fellow-
citizens, who shared his belief in the same gods, the same fate, and in the
necessity of his sacrifice and death. But the hero of modern tragedy goes
to his doom alone. This is also the most striking illustration of the
difference between drama with and without a religious content and
background.

The tragic hero's last words are full of lyricism; he sounds a note in-
audible in the earlier part of the play, but it would be wrong to call the
solitude he expresses purely lyrical. He is alone in a much deeper sense;
he is not so much alone because of his tragedy as his tragedy is an out-
come of his loneliness. If he really had any bond with others, if he were

still capable of any such bond, if he had a friend, a companion, a confidant, someone to whom he could talk, there might yet be a way out for him. But there is no one with whom he can communicate, no one capable of understanding why he was able to act only in the way he did, no one who can put himself in his shoes. That is why at the end of a great tragedy there is no more dialogue. The tragedy ends with the dissolution of its dramatic-dialogical structure; one of its paradoxes is that it ends by abolishing its own form.[1] It has therefore been held, with a certain amount of justification, though with a degree of exaggeration, that the symbolic behaviour of the tragic hero is silence. 'The hero's silence breaks the bridges that connect him with God and the world and raises him above the field of personality, demarcated and individualised by dialogue with others, to the icy solitude of the self.'[2]

The moment of his tragic downfall and silence is also his moment of truth, the realisation of his ideal, which is not above but in him, though previously it has been veiled and hidden, obscured by ephemeral distractions, but now, having stripped himself of all alien accretions, he discloses it and it helps him to triumph; and thus his coming to grief represents the climax of the paradox contained in the tragedy, not only because his defeat is a moral victory, and results in his transfiguration, but also and above all because by his fateful deed he achieves self-realisation by means of the most extreme self-alienation. Since Aristotle discussion of tragedy has centred on catharsis, but it is the effect on the spectators that has mainly been thought of in this connection. Tragedy, however, consists above all in the catharsis of the hero, whatever the degree of his guilt or lack of it, the purging of his nature of all the alien elements that burdened him. Othello, Lear, Cleopatra, are driven to the extreme limits of alienation from themselves by the death of Desdemona, Cordelia and Antony; living, being left alone with themselves, becomes henceforth intolerable to them. But at the same time all the veils and obscurities are lifted from their souls; the mist vanishes, and their own true nature appears out of the chaos, fearful but distinct. They are lost, but they have found themselves.

The modern tragedy of character is generally distinguished from the ancient tragedy of fate, and fate, which in Greek drama was transcendent, is said in modern drama to be immanent, that is to say, implicit in the hero's character and not dependent on the gods or the powers above the gods. The hero comes to grief because of his unruly character, his unbounded passions, the excesses of his nature; in fact, it is his character that is his doom. The driving force of the action is no external power, but an inner conflict; the hero is at war with himself, and thus the whole drama is internalised and becomes a drama of the soul.

The dramatic action and conflict are made tragic by the hero's discovery in himself of the reason for the fateful situation in which he finds himself

and the inevitable catastrophe that threatens him. Awareness of the wicked deed to which his fate has driven him may fill the hero of ancient tragedy with despair and horror, but he has no thought of ever searching in himself for the cause of his ruin. Without an inner conflict, without a problem of responsibility and the ultimately insoluble question of guilt, however, there is no tragedy in the modern sense.

Greek drama at most presents a situation filled with the tragic mood. The gods have acted, fate has overtaken the hero and struck him down; the picture that reveals itself before the spectators' eyes is of grief and suffering, the consequence of a curse that bears down on whole families, the victims of which are always helpless individuals. The drama consists in the mounting emotional tension, the torment, the nameless horror that seizes the hero in the face of the deed that he can barely recognise as his own. If there is conflict between the hero's character and his actions, his moral stature and his mad and criminal and self-destructive deed, it is never developed into a dramatic conflict, not only because the hero is the innocent victim of his fate, but also because he offends against the divine and moral order only after his fate has been sealed.

In *Oedipus* it is the gods and the powers of destiny that act, not the unhappy king. The drama turns on his tragic blindness, not on his tragic guilt, and the action consists exclusively in the disclosure of his unsuspecting ignorance and the madness that drove him towards his doom; in other words, it consists in his eyes being opened after it is too late. In *Antigone* the drama turns, not on an agonising decision, but on the carrying out of a decision already made. Thus again it is a drama, not of moral conflict, but of moral suffering, not of doing but of being done to; it is passive, not active, as Kierkegaard rightly says of Greek drama as a whole. Antigone's deed too is the work of the gods and of fate, and even as a tool of the higher powers she acts, not as an individual, but as a member of her family and a representative of her ancestry. The curse that rests on her is inherited; she has to pay for the sins of her fathers, and to an extent the fate of Oedipus is repeated in her story. As Kierkegaard points out, if her crime, that is to say, the reverent burial of her brother in spite of the royal ban, were represented as the isolated action of an individual, it would cease to be a Greek tragedy, and would be a modern play.[3] What makes her a Greek dramatic heroine is her lack of individuality, that is to say, the fact that hers is not an individual fate. She is the representative of her family history. Even in the *Hippolytus* of Euripides there is no moral or even really dramatic conflict. In so far as there is any conflict that is not purely rhetorical, contemplative, or lyrical, that is to say, is not a mere reflection of decisions that have already been made or carried out, it is between the divine actors Artemis and Aphrodite, not between men, or different impulses, passions, and loyalties in one and

the same man. Actually it is difficult to decide who is the real hero of this play, for the three principal characters are all more or less passive. Phaedra comes closest to the idea of the modern tragic hero in her act of self-destruction; Hippolytus in the transfiguration brought about by his death, no ray of light from which falls on Phaedra; and Theseus by reason of his greater share in the action of the drama and his involvement in the most complicated tangle of guilt and innocence. Greek drama nowhere comes closer to modern tragedy than it does with Euripides, but it is sufficient to compare *Hippolytus* with Racine's *Phèdre*, for instance, to see the gulf that divides them. In modern drama the tragic conflict is centred on the individual, though the idea of fate is partially taken over from the ancients.

Under the burden of their terrible deed Orestes and Oedipus must have felt infinitely alone and lost, but their sense of being the victims of their fate must have produced feelings in them completely different from the guilt of Othello, Lear, or Macbeth. The contrast is a consequence of the many changes undergone in the course of centuries by the ancient conception of godhead. In the first place it was Christianised, which meant that divine power was no longer subject to fate, as it was in Greek mythology; the Christian God did not 'impel from without', but moved men and things from within. Also the idea of divine omnipotence had to be supplemented by that of divine justice, benevolence, and love for fate to be superseded as the ultimate arbiter in drama and the hero's character to step into its place. Only in an age which had completely experienced and absorbed Christianity, even if it had partially moved beyond it, could the whole question of guilt as posed by modern tragedy—quite apart from its answer to it—become the hinge of dramatic action. For modern tragedy implied revolt against the Christian God, Who had to prevail, however, before He could be deposed.

In ancient tragedy the gods were involved in the dramatic action, were actually protagonists in the play, while in modern tragedy, as Georg Lukács observes, he is a spectator who never intervenes.[4] Just as modern tragedy would have been impossible without the supersession of paganism by Christianity, so did the Christian God have to leave the world again for tragic drama to be revived. Modern tragedy presupposes a world abandoned by God, and this makes the more intelligible its first appearance in the age of mannerism, with its problematical, wavering, concept of God, varying from writer to writer. Greek tragedy was still in part a cult; its beginnings were closely associated with religion, and the association never completely died away. Nothing of this has survived in the modern theatre, but, to retain the expressive image, God's presence as a 'spectator' lent something of its former grandeur and sense of dedication to tragedy played even by the humblest strolling players.

2. THE MIDDLE AGES AND TRAGEDY

In medieval times there was and could be no tragedy. In the Christian view, earthly life was vain and unsubstantial, and only with its end did a better, more meaningful life begin. Man's soul was indestructible, and death had no power over it. In our eyes the tragic hero may die morally triumphant and transfigured, but he goes to his doom feeling he has lost the game, while the Christian, even though a crushed and guilty sinner, faced death certain of a life beyond. So long as men lived and died as Christians confident of resurrection, there was no room in their lives for tragedy, and only when they felt abandoned by God's omnipotence and thrown back on themselves did a tragic element enter their lives. The hero of tragedy is godless, a man abandoned by God, a man who feels and thinks as if there were no God. Thus modern tragedy is not irreligious because, say, Shakespeare, and his contemporaries were unbelievers, but because it could not have been created by men who at the bottom of their hearts felt as Christians.

To the true Christian even the worst that may befall man on this earth can be sad, but never tragic. The modern concept of tragedy is just as irreconcilable with the Christian concept of a good and almighty God as is the Greek concept of fate. For the presence of God protects the Christian, not from suffering and death, sin and doubt, anxiety and misery, but from the solitude and utter helplessness of the victim of tragedy. The Christian has to atone for his sins, and the hand of God may bear heavily on him, but the penalty that he pays has nothing in common with the splendour and flourish of tragedy.

What tragedy there was in the Middle Ages lay in the crucifixion. Christ's death was a point of contact with ancient tragedy, which was also based on the idea of sacrifice and, in common with modern tragedy, postulated the hero's martyrdom and transfiguration. But these similarities are superficial, and do not go to the heart of the matter. Another thing that should not be overlooked is that the crucifixion was originally played, not as a *passio*, but as a *resurrectio*, an Easter play, and that it was only at a later phase, during the Counter-Reformation, that emphasis came to be laid on the tragic and horrible elements in the passion play.

Also the ideals for which the tragic hero sacrifices himself, no matter how noble he may be, do not represent the highest Christian values, and from a Christian point of view are not worth striving for at all. The hero's ideal is not that of the *anima christiana*, and the world of ideas to which he ultimately fights his way has nothing to do with heaven. Tragedy implies as radical a breach with Christian morality and recognises a moral system as different from the Christian as does Machiavellian realism. In

the history of ideas tragedy and Machiavellianism belong together even in this context.

In the Middle Ages being a tragic hero would have involved being a declared opponent of God and coming into open conflict with the order established by Him. But at that time, though there could be different degrees of distance from Him, such a thing as direct conflict with Him was inconceivable. From the medieval viewpoint, there could be no such thing as a morality in opposition to the divine. The Christian renounced the world, and did not strive to realise the divine principle in it, or even to set it in train by the destruction of anything existent, for the pride and arrogance and defiance implied by any such attempt would have been tantamount to conflict with the divine work of redemption. The Christian prepared himself for the next world, but did not believe he could assure his salvation in this. Thus it is not the certainty of salvation that makes Christian tragedy impossible, as has been maintained,[5] for a Christian cannot be certain of salvation, but the impossibility of an opponent of God's having any claim to any worth whatever, and without such worth there can be no tragic hero. In the Christian cosmos the role of rebel against God is played by the devil, who is a comic and not a tragic figure. Satan first achieves stature with Milton, that is to say, long after the medieval outlook had been superseded and the modern tragic sense of life had developed.

It is also inconceivable to a Christian that in a life-and-death struggle of the kind represented in tragedy God could play the role of spectator. In the Christian Middle Ages tragedy with God as a passive bystander was as inconceivable as tragedy with Him as an active participant. For tragedy to become a possible art form again the divine had to be banished from empirical reality, ordinary, practical life had to be disenchanted, thrown back on itself, isolated from essential being, from the spirit, from God.

So long as providence and grace, immortality and the hope of salvation, divine aid and forgiveness, were among the primary facts of life, so long as there was only one single morality valid for all Christians without exception, there were only plays with good and bad characters and actions that were exemplary or contemptible, but no tragedy with a hero 'innocent and guilty at the same time'. Such tragedy first appeared in the alienated, sceptical, spiritual world of mannerism, torn by philosophical relativism and moral dualism; and no form of literature could have been better fitted to it, and in none could its writers have done more significant and creative work.

3. THE BIRTH OF MODERN TRAGEDY

The history of modern tragedy begins with the Elizabethans.

The choice of artistic forms that originate or prove fruitful in any particular period does not depend on the models discovered or reinterpreted by scholars, but on its fundamental outlook on life. Tragedy became a topical dramatic form in the age of mannerism, not because Greek tragedy was dug up and Seneca revived, but because men's mood was governed by the tragic sense of life and tragedy most vividly expressed the historic moment, with its unhealed rift and insoluble conflicts. At the root of modern tragedy, fostering, nay forcing, its growth, lay the fundamental experience of the day—the sense of the ambiguity of all things. For a situation is tragic, not because it involves suffering, sacrifice, and death, but because it permits of no simple and straightforward attitude, because every possible course of action leads to an inextricable tangle of right and wrong, guilt and innocence, compulsion and freedom of choice. Tragedy became a typical mannerist art form above all because of the dualism of its outlook, the hero's firm roots in this earthly life and his simultaneous dissatisfaction with it, his worldly interests and ambitions on the one hand and his other-worldly and metaphysical nostalgia on the other.

Nothing is so characteristic of modern tragedy as the factor of alienation, which hardly entered Greek tragedy at all. Greek tragedy was born in an age when nothing of the Homeric world survived. But, in spite of the afflictions sent by the gods, men still felt more or less at home in the world they lived in, and they remained firmly rooted in it, though not without an uncomfortable awareness of another, subterranean world that was by no means without its hazards and prevented them from ever forgetting that life had ceased to be idyllic. Since then two thousand years nad passed, and in the interval men had become strangers, barely tolerated guests, in the world that was their home. It was a long and slow process, marked by repeated crises and periods of recovery and ever more ominous signs of approaching disaster, that led to the final alienation connected with the break-up of the Renaissance. The new thing, however, was not the phenomenon of alienation itself, but the part it played in the totality of human life. Oedipus as the mere tool of fate must have felt changed out of all recognition and terribly alienated. But his alienation from himself was the consequence and not the cause of his tragedy. Timon, Coriolanus, Lear, Macbeth, and Hamlet are inherently alienated from the world and from themselves; their tragic lot is the consequence of that alienation, and their tragedy is the tragedy of alienation.

The strongest link between the various forms of spiritual expression

of the age of mannerism, and the common theme of the works of Machiavelli, Cervantes, and Shakespeare, is the sense of alienation resulting from the unattainability of the highest human ideals and the unrealisable nature of pure ideas, which have to compromise with reality unless the latter is to remain unaffected by them. The Middle Ages and antiquity were of course aware of the dualism between the world of ideas and empirical reality, though it was still unknown at the time of the Homeric epic, the satisfying harmony and unproblematical nature of which is due to the complete homogeneity of the world it represents; and it was not yet dealt with by the Greek tragedians, who limited themselves to the critical situation in which mortals were plunged when the gods intervened in their lives. The tragic hero found himself at the edge of an abyss that split the world in two, but the tragic situation did not arise because he felt himself driven towards the other side, to the other and better half of the world, and he was not impelled towards a world of Platonic ideas or filled with a deeper sense of the ideal. Even in Plato, who made the antagonism between the ideal and the real the whole basis of his system, the two spheres do not touch. The conservative idealist maintains his contemplative attitude towards reality and puts the world of ideas at an unapproachable distance from all tangible reality, and thus for him also a collision between the two lies outside the bounds of possibility.

The Middle Ages had a deeper feeling than any preceding or subsequent period for the contrast between this world and next, between physical life and the life of the soul, between unfulfilment and fulfilment of life, but this produced no conflict that could be called tragic; such conflict could have arisen only if, in the medieval view, it had been the duty of this world to raise itself to the level of the next. Instead, however, it was the Christian's duty to prepare in this world for a life in God; in other words, the world was not a ladder to heaven, but a stool beneath God's feet. Trying to realise heaven on earth before the completion of the work of redemption and the establishment of the *civitas dei* would have seemed as absurd as trying to raise the voice of the world against the voice of God. The lack of any point of contact between the phenomenal and ideal worlds in antiquity and between this world and the next in the Middle Ages, and the resulting impossibility of conflict or collision between them, is another factor, over and above the religious factors, that prevented the appearance of tragedy in our sense of the word in either of those periods. The tragedy of inner conflict and moral dilemma was not born before the age of political realism, which grasped the nettle of the problem of rational action in the face of immediate reality, was capable of attributing moral value to an attitude that might often be practically justifiable but ideally indefensible, and had the courage and the intelligence to see that such an attitude was both acceptable and questionable.

The transition from the untragic and essentially still undramatic mystery plays to the tragedies of the new age is provided by the late medieval moralities, in which there appears for the first time the moral conflict that develops into the tragic conflict of conscience of Elizabethan drama. The most important ingredient that Shakespeare and the other dramatists of the age added were the inevitability of the conflict, its ultimate insolubility, and the hero's moral victory in downfall and defeat. It is this last, the hero's moral victory, that is the most important factor in the new tragedy, and it is made possible only by the modern idea of fate, which differs from the ancient in that the tragic hero accepts his fate and regards it as meaningful. It is tragic in the modern sense only if he accepts it. He is not, to use the familiar phrase, killed off as if by a tile falling from the roof, and his end assumes the character of necessity. It is this that gives him his significance and a touch of the superhuman, and his identifying himself with his fate saves him from seeming trivial. In his renunciation, his uncomplaining acceptance of his lot, the realisation that his passion and his deed, his defeat and his victory, are one and the same thing, he seems to cut himself off from the rest of humanity, and he himself provides the measure by which he must be judged. At a lower level there is a revaluation here not dissimilar to that which led to the Protestant doctrine of predestination. The reformers believed they could preserve the superhuman idea of God only by completely identifying themselves with His ways and will, and not seeking to justify or explain them by human standards. Luther, as we have seen, carried the idea of the incommensurability of the human and the divine so far as to speak of God's injustice, and to state that the assumption that God was unjust had at any rate a great deal to be said for it.[6]

The close connection between the fundamental outlook behind modern tragedy and the doctrine of predestination is even more strikingly illustrated by the similar attitude of both to guilt; both create the impression that it is irrelevant from their point of view. The granting of grace does not depend on good works, in the Protestant view, but is decided in advance without regard to reward or punishment, and judging the tragic hero by his guilt or innocence is similarly irrelevant. As Hegel, Schelling, Kierkegaard, and a whole series of other students of tragedy never tire of repeating, he is both innocent and guilty, and both at the same time.

The same paradox is inherent in the idea of the tragic and in that of predestination. The irrelation between faith and works in Protestantism corresponds to the discrepancy between the tragic hero's character and his actions. The latter is nobler and greater than his deeds, and retains his innocence, no matter what crime he may commit. Luther's saying that good deeds do not make a good man, but that a good man does good deeds, is in accordance with the concept of the tragic hero, who is what he

is because of the greatness of his character, not because of his deeds. He atones for a crime that he cannot help; he suffers innocently. The ultimate paradox of his destiny is that just because of the fateful deed for which he has to pay the penalty he raises himself to a higher level.

But, in spite of the unmistakable relationship between the idea of tragedy and that of predestination, it would be sheer equivocation to regard modern tragedy merely as an expression of the doctrine of predestination and to derive it directly from Protestantism. If a direct connection were assumed, and predestination were held to be the connecting link, if tragedy were regarded as a mere translation of Protestant doctrine into the language of literature, it would mean that one was allowing oneself to be led astray by linguistic ambiguity, for predestination in this context means two different things. The granting of grace differs essentially, not only from the pagan fate, but also from the *fortuna* of the Renaissance, the stars to which Shakespeare's heroes look up, or the fate contained in their own character, their own daemonic nature. The tragic powers of fate are blind, while the God who inscrutably grants or withholds His grace sees, but with eyes totally different from human eyes. Also there is no historical connection between modern tragedy and Protestantism in the sense that the former assumed and imitated the doctrine of predestination. After being completely absent in the Middle Ages, the idea of fate played an important role in Renaissance drama, and so did not find its way into tragedy by way of Protestant doctrine. But, though there is no direct causal connection between the two spiritual edifices, there is a parallelism that makes the contemporaneity of Protestantism and the rise of modern tragedy seem thoroughly meaningful.

4. THE DISCOVERY OF HUMOUR

Before the period of mannerism there is nothing in western literature that can be described as humour in the real sense of the word.

Socratic irony has hardly anything to do with humour. It mocks, dissembles, appears to say the opposite of what it means. Its aim is that of all irony, namely to ridicule, disclose weaknesses, attack and destroy. However useful, improving, and edifying it may be, there is nothing benevolent about it. Schopenhauer said that in irony a joke is concealed behind apparent seriousness, while in humour deep seriousness is concealed behind a joke.[7] The distinction may be formally correct, but it does not do justice to the fundamental difference in outlook that lies behind the two. The choice between irony and humour is not arbitrary, and the sense of life that finds an expression in humour had to be historically topical before it could be used as an appropriate literary form. Before the age of

mannerism it was unknown. In the Middle Ages there was more or less crude, knockabout comedy and more or less aggressive satire, but no humour. Even Dante, in spite of his psychological acuteness, knew nothing more sophisticated in the field of the comic than those two levels; and in this respect the Renaissance was as uncomplicated and undemanding as the Middle Ages. The age of mannerism was the first to laugh amid tears, and not to destroy everything on which it poured ridicule. For the first time life became so complex and full of contradictions that it could be met only by those two paradoxical forms of expression, tragedy and humour.

The simultaneous birth of modern tragedy and humour is no accident; for all the difference there may seem to be between them at first sight, they are rooted in the same soil. Both express the same alienation, and the same conflicting, ambivalent attitude to the basic problems of life. Tragedy follows from the intolerable demands of life in an impossible and unintelligible world, which the hero leaves because it has grown alien to him. Humour reconciles itself to the alienation which tragedy is unable to accept, but is no less dependent on alienation and, like tragedy, expresses the sense of life of a generation dominated by it.

Having humour, in the ordinary sense of the word, means maintaining a sense of proportion, seeing things in the right perspective, that is to say, looking at them simultaneously from different angles, not losing one's head under the blows of fate, remembering when one is struck by bad fortune that there is another day tomorrow, and that everything may come right after all. It means not over-estimating the importance of an evil experience, a wound, an insult, some damage done to one; bearing in mind the insignificance of the minor misfortunes of life, and reducing even major misfortunes to their proper proportions. In short, it means having equal regard both to the good and the bad in everything, always recognising the justification of different points of view, saying yes and no to something at the same time. Humour expresses a dialectical outlook, flexible, adaptable, always ready to correct itself. It is intelligible that the romantics should have valued humour so highly as a human attitude and a literary form, and that in Kierkegaard's scale of values only the religious outlook is given a higher place. It is indeed a quasi-religious feeling that is expressed in humour; a reverent understanding of the course of the world and a deep sympathy with everything human. Humour can disclose a man's worst failings and nevertheless forgive them; it can make one like him, and even perhaps praise and value him.

Cervantes understands the idealism of his knight as well as his innocent, childish nature; and he understands the madman in him too. Above all, he understands how chivalry is able to cohabit in him with madness, and how valour can be mad and madness valorous. Also he understands

Sancho Panza as well as Don Quixote, and loves them both. In an age of intolerance he is the very pattern of tolerance. The quintessence of humour lies in the tolerance that is always able to see good in evil, if not in the blindness which fails to see the pettiness and absurdity lurking in the great. But, wherever the emphasis lies, whether on the great or the small, whether the writer, following his own ambivalent feelings, treats his hero now with greater consideration, now with less, the work remains basically so human, so full of understanding, it so reconciles the reader with life, that in comparison the whole of earlier literature seems impassive, gloomy, and remote.

Cervantes understands that his hero's lack of humour is his undoing. Don Quixote is impregnable in his virtue and intransigent in his asceticism, and has no understanding for anything but his like. His tragedy, that is to say, his subjective tragedy—for the untragic humour of the work is objective, and lies, not in the hero, but in the author's attitude to him—resides in his historical displacement, in the inevitability of the catastrophe hanging over the head of a blissfully insane hero in an age of rationalism and realism. Cervantes is aware, not only of the failings that make Don Quixote so ill adapted to life in his age, but also of what his age loses by its inevitable destruction of such an amiable lunatic. This gives the whole book a deep melancholy that would be very gloomy indeed were it not at the same time so composed and conciliatory.

The double aspect that is assumed by humour, and the differing judgments of the same thing that it calls for, express an attitude similar to that of tragedy in relation to guilt. The paradoxical association of guilt and innocence in the actions of the tragic hero correspond in humour to the simultaneous absurdity and deep seriousness of the same incident, the same individual's simultaneous triviality and moral worth. It seems that only an age that felt the tragedy of an alienated world was able to express its fundamental outlook in humour also.

Humour is, however, not only a counterpart to tragedy, it is also its opposite. Tragedy is intolerant, unyielding, incapable of concessions; humour is peaceable and tolerant, though by no means superficial or cynical, and it smiles much more than it laughs. It is the opposite of tragedy, not only because it smiles where tragedy weeps and sees something encouraging and consolatory where tragedy sees no more light or hope, but also because, like Christianity—and this is another illustration of its quasi-religious nature—it does not permit despair and knows no final renunciation, and thus precludes tragedy. 'Humour is not resigned,' says Freud, 'it is defiant, it means not only the triumph of the ego but also that of the pleasure principle, which is able to assert itself against unfavourable real conditions.' [8]

Tragedy and humour have been described as basically identical;[9] this

may be acceptable in so far as it applies to their common background in the history of ideas and their similar paradoxical structure. Nevertheless, when the contents of a tragedy and those of a work like *Don Quixote* are regarded as the answer to a definite moral problem, they must be regarded as dialectical opposites, related to each other like thesis and antithesis.

Perspectivism, which is one of the essential characteristics of the mannerist literature and appears most clearly in its heterogeneous and antithetical features, also lies behind the humorous outlook, and forms one of the main themes of *Don Quixote*. In one of the most famous episodes two cousins of Sancho Panza's are enjoying themselves over a cask of wine. Asked how they like it, they reply that it is excellent, but has a strange flavour, on the nature of which they cannot agree. One says it is iron and the other leather. Eventually, when they have emptied the cask, they find a rusty key and a strap at the bottom. The moral is obviously the ambiguous nature of reality; it is as variable and multiform as the aspects from which it can be regarded. The perspective character of truth appears even more explicitly in the moral that Don Quixote draws from his discussion with Sancho Panza about Mambrino's helmet (I, 25). What is truth? To me it is this, to you that, to someone else it is something different again. A barber's basin is as good as Mambrino's helmet if it serves the same purpose, permits the same illusion.

Humour, besides expressing a dual outlook, is also an expression of the middle way, the way of moderation, the golden mean, the avoidance of extremes and excess. 'Sir,' says Sancho to his master, 'sadness was created, not for beasts, but for men, but if men give in to it too much they end by turning into beasts.' Humour is sober, rational, unpathetic, unsentimental and, in spite of its readiness to understand, forgive, and love, it is sceptical and critical. 'Aeneas was not so pious as Virgil depicts him, and Ulysses not so crafty as Homer describes him,' says Don Quixote. This sober and rational aspect of humour was not noticed by the romantics who discovered its importance in literature, though they fully realised its complexity and intellectually demanding nature. That was why Jean Paul said that there was a seriousness for everybody, but a humour only for a few.[10] Its very exclusiveness met one of the most pressing requirements of mannerism.

PART TWO

Historical

I

Outline of the History of
Mannerism in Italy

I. INTRODUCTORY

No artistic style is without antecedents or predecessors; but before they establish themselves most movements in art also have rivals to contend with, and in the development of mannerism such concomitant phenomena play a more important part than usual. In considering its beginnings similar trends in Hellenism, the late Middle Ages, or the Quattrocento can be ignored, but there can be no leaving out of account its prehistory in the High Renaissance. Indeed, mannerist features appear in so many artists, and so pronouncedly in most of them, that one is compelled to speak of a latent mannerism of the High Renaissance.

When Wölfflin compared the Renaissance to a narrow ridge, and said that no purely classical work was done after 1520, he actually over-estimated the duration of the classical period and under-estimated the significance of the anti-classical trends in Raphael in particular; at all events, he regarded the classical period up to Raphael's death as more untroubled and unproblematic than it really was. Classical purity in Renaissance art, that is to say, balance, homogeneity, and simplicity of expression, was never completely unimperilled and undisturbed, and we possess only a handful of works that can be regarded as pure examples of the classical style. Leonardo actually painted only one single work that is completely classical in the formal respect; his *Last Supper* remained the prototype of the whole style, though he himself never again attained the purity and uncompromising nature of its form. Raphael's pure 'classical' works, apart from a few Madonnas, are limited to the frescoes of the

147

first *stanza*. Michelangelo, apart from the early *Pietà* in St. Peter's and, say, the *Bruges Madonna*, produced nothing that can be regarded as a paragon of classicism; a mannerist trend has been noted in Raphael's *Eszterházy*, *Mackintosh*, and *Alba Madonnas*, the *Aldobrandini Madonna* has been described as 'practically already a mannerist work of art',[1] and similarly Michelangelo's *Doni Madonna*, dating from about 1504, can be regarded as something in the nature of mannerist.

The mannerism latent in the High Renaissance has long been recognized, though its true significance has not been adequately appreciated. Walter Friedländer in his first important study of mannerism[2] drew attention to mannerist trends in the heyday of classicism, after Hermann Voss had earlier pointed out how wrong it was to regard the High Renaissance as completely uniform and unambiguous instead of recognising that it too was a fluid, transitional, forward-moving artistic period, and that even at Florence, which at that time was much less progressive and dynamic than Rome, and showed an inclination to conservatism and a relatively slow tempo of development, there was, side by side with the rather unbending classical formula of Fra Bartolommeo, the much more flexible tendency represented by Andrea del Sarto, who was deeply rooted in the Renaissance but unmistakably pointed to the future and anticipated subsequent development in many respects.[3] Max Dvořák in his analysis of the various trends of High Renaissance art actually goes so far as to ascribe less uniformity to the Cinquecento than is usually granted the Quattrocento.[4] J. Huizinga also tends to an interpretation of this nature, and repeatedly expresses the belief that the Renaissance is a variable concept and is not to be categorically pinned down. All these scholars nurse the suspicion that the idea of the Renaissance as an age of unqualified security is mistaken, and that the origin of the subsequent crisis is to be sought in it.

The beginnings of mannerism in Italy are practically everywhere associated with the art of the High Renaissance masters. In Rome the innovators were connected with Raphael and Michelangelo, in Florence with Andrea del Sarto, and in Emilia with Correggio as the most progressive artists. In Venice the situation is more complicated, because here the vital stimulus was first provided by Parmigianino as well as the late Michelangelo. At an early stage Titian went through a mannerist phase, but soon returned to High Renaissance principles and, though Tintoretto acknowledged him as his master, he failed to play the intermediary role of the other classics. In Lombardy the connection between mannerism and the High Renaissance is still looser, for there Leonardo's pupil Gaudenzio Ferrari in becoming one of the earliest predecessors of the anti-classical movement developed against his master's trend rather than with it. But in general the new tendency is so closely associated with

the art of the classical masters that the origin of the stylistic crisis, if not the actual beginnings of the new style, must be sought in them, and Dvořák's assumption that, if Raphael had lived longer, he would have developed stylistically in the same way as his pupils,[5] can be extended to most of them. Apart from the artists mentioned above, it is sufficient to recall Sodoma and Peruzzi of Siena, Dosso Dossi of Ferrara, Pordenone of Friuli, Lorenzo Lotto of Bergamo, Paris Bordone and Schiavone of Venice, Bonifazio and Torbido of Verona, Savoldo and Romanino of Brescia, to be persuaded that the exceptions to the classical rule in the Cinquecento are almost more numerous than the examples of it, and that the ideal type of the High Renaissance was even more incompletely realised than most other stylistic patterns.

Perhaps the reasons why the formal principles of the High Renaissance were least impaired and survived the longest in the works of artists of the type of Fra Bartolommeo and Albertinelli was that they were sound and solid enough to fight their way through to classical ideas, but not alert and sensitive enough to hear the voices of doubt and dissatisfaction with classical standards that were rumbling in the interior of their spiritually more demanding, more susceptible contemporaries.

Why, then, in spite of the numerous features pointing towards mannerism that are present in the art of the High Renaissance, can mannerism not yet be said to have begun? The answer is that, at any rate until the end of the second decade of the Cinquecento, these features were the symptoms of a need and a spiritual discontent, or a mere experimentation with formal possibilities, rather than the expression of a new and positive outlook. A new style is not the result of a mere surfeit with old forms and an appetite for new, and is not present even when search and experimentation produce solutions that manage to survive and at a later stage are imbued with a new vision of life. The real change of style occurs only when the latter has taken place.

The stylistic crisis among the classical masters that can be assumed to have led to mannerism is one of those puzzling phenomena that occur in the most various periods and the most various circumstances in the history of art and point to the possibility of a new style but do not represent its real beginning. Anticipations and antecedents can be found for practically every important development in art or in outlook, and in practically every complex historical situation. But it is not the appearance of anticipations and antecedents that calls for explanation, but their becoming general, their emergence from the private into the public sphere, and their transformation from an individual whim or impulse into the accepted norm and pattern. Embryonic impulses that might lead to new stylistic forms are always present; the only question is whether and to what extent they are taken up and spread, that is to say, which of the stylistic

possibilities inherent in an age are further developed, and to what extent they establish themselves and thanks to what conditions. Innumerable possibilities of development appear in the course of centuries, most of which are dropped again; what matters to the historian is, therefore, not the discovery of a possibility, but its being adopted and adhered to.

The beginnings of mannerist, like those of romantic trends, are lost in antiquity, but mannerism as a style with historically definable limits came into existence only with the age of the Reformation, just as romanticism in the real sense of the word did so only as an after-effect of the French Revolution. Without a deeper link of this kind every impulse to a new style remains an accident of a more or less private nature and of ephemeral historical importance. The impulses towards mannerism that can be discerned before the death of Raphael, the Reformation movement, and the work of the Tuscan mannerists are still of this private and ephemeral, stylistically incoherent, type.

It is a peculiarity of mannerism that it meets its formal requirements with the means of expression of its predecessors, develops a new formal language only to a limited extent, and seeks to compensate for this lack of originality by the partial exaggeration and distortion of the traditional formal means. Though it is true that mannerism preserves a great many classical forms, it is no less true and no less striking that with it many new, complicated, bizarre, and abstruse forms appear to which no clearly definable content or ideas at first correspond. It has become a common-place in the history of ideas that forms grow rigid and fossilised, perpetuate themselves, and survive the content they were created to express. It was long unnoticed, however, and is still often overlooked, that new forms often appear that only later are filled with content and perform a function in the expression of feeling and thought, or as a means of persuading and influencing. That has obviously been the case with the cinema, the early history of which took place before our eyes; it strikingly exemplifies the fact that forms of expression can be invented and technical means developed before anyone knows what to do with them artistically. Early mannerism may have found itself in a similar situation.

Another peculiarity of the early stages of mannerism that distinguishes it from other artistic styles lies in its involvement with another artistic trend, the baroque, which was in its infancy at the same time, though it reached maturity much later. Such contemporaneity of the beginnings of two different artistic movements is unique, though competition between different styles is not an unknown or unusual phenomenon in the history of art. What is unparalleled in this instance is the fact that the beginnings of these two stylistic trends appear practically simultaneously, that one puts the other entirely in the shade for a time without causing it to wither away completely, and that the latter then emerges from the shade and

triumphantly displaces it in its turn. The simultaneity of the beginnings of mannerism and the baroque, their original rivalry, and their successive dominance are attributable partly to the circumstance that each represents one of the alternatives present in the preceding period, that is to say, the spiritualism and the sensualism that the High Renaissance for a short time managed to keep in balance, but were now in sharp and irreconcilable conflict. No more compromise between them was possible; first one prevails, and then the other; and, even if both appear simultaneously, as often happens in mannerism, the conflict remains and is never for a moment relaxed.

The stylistic situation is best indicated by the fact that most of the leading artists, such as Raphael, Michelangelo, Titian, Correggio, and, say, Sodoma, adhere alternately to the formal principles of three different styles. Fundamentally they remain classicists, but succumb now to mannerist, now to baroque tendencies. In Raphael the baroque trend can be detected before the mannerist, and in Michelangelo there are both mannerist and baroque impulses from the first, while in the school of Raphael and among the followers of Michelangelo there is a decided tendency towards mannerism. Titian, in spite of his deep roots in classicism, has a certain affinity with the baroque, and in Correggio there is actually an antecedent form of the baroque. Thus even in the first decades of the Cinquecento, and to an extent before Raphael's death, that is to say, essentially before the beginnings of mannerism proper, a proto-baroque and an early mannerism can be distinguished from the still flourishing and highly developed classicism.

The rivalry between mannerist and baroque trends ended to the advantage of the former with the establishment of mannerism as a sharply defined and unmistakable style that dominated artistic output in Italy practically until the end of the century, or at any rate until the eighties. It has been claimed that the classical period was immediately succeeded by an early baroque phase which mannerism had to displace before establishing itself and being ultimately superseded by the high baroque counter-movement in turn.[6] In reality, however, there was no baroque phase that preceded the mannerist. Both appeared more or less simultaneously, and at first were frequently combined. The baroque tendencies in Raphael, as in the *Expulsion of Heliodorus*, for instance, can be discerned earlier than mannerist tendencies of equal consequence, but in other artists an opposite sequence can be observed.

Both trends were anti-classical and were the product of the same spiritual crisis; both expressed what had become an open split between the spiritual and physical values on the harmony between which the survival of the Renaissance principally depended. The reconciliation that the proto-baroque sought to establish on an emotional basis turned out to be

premature and for the time being unviable, so it had to abandon the field to mannerism, which partly accepted as inevitable the antagonism between spirit and sensuality and made it the real content of its works, and partly sought intellectually to master it and spiritually to sublimate it, that is, moved in a direction that seems to have corresponded more closely with the requirements and inclinations of that age of criticism and crisis than did baroque emotionalism and materialism.

In regard to form, the relations between the three styles were as follows. In contrast to the broadly uniform and balanced outlook of the Renaissance, mannerism is characterised by an antithetical, ambivalent, sense of life that expresses itself in apparently irreconcilable formal structures. The baroque again expresses a more uniform attitude to reality. But, in contrast to the baroque, mannerism has in common with the Renaissance above all what Wölfflin calls the principle of 'multiplicity', for which the baroque substitutes that of 'unity'. In this sense both mannerism and the Renaissance follow an *additive* compositional principle—Renaissance classicism does this in spite of its aspiration to extreme simplification and concentration—while the baroque *subordinates* details for the sake of a uniform effect, and does so, not so much by the reduction and concentration of elements, as by permitting a dominant theme or accent to prevail. On the other hand, unlike the more superficial points of contact between mannerism and the Renaissance, the baroque and the Renaissance share a whole series of common characteristics that are of more basic importance. These chiefly follow from the fact that the baroque returned to the Renaissance naturalism and rationalism that mannerism dropped. The parallels between the baroque and mannerism, such, for instance, as the dynamic representation of space, asymmetry as a compositional principle, the inclination to the obscuration and complication of forms, and the trend to the forced, the strained, and the surprising, characteristic as they may be in certain cases, actually weigh less in the scale than the above-mentioned affinity between the Renaissance and the baroque.

The connection between mannerism and the baroque can be better explained sociologically than in purely formal terms. The fully developed baroque seems to have followed mannerism, not because the latter provided its formal foundations, though it of course made frequent use of its inherited means of expression, but because social conditions and the outlook of the age were ripe for mannerism earlier than they were for the baroque. Otherwise the baroque might have followed the Renaissance just as immediately and reached maturity just as quickly as did mannerism. But it was the latter that was better adapted to becoming the artistic language of the intellectual, international *élite* for whom the values of the Renaissance, looked at from the perspective of the ideas of the Reforma-

tion and the spiritual revolution more or less directly associated with it, had become problematic in practically every field of culture. The baroque, on the other hand, was inherently the expression of a more popular, more emotional, spiritual outlook capable of greater national differentiation. Ultimately it triumphed over the more complex, more delicate, more exclusive mannerism, because the *élite* associated with humanism, above all in matters of religion, gradually lost its authoritative role, and Roman Catholicism again became something in the nature of a popular religion that required a more popular art than that of the Renaissance or of mannerism, or even of the Middle Ages. The baroque was essentially the art of the Catholic restoration and the Counter-Reformation and, though the new national churches were Protestant, and Catholicism and its hierarchy culminated in the supra-national papacy and Roman church, henceforward the Catholic national churches also differentiated themselves more than they had done previously. The internationalism of culture suffered a defeat all along the line.

In the course of the seventeenth century the baroque, notably in France, developed into a courtly, aristocratic art, working up its emotional elements into an impressive pose and developing its points of contact with the Renaissance into a new, severe, sober classicism in which all the emphasis was on the principle of authority. In its courtly form it nevertheless preserved so much of its original spontaneity and its feeling for the natural and the reasonable that it never declined into the eccentric sophistication and strained pursuit of originality that characterised certain forms of mannerism. Nevertheless, in spite of Versailles and the pompous baroque guise that other courts assumed under its influence, the courtly style *par excellence*, in the sense of exclusivity and fastidiousness, was mannerism. In all the leading European courts of the sixteenth century it enjoyed the foremost position, and a far more undisputed one than any subsequent style. The court painters of all the connoisseur princes of the age—Cosimo I in Florence, François I at Fontainebleau, Philip II in Madrid, Rudolph II in Prague, Albrecht V in Munich—were mannerists. The customs and tastes of the Italian courts spread throughout the west, and so did patronage of the arts. This was developed to an unprecedented degree at Fontainebleau, and the court of the Valois had characteristics reminiscent of the later Versailles. But it was the smaller courts, with their less magnificent and public way of life, that were in closer harmony with the intimate and sophisticated nature of mannerism. Bronzino and Vasari in Florence, Bartholomeus Spranger, Hans von Aachen and Josef Heintz in Prague, Frederick Sustris and Pieter Candid in Munich, enjoyed, in addition to the munificence of their princely patrons, the more intimate and freer environment of a less pretentious court than did their baroque successors, and with it the advantages of freedom from monumental tasks,

the carrying out of which would have caused most of them greater difficulties than did the production of the little pictures with an erotic content, the size of which accorded excellently with their inclination to gem-like delicacy and playful virtuosity of execution.

Even such a gloomy and unapproachable man as Philip II seems to have been on terms of surprising cordiality with his artists. His favourite portrait-painter was Coello, whose cool and remote manner and concern for lifeless accessories must have been particularly sympathetic to him, and a private corridor connected the royal chambers with the artists' workshop, which he obviously visited frequently and without any special formality. Rudolph II shut himself up from the world in the Hradschin with his astrologers, alchemists, and artists, and had pictures painted the gay and cultivated, elegant and sophisticated, eroticism of which suggests a carefree, rococo-like environment rather than the gloomy residence and erratic company kept by a madman. Both these psychopaths, who incidentally were cousins, always had money to spend on art, and always had time for artists and dealers. But though they employed the best artists and must have had some appreciation of the quality of their work, their collections were like cabinets of curios. To an extent the piquancy and virtuosity of the works of art that they acquired fitted in well with these; they collected freaks of nature just as enthusiastically, and there was a far-fetched though perhaps not completely irrelevant connection between the two. Incidentally, this characteristic of mannerism was noted by Galileo, who in his remarks about Tasso compares the alleged formlessness of the *Gerusalemme Liberata* with the medley of exhibits in the art and curio collections of the time.[7] This strange interest is obviously related to the fact that there is always a curiosity element in a mannerist work of art; for all the richness and depth that it may contain, there is always an element of contrivance about it. Also the private, secretive, one might almost say jealous, character of the relations between the collector of the time and his collection is very evident. The pictures that the princes had painted were to a great extent intended, not for their state rooms, to impress the public, but to be enjoyed in secret, alone, or in an intimate circle. The purpose for which they were commissioned was mainly that of giving pleasure rather than providing any other kind of spiritual satisfaction or fulfilling any other function of which a work of art is capable. Never was art produced under princely patronage less adapted to public and propaganda purposes than the elegant, erotic little pictures that enjoyed high favour at the courts of the age of mannerism.

2. THE LATENT MANNERISM OF THE HIGH RENAISSANCE

The classicism of the Renaissance attained its purest and most complete though brief fruition in the works of Raphael. With the masterpieces of Greek classical art, they provide the most perfect example of balance between nature and art, relaxation of form combined with complete mastery of matter, total avoidance of exaggeration and strain, complete ease and liberty combined with power and poise, reserve combined with the utmost concentration—in short, that perfect equilibrium between the elements of a work in which the essence of classicism lies. Since the time of the Greeks no works of art had been produced in the west that were more correct in their relationship with nature and more imposing in their form. Here for a brief historical moment western man's dream of nobility, greatness, and beauty was transformed into tangible shape. The power to realise the dream did not last for long, but the generations continually returned to gaze with renewed wonder at the works of art produced in that happy hour. After the turn of the last century, the psychologism and intellectualism of which made it uncommonly difficult to do justice to an art like that of Raphael's, men are beginning, in spite of the anti-classical trend that dominates the art of the present, again to understand the admiration that earlier centuries felt for it. The former enthusiasm may have subsided once and for all, but the realisation of the classical ideal in the works of Raphael is appreciated as unreservedly as it has ever been. No matter how many elements of his style he may have borrowed from others, no matter how extroverted his art may be, or how rhetorical his diction, or how little mystery there may be in his figures, they express a beauty and a majesty and have a mastery of line, a melody and harmony of form, for which the art of later times provides no parallel. His position as the representative *par excellence* of modern classicism is assured. The remarkable feature of his historical role—and this is the point on which debate seems far from reaching a conclusion yet—is that he is also the artist in whom the breach with classicism appears most strikingly, the artist who, while remaining within the bounds of classicism, most distinctly anticipates future development.

During the last five or six years of his life, that is to say, roughly from the *Fire in the Borgo* onwards, Raphael moved unmistakably in the direction of mannerism. During this period his workshop, like his school later, worked predominantly in that spirit; and, though the master's share in the production of his workshop is not exactly known, it seems certain, as Dvořák says, that, if he had lived longer, he would have gone through the same stylistic development as did his pupils. At all events

there is no reason to suppose that any work was done in his school or his workshop that he would not have approved or encouraged.

In Michelangelo mannerist characteristics not only appear earlier than in Raphael; they can be said to be present in his work practically from the outset, and they appear unmistakably as early as in the *Doni Madonna* (Pl. 1). If the matter is considered in a wider historical context, however, the prehistory of mannerism will be seen to begin with Raphael rather than with Michelangelo, not only because the former was more of a contemporary in the true sense of the word, that is to say, more representative of the topical artistic trends of the time, but also because through his school he exercised a more immediate impact on subsequent artistic development than did Michelangelo, whose influence, though from a certain period onwards it was practically universal, reached that degree of magnitude only very much later. In the years between Raphael's death and the sack of Rome it was not the mannerist trends in his work that were immediately followed, but during those years and for a long time afterwards Michelangelo's influence was not mannerist in character either, and was in any case slight. At a later phase of their development Pontormo, Rosso, Beccafumi, and Bronzino were all influenced by Michelangelo, and most of the painters of repute of the second and third mannerist generations, from Vasari and Salviati to Pellegrino Tibaldi, demonstrate a Michelangelesque trend; the school of Raphael had to struggle hard against its impact before gaining a second victory over it. But Michelangelo's influence was not really effective until the thirties, and reached its peak only between 1540 and 1550. The first two decades after Raphael's death are still completely dominated by his school. The bitter complaint of Sebastiano del Piombo will be recalled, who suffered so severely from the master's competition during his life-time and now, in spite of Michelangelo's support, was unable to establish himself properly in the artistic life of Rome because all important commissions went automatically to Raphael's pupils. The Michelangelesque trend strengthened considerably towards the end of the thirties, and after the death in 1547 of Perino del Vaga, who had achieved a position of great repute and influence in Rome during those years, for some time enjoyed a position of practically unchallenged supremacy. At the end of the fifties and in the course of the sixties this was succeeded by a third Raphaelesque wave which, besides influencing the numerous followers of Parmigianino, affected the most varied artists, from Zuccari to the Cavaliere d'Arpino. Nothing better illustrates the change of taste than the fact that Vasari, who was so devoted to Michelangelo, to an extent plays up Raphael against him in the second edition of his *Lives* (1568) because he now recognises the latter as the more balanced artist.

The *Fire in the Borgo* (Pl. 2), painted between 1514 and 1517, is the

first larger painting that can be called mannerist. Though the execution was completely in the hands of Giulio Romano and Francesco Penni, Raphael's share in the design and stylistic character of the work seems indisputable. The fact that easel paintings from Raphael's workshop of the same period show fewer marks of mannerism hardly diminishes the authenticity of the fresco. The stylistic variety of the works of those years is amply explained by the abrupt change in taste that was taking place and the spread of eclecticism.

The fresco shows a fire in the Borgo quarter of Rome which was extinguished thanks to a papal blessing. The performance of this miracle by the Pope is painted quite small, and relegated to the background; the foreground is occupied by the big figures of the victims of the fire and their helpers and rescuers. Removing the most important part of the action from the centre of the picture in this way is an illogical and anti-classical feature that appears very early in Raphael, in the *Expulsion of Heliodorus*, for instance, where the praying priest is shown on a much diminished scale in the background, or in the *Mass of Bolsena*, in which the principal are smaller than the subsidiary figures. With this there appears for the first time in art a relativism that abolishes the earlier relationship between the more important and the less, as well as the logical distribution of emphasis between substance and symptom. The prominence given to the subsidiary figures in the *Fire in the Borgo* is evidently a mere pretext for displaying their fine athletic and statuesque physique in decorative and studied poses that are inappropriate to the theme. Their proportions are unusual and partly unnatural, their movement unmotivated, gymnastically impressive but practically pointless. The wall in the left foreground, which is cut away for no visible purpose or reason, serves as a kind of gymnastic apparatus for their acrobatic performance; also, actually like all the architecture in the picture, it suggests something in the nature of stage scenery. One accepts, as part of the rules of the game, as one would in the theatre, the fact that it has to be climbed over, though there would be nothing to stop anybody from simply walking round it. Classical naturalism produced the illusion of reality with a minimum of 'conscious self-deception'; but this picture, with its reversal of the importance of the various sections of space, its relegation of the principal action to the background and its promotion of subordinate figures to the foreground, its causing them to act in a manner irrelevant to the theme and the purely decorative use that is made of them, is nothing but a piece of make-believe, and as such is a test case of anti-classicism, a retraction of the stylistic principles on which Raphael's first *stanza* were based.

The proportions of the figures, particularly those of the centre group, are as unconvincing as their whole behaviour, or their physical nature in

relation to their part in what is taking place. The kneeling woman with raised arms and her back to the spectator, who is a pure show figure, like the female figure carrying a vessel on her head, seems much too big, not only in proportion to the children near her, but also to the woman seen in profile on the right of the group. Their spatial effect as repoussoir figures, a device introduced by mannerism and preserved in the baroque, which in both styles serves the purpose of dynamising depth, is striking and impressive. The relationship between the large subsidiary figures in the foreground and the tiny form of the chief protagonist in the background adds tension to the whole picture, gives increased optical intensity and more concentrated strength to the scene, in spite of the loose connection between the numerous episodes. The figure of the Pope, in contrast to the classical principle of composition followed by Leonardo in the *Last Supper* and Raphael himself in the earlier frescoes in the *stanze*, is removed from the vanishing point, which produces another unsettling element, disturbing to the sense of harmony, that nevertheless increases the dynamic effect of the work. Another dynamic feature, in the disruptive sense, is that the individual groups and figures, in spite of the streams of energy which run through the whole scene, remain isolated from each other and represent separate sources of strength. Their isolation in space, which to an extent makes them seem self-contained figures in the round, is just as anti-classical as is the expressionism of their features and attitudes, which is extreme, provided they are not mere studies from the nude or show-pieces, like the half-naked man on the steps on the right or the woman passing him water in a vessel. Beautiful though these figures are in themselves, for all the strength and mobility they express, they do not create the impression of being moved from within; they are much more like puppets artificially set in motion from without. The predominant factor in the impact they make is the compulsion to which they seem to be subject; indeed, the inner inertia of the figures is and remains a fundamental mannerist characteristic.

The chief mannerist feature of the *Fire in the Borgo*, however, is the treatment of space, that is to say, the distribution of the figures in the picture. Not only is the usual function of foreground and background reversed, but the massing of the figures is uneven and unusual. Overcrowded areas are broken up by empty spaces; the foreground is crowded, the middle ground is left practically empty, and in the background there is again a closely packed group. Another mannerist feature is the tendency to develop the picture in depth instead of in breadth, and to transform a broad canvas into a tunnel boring deeply into the background.

The individual parts of the architectonic ensemble, the classical columns in front, the Renaissance building in the loggia of which the

Pope is seen, and the early Christian basilica in the background, do not really agree, and strikingly illustrate the eclectic taste of mannerism in such matters. The faultlessly drawn columns demonstrate the newly awakened antiquarian spirit of the age, and are something of an anticipation of the future trend of *veduta* painting. The fine group showing a young man carrying his father on his back ('Aeneas and Anchises') recalls Hellenistic sculpture. The magnificent figure of the woman carrying a vessel on her head is a synthesis of a figure already seen in Filippo Lippi and Ghirlandaio with that of a Sibyl of Michelangelo's. The elements of which the picture is composed could hardly be more heterogeneous.

Raphael's tapestries have been called the Parthenon sculptures of modern art and the complete fulfilment of the stylistic ideal of the Renaissance. Of all Raphael's works they have exercised the greatest influence, and they became the model of monumental composition in western classicism. Academic teachers and critics have always rated them higher even than the *Disputà* or the *School of Athens*. Questions of primacy of this kind are not particularly inspiring; much more interesting is the problem of the classical purity of the tapestries, the cartoons of which were produced roughly at the same time as the so unclassical *Fire in the Borgo*. But this turns out to be less baffling than it might seem at first sight. It has been rightly pointed out that there is an almost too manifest perfection and infallibility about the tapestries, as if they were a final and ultimate demonstration of how such work was to be done;[8] and surely there could be no better evidence of the crisis of classical art, which had ceased to be self-evident and spontaneous, to the extent that it ever had been spontaneous. Its transformation into a doctrine was now in progress, and from that it was only one step to its becoming problematical. Barely twenty years had passed since Leonardo's *Last Supper*, and in that short space the High Renaissance had grown ripe, or over-ripe, and lost its youthful vigour, its incalculable and ever surprising originality. That the High Renaissance contained within itself the germ of its own disintegration is made plain by the fact that the tapestries were used for instructional purposes; and with that classicism lost the uniqueness, the irrepeatable and apparently improvised quality inherent in a young, vigorous art capable of renewing itself from its own resources. Mannerism reacted to the strict normativity and authority attributed to the art of Raphael by pursuit of originality and indulgence in excessive subjectivism and irrationalism, for in a dynamic culture like that of the Renaissance artistic rules remained valid only so long as they were not laid down and codified.

The last picture in which Raphael took an active part, the *Transfiguration* (Pl. 3), shows mannerist characteristics as unmistakable as those of

the *Fire in the Borgo*, but makes an impression of even greater lack of stylistic unity. The work was commissioned in 1517, and is believed to have been completed in the year of his death. The general opinion is that it was designed by Raphael, partly painted by him, and finished by his pupils Giulio Romano and Francesco Penni. The lower half, in which the mannerist imprint is more definite, appears to a great extent to be the work of Giulio.[9]

The composition is in two distinct parts. The upper part shows Christ in a sea of light hovering between Moses and Elias; at His feet three disciples lie on a mountain-top, dazzled by the light. It is this part of the picture that represents the Transfiguration proper. Below is a rendering of the story of the boy possessed by a devil as described in St. Matthew, XVII, 1–21, and St. Mark, IX, 1–29, immediately after their account of the Transfiguration. The events in the upper and lower halves are unconnected, the only link between them being their contiguity, as in the Gospel. In mannerist terminology the boy's pointing gesture has the effect of a striking and not immediately intelligible *concetto*, the relationship of which to the rest of the picture remains obscure, as he can see no more of the celestial event than the other terrestrial participants in the action.

The painting follows the pattern of numerous Renaissance Madonna compositions and Ascensions, that is to say, the two-storey structure also used by Titian. In the upper part Raphael adheres on the whole to the classical principles of the Sistine Madonna. The formal connection between the two storeys makes the impact of the irrational relationship between them even more anti-classical and mannerist. The miracle of the Ascension by itself, or associated with a passive crowd of spectators as rendered in Titian's *Assuntà*, would in the now spiritually disturbed temper of Rome have seemed too unexciting and undramatic.[10] Wölfflin points out the contrast between the two parts of the composition, which reminds him of the conflicting moods of the *Heliodorus* fresco, only he takes too external a view, referring as he does merely to the difference between the solemn stillness of the heavenly scene and the noisy throng in the terrestrial scene below.[11] To stimulate the imagination of a generation jaded with the old commonplaces, it was necessary to point the contrast between the wild, grim, and gloomy, unexplained and inexplicable human drama and the bright, superterrestrial vision blazing with fiery light; only a stimulus of this kind accorded with its interest in the irrational and mysterious. However, the mannerist feature is not so much the mere contrast between the two parts of the picture and the dramatic impact thus made as the enigmatic relationship between them, which is left unexplained. It would never have occurred to an earlier painter to use the juxtaposition of the two scenes in the Bible as an

excuse to represent them pictorially together. This in itself creates a puzzling effect.

The stylistic and qualitative difference between the two sections of the picture is not attributable to the greater or lesser share in its execution of individual pupils of Raphael. No pupil, or even group of pupils, could by themselves have been responsible for a predominant part of the picture. Apart from the fact that drawings both for the upper and lower parts exist seemingly in Raphael's own hand, it is evident from the Vatican frescoes, subsequently produced by Raphael's pupils without their master's guidance, that a work such as the *Transfiguration*, both as a whole and in all its important details, could not have been painted without his extensive cooperation. With the exception of the deep, dark, inky shade characteristic of Giulio Romano, Raphael was responsible for the whole painting, with all its virtues and, if you like, failings. It is inconceivable that in a work as significant as this, on which, according to Vasari, Raphael worked until it was complete, anything essential should have been changed without his consent. It is now generally accepted that the finishing touches were put to it only after the master's death,[12] but that does not mean that any changes of consequence not in accordance with his ideas were made in the picture.

Characteristic of Raphael are not only the draughtsmanship of the magnificent figures, the grandeur of line and the sustained *élan* of the composition, but also the elevated mood and solemnity of the whole. No artist other than he could have produced types of such vigour and dignity, physical forms of such beauty, harmony, and verve, such splendid, sweeping draperies, such roaring floods of energy, as are achieved here, particularly in the group of apostles. But neither the pupils' share in the execution of the lower part was purely mechanical, nor did Raphael himself paint the upper part entirely himself. As has been rightly pointed out, the face of Christ is so conventional and expressionless that it must be the work of a pupil.[13] In fact the whole figure of Christ seems to have been executed by Penni, and is obviously one of the parts of the picture that were incomplete when the master died. Raphael himself would hardly have entrusted such an important part of it to another. This would dispose of Vasari's statement about the state of the picture at the time of Raphael's death, as well as the inherently incredible story that it was hung over the master's bier with the upper part complete and the lower still blank.

Raphael's hand is unmistakable in the draughtsmanship of the principal figures both on the left and the right side of the lower half, though the latter are treated in a harder, cooler, less painterly, more affected, mannerist fashion than those on the left. The apostles still belong to the type of the figures in the *Disputà*, the *School of Athens*, and the tapestries

of *The Miraculous Draught of Fishes* and *Christ's Charge to St. Peter*; not only do they bear the stamp of a unique race of men, they are suffused in a painterly glow the secret of which was not inherited by his pupils. Of the figures on the right, it is above all the fine kneeling female figure (Pl. 4), in spite of all the differences in her rendering from the broad, expansive draughtsmanship and rich coloration of the apostles on the left, that betrays Raphael's own hand. She is strongly reminiscent of the similar kneeling figure in the *Fire in the Borgo*, but displays herself even more ostentatiously, appears even more isolated and, with her elegant and complicated hair-style and her sophisticated, unnatural attitude, is even more affected and mannered. This figure may well have been executed by Giulio Romano but, no matter whose hand it was who held the brush, she originates with Raphael, and has a beauty and grace that reappear only with Parmigianino and his followers and not in any of Raphael's immediate heirs.

This figure is the most mannerist and enigmatic detail in the picture. In view of her girlish look, it seems strange that she is supposed to be the mother of the possessed boy. But the real reason why she stands out is that she is so much more posed, theatrical, and 'beautiful' than the other figures. She is not only a show-piece, there for her own sake, but also fulfils a function of contrast, not coordination, in relation to the rest of the picture. Unlike the others, who are emotionally and functionally more natural, she is an intricately constructed figure behaving in an artificial way and presenting herself in an impossible, however decorative, pose. The artificiality of her whole appearance is evident even in the way in which the violent twisting of the upper part of her body is combined with her devout kneeling in prayer, as well as in the concentration of so much energy, passion, and indignation into such a clean, even precious, form. But the most remarkable feature is the cool, hard shell that separates her from the rest of the picture, in the totality of which she seems merely to fill a gap.

Another strikingly unclassical characteristic of this painting is the treatment of space, with the middle left empty and the cavity in the lower half of the composition running diagonally from left to right into the depth. The diagonal is of course a baroque rather than a mannerist formal element, but the narrow corridor in such a prominent position creates a very mannerist effect. The violent movements and the many hands at play, and the excessive emphasis on their parallelisms and counter-movements, their consonances and dissonances, are also mannerist.

Whatever Raphael's direct share in the design and execution of the *Transfiguration* may have been, this work undoubtedly represents the state of development of mannerist tendencies in his school, and obviously also in his own artistic development, at the time of his death. During

his life-time there were only tendencies of this kind among his pupils; mannerism in the true sense of the word cannot be said yet to have been present. The transition to the new style was completed only by Perino del Vaga, who demonstrated his adherence to it in his contributions to 'Raphael's Bible' in the Loggias of the Vatican, his *Last Supper* (Pl. 5), for instance; and by Giulio Romano, who went furthest in developing the early forms of mannerism within the school, but went over to mannerism as an independent and creative style only much later. None of the other pupils of Raphael played a notable role in the formation of the new trend. Polidoro del Caravaggio never underwent a stylistic crisis; he adopted certain not very striking mannerist formal elements within the school, apparently without becoming aware of any conflict between them and the principles of classicism. Giovanni da Udine was practically untouched by mannerism, and remained fundamentally a Renaissance artist. After Raphael's death Francesco Penni declined into insignificance, in spite of his previous promise. Baldassare Peruzzi was one of the artists who successfully made the transition from Raphael's style to mannerism, but strictly speaking was never a member of the school.

Apart from his immediate pupils, Raphael's spirit first made itself felt outside the artistic territory of Rome and Tuscany, that is to say, mainly at Parma and Bologna. In Rome itself its influence did not become strong again until the middle of the century, and then again, in a third wave, in late mannerism. The followers of Raphael took as important a part as did those of Michelangelo in the development of the Roman monumental style, the form assumed by mannerism in the middle of the century. Perino del Vaga, Sebastiano del Piombo, Vasari, and Salviati all played similarly important roles in this.

Giulio Romano is the only direct pupil of Raphael's who with his mannerism developed completely new forms, independent of his master's aims. His use of dark colouring had always produced a slightly alien effect in Raphael's school, but he first found his own special, unorthodox artistic language in the decorations of the Palazzo del Tè at Mantua (1532–34), notably in his *Fall of the Giants* (Pl. 8), a fresco that covers the walls of a whole room. Here he strikes a new note, not only in the style of the school, but also in mannerism as a whole. There were already examples of the strange, mysterious, and sinister in the art of Rosso and Beccafumi, but the rendering of a vision as nightmarish as this was a complete innovation in Italian art. The dream was to become a favourite mannerist theme, particularly in literature, and here it assumes the form of an anxiety dream. It should not of course be assumed that fear of life and an atmosphere of impending doom prevailed at the court of a Renaissance prince of the type of Federico Gonzaga, but ten or twenty

years earlier it would neither have occurred to any princely connoisseur to have one of his rooms decorated with a horror picture of this kind, nor would he have approved of it. But the very fact that anyone should take pleasure in a picture that creates the impression that the whole room is on the point of collapse and that everything is about to disintegrate into chaos is highly remarkable in such an environment. The taste for horrors, for giants and monsters, for battles of Titans and cataclysms, was, however, far from being a private idiosyncracy of Federico Gonzaga's or Giulio Romano's. On the contrary, it was widespread, as is illustrated by the universal popularity of such an unusual subject as the Cyclops Polyphemus. To quote a few examples only, apart from the use made of it by Giulio Romano in the Palazzo del Tè (Pl. 9), Sebastiano del Piombo uses it in the Farnesina and Pellegrino Tibaldi in the Palazzo Poggi at Bologna; and Góngora also makes Polyphemus the hero of one of his longer poems. The subject had an especial piquancy to mannerist taste because of the scope it offered for perverse play with extremes, the erotically exploited contrast between the brutal giant and the gentle Galatea.

Expanding the concept of mannerism to include practically the whole of the sixteenth century and the subsumption under it of practically all the representative artists of the age never meets with greater resistance than in the case of Michelangelo, who seems much too powerful, unique, and independent to be called a mannerist, a term always associated with extravagance and affectation. One of the reasons why it is so hard to reach general consent on the significance and definition of the style is that such an unlucky name has become attached to it, distracting attention to characteristics which are by no means the most essential, let alone the most permanent. Critics are reluctant to describe Michelangelo or Shakespeare as mannerists, feeling that this involves drawing excessive attention to the forced and arbitrary features which are certainly not lacking in their art. If some other phrase, such as the 'crisis of the Renaissance', were used in connection with the masters of the age, nobody would have the slightest objection. Here we are really faced with a misconception. Those who refuse to see the stylistic principles of mannerism in the art of Michel-angelo are generally unable to dissociate a judgment of value from the concept of style, and seem to forget what theoretically they would hardly deny, namely that style is a concept independent of value or aesthetic quality. The personal merit of an artist and the value of his work is not a stylistic question. In talking about style it must always be borne in mind that every artist, great or small, conformist or nonconformist, traditionalist or rebel, is an individual case, an 'exception'. Normally the greater an artist, the greater his resistance to the restrictions of a collective

style, but often a lesser artist is more original, more self-willed, less capable of adaptation, than a more important one.

Michelangelo, indeed, was never only a mannerist. But he was never only a baroque artist or a pure Renaissance artist either. The various stylistic characteristics always appear in his work in more or less transient and mingled form, and the concepts of the Renaissance or the baroque no more exhaust the nature of his art than does that of mannerism. Moreover, this stylistic ambiguity is not confined to Michelangelo or to Tintoretto or El Greco; artists like Lorenzo Lotto, Correggio, and Baroccio also straddle the boundaries of the various artistic trends of the Cinquecento. How little the greatness of an artist has to do with the neatness with which he can be dovetailed into a stylistic category is most strikingly illustrated by Rubens or Bernini, who are much more completely baroque than most of the lesser representatives of that style.

But, though every artist in certain respects is a special case, nevertheless he inevitably bears the stamp of his age. Every stylistic classification necessarily neglects and does violence to the individual artistic phenomenon, but even the most unique phenomenon has its historical place, and is more or less closely connected with other contemporary historical phenomena. The coincidence of certain characteristics of an artist's work with those of the predominant stylistic trend can always be described as accidental, as has been specifically done in the case of Michelangelo;[14] but it is precisely from the accumulation of such 'accidents' that the notion of style arises. A style is not established deliberately or consciously, and its principles are not invariably and consistently followed. The artist generally finds himself in harmony with them unknowingly and unsuspectingly, and just as often he diverges from them equally unknowingly and unsuspectingly. But that does not destroy the stylistic nature of his art. True, Michelangelo is more difficult to classify in this respect than many other artists, but he is by no means alone in that respect. The description of Shakespeare and Cervantes as mannerists meets with just as little general consent, and protests are occasionally made against the description of Bach as baroque or Mozart as rococo; and even Beethoven's stylistic position is by no means unquestioned. The Germans regard him as the very essence of the classical, while the French describe him as a romantic, and with good reason.

That Michelangelo represents a breach with the classicism of the High Renaissance is unmistakable; his relationship with mannerism, however, not only varies in depth and intensity in different stages of his artistic development, but at no stage does it dominate his art completely. Non-mannerist characteristics are to be found in all its phases. His figures, for instance, always possess a substantiality that is characteristic of the Renaissance and the baroque, but is alien to mannerism, though the

'weight' generally ascribed to them[15] is by no means always present in the same degree. But, though they are never actually 'of flesh and blood', with the single exception of the *Pietà Rondanini*, they are never pure shadows, mere forms or symbols, as they so often are with the mannerists. One of the strongest objections to over-emphasising the mannerist character of Michelangelo's art is, no doubt, his sense of weight and gravity, his fondness for cubical and solid, block-like shapes, his concentration of masses. His conception of the human body as an organic and substantial entity, never lending itself to mere decorative purposes, is and remains a strikingly anti-mannerist feature of his art.[16]

It is true that his sense of form in general is characterised by a certain weightiness and massivity and a strong trend to the compact and voluminous, though examples of tall and slender forms, like the so-called *Victory* and the *Libyan Sibyl* are not lacking. But it is wrong to regard the slender proportions of the figures as the only or most important criterion of the presence of mannerism, and to forget that inconsistent filling of space, conflicting standards of size, incongruous composition, exaggerated expressionism side by side with the most aloof passivity, classical beauty beside ugliness, devaluation of the individual, and a corresponding lack of interest in the single figure and, most of all, uncompromising spiritualism and transcendentalism, are all mannerist features which give their predominant stylistic character to works such as *The Last Judgment* and the Pauline Chapel frescoes. When one's attention has once been drawn to features of this kind, similar features will be discerned in other works of his, notably in the Sistine Chapel and the Medici tombs, as well as in earlier works, and they will be recognised as practically permanent characteristics of his style, though they recur with different degrees of poignancy and predominate only for relatively short periods. But in bearing in mind this fluctuation of mannerist trends in his art, it is important to note that they are strongest in his late, and not, as has been suggested, in his Florentine period.[17]

Michelangelo is the first artist of the Cinquecento to show premonitory signs of mannerism, and his *Doni Madonna* (Pl. 1), dating from about 1504, is the first work that has features pointing in the new direction. But that does not mean that this is the beginning of mannerism as a predominant historical style. For the time being it remains a completely non-committal 'tendency', which is not directly taken up and developed by the first real mannerists, Pontormo, Rosso, Beccafumi, and Parmigianino, and has no direct sequel even in Michelangelo's own development. Michelangelo returns to the trend of his early works, but does not return to the special kind of 'mannerism' that is in them and, though later the whole mannerist movement comes under his influence, the link does not consist of its taking up and continuing his mannerist beginnings. The

first generation of mannerists certainly studied his works, but at first did not find the vital stimuli in him. It was the master's middle creative period that provided them. Thus Michelangelo no more fathered or founded mannerism than he brought the movement to fruition. He remained isolated from its real founders, and was not one of those who drew the ultimate consequences of its stylistic possibilities or produced its most characteristic works. What he did was to provide the decisive impulse to mannerism after it had reached a relatively advanced stage of development, and thus showed the direction in which greatness lay to those who brought it to perfection, above all Tintoretto and El Greco. The *Last Judgment*, the most important of all Michelangelo's works in this respect, was painted at the end of the thirties, that is to say, at a time when the works of Pontormo, Rosso, Beccafumi, and Parmigianino that laid the real foundations of the style had long been in existence. The earlier quasi-mannerist works of Michelangelo, above all parts of the Sistine Chapel ceiling, namely the spandrels, painted at a time when they might have influenced these artists in their youth, did not in fact do so, because early Tuscan and Emilian mannerism moved on a completely different spiritual plane. Similarly the Medici tombs, which Michelangelo worked on during his absence from Rome (1520–34) and exercised a great influence on later Florentine mannerism, made no impact on the early form of the style. But, in spite of the many manneristic features of the Medici tombs, they still preserve on the whole the proud spirit of the Renaissance which Michelangelo renounced in his next great work, the *Last Judgment*, to which the mannerists adopted an ambivalent attitude from the beginning.

Instead of the alleged influence of Michelangelo on the beginnings of mannerism, a more profitable subject for discussion might be the traces of the Parmigianinesque in his own art, at any rate in a work such as the *Victory* (about 1527) (Pl. 10), which not only recalls the grace and elegance of Parmigianino's figures, but also shows a definite tendency, that never reappears so strongly in Michelangelo, to elongate his figures and exaggerate their proportions in favour of height. The shaping, which as early as his *David* accorded with the canon of Lysippos rather than with that of Polycleitos, here results in a further lengthening of the body and diminution of the head, while the legs from those of an athlete become those of a dancer.

Attention has frequently been drawn to the affinity between Michelangelo's life-long personal tendency to squeeze forms of large dimensions into relatively narrow limits and the basic mannerist principle of emphasising the disproportion between content and frame.[18] It is doubtful, however, whether this disproportion, which is evident in Michelangelo as early as his *Doni Madonna* and *Bargello Tondo*, meant the same thing

to him as it did to the later mannerists, and whether he had the same feeling as they of being hemmed in and threatened, exposed to the assault of alien powers, or had associations similar to theirs with nightmares in overcrowded rooms. The fact that Michelangelo maintained to the end this forcing of figures into an uncomfortably restricted space, though he did so with varying degrees of violence—the trend is evident in the Sistine Chapel, the Medici tombs, and in the original design for the tomb of Julius II—shows that its significance for him did not diminish in the course of time. In his early works the oversized aspect of the figures may have served mainly to express their power and majesty, but in his later work the emphasis seems to be on the confined space that surrounds them, and the resulting impact is accordingly of pressure, compulsion, unfreedom, as it is in mannerism in general and in a number of his own poems. The body is the prison of the soul, and its aim and aspiration is to escape from it.

> . . . *alcun' opre buone,*
> *per l'alma, che pur trema,*
> *cela il soverchio della propria carne*
> *con l'inculta cruda e dura scorza.*

The *Doni Madonna*, apart from its circular composition and the forcing of relatively big figures into a narrow space, has other features in common with the roughly contemporaneous *Bargello Tondo* and the stylistic quality of sculpture in general. The influence of plastic modelling, which develops forms more completely and isolates them in space, automatically produces a certain mannerist effect in Michelangelo the painter, for it contributes to creating the impression of a world in the process of atomisation. In addition to the resulting isolation of the figures, far the most striking mannerist feature about the picture is the fashion in which the body of the Virgin turns on its own axis in a direction opposite to that of the Child. The contortion produces the effect of a strong contrapposto and becomes the pattern of the *figura serpentinata*, the fundamental formula of Michelangelo's figure-drawing, further developed in the *Medici Madonna* and the *Victory* and pushed to extremes in the Virgin in the *Last Judgment*. According to Lomazzo,[19] Michelangelo advised the young Marco da Siena always to adhere to this formula, for the whole secret of painting lay in it. In this he remained basically faithful to the principle observed since Leonardo of providing an optically impressive equilibrium between the various parts of a figure, but with him it served the special purpose of giving a relative lightness to heavy and massive limbs by the dash and counterplay of serpentine curves.

The *Doni Madonna* has a whole series of other mannerist features as

well, notably the duplication of attitudes and movements, the consonances of which give the picture a very formal, abstract, rhythmical character. The Virgin's rather violent and forced, though brilliantly executed, arm movement, which is emphasised by such a parallelism, produces a mannerist impact in this sense. But the most daringly mannerist feature of the picture, and that which points most distinctly to the future, lies in the contrast between foreground and background, which are associated by no perspective unity, and have no other spatial factors in common. The figures in the background diminish in size so rapidly that only a much greater distance than is to be assumed here could justify the difference in dimensions between them. Even the half figure of the boy in the middle-ground is relatively too small, while the figures in the background create the impression of belonging to a completely different spatial and incidental context to those in the foreground.

A certain mannerist trend is to be detected even in Michelangelo's *David*, executed between 1501 and 1504. The exaggerated proportions of the limbs, that is to say the arms and hands, which are obviously intended to be strong and impressive rather than beautiful, is anti-classical and, judged by classical standards, ugly. On the other hand, the slender shape of the body, reminiscent of Lysippos and partly of Parmigianino, is executed, in accordance with the contradictory principles of mannerism, in pursuit of an abstract ideal of beauty which leads ultimately to the *Victory*. The cartoon of the *Battle of Cascina*, completed in 1505, was also to an extent mannerist with its complicated and partially forced attitudes, rendered in sharp antitheses and consonances. A fact with a significant bearing on the stylistic character of this work is that Berruguete began studying and copying it immediately on his arrival in Florence (1508), and Vasari incidentally mentions a whole series of early mannerists, including Pontormo, Rosso, Tribolo, and Perino del Vaga, who copied it. The contact between mannerism and the art of Michelangelo really dates from that moment, though the mannerists' own trend lay in a different direction.

After this early, still non-committal and, on the whole, isolated premonition of the revolution ahead, the ceiling of the Sistine Chapel (1508–12) is so full of mannerist elements and its anti-classical stylistic features are so unmistakable that they could serve to illustrate the disintegration of the Renaissance just as well as its fruition. In this masterpiece of Michelangelo's, mannerist elements again appear, chiefly in the disproportion between the dimensions of the individual figures, that is to say, the *Prophets* and *Sibyls* (Pl. 11) that dominate the whole ceiling, and the area that is devoted to them. The dominating impression created is the monumentality of the figures, which is an effect in harmony with classical aspirations, but at the same time there is a feeling of overwhelming

external obstacles and barriers against which even these superhuman creatures would struggle in vain. Corresponding to the narrow wall-niches into which the *Prophets* and *Sibyls* are forced are the uncomfortably small socles on which the *Ignudi* sit or crouch (Pl. 12). The earlier painted figures move less freely than the later, and similarly the principle of frontality or profile view is more strictly observed at the beginning. But, as the work proceeds, not only do the figures grow in proportion to the framework they occupy, but they twist more and more violently and in ever more complicated angles. Michelangelo goes furthest in this exaggeration and forcing of positions in *Jonah* and the *Libyan Sibyl* (Pls. 13, 14), which Wölfflin characterised as 'much ado about nothing' and the 'demolition of tectonic limits'. But the most distinctly mannerist parts of the Sistine ceiling are the spandrels, and the most interesting of these, that is to say, not only the richest in formal problems but also that which points most conspicuously to the future, is the *Brazen Serpent*. Until Tintoretto's great paintings for the Scuola di San Rocco, mannerism produces nothing stylistically more momentous and impressive. Not only does the composition show the crowding of space characteristic of the style, and the compression of the figures into an area much too small for them, but also an intensive use of what was then the new artistic device of differentiating foreground and background by repoussoir figures, which was soon to be used by Correggio, though in the service of a sense of space that inclined to the baroque. In the baroque the view opens out to the infinite with which the space occupied by the beholder is brought into connection, but here this space and that inside the picture are relative to each other, and intensify the impression of precariousness which is now the true condition of everything apparently fixed and permanent. As a result of suddenly penetrating into the depth of the picture, the whole scene is so charged with energy and tension that there seems to be no point of rest or stability in it (Pl. 15). Even the axis connecting the heads and the centre of gravity of the most prominent figures with each other bends into the depth and contributes to creating the feeling of a world that has begun to wobble and threatens to collapse.

A further great advance in the direction of anti-classicism is represented by the Medici tombs (1521–34), the chief mannerist features of which are recognised by Wölfflin, though he does not describe them as such.[20] Above all, he draws attention to the disproportion between the lying figures and their supports, the smallness and the slope of the lids of the sarcophagi from which the figures would necessarily slip by the force of gravity; he notes how recklessly, from the classical point of view, the figures cut through the line of the cornice behind them, how crassly they draw attention to the conflict between the architectonic and plastic elements, and how flat and narrow the niches are by classical standards in

relation to the seated figures; and he also points out that the central niche, in contrast to the principle followed by Leonardo in the *Last Supper* and Raphael in the *School of Athens*, for instance, is left unadorned and thus unemphasised in relation to the lateral niches. Wölfflin mentions these things with a critical undertone; only the wealth and virtuosity of the physical attitudes and movements receive his unqualified praise. He writes with enthusiasm about the originality and power of impact of the poses, such as that of the *Dawn* (Pl. 16), and the boldness with which she rolls forward to involve the spectator, and of the intersections such as that created by the upraised leg of the *Day* (Pl. 17). He is far too acute an observer and distinguished an art historian (though perhaps he is not always quite so reliable a critic) to fail to note the new spirit that is present in these figures in spite of their contrapposto deriving from the Renaissance; he sees that the 'freedom and joy' of the Sistine Chapel is no longer in them, that their movements have grown 'clumsier and heavier' and that 'their bodies weigh like mountains and move unevenly and with difficulty'. He observes and describes what he sees very well, however he evaluates it.

Up to this point the mannerist elements in Michelangelo's work at most appear in association with other stylistic characteristics, and are modified chiefly by Renaissance and partially also by baroque elements. But from the *Last Judgment* (1536–41) onwards mannerist tendencies appear in more independent, though still not completely untrammelled form (Pl. 18). Henceforward his artistic development mainly belongs to the history of mannerism. The mannerist trends present in his earlier works cannot be brought into any direct connection with the mannerist purposes of other artists; no such connection can be said to exist, either in the active or the passive sense, even in the 'Parmigianinesque' quality of the *Victory*. With the *Last Judgment* not only does Michelangelo's corresponding influence become effective in the real sense of the word, but also there begins the period of mannerism, and of western art in general, that can be described as Michelangelesque *par excellence*. Walter Friedländer calls the *Last Judgment* the 'tremendous paragon of mannerism',[21] which is an exaggeration and a simplification, because the Michelangelesque trend at most represents one of the at least two fundamentally different tendencies of the style. But there is no doubt that it was the most powerful of the external impacts on mannerism, and that the most important and progressive representatives of the later form of the style took the lead from the *Last Judgment*. Hitherto Michelangelo's mannerism had been a mere prelude, even if a very promising one, and a partial anticipation of a stylistic form that had still to be established; it had been his personal reaction to a crisis which was in progress. But with this work his mannerism becomes representative, an authoritative expression of the prevailing outlook, the

universal formal language of a generation—in short, an artistic style in the sense of a collective spiritual movement.

This work of Michelangelo's never achieved the popularity of the great works of the Italian Renaissance, neither that of Leonardo's *Last Supper* with its pure, transparent, crystalline form, nor that of Raphael's frescoes in the first *stanza* with their sweeping flow of melodious lines, nor that of the Sistine Chapel with its synthesis of power and beauty. It is no monument of youth and beauty, but a picture of dismay and despair, a cry for succour and redemption from the chaos that threatened to swallow up all human and terrestrial things. It is the first important artistic creation of the new age. It has ceased to be 'beautiful', and points back to the medieval works that are not yet 'beautiful', but only expressively, spiritually, significant. The relative indifference towards the work is above all due to its lack of sensual, painterly appeal. It is almost colourless, and to an extent must have been so when it was painted. Michelangelo renounced the impact of colour by painting his figures nude, thus depriving them of the variety obtainable by the use of costumes and draperies. In comparison with most of the works of the High Renaissance, the *Last Judgment* is unattractive, inhospitable, uncomfortable. It makes a cold and rigid, severe and repellent impression, and does nothing whatever to satisfy the spectator's desire for a sense of Utopian happiness or to fulfil his dream of harmony, and there is no trace in it of *kalokagathia*, or of Olympian harmony. On the contrary, it seems to announce that the good is by no means always beautiful, and that the truth is often dreadful. It does not even make the concession to the spectator of presenting its theme coherently and logically. It is full, not only of unattractive details, but also of gaps and contradictions. The whole consists of loosely composed groups and more or less isolated episodes that create the impression of being the scattered fragments of a vision, the eruptive force of which provides the connecting link between the different parts of the picture.

The artist is obviously so filled with what he has to say, and what he has to say is so much more important to him than regard for unity of form, that he seems to be improvising in the way that Beethoven or Goethe improvised in their old age. Everything struggles out as a 'fragment of a great confession' of the soul, and at this level and in this context any obvious adaptation or harmonisation would amount to falsification. That, of course, does not imply that a work created in this way is formless and unorganised; it merely follows other, generally more complicated and less transparent principles of form than a classical work.

The structure of the picture was dictated, not so much by the fact that the wall for which the huge fresco was intended was so closely covered by scaffolding that Michelangelo could see only that part of it on which he was actually working, as by the circumstance that this way of working

was, so to speak, in a kind of pre-established harmony with the stage of development he had reached at that moment. Unity of form in the classical sense had ceased to be his highest artistic principle, and the spiritual homogeneity of the vision of life that he had now conceived was too solidly based to be endangered by the apparently arbitrary arrangement of his material.

Not even the beauty of line that appears in places, an entirely inappropriate complacency of attitude or gesture, disturbs the impression that everything here is the product of an irresistible urge to inner truth. The source of the work is not external observation, but an inner vision, an illumination. The logic of external observation has to be destroyed and the deceptiveness of perceptual experience abandoned to enable inner experience to speak; and the more thoroughly the laws of empirical reality are ignored, the more imperatively do those of the inner vision prevail. The most striking thing in this respect is the disproportion of the figures in relation to each other. The size of the figures is often independent, not only of the laws of physiology, but also of any regard for their spiritual significance and their role in the action represented; and not only are the formal principles of the Renaissance defied, but also those of medieval art, in which, though natural laws were often ignored, regard was had for some other principle. The disproportionate size of the figure of Christ, for instance, may be explained, in accordance with the medieval principle, by his role as the spiritual centre of the picture, though the athletic dimensions of his torso are by no means in harmony with the rest of his body. The colossal form of St. Peter, however, is completely unmotivated, and his huge left arm in particular seems quite arbitrary (Pl. 19). The disproportion of the different parts of the picture is the expression of a feverish dream, a wild, turbulent hallucination (Pls. 20, 22), in which strange shapes suddenly appear and vanish again, become more and more abstract and less and less personal, and increasingly represent the species 'man' and decreasingly any single human being. The theme is the drama of humanity, of man, not of any particular individual or group of individuals. Thus art, untroubled by any illusionism, again becomes symbolic in the medieval sense. This also explains the remarkably indifferent, actually sophisticated, and almost affected expression of the Virgin (Pl. 21). Even Christ in his Apollonian pose seems much too correct and aloof to be regarded as anything but a symbol.

The visionary and irrational frame of mind, the chaotic and bewildering nature of the experience, the disconsolate mood of the drama of mankind, and the longing for redemption that fill the work, are nowhere more significantly expressed than in the remarkable sense of space that pervades the picture, which is completely different from that of the Renaissance. The sense of being lost and disoriented nowhere makes itself better

felt. In contrast to the homogeneous, uniformly organised, and precisely delimited spatial areas of Renaissance painting, space is here broken up into unreal, discontinuous, isolated patches, which are neither seen from one particular angle nor measured by any single standard. The discontinuity and unreality of the pictorial space is chiefly the consequence of the abandonment of the principle of creating illusion by perspective which was fundamental to the Renaissance. This is most strikingly evident in the undiminished proportions of the uppermost figures in the composition which are farthest from the observer, and consequently seem too big. However, the spatial discontinuity is perceptible everywhere; the various parts of the picture form completely independent perspective units, each with its own optics and vanishing point, with the result that the whole is a conglomeration of distinct visual systems. Thus a number of superimposed, parallel spatial areas can be distinguished.[22] The effect of the whole is startling and disturbing, not only as a consequence of the fact that it conflicts with the principle of creating illusion by a uniform perspective, in that the uppermost figures are shown with a lack of foreshortening and thus seem over-dimensional, but also because of another peculiarity which is a consequence of the former, that is, the excessive weight given to the upper part of the picture, which creates the impression of being unstable, threatening, overhanging the spectator as if about to crush him.[23] Nothing could be more mannerist than the picture's precarious state of balance.

The two frescoes in the Pauline Chapel, the *Conversion of St. Paul* and the *Crucifixion of St. Peter* (1542–49) represent the next stage in Michelangelo's wrestling with the problems of mannerism (Pls. 23, 24). Here nothing whatever survives of the Renaissance ideal of beauty and harmony. The figures have lost, not only their physical attraction, but also their personal initiative; there is something unfree about them, they have become dream-like automata, as if they were under the spell of some mysterious and ineluctable compulsion, some fearful pressure of undiscoverable origin. They stumble about as if dazed and lost on the earth which is no longer their home. Empty spaces alternate with uncannily overcrowded areas, desolate wastes with tightly packed throngs, as in an evil dream. But here the emphasis is less on the optical discontinuity of space, as it was in *Last Judgment*, than on the completely different valuation of individual spatial areas and the abrupt juxtaposition of differently occupied spaces. Spatial depth is not built up gradually, but is torn up. Diagonals break through the different levels and bore yawning holes into the background. The spatial coefficients of the composition seem to be there merely to express the lost and homeless state of mankind. Figures and space, men and the world, seem no longer properly to belong to one another. The actors have lost the last relic of individuality; the marks of

age, sex, temperament, fade and grow dim, everything tends to generality, abstraction. In the face of the tremendous implications of being human, of mankind's tragic lot, personality and individuality dwindle into insignificance.

In the *Conversion of St. Paul* the earthly scene is squeezed into an impossibly small area, a shallow stage of Giottesque character in contrast to which the scene in heaven represents a vision that goes beyond any conception of size. Michelangelo's epoch-making innovation in composition and the representation of space is that, in contrast to Raphael's tapestry, the horse, instead of galloping sideways out of the picture, is galloping into it, in a direction opposite to that of the saint. The significance of this lies, not so much in the unusual power of this incursion into the depth of the picture, a feature which the painting shares with many others, particularly of the baroque, as in the creation of a dimension which, as the whole action is restricted to the foreground, is put to no further use. This functionless dimension is a characteristic example of the irrational mannerist treatment of form. The horse galloping away leads into the void, and connects the lower part of the picture with the upper in the most superficial manner, but essentially underlines the work's spiritual core, if not by its strong foreshortening, by its diagonal position turned to the left. Its perspective foreshortening, which in its exaggeration recalls the early stages of this technique, and calls to mind works such as Mantegna's *Dead Christ*, creates the impression in this context of being a mere *concetto*—striking, impressive, but inorganic. The river-god motive that Michelangelo chooses for St. Paul lying on the ground is just as paradoxical, and produces the effect of a foreign body in the work as a whole.

The *Crucifixion of St. Peter* creates even less of an illusionist impression than do the other paintings of Michelangelo's late period. Its most striking feature is that the individual groups, as in medieval painting, are placed above instead of behind each other. As in the *Last Judgment* and the *Conversion of St. Paul*, a uniform standard of proportion is lacking. Figures standing side by side are rendered in different sizes for no perceptible reason. No attempt is made to create the impression of a spatially and scenically adjusted and integrated event; on the contrary, all the skill that the painters of the Renaissance had gradually acquired in this matter is deliberately cast aside. As in the other fresco in the Pauline Chapel, figures are cut off by the lower edge of the picture solely for the mannerist purpose of connecting the picture space with the spectator's real space, and are not used as repoussoir figures to create depth. Again, the bearded giant in the lower right-hand corner creates the impression of being an independent idea, having no connection, or only an emotional connection, with the rest of the picture. The discrepancy between the over-crowded and empty areas is even more marked than in the *Conversion*

of St. Paul. On both sides of the composition not an inch of space is left free, while in the rendering of the central part, the crucifixion itself, there are yawning gaps, and the background leads the eye into an endless, unpopulated, desolate waste. The elliptical curve which encloses the crucifixion scene and remains open only in the middle of the lower edge of the picture is planimetrically ornamental, that is to say, eminently mannerist. Its planimetric character is the more remarkable and paradoxical in that, in addition to the recession of space in the background, a strong spatial effect is created by the diagonal position of the cross.

After completing the frescoes in the Pauline Chapel Michelangelo did no more work on a large scale. The *Pietà* in the Duomo at Florence (1550–55), the *Pietà Rondanini* (1556–64), and the drawings of a crucifixion are the whole artistic yield of the last fifteen years of his life, and both the *Pietà* were left unfinished. The *Pietà Rondanini* (Pl. 25) undoubtedly represents an extreme case in Michelangelo's work, and it has led to the totally erroneous view that it is his only really mannerist work. If it is hard to classify Michelangelo's other works stylistically, this one is no easier. Primarily it seems to be not a work of art at all, but an ecstatic confession, moving at the extreme limits of what can be expressed in sensuous form or conceived in aesthetic terms. To the naïve observer it seems formless, toneless, almost inarticulate. On the one hand it makes a completely spiritualised, dematerialised, disembodied impression, and on the other its creator seems to have abandoned as unattainable his aim of expressing his feelings and thoughts in material form, and therefore to have contented himself with merely hinting at them, as at things that lie beyond the reach of artistic expression in the traditional sense. But, in view of the unfinished state in which the work has come down to us, it is hard to say how far Michelangelo might have been willing and able to go in expressing the things of which only hints are given. There are, however, certain features of the work that could hardly have been changed, and show a consummate spiritualism and an extreme measure of irrationalism and anti-naturalism. The exalted height and ascetic unsubstantiality of the figures are driven to the limits, and correspond to thorough-going changes that took place while Michelangelo was still working on the group. The inwardness of the relations between mother and son that so strikingly differentiates even the Florence *Pietà* from the early work in St. Peter's here becomes a real mystical union. The two figures soar in a winged embrace, and seem to have thrown off all terrestrial weight. The consonance of the lines of the bodies, which in mannerism so often remains mere formal play, is here imbued with the deepest spiritual content; it expresses the identity of the Saviour and His mother, and the work of redemption He performs on her and through her on mankind.

Michelangelo's influence grew steadily after the thirties, and gradually

conquered all Italy and the greater part of the west. European art of the forties was thoroughly Michelangelesque. The art that now came into fashion concentrated on emphasising the human anatomy, that is to say, the muscles, thorax, and thighs, and the plastic articulation of the human form. It stressed the volumes and curves of the principal parts of the body, made great play with physical movement, exaggerated the activity and mobility of its figures, and accentuated every factor that drew attention to the latent strength and energy contained in the human physique. Dynamically charged contrast, strong foreshortenings, sharp and complicated intersections, the consonance and dissonance of movements were especially favoured, to such an extent that these have often been regarded as the essential features of mannerism, and the whole style has been identified with the Michelangelism that expresses itself in them. Even the definition of mannerism as a style based on the 'manner of a certain artist', to be found, for instance, in Lodovico Dolce's *Aretino* (1557), seems to have been formulated with Michelangelo in mind, for what other artist was there on whom the artistic practice of the whole generation could have been based?

Michelangelo's artistic influence was immeasurable; it was more widespread and deeper, though perhaps not more long-lived, than that of any other master. Wölfflin speaks of the 'dreadfulness' of his influence,[24] of the 'dazing effects of compact masses' that were now sought for, of the loss of the sense of Raphael's 'architectonic' form, of the lack of interest in 'spaciousness'; and the prevalence of a 'terrible overcrowding of the pictures', a 'conflict between space and filling', and an 'inadequate relationship of objects to their frame'. Pictures painted under Michelangelo's influence, such as Bronzino's *Christ in Limbo*, remind him of an anatomical museum, and Tibaldi's *Adoration of the Shepherds* suggests to him a group of athletes, every one of whose movements is forced and posed for exhibition.

For the last thirty years of his life, which he spent uninterruptedly in Rome, Michelangelo was without rivals in Italy. His fame was at its peak, and he was the object of a veneration such as no artist has enjoyed before or since. Though his contemporaries were unable fully to understand the meaning of his last works, the whole art of his age was under his aegis. The only artist who could stand comparison with him was Raphael and, now that Raphael was dead, he was surrounded only by his own satellites and those of his former rival. The influence of the venerable master made itself felt even in the school of Raphael, on which it imposed self-examination and a consequent renewal, and appeared principally in the representation of the human body, though this was carried out in Raphael's spirit (Pl. 26). Monumental composition, such as practised mainly by Perino del Vaga, shows such a profound Michelangelesque influence that he can be

177

said already to represent a synthesis of the styles of the two leading masters of the High Renaissance. However, it was mainly the style of the Sistine Chapel that set the standard for Roman monumental painting, and even the definite mannerists were most deeply influenced by the penultimate Michelangelo, the painter of the *Last Judgment*, and not the creator of the Pauline Chapel frescoes and the last *Pietà*. Tintoretto and El Greco themselves in their relation to Michelangelo did not go beyond the *Last Judgment*, though in their own work they developed to a stage corresponding to the master's late style.

But it was not of course these artists, though they were closest to Michelangelo's spiritualism, who made the first transition from his art to mannerism. The function that in the school of Raphael was carried out by Giulio Romano and Perino del Vaga was completed in Michelangelo's immediate entourage by Sebastiano del Piombo, Marcello Venusti, Daniele da Volterra, Marco Pini, and Jacopino del Conte (Pls. 27–33). These artists cannot be called pupils of Michelangelo, for, in spite of the large number of his followers and his unprecedented influence, there were no such pupils in the real sense of the word. At all events, there was never a school of Michelangelo in the sense that there was a school of Raphael, that is to say, a group of artists who were trained by the master, grew up in his workshop, and developed into independent personalities under his guidance. There were only imitators and emulators of the great man, more or less finished artists who allowed themselves to be guided by his genius or subjected themselves to it.

Genuine mannerism, however, was a product neither of the school of Raphael nor of the followers of Michelangelo, and it came into being, not in Rome, but mainly in Florence, partly in Siena, and somewhat later at Parma, and its real creators were Pontormo and Rosso, both pupils of Andrea del Sarto, who was, generally speaking, a purer and more unambiguous representative of the classical style than the chief masters of the Roman High Renaissance, but nevertheless displayed certain premonitory signs of mannerism in his art. It is remarkable, however, that the first definite and unmistakable representatives of the new style should have been pupils of an artist in whose own work the trend occupied only a minor place, while the pupils and immediate spiritual heirs of masters who were as deeply involved in mannerist tendencies as Raphael and Michelangelo can, perhaps with the single exception of Giulio Romano, hardly be described as mannerists in the proper sense of the word.

A role similar to that played by Andrea del Sarto in the birth of mannerism in Florence was played at Parma by Correggio who, though he departed farther from the classical style than the Florentine master, came closer to the baroque. At all events, his pupil Parmigianino played as prominent a part in the origin of the new style as did Pontormo or

Rosso, though it became topical later. But what he took over from his master—and this formed by no means an inconsiderable part of his artistic armament—affected his mannerist aspirations only to a relatively minor degree, while Pontormo seized precisely on those elements in the art of Andrea del Sarto which pointed most definitely in the direction of mannerism. Andrea was one of the chief representatives of the High Renaissance in Florence, and his early works are completely under the influence of Leonardo, Fra Bartolommeo, and the young Raphael. A number of his pictures are paragons of harmoniously balanced composition in which everything seems to be obtained with the simplest means, and they have real greatness. In one respect he oversteps the boundaries of Florentine painting from the first. He is an artist of colour, and his colours have a brightness, warmth, and bloom, and are livelier and richer in shades than those of the other painters of his native city (Pl. 34). In this respect he obviously learnt, not only from Leonardo, whose *sfumatura* technique he continued, but also from the Venetians, whose soft, painterly brushwork and sense of colour values seem to have had a vital influence on his style. As a colourist he goes so far as to use iridescent colours, thus anticipating a definitely mannerist device. Certain features of his art long since described by Wölfflin, such as the 'tired beauty' of his colour and line or the 'bold arrangement' of his figures, and the 'conscious elegance' that he never abandoned,[25] contrast sometimes in greater and sometimes lesser degree with the principles of tectonic severity, effortless, free rhythm, simplicity, and grandeur that are otherwise characteristic of his classical style, and themselves indicate a tendency towards mannerism. It is well known that, as a consequence of an anti-classical tendency in his artistic development, he took over certain features from Dürer as early as 1515, but for him Dürer's influence certainly did not have the importance it had for Pontormo, or Vasari would not have reproached the younger artist for it so severely. Nevertheless the approach to Dürer was a departure; it meant his moving farther away from the classics and nearer to what, from Vasari's point of view, seemed the problematical.

As for Correggio, it was not the most anti-classical features of his art that made the deepest impression on Parmigianino. His principles of form, which were contrary to those of the Renaissance and were essentially directed towards a subjective illusionism, and devices such as the lateral accent and the eccentric perspective of his composition, generally anchored to a diagonal, or the space-creating function of his excessively large repoussoir figures, were predominantly baroque in character, and did not have a decisive influence on Parmigianino. But there are also mannerist trends in Correggio, and these made a stronger impact on him. They consist chiefly in a tendency to an elongation of forms, an aristocratic refinement and dematerialisation of the body, particularly the hands (the *Marriage*

179

of St. Catherine in the Louvre (Pl. 35) and the so-called *Day* at Parma (Pl. 36)); a taste for flowing curves and serpentine lines (*Jupiter and Antiope* in the Louvre (Pl. 37)); involved figure-groupings with a wealth of consonances and dissonances (*SS. Placid and Flavia* at Parma (Pl. 38)); contrast between occupied and empty space (the *Agony in the Garden*, Wellington Museum, London (Pl. 39)); complicated postures of the kind used by Michelangelo in the Ignudi in the Sistine Chapel (dome decorations in the principal churches of Parma); sudden changes of proportion within the same work (*Madonna with the Soup-Bowl*, Parma (Pl. 40)); and affected, dance-like attitudes and encumbered, unclear, spatial relations (*Madonna with St. George*, Dresden (Pl. 41)). But Parmigianino's peculiar mannerist style was mainly the consequence of his own invention and, in so far as he accepted outside stimuli, Raphael was of no less use to him than Correggio. Even in his master's art it was the features akin to Raphael's grace and sense of beauty and the delicacy and elegance of his forms that most appealed to him, and it was these that he transformed into purely mannerist values. With the most characteristic feature of Correggio's art he was actually in conflict for, though he had a great deal in common with his master's sensibility, in contrast to the latter's artistic sensualism, his *pastoso*, warm, rich, painterly technique, his mellow colours, soft shadows, and atmospherically veiled contours, he developed a way of painting with clear, cool colours and sharp, firm outlines, in short, a style that was sensual only in matter and not in its means of expression, creating an effect that is the more perverse because it is apparently done without passion or intoxication of the senses. The erotic and feminine elements in Correggio are preserved without the warmth and spontaneity of his forms of expression, and that is what makes them mannerist.

3. THE FIRST MANNERIST GENERATION

The first decades of the Cinquecento in Florence were years of political upheaval which affected the whole cultural life of the city. In 1512 Giuliano de' Medici returned to Florence from his banishment and put an end to the rule of Soderini and with it the republican régime. The way was open for the transition from republicanism to monarchy and absolutism, and the installation of Cosimo as Grand Duke was only the last step on the path to usurpation and despotism. Quietly as everything apparently occurred, the downfall of the republic must have had a disturbing effect on intellectuals and artists, though among them there were certainly enough enemies of the republic, such as Baccio Bandinelli. The return of the Medici meant a sudden increase in commissions for artists—Pon-

tormo, for instance, received five from the usurpers and their retinue between 1512 and 1515.[26] Though these must have been tempting enough, and too much political sense and interest in public affairs should not be attributed to artists such as him, events must nevertheless have caused a general tension and sense of crisis from which no one could remain immune. Most artists were far from sharing the republicanism and democratic ideas of Michelangelo, however problematical these in themselves may have been, but such a sensitive and even morbid character as Pontormo—and his sensitivity was, as is well known, a widespread phenomenon of the time—can hardly have isolated himself from the influence of the changes taking place about him; they must at least have contributed to keeping him in a state of continual unrest.

Part of the explanation of why mannerism was born in Florence is undoubtedly the fact that at the time when Michelangelo and Raphael moved to Rome the centre of gravity of development had shifted to that city, which became the real home of classical art, while Florence was now able to move more freely of the hitherto prevailing tradition. But, to understand subsequent developments, it is necessary also to recall that after the sack of Rome Florence regained something of its former importance as an artistic centre, and the seeds of the new style that took root at the time of Giuliano's seizure of power were able to come to full blossom there. In any case, the lavish patronage practised by the usurper and its accompanying ambiguity were not entirely inappropriate to the complex and contradictory nature of the style.

Mannerism was not born overnight, not only because no new style ever is, but also because Pontormo, who played the most decisive part in setting its standards, developed his own artistic language only gradually and subjected it to more or less fundamental changes from one work to the next. Thus, in spite of Pontormo's thoroughly creative role, the stylistic transition in the relationship between his art and that of his predecessors is a gradual one and, as continually new aspects of mannerism appear in his work, the total result is not by a long way a uniform style, but rather a very broken picture of a complex personality, the most permanent feature of which is opposition to the classical tradition. To gain a complete picture of Pontormo's art, and see it as a uniform, coherent stylistic phenomenon contrasting with the scattered and imperfectly integrated mannerist experiments of the masters of the High Renaissance, the different aspects of his personality must be regarded as the various facets of an artistic purpose which he nowhere declares fully and completely, but has to be established from his works by a kind of synthesis. No such stylistic unity of the mannerist features in the art of his predecessors can be established, and the 'mannerism' of a Raphael or a Michelangelo always remains a stylistic factor more or less impeded and overlayed by other trends.

True, the stylistic coherence of the distinguishing features of the new style, spiritualising and subjectifying the classicism of the High Renaissance, is hidden in the art of Pontormo, but for all that it is present and can be brought to light.

In considering his works, it is a cause of continual surprise that he never remains satisfied with any of his epoch-making achievements, and even after the greatest of them never ceases searching further and pursuing new aims, and that in the course of his career he so often feels compelled to question and practically devalue his previous attainments. He repeatedly arrives at solutions that he might easily have developed into a fruitful personal style that would have assured him security and success. He might have regarded as such solutions the facility that he achieved with the *Visitation* at the Annunziata, or the consummate artistic language of the fresco at Poggio a Cajano, or the spiritualism of expression in the Passion frescoes at the Certosa di Val d'Ema, the magnificent homogeneity and inner balance, the sense of resolved tension, of the *Descent from the Cross* in the church of S. Felicita and the *Visitation* at Carmignano, but he had to reject the validity of each of these formal attainments and finally fling himself into the problems of the S. Lorenzo frescoes.

Pontormo found important elements of mannerism ready to hand in his teachers, predecessors, and contemporaries, in Piero di Cosimo, Andrea del Sarto, Alonso Berruguete, and Michelangelo, and he discovered others himself in the five or six different stages through which he went in the course of his career. Vasari distinguishes three phases in his work: his early period, still characterised by adherence to classicism; that of his imitation of Dürer, which he dates from the Certosa frescoes; and a final, Michelangelesque phase principally occupied with the painting of the S. Lorenzo choir. This, however, is far from doing justice to the multiplicity of stylistic trends characteristic of his development. There are more breaks in it than Vasari assumes, and the deepest are not where he puts them. The breach with classicism took place long before the Certosa frescoes, and the influence of Dürer was far from being as unprecedently new or as important as he believes. Also, of course, the Michelangelesque phase began before the decoration of the S. Lorenzo choir.

Pontormo's first important work, the *Visitation* in the Annunziata in Florence (Pl. 42), dating from 1514–16, represents the first peak in his development, his first complete success. The twenty-year-old artist still expresses himself partly in the formal language of Andrea del Sarto and Fra Bartolommeo, and the nobility and *grandezza* of the work, its grand manner and relaxed rhythm, the beauty of its types, draperies, and poses, are reminiscent of Andrea's neighbouring *Birth of the Virgin*, which was painted shortly before (1514). Everything is still imposing and majestic, harmonious symmetries, curves, and flowing lines are preserved,

and nothing is exaggerated or forced, or used for the sake of sheer virtuosity. Nevertheless a personal mannerist note can be detected, of which there is yet no trace in the art of Andrea del Sarto, though he shows signs of it later. In spite of all the picture's reserve, there can be discerned in it a certain liveliness and sharpness of glint in the eyes and a still completely controlled but nevertheless already acute inner tension. But the most personal and most definitely mannerist features are the premonitory signs of self-consciousness and complacency in the poses of the two figures seated on the steps. These, though apparently still unforced and accidental, are unmistakably calculated for effect; the boy, almost narcisstically occupied with himself, who recurs in the decoration at Poggio a Cajano and is also familiar from Andrea del Sarto, and the woman who looks so composedly and candidly at the spectator and yet keeps so much back for herself. These two figures are brought so strongly into the foreground that they thereby play a distinct role hardly consistent with their subsidiary status, and are thus accentuated in a fashion irreconcilable with classical principles.

The Visdomini altar with the *Madonna and the Saints* (1518) shows in further developed form all the characteristic features that have already appeared in the *Visitation*. The relationship of the figures to each other is more tense, their movements are more restless, and concentration on the human form and the grouping of the participants occupies the artist's attention even more exclusively; everything else, particularly the architecture, retreats very much into the background. Also the ostentatious grace, the affectation and desire to please, particularly of the children, and the taste for the artificial and unspontaneous that here leads to characteristic mannerist dance poses, are pushed a stage further.

If one wishes to search for the origins of mannerism in Pontormo's early work, apart from the artist's own invention, which plays the most important part, and the similar tendencies in his classical teachers and masters, a certain importance must be ascribed to the Spaniard Alonso Berruguete, whom Vasari mentions in his *Lives* and Michelangelo describes in his letters as a gifted young painter, who came to Florence in 1508 and remained there until 1518. Berruguete was somewhat older than Pontormo and, as has recently been shown,[27] influenced both him and Rosso, on whom he seems to have made a deeper impression, in the successful solution of mannerist problems. His *Salome* in the Uffizi and his *Madonna and Child* in the Loeser collection (Palazzo Vecchio, Florence) (Pls. 43, 44) anticipate a whole series of features that appear only later in the two founders of the style.

Pontormo's definite breach with classicism and the real beginning of his mannerism appear in his representations of the *Story of Joseph* which formed part of the decoration of the bridal chamber for Pier Giovanni

Borgherini, on which Andrea del Sarto, Granacci, and Bachiacca also worked. The most important of Pontormo's contributions is the *Joseph in Egypt*, in the National Gallery, London (Pl. 45), which probably dates from 1518 and certainly not later. Any history of the final form of mannerism must start from this work, though only a limited aspect of the new style appears in it, many of its most important elements have yet to be developed, and Pontormo has not yet achieved complete independence and, even when he uses apparently novel stylistic means, still relies on the work of older artists. Of special importance among the latter is his master Piero di Cosimo, whose formal language, as illustrated, for instance, in the *Legend of Prometheus* (Alte Pinakothek, Munich) (Pl. 46) or *The Discovery of Honey* (Art Museum, Worcester, Mass.) with its diffuse, episodic, narrative technique, is followed by Pontormo in his *cassone* style, characterised by the large number of episodes and small figures involved. One of the elements, among others, in Piero di Cosimo's *Prometheus* picture which Pontormo must have remembered is the figure on the central pedestal, which, with its state of being half-way between the organic and that of a lifeless artifact, undoubtedly provided the example for similar figures in *Joseph in Egypt*. Traces of the influence of Bachiacca, notably of his paintings of Joseph (Pl. 47), appear in Pontormo, but the importance that should be ascribed to this is hard to decide, just as it is difficult to say how much give-and-take there may have been between him and Andrea del Sarto regarding the Borgherini pictures. No doubt the influence was reciprocal. Though Pontormo's share is perhaps not yet evident in Andrea del Sarto's pictures of Joseph in the Palazzo Pitti (Pl. 48), traces of his influence can undoubtedly be seen in the *Tribute to Caesar* (1521) at Poggio a Cajano (Pl. 49). During his former master's absence from Florence in 1518 Pontormo himself became a reputed master, and after his return Andrea del Sarto was obviously influenced by the younger artist. In any case, his fresco at Poggio a Cajano shares a number of features with Pontormo's earlier *Joseph in Egypt*, notably the composition in two compartments with the flight of steps as a connecting link or dividing-line between them, the movement characteristic of the whole scene, and the way in which the observer's attention is drawn from one side to the other, the nimbleness and fluidity of the attitudes and movements, the landscape background penetrating far into the depth, the characteristic use of architecture and sculpture, particularly the steps, the open bay of the upper floor and the figures on pedestals, the light colouring and the breaking up of the picture plane into a number of small and carefully worked areas of colour.

In comparison with his earlier works, the most original and impressive feature of Pontormo's stories of Joseph is the atomisation of the composition into a multiplicity of groups and small figures, closely packed to-

gether in places. Instead of the previously pursued ideal of monumentality and unity, a kind of anecdotism and an adding of incident to incident is now the prevailing stylistic principle. Since Piero di Cosimo this anecdotal style is not essentially new in Florentine painting, but the execution is so delicate, and such gem-like treatment is given to the individual enamelled surfaces, that the effect is highly original; it initiates a technique that first comes into fashion with the pupils and followers of Bartholomeus Spranger. At all events, this is the first appearance of a characteristic feature of mannerism, that is to say, a striving for elegance and decorative effect attained, not by the grandiose proportions of classical forms, but, on the contrary, by their diminution, by a demonumentalisation of Raphael's *grazia*.

Pontormo's *Joseph in Egypt* also contains a number of other, less specific, features that are nevertheless characteristic of mannerism as a whole. One of the most important is the displacement of the main theme from the centre of the stage; in this case Pharaoh's reception of Joseph and his family is relegated to a corner. Partly connected with this is the breaking up of the composition into more or less independent parts, a feature that recalls medieval painting, not only because of their juxtaposition, but also because of the fashion in which the separate groups are seen over one another instead of side by side, with a very high horizon. The picture contains numerous details only loosely connected with its real theme, and in the right top corner there is actually a small separate scene, showing the blessing of Jacob, that is hardly connected either formally or thematically with the rest; its only link with the episode in Egypt is that it is a future incident in Joseph's family history.

The fragmentation of space and the use of different spatial values in the same picture are partly the cause and partly the consequence of this atomising composition. The figures, even in groups side by side with each other, are sometimes of completely different sizes. The alternation of crowded and empty spaces, familiar from the pre-mannerism of the High Renaissance, is driven to extremes, and the aim of creating the perfect illusion of space is completely abandoned. Parallel with this spatial incoherence is the inconsistency with which reality as a whole is rendered; that is to say, different details of reality are represented with different degrees of realism. In this respect the effect of the figures on pedestals is particularly confusing, because at first sight it is hard to tell whether they are living forms or lifeless objects; and, when one has finally decided that they cannot be living and that they are images within an image, artifacts within an artifact, stage properties within a stage, the effect is surprising and disturbing to one's criteria of reality. The whole fantastic architecture, seemingly designed rather to break up and divide rather than consolidate the pictorial space and continuity, creates the same effect. Considerable

portions, notably the whole complex on the right, are pure stage scenery, devoid of any tectonic logic or appearance of solidity. The most remarkable of the strange details of this architecture is the flight of steps ascending steeply into the air with no railings or support, and serving only to increase the sense of insecurity that fills the whole work. Steps, like the ladders that play such an important part in so many crucifixions and descents from the cross in the painting of the age, are a favourite mannerist motive; both, with their precarious balance, have a symbolic significance for the style.

The fresco *Vertumnus and Pomona*, in the Villa Medici at Poggio a Cajano (Pl. 50), painted in about 1520, is characterised by even greater narrative ease than the pictures of Joseph. It is the most relaxed, the gayest, and the least enigmatic picture that Pontormo painted. None of the fantastic, bizarre, and piquant details of the earlier pictures reappear in it. Only the stylistic elegance remains, but a change has come over it; it is bolder, more sure of itself, less strained. It is an aristocratic style in pastoral form—spiritual without being nervous, poetical without sentimentality, delicate without decadence. It is unquestionably the most unbroken and homogeneous of Pontormo's works; nevertheless it is not completely 'naïve' or free of all play with form. It is penetrated by a restrained rococo feeling, its apparent naïveté conceals the most extreme refinement, but the rift present in all pastoral poetry is something it cannot disguise. Structurally, too, it is far from simple, and not without its inner contradictions; it combines a delicate feeling for nature with uncommonly complex and carefully developed Michelangelesque forms deriving from the Sistine ceiling, an apparently spontaneous pleasure in things with an almost geometrical sense of order, and with principles such as that of the predominance of planimetric organisation, a somewhat monotonous repetition of verticals and horizontals and a not entirely unobtrusive consonance of contours. In spite of all its apparent spontaneity, the whole is ultimately caught up in a network of not very flexible formulas. The fact that the whole system of relations is so cleverly camouflaged illustrates the special skill attained by the artist at this stage of his development.

The brief period of internal and external peace during which the fresco in the Villa Medici was painted came to an end with the outbreak of the plague at Florence that led to his acceptance of the invitation to the Certosa di Galluzzo di Val d'Ema to carry out a series of frescoes, and was followed by another stylistic crisis. This marks the third important stage (1522–25) on Pontormo's way to the realisation of mannerism. It is generally described as the real turning-point in his rejection of the art of the High Renaissance and the Mediterranean sense of harmony and his approach to the spirit of the Middle Ages and the north. That, however, is an over-simplification, as he had always been moving away from classi-

cism and, if there was a moment when he definitely turned his back on it, it was much earlier. The Certosa frescoes are of immense stylistic importance just the same. If the *Visitation* in the Annunziata marks the beginning of narcissism and exhibitionism in mannerist art, and *Joseph in Egypt* shows a curious and bizarre method of expression that is irreconcilable with classical rationalism and realism, the Certosa frescoes demonstrate the conquest of a spiritual realm of which there was no previous trace in Italian art. Real religious art had of course existed previously in Italy, even if not in the immediately preceding period, but in a country that had no gothic past in the north European sense Pontormo's spiritualism was new. In attributing the stylistic change to Dürer's influence, Vasari's mistake lay less in his misinterpretation of its nature than in his overlooking the fact that the German master had long been known in Italy because of the wide dissemination of his graphic work, and that his influence appeared as early as in Andrea del Sarto's *Pietà* (1515–16), known to us only from Agostino Veneziano's engraving; in other words, his influence was exercised, so to speak, before Pontormo's eyes. What happened in this instance was what always happens in the case of external influences; not till a new spiritual need appears do the sources of inspiration begin to speak. In Pontormo's case too the path to his new artistic purpose and spiritual orientation must already have been prepared when Dürer opened his eyes and his mind to the direction his own art must take.

All the five scenes of the Passion in the Certosa frescoes have something in common, both in subject and form, with Dürer's series of woodcuts. So far as subject is concerned, it is not merely individual types or costumes or attitudes that are taken over, and the formal resemblances are by no means limited to externals, but point to a much deeper spiritual common factor. The most striking of the resemblances consists in the strong tendency to bring the figures forward, so much so that the lower edge of the painting sometimes cuts off, or touches, their feet. The consequence is an extraordinary foreshortening and a sudden towering of the foreground figures that often gives them an uncanny reality and a physical presence in striking conflict with their spiritual nature. This overcharging of the foreground draws the observer into the world of the picture and simultaneously shuts him out of it by the abyss torn open by his sudden confrontation with the figures. As can be seen most unmistakably in *Christ before Pilate* (Pl. 51), the formal structure of these frescoes is everywhere symbolic and serves to communicate a special spiritual content. The guards in *The Resurrection* (Pl. 52) not only recall Dürer's lansquenets, not only provide a striking foreground and draw a magic circle round the figure of Christ, but their whole physical constitution and attitude also have an earthly weight and substance which provide the desired impact

by their contrast with the transfigured body of the Redeemer, His weight-lessness and spirituality and His soaring towards heaven. A similar magic circle surrounds Him in the scene before Pilate, only here the isolating, accentuating, and transfiguring effect of the arrangement is yet stronger, because He is surrounded by the busy people of everyday life and appears in the bright light of day. In this fresco the artist uses two devices, lightening of the colours and elongation of the forms, that are characteristic of the whole series but here are carried to extremes. In none of his earlier and only seldom in his later works does he elongate a figure to the extent he does in the case of Christ in this instance. Apart from the uncommonly tense relations between head and body, the slenderness of the spiritualised, dematerialised form is accentuated by the vertical folds of the robe and the servant who continues the upward line of the figure of Christ, a means that helps to emphasise both the central axis of the composition and the verticalism of the whole formal structure. The slenderness and delicacy of the figure of Christ is further increased by its being seen in profile; its broken line and slight forward tilt is full of a moving humility and gentle devoutness.

In all these frescoes, the light colours and elongated forms serve to diminish the plasticity of the bodies, create the impression of dematerial-isation, and emphasise the spirituality of the sacred personages. Henceforward Pontormo adheres as a general stylistic principle, not only to the elongation of forms, but also to the longitudinal shape and verticalism in general. From now on this tendency dominates all his composition in its totality and in its elements, just as vertical organisation dominated the whole of gothic architecture and its subsidiary arts. The use of light colours also remains a permanent feature of his art, and of practically the whole of mannerist painting after him.

Though in his *Joseph in Egypt* Pontormo shows that he has discovered many of the features of his mannerist style, this work, and the stage of development that it represents, still has a great deal in common with the art of Andrea del Sarto and the other masters whose pupil he was. With the frescoes in the Certosa di Val d'Ema he notably increases his distance from the classical tradition, but the chief and most fundamental trend of his mannerism, that to abstraction, first appears plainly in his two next large and most successful pictures, the *Descent from the Cross* in S. Felicita (Pl. 53) and the *Visitation* at Carmignano (Pl. 54). The abstraction appears in its most unmistakable and stylistically most significant form in the renunciation of real, three-dimensional, cubically limited, and perspectively definable space. The architectonic frame plays a minor part in Pontormo's art from the outset. As early as the *Visitation* in the Annunziata, architecture serves purely as a kind of stage setting, and in the *Visdomini Madonna* it is barely even that. In the *Descent from the Cross* all hint of

spatial relationships by architectural means is dropped, and in the Carmignano painting the quasi-architectural background is so bare, so purely geometrical, that it serves exclusively as a framework and seems no longer even an inherent part of the picture. In these works a formal structure of human bodies is built up, and in the *Descent from the Cross* this takes the form of a kind of acrobatic performance; the bodies tower on top of one another with no visible support in a state of precarious, momentary equilibrium, expressing the keen sense of impermanence that becomes such an important theme of mannerism.

Distinctly though mannerism presents itself as an independent style with Pontormo's progress in abstraction, particularly in the representation of space, and with his growing independence of his former masters, at any rate premonitory signs of such abstraction are already to be found in Andrea del Sarto, who partially does away with the stability, balance, and rationalism of the classical rendering of space. His frescoes in the courtyard of the Scalzo, from the *Dance of Salome* (Pl. 56) and *Decapitation of John the Baptist* (Pl. 55) onwards, illustrate as early as the beginning of the twenties the disruptive ferments to which classical space was becoming increasingly subject. The principal figures are displaced to one side, and unimportant subsidiary figures are excessively emphasised by assonances or contrasts; symmetrical and axial arrangement is disturbed by lights irregularly distributed over the whole composition; and the main action takes place in a shallow plane right in the foreground.[28] It is this last factor that prepares the way for the concentration on the human form and the neglect of its environment that is characteristic of mannerism. The effect is increased by the over-dimensional size of the figures, and the fact that the scene takes place on a practically bare and unfurnished stage. This gives an abstract, unreal, inhospitable character to space, which becomes a medium in which men move as in an alien world; figure and space, man and his environment, do not really belong together.

The principles of Pontormo's own artistic development, and with it those of the whole mannerist movement, were confirmed by the fact that the two paintings in which he realises his stylistic ideal in its purest and most uncompromising form, the *Descent from the Cross* (1526–28) and the *Visitation* (1528–30) are also his most important works, and that to achieve its greatest triumph the style remained as intransigent as ever and made no concessions to a less paradoxical and abstract way of expression. These two paintings, which represent the summit of Pontormo's art and are marked by the most rigid and complex structure and filled with the most intense spiritual life, the greatest dramatic tension and the most delicate sensibility, are also the most successful creations of early mannerism in Italy and two of the most important paintings of the Cinquecento. In the *Descent from the Cross* there can be said to be a certain excess of refinement

and self-consciousness, a certain formal exaggeration and an effort bordering on the strained, and there may be a lingering feeling that the success is a *tour de force* and an accident, but everything in the *Visitation* suggests unerring necessity and Michelangelesque greatness. Mannerism never came closer to the real spirit of the Sistine Chapel. Even Pontormo's so-called Michelangelesque period, which dates from the beginning of the thirties and culminates in the painting of the S. Lorenzo choir, in relation to this picture represents a departure from the master's spirit rather than a closer approximation to it.

Michelangelo's influence on Pontormo neither begins with nor is at its most fruitful in the period of the S. Lorenzo frescoes, but in this final period, though he never becomes a representative of the fashionable Michelangelesque tide, the painter of the Sistine Chapel ceiling, and also gradually the painter of the *Last Judgment*, acquires a new and vital significance for him. Pontormo never loses his independence in relation to Michelangelo, but during these years he undoubtedly passes through the most severe crisis of his artistic development. For the S. Lorenzo frescoes of the Fall, the Flood, and the Resurrection, which were whitewashed over in the eighteenth century and are known to us only from drawings by the artist which have survived, were obviously among the most tormented and enigmatic of all his works. The drawings show chaos, ruin, and destruction, and struggle for redemption and salvation (Pl. 58), but the mood that fills them, the dominant mood of the last ten years of the artist's life, is a tragic and desperate one.

Rosso Fiorentino was a contemporary of Pontormo's; both were born in 1494, were pupils or at any rate followers of Andrea del Sarto and, in spite of their great spiritual and temperamental disparity and differences in taste, must be placed together, not only as two similarly tragic figures of a tragic age, and as two equally great artists rooted in the same spiritual soil, but also and above all as the two personalities who played the most important part in the break-up of classical art and the creation of a new, uniform style, as distinct from the individual mannerist experimentation engaged in by the classics themselves.

The principal feature common to both these artists, within the uncommon wealth of variations peculiar to mannerism, is that they share a spiritualism that is in full accordance with the great cultural problems of the age but is altogether alien to the later exteriorisation and simplification of the style. This applies to Rosso just as much as it does to Pontormo, at any rate so long as he remains in Italy. There is, however, a difference in their spiritualism; Pontormo's, in accordance with his melancholy, alienated, and misanthropic nature, was deeper and more heartfelt. Rosso's temperament was more violent and thrustful, and his spiritualism was

accordingly more radical, more intolerant, and more inclined to excess and extravagance (Pl. 59). Both were equally opposed to classicism but, in comparison with his more cautious comrade, Rosso was much more revolutionary; he was the mocker and blasphemer *par excellence*. Pontormo seems to link every innovation with the thread of tradition, while Rosso always creates the impression of wanting at all costs to do away with the past.

His *Assumption of the Virgin*, painted in 1517, in the Annunziata, like Pontormo's *Visitation* in the same place, still moves more or less within the limits of the art of Andrea del Sarto and Fra Bartolommeo, though the livelier colouring and more restless treatment of light create a more unclassical effect, and some of the figures show anticipations of his tendency to physiognomic exaggeration. Also the consolidation of the terrestrial group into a solid wall is much more ostentatiously formal in character than even the most personal feature in the corresponding early work of Pontormo. In this fresco, no doubt because of its company, Rosso still shows a certain restraint; in the next, the *Madonna with Saints* (in the Uffizi), painted in 1518, his taste for the bizarre and even grotesque appears more definitely. But though, in contrast to the more conservative Pontormo, he appeared practically from the first in the role of a fearless innovator with no respect for anything or anybody, later they exchanged roles and, while he completely adapted himself to all that was required of a court painter in France and developed into a willing conformist, Pontormo became more and more unapproachable as time went on and seems finally to have grown completely indifferent to the opinions of his fellow-men while he was engrossed in his desperate efforts to complete the S. Lorenzo frescoes.

Rosso's first great achievement, and in many respects his masterpiece, is his *Descent from the Cross* (1521) at Volterra (Pls. 61, 62, 63). It displays his artistic personality, not to be confused with that of any other painter, including Pontormo, in fully developed form, for even Pontormo is never so original, so surprising, and so wilful. Pontormo's art, though it is certainly no less spiritual and introverted, never reaches such a pitch of spiritual and emotional tension, and its expressionism never attains such dramatic power as does the art of Rosso at this stage of his development. The *Descent from the Cross* of course shares numerous stylistic features with Pontormo—above all the tendency to abstraction and spacelessness, the emphatic subjectivism in general, the unrealistic and irrational way of representing reality and the inclination to formalism, though this last is never so pronounced in Pontormo as it is in this painting of Rosso's, where the whole composition is organised on a system of decorative relations dominated by parallelisms and consonances. The two ladders to the right and left of the cross, with their similar position yet reversed relationship to the picture plane, the two symmetrically placed

men on the ladders with the similar and at the same time reversed position of their legs, the repetition of the contours of the figures of Christ and the man holding his knees, the consonance of the lines of the two women accompanying Mary, the correspondence between the old man bending high up over the cross and the young woman below bending over the Virgin's feet, and the fact that both figures extend practically over the whole width of the picture, are all examples of Rosso's play with formal effects, in which Pontormo never engages in so artificial and exaggerated a manner.

True, the fundamental design of the *Descent from the Cross*, the elongation of the proportions, plays just as important a part with Pontormo as it does with Rosso, though the former never pushes it to the point of distortion as does the latter. Common to both is the tendency to substitute lighter, looser, to a great extent sharper and harsher colours for the relatively dark and heavy tones of the classics. Rosso at all events is much more radical than Pontormo in this respect. Not only does he use more peculiar, more glowing, more richly variegated, and more iridescent colours, but as a colourist he also tries to create more bizarre, fantastic, and uncanny effects. There are other features in which his art differs fundamentally from Pontormo's. Chief among them are his fitting of the figures into apparently inorganic cubic forms, his sharpening of the contours into cutting edges, his breaking them up by acute angles, and his turning the bodies into prisms by splintering them into forms with flat surfaces; his physiognomic characterisation, the exaggerated expressions of surprise, grief, or suffering he gives his figures, and the unusual, abnormal, and caricature-like types he chooses; and finally the dream-like or nightmarish, macabre and ghostly quality of the mood as a whole. All this seems inherently intended to produce the impression of a life that is haunted as well as spiritual and, so far from being simple and straightforward, is full of pitfalls.

The same purpose is obviously served by the agitated, frenzied, dashing about of the figures, the sudden, violent, expressionistically emphasised gestures, the use of flaring, flickering colour as if lit up by a flash, in short, the whole restlessness of the work, which contrasts sharply with the contemplative spirit that prevails with Pontormo. Even the tall, narrow shape of the picture, already used by Pontormo, is so exaggerated as to become an additional source of unrest. The dynamics of the scene, and in particular the hurried nature of all the action in the upper part, can best be described as a gymnastic effort. A similar use of ladders as 'gymnastic apparatus' in Crucifixion scenes appears in Bachiacca and Puligo (1515–18), and Rosso may have seen one or other of Bachiacca's two *Descents from the Cross* (in the Uffizi and the Museo Civico, Bassano), which seem to go back to a type of representation created by Perugino.[29]

The special character of Rosso's next important work, his rendering of the biblical episode *Moses Defending the Daughters of Jethro* (about 1523, Uffizi) (Pl. 64), and the important part played by it in his development, are due to the unique, paradoxical, and at that time completely novel treatment of space. The paradox consists in the remarkably powerful spatial effect, notwithstanding the absence of all indication of depth, whether by perspective foreshortening, or architectonic or other localisation. The effect is produced exclusively by the combination of human forms, which have the autonomy that Pontormo tried to give them; that is to say, there is a complete abstraction of all external scenery in the rendering of the group and its definition in space. The scene is nevertheless divided into three distinct levels of space, or rather of relief. Rosso limits the non-human spatial coefficients to one single step which separates the spatial level of the foreground from that of the middle, and a balustrade which separates the latter from the background, and thus divides the picture space into three zones. The constituent principle of the space thus divided into three layers in which the action takes place is that the figures are arranged behind or above one another instead of forming a continuum. Another feature of this paradoxical spatial organisation is the combination of the exaggeratedly plastic rendering of the physical volumes of the figures with the flat and frontal, so to speak two-dimensional, aspect characteristic of the work. This aspect is emphasised chiefly by the frontality of the figures, that is to say, the parallelism of their positions and movements to the picture plane. Incidentally, in spite of the plasticity of the individual figures, there is a certain flatness about them, as they are not so much modelled in the round as broken up prismatically and show all sorts of corners and edges.

The mannerist character of the space is essentially a result of a *horror vacui* that is not, as it is in so many cases, associated with the practice of leaving it empty in places, but results in this instance in such an overfilling of the whole picture that the effect is similar to that of a tapestry with a crowded ornamental pattern. The chief means of formal organisation again consists in a harmonisation and repetition of forms and contours, only this time it is carried much further. The lines of the arms, legs, shoulders, and backs emphasise and strengthen each other; they recur with the regularity of a musical rhythm and the variations of a canon or fugue. The heads of the chief participants in the fight are so arranged as to form a single vertical line, and are like three consonant accents. Moses, the chief protagonist and formal centre of the composition, is closely connected with all the other figures—the curve of his back with the line of the back of the man collapsing in the foreground, his raised right arm with the arm (cut off by the edge of the picture) of the man dashing in from the left and the outstretched arm of the puppet-like, terrified girl in the centre,

and the line of his left thigh and calf with the body of the dead man in the right foreground. The whole figure with its moving arms and legs resembles a wheel with rotating spokes, drawing everything into its revolving motion. But, in spite of all the success with which everything is connected with everything else, it is impossible to resist the feeling that the artist has perhaps gone too far and has overstepped the mark of what is formally organisable. At all events, there is an excess of form here at the expense of spiritual content and expression. One of the great dangers of mannerism is near at hand.

Rosso's third great work, though its greatness lies rather in its art-historical importance than in its artistic merit, is the *Transfiguration* in the cathedral of Città di Castello (1530) (P. 65). It was painted during his wanderings after the sack of Rome, and vividly expresses the sense of crisis, the insecurity and fear, characteristic of those years. The strangeness of the rendering, the eccentricity of the types, the fantastic costumes, and the abstruse combination of far-fetched motives chosen with defiant arbitrariness, have struck the critics of all generations. Vasari's remarks about 'Moors, gypsies and the strangest things in the world' have been repeated on all occasions, for they express the general feeling that here we are faced not so much with a high spiritual mystery as with a procession of masks. The arbitrary and extravagant features are the more striking and conspicuous in that they are associated with entirely different classical formal elements which Rosso made his own during his stay in Rome from 1524 to 1527. An example is the imposing female figure in the left foreground, who is of a really classical majesty and beauty. In comparison with her the corresponding figure on the other side seems actually grotesque, not only because of the fantastic costume, but also because of the completely different proportions, reducing the head to about one-tenth of the length of the body. We are not confronted with a mere return to the expressionism of the *Descent from the Cross*, for all the violence of that work remains within the limits of a homogeneous style, while here there is a surrealistically playful and arbitrary formal complex which is less an end in itself than a protest against the all-too-easily attainable equilibrium of classical art.

Immediately after the completion of the *Transfiguration* there took place the most important event in Rosso's life—his migration to France, which seems to have brought about a sudden change, not only in his style, but also in his whole outlook. From an artist of the extreme *avant-garde* he turned into the master of a well-nurtured, balanced, though still piquant style, and the rebel and innovator became a docile servant of his royal patron and courtly public. Of this there is no doubt, though little of the work he did in France survives in its original form. Only a few traces of his work at Fontainebleau remain, as most of it was replaced or restored

and partly altered by other artists, chiefly Primaticcio. What we know of his activity there is based on contemporary engravings and his own drawings, the authenticity of which is not always beyond doubt. His development in France cannot be followed, particularly in view of the fact that it was never at any time straightforward and consistent even at home in Italy, that is to say, under much more uniform conditions. Not only did he make daring leaps from one important work to the next, like Pontormo, but sometimes he took a step backwards, and often took such a huge leap forward that it could hardly be described as a development. It seems highly probable that the impressions he received in Rome exercised a powerful after-effect, and the predominant influence in the frescoes at Fontainebleau must have been the decorative style of the school of Raphael, or more specifically that developed by Francesco Penni and Perino del Vaga.

The *Pietà* in the Louvre (1537–40) (Pl. 66) is connected by many links with the earlier works executed in Italy, but most closely with the story of Moses; in contrast to the latter, the Roman influence appears in the increased rationality, greater simplicity, and greater compactness and unity of composition. The fact that the types in general are more imposing and majestic and are drawn in a more broadly sweeping manner, and that the whole scene is dominated by a single stream of movement and a single great line of direction, must also be ascribed to this influence. On the other hand, the overcrowding of the space, the packing together of the figures, and the abandonment of the last remnants of any comfortable relationship with the environment, merely so that the latter may appear as general and undefined as possible—remain unchanged, or are actually more pronounced. Space in the real sense of the word can hardly be said to exist here; the extraordinarily shallow layer filled by the composition has merely the depth of a relief. Apart from the relationships of the figures to each other, the only spatial indication is provided by the cushion on which the body of Christ lies; the figures themselves are woven into a tighter mesh of crossing, consonant, and contrasting lines and curves than occurs even in the story of Moses. The place of the play with horizontals and verticals in the latter is taken in the case of the *Pietà* by the strong emphasis laid on a single diagonal,[30] the predominance of which creates the same baroque-like impression as does the pathos of the picture, which contrasts with the artist's earlier intellectualism. However, it is the only known work of Rosso's late period in which he preserves the power and spiritual intensity of his youth. To compensate for the loss of these things, in the Fontainebleau decorations, the forced and strained elements of his earlier period make way for a more fluent way of expression.

Dvořák claims that Rosso's work at Fontainebleau leads directly to the 'light, elegant and witty play of fantasy' that 'becomes characteristic of

French art as well as literature in the second half of the century and can be counted among the characteristics of French art in the following period also'. He adds that:

> Rosso was certainly not the first to produce this spirit, the roots of which reach further back and are connected with the late gothic culture of France and its pleasure in intellectual subtlety. Rosso may have approached it here for the first time but, by linking it on the one hand with the poetical trend of the school of Raphael, that unique world of poetical fiction, and with Florentine delicacy and Michelangelesque mastery of form on the other, he gave it an artistic content the effects of which can be traced right into the nineteenth century.[31]

The objections to this train of thought are those that can be made to all arguments based on constancy of national character or unchanging racial characteristics. The refinement of taste, elegance of expression, and wit generally regarded as typical of French art and literature are to a great extent the products of mannerism and only to a slight extent a heritage of the gothic, and are least of all the result of any racial disposition. The extent to which Italy, the example of Italian mannerism, and the activity of Italian artists in France may have contributed to the development of these tastes and talents is, however, a question independent of that of the significance of mannerism in the history of French culture and the western spirit in general.

Domenico Beccafumi, who with Pontormo and Rosso completes the trio who founded Tuscan mannerism, in spite of the Sienese artistic heritage that he received through Sodoma, freed himself more thoroughly and radically of emotional baroque tendencies than did Rosso, for instance, who ended by showing signs of the stylistic ambiguity which can be detected in the works of practically all the artists of the Cinquecento during the years of crisis. In 1512, immediately after his return to Siena from a stay in Rome, he seems to have been closer to mannerism than his ten-year-younger colleagues in Florence, and once he found his way to it he remained much more consistent in the use of its forms than they did. But there are peculiarities in his mannerism that differentiate it in many respects from that of Pontormo and Rosso. The most striking are the more painterly style, the warmer and more differentiated colour tone, the broader, though not more *pastoso* brush technique, and the new chromatic values. He uses not only a wider range of colour, but also stronger contrasts on the one hand and richer gradations on the other. Many of his tones emerge harshly from the background and are emphasised by violent streaks of light. The objects illuminated in this way stand out coldly and

crudely, but others gleam darkly, like coals under a heap of ashes. The sharp, acid effects are balanced by the warmth he obtains in screening the lights. He often uses thin, light colours which fade into one another, approaching a water-colour technique, while in other cases he uses heavy, dark tones and deep shadows. Modest beginnings in this direction were made by other artists, but he is the first to exploit the special effect of iridescent colours, and thanks to him these become one of the technical means of mannerist painting.

There is also an essential difference between his art and that of the Florentines in matter and mood. He is no less progressively minded and preoccupied by problems, but he is much less intellectual than Pontormo and less arbitrary in his choice of means than Rosso; in accordance with the petty bourgeois spirit of his birthplace, he represents a much more popular and much less sophisticated taste. His pictures often recall medieval mystery plays with their hell-fire and heavenly magic. The harsh contrasts he is so fond of using are also reminiscent of these; unlike the delicately balanced contrasts of the Florentines, they have a rather obtrusive and distinctly theatrical effect. Sometimes he is as bizarre and fantastic as Rosso, but his impact is ghostly rather than spiritual or other-worldly, and he pursues horror effects where the more sophisticated Florentine is satisfied with strangeness and mystery.

Beccafumi's principal works, the *Fall of the Angels*, *Christ in Limbo* (Siena, Pinacoteca) (Pls. 70, 71), and the *Last Judgment* (Siena, S. Maria del Carmine) (Pl. 72), were all painted in the third decade of the Cinquecento, and represent his style at the summit of his development. The magnificent, though still rather chaotic composition of the first of these paintings yields to a more lucid arrangement in the *Last Judgment*, a work that is also richer in painterly values, though in certain details, such as the nudes in the foreground, for instance, the *Fall of the Angels* remains unsurpassed by him. Even *Christ in Limbo*, the most mature of his great altar-pieces, is in the last resort only a combination of splendid individual figures the Michelangelesque origin of which is striking, most obviously so in the repoussoir figure in the centre of the foreground, the 'Eve', and the man of athletic stature behind Christ, whose forced attitude is quite distinctly mannerist. All these figures have an exquisite beauty that has always been rightly admired, though it is somewhat self-conscious, self-sufficient, and detached in relation to the rest of the picture. Less successful than the individual figures is the formal organisation of the pictorial elements by the correspondence of attitudes and consonance of movements which is a principal source of the artistic impact made by the two Florentines. Beccafumi's use of formal parallelism is sometimes noticeably naïve and provincial, as, for instance, in the case of the two men looking up to Christ in the Limbo picture.

His smaller compositions are often more attractive and in many respects more interesting than the big, representative works. Most notable of them is the *Birth of the Virgin* in the Pinacoteca at Siena (Pl. 73), a picture that shows the artist at his best, not only because of the originality of the arrangement, the lateral grouping of the figures, which is executed with a supreme sense of weight and balance, but also because of its painterly qualities. From the point of view of stylistic development, the significance of the work lies above all in its rendering of space. It is one of the first mannerist paintings in which there is emphasised recession, a sudden and violent thrust into the depth by way of a long and narrow channel. This arrangement, which is basic to the optics of the picture, is produced here by a flight of rooms, that is to say, by the view into a second room opened up by the door in the background. The tendency to lay emphasis on depth is to an extent underlined by the displacement of the vanishing point to a position close to the edge of the picture, that is to say, by the use of a spatial coefficient that produces an uncommonly striking effect because of its unusualness and directive emphasis.

In about 1530, when Pontormo was showing the influence of Michelangelo's later style and Rosso settled in France, the first, revolutionary, impassioned, and almost feverish phase of mannerism, mainly characterised by an expressionistic spiritualism, came to an end, and a period of quieter, more exteriorised, spiritually more aloof, stylistic aspirations set in. This saw the beginning of the artistic maturity of Bronzino and Parmigianino who, like Pontormo and Rosso, were born in the same year (1503). The ten years that separate the dates of birth of the two pairs of masters are of vital historical importance; the difference in age partly explains the greater calmness of mood of the younger pair.

The second phase of early mannerism that now began prepared the way for the style of the second generation, that of mature, academic mannerism, the so-called *maniera*. Nevertheless Bronzino and Parmigianino are and remain the contemporaries and share the mentality of the founders of the style, and have much less in common with the academicians, though basically they have thrown off the revolutionary spirit of the *avant-garde*. They introduce the process of normalisation and the laying down of rules. With them there begins the setting up of established models for the artist to follow, and their works, instead of succeeding one another with arbitrary and improvised solutions lacking in any real continuity, are adapted to a homogeneous style. This style is by no means impersonal but, because of its tendency to formulas, bears within itself a propensity to the depersonalisation of the means of expression. In comparison with Pontormo's and Rosso's spiritualism and expressionism, wealth of imagination and boldness of invention, warmth of painterly

style and brilliance of draughtsmanship, Bronzino seems cold, stiff, and pedantic and Parmigianino artificial and mannered, that is to say, not free of a tendency to the stereotyped. In both there is discernible an inclination to cling to certain formulas, in contrast to the continually changing, dynamically charged, emotional world of Pontormo and Rosso.

By his imitation of Michelangelo, Bronzino, partly under the direct influence of the master,[32] partly stimulated by Pontormo's Michelangelesque development,[33] took the decisive step in the direction of Vasari and his followers. With him there appear for the first time in mannerism in the narrower sense of the word the external marks of Michelangelism; emphasis on physique and the muscular system, sculpturelike modelling, marble-like coldness and smoothness of surfaces manifest themselves to an extent that is otherwise characteristic only of Michelangelo's direct followers. In Bronzino all this is still remote from the academicism of Vasari, but we are faced with an important turning-point in artistic development, and a not unimportant one in political and social history. The consolidation of princely rule was in sight, and by assuming a courtly character mannerism simultaneously lost its arbitrary, wayward features. For the first time, though only temporarily, the dependence of the style on classical art outweighed its opposition to it. Thus the authoritarian spirit that prevailed in courtly Florence established itself, and fixed standards were clung to wherever possible.

The ideal of cool and unapproachable *grandezza* which the Duchess Eleonore brought with her from her Spanish home was most immediately and palpably realised in art by Bronzino, who with his correctness of form and flawless technique was the born court painter. At the same time, he was also a typical and unmistakable mannerist by reason of what he betrays about himself and those whose portraits he paints, as well as by what he holds back and conceals behind the cold and severe expressions, the self-discipline that his sitters preserve in relation to the outside world, the 'armour of cool bearing'[34] with which he protects them against the importunity of the inquisitive. Pontormo had painted exquisite portraits (Pls. 76, 77), highly characteristic of the style, which in certain respects were never to be surpassed, but Bronzino was the first representative mannerist portraitist who pointed the way and served as an example for the whole movement to follow. With him the face is obviously not the mirror of the soul, but its mask, and the portrait is an art form that conceals as well as reveals. The painters of the Renaissance did not doubt their ability to portray men truly and completely by their physical and in particular their physiognomical features, and their models had not the slightest objection to being portrayed as they really were. Now the possibility of such true portraiture was neither believed in nor aspired to, the less so as both artist and model seem to have felt that the soul is just as

alienated by its physical shell as it is by any other material medium, and that consequently in the last resort the face is just as alien to the soul, just as external and material as, say, a man's clothes, jewellery, or weapons. Thus the contrast, or even the qualitative difference, that continually surprises and often puts us off in the portraits of the age, namely that between the real portrait and the accessories that are often painted with such meticulous care, simply did not exist for Bronzino and his patrons.

The enlarged hand in the foreground of Parmigianino's *Self-Portrait from a Convex Mirror* (Vienna, Kunsthistorisches Museum) (Pl. 78) links the spectator with the image that the painter sees in the mirror, but at the same time puts a barrier between him and the picture, that is to say, between the painter and the outside world. The hands of Bronzino's portraits fulfil a similar function. They are, of course, part of the characterisation of the high breeding of his models, but at the same time they put a distance between the observer and the persons portrayed, create a barrier that prevents them from betraying their personality through their portrait. Those fine, delicate, cool hands keep one away; they are part of the 'armour' behind which all feeling, directness, and intimacy are shut off. They are part and parcel of the 'accessories', like the rich detail of the costumes, the carefully worked jewels and weapons, the architecture and sculpture, and the other things that prevent direct contact with the person portrayed (Pls. 79–83).

The court painters of the age, no matter whether their names were Bronzino or Coello, Holbein or Antonis Mor, all had to portray their models, the members of princely families and their courts, with an objectivity that deadened all sensibility and emotional directness in them. Dürer and his contemporaries showed their models directly involved in the course of the world, and nobody had any objection; Holbein and the other portraitists of his age had to show them in an attitude of reserve and apparent indifference.[35] The sense of alienation prevailed, not only in the lower classes of society, but also among its leaders; and in portraiture this expressed itself in an ostentatious indifference towards the observer. In the subsequent baroque period, when absolutism had created a much greater distance between rulers and ruled, this expression of indifference vanished from the portraits of kings and princes. They looked about themselves more proudly, but seemed to have grown personally more approachable.

Nowhere is it more evident than in portraiture that narcissism is only the obverse side of alienation. The complete self-withdrawal and concentration on themselves of the models of Bronzino and most of the mannerist portrait painters is not only a result of their alienation from the world, their separation from mankind, but is also an aspect of their isolation, their sense that they have nothing in the world except themselves, or nothing better or nobler or more worth while.

Bronzino as a painter of religious and allegorical compositions is a long way behind Bronzino the portraitist. In the portraits the smoothness, coldness, and stiffness of the way of painting is stimulating because of the meaning it helps to convey, but in the rendering of scenes from the Bible or literature all this has a lifeless, artificial, and monotonous effect. His Venuses, his Eve, and other similar nudes are in general academic, though in their way they are masterly studies after ancient models. They are beautiful, rigid, and bloodless, like marble. The posture of the individual figures is forced, the relations between them are complicated and often hard to discern, the movements seem studied, and the groups, notably in *Christ in Limbo* (Florence, Museo dell'Opera di Santa Croce) (Pl. 84), are closely packed together without reference to spatial values such as the variation between over-crowding and emptiness of different areas in Pontormo and Rosso or recession in Beccafumi. Also the emphasis and combination of forms by consonance and parallelism lacks the power that it had in Bronzino's predecessors in Florence and tends to be academic in character.

In Bronzino's female figures, notably the Venus in the London Allegory (Pl. 85), there appears a new feature of great importance for future developments, though perhaps not of very great importance from a strictly artistic viewpoint. This is the first emergence of that special form of sensuality, so characteristic of later mannerism, that has been described as 'secret eroticism' and must have been in mind when this period was described as the 'birth-hour of prudishness'.[36] This prudishness, or what is referred to by that term, is another phenomenon connected with courtly prejudices, rules of etiquette, and aristocratic camouflage. Sex is subjected to a ritual to make it the more subtly enjoyable, and a veil is drawn over it, not to conceal but to emphasise it. All concealment draws attention to what is concealed, and all prudishness is the sign of a bad conscience; but in mannerism the real purpose of concealment is to reveal, and prudishness is merely a form of repressed lasciviousness.

Mannerism splits from the very beginning, so to speak, into an introverted spiritual and expressionistic trend on the one hand and an extroverted artistic and decorative trend on the other; this to an extent lies within the potentialities of every single artist of the age, and is inherent in the dialectical nature of this style torn by conflicting urges. But it is only with the beginning of the second phase of early mannerism that the resulting antithesis of formal principles becomes unmistakably clear. It is Bronzino's and Parmigianino's formalism that makes the spiritual nature of Pontormo's and Rosso's art so striking, and it is only when one bears these artists' work in mind that Parmigianino appears as affected and Bronzino as stiff and cold as they seem to us to be. Both trends, the essentially spiritual and expressionist art of Pontormo and Rosso as well as

Parmigianino's aspiration to beauty, harmony, and elegance of form, remain fundamental to mannerism. From time to time one or the other may seem to predominate but, except in works of minor importance, neither ever completely disappears. In spite of the predominantly decorative trend, irrepressible expressive impulses are at work in Parmigianino, just as decorative and formal trends are present in Pontormo and Rosso side by side with their sublimated spiritual interests. The trend initiated by Pontormo reaches its peak in the art of Tintoretto and El Greco, while that which Parmigianino originated to a great extent comes to fruition under the immediate influence of this so short-lived master, in the absence of whose influence the *maniera* and the academicism of the second generation of the artists who followed his manner would have been unthinkable. The cult of the pleasurable and the precious that dates back to him, and the cultivation of a rather finical and affected beauty of line, remain a permanent element in subsequent development, even where the formal and decorative are far from playing such a decisive role as they do in the *maniera* or the academicism of the middle of the century. Even the formal language of Tintoretto and El Greco, which represents the deepest and most spiritual form assumed by mannerism, would have been inconceivable but for the impact of Parmigianino.

If Parmigianino is held to be the mannerist *par excellence*, and his influence is regarded, not merely as a constituent element, but as the essential characteristic and *sine qua non* of mannerism,[37] the necessary consequence in formulating a definition of the style is that, while due attention will be paid to its aspiration to grace and beauty and its tendency to the sophisticated and affected, injustice will necessarily be done to the other, equally important factor, namely its aspiration to expressionism and spiritual depth; and consequently the real criterion of mannerism will be the exquisite and artificial, thus unacceptably restricting, if not actually distorting, the concept. Spiritualism and formalism are just as inseparably linked in mannerism as are the principles described by Dvořák as those of deduction and induction. If justice is to be done to the antithetical nature of the style and the dialectical development of its forms, neither element must be neglected, and it must continually be borne in mind that both are borderline terms and in practice are invariably interwoven with each other, though the individual representatives of the style are always more closely associated with one or the other. If the introverted spiritual element predominates in the art of Pontormo, Rosso, Beccafumi, Tintoretto, Barocci, Bruegel, and El Greco, the extroverted artistic and decorative element prevails, not only in Parmigianino, Bronzino, Vasari, and the representatives of the *maniera* in the narrower sense, but also in artists such as Primaticcio, Niccolò dell'Abbate, Federico Zuccari, Procaccini, Spranger, Wtewael, Bloemaert, Hans von Aachen, and Josef Heintz. At

all events, the two trends characteristic of the whole style appear side by side or in immediate succession in all the three phases of development that can be distinguished in the history of mannerism; in each, side by side with a trend inclining towards spiritualisation and expression, another trend is discernible leading in the direction of formalism and decorative values. But the various factors in the stylistic dialectic, spiritualism and sensualism, expressionism and formalism, introversion and extroversion, always appear in different degrees of strength and effectiveness.

Parmigianino is one of the most original artistic personalities of the Cinquecento and undoubtedly one of those who contributed to the development of the artistic means of mannerism in the most creative way. Nevertheless his special version of the style is not a complete innovation, or an entirely personal variation, or even a variation he developed in reliance only on Correggio. In any case, it is to the latter that he owes the light and gentle flow of his line, his sensuous delicacy of draughtsmanship and voluptuousness of form, his feminine sensibility and erotic subtlety. The other main source of his style is the work of the Roman classics, which he had the opportunity of studying during his stay in Rome between 1524 and 1527. Both Raphael and Michelangelo became so important to him that without them many of his later works, in particular the Steccata decorations, would have been inconceivable. Parmigianino's relationship with the classical masters was much less problematical and ambivalent, that is to say, much more positive, than that of Pontormo and Rosso, and he could with a certain amount of justification be regarded as a follower of the school of Raphael, and in one phase of his development even as a representative of the Michelangelesque trend. But an important source of his conception of mannerism was also provided by the Florentine mannerists, and he must have been particularly impressed by the works of Rosso with all their strangeness. It is noteworthy that Parmigianino's stay in Rome coincided with Rosso's, which makes a closer contact between them seem most probable. The influence of Rosso's extravagant manner is evident even in a late work of the younger artist such as the *Madonna del collo lungo*, in which, among other things, the tiny background figure with the scroll, both because of its proportions and its lack of connection with the rest of the picture, might well have been an invention of the painter of the *Descent from the Cross* at Volterra or the *Transfiguration* at Città di Castello. True, a great deal of Rosso's fire and turbulence disappears in Parmigianino, and with the diminution of the blaze mannerism gradually assumes the stereotyped forms of preciousness that herald the *maniera*. A number of artists whom Parmigianino met in Rome, such as Perino del Vaga, Giulio Romano, and Sebastiano del Piombo, either belonged to the school of Raphael or were followers of Michelangelo, and thus already moved in the spiritual atmosphere of mannerism, and not

only confirmed him in that trend, but obviously also counteracted the influence of Rosso's extravagances and contributed to the quietening down of the style.

Another artist who must be taken into account in connection with the formation of Parmigianino's style is Pordenone, as represented above all by his frescoes in the cathedral of Cremona (Pl. 86). His dynamic style in general, his emphasis on subsidiary figures at the expense of the protagonists, his overloading of the foreground by not confining himself merely to the use of repoussoir figures, but by actually breaking through the picture plane and making, for instance, a horseman jump out of the background into the onlooker's space (Pl. 87), in short, the original fashion of his disintegrating the homogeneity, unity, and compactness of classical representation, provided a strong impetus in the direction of mannerism, particularly in Venice, with which he was connected by many ties; and this influence must have affected Parmigianino, who in his *St. Isidore* (Pl. 88), a fresco painted as early as 1522 in the church of S. Giovanni Evangelista at Parma, uses, for instance, the illusionistic effect of the strongly foreshortened form of a rearing horse with forelegs protruding into the space in front of the picture plane.[38] This was undoubtedly suggested by Pordenone's Cremona frescoes, which were executed in 1520–21, but must have been known to Parmigianino before he completed his own frescoes.[39]

Though Parmigianino was a follower of Correggio, baroque elements take second place to the mannerist elements in his artistic formation, as they do with the immediate successors of Raphael and Michelangelo. The 'baroque' Correggio becomes a source of inspiration in the history of painting only much later, and Parmigianino took from him only what there was to be exploited manneristically. The relative importance of the two artists is not affected by all that. Playing up Correggio against Parmigianino is an old hobby-horse of conservative art historians. Whatever valuation is placed upon them as artists, the stylistic connection would remain the same if the distribution of talent between them were reversed. The work of an artist like Parmigianino, whose purposes were in many respects in conflict with those of Correggio, cannot be judged by standards derived from the art of the latter; and there is the less justification for reproaching him with artificiality and affectation as spontaneity and directness are not among the predominant features of Correggio's art either. However that may be, Parmigianino had no desire to create a spontaneous or natural impact; on the contrary, those were things that he specifically wished to avoid, and he must be judged as an artist above all by the extent to which he achieved his aim. It is possible, under the influence of the baroque and impressionism, to take more pleasure in Correggio's more sensuous, richer, and more mature colouring, and in his

mellow and apparently improvised way of painting, than in the smooth and hard, porcelain-like surfaces and the cold and bright enamel brilliance of Parmigianino; the latter, however, will have been among the things which he felt to be progress in relation to the work of the older master, and perhaps cost him a greater expenditure of effort than would have been involved in simply continuing with Correggio's way of painting.

All Parmigianino's artistic aspirations were concentrated on achieving a new ideal of physical beauty (Pl. 89), a new psycho-physiological human type, more delicate, more highly bred, more cultivated, with more highly developed nervous reactions, more thin-skinned and vulnerable by nature than that of his predecessors, but also more capable of and more eager for pleasure (Pls. 90, 91). Both he and his models seem more delicate, more nervous, more morbidly constituted than Bronzino and his princely and aristocratic employers and patrons. He had more freedom of action than the courtiers and court painters in Florence, but in reality he was just as inhibited, fastidious, and sophisticated as the latter, for he represented the same aristocratic, or aristocraticising, discriminating society, living a life regulated by conventions and etiquette, though not the same level of that society. However political and social conditions developed from place to place, there gradually spread throughout Italy and the civilised west a style of life based on the ideal of courtly culture, and accordingly there came into being an exquisite courtly style, a kind of rococo, at least as subtle as the art of the eighteenth century in France, but in many respects richer and more complex. With this, mannerism began to assume a universal, international character which the art of the Renaissance had never had; and, as it spread throughout the west, the virtuoso, precious, playful artistry of Parmigianino became a factor just as important as the strict Michelangelesque canon, which gained general recognition at about the same time. How well the two elements could in certain circumstances be combined is best illustrated by a work such as Michelangelo's *Victory*, which dates from that time and actually shows traces of Parmigianinesque formalism.

The *Madonna with the Rose*, in the Dresden gallery (Pl. 92), dates from the period of Parmigianino's maturity, when his reputation in Italy was becoming universal and was establishing itself internationally as well (1528–30). The picture shows for the first time, not only his elegant, highly-strung, highly-bred human type in fully developed form, his freely flowing line and effortless form, but also the subtlety with which he renders the provocative, erotic charm of his figures. That his Virgin was originally intended to be a Venus seems thoroughly credible. Never has she been more sensually, more seductively rendered, with her transparent dress, the veil-like material of which seems delicately to caress the blossoms of her breast. And never was the Child given such a close

P

resemblance to a sly Cupid or made to look more like a pagan ephebe. With Parmigianino the narcissism introduced by Pontormo, and even by Correggio and Andrea del Sarto, makes its entry into religious art. The sacred personages totally preoccupied with themselves now develop an unrestrained coquettishness and an unashamed exhibitionism; they apostrophise the observer, make eyes at him, use all the arts of seduction to attract his attention to themselves and gain his sympathy.

Parmigianino's masterpiece, the *Madonna del collo lungo* in the Uffizi, painted at the end of his career (begun in 1535 and left uncompleted) (Pls. 93, 94), combines all the important stylistic tendencies of his later period and carries them to extremes. In addition to the complex heritage of Rosso, it shows the most exaggerated elongation of forms, the slenderest bodies, the longest legs and narrowest hands, the most sensitive female face and the most delicately modelled throat, and includes the most irrational combination of subjects, the most disparate proportions, and the most unintegrated representation of space. No pictorial element seems to fit with any other, no figure behaves in accordance with the laws of nature, no object fulfils the function normally ascribed to it. It is impossible to tell whether the Virgin is sitting, or standing, or leaning against a support which may be a throne. The laws of gravity would cause the child to slip from her knees immediately, and there is no knowing whether she is looking at the child or is exclusively preoccupied with herself and her own thoughts. There is also no knowing where the scene is taking place— in an open hall or in the open air. If it is the former, what is the row of columns doing in the background, and if it is the latter, what is the meaning of the heavy curtain? In any case, what sort of columns are they, having no capital, completely functionless as they are, in fact resembling the factory chimneys with which they have been compared? And what do the boys and girls pressed closely together in the left corner of the foreground represent? Angels? Dvořák's suggestion that they are an ephebe and his companions bringing an offering to the Virgin, who looks rather like a sublimated, graceful idol, seems more probable. With this we reach the point which devotional art of this kind was bound to reach—a pagan cult of beauty. The art of Parmigianino has nothing to do with the spirit of Christian revival, with Michelangelo's inner struggle or Tintoretto's way to orthodoxy, however much it may owe to the one and however much the other may owe to it. Parmigianino found a new approach to the autonomous realm of beauty to which the Renaissance had already found a way. The aesthetic outlook as one aspect of mannerism had split off from its other components and in its isolation led to works of great beauty and charm, though the most important artistic achievements of the style required its various elements and aspects to be reunited again.

4. MATURE AND LATER MANNERISM

The beginning of the second period of mannerism, like the first, was connected with a political upheaval. On the earlier occasion the return of Giuliano de' Medici led to the destruction of the democratic régime, the liquidation of the republic, and the laying of the foundations of the autocracy which now, round about the middle of the century, began to consolidate itself under the Grand Duke Cosimo. In principle the transition to autocracy was not new, but was merely a consequence of the expulsion of Soderini and the last step in a series of events that followed each other with apparent inevitability. The consolidation of princely rule assumed the form of a process of pacification. The conservative transformation of society, the abandonment of republicanism and democratic ideals, the aristocratisation of the upper classes and the surrender of political influence by the lower, were already *faits accomplis*. The great number and the importance of the artistic commissions that went with the style of life of the new ambitious court gave the artists of Florence nothing but satisfaction and led to their complete reconciliation with the régime, in so far as any reconciliation was necessary.

The fashion in which Cosimo I organised artistic production in Florence, adapting it to the service of his political aims and the purposes of courtly representation and propaganda for the idea of sovereignty, provided a foretaste of the artistic policy and methods of Louis XIV and Colbert. Even Lebrun had his predecessor; Vasari in Florence played the role of the art dictator of the *roi soleil* at Versailles. Moreover, Vasari displayed a talent for organisation similar to that of Lebrun and, above all, grasped just as completely the significance of teamwork in meeting the needs of a court thirsty for magnificence and insatiable in its artistic demands. This task was as well fitted to the nature of his talents and that of his colleagues as it was to the gifts and skills of Lebrun and his aides, who distinguished themselves above all by their adaptability. Indeed, in both cases the objective was the maintenance of a uniform standard of quality and the provision of faultless sets of decoration rather than the production of individual masterpieces. In these conditions unique and outstanding talents that went their own lonely way could no longer establish themselves in Florence. The tasks themselves, particularly that of the decoration of the Palazzo Vecchio, were important, and an unusual wealth of material resources was put at the artists' disposal, but artistic freedom was suppressed almost as thoroughly as political freedom, and the liberalism that had been enjoyed by earlier generations was now as undesired in artistic matters as it was in civil life (Pls. 95, 96).

A kind of despotism began to prevail in art too; the Florentine painters

were not only in the service of a court and an influential production manager, but were also subject to a supreme Central Italian, Roman–Florentine artistic canon that came to hold undisputed sway. The artistic style of the second mannerist generation is essentially determined by these circumstances. Both the influence of Raphael and that of Michelangelo assumed a doctrinaire character, and that of the latter was positively dictatorial. No artist inclined towards mannerism remained free of his influence, and most became his adoring slaves. Thus Florentine mannerism merged with the Roman monumental style, and the *maniera* of the school of Vasari became just as essential a part of what was now practically an official style as the tradition of the Roman classics.

In the work of liaison between Florence and Rome Salviati perhaps played an even more important role than Vasari himself, not merely because of his incomparably greater talent and his deeper understanding of the monumental form, but also because he spent a much longer time in Rome. He first went there with Vasari in 1531 and remained, while Vasari soon returned to Florence; that is to say, he interrupted his stay in Rome in 1539 to undertake a two-year journey which took him, among other places, to Mantua and Bologna. Meanwhile Perino del Vaga had returned to Rome after an absence of ten years. He took artistic possession of the city (Pl. 97), and revived the prestige and influence of the school of Raphael at the expense of the followers of Michelangelo, in particular Sebastiano del Piombo. But Salviati himself, with his *Visitation* in S. Giovanni decollato painted in 1538 (Pl. 98), had now associated himself with the Raphael tradition, and combined this with Michelangelo's treatment of form in a manner that became the model for the monumental style of the second mannerist generation. A similar function was fulfilled by another Florentine, Jacopino del Conte, who between 1538 and 1541 painted three frescoes and an altar-piece also for S. Giovanni decollato, that great exhibition place of mid-century Roman monumental art (Pl. 99). The style of both artists adheres on the whole to the same formal principles and bears witness to the uniformity of their aspirations, though Salviati was far superior to his colleague and soon put him in the shade.[40] In 1541, when Jacopino painted his *Baptism of Christ* (Pl. 33) and Salviati returned to Rome from his travels as a master able to keep pace with the times, armed with new experiences, and in particular enriched with deep impressions derived from the art of Parmigianino, his superiority became evident.

Among the artists who best represent the Roman monumental style of the age is Daniele da Volterra. In his *Descent from the Cross* of 1541 in the church of Trinità dei Monti (Pl. 30) he not only combines the Raphaelesque way of expression with the Michelangelesque sense of form which naturally predominates with him, but also he already shows

signs of Salviati's influence. With this the heritage of the first generation of mannerism, as seen, for instance in Rosso's *Descent from the Cross*, reappears to a certain extent.[41] If either of the two contemporaries shows a closer affinity to Rosso's somewhat too insistent play with line, it is Daniele; Salviati's attitude to his fellow-Florentine is much more reserved.

This grave and imposing monumental art had narrow limits, however, both in space and in time. Outside Rome, and after the middle of the century in Rome itself, it gave way everywhere, and particularly at Bologna, to North Italian, that is, Parmigianinesque influence. This established itself even in Florence, in so far as Vasari made less impact with the monumental than with the more decorative features of his art and gained a wide following chiefly as a master of interior decoration. With that his school set off in a direction different in more than one respect from that of Roman monumentality. Now for the first time mannerism became manner, *maniera*, and the mannerist became the mannered. The style of Pontormo, Rosso, Beccafumi, and Parmigianino was still thoroughly creative, original, and revolutionary, but the manner of the second generation partly degenerated into a mechanical routine devoid of originality, repeating set patterns and following ready-made examples instead of nature. The mannerist form that owed its vitality to its conflict with classicism and the natural and rational vision of life, the objective and normative representation of reality, declined into a mannered formula, an established, abstract and, broadly speaking, unvarying pattern. It is interesting to note that the seventeenth-century critics, that is to say, the Belloris and Malvasias, do not attack the artists of the first mannerist generation whom, thanks to their correct though not entirely unprejudiced feeling for artistic values, they are able accurately to differentiate from the later; the objects of their denunciations are Vasari, Samacchini, Procaccini, and their like, whom Malvasia specifically mentions as horrifying examples.

The second period of mannerism, significantly enough, is also that of the birth and rapid development of academies and art schools, the formulation of more or less explicit and teachable rules of painting, and untrammelled authoritarianism in artistic practice. This applied both to form and content, and to lay and ecclesiastical art alike, and its exercise was shared between the patrons of art and their advisers, the clerical authorities and the art experts. These circumstances were in perfect harmony with Vasari's position and duties as well as with his personal inclinations, and in all this the spirit of the Council of Trent also came to make itself felt. The liberalism of the church in relation to art gradually ceased; artistic production came under the supervision of theologians, and painters, particularly when undertaking church commissions, had to abide by the instructions of their spiritual advisers. Later, during the

decoration of Caprarola, Taddeo Zuccari was given instructions even about the choice of colours, and during his work in the Sala Regia Vasari adhered strictly to the advice of the Dominican Vincenzo Borghini, the great authority on art matters of his time.[42] The theoretical and dogmatic content of the mannerist fresco cycles and larger altar-pieces is generally so complicated, and requires so much theological and philosophical knowledge, that cooperation between painter and theologian must be assumed even when there is no evidence of it.

Vasari's *Immaculate Conception* (1540–41, in the SS. Apostoli, Florence) (Pl. 100) is characteristic both of the style and the artistic spirit of the age, as well as of the special talent, with its flexibility and its limitations, that he brought to such work. The Immaculate Conception was the subject of much ecclesiastical debate around the middle of the century, and was a very difficult one; its rendering involved dogmatic implications which obviously made theological advice essential. Without such advice no artist would have ventured on the symbolism of the Fall or of figures such as Abraham, Isaac, Moses, etc., in that context. In the drawing of his already rather stereotyped figures, particularly those in the foreground, Vasari keeps to the Michelangelesque athletic types, the contrapposto effects, the characterisation of old men and a great deal in the attitude of the Virgin. The handling of space and the filling of the picture plane depart, however, from the spirit of the great master; posed models are used and the practised postures do not suggest real depth or produce the effect of balanced decorative order. Though by no means unskilful, the picture is the first boring and 'academically' uninspiring picture by a leading mannerist.

It is no accident that Vasari was the founder of the first proper academy of art. Earlier academic institutions were no more than improvisations; they had no regular curriculum, confining themselves to casual and disconnected evening classes, and consisting of loosely associated groups of teachers and pupils. The academies of the age of mannerism, however, were rigidly organised institutions,[43] and above all the teacher–pupil relationship was as clearly defined as it had been in the guilds, though on different principles. The academies had to fill the gap left by the guilds in representing their members' economic and professional interests, but it was chiefly as training schools that they did so; and they quickly developed into a different kind of the old, narrow-minded, intolerant, and unprogressive institution. The teaching was actually much more pedantic, because more systematic and less personal, than it had been in the guild workshops. Developments tended inevitably towards the ideal of a canon of instruction that was first realised in classical France, but originated here. The spirit of the Council of Trent, the looming Counter-Reformation, the *maniera*, authoritarianism and academicism, all belonged to-

gether, and were merely different aspects of one and the same thing; hence it seems so reasonable that this middle period of mannerism should also have been the birth-hour of the academies. In many aspects the way was already prepared for the transition from the guilds to the academies; in many places artists had come together outside the guilds in so-called confraternities, which were relatively liberal religious and charitable organisations. There was one of these in Florence, the Compagnia di S. Luca, and Vasari was able to build on this when he persuaded the Grand Duke to found the Accademia del Disegno in 1561.[44]

In spite of their unequal talents, Vasari and Salviati can be said to have shared a tendency to academicism to the extent that their mannerism is marked by the same previously unprecedented ecclecticism and that they combined the most important traditions and innovations of the age, that is, not only Raphaelism and Michelangelism, but also the achievements of Parmigianino and the trends deriving from him and the survivals from the first period of Florentine mannerism. In Salviati this is not in the least disturbing in masterpieces such as the *Visitation* in S. Giovanni decollato, the *Caritas* in the Uffizi (Pl. 101) and the *Allegory of Peace* in the Palazzo Vecchio, but Vasari never lets us forget his eclecticism. The works in which he shows his best side as a decorator in the grand style, above all, the frescoes of the Cancelleria in Rome (Pl. 103) and the most successful wall paintings in the Palazzo Vecchio (Pl. 104), are those in which he is least objectionable in this respect, though there is nothing great about these other than their size. Salviati's *Visitation*, on the other hand, shows how much of the real greatness of classical art survived within the limits of academicism and the *maniera*. The same difference that is evident between Salviati's and Vasari's historical paintings is to be seen in all their art, including their portraits, though both build on the same Florentine foundations, the portraiture of Pontormo, Rosso, and Bronzino. Vasari's portraits are sober and correct, their colours are cool, dull, and unappealing, while Salviati as a portraitist shows qualities possessed by no other Central Italian master of the time; he conceives his pictures in a warm, almost lyrical tone, similar to that of Venetian painting, which he also recalls as the only representative of Italian mannerism of the middle period who is comparable with Tintoretto.

Among Vasari's most remarkable achievements was the formation of a group of artists who, because of the uniformity of their aims and the closeness of their cooperation, can be described as the first mannerist 'school'. He trained pupils in such large numbers, and in such an adaptable and flexible spirit, that they were suited in every respect to spreading his version of mannerism throughout Italy and beyond; and by becoming his colleagues and cooperators they made possible the execution of the commissions entrusted to him by the Grand Duke, thus making of mannerism

a collective possession, a form of art that could be passed on and further developed. The remarkable feature of Vasari's work as organiser and teacher was that under his guidance his pupils and aides produced more attractive works than most of those he produced himself.

The most gifted and best known of his followers were those who took part in the production of the paintings in the *studiolo*, Cosimo's study in the Palazzo Vecchio, the most successful collective work done by the group. Those who took part in it included Jacopo Zucchi, Francesco Poppi, Battista Naldini, Girolamo Macchietti, Mirabello Cavalori, Giovanni Stradano, Maso di San Friano, Santi di Tito, and, in closer connection with Bronzino, Alessandro Allori (Pls. 105–8). No fewer than twenty-six young artists were engaged in the execution of the roughly thirty pictures, of relatively small size and largely elliptical shape, painted between 1570 and 1572. It is characteristic of mannerism in general and this trend of it in particular, with its secretive attitude to private life, shutting off all inner matters from the outside world, that the best available talents and the most meticulous care should have been devoted to the decoration of a small, windowless room to which but few had access. The really remarkable feature is not so much that all this talent and expense should have been lavished on one of the Grand Duke's private apartments, but that the room in which the omnipotent master of a magnificent palace spent most of his time and kept his favourite pictures should have been so small and dark.

The paintings in the *studiolo* are small in size and full of small figures. They consist mostly of renderings of mythological or historical events, or illustrations from practical life showing industrial processes and technical inventions. Most of the figures are slender, often delicate, shown as nudes with an erotic flavour. This feature increases the impression of secrecy and privacy conveyed by the practically inaccessible royal chamber. Both the minute work and the erotic tone that became characteristic of late international mannerism, as practised principally by Dutch artists at the various European courts, originated in this *studiolo* style, besides the Parmigianinesque artistic tradition as passed on by Primaticcio and further developed at Fontainebleau. To be sure, Parmigianino was not without influence on its origin, but the Dutch artists Stradano, Candido, and Sustris, who belonged to the Vasari circle, took by no means a lesser share in it than his immediate pupils and the school of Fontainebleau.[45]

In the middle of the century yet a third trend besides the Roman monumentalism of the followers of Raphael and Michelangelo and the Florentine academicism of Vasari appears in the stylistic complex generally known as mature mannerism. Its formal principles are neither uni-

form nor locally restricted, but its character is nevertheless unmistakable, and is due to the impact of North Italian painting, more particularly that practised at Parma. It is true that a not inconsiderable Parmigiani-nesque influence appears in the other two trends, particularly the Floren-tine, but in Northern Italy, above all at Bologna and Venice, it was the real origin of the mannerist change of style, and Parmigianino enjoyed an authority that competed with that of Michelangelo. At all events, he played a more important part in the history of mannerism in that area than Pontormo or Rosso, for instance.

The chief representative of the Parmigianinesque trend at Bologna, and the artist who had most to do with its spreading beyond the city and the country, was Primaticcio (1504–70). No one was closer than he to the master's gentle, elegant, erotic style, and consequently no one was better equipped for passing it on to the French artistic public of the time; and at Fontainebleau, where he went in 1532, to work with Rosso and assume the artistic leadership after his death, besides becoming one of the two founders of mannerism in France, he played an even more important role than his predecessor in developing the variety of the style that accorded with French taste.

At Fontainebleau little of his work remains, for what can be seen is mostly that of restorers. But we possess a number of attractive drawings by him in which Parmigianino's flow and elegance of form are developed in an uncommonly skilful though somewhat one-sided manner (Pls. 111, 112). One of the few paintings that can be ascribed to him and un-doubtedly dates from the time of his artistic maturity in France is the fine and well preserved *Ulysses and Penelope* (Wildenstein Galleries, New York)[46] (Pl. 113). The fashion in which the whole scene is brought forward into the narrow strip of foreground, the renunciation of illu-sionist effect in the treatment of space, which in any case is disturbed by the diminutive background figures, the consonance of the forms that dominate the composition and the melody of line thus attained, the preciosity and grace of the figures, and in particular the porcelain-like, smooth, and nevertheless sensually seductive modelling of the surfaces of the bodies, features all of which remain completely within the boun-daries of mannerism, strikingly illustrate the fertility of the Parmigiani-nesque heritage. The formula thus interpreted is so flexible and extensible that it is easy to understand why Primaticcio should have been regarded by his generation not only as an uncommonly attractive artist, but also as a reliable teacher and guide.

Niccolò dell'Abbate (about 1512–71), Primaticcio's junior by a few years, reached a lower level artistically, but a more advanced one from an art-historical point of view. His path frequently crossed that of Primaticcio, whom he probably met at Mantua before his years at

Bologna, and it was obviously to him that he owed his call to France, where he worked under his guidance and played a by no means unimportant part in the full development of the style of the school of Fontainebleau. As a landscape painter he enriched mannerism with a new and autonomous form (Pls. 114, 115). Apart from a number of attractive though not very important works, special mention must be made of his *Conversion of St. Paul* in the Vienna Gallery (Pl. 116), the attribution of which to Parmigianino has not gained unqualified acceptance.[47] Few paintings, even mannerist paintings, are more unnatural, more precious, more curious, so full of playful high spirits, so striking, even if not entirely convincing, with its wealth of curved line, as this version—or, should one not rather say, parody?—of a Biblical episode used by Michelangelo for one of his most pathetic creations. Mannerist proportions are given to the horse, which fills nearly the whole surface of the picture, and its diminutive head ceases to recall even the proportions of a work like the *Madonna del collo lungo*, but is more like a pin-head. Its movements make it look like a creature straight out of the Spanish Riding School, and St. Paul himself combines the gestures of a river-god with the devout, upward glance of the worst type of baroque devotional painting. In everything the bizarre and whimsical are driven to extremes, strangely enough without the picture's altogether losing the quality of a *trouvaille*.

Pellegrino Tibaldi (1527–96) continues the same Bolognese tradition, stemming from Parmigianino and further developed by Primaticcio and Niccolò dell'Abbate, but in his case influences going back to Michelangelo are stronger than they are with other representatives of Bolognese mannerism. In 1549 he went to Rome, where undoubtedly an original affinity was reinforced by a direct study of Michelangelo and personal contact with his followers, particularly Daniele da Volterra, and by closer acquaintanceship with the works of Salviati. After two years he returned to Bologna, where he set about the decoration of the Palazzo Poggi, which is his most successful work, and one of the most impressive achievements of the middle period of mannerism (Pls. 117–20). Tibaldi is the most gifted painter who appears in the later phase of this period of Italian art outside Venice. His art always preserves a fascinating originality in the invention of forms, and has an intensity of vision that in his country and his time can be assessed only by the standards established by Tintoretto himself, though his work is no doubt much more limited, less spiritualised, and more mannered than that of his great contemporary. Also he is the only artist of his generation within the Michelangelesque tradition who, in spite of his adherence to the now stale athletic representation of the human form, was still able to attain surprising and completely convincing effects (Pls. 121–3).

Lelio Orsi (1511–87), though he occasionally creates the impression of

being a highly individual and eccentric artist, is the best representative of the eclecticism of his generation in Emilia. He is associated with the Emilian tradition by way of Correggio and Parmigianino, with that of Central Italy by the academicism of Vasari and the Mantuan style of Giulio Romano, and with that of Roman classicism by the influence of Michelangelo, which puts all his earlier artistic experiences into the shade, particularly after his stay in Rome (1554–55) (Pl. 124). No mannerist before him produces such distinctly surrealist effects, none so arbitrarily and irrationally combines things belonging to different spheres of reality, none treats space in such an unreal, dreamlike, and at the same time so tangible fashion as he does in his religious allegory *Christ between Crosses* (Pl. 125), which has so much of Salvador Dali's obtrusiveness and piquancy about it, though with the difference that with him the *concetti* of abstruse combination of subjects, jumbled pictorial space, violence, placing apparently real figures in an unreal, symbolical framework, and so on, are first-hand, while with most modern surrealists these things create the impression of being derivative, artistically irrelevant, and dated from the first. The ornamental complexity given to a formal element, such as the cross is given by Orsi, was no more new and original at the time than many other details of the picture, but the way in which the figure of Christ is connected with the tangle of ornamental motives, the strange discontinuity of the spatial elements, and the eerie, other-worldly mood produced by the repetition in such quantity of the symbol of death and faith were and remain original.

In Venice, in accordance with the unique and to an extent independent development of art in that city, the 'mannerist crisis' occurred later than in the other leading cultural centres of Italy. At a time when elsewhere in the country the High Renaissance was producing works of classical purity at most sporadically, the local variety of classicism, which for all its greatness was never comparable in stylistic purity with that of Central Italy, still flourished. Besides Titian, Lorenzo Lotto, Bonifazio Veronese, and Paris Bordone remained essentially High Renaissance artists, in spite of occasional side-steps and temporary experiments with mannerist forms (Pls. 127, 128). Hardly any trace of stylistic crisis is to be discerned in Venice before the thirties, and the real mannerist wave reached the city only after 1540. Except for Pordenone on the mainland, in the first decades of the Cinquecento premonitory signs of mannerism can be said to have been present in Venetia, if at all, in Lorenzo Lotto (about 1480–1556), who displayed, relatively early for a Venetian, the taste for piquancy, the inclination to the eccentric and bizarre, and in some of his portraits the sensibility and aristocratic refinement that are among the criteria of the style. Works like the *Marriage of St. Catherine*

at Bergamo (Pl. 129), the *Annunciation* at Recanati (Pl. 130), the *Pietà* in the Brera (Pl. 131), and the *Male Portraits* at Venice and Milan (Pls. 132, 133) are perhaps the best examples of the mannerist tendency in his art.

Mannerist influences came to Venice from Florence, Rome, and Parma. At first it was the art of Parmigianino that made the strongest impact, and the effect on Schiavone and Jacopo Bassano in particular was to produce something in the nature of a Venetian variety of the Emilian trend. Schiavone (about 1522–63) seems to have been the artist who first familiarised the Venetians with the style of Parmigianino, and he may have been in personal contact with the young master at Parma in the thirties. The few works attributable to him, that is, the *Adoration of the Magi* in the Ambrosiana (Pl. 134) and the *Christ bearing the Cross* in Budapest (recently ascribed to Jacopo Bassano) (Pl. 135), display such great similarity to Parmigianino's fluency of line that a close connection can be assumed.[48]

Pordenone, as is known, played a certain part in the development of Parmigianino's own style, but apart from that exercised a direct effect in Venice, however the give-and-take between him and Titian in particular may have been distributed. The young Pordenone met Titian at Padua and Vicenza in about 1506 and came under the influence of the Venetian artist, who was still very young himself. But later, that is to say, after 1515, when he returned from Rome to Venetia, he in his turn exercised an unmistakable influence on Titian. A work as early as the *Assuntà* in the church of the Frari shows traces of Pordenone's explosive illusionism, and much later, in the *Battle of Cadore* (1537–38) Titian, as is shown by a copy and an engraving after the lost painting, and a drawing as well (Pl. 136) seems to have been stimulated by the same motive of a galloping horseman which had made such a deep impression on Parmigianino. In the course of his development Titian outgrew Pordenone's influence, but the latter survived all the more obstinately in Tintoretto[49] (Pls. 138, 139). Relics of Pordenone's invention lie concealed, for instance, in certain forms that he took over directly from Titian, such for instance, as the *sotto in sù* aspect in the *Miracle of St. Mark*. Pordenone must also have had an important influence on Jacopo Bassano, in whose artistic development stimuli derived from Bonifazio Veronese and Schiavone were thus deepened and broadened.[50]

For Titian the crisis was not by a long way overcome by his resistance to the first temptation. The ceiling paintings, *Abraham's Sacrifice*, *David and Goliath*, and *Cain and Abel* (Pls. 140, 141), painted in about 1543–44, now in S. Maria della Salute, represent a distinctly mannerist phase in his development, the way to which was paved by his *Presentation of the Virgin in the Temple* (about 1534–38) and continued by the *Christ Crowned*

with Thorns in the Louvre (about 1542). The renewed crisis has been explained on the one hand by Tintoretto's entry into the master's workshop,[51] and on the other by the influence of Giulio Romano.[52] These critical years were followed by another, more peaceful period. His *Prometheus* (or *Tityus*) in the Prado, dating from about 1550, is an echo of a phase of development beyond which he had now passed; but the fact that the elder Spanish art critics held it to be a copy of the mannerist Sanchez Coello is an indication of its style.[53]

The problems and doubts that Titian must have felt about mannerism were certainly not Tintoretto's, if the latter indeed harboured any such doubts. To understand the different attitude of the two artists to the problems of their age, it must be appreciated that they dealt with different sections of the public and different patrons. There was no princely court at Venice, and Tintoretto did not work for foreign courts or foreign princes, as Titian did; and it was not till late in his life that he was granted commissions by the republic. Instead of relying on courtly and state patrons, his livelihood depended chiefly on the church and on the confraternities, which were essentially religious institutions. His deep involvement in religious problems and feelings may have been partly the cause, partly the consequence, of association with these patrons. At all events, he is the only artist in the Italy of his time in whom the religious revival is as profoundly expressed as it is in Michelangelo, though in a very different form. He put his art at the service of the Confraternity of S. Rocco, a member of which he had been since 1575, on terms so modest that his primary motive must have been emotional. But, though Titian and Tintoretto were connected with different sections of society, neither was outside social causality, and neither is conceivable as an artist unconnected with the vital questions of their age. But these questions presented themselves to them in different forms and with different stress. The problems of religious renewal, which seem completely to have dominated Tintoretto's mind, at any rate from a certain period onwards, were not especially important to Titian. Tintoretto was certainly not gripped by them in the dramatic fashion of Michelangelo, who from the days of the impact made on him by Savonarola in his youth to the time of his association with the Catholic reform movement felt the struggle for the realisation of true Christianity to be a highly personal one. To Tintoretto all the things for which Michelangelo was still struggling had become a more certain possession, but he still felt alienated from the world to which Titian so easily reconciled himself, and his Christianity failed to give him the cheerful glow of peace that the baroque carried over into art from the spirit of the victorious Counter-Reformation. There still clung to his faith the flavour of a bitter, barely ended struggle; it was still full of insoluble mysteries everlastingly beyond the range of the human intelligence, full

of discontent with the shortcomings of this material world. It was this above all that made him a mannerist.

Tintoretto draws on all three sources of mannerist inspiration, the Florentine, the Emilian, and the Roman, though the alien elements in his art are not equally divided, and the Michelangelesque and Parmigianinesque far outweigh the others. But he works up all his influences in such a supreme and creative fashion that he arrives at a highly individual mannerism and, though it is permeated by Venetian stylistic characteristics, it is by no means a local form of it; on the contrary, it bears the stamp of that 'universality' which, for want of a more appropriate term, is generally used to describe the art of the great masters. So far as its sources are concerned, Tintoretto's art is composed of the same elements as that of the artists of the Bologna group, except that with these, apart from Tibaldi, the Parmigianinesque influence predominates, while with him the Michelangelesque influence is the stronger and becomes the vital one in the final formation of his style. Nevertheless, the formal language of Parmigianino also remains of fundamental importance to him, and performs the balancing, dialectical function that continually falls to formalism in the history of mannerist art. Tintoretto's role in the dialectic of historical development was essentially that he brought into play the spiritual forces of expressionism as against the extroverted academicism that prevailed in the first phase of mature mannerism, and he gave its special imprint to the second phase by his introverted, spiritual art. But he would have taken no really active, productive part in this dialectical process if he had not been aware in himself of tendencies opposite to his spiritual tendencies and these had not played an essential role in the development of his style.

His position in the history of art is unusually complicated because, though he is a mannerist of Michelangelesque origin, it is not the mannerist trends in the art of that master that made the deepest impression on him. The mannerism of Parmigianino, or even of Vasari and Salviati, who stayed in Venice in 1540, made a much more distinct, manneristically more one-sided though artistically less important, impact on him than did that of Michelangelo. It is he, however, and not the international Michelangelesque mannerism, with which he has certain points of contact but from which he nevertheless remains aloof, that is the Roman master's real heir.

The real difference between Michelangelo and Tintoretto as mannerists is that, while the former went through a number of limited, though uncommonly important, mannerist phases of development, the latter, in spite of certain fluctuations and different degrees of intensity with which he pursues the stylistic principles fundamental to his art, always remains essentially a mannerist. True, he preserves a great many of the artistic

achievements of the High Renaissance, and anticipates certain aspects of the baroque, but he never had 'reservations' about mannerism of the kind that are sometimes attributed to him.[54] There are only two phases in his development in which non-mannerist tendencies appear more strongly. The first, from 1548 to 1550, during which he painted works such as the *Miracle of St. Mark*, *Adam and Eve*, and *Cain and Abel*, shows a predominantly classical influence, characterised by strength and dynamism and directed by the ideal of plastic and monumental form. The second includes the years of his later old age, the style of which is best illustrated by the *Visitation*, in the Scuola di San Rocco, the *Battle between St. Michael and Satan*, in the Dresden Gallery, and the *Adoration of the Magi*, in the church of S. Trovaso in Venice. In spite of their predominant mannerism, these works are closer to the baroque than anything else he painted.

The most important event of Tintoretto's early period takes place at the end of the forties when, no doubt under the influence of a visit to Rome, he drops his early Parmigianinesque manner, characterised by a sympathy for Pordenone, Bonifazio, and Schiavone, and enters a phase of which the most important outcome is the epic-dramatic style of the *Miracle of the Slave*, painted in 1548, in the Venice Academy (Pl. 144). The predominant stylistic principle of this phase is the plastic form and closely integrated grouping of Roman monumental painting. In the years that follow, which are exemplified by such works as the *Creation of the Animals* (1550–51, Venice Academy) (Pl. 145), *Vulcan, Venus, and Mars* (about 1550, Munich, Alte Pinakothek) (Pl. 146), the *Presentation of the Virgin in the Temple* (about 1552, Venice, Madonna dell'Orto (Pl. 147), and *St. George and the Dragon* (the 1550s, London, National Gallery), he returns on the one hand to the looser and mellower way of painting and the more planimetric and decorative composition of his early period and on the other to a more definitely mannerist representation of space and a more arbitrary distribution and proportioning of pictorial elements. His desire to escape from the classical principles of unity, dramatic presentation, and substantial treatment of the material world is unmistakable, free play with form is carried rather too far and made too obtrusive, and for a relatively short time he draws closer to the formalism of the Emilian painters of the middle of the century than is fundamentally in accordance with his artistic purpose. His 'spiritual rebirth', as Dvořák calls it, does not really take place until 1560, when he has dropped this formalism without sacrificing the mannerism of his form, that is to say, its complete prevalence in relation to reality, or, more specifically, its independence of proportions and spatial coefficients. His abandonment of formalism is chiefly marked by the disappearance of the playful element from his form. The unnatural becomes the supernatural, the unreal becomes the

other-worldly, and the irrational assumes a higher spiritual quality. In comparison with the gravity of his new formal language, even Pontormo's way of expression seems strained and abstruse, and Rosso's freakish and coquettish. Tintoretto moves farther and farther away from the art of his immediate contemporaries. How little understanding they had of the nature, novelty, and singularity of his artistic aims and achievements is illustrated by Vasari's description of him as the 'most fantastic and extravagant spirit that the art of painting ever had to offer', a painter who 'followed the strange moods of his mind as planlessly and indiscriminately as if he wanted to show that art was no more than a joke'. True, this judgment dates from before Tintoretto's 'spiritual rebirth', but there is no reason to suppose that Vasari would have changed his mind.

The three paintings of the story of St. Mark, dating from about 1562, and the first group of pictures painted for the church and the Scuola di S. Rocco in 1565–67, that is to say, the *Crucifixion* in the Sala dell'Albergo, the *Ecce Homo*, and the *Christ Bearing the Cross* (Pl. 155), are the first in which the spiritual rebirth appears. The transition to this phase is provided by the *Marriage at Cana* of 1561 (Pl. 154), in S. Maria della Salute, which basically anticipates the vision of space of the later *Last Supper* in S. Giorgio Maggiore and produces spiritual concentration by means that contrast sharply with classical principles. The next phase in his development is represented by the second group of big paintings executed in the course of two periods (1576–81 and 1583–87) for the upper and lower hall of the Scuola di San Rocco. The most important paintings that illustrate the stylistic advance and the new artistic peak achieved by Tintoretto are the *Brazen Serpent*, *Moses bringing forth Water from the Rock*, the *Baptism*, *Agony in the Garden*, and *Ascension of Christ*, dating from the first of these periods, and the *Annunciation*, the *Flight into Egypt*, the *Maria Aegyptiaca* and the *St. Mary Magdalen*, from the second.

All these are religious pictures in the strictest sense of the word, and they are completely and exclusively religious in a way that no pictures had been since the Middle Ages. They represent practically the whole universe of the Bible and of Christian dogma, the heroes of the Old Testament, the accounts of Christ's life and the sacraments of the church, and as such form the most comprehensive series of Christian paintings since Giotto's cycle of frescoes in the Arena Chapel; and at the same time they are imbued with a religious spirit comparable only to that of the greatest works of the Middle Ages. In comparison with Tintoretto, Michelangelo is a pagan wrestling with the Christian mysteries. To Tintoretto these have not ceased to be baffling and impenetrable, but they have lost their torment. The events of the New Testament, the Annunciation, the Visitation, the Baptism, the Temptation, the Last

Supper, the Crucifixion, the Ascension, are not mere episodes in the drama of redemption, as they were to Michelangelo, but the manifestation of the inscrutable mysteries of Christianity and the transformation into history of the sacraments originating in Christ. They are revelations, not provocations.

The word 'visionary' is so frequently used in connection with art, and is so thoughtlessly and over-readily applied to mannerism, that it has almost ceased to have any definite meaning. Its application to Tintoretto is justified by the mythical, actually fantastic, element that is inseparable from his art, in spite of its unmistakable naturalism. The real and unreal, the natural and unnatural, the worldly and other-worldly, are so closely and indivisibly combined as to have no parallel, even in a period as rich in paradoxes and contradictions as this. Taine speaks of his *monde inconnu, fantastique et pourtant réel*.[55] The mysticism and fantasy of his art is inherently unorthodox, but its sacramental character, its dogmatically impeccable interpretation of Biblical events as the origin and the means of grace and salvation, give it a Catholic imprint and justify regarding it as the first unmistakable outcome of the direct impact on art of the Council of Trent and the Counter-Reformation. If there are baroque elements in Tintoretto's art, they are attributable to the same influence. The spirit of his work in its later manifestations is similar to the rigour and zeal that led to the restoration of the church in general, and behind it there is a spontaneous emotionalism and dramatic pathos that contrasts with mannerist intellectualism and partly corresponds with the climate of the baroque. But, to see how deeply his art remains rooted in mannerism in spite of all this, it is sufficient to compare his work with that of a Bernini or a Rubens. The remarkable feature about it is that the orthodox Christian feeling of the earlier is to an extent lost in the works of the final period. The vision of life expressed in these, above all in the big landscape compositions, the *Flight into Egypt*, and the two *Marys* in the Scuola di S. Rocco, is pagan and mythical, monotheist at most in the Old Testament sense, but certainly not evangelical. Thus, in spite of his deep religious and Catholic feeling, Tintoretto, like a true mannerist, moves between two worlds to the very end. This split in his nature perhaps explains why it would never occur to anyone to describe even his most passionately religious works as devotional pictures, though the term is applied without hesitation to many paintings by the far more worldly and sensual Rubens.

Tintoretto remains loyal to the fundamental stylistic principles of mannerism from first to last. In all his works there are the characteristic elongation of forms, the preference for tall, slender figures, the unequal filling of space, the abandonment of tight concentration, the relegation of the principal scene from the foreground or centre to the background

Q

or side, figures sometimes packed together and sometimes scattered widely apart, strong recession brought about by foreshortening, repoussoir figures or diagonals, emphatic contrast of dimensions, lighting, and postures, repetition, parallelism, and consonance of motives, lines, and forms, the removal of the protagonist from the centre of the picture and the consequent devaluation of the individual in favour of the group, as illustrated, for instance, by the removal of the stress from the figure of Christ to emphasise that the point is a universal message concerned with the whole of mankind.

Tintoretto enriched the formal language of mannerism by a means of expression that bore his own imprint but was basically not completely new, though in the version that he gives it it creates a completely novel effect. Different kinds and levels of reality occur side by side in mannerist paintings practically from the beginning. It is sufficient to recall the strange quality of the statues in Pontormo's *Joseph in Egypt* to be aware of the wavering sense of reality and the problematic nature of the criteria of the true and the genuine. In Tintoretto there is no more doubt of the kind and extent that prevailed with Pontormo and his contemporaries; he has made his choice, and feels firm ground under his feet, but he has not completely lost the sense of living between two worlds, and his art is still haunted by the idea of the dichotomy of the spiritual universe. This appears nowhere more plainly than in the dualism of his way of expression. He uses two different techniques for rendering the two realities, the nature of which in relation to each other he is either unable or unwilling clearly to define; he seems to desire merely to indicate the difference between them. He describes one realistically and plastically, and the other flatly and sketchily, merely hinting at forms. Thus some of his figures make a direct impact on the senses, while others are dematerialised, as if made of fog or mist. The most remarkable feature, however, is that, besides being completely inconsistent in the use of this method, to which he resorts only occasionally, though he does so in almost every phase of his artistic development, he does not restrict the shadowy, dematerialised technique to the figures he wishes to represent as the most spiritual or spiritually most important. In this too he remains a mannerist, thinking and creating rhapsodically and not systematically; to him the ambiguity of life is of greater consequence than precise distinctions and definitions. The two different methods of representation seem primarily intended to indicate that we live simultaneously in a world of spirit and another of tangible fact without ever knowing exactly where the boundary between them lies. But no doubt we are also confronted here with a kind of *concetto* similar to that characteristic of mannerist literature.

The contrast between Tintoretto's plastic and realistic and his sketchy

and flat manner in one and the same painting appears in very early works executed about or shortly after 1545, that is to say, in his *Moses* at Frankfurt (Pl. 142) and the *St. Ursula* in the church of S. Lazzaro dei Mendicanti in Venice. From the same period there dates the *Washing of the Feet* in the Escorial (Pl. 143), in which he introduces another important innovation, namely the extension of the picture space by a backstage connected with the foreground in the form of an open street, producing a *veduta*-like effect of depth and creating quite a different kind of reality from that of the rest of the scene. This backstage feature, not only because of its general spatial characteristics, its ravine-like depth, its sudden perspective narrowing and eerie emptiness, but also because of its rather pedantic and rigidly classicist architectonic form, now assumes a more than passing significance for him. Indeed, in a work as late and as important as the *Finding of the Body of St. Mark*, dating from about 1562, it forms the principal scene. In this stiff, empty, desolate scenery the chill of the alienation characteristic of mannerism gains the upper hand over his religious zeal.

His history as an independent, creative master begins with *St. Mark Rescuing a Slave* (Pl. 144), a work that marks the departure from his first, more or less Parmigianinesque manner and, in spite of its adherence to the Roman classical tradition, shows a whole series of piquant mannerist characteristics. Apart from the works of the two chief masters of Roman classicism, and above all Sebastiano del Piombo, during his stay in Rome Jacopino del Conte's *Baptism of Christ* and Daniele da Volterra's *Descent from the Cross* seem to have made an especially deep impact on him. Salviati's *Visitation* must also have played a part in the development of the new style that appears in the *Miracle of St. Mark*. Equally due to the impressions gained in Rome is the fact that among the mannerist formal elements there are a number of Raphaelesque origin, more specifically from the *Fire in the Borgo, e.g.*, the man climbing the wall on the left and the unequal distribution of the figures, particularly the crowding of the foreground with supers. On top of this there is the emphatically mannerist feature that at once catches the observer's eye, namely the abrupt foreshortening of the saint who has descended like a lightning flash from on high. It may well have been these stylistic features, which are extremely striking, though not so very numerous, that caused Dvořák to describe the work as the 'first powerful creation of mannerism in Venice',[56] though, as has since been shown, it in fact marks a moderation and diminution rather than a growth and extension of Tintoretto's mannerist tendencies. Two paintings dating from the same period, *The Fall* and *Cain and Abel* (1550–51) in the Academy at Venice, show a further retreat of mannerist features in favour of classical plasticity and monumentality. Strangely enough, however, the *Creation of the*

Animals (Pl. 145), painted at the same time and apparently belonging to the same series, differs stylistically from these in nearly every respect. Above all, it lacks both the plasticity and the dramatic vigour, as well as that special form of classical monumentality that combines grandeur with simplicity and economy of means. In this painting Tintoretto to a certain extent returns to the formalism and ornamentalism of his early period. The composition is almost completely tied to the plane and, with its parallelism of movements and the domination of the formal organisation of the picture by the horizontals, its pattern is the simplest to be found anywhere in his work.

A thoroughly progressive tendency, pointing to the future in more than one respect, again manifests itself in a group of paintings the stylistic character of which first appears in *Vulcan, Venus, and Mars* (1550), in the Alte Pinakothek at Munich (Pl. 146), as well as in a number of works more or less similar in character painted between 1550 and 1560, including the strongly mannerist *Judith and Holofernes*, in the Prado, the two paintings of *Susanna*, in the Louvre and in Vienna, the *Rescue of Arsinoe*, in the Dresden Gallery, and the *St. George and the Dragon*, in the National Gallery in London. This group includes those works of Tintoretto that are relatively the most erotic, a feature they share with the prevalent trend of the otherwise so different international mannerism. Stylistically these paintings differ greatly from each other, particularly in their representation of space. Some, such as the two *Susanna* pictures, for instance, are composed basically in the plane, while others, as is most strikingly illustrated in *St. George and the Dragon*, are dominated by the principle of depth. The same attitude to space, and the same exaggerated emphasis on depth, characterises the *Presentation of the Virgin* in the Madonna dell'Orto (Pl. 147), painted after the beginning of the fifties, which in everything else diverges from the artist's style of this period. In subject and mood it heralds the religious climate of the paintings of the Scuola di S. Rocco, while stylistically it harks back to the type of mannerism chiefly stimulated by Tintoretto's stay in Rome, and in particular the influence of the *Fire in the Borgo* that led to an extension and a modification of his Parmigianinesque manner. Reminiscent of the latter are, among other things, the enlargement into huge repoussoir figures of the onlookers in the foreground; the relegation to the background of the principal figure, who is made quite minute; the striking resultant recession, combined with an equally striking tendency to height; and the wall on the left by which the spectators are packed to one side. The total effect on the observer is of a funnel-shaped void sucking him in, inducing him to measure with his eye the height and depth of the staircase steps. However, the form, consummate though it may be in itself, makes too deliberate, calculated, almost obtrusive an impact. The formal *trouvailles*

are too independent of the spiritual content, and their place could obviously be taken by others.

The artist's 'spiritual rebirth', which takes place at the end of this period and leads to a deepening of his religious feeling and vision of life, thus also involves a closer, more direct, adaptation of form to content and a more indissoluble connection between them. Like Pontormo before and El Greco after him, he achieves equilibrium between the two factors by an evident spiritualisation of form, but not by any abandonment of its mannerist nature. He spiritualises form by giving it meaning, that is, he makes it seem the only possible way of expressing the content—though with him, as with others, this may be mere illusion. Thus the purely stylistic outcome of his spiritual rebirth is yet another justification of mannerism by the success achieved by its forms, though the piquancy and paradox of its way of expression still remain.

The first well-known painting in which he achieves such complete spiritualisation of the mannerist form that it seems to be the self-evident and untranslatable language of his art is the *Pool of Bethesda* (1559) (Pl. 148), in the church of S. Rocco in Venice. The packing together of figures into a relatively narrow space, the oppressive airlessness of which suggests a nightmare, is one of the oldest mannerist devices. The distinctive use made of it in this case is that there is nothing abstract about it, but that it is a completely convincing, naturalist rendering of the theme. Christ is seen with a crowd of sick persons pressing round him in a dark, narrow, low room; the Saviour is redeeming mankind from the chaos and darkness of the world. The problem of the formal presentation of the spiritual content is for the first time completely mastered. The metaphor becomes a symbol, because the distance between form and meaning is abolished, and the painting renders reality as convincingly as it conveys an idea.

The same stage of development, though still with a certain over-emphasis of the formal elements, is illustrated by the three paintings from the story of St. Mark, dating from about 1562. Here too the primary feature is the spiritualisation and symbolic interpretation of the mannerist conception of space. But, in contrast to the *Pool of Bethesda*, in which everything hinges on the interpretation of an overcrowded room, here we are confronted with the implications of a void. The saint, and all holiness with him, have left the world, which is gloomy and desolate in consequence. In *St. Mark rescuing the Saracen*, in the Venice Academy (Pl. 149), he still appears as a living and acting personality; he has cut himself off from the earth, which is veiled by deep shadow and lies concealed in darkness, but the sea over which he appears is churned into huge waves, and in his act of rescue he links the sea and the cloudy sky. The result is the magnificent 'Jacob's ladder' from the top of which there

is a view reminiscent of the 'reversed perspective' of the Middle Ages, which makes the figures nearest the observer seem smallest. In other words, a repoussoir effect is achieved by this bird's eye perspective, and the result of the reversal of its original function and the dimensional relationship resulting from it is a complete dynamisation of the space. Such is the impact resulting from the soaring effect that dominates the scene, combined with the embracing of such an enormous distance, that, though the construction is limited to two slender human forms, the painting as a whole acquires an elemental, cosmic character, and strikes the spectator as the first of those 'macrocosmic fantasies'[57] that henceforward play such an important part in Tintoretto's work.

In the other two St. Mark pictures space is dealt with rather differently, though again the primary concern is the interpretation of empty space. But, while in the first the dominant spatial principle is the ascent into the height, in the second, the *Removal of the Body of St. Mark*, also in the Venice Academy (Pl. 150), it is recession into depth, which was a well-known mannerist feature practically from the beginning. But here space, and empty space in particular, plays a much more important part than before; it dominates the whole work and gives it its fundamental tone. The setting, which recalls the backstage in the *Washing of the Feet* in the Escorial, because of its bare and sober, *coulisse*-like quality, is most suitable for the action which takes place. The emptiness and desolation of the scene, of which only the edges are occupied, are logically justified by the storm that is breaking out, but emotionally—and it is this that must have been the decisive factor behind it—are an expression of the sense of alienation. In no work of Tintoretto's is the world made to seem such a disconsolate wilderness as this city from which now even the saint's mortal remains are being removed. The uncomfortable, disquieting feeling produced by the picture is increased by the shifting of the vanishing point from the centre and the consequent laterally shifted axis of the whole composition. Everything is removed from its normal balance and context. The only compact group, that in which the principal actors are closely packed together, is in the right foreground, in the corner opposite to that on which the perspective orientation hinges. This is another factor that contributes to awakening a sense of precarious balance in the spectator, and the ghostliness of the scene is increased by a whole series of others. Apart from the uncanny light effect produced by the flashes of lightning, the small, shadowy, hovering forms in the background and on the left, whose insubstantiality contrasts with the plastic articulation and over-dimensional size of the principal group, contribute to the same effect, as does the veil blown into the empty square by a gust of wind and the tip of a curtain of undiscoverable origin in the left foreground corner, the apparent irrelevance of which to the scene

recalls the drapery on the same side of Parmigianino's *Madonna del collo lungo.*

An effect similar to the uncertain, wavering impression produced in this painting by the lightning is created by the nocturnal illumination of the catacomb-like burial-place in the *Finding of the Body of St. Mark,* in the Brera (Pl. 151). The picture space is turned into a long, narrow ravine, at the end of which a vault is opened and lit up by a torch. The foreground is left in ghostly darkness, and is given merely a kind of stage illumination proceeding from the suddenly revealed saint, who is the only source of light, the rest of the world being sunk in darkness and insubstantiality. The abrupt foreshortening of the dark room produces an eerie effect that recalls the mood produced by the same perspective means in Mantegna's *Dead Christ,* in the same gallery.

In most of the group of paintings done for the Scuola di S. Rocco between 1576 and 1587 a soaring, two-storey composition dominates the organisation of space. In the course of development, the beginning of which from the point of view in question is the *Raising of Lazarus* at Lübeck (Pl. 152), this idea gains greatly in dramatic force and optical impressiveness.[58] The contrast between the various levels by which the protagonist and the others are separated, and the prominence of Lazarus in spite of his foreshortening in the Lübeck picture, are so sharply pointed and striking that in a similar work for the Scuola di S. Rocco the artist feels it appropriate to diminish the tension thereby produced (Pl. 153). The point, however, is that he preserves the striking *concetto* of reversing the usual spatial relationship between Christ and Lazarus, and places the Redeemer immediately below the resurrected figure, with the result that the picture is dominated, not by the miracle worker, but by the miracle, the infusing of life into the body of the dead man.

The first work executed for the large upper hall of the Scuola, and the first of this whole period, is the ceiling decoration with the story of the *Brazen Serpent* (1575–76) (Pl. 156). If the term 'macrocosmic fantasies' ever applies to the work of Tintoretto, it is in relation to paintings of this type. Here, as in *Moses bringing forth Water from the Rock* (Pl. 157), the work that immediately follows it, and most of the works of the next few years, the events that unfold before the beholder's eyes are not merely of a human, or Christian and Biblical, nature, but are of an essentially cosmic character, showing scenes in a primordial drama in which the prophets, Moses, and the saints, as well as Christ and God himself, are participants in, not the directors of, the spectacle. The *Brazen Serpent* is certainly the most formidable and ambitious painting of the Cinquecento since Michelangelo's *Last Judgment*; as a pure composition it is even more successful, though in details it may lack the *maestro divino's* greatness. The cosmic character of the work and its primordial power are

above all due to the use of light as the ordering and organising principle. Light is not merely one of the means by which the painting is given formal articulation and painterly appeal, but is the real element in which all its vital components move; it is of the same substance as the fire of the serpents sent by God as a punishment, and also proceeds from the brazen serpent of the prophet intended to purge Israel of transgression and sin. In the picture of Moses striking water from the rock everything is rendered on a smaller, though by no means human, scale. The prophet stands on a hill high over a crowd in an exposed place, like an actor on the stage. His form is surrounded by the arching jet of water he has struck from the rock, and is thus isolated from the rest of the scene and simultaneously accentuated. Over him God hovers, half concealed in a dark cloud. His form is circumscribed by a circle that seems to glow and rotate like a wheel of fire, and at the same time the wheel shares something of the substance of the jet of water that frames the prophet's outline. The similarity between the two structures, which are also formally related to each other and almost touch, brings the miracle-worker into both an optical and a substantial relationship with God. Moses is a counterpart of the Creator, and participates with Him in the same cosmic event. He thus to an extent loses something of his theatrical character, and becomes a supernatural being, part of the divine machinery; with the result that both protagonists in the great drama are like two heavenly bodies, each with his own sphere and orbit, but both belonging to the same system.

In the most important works of Tintoretto executed between 1576 and 1587 for the same hall of the Scuola, that is to say, the *Baptism*, the *Temptation*, the *Agony in the Garden*, and the *Ascension* (Pls. 158–61), the macrocosmic drama is told in a way that to an extent creates the impression of a certain unorthodoxy, in spite of the artist's deep religiosity and unswerving Catholicism. Though all trace of the intellectual unrest of a Pontormo or Rosso, or of the tragic problems of Michelangelo, has vanished, from the ecclesiastical point of view they cannot be regarded as completely conformist or in complete harmony with the ideas of the Counter-Reformation. Most of them are too deficient in historical definition and connection with the human state to be described as Christian and Biblical; and it is here that there appears in Tintoretto's vision of life the conflict that prevents him, whether to the advantage of his art or otherwise, from overstepping the bounds of mannerism and becoming a representative of the Counter-Reformation and the baroque.

In most of the paintings of this series Tintoretto holds fast in particular to two formal means he had arrived at previously—the division of the composition into two superimposed planes and the rendering of two different levels of reality in the same work, one plastic and substantial and the

other fleeting and shadowy. This latter differentiation is seen most impressively in the *Baptism* and the *Ascension*; here there is no more of the constraint in the use of the method that clings to the Moses picture at Frankfurt or to the *St. Ursula* in S. Lazzaro dei Mendicanti; the artist seems to have discovered a new meaning in this originally rather playful technique. This can hardly be that assumed by Dvořák in his interpretation of the different fashions of representation involved in the *Ascension*. He attributes the shadowy treatment of the apostles in the background to the idea that only Christ is real and that everything terrestrial is insubstantial in comparison.[59] This is not tenable, for the simple reason that the two separate groups of apostles are themselves portrayed with different degrees of substantiality and move on different planes of reality. The two in the background are much more insubstantial, shadowy, and sketchy than the group in the right foreground. A better explanation of the inconsistent treatment of different parts of the scene seems to be that the artist, in view of the visionary nature of his theme, renounced *ab ovo* the immanent logic of an illusionistic rendering without, however, attributing any special value to the exact differentiation and localisation of the various kinds of being. The essential to be borne in mind is the heterogeneous and contradictory nature of reality as seen by mannerism in general. In mannerist art things are seen alternately in concrete and abstract form, now as substantial, now as insubstantial, and now one and now the other aspect is uppermost. Appearance and reality, truth and illusion are inextricably interwoven, and we live in a borderland of wakefulness and dream, knowledge and intuition, sensuous and ideal awareness; it is this that matters, not precise determination of the boundaries between the various provinces of being. The point is the difference between the two worlds we belong to, between which there is no making any final and exclusive choice, and not the logical description of individual spheres in one way or the other. If there is one single method of expression to which Tintoretto holds fast, it is at most that he generally uses the shadowy, fleeting, sketchy manner only for his background figures. But, as we know that in mannerism spatial situation in itself says nothing about the significance of the pictorial element, conclusions of Dvořák's kind cannot be drawn.

In the *Baptism of Christ* (Pl. 158) Tintoretto makes more extensive use of the shadowy, improvised, as it were sketched-in-with-chalk method of representation than in the *Ascension* (Pls. 160, 161) of the same period. At the same time, he makes it more evident that he is also pursuing a formal, decorative purpose, and is trying to give the subject a special painterly appeal. This intention appears most plainly in the *Adoration of the Magi* (Pls. 162, 163), dating from the last years devoted to the decoration of the Scuola di S. Rocco (1583–87). The group of horsemen in the

retinue of the three kings passing by in the background is undoubtedly one of the most masterly and effective improvisations in painting.[60]

The final stage in the development of his macrocosmic fantasies and also of his mannerist conception of space is reached with the three big landscapes of his late period, the *Flight into Egypt*, the *St. Mary Aegyptiaca*, and the *St. Mary Magdalen* (Pls. 164–6). The Biblical content of these is increasingly transformed into mythology and cosmography. In the last two the scenery consists of huge, primordially romantic, ideal landscapes from which human figures have almost completely vanished. Nature itself, with its magical strangeness has nothing to do with the intimate poetry of Venetian landscape painting, or the human proportions of earlier landscape painting in general. Only in Bruegel is there to be found a similar scale, a similarly comprehensive breadth of cosmographical vision, and a similar bold advance into space. The similarity of the two masters' conception of space derives from the identity of the spiritual crisis in which the art of both is rooted.

Tintoretto's fantasy landscapes no longer correspond to any reality; they are conceived on a scale that surpasses ordinary experience—they breathe the atmosphere of cosmic space. In spite of the immensity of conception, however, they do not overstep the limits of the human intelligence and imagination. The space into which the beholder is transported is boundless and immeasurable, but is not 'infinite', does not spell the *silence éternel* of Pascal or the dehumanised void of the metaphysics of his century. It seems to be on a scale beyond appraisal, but remains finite, does not lose itself in the spaceless and the supersensual. It is therefore wrong to regard the representation of space in Tintoretto's late period as the 'transition to the baroque'.[61] It is only in the next century that the idea of infinite space appears in landscape painting, as it does in philosophy, and it is sufficient to compare his spatial fantasies with the visions of infinity of Claude Lorrain, Hercules Seghers, and Philip de Koninck, or to recall the spatial concepts of Rubens or even of minor baroque artists, to realise that Tintoretto may have led the way to the baroque conception of space in the field of art, just as Copernicus did in science, but did not reach it.

The *Paradise* in the Doges' Palace (Pl. 168) is one of the last important works that, though to a great extent carried out by pupils and assistants, represents the form, if it does not completely represent the quality, of the master's last manner. This too offers us a macrocosmic fantasy. Without any landscape background or spatial definition, it illustrates the celestial machinery that has dominated Tintoretto's vision of the world ever since the Moses paintings in the Scuola. In conformity with the characteristic mannerist suppression of personality and the subjection of the individual to a higher order, the figures are transformed into the re-

volving planets of a solar system. The most striking evidence of the loyalty to mannerism that Tintoretto maintains to the end, in spite of his occasional side-steps into the baroque (Pl. 169), lies in what could, if one wished, be called the chaotic, or alternatively the superhuman concepts and scale, on which the heavenly system in the *Paradise* is conceived. In spite of the exuberance of the forms and the over-dimensional proportions, it is impossible to imagine anything less baroque, or less in harmony with Wölfflin's principles of 'uniformity' and the 'painterly'.

A qualitatively more positive side of Tintoretto's late style appears in the last great work essentially by his own hand, the *Last Supper* in S. Giorgio Maggiore, dating from 1592–94 (Pl. 170). This is one of the master's most unequivocally mannerist creations, and, with its rendering of space, the disproportionately large repoussoir figures, the sharply diagonal position of the table, the strong recession and abrupt foreshortening, the relegation of the protagonists to the background, the tendency to lack of clarity of detail, over-emphasis of light effects, consonance of lines and contrast of movements, it might almost seem too formalistic, were not the whole picture at the same time so deeply sublimated and spiritualised as are few other works in the history of painting. No other work of the master can make the same claim to be his testament; and no other demonstrates so unmistakably that his real and only heir is El Greco, in whom alone the spirit of the *Last Supper* lives on.

Jacopo Bassano (about 1510–1592) adopted mannerism in a fashion characteristic of Venice, and in his interpretation and the use he made of it he in a way presents a parallel to the career of Tintoretto. The most markedly Venetian feature of mannerism, introduced by Schiavone, consists in a transformation of Parmigianino's smooth way of painting into a rich, luxuriant, painterly style, as it were, improvised with the brush; and in Bassano's mellow use of colour which, like that of his fellow-Venetians in general, is closer to the early period of mannerism, as well as to the period of transition to the baroque, than it is to the *maniera* with which the main period of Venetian mannerism is contemporary.

His mannerism is not, as has been maintained, restricted to his 'second manner',[62] and is not by a long way a mere transitional phenomenon, as it is with Titian, but is so closely associated with other, chiefly baroque, stylistic trends that he cannot be described as a mannerist pure and simple. Apart from his increasingly painterly manner and the tendency to organise his compositions in depth, superseding thereby the planimetric principle, his elongated proportions gradually even out, his mood grows calmer, and the poetic-fantastic element disappears. In the course of time he develops into a one-sided specialist, ending up by painting nothing but

peasants, shepherds, and herdsmen in his extensive workshop; and he renders even Biblical episodes in the form of such genre paintings (Pl. 171).

The *Decapitation of John the Baptist*, in Copenhagen, which is assumed to date from about 1550 (Pl. 172), shows the artist's mannerism at its apex under the influence of Pordenone, Parmigianino, and Schiavone. This picture lacks the painterly style of the similarly mannerist but much later and much more 'Venetian' *Adoration of the Shepherds*, in the Galleria Borghese in Rome, and the still later *Entombment*, in the Vienna Gallery (Pl. 173). In contrast to the latter, which is much more uniform in the baroque sense of the word, the *Adoration of the Magi*, in the same collection, dating from shortly after 1560 (Pl. 174), shows that Bassano remained in essentials loyal to the mannerism of his earlier years, or else returned to it.

Certain features of the art of Tintoretto, as of that of a number of other painters born in about 1520, belong to the late mannerist period. But the baroque tendencies, which can be attributed to him, and also to Jacopo Bassano, for instance, only by greatly straining the stylistic concept, first become unmistakable with Paolo Veronese (1528–88), who was about ten years his junior. The latter belongs to a generation in whose art the Renaissance, mannerism, and the baroque are most closely and indissolubly combined. He preserves the harmony, serenity, and severity of the Renaissance, and anticipates the festive magnificence of the baroque, without dropping the piquancy and finesse of mannerism. The influence of Parmigianino, which obviously came to him by way of engravings, is very striking in his early, and is still perceptible in his later, works. The influence of Pordenone and Roman mannerism, particularly the school of Raphael and the followers of Michelangelo, with their strongly emphasised foreground components, abrupt foreshortening, and unilateral massing of figures, as for instance in the ceiling paintings in S. Sebastiano in Venice (Pl. 176), or in the *Magdalen laying aside her Jewels*, in the London National Gallery (Pl. 177), which is so reminiscent of Tintoretto, remains an important factor in his art; only the exaggerated Michelangelesque drama and plasticity of his early period, notably illustrated by the *Temptation of St. Anthony*, in the Museum at Caen (Pl. 178), has disappeared.

To the extent that Veronese develops his delight in colour and his sense of decorative theatrical arrangement, his art draws nearer to the baroque and its mannerist features fade; it ends by containing little of the spiritual sublimity and formal complexity of Tintoretto. Perhaps nothing is more characteristic of the structural simplification of his large paintings of banquets, in spite of their crowded formal quality, than the frontal position of the tables and the symmetrical arrangement of the groups, which would hardly have satisfied any genuine mannerist.

True, they do not completely satisfy the requirements of the baroque either. For, if the frontality, to mention nothing else, as a principle of unification is baroque in nature, the planimetric principle is the reverse of baroque. In the decorative frescoes of his late period, particularly in ceiling paintings such as the *Triumph of Venice* in the Doges' Palace, Veronese develops an illusionism which is strikingly baroque, but even these works, in spite of their illusionism, their dynamism, their happy, festival mood, and their lavishness in figures and requisites, are not really baroque in character. They are not homogeneous and unbroken enough, compositionally they are not sufficiently compact and ponderous, and emotionally not as powerful and explosive as any genuine and uninhibited expression of baroque feeling would be.

After the middle of the century, when mannerism in northern Italy was still producing novel and artistically valuable works, and actually reached a peak with Tintoretto, in Rome the style showed more and more striking signs of exhaustion. It adopted a new face, became more 'Roman' than it had ever been, but the sources of renewal that came to it from elsewhere in Italy, particularly from Florence, were drying up.

The new face was revealed principally in the work of the Zuccari and their followers, which resulted in another revival of the Raphaelesque trend at the expense of Michelangelism and led to a very noticeable moderation of the style. At the same time external influences increasingly lost their importance. The Roman monumental style of the thirties and forties was in many respects still dependent on the Florentine *maniera*, and cannot by a long way be regarded as an independent local school.[63] The Zuccari were the first since the masters of the High Renaissance to establish a Roman school with a special character and particular aims, though they did so in an extremely eclectic spirit. It is not, however, correct to derive the whole eclecticism of late mannerism from them. The real foundation of the later mixture of styles was the *maniera* of Vasari, though this was less heterogeneous and less syncretic than the art of his heirs and successors. In two important respects the Zuccari eliminated the last relics of the excessively extravagant and piquant mannerist ways of expression that still survived with Vasari and his generation, and thus laid the foundations of a final stylistic equilibrium; they clarified and simplified the involved composition according to the principles of Raphael, and did away beyond recall with the violent twists and turns and obtrusive formal contrasts of Michelangelism.

About the year 1560, when Taddeo Zuccari (1529–66) began painting his big wall decorations, hardly anything survived of the strain and violence that in general characterised the artistic practice of the Michelangelists. The first crisis of Michelangelism in the forties could still be

met from a very strong position, in spite of the powerful reinforcement of the school of Raphael represented by Perino del Vaga. But twenty years later the influence of Michelangelo was only one of the factors that determined artistic production, and it was certainly not the most progressive or authoritative. Apart from the most striking characteristic of the Zuccari style, the ready intelligibility and planimetric quality of Raphaelesque composition, it is notable for its departure from the unpainterly Florentine approach which had hitherto prevailed in Roman art. In Taddeo the trend to the painterly, the impulse towards which came to him principally from Parma, is stronger than in the younger Federico (about 1540–1609) who, though he dropped the plastic ideal both of the Florentines and of the followers of Michelangelo, nevertheless still practised a linear rather than a distinctively painterly style. Apart from the Emilian and Venetian schools, the two brothers were chiefly influenced in this connection by Barocci, who was the real intermediary between Correggio and them.

The essentially new and to an extent epoch-making feature of their art, and that of Federico in particular, is and remains the often astonishing simplicity and directness of the statement, that is to say, the unmistakable effort to avoid all superfluous complication and purposeless deformation, as well as everything playfully interesting and odd. There are drawings by Federico, those of the *Artists in the Medici Chapel*, in the Louvre, for instance (Pl. 179), that display an almost classical economy of means and a striking evidence of tone by keeping to the simplest horizontals and verticals in the organisation of their material. Since the twenties it had occurred to no one in Italy to draw in this spirit. This was the most striking breakaway within mannerism from its own earlier excesses; and at the same time it was a demonstration of the imminence of a change of style, because the nervous and intellectual strain associated both with the production and the appreciation of mannerist works was no longer tolerable. The new art that lay ahead involved relaxation of tension, surrender to uninhibited feelings, contentment with relatively simple and unparadoxical ideas, taking comfort and refuge in a self that was more spontaneous and at one with itself.

Their influence, their view of art, and the importance of the commissions that came their way, gave the Zuccari a position similar to that of Vasari in Florence. The decoration of the Sala Regia in the Vatican and of the Palazzo Farnese at Caprarola (Pl. 180), begun by Taddeo and continued after his death by Federico, are among the most important works commissioned in the mannerist period, and complete the series of monumental decorations that began in Rome with Perino's work in the Castel Sant'Angelo and were continued in Florence with the decoration of the Palazzo Vecchio by Vasari and his followers. There is more than

one reason for comparing the historical importance of the murals at Caprarola with those in the Palazzo Vecchio. In both instances the task involved the cooperation of a whole company of artists and led to the formation of a local school of art, besides contributing to the spreading far beyond the cities concerned and, indeed, beyond the borders of Italy, of the influence of the artist in charge and of the special version of mannerism now developed.

Those who worked on the mural decorations of Caprarola from the sixties onwards included, apart from the Zuccari, artists so different as Giovanni de' Vecchi, Raffaellino da Reggio (Pl. 183), Bartholomeus Spranger, and Antonio Tempesta, who came from Stradano and served as a direct link between the *studiolo* circle and this group, that became an increasingly cooperative community. Without this collective and its influence, the form assumed by mannerism in the west and north of Europe, with its variations, such as that of the so-called 'Rudolphine group' (Spranger, Hans von Aachen, Josef Heintz), that of the Munich court (Sustris, Candid), that of the Haarlem Academy (Cornelis, Goltzius), and the school of Utrecht (Wtewael, Bloemaert), would have been inconceivable.[64] A work, for instance, such as the uncommonly attractive though in itself not very important *Tobias and the Angel* by Raffaellino da Reggio (Pl. 184), a pupil of Lelio Orsi, in the Galleria Borghese in Rome, shows at its best the close connection between the precious form of the later international mannerism and the elegant fluency of the style developed in the Zuccari circle. Wherever the individual components of the latter may have come from, the foundations of the international trend, as followed mainly in the Netherlands and the German-speaking countries, were developed in Rome after the middle of the century. Its Florentine origins are undoubtedly of great importance, and the formal language both of the *studiolo* group and of the first mannerist generation remains a vital element in development down to the last offshoot of the Spranger tradition. The Roman elements, in the narrower sense of the word, are just as important in the new trend, however, and they are enriched by the vital North Italian influences, particularly those deriving from Correggio and his followers.[65]

In addition to those who worked in Rome under the guidance or influence of the Zuccari, there were other busy and successful artists whose basic allegiance, though they were not entirely free of mannerism, lay elsewhere. Notable among these is Scipione Pulzone, whose sober, matter-of-fact portraits, completely free of all affectation and intellectual conceits, at any rate so far as substantiality and naturalness of representation is concerned, are closer to the baroque than to mannerism. Another artist who worked in Rome and was, if possible, even more independent of mannerism was Girolamo Muziano, who created a new genre, that of

baroque landscape and *veduta* painting, just as Pulzone initiated a portraiture that corresponded with the requirements of the new social atmosphere.

An artist who not only was and remained a mannerist but actually developed mannerism to a new climax, though he remained remote from the Zuccari circle, was Federico Barocci (1535–1612). He lived for the greater part of his life at Urbino, his home, where he did most of his work, but stayed repeatedly in Rome, in the middle of the fifties and again between 1560 and 1563, and undoubtedly reinforced the influence of the Correggesque trend in the Zuccari circle.

After Tintoretto, Barocci is the greatest Italian painter of the second half of the century and, in spite of his dependence on Correggio and his return to Raphaelesque forms, the most original. It is astonishing that in this advanced stage of its development mannerism still turned out to be so productive and capable of such radical innovation, for there was no precedent for the variation of it that came into being with him. In that age of alienation, no mannerist, not even Correggio in his own language, achieved such warmth and spirituality of expression, such unblunted brilliance and spontaneous abundance; no one else was still capable of so completely infusing his work with emotion, piety, and simple evangelical mood. This too heralded the age of the baroque, with which Barocci's art has a number of points of contact. But, however strong the baroque elements may be in certain works of his, such, for instance, as the *Flight into Egypt*, in the Vatican (Pl. 185), he can no more be called a baroque artist than can his master Correggio or his great contemporary Tintoretto. He too is one of those representatives of the age—and the last of them—who combined Renaissance, mannerist, and baroque elements in their art, with the mannerist tendency still predominating.

The most strongly mannerist feature in Barocci's paintings is the treatment of space, the packing together of figures, as in the *Madonna del Popolo*, in the Uffizi (Pl. 186), and the relegation to the background of the most relevant part of the action, as in the *Circumcision*, in the Louvre, or the *Last Supper*, in the Urbino Gallery (Pls. 187, 188). The strained and ostentatious working out of the compositional relations, as in the *Descent from the Cross* of 1569, in Perugia Cathedral, which actually recalls Rosso's treatment of the subject, makes the same effect (Pl. 189).

Finally, mannerism produces a number of attractive works in Lombardy, most of which, however, belong to the seventeenth century and can to an extent be claimed for the baroque. The most eminent artists concerned are Giovanni Crespi (Cerano), the Procaccini, Morazzone, and Tanzio Varallo (Pls. 190–2). On the other hand, at about the same time mannerism assumes completely perverted forms in the bizarre human heads composed of fruits, leaves, branches, and the most various artifacts

as painted by the Milanese Giuliano Arcimboldo (1517–95) (Pl. 193). In these the connection between mannerism and modern surrealism appears in its most striking, though by no means most important, form. The works of any really considerable mannerist, those of Rosso, Parmigianino, or El Greco, for instance, better illustrate the affinity of the two styles, which consists in their indecision between two worlds, their awareness of conflict between two orders of being, rather than in the mere confusion between living and dead, organic and inorganic, characteristic of Arcimboldo's monstrosities.

Another characteristic example of late mannerism is provided by the extraordinary eclectic nature of the work of the Genoese Luca Cambiaso (1527–85), the most important elements of which include the 'cubist' form (Pl. 194) and an erotically flattering and structurally complicated treatment of the human body (Pl. 195). With the latter, as is best illustrated by his *Venus and Adonis* in the Palazzo Barberini in Rome, the artist may have played a certain part in the development of late international mannerism.

The best example, however, of the insipidity to which the mannerist inbreeding of forms finally leads is provided by the notorious Cavaliere d'Arpino, the so-called last mannerist, who until his death in 1640 remained loyal to the doctrinaire spirit of late Roman mannerism and showed nothing of the flexibility, freedom, and vivacity of the style of his Lombard contemporaries as rejuvenated by the early baroque. He survived Caravaggio by thirty years, yet totally ignored the revolution brought about by him, and represented the worst side of the eclecticism and conservatism of a style that had once been so bold and adventurous. He played into the hands of art historians and critics who wished to stamp mannerism as inherently sterile and stereotyped, and helped them to make a bogey of it.

In spite of the need for a radical change of heart and a return to the natural and rational, to readily intelligible forms and freedom from the fantastic and bizarre, the baroque, apart from its external points of contact with mannerism, displays a far from negligible inner affinity with the expiring style. Even the external points of contact do not arise merely from the circumstance that mannerist and baroque trends often appear simultaneously and continue side by side; mannerist tendencies still linger on in artists who have definitely gone over to the baroque. In this connection it is sufficient to recall Caravaggio's *Flight into Egypt*, in the Galleria Doria in Rome (Pl. 196), and his *St. Matthew* (formerly in the Kaiser Friedrich Museum in Berlin, missing since 1945), Ludovico Carracci's *Conversion of St. Paul*, in the Pinacoteca in Bologna, or Poussin's *Rinaldo and Armida*, in the Dulwich Gallery. The principal factor shared by the two styles is their anti-Renaissance trend, their link

with the supersensual and other-worldly, which is just as characteristic of the baroque as it is of mannerism, in spite of the former's stronger sense of reality and more rigid rationalism. The visionary character of mannerism is preserved in many of the most important works of the baroque, which is never without a touch of fantasy, though it is never so fantastic as mannerism.

It is only in the later phases of its development that the baroque deliberately and systematically turns against mannerism. True, its earlier statements, as in Caravaggio or the young Rubens, for example, are anti-mannerist in feeling, but technically they preserve a whole series of mannerist features. In the latter part of the seventeenth century French art criticism was directed against preciosity, that is to say, against an artificial expression that had become socially questionable, but not against anti-naturalism as such; in speaking of naturalness, it always meant reasonableness. Caravaggio, however, is a true naturalist, and therefore rejects everything in mannerism that he feels to be in conflict with nature, but he preserves a great deal that he is able to reconcile with his feeling for the natural. Thus elements of mannerism survive in the baroque, varying with its different trends and representatives, and some are for the time being everywhere preserved.

The complete and final breach with mannerism and its heritage was first made by classicism, partially within the baroque but mostly rather as a reaction against it. In France the baroque assumed from the outset a rigorously formal, classical shape. This was better fitted to the absolutist and aristocratic spirit of the predominant social order, and to the outlook of an aristocracy trying to adapt itself to a more rational way of life, than to the atmosphere of the more liberal and less disciplined smaller courts in which there persisted the fantasy and subjective anarchy mirrored by mannerist art.

In this sense the classicism that in some countries succeeded the baroque and in others the rococo, but after the middle of the eighteenth century prevailed everywhere in the west, was a vital turning-point, in some respects the most revolutionary in western art since the crisis of the Renaissance and the beginning of mannerism. It brought to a definite end the age of the Renaissance, which in broad outline lasted from the fifteenth to the eighteenth centuries, and opened up an entirely new period of development, the age of reason and moderation that sought to reconcile contradictions in art and thought. It was characterised by an ever-increasing sense of reality, the scientific outlook, naturalism in theory and practice, the mechanisation and technicalisation of life, the isolation from each other of the different provinces of spiritual approach and intellectual endeavour, the progressive segregation of the various spheres of culture, and of specialisation in every field of activity.

After the storms of the exuberant baroque, classicism can be regarded as a return to the abstract, undynamic forms of the *maniera*, an artistic trend that developed from the academic style of the second and third mannerist generations. A more satisfactory alternative, however, bearing in mind the predominance of the expressionistic and spiritual trends of mannerism and its essentially anti-classical stylistic elements, is to regard the baroque and the rococo as to an extent a continuation of mannerist principles of form, and the classicism that finally turns its back on these principles as the real end of the mannerist movement that thus survives. However that may be, the change from mannerism either to the baroque or to classicism was an event of enormous importance in the spiritual history of the west. It was an immense gain, and at the same time an immeasurable loss. Rubens, Rembrandt, Velazquez, Racine, and Bach were on the way, but so were David, Voltaire, and Pope. On the one hand there was tremendous enrichment, and on the other a deplorable and disastrous decline and decay of that unity of sensibility that has been recognised as an essential feature of Elizabethan literature. The time had passed in which a Shakespeare or an El Greco could appear, and an age was approaching in which they would no longer be fully intelligible.

The end of mannerism marked the beginning of a new crisis, which led ultimately to the rationalism of the eighteenth and the naturalism of the nineteenth centuries. The revolt against materialism and dogmatism, the despiritualisation and depersonalisation of life of which mannerism was born, remained a passing episode. With classicism a new wave of dogmatism, coercion, and reification of human relations set in. In the eighteenth and nineteenth centuries the battle that mannerism conducted against the depersonalisation and materialisation of culture was given up. The modern state, large-scale industry, and the over-populated city involved the complete bureaucratisation, alienation, and mechanisation of life. But at the same time the great writers, artists, and psychologists of the century, the 'great nineteenth century' as Thomas Mann called it, the works of Stendhal, Dostoevsky, Tolstoy, Baudelaire, Freud, Proust, Cézanne, and Van Gogh, led the way to a new spiritualism that again directed attention to mannerism and its struggle against the despiritualisation of culture.

II

Mannerism Outside Italy

1. FRANCE

ALL the nations of the west were confronted within a short period with the same problems, the same conflicts of conscience, the same cultural crisis, and mannerism developed into a universal form of western art in response to a universal need. The different national variations are all more or less directly connected with the art of the Cinquecento in Italy, but with different phases and trends of the development there. The school of Fontainebleau is linked with the style of the first mannerist generation in Tuscany and Emilia; 'later international mannerism' in the Netherlands, which outside its own home prevailed mainly at the courts of Prague and Munich, is connected with that of the second generation, the *studiolo* artists of Florence, the Parmigianinesque tradition as further developed chiefly at Bologna, and Roman eclecticism; and finally El Greco, the greatest representative of the style, is associated with the Venetian variety developed by Tintoretto.

The fact that in the visual arts western mannerism was everywhere affected by Italian influence does not mean that it established itself in the various countries independently of native conditions or that similar developments might not have taken place in the absence of that influence. In literature, for instance, there is no doubt that there was a definite independence of development in Italy and Spain, and it can be stated confidently that forms of mannerism very similar in many respects developed spontaneously in both countries, each based on its own literary traditions and stimulated by similar problems, and that neither was significantly influenced by the other. In painting, the art of the so-called 'Antwerp mannerists of 1520' can be regarded as having been hardly influenced by the first representatives of Italian mannerism; it obviously stemmed from native, late gothic, and previously borrowed Italian forms, but at all

240

events it developed as a concomitant phenomenon in relation to Florentine mannerism and not under its influence.

The first stylistically distinct and uniform artistic movement that appears outside Italy under the influence of Italian mannerism is the school of Fontainebleau. The real mannerist revolution did not affect Europe until the forties, however, so that the art of Fontainebleau is to be regarded as a not entirely original offshoot rather than a creative development or independent variation of the Italian style. In France, as in the Netherlands, the soil may have been prepared for mannerism by the late gothic tradition, which nowhere had deeper roots than in that country; but the peculiarity of the French situation was that the gothic trend, which had become rather provincial in character, had to be superseded to clear the way for mannerism. The stimulus to this was provided mainly by Francis I's expedition to Italy, and partly also by the Italian artists at Fontainebleau. In one respect the development of mannerism in the two countries was characterised by opposite trends: in Italy it was associated with an approach to the spirit of the Middle Ages, while in France this had first to be shaken off. Mannerism, in fact, was the form in which the Renaissance came to France, and this more or less applies to the greater part of the west. In the Netherlands also no hard and fast dividing line can be drawn between the 'Romanists' and the first mannerists and, whatever differences may otherwise be discernible between them, both alike are intermediaries between the Italian and the north European Renaissance.

Originally the Renaissance was a local affair, limited to Italy; only in its state of disintegration, in the form of courtly mannerism, did it become a general European movement, the first great international style since the gothic. Its spread was connected with the development of princely absolutism and the objective of establishing an intellectually and artistically ambitious courtly environment for the propagation of the principle of sovereignty. Fontainebleau was the first court of this kind in the west, and established the pattern of courtly culture that was followed all the way down from Versailles to the households of the smallest eighteenth-century German petty princelings. Hence its unparalleled historical importance. Even if it is assumed that all the vital impulses that led to mannerism in the west came from Italy, including both those that led to the formation of the school of Fontainebleau and those that developed into the later international mannerism, and that the French played no creative role in the development of the style, the intermediary role played by Fontainebleau between Italy and the rest of Europe can hardly be overestimated.[1]

It was at Fontainebleau that Primaticcio first combined painting and sculpture into that perfect instrument to which the whole art of interior

decoration of the baroque and the rococo owes its brilliance (Pls. 197–9), though he did so on the basis of his cooperation with Giulio Romano at Mantua; and it was at Fontainebleau that features such as the eroticism that prevailed in later mannerism were developed (Pls. 200–2), though this too of course went back to Italian origins, to the style of the *studiolo* artists, but principally to Parmigianino and his followers, as well as to certain reminiscences dating from the first mannerist generation, *e.g.*, the works of Beccafumi (Pls. 203, 204). Even if one leaves out of account all the technical and thematic achievements of this kind, Fontainebleau led to the production of works by many of the often nameless representatives of the school that, though less distinguished than those of the best Italian artists, were executed in a formal language which, in contrast to the mostly excessively individual and hardly repeatable way of expression of the Italians, developed into a 'vernacular', if such a term can be applied to the idiom of an exquisite courtly society. The appealing treatment of the female form became the common artistic possession of a whole generation, the attractive, suggestive representation of erotic themes became a practice that could be taught and learned, continued and further developed. Mannerism turned into a form of social culture which, though it created no great individual works, laid the foundations for the high average level henceforward characteristic of French art. Thus, though its individual products are much less considerable, the elements of the style remain a much more organic and indispensable component of later art in France than in Italy, for instance.

Strangely enough, French mannerism produced incomparably more important works in sculpture than in painting. These too were produced partly under Italian influence, particularly that of Benvenuto Cellini, who was active in France at the same time as Primaticcio and Niccolò dell'Abbate and represented an artistic outlook similar to theirs and in conformity with the *maniera*, that is to say, from the historical point of view was half-way between the art of Baccio Bandinelli and that of Giovanni Bologna. But Cellini spent too little time in France—he was there in 1537, and again from 1540 to 1545—for the flourishing of sculpture that took place there to be attributable to him. The phenomenon may be connected with the fact that many of the greatest French medieval artistic achievements were in sculpture.

However that may be, it was Jean Juste, a French sculptor, though of Italian origin, who, between 1517 and 1531, with the cooperation of members of his family, created the tomb of Louis XII and Anne de Bretagne at St. Denis (Pls. 205–7), the first mannerist sculptural work in France, and the first great and for a long time unparalleled example of mannerist art in that country. There can obviously be no question of Cellini's having exercised any influence in this case, and any other Italian

mannerist influence can have been only minimal. On the other hand, there is hardly another French work of art that so vividly illustrates the vagueness of the boundary between the late gothic and mannerism and the smooth and almost unbroken transition from one to the other; and there are few examples that so well illustrate the peculiar mannerist combination of naturalism and idealism, sensualism and spirituality, sober realism and exalted sense of beauty. The bellies of the two bodies have been slit open and sewn up again after removal of the entrails—this is represented with minute and almost horrifying verisimilitude. Yet the two lying thus in the stiffness of death are indescribably beautiful; the dead king's face, with pointed nose and open mouth, showing a pearly row of teeth, is one of the most unforgettable in sculpture; the queen, with her soft, loosened hair and her head dropped backwards, and the melodically articulated line of the mouth, chin, and throat, is one of the loveliest women who has ever been immortalised by art. This extraordinary combination of death and beauty, perishable flesh and indestructible form, this testimonial to the spirit's survival after death, these dead bodies infused with life, this reflection of the ideal in the material—what term other than mannerism can be applied to it all?

The two most gifted followers of the Italian mannerists in France are also sculptors—Jean Goujon, who was active around the middle of the century, and Germain Pilon, who was rather younger than he. In the former the influence of Parmigianino and Cellini is the more striking, and in the latter that of Primaticcio. Both work up the foreign influence in a very original and, in so far as is possible within the limits of an essentially international style, in a very French fashion. Goujon leads the way towards the elegant, decorative, courtly artistic tradition that prevailed in the west for more than two centuries (Pl. 208), while Pilon lays the foundation for a more expressionist trend in which French formalism found its own inner corrective (Pl. 209).

In portraiture in particular French mannerism produced uncommonly attractive works, which are among the best of their kind. In addition to those of François Clouet (1510?–after 1574), the portraits painted by Antoine Caron and François Quesnel are characteristic examples of this princely and aristocratic art (Pls. 210, 211). The most original and productive representatives of mannerism in France, however, are the engraver and etcher Jacques Callot (1592/93–1625) and Jacques Bellange (at Nancy between 1602 and 1617), also known primarily as a graphic artist. Both tended to the bizarre, the artificial and sophisticated, and in many respects came very close to the preciosity of international mannerism. In Callot the erotic element plays no noticeable part (Pls. 212, 213), but Bellange introduces such an audacious and frivolous worldliness even into his religious work that in comparison Parmigianino himself seems

devout. In the elongation and refinement of his figures, the nervous constitution of his types, their affected attitudes, movements, and gestures, and the ornamental arrangement of the pictorial elements in general, he attains a degree of extravagance that exceeds anything of its kind ever produced by mannerism. The play of hands in his *Annunciation* is very characteristic of his virtuoso display of gestures that partly repeat and partly contrast with each other (Pl. 217). Apart from the usual means of mannerism, that is to say, the consonance and repetition of forms, he also uses every conceivable other device to produce such effects. In the *Three Marys* he actually returns to Wickhoff's 'continuous' method of representation (Pl. 216), which had rarely been applied since the Middle Ages, as a way of producing the repetition of forms, that is, he shows the principal group of the three female figures in two different phases of the action within the same frame. This method, which in medieval paintings seems so naïve but is nevertheless so effective and meaningful, as it enables the artist to render an epic content of which he would be otherwise incapable, is here extremely artificial and constrained, though in itself very attractive.

2. DUTCH AND LATER INTERNATIONAL MANNERISM

The share of the still surviving gothic tradition in the origins of French mannerism was certainly considerable, and the earliest Netherlandish 'mannerist' painting, chiefly that of the Antwerp group of about 1520,[2] was inseparably connected with the gothic (Pl. 218). It is consequently impossible to differentiate between what is *still* medieval and what is *already* mannerist in these cases. Thus, as in France and to an extent everywhere in the west outside Italy, the Renaissance was skipped in the Netherlands. Nevertheless it would be just as wrong here as elsewhere to derive mannerism from medieval reminiscences and a retrospective outlook. Throughout the west medieval monuments survived in greater numbers and greater proximity than those of antiquity. The problem of the origin of the Renaissance prompts the question why monuments which had been known for such a long time suddenly began to play a new and creative role; the problem, however, of why the external influence became effective from a certain moment in time onwards is even more acute in relation to mannerism and the Middle Ages. Medieval art nowhere ceased to survive and exert an influence, and if it is correct that it awoke to new life, meaning, and effectiveness in mannerism, the question of why the change of style took place is not answered by pointing to an increased interest and deeper understanding of the Middle Ages; the new interest in and deeper understanding of medieval art must itself be ex-

plained. It is the new vision of life and artistic outlook that are always the primary factors, and these often seek and sometimes find predecessors in the past. The excessive emphasis occasionally laid on medieval parallels to mannerism, impressive though these often are, is therefore unjustified.

Apart from Antonis Mor (1511–76/78), who was one of the greatest portraitists of this and in fact of all ages (Pls. 219–21), and painters such as Jan Mostaert, Lucas van Leyden, and Jan van Scorel, whose most successful work is also portraiture, Peter Bruegel the Elder (1525/30–69) is the first independent Netherlandish mannerist of importance and real creative power, an artist who not only produced a completely new personal variation of the style, but also became one of its most important representatives. Apart from El Greco, he is the only mannerist able to hold his own in the presence of Tintoretto, and the only one who, besides giving a similarly profound and comprehensive form to the style in general, presents us with a cosmic vision that can be set side by side with that of the Italian master. His feeling for the universal is, like Tintoretto's, the basic component of the creative experience, though unlike him, the things that give rise to this feeling are often trivial—a tree, a mountain, the depth of a valley, a wave, a procession of clouds, or a bird on the wing. In Tintoretto everyday life fades in the breath of the universe, while in Bruegel it is immanent in the objects of everyday experience. The result is a completely new kind of symbolism, which to an extent conflicts with all earlier kinds. In the Middle Ages, the last previous period of symbolic art, it was by departure from ordinary reality and becoming abstract and stylised that a work was given its higher and more comprehensive meaning, while with Bruegel the symbolic power increases with the triviality of the symbolic object. Because of the abstract and conventional nature of its symbolism, there was only one correct interpretation of a medieval work of art, but since the age of mannerism innumerable interpretations of great works have been possible, because of the closeness to life of their themes and their immediate involvement with the stream of concrete experiences. The paintings of Bruegel, like the works of Shakespeare or Cervantes, have to be reinterpreted for every generation. Their symbolic naturalism, with which the history of modern art begins, originates in the mannerist view of life, its dualism, its dialectic, its paradoxical combination of opposites, and involves on the one hand the complete overthrow of the blissfully naïve faith, say, of the Homeric age in the homogeneity of things, the meaningfulness of life, and the presence of the gods in this world, and on the other the end of the clean and neat distinction drawn by medieval Christianity between the true and the false, the real and the unreal. The world is no longer meaningful just because it exists, as in Homer, and works of art are not the truer the more they depart from ordinary reality, as in the Middle Ages. But, because of their

imperfection and inherent meaninglessness, they point towards a fuller and more meaningful whole, which is not there for the taking, but has to be striven for.

The classification of Bruegel as a mannerist still sometimes rouses objections as strong as those made against the application of the term to the relevant trends in Michelangelo, or to the work of Tintoretto himself. Max J. Friedländer actually maintains that Bruegel is the only artist of the middle of the sixteenth century who remains 'uncontaminated by the disease'.[3] His allegedly healthy and spontaneous attitude to nature has been regarded as the opposite of mannerist, which both shows blindness to the highly developed, though often inhibited, feeling for nature of most mannerists and overlooks how equivocal was Bruegel's love of nature and the extent to which it was the consequence of his despair about mankind. Contrasting his humour with the alleged lack of humour in mannerism involves another double mistake. Bruegel's humour is no more innocent and innocuous than the mood of Rabelais, Shakespeare, or Cervantes is humourless. All three share the same kind of detachment, the fruit of bitter experience and ultimate reconciliation with the course of the world. This is the last of the ways in which Bruegel differs from the other representatives of mannerism.[4]

At first sight he indeed seems to have little to do with the mannerists. He lacks the displays of bravura, the artistic finesses, the convulsions and distortions, the arbitrary disregard of proportions and spatial relations. Particularly when his genre paintings of peasant life are considered in isolation, he seems to be a robust naturalist, who does not fit at all into the intellectual, problem-ridden, and equivocal world of mannerism. In reality, however, his outlook and philosophy of life are just as sophisticated and unspontaneous as those of other mannerists; not only in the sense of self-consciousness in which all post-Renaissance art is the opposite of naïve, but also in the sense that the artist does not merely offer us a rendering of reality, but deliberately and consciously presents us with his own personal interpretation of it; indeed, 'this is how I see it' could be the title of all his works. It is this feature, combined with his symbolism, that is the revolutionary and eminently modern element in his art, and of mannerism in general. Only the capricious artistry of most mannerists is lacking in Bruegel, but not their piquant individualism, their determination above all to express themselves, and to do so if possible in a totally unprecedented form. One's first encounter with Bruegel is characteristic of the surprising effect of mannerist works in general; they are not just striking, their individuality imprints itself on one's mind in a quite special manner. Bruegel's method of expression is unforgettable, even to those who have gained an entirely superficial impression of his work and are unaware of the subtleties of artistic form.

One of the most conspicuous features of Bruegel's mannerism is his submergence of the individual in the mass or in nature. The individual's plight, his pleasures and pains, are subjected to the tragedy or tragi-comedy of life as a whole, and are reduced to insignificance in comparison. The origins of landscape painting are connected with this relegation of the individual and of humanity itself from the centre of the universal stage. Only when this world below had ceased to be a mere stage on the road to redemption, that is, a mere temporary dwelling-place for man-kind, and man himself, with his aspirations to salvation, had ceased to be the purpose of creation could landscape painting develop into an inde-pendent branch of art. The connection between this process and 'the breach in the unity of the Renaissance' was recognised by Dvořák,[5] only he believed that the breach was brought about by the reception of the Renaissance by the north of Europe. In fact, however, landscape painting originated in the Netherlands and Germany independently of any such process, for the simple reason that the Renaissance, with its individualism and anthropocentrism, never established itself in northern Europe and, in so far as it took root there, did so after landscape painting had already begun. In the Germanic countries landscape painting was able to develop freely because it never encountered the obstacle of the in-dividualism and anthropocentrism of the Italian Renaissance, and con-sequently never had to shake it off; the loosening of the hold of Chris-tian dogma and men's release from the bonds of a philosophy of life oriented to a world beyond were sufficient to make it possible.

Bruegel stayed in Italy in 1552 and 1553, and perhaps somewhat longer and, though features of all kinds pointing to Italian influence appear in his work of the next few years, the young artist returned for the time being to the old northern European style of additive composition, multi-plicity of subjects, and overfilling of the picture with episodic scenes. The works executed about the year 1560, such as the *Netherlandish Proverbs* of 1559, in the Berlin Gallery (Pl. 222), the *Children's Games* of 1560, in the Kunsthistorisches Museum in Vienna (Pl. 223), and the *Triumph of Death*, in the Prado, dating from about the same period, still bear the stamp of the older Netherlandish painting as specifically represented by Hierony-mus Bosch, not only in matter and mood, but also in the organisation of the pictures, the loyalty to the principle of scattered and juxtaposed motives, that is to say, a method that conflicts with the classical principle of concentration, as well as to an extent with the Italian rendering of space or formation of groups in general.

In all these paintings, as well as in the *Procession to Calvary* (1564), in the Vienna Gallery (Pl. 224), the spatial background or landscape, as the case may be, is so constructed as to present as wide an expanse as possible to the eye by means of a high viewpoint. Thus the effect is of a panorama

rather than of a striking, dramatic scene. The swarming figures, mostly supernumeraries or spectators, in fact produce the effect of an ant-heap, as they have been described; only the group with the Virgin and her companions in the foreground stands out of the throng, while even Christ disappears somewhere in the background. One of the miracles of this art is, however, that the picture, in spite of its hazy articulation and apparent chaos, is one of the most unforgettable in the whole history of painting.

But, apart from the Old Netherlandish multiplicity of subjects and the tapestry-like profusion of the compositional elements, in certain of its parts, in the group about the Virgin, for instance, there is so strong a predominance of mannerist features in this picture, such as the Parmigianinesque slenderness of the figures, the affectation of the movements, and an elegance of costumes otherwise unparalleled in Bruegel, that they cannot be attributed merely to the after-effects of his stay in Italy. It seems much more reasonable to ascribe them partly to a study of the then widespread engravings after the works of the Italian mannerists, and partly to the artist's contact with the mannerist style then fashionable in the Netherlands, as represented mainly by Frans Floris and his workshop. The *Adoration of the Magi*, in the National Gallery in London (Pl. 225), dates from the same period (about 1565), and displays similar mannerist features, *i.e.*, the tendency to elongation of the figures, particularly in the case of the three kings, the special care devoted to their costumes, the refinement of their attitudes and an unmistakable predilection for slender and delicate hands. Also, if one forgets about her peasant-like crudity, there are mannerist features in the proportions given to the Virgin, in particular the relationship of the head to the rest of the body. The whole composition, with its diagonal pattern and tendency to height, is Italian and Correggesque, and the contrast with the banality of the types and their realism increases the mannerist impression.

What Bruegel was obviously trying to express in paintings such as the *Children's Games* or the *Proverbs* was primarily the sense of the absurd and grotesque with which the sight of the life and bustle of the world and human habits and conventions filled him. He wanted to show what all these things looked like from the outside, when only the externals were seen and the surface was left unpenetrated. The effect is of a ghostly, eerie, and chaotic puppet play. It is characteristic of Bruegel's pessimism, particularly that of his youth and early manhood, that what he saw and showed of humanity was often only this surface.

Mannerism, that makes such extensive use of the disguises of the spirit, its indirect manifestations and expressions, distortions and displacements, masks and metaphors, in the works of its most important representatives also contains criticism of these things; that is to say, it points to their in-

adequacy as well as their inevitability, to the limitations they impose on the mind and the obstacles they put in the way of the apprehension of truth and all that lies outside the self as well as the prospects they open up to the imagination. It is the fate of the spirit, or, as Georg Simmel calls it, the tragedy of culture, that every form of expression necessarily becomes stiff and soulless, the life as the expression of which it originated departs from it, and it ends up as one of a multitude of fossilised forms, images, values, systems, that conceal from us our true nature. In mannerism the spirit was more exposed to this danger than it had ever been before, but was also more aware of it. The whole philosophy of the time revolved round a *docta ignorantia*; man did not know what he really was, what he was living for, whether he was living or dreaming or merely playing some sort of part he had been allotted. Bruegel seems to have been fully aware of this enigma, and in his paintings showing aspects of life that had become automatic and mechanical—its games, masquerades, proverbs—he seems to have been trying to express by their absurdity and senselessness the enigmatic nature of the whole of human existence. The betrayal of nature and truth by form, or the transformation of nature and truth in mere form, which occurs even in a religious work such as the *Adoration of the Magi* and leads to the creation of an intermediate realm on the borders of the two worlds, between reverence and irony, the sacred and the trivial, a highly questionable domain in which the artist often seems to move in utter perplexity, is the most essentially mannerist element in his art.[6]

In the course of years Bruegel's pessimism diminishes, however, and, to judge by his representations of the *Months* of the middle of the sixties, seems to have been followed by a new attitude to nature, in which there is a closer bond between man and his environment. At first this is a rather melancholy, resigned reconciliation with life. But then man takes another step up the ladder of creation, though his coarse and crude and clumsy nature clings to him to the end. The *Months* are among the most magnificent of Bruegel's works and, in the narrower sense of the word, the least mannerist (Pls. 226–8). Their stylistic character derives chiefly from their symbolical meaning and the sense of the universe that infuses them. In comparison with most of the drawings of the time of his Italian journey (Pl. 229), the cosmic breadth of this feeling has diminished, the scale is smaller, more human, more graspable; the treatment of space, its tendency to depth, the repoussoir figures that are hardly ever absent, and the wide panorama that opens up before the beholder, are still mannerist, however, and without the artistic aims and means created by mannerism the way of expression would be unthinkable.

Another turning-point in Bruegel's development takes place in about 1567, leading both to a further approach to the Italian way of pictorial

representation and to an increased naturalism, that is to say, a more con-
crete and trivial view of reality. This phase is represented by a number
of his most popular works, the *Peasant Wedding*, the *Peasant Dance*
(Pls. 230, 231) and the *Peasant and the Birdnest*, in Vienna, and the
Parable of the Blind, in Naples. As is most plainly demonstrated in the
Peasant Wedding, in spite of the more everyday subject and its more
natural treatment, he now makes more intensive use of the mannerist
means of pictorial organisation, in particular the uneven occupation of
space, the shifting of subsidiary figures into the foreground and conse-
quent relegation of the principal figures, and the compositional pattern
based on a diagonal. Dvořák notes the resemblance between the *Peasant
Wedding* and Tintoretto's *Marriage of Cana* (1561) in S. Maria No-
vella, and remarks that the resemblance is so striking that it might be
assumed that he had seen a copy of the latter. But the formal organisation
of the *Peasant Wedding* resembles even more closely the two last versions
of Tintoretto's *Last Supper*, that dating from the period between 1576
and 1581 in the Scuola di S. Rocco and that of 1592–94 in S. Giorgio
Maggiore. These works were painted long after Bruegel's death, thus
excluding an assumption which seemed rather fanciful even in relation to
the *Marriage at Cana*. As there can be no question of Tintoretto's having
been influenced by Bruegel, we are left with stylistic parallelism as the
only possible explanation. In addition to general mannerist compositional
principles, such as the unequal distribution of the figures in space, the
reversed positions of the chief actors and the bystanders, and the im-
portance of the diagonal, Bruegel's painting has in common with the final
version of Tintoretto's *Last Supper* mainly the fact that the bride in one
case and Christ in the other, that is to say, the principal personages, are
given the same unfavourable position and are recognisable practically
only by their external attributes. The only difference in organisation is
that Tintoretto shows the whole composition in reverse, as if he had had
in front of him an engraving of Bruegel's picture.

It is above all to works such as the *Peasant Wedding* and the *Peasant
Dance* that Bruegel owes his reputation as a naturalist and peasant painter.
So far as the commonplace nature of the subject-matter and the directness
of representation are concerned, these works certainly show his naturalism
at its most developed stage, but it should not be forgotten that he was a
skilled and conscientious naturalist from the first, and that these paintings,
as is shown by their similarity to those of Tintoretto, actually include
more rather than fewer mannerist stylistic features than his earlier works;
indeed, they are the best illustration of how intimately mannerism can
combine formalism and truth to nature, spontaneity and convention,
objectivism and subjectivism. Thus there is no objection to calling Brue-
gel a naturalist and peasant painter, provided that it is not intended to

imply that he was an artist of the humble, or painted his pictures with such a public in view. That would be a double error, both of common-sense and of fact. Humble people are not in the least interested in the life of their own kind, and the poor are not in a position to acquire works of art even today, and were still less so in Bruegel's time. His peasant pictures, as is well known, originated in courtly art.[7] The first renderings of country life occur in the calendar pictures of expensive prayer-books such as that made for the Duc de Berry, and tapestries intended for courtly circles, showing, besides ladies and gentlemen engaged in hunting, dancing, and other social occupations, peasants hewing wood or working on the vines. Similarly, the public for whom Bruegel painted certainly also belonged to the most prosperous and cultivated sections of society. In 1562–63 the artist moved from Antwerp to courtly and aristocratic Brussels, and that corresponded with the change of style that led to his last manner; henceforward he devoted himself more and more exclusively to the representation of peasant life.[8]

Even a cursory survey of Bruegel's art such as this cannot be concluded without mentioning another work, the *Storm at Sea*, in Vienna (Pl. 232), which one is bound to regard as his testament, rather like van Gogh's *Cornfield with Ravens* (Pl. 233). There is a great deal in common between the two, and it is not restricted to theme—the impact of van Gogh's cornfield being similar to that of Bruegel's storm-swept sea. They share, not only the same tragic mood and dramatic expression but, what is even more remarkable, also the main compositional lines on which they are organised and, above all, the synthesis of the elements immanent in the style of both that, in two similarly critical periods in the history of the western world, made possible a similarly complete artistic triumph.

As is most strikingly demonstrated by his renewed adherence to mannerism in the middle of the sixties, Bruegel did not remain completely independent of the then fashionable trend of Netherlandish painting, in relation to which he represented in many respects the old Flemish tradition, from which he departed as little as Shakespeare did from the old popular theatre or Cervantes from the old picaresque novel. The later mannerism developed in the Netherlands by the heirs of Frans Floris and under the predominant influence of Bartholomeus Spranger finally broke the link with this tradition, and established closer connections with Italian and French than with its native models.

Unlike the art of the Renaissance, but like that of the Middle Ages, that is to say, the late gothic, mannerism was international from the first. It sprang from a spiritual crisis that affected the whole of Europe and harked back to medieval reminiscences which, whether they turned out

to be stylistically formative or not, were common to the west and appeared in mannerism everywhere. Nevertheless, in spite of the fundamental uniformity of its stylistic principles, until the final phase of its development it displayed noticeable differences in individual countries. In the course of time these faded, and they ended by disappearing. Late mannerism was distinctly uniform and syncretic in character. It increasingly became a fashion, and as such conquered the courts, that is to say, practically all the art patrons of the civilised west. That is mainly why to later times mannerism became synonymous with cliché and empty virtuosity.

The close connection between later international mannerism and Italian art was established in the middle of the century mainly by Netherlandish artists who were members of the Vasari school and the *studiolo* group, such as Frederick Sustris (1520–91), Giovanni Stradano (born 1523) and Pieter Candid (died 1628) (Pl. 235), but primarily by Bartholomeus Spranger (1546–after 1627), the real founder and chief representative of the international style, who took part, among other things, in the decoration of the Palazzo Farnese at Caprarola and from there spread important influences all over Europe. He became a universal celebrity principally through the work of Hendrick Goltzius (1588–1617) (Pls. 236–8), the most important and most popular engraver of the age, and he had followers and imitators, first in the Netherlands, and then throughout the western world. Where he did not work in person, as in Prague, he exercised his influence through the 'Goltzius style' that completely bore his imprint and became the point of departure of a new trend at the courts of the Bavarian dukes in Munich and Augsburg as well as in his own home and at Prague.

In the Netherlands the mannerism for which the way was laid by Lucas van Leyden (Pl. 239), Jan van Scorel, and Martin van Heemskerck was further developed by Frans Floris (1517–70) and his contemporaries, and then by the representatives of the school of Haarlem, Karel van Mander (1548–1606), Spranger, and finally Cornelis van Haarlem (1562–1638), who took the turn to syncretism and eclecticism, fashionable elegance and preciosity, that for the first time secured the Netherlands a leading position in western art. But this was neither a simple and logical extension of previous developments of mannerism under Italian influence, nor was it the consequence of political or social changes, as were similar developments in other countries, where they were connected with the growth of courtly culture. In the Netherlands, strangely enough, the change of style first took place in the bourgeois-minded northern provinces. In addition to those that continually flowed in from Italy, new and partly different influences seem to have made their appearance. Though its most important elements came from that country, in Italy itself late mannerism never had the preciosity it acquired in the

Netherlands, even before the influence of the courts at which the artists later worked made itself felt. It is this fact that must have led to the over-emphasised, though not completely idle, assumption that French influence was a source of later mannerism in the Netherlands.[9] For, apart from the fact that many Netherlanders of minor significance worked in France and returned home with important experiences not exclusively of Italian origin, Spranger himself was in Paris in 1565, before he settled for a longer period in Italy, and both Bloemaert and Wtewael spent a period in France in their youth.

The robustness and clumsiness of the figures that often hampers the art of Heemskerck and Frans Floris, in spite of their perfect mastery of anatomical forms and the dynamic play of movements, completely disappears in Spranger, who ends by suppressing all trace of the exaggerated dynamics and display of energy characteristic of Michelangelism. In many of his works he preserves the strongly plastic, unpainterly treatment of the human form and the cold, smooth, marble-like surface, but his plasticity is without the violence of the epigones of Michelangelo. The most characteristic feature of his style is the gentle, delicate treatment of the female nude; he discovers a new aspect of its attraction still un-suspected by the followers of Parmigianino. His art is more subtle and suggestive, and reaches the borderline of indecency. He toys with novel and unusual sexual effects, the attraction of excessively young love objects, emphasises secondary sexual parts of the body, exchanges the roles of the sexes. The men are too masculine and their virility is exag-gerated, and the women too gentle, too childish, too helplessly exposed to violence, or alternatively the male, obviously yielding to homosexual tendencies, plays the role of the female, disguising himself and behaving as such, like Hercules at Omphale's spinning-wheel. The contrast of opposites that so preoccupied the age was now extended to the sphere of sex. Spranger, not content with contrasting the sexes, shows us the female in the male and occasionally also the male in the female (Vertumnus and Pomona, Judith and Holofernes); and stimulation is found in age as well as in youth; hence the interest in the rendering of younger and younger girls on the one hand and older men on the other.

In the works of the schools of Haarlem and Utrecht, and of the Rudol-phine circle in Prague and the Bavarian court, mannerist formalism is more pronounced than ever. The most striking characteristic of the new international style is a preoccupation with preconceived ornamental compositional forms and a concomitant complete lack of interest in the objects rendered, except for their erotic content and lascivious flavour, or in nudity as an end in itself, in mythological subjects that call for the re-presentation of the nude. Also characteristic is the use of small and dainty formats, the production of delicate, decorative objects, the elegance and

the meticulous, gem-like execution of which was in complete harmony with courtly taste.

The allegorical content of Spranger's *Triumph of Knowledge over Ignorance*, in the Vienna Kunsthistorisches Museum (Pl. 240), is a mere pretext for producing a purely erotic effect. The clothing of the principal figure enables the greater part of the body to be seen either unconcealed or under an illusory concealment that makes it the more seductive. The sparse clothing clings flatteringly to the form, and its only purpose is obviously to increase the appeal of the nude by contrast.

In accordance with the taste of his patrons, most of Spranger's paintings are of love scenes from Greek mythology, but he gives the same suggestive flavour to his rendering of a Biblical episode such as *Susanna and the Elders* (at Schleissheim) (Pl. 241). The arrangement and attitude of the figures in the work, which is one of the artist's most successful, is of the well-known 'sacrifice of Isaac' type, and was obviously chosen for the sake of displaying the nude form of Susanna in an interesting and difficult, but above all seductive, pose. One of Spranger's most characteristic, most appealing, and at the same time lewdest works is the small masterpiece *Hercules and Deianeira* in the Vienna Gallery (Pl. 242). Typical examples are the two rococo-like, exquisite and ingratiating paintings on copperplate in Vienna, *Hercules and Omphale* and *Vulcan and Maia* (Pls. 243, 244). One of his stylistically most interesting works is *Hermaphroditus and the Nymph Salmacis*, also in Vienna (Pl. 245). The choice of subject is highly illustrative of the taste of the time and of the fashion prevailing at Rudolph's court. The nymph falls in love with Hermaphroditus, the son of Hermes and Aphrodite, but the latter does not return her feelings, and she therefore appeals to the gods to be united with him. The gods grant her request, and they are united in the waters of a spring; henceforward all who bathe in it become hermaphrodites (Ovid, *Metamorphoses*, IV, 285–388). The nymph, like Susanna in the picture at Schleissheim, is painted in a difficult and ornamentally complicated pose. Her serpentine lines, and the exaggerated difference in dimensions between the two figures of the composition, for which perspectively there is little justification, recall even more strongly than most of the other works of Spranger the Italian masters whose follower he remains, however personal may be the way of expression that he develops in relation to them. This is always rather affected and superficial, but his flow of line and elegant form has hardly any parallel in earlier painting, and its historical importance is outstanding. Without it the whole of later international mannerism, both in its beginnings at Haarlem and Utrecht and also in the courtly forms that it assumed in Prague and Munich, would have been inconceivable.

Cornelis van Haarlem, with whom mannerism in his birthplace reached

its peak, adopted the technique of Spranger and Goltzius but, though his composition is more ambitious than that of his predecessors, he turns out to be rather backward and provincial in the outcome (Pl. 246). With his big foreground figures, rigid ornamental patterns, the loose connection of his groups, nudes and postures in academic taste, and the cold calculation of details, which permit the emergence of no uniform dramatic effect, he recalls, not only Heemskerck, but also as early a mannerist as Lucas van Leyden.

The masters of the Utrecht school, Abraham Bloemaert (1564–1651) and Joachim Wtewael (about 1566–1638), represent a much more advanced stage of development, as well as an artistically more important form of the late style. Bloemaert's mannerism is less constrained than that of the Haarlem painters of the age; he is more moderate in the imposition of mere form, his proportions and spatial relations are less arbitrary and exaggerated, and he concentrates less exclusively on the erotic. Nevertheless he preserves the delicacy, the elongation, and the often functionless exhibitionist attitude of the figures, their affectation and preciosity, their inner distance from the events represented, in short, all the characteristics of mannerist formalism. That is, he does so for many years. Eventually a fundamental change takes place in him. He goes on living and working long enough to take part in the movement leading away from the exaggerated form of late mannerism towards a Caraveggesque baroque realism in the manner of Hendrick Terbruggen and Dirck van Barburen, and he even shares in the trend towards a kind of academic classicism in the manner of Cornelis van Poelenburgh. Thus his development can be said to sum up the whole course of Dutch painting from the end of the sixteenth until the middle of the seventeenth century, though with the omission of the form in which it scored its greatest triumphs; and he demonstrates that mannerism, contrary to what was assumed from his long life and prolonged activity,[10] was in fact superseded at the time of the greatest achievements of Dutch painting and was fundamentally irreconcilable with the mature art of Frans Hals, Rembrandt, and Vermeer.

Bloemaert's early work, *Judith Showing the Head of Holofernes to the People*, in the Vienna Gallery (Pl. 247), dating from 1593, is still extremely mannerist, though a certain baroque restlessness of movement and lighting and a baroque theatricality of arrangement are already evident. Other works from the same period, including the *Miracle of the Loaves* (1595), brilliantly rendered in an engraving by J. de Gheyn (Pl. 248), and the *Birth of Christ*, at Göttingen University (Pl. 249), are less 'baroque', that is to say, more exquisite and sophisticated, more mannerist and actually mannered in that sense. *John the Baptist Preaching*, in the Rijksmuseum at Amsterdam (Pl. 250), more progressive in the representation of landscape than in that of the figure, belongs to the same group. What

we may call Bloemaert's Terbruggen period is represented by the *Adoration of the Magi* of 1624, in the Centraal-Museum at Utrecht, and the transition to what can be called his classical period is represented by the somewhat later *Theagenes and Chariclea* (1626) (Pl. 251).

Joachim Wtewael's art is more even in style. His most successful works, such as the *Adoration of the Shepherds* of 1598, in the Centraal-Museum at Utrecht, of which there is an attractive variation in the Ashmolean at Oxford (Pl. 252), and his *Joseph and his Brethren* (1605), at Utrecht (Pl. 253), which already displays certain baroque features, show him closest to Bloemaert of the same period. Characteristic of Wtewael's rendering of form in general is his so-called 'dough' style; he makes his figures, particularly their hands and also to an extent their muscles, cheeks, and eyelids, look as if they were kneaded. He shares this feature with other late mannerists, Bellange and Bloemaert, for instance, and it later recurs in southern German baroque and rococo.

During his stay at Haarlem in 1583 and 1584 Spranger exercised a decisive influence on the school there, and through it on the whole of late mannerism; and similarly, when he later became court painter to Rudolph II at Prague, the impact he made affected the courtly style of his time all over Europe. Under the influence of his works mannerism, which had been so rich in courtly elements ever since Bronzino and Vasari, now assumed the preciosity, gallantry, and playful eroticism which with Hans von Aachen (1552–1615) and Josef Heintz (1564–1609), those court painters *par excellence* who were active at Prague, superseded all other features and gave their art a pronounced rococo-like quality. The slender now became thin, women became small-hipped and small-breasted, and the affected degenerated into the blasé. Love became a habit instead of a passion; it was conducted with subtlety and never proved intractable, was at best amusing, and was never more than a mere pastime.

With these artists German mannerism flowed into the main stream of the international style, and by no means as a mere tributary; it became a predominating influence, if only for a short time. Its sudden prominence does not, however, mean that it was a recent growth.[11] The idea that mannerism is everywhere an outcome of the Italian Renaissance, its reception and its crisis, is at first sight very tempting, for all the national variations of the style are indeed more or less closely connected with the Cinquecento in Italy. This connection is, however, not always the primary factor in the origin of the style, but may take second place behind local circumstances. In Germany, where the connection with the Italian Renaissance was relatively loose, though effective nevertheless, the negative reaction to classicism, which was the factor that led to the appearance of mannerism in Italy, was delayed until the time of the later, international form of the style.

But, apart from parallel phenomena in the prehistory and early history of mannerism, as for instance, those of Gaudenzio Ferrari (about 1471–1546) and Wolf Huber (1485–1553) (Pls. 256, 257), or Lodovico Mazzolino (1478–1528) and Albrecht Altdorfer (1475/80–1538) (Pls. 258, 259), in whom the role of give-and-take and the share of medieval reminiscences and anticipation of later development is hard to define, the mannerism of a Lucas Cranach (1472–1553) or a Hans Baldung Grien (1475/80–1545) (Pls. 260, 261), though it differs from the Italian in many respects, is already obvious; and the mannerist element is evident even in Grünewald (1470/75–1528) (Pl. 262), who is more loosely connected with Italian art and much more closely connected with his own medieval cultural tradition than most of his contemporaries.

The influence of the gothicising German artists on mannerism abroad may have been of greater or lesser importance, but the first really great international success of German mannerism was in portrait painting, the field of its most magnificent achievements. Holbein was the first and greatest German mannerist to acquire a world-wide reputation (Pls. 265–70). In relation to him the German artists at the court of Prague must be content to play a secondary role. But graver injustice is done to many German portraitists, such as Christoph Amberger, for instance (Pl. 271), by reason of their proximity to the incomparable master.

Associated with the court painters in Prague was a sculptor of unusual talent, Adriaen de Vries (about 1560–1629), a Netherlander like his supposed master Giovanni Bologna, whose worthy successor he was. Like the Dutch painters, he produced a most exquisite version of late mannerism (Pl. 272), and, like them, provided a strong link between the Italian tradition and its final outcome in western Europe. He represents the transition between the development in sculpture which proceeds from Benvenuto Cellini (1500–37) (Pls. 273–5) and the immediate followers of Sansovino and Michelangelo, that is to say, Baccio Bandinelli, Vincenzo Danti, and Tribolo (Pls. 276, 277) and leads to Giovanni Bologna (1524–1608) (Pls. 278–81) and Alessandro Vittoria (1525–1608) (Pl. 282), and the last, now nearly classical phase of the style. Thus, like Bloemaert, he stands on the threshold of a new age, but his art is and remains to the end fresher, more unbroken and homogeneous.

3. SPAIN

El Greco has no Spanish predecessors, though a Spaniard, Alonso Berruguete, could with some justification be regarded as the first mannerist, as he developed certain mannerist forms in Florence even before Pontormo and Rosso. Apart from him, only the portrait painter Alonso

Sánchez Coello (1531/32–88) (Pl. 283) is worthy of mention before El Greco; he became court painter to Philip II in succession to Antonis Mor, whose pupil he was, and made an important contribution to establishing the form of portraiture that soon prevailed at the courts of Europe. After El Greco's death mannerism came to an end in Spain, where it never had other representatives of consequence, unless the Italians Pellegrino Tibaldi, Luca Cambiaso, and Federico Zuccari, whom the King employed between 1583 and 1594, are regarded as such.

El Greco himself was by artistic education more Italian than Spanish, though perhaps nowhere outside Spain, or perhaps actually outside Toledo, would he have developed the form of spirituality peculiar to his art, to which mannerism in this late phase of its development—the artist died in 1614, that is to say, twenty years after Tintoretto—has nothing comparable to offer. Even in Italy, apart from Tintoretto, El Greco has no real spiritual predecessors. Michelangelo influenced him, as he did his whole generation, but not in any definitely mannerist sense, and El Greco's attitude to him, whatever truth there may be in his allegedly derogatory opinion of the artistic qualities of the *Last Judgment*, was too problematic and contradictory to be compared with the link between him and Tintoretto.[12] A number of other Venetian painters, such as Titian, Schiavone, and Jacopo Bassano, had a bigger share in the formation of his style than any non-Venetian artists. In Rome, of course, the artistic heritage of Michelangelo, not to mention the incomparable example of his dedication and moral purpose, influenced him in innumerable ways that can now hardly be verified. There too the Raphaelesque, and more particularly Parmigianinesque, influence that had already powerfully affected him through the Venetians played a direct part in the development of his style. But the great and vital influence was and remained Tintoretto, whose 'spiritual rebirth' coincided with El Greco's second stay in Venice between 1572 and 1576.

Direct formal borrowings from Michelangelo are rare either in his earlier or later works; the most striking is in the use of the compositional form of the Florence *Pietà*, in the representation of the same subject in the Pennsylvania Museum of Art, and in the *Trinity*, in the Prado.[13] Other works, above all the *Martyrdom of St. Maurice*, are influenced by Michelangelo in a deeper spiritual sense. The *Purification of the Temple*, in the Institute of Arts in Minneapolis, dating from the period between 1570 and 1575 (Pl. 284), a masterpiece of his Italian period, shows a striking advance in relation to an earlier version that is much more under the Venetian influence, and is a good example of the synthesis of the Venetian and Roman elements, that is to say, in the treatment of space and architecture, which points to the former, and of the human figures and their integration into the space, which points to the latter. The most remarkable

feature of the composition is the unequal distribution of the figures in the space, which shows that he developed certain components of his mannerism very early and brought it with him from Italy as part of his artistic equipment.

El Greco left Italy at the end of 1576 or the beginning of 1577, and lived at Toledo for the rest of his life. The precise reason for his move to Spain is unknown; perhaps the Spanish religious spirit was inherently better suited to him than the more worldly culture of Italy, though at first he seems to have had a worldly and courtly career in mind. Not till some time had passed did he decide to settle permanently in Toledo instead of Madrid; the former, even after it had lost its position as capital and royal residence, remained the cultural centre of Spain, the centre of its literary and religious life and the favourite residence of the aristocracy. Successful though he became with this public, the spiritual and social *élite*, and, to judge by the numerous repetitions of certain commissions, highly though he was esteemed by the intelligentsia, and more particularly the clergy, at court he apparently had no success. His permanent residence at Toledo and his dependence on ecclesiastical patronage were no doubt partly the consequence of his failure with the King. His first attempt to gain the royal favour with the *Dream of Philip II*, in the Escorial, painted before 1580, must have been successful, for the commission for the *Martyrdom of St. Maurice and the Theban Legion*, also in the Escorial, followed soon afterwards. This painting was executed between 1580 and 1582 and was El Greco's first supreme masterpiece, but it seems to have been too severe a test for the connoisseurship of Philip II. To a patron of the arts who at heart was well disposed towards mannerism, but whose favourite painter was Titian, the powerful and violent, uncompromising and often actually provocative form, with its contrasting proportions and unusual spatial relations, in particular the paradoxical repetition of the principal group, must have seemed too daring.

At Toledo, however, where a deeply religious and actually mystical atmosphere prevailed, his success was immediate, and it grew with the years. It was the heyday of Spanish mannerism, and the most important representatives of Spanish intellectual life lived there, including Góngora, Cervantes, Lope de Vega, Tirso de Molina, Hortensio Félix Paravicino, and St. Teresa.[14] The artist counted most of the poets, philosophers, and theologians whose home was at Toledo as his friends. Paravicino's sonnet and the critical writings of the painter and author Francisco Pacheco about his work best reflect his unqualified acceptance by this public. If one forgets for a moment that living in Toledo was like living on an island, and that in spite of everything the intense spiritual life of the place was a dream that had soon to come to an end, it is easy to be led astray, like many Spaniards, into not only identifying El Greco with

Spanish mannerism but also equating mannerism itself with Spain. There could never be any hope, however, of persuading enthusiasts of the type of Unamuno that even in Spain mannerism has ceased to be the living present, be it in the sense that Don Quixote is the eternal symbol of the Spanish spirit, Góngora the quintessence of Spanish poetry, El Greco the Spanish visionary *par excellence*, or that the paradoxical nature of mannerist thought represents the inherent split in the Spanish national character.

Criticism of El Greco before the end of the seventeenth century hardly occurs, but with the development of classicism and rationalism dissent becomes increasingly evident. First his 'extravagance' is deplored and attributed to his allegedly disturbed mind, and then to his alleged eye trouble. Also his contemporary Francisco Pacheco refers to his 'paradoxical views', but says that, even if one does not always agree with these, the artist must yet be counted among the greatest of men.[15] However in 1673, in his *Discorsos practicables del nobilisimo arte de la pintura*, Jusepe Martínez speaks in critical terms of the extravagant nature both of his art and of his character, and ascribes his having had so few pupils to the circumstance that few were willing to follow his strange and abstruse views.[16]

Immediately after his arrival at Toledo El Greco was commissioned to paint a picture for the high altar of the church of Santo Domingo el Antiguo. In this painting of great size, an *Assumption* (dated 1577, in the Chicago Art Institute) he shows himself to be already a mature master, able to make independent use of what he has learnt from Titian and Tintoretto, having at his command the whole mannerist vocabulary, capable of making sovereign use of elongation of forms, parallelism and contrast of lines, the *figura serpentinata* and massive foreground figures. His next picture is the *Resurrection* (1577–79), painted for the same church (Pl. 285), and in this certain mannerist features, in particular the contrasting formal structure, posture, and movement of the two startled soldiers, is more striking and more characteristic of the whole composition than in any earlier work. He must still have been busy with this painting when he received another important commission, this time for the sacristy of Toledo Cathedral, for an *Espolio*, a subject that had already occupied him during his stay in Venice. The reputation that he gained with these works seems to have encouraged him to seek the King's favour. For this purpose he prepared two small sketches, and was commissioned to make a picture of one of them, known as the *Dream of Philip II* (also as the *Adoration of the Sacred Name of Christ* and the *Allegory of the Holy League*).

Strangely enough, this picture which, unlike the second, the *Martyrdom of St. Maurice*, gained the royal favour, makes greater demands on the understanding of the present-day public than does the latter, which is

certainly better balanced, less 'medieval' in structure and theme, and more easily reconcilable with the modern sense of reality. In the *Dream of Philip II* (Pl. 286), particularly in the upper part of the composition, El Greco already displays such mastery of late mannerist formal means and such a mature and independent talent that it can be taken as the beginning of a new phase of stylistic development. The most characteristically mannerist element fundamental to the composition is the repetition of the triangle including the principal group of figures, the Pope, the King, and their retinue, by the smaller triangle of the jaws of hell. Since the Middle Ages there has been no such fantastically unreal combination of subjects or such far-reaching irrationalism of proportions. The 'naïve' rendering of the crowd behind the principal group, in which the heads are on top of instead of behind each other, is also medieval. The contrast between this crowd, the members of which are packed together like sardines, and the void that stretches away in all directions behind them is certainly not an invention of El Greco's, but he uses the device in a more radical and un-realistic manner than his predecessors. In the upper half of the painting he combines in highly mannerist fashion the deep spirituality of his art with a supremely skilful, almost playful, formalism (Pl. 287). Character-istically he intersects the two angels in the left-hand corner by a streak of cloud in order to repeat and emphasise the diagonally mounting line of the triangle containing the Pope and the King. This in itself is not particularly remarkable or original, but is made so by the following device. The upper part of the bodies of the two angels is hidden by the strip of cloud, and their shape is indicated by that of a third angel, who is seen in full. The lower part of the angel's body is thus repeated no fewer than three times.

The next picture painted for the King tells the story of the *Martyrdom of St. Maurice* and the legion under his command, which was converted to Christianity and refused to make the usual sacrifice to the pagan gods before setting out on active service (Pl. 288). As a penalty every tenth man was ordered to be decapitated. This story is told in three successive scenes in accordance with the so-called 'continuous' technique, and the figure of the chief protagonist appears at least twice. This familiar medieval device, as seen in Duccio's *Agony in the Garden*, was gradually given up in the course of the Renaissance and had hardly been used since Masac-cio's *Tribute Money*. Here El Greco uses it as a medieval reminiscence, as Bellange does later. In the foreground the saint is seen very prominently; he seems to be making a declaration of faith to the superior commander rather than trying to divert him from his immediate purpose. In the middleground, where the execution of the martyrs has already begun, the scale is suddenly reduced. St. Maurice is standing beside a beheaded body and a man awaiting the executioner's stroke. In the background, still further reduced, more victims are approaching the place of execution.

Their martyrdom and imminent salvation is being celebrated by choruses of rejoicing angels in the heavens overhead.

The high ground on which the protagonists are seen, in contrast to the usual practice, sinks towards the middleground and then rises again towards the background. This seems strange to an eye brought up on classical art, but produces the striking effect at which mannerism aims. For the irregularity of the ground further complicates the broken and fragmented space, and increases the sense of unrest. Bruegel notoriously applies this method in some of his representations of the *Months*, but El Greco, unlike him, uses, as has been pointed out, a kind of stage technique, in that he assigns the 'acts of the drama' to different settings,[17] thus recalling the 'mansions' of the medieval theatre on which different scenes were enacted side by side.

El Greco painted other pictures of equal and greater merit, but never anything more daring, or more successful in its daring. In the whole of mannerism there is nothing that surpasses it in this respect. Nor is there any work, either by him or anyone else, that comes nearer to the spirit of the late Michelangelo, the creator of the Pauline frescoes. El Greco was the only artist capable of breathing in that rarefied atmosphere. He also seems to have been influenced by Michelangelo's last frescoes in the formal respect. He had used the division of the composition into an earthly and a heavenly scene in the *Dream of Philip II*, and he preserves it to the end. This is not merely a harking back to the traditional representation of the Ascension, but is obviously taken from the *Conversion of St. Paul*, and he makes it an artistic means of supreme importance for his own future development and the final shape of his formal language.

El Greco grows to full maturity with the *Burial of the Count of Orgaz* (Pl. 289), which he painted for the church of Santo Tomé at Toledo, between 1586 and 1588, only a few years after the *St. Maurice*, and with it he attains the most balanced period of his artistic development and the culmination of mannerist painting as a whole. So far as the relationship between the two parts of the composition are concerned, it still contains a great deal that is traditional. Above all, it preserves a balance between the lower and upper half, the earthly and the heavenly scene, that accords with classical Assumptions in general and Titian's *Assuntà* in particular. The lower part keeps to the traditional pattern of entombments and scenes of bewailment that had been a staple of Italian art since the time of Giotto. But the work departs from classical prototypes in that it differentiates more distinctly than did the Renaissance between earthly and heavenly events in such cases. Even in the stylistic respect El Greco's treatment of the two parts is different, that is to say, he gives them different degrees of realism. The scene below, showing the mourners, recalls the directness of the great Dutch portraitists. The row of pearls of heads,

as Dvořák called this marvellous group portrait, in which the rendering of distinct personalities is so perfectly combined with the aristocratic-ascetic stamp of the class to which they belong, and the beauty and sensitivity of the individual is so completely merged with the characteristics of a highly bred species, is a masterpiece of psychological and physiological observation. The scene in the clouds above is seen with different eyes. Here the artist describes with exuberant imagination, a sweeping flow of line and ebullient richness of form a supernatural vision of the world beyond, the beauty of which has nothing in common with that of the men below. The ornamentalism that prevails in this part of the picture, contrasting with the realism of the lower part, carries a new meaning, fulfils a new function and, unlike the formalism of late mannerism in general, becomes a means of spiritualisation.

When El Greco was commissioned to paint the burial of the Count of Orgaz (who was the patron of the church of Santo Tomé and died in 1322) and the legend associated with the burial, it was laid down that it should show the following. While the priest, in the presence of other ecclesiastics, was celebrating the mass for the dead, St. Stephen and St. Augustine had descended from heaven and set about burying the body. One was to be shown holding it by the shoulders and the other by the legs. The assembled mourners were also to be shown, as well as heaven with its celestial host opening to receive the departed. El Greco renders this in such a way that the whole heavenly scene remains invisible to the congregation, with the exception of a robed priest in the right foreground corner, who looks up in marvel and indicates the miraculous scene, and a boy in the other corner, who points to it with his finger in the medieval manner. Apart from these two, all those present are absorbed in the service. How much the boy in his innocence sees and understands of the transfiguration is not clear. His function, in contrast to that of the priest, seems to be purely technical and formal, and to have no spiritual signification; in any case, rather than a repoussoir figure intended to create the impression of depth, he is obviously one of the foreground figures whose role in mannerism is to connect the domain of art with the world of the spectator, linking fiction with reality, the picture space with real space. Their purpose is not the creation of illusion, as it is in the baroque, but the opposite. They make play with illusion, point to the existence of the two worlds that are entered upon in entering the world of art, and emphasise the narrow edge between imagination and reality, poetry and truth, dream and real life, on which mannerism moves.

Apart from the varying criteria of reality, the *Burial of the Count of Orgaz* also displays a number of other unmistakably mannerist characteristics, though the violent, forced, and eccentric features are so much in abeyance that it would not be completely amiss to speak of a mannerist

classicism in this instance. Nevertheless the mannerist dualism is plainly present, and in El Greco's position between court and church, his turning away from the courtly to the ecclesiastical spirit and his divided loyalties between them, make themselves felt more strikingly than usual. His failure to secure permanent employment from the King was a sign that a cleavage had begun in Spain between courtly and religious culture, that the courtly forms of mannerism had grown too narrow for an artist like him, and conversely that the problems of mannerism in his sense had grown too difficult for the court. But he would have been no true mannerist if he had been capable of completely resolving the contradictions inherent in his style. Though in the stage of development marked by the *Burial of the Count of Orgaz* he has far outgrown the courtly origins of his style, he does not repudiate them.[18] On the contrary, the picture shows a ceremonial scene correctly in court taste, while it simultaneously rises into a world in which not only courtly things, but all social and human affairs are left behind. It is at one and the same time the correct representation of a ceremony and the rendering of a spiritual drama connecting heaven and earth, a profession of faith infused with the deepest, tenderest, most mysterious spirituality. Courtly forms mastered with effortless skill are preserved in the representation of immediate reality as perfectly as spiritual reality prevails in the higher region. Tintoretto's final mannerist style came into being only after a Michelangelesque phase of development in which epic-dramatic work predominated; and similarly El Greco does not achieve his extreme mannerism, with its deformations, overstraining, and exaggeration of forms—features which are now more and now less violent, and are sometimes of greater and sometimes of lesser significance, but never fade away completely and remain the most striking characteristic of his later works—until after the realisation of the *Burial of the Count of Orgaz* with a harmony of form the stylistic quality of which could be called classic but for its unmistakably precarious nature.

After a transitional phase between the end of the eighties and the middle of the nineties, he enters a period of complete emancipation from empirical reality and the formation of a totally non-naturalist, spiritualised, visionary style which lasts for fifteen years, until about 1610, and results in the religious paintings, mostly large-size altar-pieces, with which his art is normally identified. Just as his subjects, the *Baptism* and the *Resurrection of Christ*, the *Annunciation*, the *Immaculate Conception*, and the *Descent of the Holy Ghost*, rise from the earth into the clouds and move in a space that grows more and more abstract, so does his own spirit depart more and more definitely from all earthly and sensual things. The bodies that he paints are transfigured; they have lost their substance as well as their form, and have been turned into weightless, lambent flames. Their solid, tangible corporeality has been transformed into pure colour

and light; they are absorbed in light, become embodiments of light, light is the medium in which they take shape. El Greco abolishes their earthly form and material being and turns them into astral bodies.

Prominent as is the role given to colour, in accord with the predominance of light in El Greco's later works, he is far from making lavish use of varied colour effects. To the extent that his style departs from naturalism and becomes more and more spiritualised, the colours grow more monotonous; very effective harsh tones often occur, but even these are on a very restricted scale, and in general they are poor in painterly gradation and shading. They mostly provide sharp contrasts that conflict with the harmonious sense of colour which, with the relatively brief interruption represented by mannerism, prevailed from the beginning of the Renaissance until the end of impressionism. Instead of the subdued tones of the Renaissance and the baroque, the warm flesh colours, the rich green of the trees, the deep, sonorous brown that the Venetians used with so much painterly effect, El Greco prefers shrieking colours, a bright cold blue, a poisonous yellow, a sharp green, and a mauve that hardly appears in nature. Colouring loses more and more of its own independent value, its sensuous appeal, and its material power of expression; its function is increasingly restricted to the conveying of light, and its dematerialisation and desensualisation of material objects suggests an effusion of spirit. El Greco changes his application of paint and brush technique at the same time. His style grows more and more painterly, but not in the sense of becoming more *pastoso*. Like most mannerists, he always applies his colours thinly but, while earlier, that is to say, mainly since the *Burial of the Count of Orgaz*, he had used an improvising, broad brush technique, he now atomises his surfaces into small areas of colour, works with small, thin brushes, and places short, narrow, pointed strokes next to and under each other, so that the whole painting becomes a scintillating web of particles of colour and light. The result is a flicker and sparkle that does not glow or warm, only gleams and glitters, but is full of painterly appeal. Neither the colouristic nature nor the luminescence of his paintings change in the course of years, but they are produced by different means and for a different purpose. El Greco remains the colourist that he was, but develops from a technician into a magician of light and colour. There is no more Venetian complacency about his colouring and his light shines as if from another world, not from a real source of light, as it does in chiaroscuro painting.

The function of colour and light in El Greco has to be taken into account if one is to understand his claim (if indeed he made it) that he could have painted the *Last Judgment* better than Michelangelo. Colour did not by a long way have the importance for him that it had for Titian, for instance—with the exception of his early Venetian period, perhaps, he

can never be said to have taken a direct, sensuous pleasure in it—but it always plays a vital part in his art, while with Michelangelo it never does. Moreover, it preserves its importance for him even in his old age, when the colouring in his pictures quietens down and dwindles away. He remains a colourist even when he uses only two basic shades—gradations of red and ochre yellow—on a greyish-brown priming, which he heightens with white, and gradually drops all the other colours.

The *Baptism of Christ*, in the Prado (Pl. 292), dating from 1596–1600, is one of the first pictures in which the format and the proportions are in the style characteristic of the artist's old age. Everything is now concentrated on emphasising the slenderness and height of the figures; elongation becomes the dominant stylistic principle in every respect. The tendency to height is not, as it generally is in mannerism, restricted to elongation of the figures, but also appears in the tall shape of the paintings, particularly the big altar-pieces, which are often twice as high as they are broad, and sometimes, as in the *Baptism* and other paintings belonging to the same group, even higher. The human form itself undergoes further stretching, however. Such exaggeratedly elongated figures as those of Christ and John the Baptist in this painting, or of the man tumbling backwards to the ground and the other man standing upright next to him in the *Resurrection* (painted in the years immediately after 1600, also in the Prado) (Pl. 293), are almost unprecedented, even in the work of the boldest mannerists. The raised arms and legs of the figures in the *Resurrection* make them seem even taller than they are. These towering limbs have the effect of exclamation marks, drawing attention to the spiritual centre of the picture in the heights. The proportions seem wrong and paradoxical only because the subsidiary figures are given such an inordinate amount of room in relation to the form of Christ. They carry to extremes the mannerist principle of subordinating primary to secondary components. Nevertheless the radiant figure of Christ dominates the composition, and hovers transfigured and triumphant in its harmony over the chaos of a scene that is like a fall of the Titans. The same principle of elongation prevails in the *Baptism of Christ*, with the difference that here the figure of Christ is brought into the foreground and is accordingly enlarged. On the other hand, the angel on the left is even more elongated than the foreground figures in the *Resurrection*—in this case the head is no more than one-twelfth of the whole body.

Nothing is easier to understand than that until the age of modern expressionism such creations had the effect of caricatures. With the end of mannerism there was no approach open to an art in which divergences from normal experience were not the result of extravagance or incapacity, but were the expression of otherwise inexpressible emotions and ideas. Only in our own age has it again been recognised that art

has no need completely to renounce the apparently ineffable, and that, on the contrary, it can indicate indirectly what it cannot state directly, that gaps, contradictions, and apparently absurd distortions are often no more than a compromise between an originally clear vision and its final realisation, and that where a gap, contradiction, or distortion appears a link in the chain of what is renderable is missing, that is to say, that there may perhaps be a blind spot in our own eyes. We have learnt to behave more tolerantly and humbly in the presence of a work of art and to wait until it speaks to us, until we have learnt its language. Mannerism came to an end because the language of an art such as that of El Greco ceased to be understood.

Among the subjects dealt with by El Greco with the greatest artistic and, to judge by the numerous variations, also practical success in this late phase of his career was the *Annunciation*. One of the most vivid, colourful, and painterly version of it is in the Thyssen–Bornemisza collection at Lugano-Castagnola, dating from the years between 1595 and 1600 (Pl. 294). It is considerably smaller than the picture in the Museum of the Biblioteca Balaguer, Villanueva y Geltrú, which is less brilliant in colour, but hardly different in design.[19] The *Pentecost* belongs in every respect to the group of the great altar-pieces of this period, though the copy in the Prado is a later version, perhaps not completely by the artist's own hand.[20] The upper part, however, in contrast to the other pictures in the series, shows a calmer mood, though this is counter-balanced by the greater unrest of the lighting. The picture moves in light, and light keeps it in movement, leaping like a wave from one head to the next, caressing and surrounding all the forms and figures, linking the various parts of the vision with each other—it is, indeed, the element in which the spirit descending on the scene becomes effective and, as it were, visible.

The relative calm is only temporary; the *Immaculate Conception*, in the Museo de Santa Cruz at Toledo (Pl. 295), is expressionistically the most restless, disturbed, tense work of the whole group, in the compositional arrangement as well as in the treatment of the individual figures and in the colouring. The elongation of the human form reaches its climax, the disproportion of the single parts of the body, particularly of the head in relation to the rest of the figure, is unprecedented, and the bodies stretch and bend as if they were made of paste. Moreover, it almost seems as if certain limbs—the shank of the angel on the right below, for instance—are about to detach themselves in the surrealist manner and begin floating about independently in space.

The period between the *Burial of the Count of Orgaz* and the end of that of the great altar-pieces is marked by the painting of El Greco's most remarkable portraits. The first, the *Portrait of an Unknown Gentleman* in

the Prado, dating from after the middle of the nineties, still betrays the proximity of the mourners in the *Burial of the Count of Orgaz* (Pl. 296). The type represented and the style are the same. But a new spirituality and intensity of expression is achieved with the *Portrait of Cardinal Fernando Niño de Guevara*, in the Metropolitan Museum of New York, dating from the period about 1600 (Pl. 297). In its close reserve, that yet enables so much to be suspected, it is a prototype of mannerist portraiture. By his cool, severe, fanatical expression, El Greco cuts off the Grand Inquisitor from the world as if by a wall, and thus the portrait becomes one of the great symbols of the age of the Counter-Reformation and men's alienation from each other and from themselves. One of El Greco's most fascinating works, and one of the finest portraits of all times, is that of *Félix Paravicino*, the priest and poet, dating from 1609, in the Boston Museum (Pl. 298). The painter and his model would have been no mannerists if they had dropped all the veils by which the soul preserved its secrets and all the defences that it erected against the world; but the model is a poet, an artist like the painter himself, and he breaks through the wall of alienation, if only as it were, for a moment. Paravicino's soul flashes through his eyes, and his blood-red mouth is like an open wound—as Góngora or Calderón would say. Underneath the calm surface everything is vibrant, and even the back line of the armchair, which in the picture of the Grand Inquisitor sinks somewhat, but only because the chair is placed askew, here slants more sharply, and seems to express an inner tension, a not completely concealable nervousness.

The last years of El Greco's life are marked by yet another stylistic change. In certain respects the works produced now outdo all his earlier ones, and, with the exception of Michelangelo's *Pietà Rondanini*, go further in abstraction from reality than any work of art since the early Middle Ages. At the beginning of the period there comes one of the least abstract works of the artist's last years, the *View of Toledo*, in the Metropolitan Museum, that must have been painted after 1600 (Pl. 299). Apart from the doubtful *Mount Sinai*, only two landscapes by El Greco survive. The subject of both is the same, and of the two this is the more important. It has an indescribable visual power and, if that so often misused word 'visionary' is ever appropriate, it is here. The picture shows a dark, eerie, stormy landscape overhung with clouds, illuminated by lightning flashes and plunged in night, in which the town, with its bone-like grey buildings, apparently dead and haunted only by ghosts, stands fossilised and lifeless, like its own memorial—a true mannerist dream picture, in the borderland between vision and reality, life and death, closed and mysterious, mute, cold, and like lava, under which fire perhaps still glows. It is characteristic of the paradoxical nature of the work that, in spite of its usually restricted scale of colours, it shows El Greco's colouring at its

highest perfection. The general impression is of mere variations of green; but closer inspection shows that the colour scheme includes fine gradations of brown and grey, some blue, and a great deal of black.

The *Laocoon* in the National Gallery in Washington, one of the masterpieces of the artist's final period, was painted in about 1610 (Pl. 300). With its prominent landscape background, it recalls both thematically and in conception the *View of Toledo*, though many years must have passed since the execution of the latter before El Greco could have produced a work of this kind. The abstract nature of the *Laocoon*, which appears above all in the formation of its figures, their dreamy, mechanical, puppet-like lifelessness and their lack of relation to their environment, marks it off sharply from all his previous work. The painting is obviously suggested by the Hellenistic group; the most obvious difference is that it shows six figures (the sixth was discovered when the picture was last restored) instead of three. Also, as is only natural, there are a large number of stylistic differences, of which the most striking is the contrast between its mannerist coldness and passivity and the 'baroque' drama and dynamism of the original. The theme of the latter is the struggle with the serpents, and the effort, passion, and pain involved. In El Greco's painting two of the three participants in the drama are on the ground, though they do not seem to have been struck down by them; the son of Laocoon lying half outstretched has perhaps not been killed, or even touched, by the serpents, and the other son, like his father, instead of being engaged in a life and death struggle, seems to be ostentatiously exercising his muscles. Two of the other figures present are said to be Apollo and Diana, and they are rendered even more insubstantially than the protagonists, and seem to be devoid of bone and muscle. Certain features of the work are reminiscent of early mannerism, particularly the strong occupation of the foreground, the empty middleground, and the arrangement of the figures in a planimetric pattern. The three principal figures form a simple geometrical pattern, with two parallels connected by a diagonal, the continuation of which leads to the heads of the onlooking gods.

Another masterpiece of the final period is the *Fifth Seal of the Apocalypse*, in the Metropolitan Museum, painted at about the same time (Pl. 301). Its relationship with the *Laocoon* is unmistakable. The many nude figures, their gentle, insubstantial form, their elongation and bending, their weightless fluttering about in space, the parallel wavy lines with which they are drawn, are features common to both works. The great difference between them, however, lies in what the rendering of the apocalyptic scene has in common with the great religious compositions of the penultimate period, that is to say, in the completely sublimated, introverted nature of the picture. The theme is this passage in Revelation, VI, 9–11:

T

And when he had opened the fifth seal, I saw under the altar the souls of them that were slain for the word of God, and for the testimony which they held:

And they cried with a loud voice, saying, How long, O Lord, Holy and true, dost thou not judge and avenge our blood on them that dwell on the earth?

And white robes were given unto every one of them; and it was said unto them, that they should rest yet for a little season, until their fellow-servants also and their brethren, that should be killed as they were, should be fulfilled.

St. John here sees the day of judgment approaching. The huge, formally exaggerated figure in the foreground, of which there is no second example in mannerism, is the saint himself. He is kneeling with ecstatically raised arms, between heaven and earth, superhuman in size and embracing heaven and earth with the superhuman power of the spirit. The martyrs kneeling or standing beside and behind him differ from him in size and substance, and also move in a world different from his. He is great, but they are blessed. This is also expressed by their nudity, another reminiscence of medieval art, in which the blessed appear nude in God's presence. These weightlessly hovering bodies (Pl. 302) may also suggest psychoanalytic interpretations, such as unconscious birth memories and fantasies of the maternal body. The difference in proportions and substantiality of the individual parts are not, however, completely explicable either logically or psychologically; they are the consequence of immanent stylistic factors. For not only is the saint bigger, actually three times as big, as the kneeling figure beside him, but there are also considerable differences in size even among the group of the blessed, and they are not all of the same substance. The third figure from the right, for instance, is much more muscular and robust, and produces a much more real effect, than the others. In all of them there is a certain arbitrariness in relation to empirical reality that expresses the visionary and hallucinatory character of the whole scene and the transcendence of the spiritual world to which all this art is directed.

To El Greco's last period there belong two versions of a remarkable composition that in many respects falls entirely outside the framework of his other works, that is to say, the *Christ in the House of Simon*. In what is apparently the earlier version, in a private collection in Cuba, the scene takes place in a closed room; in the other, in the Winterbotham Collection in the Art Institute of Chicago, it is in an open hall with architecture in the background (Pl. 303). It is obvious that in these pictures, particularly in the second version, the architecture plays a role basically different from that in his previous works. In a strangely bare, inhibited, mannerist way, it is much more conspicuous than in any phase of El Greco's

development, apart from his early Venetian and Roman periods. In contrast to these, however, its impact is as bizarre and has as little practical purpose as in Parmigianino's *Madonna del collo lungo*, for instance. To say nothing of the odd structure with the dome and tower in the centre, the tympanon, resting on a single column and placed rectangularly against the façade of the building in the left hand corner, is nothing but an abstruse *concetto*, the effect of which is highly surprising at this stage of El Greco's spiritual development.

Both versions show a variation of the traditional form of the Last Supper. Those present, in addition to Christ and the twelve apostles, are a serving girl and two guests, Martha and Lazarus. The picture is full of a quiet devotion, but preserves a ceremonial coldness which, like the architecture and to an extent the manner of painting, recalls Giulio Romano. The mannerist piquancy of the treatment of the theme also expresses itself in other features that conflict with the fundamental solemnity of the mood. Martha is shown as a stylishly dressed, elegant young lady with courtly manners, and the hands of Lazarus and the apostles, like those of Christ, are just as aristocratically slender and delicate as those of the figures of the fashionable court painters.

The highest stage of El Greco's artistic development, in the sense of the most extreme abstraction from ordinary experience, is reached with the *Visitation*, at Dumbarton Oaks, near Washington (Pl. 304), and the *Marriage of the Virgin*, in the Rumanian National Museum in Bucharest (Pl. 305). In these works, which must have been among the last carried out completely by his own hand, he departs farthest from the dualism of formal principles that dominated his whole development in spite of his numerous stylistic changes, and he arrives at a dematerialised, perfectly sublimated expression of his vision that is utterly remote from reality. The human form loses its physical substance, its weight, its solid modelling, and is on the point of losing its very outlines. It dissipates and loses itself in light, becomes a fleeting shadow. The ultimate emotional impact of these pictures arises from a paroxysm of intoxication with light, a sense of floating and gliding, immersed in a spaceless and airless medium.

The difference between these paintings and the *Pietà Rondanini*, the only other work with which they can be compared, is that, while Michelangelo in his remoteness from the world seems almost inarticulate, El Greco still speaks a completely coherent language, though a highly individual one. He is so far from feeling any difficulty in expressing his thoughts that he uses a whole series of the most subtle artistic means of the fashionable manner.

III

Mannerism in Art and Literature

I. MANNERISM AND THE BAROQUE IN LITERARY HISTORY

IN literature mannerism began and ended later than in the visual arts. It cannot be said to have prevailed before the last quarter of the Cinquecento, but it survived until the middle of the following century and even later, that is to say, into a period when in the visual arts the baroque was in full flower. This lack of contemporaneity of stylistic change is primarily derived from the fact that painting and sculpture were still the leading arts in the west, and this also explains why mannerism at first produced works of a higher average level in those arts than it did in literature, though ultimately its achievements in the latter, above all in the works of Shakespeare and Cervantes, outdid those in all the other arts.

Art history, which is faced much more frequently with anonymous works, and was therefore from the outset much more frequently called on to concentrate on stylistic characteristics, seized earlier on the concept of mannerism than did the history of literature or music. Yet it possesses no monopoly of the idea, and literary history, thanks to the more ample thematic material at its disposal, could have arrived at a more concrete definition of mannerism than art history, which is always exposed to the danger of excessively formal interpretations. But so far it has made no use of the opportunity, and there is no mistake that occurs more frequently in its works, and none that is so confusing and vexatious in the present stage of the history of styles, when interest in mannerism is widespread, than the continual confusion of mannerism with the baroque; that is to say, the use of baroque formal principles for the interpretation of

literary trends and works which are unquestionably mannerist and are historically meaningful only if understood as such.

Many otherwise meritorious literary historians—and this applies almost without exception to the French, who have just got used to the concept of the baroque—succumb to the error, when dealing with obviously mannerist works, of talking of 'baroque' or at best 'precious', if not actually 'classical' literature, in the particular sense that they give to the word. However, the confusion between mannerism and the baroque in literature begins with no less a historian than Wölfflin, who in his early work, *Renaissance und Barock*, still, intelligibly enough, describes as baroque what to the present-day reader is the unmistakable mannerism of Tasso in contrast to the classicism of Ariosto. It is also understandable that Benedetto Croce and Karl Vossler, who were not very well versed in art history, like the workers of the next generation,[1] who were deeply influenced by impressionism, but not by expressionism or surrealism, should have clung to the same mistake. It is, however, surprising that younger scholars, including those who devote themselves principally to the literary history of the mannerist period, in other words, work on a stylistic period on which so much light has been shed in art history in recent years, should still confuse mannerism with the baroque, or alternatively adopt such a narrow interpretation of mannerism that they include under the baroque important phenomena essentially mannerist in character.[2]

Even the participants in the congress of the Accademia dei Lincei in Rome in 1960, which among other things set itself the task of defining and delimiting in relation to each other the concepts of mannerism, the baroque, and the rococo, seem neither to have brought clear and unambiguous ideas on the subject to the congress nor to have taken them away from it. In the papers read the same vagueness prevailed in relation to the meaning of mannerism and the baroque in literature, that is, the two concepts were just as inconsiderately confused with one another, as they are in literary history in general, and no attempt was made to reach any unanimity on the subject, and not even the desirability of attaining such unanimity was noted. Even those participants whose familiarity with these concepts was obvious [3] refrained from pointing out the inadequacy of the concepts of the others. The most remarkable fact, however, is that critics who have discovered for themselves the nature and meaning of mannerism in literature still refer to the works concerned as 'baroque' or 'precious'.[4] True, the concept of the precious, particularly in French literary history, has recently undergone a thorough revaluation and is used in a much more comprehensive sense than in the past, so that it has now come to mean something that partly coincides with mannerism, but still partly lies in the domain of the baroque.[5]

While the concept of the baroque is gradually making its way into French literary history, however, English literary history still tries to manage without it, and uses instead a rather vague concept of the Renaissance. To make up for this, a distinction is more frequently drawn between Elizabethan literature and the metaphysical poets on the one hand and between Elizabethan literature and the preceding English Renaissance in the narrower sense of the word on the other, but without sufficiently elucidating the stylistic difference between the mannerist period, whatever name may be given to it, and the succeeding baroque, and drawing a dividing line between them accordingly. Even when, by way of exception, the concept of mannerism is borrowed from art history,[6] there seems to be insufficient familiarity with its implications, and a certain constraint is evident in its use.

Though it may seem so at first sight, whether a work of art or an artistic or literary trend is described as mannerist or baroque is not merely a question of nomenclature. These concepts do not date from yesterday or today. By applying them to a phenomenon one stamps it, connects it with artistic manifestations, particularly in the case of the baroque, with which more or less accurate ideas are associated. Now, if artistic products which are on the borderline between mannerism and the baroque, to say nothing of works that are completely mannerist, are described as baroque, attention is automatically distracted by such shifting of emphasis to their emotional and rhetorical or illusionist and dynamically explosive components, and the intellectual element in their impact is neglected. In other words, the significance of the complex, the problematical and the paradoxical in their aesthetic structure is underrated. At all events, the classification of mannerist works and trends as baroque is an over-simplification, and therefore a falsification, of the phenomena referred to.

However, the persistent misunderstanding of the role of mannerism in literature and its confusion with the baroque obviously has deeper reasons than, say, the insufficient art historical experience of literary historians; the explanation lies rather in the inadequacy of the concept of the baroque with which scholars usually work. Its essential characteristics are generally taken to be its subjectivism, immoderation, and exuberance, thus leaving out of account the fundamental factor, which is that it is an emotionally determined artistic trend appealing to broader sections of the public, while mannerism is essentially an intellectually and socially exclusive spiritual movement. That is the vital distinction, notwithstanding the transitional phenomena and the mixtures between the two that are far from being exceptional. Formal peculiarities, even when they are so striking and fundamental, for instance, as that a mannerist work is a juxtaposition of relatively independent motives and to an extent preserves its atomised structure, while in a baroque work a unifying

principle always prevails, everything is aimed at producing a uniform total effect, and consequently everything is subjected to a dominant accent, are merely of secondary importance in comparison with the predominance of an intellectual attitude in the one and an emotional attitude in the other. More or less all the other characteristics of mannerism depend on the fact that it is a more sophisticated, reflective, broken, style, saturated with cultural experiences, while the baroque is spontaneous and simple in comparison. At all events, the baroque represents a return to the natural and instinctual, and in that sense to the normal, after the extravagances and exaggerations of the immediately preceding period. Thus there is no particular point in emphasising the bizarre and surprising as stylistic characteristics of the baroque though, in accordance with its tendency to the pathetic and the exuberant, it retained the link with mannerism for a very long time by means of such features. The essential factor in differentiating between the two styles, that on which special emphasis must be laid in comparing them, is the elimination of the paradoxical, the complicated, and the sophisticated, that is to say, of the formal peculiarities that followed from the intellectual and abstract nature of the mannerist artistic purpose.

The carelessness with which the concepts of mannerism and the baroque are used and confused with each other in literary history is the more deplorable in that the transition from one to the other is one of the sharpest rifts in the history of western art and literature, in spite of the fact that the former anticipates a good deal of the latter, while the latter preserves so many features of the former. If, as so often, or indeed mostly, happens, Góngora and Marino or John Donne and Andrew Marvell are claimed for the baroque, what is one to say of the style of Guarini and Chiabrera, Dryden and Milton, or Racine and Boussuet in relation to them? It may be true that sometimes, as in the case of Tristan l'Hermite, for instance, it is hard to say whether one is faced with a mannerist or precious poet, or with a representative of the baroque,[7] but in spite of the occasional confusion of stylistic elements it is perfectly possible to distinguish the characteristics of each from those of the other; and even in borderline cases, when it may be impossible completely to disentangle the stylistic features interwoven with each other, the task of theoretically establishing the distinction between the two stylistic trends remains.

The first question that arises is: To what extent and in what sense is it possible to describe mannerism as an artistic trend common to the visual arts and to literature? The spiritual climate of the age, that kept emotional life repressed and indulged in intellectual complexity, difficult dialectical formulations, and paradoxical contrasts, entailed similar formal solutions in the different arts as well as a choice of similar subjects. Mannerist paintings generally lack uniformity of composition and fall into a number

of more or less independent parts, individual scenes, groups and figures, and a mannerist poem is similarly composed of images that to an extent can be contemplated and appreciated separately. The accumulation of comparisons, metaphors, conceits, antitheses, plays on words, and *jeux d'esprit* of all sorts correspond to the more or less arbitrary juxtaposition of unusual and surprising aspects, the affected poses and movements, the strange and forced attitudes, displayed by the figures in a mannerist painting. Both can be said to share the same lack of feeling for proportion, unity, and order.[8] Thus, if mannerist poetry and painting are both called atectonic,[9] meaning no more than that there is the same lack of formal consistency in them, the transfer of categories from the visual arts to literature is perfectly legitimate. It is also legitimate to attribute the consonance or repetition of themes and situations in painting and literature to the same formal principle. To quote a well-known example, in the repetition of the core of the tragedy of *King Lear* in the Gloucester episode, the conflict between father and daughters, their ingratitude and cruelty to him, and the correspondence of the blindness of the one to the inner blindness of the other, and even that between the king's madness and the dissimulation of Edgar, we are obviously faced with a parallelism of the kind used by mannerist painters. Behind each there is the same compulsion to use the same form to express the same experience, that is, to express the same thing in different variations or different things in consonant forms. The similarity of formal means in the different arts originates in the same outlook; the essence of things has become unstable and inconstant, and all is in a state of flux and perpetual change.

Generally, however, transferring the formal principles of the visual arts to literature results, not in establishing any real identity, but in equivocation, as, for instance, when a sonnet of Spenser is called 'linear' in contrast to Milton's 'painterly' *Il Penseroso*, or when one poet is said to follow the principle of 'flatness' and another that of 'depth'.[10] Concepts such as 'linear' and 'painterly', 'plane' and 'depth', have aesthetic significance only in relation to the visual arts; in other contexts they are vague, ambiguous, almost completely devoid of content. Painterly effects in poetry and the visual arts convey quite different meanings. The epithet 'painterly' implies a certain abandonment of drawing, plastic modelling, and massive accumulation of forms, and emphasis on colour, light, and effects originating in the process of painting itself. In contrast to the visual arts, however, painterly effects can be produced in any kind of literary style and, if classicism is not abundant in such effects, neither is mannerism. A style rich in metaphors is not necessarily painterly; metaphors can produce the most varied associations, acoustic or even optical, but not necessarily 'painterly', that is to say, suggesting atmosphere, tone, and mood rather than solid objectivity. Romantic, and to an extent

baroque, poetry are obviously painterly, but even here the word does not carry the meaning that it has in the visual arts, though it can be used in a limited or modified sense. Concepts such as 'depth' and 'plane', however, as defined by Wölfflin, for instance, have no meaning in relation to literature, for depth of thought, which may have poetic meaning and value, obviously has nothing whatever to do with spatial depth in painting, which is without equivalent in the formal structure of poetry. Lessing in his time was already aware that the poet has to transfer spatial categories into those of time, and he seems also to have recognised that the principle *ut pictura poesis* has only a limited meaning.

In every art the problem of form is tied up with its own medium, its own language, and the solution of a problem in one is not automatically transferable to another; from the point of view of the other, the problem itself may be meaningless or non-existent. Thus the formal peculiarities of mannerist painting, sculpture, and architecture have no precise equivalent in literature, and the stylistic unity in this instance appears in a common spiritual disposition rather than in similar formulations. Common to mannerism in all the arts are intellectualism and irrationalism, a mingling of the real and the unreal, a predilection for striking contrasts and insoluble contradictions, and a taste for the difficult and paradoxical. But these features are not essentially formal in nature and are directly related to the fundamental outlook and sense of life of the age. The characteristic formal principles of mannerism in the visual arts, its way of rendering space and the proportions of the body, its treatment of colour and light, its ornamental organisation of the specific material and the adaptation of the material to the framework, are all restricted to those arts. Wölfflin's two most important pairs of contrasting concepts, those of plane and recession and of the painterly and the linear, are inapplicable to the other arts, and those of closed and open form can be applied to them only by stretching their meaning; for the purpose of structural analysis they must be replaced by other concepts rooted in the formal language of the arts concerned. A concept such as that of space can be of service to literary history or criticism only as an unambiguous example of a category characteristic of one particular mode of expression.

2. THE CONCEPT OF SPACE IN MANNERIST ARCHITECTURE

In the history of the visual arts the attitude to space changes according to whether a culture is static and conservative, essentially introverted and spiritual, or is dynamic, active, extroverted, and enjoys reality. Static and conservative cultures, not inherently open to direct experience and the outside material world, that is to say, most archaic cultures, such as

those of early antiquity and the early Middle Ages, in accordance with their flight from the world or their indifference to reality, deny or neglect space, and for preference represent the human form in abstract isolation, with no indication of its environment and without any trace of locally conditioned atmosphere. In a dynamic culture the fundamental factor in the organisation of a picture is as a rule the rendering of space in depth, while in a static culture it is the ornamental filling of the picture plane, that is to say, the planimetric arrangement. The paintings of the early Middle Ages are spaceless; the artist's guiding light is the world beyond, he remains detached from reality, and creating the illusion of space is not one of his aims. Only towards the end of the period does space again become the substratum of life, things begin to move in it, and light effects and atmospheric phenomena emerge. This development culminates in the Renaissance, when problems of space claim a large part of the artist's attention and signs of obsession with them appear. With mannerism this preoccupation diminishes, but does not disappear. Here too the attitude of the mannerist is ambivalent; sometimes he carries spatial effects to excess, sometimes he ignores them altogether. He combines a tendency to depth with a tendency to the planimetric. The exaggerated plasticity of his figures, or their vehement movements or emphatic postures, emphasise their spatial quality, but they are bound in a surface pattern or move in an unreal space lacking in organic continuity and composed of heterogeneous elements.

One of the fundamental principles of Renaissance composition was the uniformity of the scene rendered, its local coherence, in short, logical, spatial relations. The whole system of perspective, proportions, and tectonics was only a means of creating the effect of space. Mannerism led to a breaking up of this structure, the scene rendered was split up into areas separated from each other externally and differently organised internally, and the result of this process of atomisation was that the dimensions and the spatial position of the figures ceased to bear any logical relationship to their significance from the point of view of content.

The spatial harmony of the Renaissance went the way of its spatial logic, and the easy and comfortable relationship between object and environment was lost. Figures were packed together in a corner or lost in a vast, vague, unlimited area, as if to express the sense of rootlessness and being astray. Instead of feeling sheltered and secure, they seem to be in the grip of an uncontrollable unrest, a need to roam and escape all limitations and confinements. This compulsion in the visual arts leads to a tendency to transgress the immediately visible and penetrate to greater depths; it appears everywhere, but is continually inhibited and runs into resistance.[11] The geocentric universe had grown too narrow for astronomy, and compact Renaissance space similarly became untenable

in art. But, just as philosophy and science before Giordano Bruno and Pascal were incapable of tackling the idea of infinity, so did artists feel insecure as soon as they left limited and well defined space. They ran away from the narrow confines of classical art, but nevertheless continually sought to interrupt their spatial flight and put obstacles in the way of their drive into depth instead of giving it free rein, as happened in the baroque.

Mannerism, which discovered the spontaneity of the mind and recognised art as an autonomous creative activity, developed, in accordance with the spirit of that discovery, the totally new idea of fictitious space. To the Middle Ages space was either non-existent, unreal, or irrelevant; its paintings have neither real space nor depth. Antiquity and the Renaissance saw no theoretical difference between the space in which the work of art moved and that of the spectator. There was no structural difference between the two, though they were separated by an impassable boundary and the work of art remained in its unapproachable isolation. Mannerism first established the difference between them, and at the same time, by means of its foreground figures and similar devices, built a bridge between them that emphasised the gulf by spanning it. For anything in a work of art that takes account of a spectator, including the use of repoussoir figures and such expedients, transcends it, destroys the completeness of the illusion, and recalls its fictitiousness, in other words, reminds the spectator of the self-deception necessary to the artistic experience, thus robbing it of its spontaneity and self-evident quality.

Before mannerism appeared, artistic styles were either tied up with definite spatial conceptions or totally ignored them, but henceforward there was a space problem, that of the relationship between the space within and that without the picture. How was the transition from one to the other to be managed? How far and in what way was the validity of one affected by the other? Was one more real than the other? Was it merely a function of the other? Was picture space real only so long as its immanence remained unimpaired? Whatever the answers to these questions might have been, the artist's creative function, that is to say, his fabrication of a new objectivity, appears nowhere more strikingly than in the new problem of space. For the non-illusionist treatment of space enhanced awareness of the self-deception inseparable from the appreciation of art, and made the fact that the work of art was an artifact more obvious.

The shattering of the coherence of life brought about by the appearance and endurance of a concept of space differing from normal spatial conceptions also caused the fundamental mannerist experience of alienation to be expressed, often with greater power and effect than elsewhere. The paradox of the juxtaposition of two competing categories of space was driven to its greatest extremes in architecture, that is to say, the

form of visual art that is most closely associated with the space of real experience and in certain respects produces the most immediate impression of reality. In many ways a building is part of empirical reality, and, though it may be felt artistically to be autonomous, and as such may be isolated from the rest of reality as a self-centred system of formal relations, this represents a very special and merely transient aspect; the building neither abolishes nor undermines nor permanently alienates itself from reality. But the main difference between mannerist and all other architecture is that it creates a conception of space irreconcilable with empirical spatial conceptions and involves a confusing antagonism of the criteria of reality. All architecture that is not purely utilitarian to an extent raises the beholder out of everyday life, but that of mannerism isolates him from his environment, not only in the sense that it takes him to a higher plane, places him in an unusual, ceremonial, harmonious framework, but also in that it emphasises his alienation from it. Many of the most important characteristics of mannerism appear here in their most striking form: the sense of restriction and unfreedom in spite of all its desire for release; the flight into chaos in spite of all its need of protection against it; the tendency to depth, the advance into space, the effort to break out into the open combined with the sudden sense of isolation from the environment; the continually inhibited *élan*, the screened-off view, the principle of the coulisse and the paravent which, unlike a wall, that sets a limit to the eye and gives it an aim, merely conceals and rouses curiosity; the association of a *horror vacui* with an *amor vacui*, the overloading with decoration of relatively small areas of wall surface, in other words the planimetric principle again in an art which is that of spatial depth *par excellence*; and with all this the fundamental inner contradiction that allows logical formal principles to be followed here even less consistently than elsewhere in mannerism.

Standing in front of the colonnade of the Uffizi or in the anteroom of the Laurenziana, instead of a sense of elevation to a higher, more even, more peaceful level of existence, one feels bewildered, uprooted, insecure, removed to an artificial spatial structure that seems abstract in relation to ordinary experience. The building is neither a part or continuation of empirical reality, nor is it an artifact felt to be a sublimation or summary or quintessence of that reality; the impression it creates is that the order of things that applies elsewhere has been displaced by another, fictitious order.

Vasari's *Uffizi* (begun in 1560) is one of the most characteristic buildings of this kind (Plate 306). In contrast to the strictly enclosed courtyards of the High Renaissance, such as Bramante's, or that of the Palazzo Farnese in Rome, which create such a strong impression of delimita-

tion, repose, and finality, that of the Uffizi is so extremely elongated that it seems to be an open street. The effect of penetration in depth is the greater in that at the end it is perforated, and does not provide the promised resting-place for the eye. The courtyard extends like a corridor, but is cut off instead of leading into the open; and this too happens in an ambiguous and indecisive way. The loggia that forms the narrow side opens in the middle into a wide arc, neither providing a firm boundary nor letting the eye wander unrestrictedly in the distance. At the loggia the Arno is suddenly reached, creating a feeling of even greater bewilderment; it is still hard to decide whether one is in an enclosed space or in an open street, particularly as one side with its row of columns creates the impression of a courtyard façade, while the ground floor of the other suggests a street frontage. The whole is a typical instance of a manneristically inhibited attempt at flight, a borderline position between two orders, two different systems, creating a feeling of unrest and uncertainty. Only the sides of the courtyard are marked clearly and unambiguously, just as one side of a mannerist painting is often emphasised by being densely lined with figures, this indicating the orientation of the composition in depth.

In the anteroom of the *Laurenziana* (designed in 1524) the sense of unrest experienced in front of the Uffizi increases to actual discomfort (Plate 307). Here Michelangelo renounces, not only the uniformity, balance, and harmonious rhythm of classical architecture, but also its tectonic logic. The senseless dimensions, particularly the massive flight of steps in relation to the limited space, the exaggeratedly heavy frames of the blind and therefore so shallow-looking windows, the huge consoles, which seem all the huger by reason of the fact that they fulfil no purpose, are too obvious to call for special mention. Other, less striking, factors, however, contribute just as much to the discomfort of the total effect, for instance, the columns in the niches, which are obviously as functionless as the consoles, and the articulation of the walls, which create the impression of a *palazzo* façade, leaving one with feelings even more conflicting than those produced by the Uffizi. There it was merely doubtful whether one was looking at a courtyard or street façade, but here the street façade is forced into an interior the bounds of which it threatens to burst, and the sight is almost as alarming as is that of the room with Giulio Romano's *Fall of the Giants* in the residence at Mantua.

The same hesitancy between two alternatives characteristic of the architecture of the Laurenziana and the Uffizi is also the most striking feature of Giulio Romano's *Palazzo del Tè* (1526–34). It is hard to say whether, when one is facing the street front, the ground and first floors form a unit, that is to say, whether, as has been pointed out,[12] it is a two-storey structure or a single vertical one, because the pilasters and the bands between the rows of windows compete with one another, leaving

the issue open. The breaking up of the façade by means of pilasters separated from each other by completely irregular intervals is totally mannerist and in conflict with High Renaissance concepts of beauty and architectural logic. There is even greater emphasis on the apparent one-storey construction in the courtyard façade (Pl. 308), which displays still more irregularities. The feeling of uncertainty and unrest is increased by other irritants. The intervals between the excessively massive columns leaning against the wall are unequal, the rustica is deliberately interrupted in places as if to create the impression of improvisation or of a picture left in a sketchy, unfinished state. Every third triglyph of the entablature hangs over the architrave into the area of the columns, creating the feeling of something out of place, though perhaps it is exaggerated to say that the building seems threatened with collapse.[13] The style used by Giulio Romano for his own house at Mantua (1544) is, though less extravagant, just as inconsistent with the Renaissance in feeling (Pl. 309). The predominant feature here is that everything that in High Renaissance architecture is voluminous, weighty, tectonic, and plastic is turned into flat, decorative, delicately ornamented surfaces. The building material itself begins to lose its substance, and the façade, the articulation of which is mainly linear, turns into a coulisse-like stage property.

This is also the most striking characteristic of Baldassare Peruzzi's *Palazzo Massimo alle Colonne* in Rome (1535) (Pl. 310). With its curved surface, the façade looks like a screen, and the flat and apparently thin wall of the upper storey increases the impression. The stage-scenery effect, with its deceptive quality, prevails in every detail of the building. All that is visible betrays nothing of the play of forces by which the structural equilibrium is produced, and above all nothing of the real relationships between burden and support. The courtyard front is even less functional in appearance than that facing the street, the two upper storeys of which are screened off rather than opened to the outside world by the façade wall, while the excessively small windows with their cartouche-like, delicate frames are like dormers that do not admit much light. Apart from the game of hide-and-seek between ends and means, the most important factor in the total impression is the effect of contrast that reflects the mannerist sense of conflict and contradiction. Of far greater importance in producing this than the often-mentioned disproportion between the allegedly too weak supports of the ground floor and the height of the upper floors is the sharp optical contrast between the lower part, with its plastically protruding columns, the striking alternation between well-lit surfaces and parts left in deep shadow, and the upper part, which as a consequence of its flatness and weak articulation is brightly lit up and is in shrieking contrast to the dark entrance.

The planimetric principle is more or less adhered to in most mannerist

buildings, including those that are richly decorated, like the *Villa Medici* in Rome (1544) (Pl. 311), even when, as in the courtyard of the *Palazzo Spada* (1540) (Pl. 312), the decoration includes free-standing figures in niches. A remarkable contrast to such ornamental lavishness is provided by the puritanical severity and simplicity of buildings such as Bartolommeo Ammanati's *Collegio Romano* in Rome (1583–85) (Pl. 313), the complete explanation of which lies neither in their spiritual purpose nor in the ideas of the Counter-Reformation, which by this time were becoming widely spread. A certain monotony, an occasional economy of decorative forms, a certain bloodlessness and lifelessness here and there, are just as inherent in the antithetical nature of mannerism as are over-loading, ostentatiousness, and playful pleasure in the arabesque, and are hardly ever completely lacking in works that are representative of the style. This puritanism has practically nothing to do with functionalism. Indeed, it is much more like its opposite, that is to say, a fictitious, simulated functionalism. Sometimes, as in the *Escorial*, for instance, the severity and simplicity is nothing but exhibitionist play with puritanism and asceticism. The building displays its 'introversion' in a shriekingly ostentatious manner. Besides being the residence of the most powerful monarch of his time, it includes a church and a monastery, yet in reality it is no more than the hideout of a lonely man withdrawn from the world, and the colossal proportions serve no practical purpose and are nothing but a sham. Philip II lived in his palace like a monk in his cell; the Escorial combines grandeur with exaggerated simplicity in the same mannerist fashion as he did in his way of life.

Most mannerist buildings are unpractical, uncomfortable, ill adapted to their purpose. The study of the Grand Duke of Florence was small and windowless, and the palace of the Duke of Mantua is at first sight so sober and modest that it is hard to think of it as a royal residence; Palladio's villas, those prototypes of modern buildings designed for pleasure and comfort, are more like show-pieces than practical homes for living in. They are mostly over-dimensional, the entrance porticos suggested by Greek temples are forbidding rather than inviting, and they isolate themselves from the surrounding landscape or garden instead of combining with them and encouraging closer contact between man and his environment, as one would expect.

Mannerism is quintessential *art*; it turns everything natural into the artistic, the artificial, often the artful. It eliminates the sounds of nature, the unformed raw material of life, and rejects everything direct, spontaneous, and actual, turning it into an artifact, a thing shaped and fabricated and remote from nature, however close and familiar it may remain to *homo faber*. There is something inherently abstract, lifeless, and unnatural about architecture, which in form is farthest removed from the

objective and imitative arts, but mannerism increases its abstraction and remoteness from nature, and it does so in the most striking and paradoxical fashion in the villa, which now so sharply and rigidly isolates itself from its background, as if to emphasise, not their basic unity, but the irreconcilable antagonism between building and environment, civilisation and nature, man and his surroundings. In the garden or the landscape the mannerist villa is like a foreign body. The unity between the two achieved in a more or less unsophisticated way in the Renaissance has been lost, and the artificial unity realised by the baroque not yet attained.[14]

Vignola's *Palazzo Farnese* at Caprarola (1547–59) already displays the most complete alienation between a country house and its environment (Pl. 314). The uncomfortable, stiff, unnatural character of the building is emphasised in every conceivable way: by its unusual dimensions, its strongly accentuated cubic shape, its unmitigated stony quality, its fortress-like, elevated situation surrounded as if by an entrenchment, and above all the heavy framework of ramps, steps, and terraces all round it, to say nothing of the three entrances superimposed on one another that seem to move the inhabited part of the building as far away as possible instead of bringing it closer.

The *Villa Lante* at Bagnaja, begun in 1566, also by Vignola (Pl. 316), displays the same lack of integration of architecture and natural environment, though here the effect is produced in the opposite way. At Caprarola the architecture is over-sized, its weight is not merely dominating, it is actually oppressive. At Bagnaja the buildings are made to seem so diminutive in relation to the garden as to be almost imperceptible. There is something unreal and abstract in the relationship of both kinds of buildings, big and small, to the landscape or garden; the former is out of proportion on a gigantic scale, while the latter suggests a doll's house, a toy. In both instances, in spite of the effect resulting in one case from the architecture and in the other from the garden, one has the impression, not of the unproblematical, effortless manipulation of the given means and a straightforward striving towards an unambiguous goal, but of a *tour de force*, a brilliant conjuring trick.

The contention that building and environment were first harmonised in Palladio's villas has been definitely enough refuted.[15] The antagonism between earlier mannerist villas and their surroundings is present in them too. They remain a foreign body in garden and landscape, and their abstraction is given additional emphasis by their box shape, which in the *Rotonda* (begun in 1551 and partially ready for occupation two years later) assumes the form of a regular cube (Pl. 318). In many respects this masterpiece of Palladio's is one of the most typical examples of mannerist architecture. The chief mannerist feature is the effect of sur-

prise produced in the visitor; the apparently long approach between narrow walls turns out to be much shorter than it looked, and the peep-show building he caught sight of turns into a surprisingly massive and sizeable reality much sooner than he expects.

The principle of elongation prevails in the architecture of mannerism just as it does in painting and sculpture. Thus features like the corridor, the gallery, and the long, street-like courtyard are characteristic of it, and that is why it makes such frequent use of long, narrow approaches to further rooms in the interior of a building or to the entrance of a *palazzo* or villa in the open air. These approaches are puzzling and curiosity-rousing and prove to be deceptive; besides turning out to be shorter than they looked, they finally reveal, if not a miracle, at any rate a piece of marvellous reality. But it is the deception that is the real aim. The colon-nade in the rear courtyard of the *Palazzo Spada* is the most striking example of this kind of optical game (Pl. 320). It is made to look longer than it really is by a perspective device, the gradual diminution of the distance between the columns. At the entrance to the colonnade this is imperceptible; the unsuspecting visitor takes what he sees to be nothing but perspective convergence. True, the colonnade was built much later than the *palazzo* itself, but the idea is typically mannerist; when the baroque made use of this device in the Scala Regia in the Vatican, it was only being faithful to the heritage.

Finally, the complete consonance of the four façades of the *Rotonda* is also mannerist. This recapitulation, besides producing a very im-pressive effect, greatly contributes to isolating the building from its environment by emphasising its geometrical shape and thus enhancing its abstract quality.[16] Not only does it in fact sharply isolate itself from its environment, but it looks so stiff and unapproachable that it is hard to understand how anyone could live and feel comfortable in it.

In his *palazzi* Palladio is the same mannerist as he is in his villas. Above all, he mingles courtyard and street façades just as Vasari does in the Uffizi, except that to an extent he does so in the opposite way. While Vasari turns a courtyard into a street, Palladio gives the articulation and shape of a *palazzo* courtyard to his street façades. The most character-istic example of this is the *Palazzo Chiericati* at Vicenza (1550) (Pl. 319).

In his church architecture Palladio uses even simpler classical elements than in his other works. It is chiefly to this that the survival of his reputation until the end of the eighteenth century is due. The classical forms that are always prominent in his work made it acceptable to later periods and the more deep-seated mannerism in it negligible or pardon-able. The exterior of his churches is most misleading in this respect (Pl. 321). Both internal and external architecture, however, are dominated by the same forms and display their shining white classicism with the same

ostentation. But the façades are almost puritanical in their simplicity in comparison with the complex pattern of lines and forms, involved inter-sections and vistas in the interior (Pl. 322).

3. LANGUAGE AS A CREATIVE MEDIUM

It is architecture that makes it most evident that the formal principles of the visual arts cannot be simply transferred to literature, and that the means of representation involve problems which are not only solved differently, but also present themselves differently in the two spheres. In mannerism, in which the instrument of expression and the element in which the representation moves is to an extent end as well as means, content as well as form, this is even plainer than elsewhere. It is also implicit in the point made by Mallarmé when he said to Degas that poems were written, not with ideas, but with words.

In architecture, space is not merely the medium in which architectonic ideas are realised, but is the very essence of the possibilities, combinations, and complications that are the real source of artistic invention; and similarly in poetry—particularly mannerist poetry—language is not only the means of expression, the alpha and omega of the artistically possible, but also the source of inspiration; it is not only the form, but also the matter and content of the poetic experience. Mannerist poetry is not only, like any other, the art of words, tied to words and rooted in the nature of language, but also arises out of the spirit of language, not so much filling it with content as deriving content from it.

The determining factor for the attitude to language and its handling in the age of mannerism must have been the sense of the autonomous existence led by words and phrases and their compliance with a creativity of their own; the feeling that it was language that thought and wrote for the poet. This same feeling lay behind the theory and practice of the so-called 'automatic writing' which the surrealists claimed to practise, and explains a number of features that their art, which they held to be nourished exclusively by the unconscious, shares with mannerism. Common to both is the belief that language, like the means of expression of art in general, must be allowed to go its own way, and that the artist handles these means with a sleep-walker's assurance. The unconsciousness of the creative process thus assumed recalls the notion of inspiration applied by the romantics, whose doctrine and practice were otherwise rather opposed to that of mannerism.

The mannerist literary style, with its wealth of imagery and metaphor, is unclassical without being in the least romantic. It is unrestrainedly luxuriant, and revels in words and images, but is neither colourful nor,

in spite of its surprising sound effects, can it be called musical. Nevertheless, if there are two fundamental tendencies in literary style, and imagery and rhythm can be regarded as its two basic elements, the language of mannerism is directed towards the former and that of classicism to the latter. The language of the classics is lacking in piquancy and spice; its appeal lies in its articulation, the pace and flow of the sentences, and the weight, emphasis, and sustained power of the diction. Its effectiveness depends on accuracy, suppleness, and smoothness of statement, and not on colour and shade, preciousness or exoticism of expression. The language of the classics is elevated, but it is neither colourful like that of the romantics nor does it indulge in figurative associations like that of the mannerists.

Flaubert's style, as Proust points out, is almost completely free of images; not a single fine metaphor occurs in him. The author of *Madame Bovary* and the *Éducation sentimentale* in fact writes an anti-mannerist style *par excellence*. It is all line, tempo, and rhythm, everything is directed to the articulation of the content to be communicated, the expression of which must fit it like a glove.

This is the celebrated passage in which he describes how Emma accompanies Dr. Bovary, her future husband, to the door, after he has examined his patient, her father:

> Elle le reconduisait toujours jusqu'à la première marche du perron. Lorsqu'on n'avait pas encore amené son cheval, elle restait là. On s'était dit adieu, on ne parlait plus; le grand air l'entourait, levant pêle-mêle les petits cheveux follets de sa nuque, ou secouant sur sa hanche les cordons de son tablier, qui se tortillaient comme des banderoles. Une fois, par un temps de dégel, l'écorce des arbres suintait dans la cour, la neige sur les couvertures des bâtiments se fondait. Elle était sur le seuil; elle alla chercher son ombrelle, elle l'ouvrit. L'ombrelle, de soie gorge-de-pigeon, que traversait le soleil, éclairait de reflets mobiles la peau blanche de sa figure. Elle souriait là-dessous à la chaleur tiède; et on entendait les gouttes d'eau, une à une, tomber sur la moire tendue.

The style here does not basically differ from any random passage from Bossuet, say, from the funeral oration on Henrietta of England:

> Au lieu de l'histoire d'une belle vie, nous sommes réduits à faire l'histoire d'une admirable mais triste mort. À la vérité, messieurs, rien n'a jamais égalé la fermeté de son âge, ni ce courage paisible, qui, sans faire effort pour s'élever, s'est trouvé par sa naturelle situation au-dessus des accidents les plus redoutables. Oui, Madame fut douce envers la mort, comme elle l'était envers tout le monde. Son grand coeur ni ne s'aigrit ni ne s'emporta contre elle. Elle ne la brave non plus avec fierté: contente de l'envisager sans émotion, et de la recevoir sans trouble.

In spite of all the difference in circumstances, theme, and period, and the disparity in character of the two authors, the style of both is characterised by the same objectivity and simplicity of expression, the same absence of inorganic adornment, superfluous imagery, or metaphorical digression, the same concentration on rhythmical articulation of delivery and clarity and precision of thought.

Nor is there any doubt about the relationship of Racine's style to classicism, though his way of expression is far more complex and its origins are far more involved than that of Bossuet, and in certain respects also that of Flaubert. Even in a passage the content of which inclines so strongly to the baroque and to romanticism as Phèdre's passionate self-revelation, it has more in common with the examples quoted above than with any non-classical text:

> J'ai revu l'ennemi que j'avais éloigné:
> Ma blessure trop vive aussitôt a saigné.
> Ce n'est plus une ardeur dans mes veines cachée:
> C'est Vénus toute entière à sa proie attachée.
> J'ai conçu pour mon crime une juste terreur:
> J'ai pris la vie en haine et ma flamme en horreur;
> Je voulais en mourant prendre soin de ma gloire,
> Et dérober au jour une flamme si noire.

His language is as well ordered and logically disciplined as that of Bossuet or Flaubert; even in its most violent outbursts it is clear, controlled, almost sober and, in spite of its elevation, unadorned. Only the last line quoted above contains an oxymoron reminiscent of mannerism, but otherwise the whole of this important passage, which is as characteristic of the play as it is of its author, is totally free of exaggeration and hyperbole, and even of images and metaphors; for the description of a woman unhappily in love as suffering from a bleeding wound, or her calling her passion a flame, can hardly be called images, and at the time when the tragedy was written were felt to be even less so than present-day usage may make them appear.

In an entirely different style Chateaubriand writes:

> Le soleil tomba derrière le rideau des arbres; un rayon glissant à travers le dôme d'une futaie scintillait comme enchâssé dans le feuillage sombre; la lumière, divergeant entre les troncs et les branches, projetait sur les gazons des colonnes croissantes et des arabesques mobiles. En bas, c'étaient des lilas, des azaléas, des lianes annelées aux gerbes gigantesques; en haut, des nuages, les uns fixes, promontoires ou vieilles tours, les autres flottants, fumées de rose ou cardées de soie. On voyait dans ces nues s'entr'-ouvrir des gueules de four, s'amonceler des tas de braise, couler des rivières de lave; tout était éclatant, radieux, doré, opulent, saturé de lumière. À l'orient la lune reposait sur des collines lointaines; à l'occident

la voûte du ciel était fondue en une mer de diamants et de saphirs dans laquelle le soleil à demi plongé semblait se dissoudre. La terre, en adoration, semblait encenser le ciel, et l'ambre exhalé de son sein retombait sur elle en rosée comme la prière sur celui qui prie.

Here everything is turned into qualitative sense impressions; things have volatilised, turned into light and colour effects, insubstantial, barely tangible shapes. They are the mere substratum of moods and subjective states of mind, reflecting tones and colours, light and shade, movement and change; they are the sounding-boards for the music with which nature is filled. The style has become more 'poetical', and its essence lies, not in its elevation, but in its overtones. Reason is no longer one of the powers that control it; it is sensuous, but not fantastic, like the language of mannerism.

The style of a Théophile de Viau has as little to do with romanticism as with classicism:

> Ce ruisseau remonte en sa source;
> Un boeuf gravit sur le clocher;
> Le sang coule de ce rocher;
> Un aspic s'accouple d'une ourse;
> Sur le haut d'une vieille tour
> Un serpent déchire un vautour;
> Le feu brûle dedans la glace;
> Le soleil est devenu noir;
> Je vois la lune qui va choir;
> Cet arbre est sorti de sa place.*

This is as colourless and toneless, as 'unpoetical' as the style of a classic, and as anarchical as that of a romantic, but the poet jumps neither from one idea to the next nor from one sense impression to another, but from association to association, from absurdity to absurdity. The apparent temerity of ideas conceals a desperate disorientation, while in the language of romanticism the sense of being lost in the world assumes the form of complete introversion.

Characteristic of the classical or neo-classical style is a certain economy, if not actual brevity. It can be powerfully rhetorical, but is never overloaded, as both the mannerist and the romantic often are. It has repeatedly been observed that the exquisite, subtle, accomplished, highly ornamented way of expression of mannerism is not always a sign of riches, but often of poverty, embarrassment, and inadequacy, and its overcharged and complicated nature has been attributed to the feeling that

* This stream is flowing back to its source / An ox is climbing the belfry / Blood is flowing from this rock / An asp is mating with a she-bear / At the top of an old tower a snake tears a vulture to pieces / Fire burns in ice / The sun has turned black / I see the moon about to fall / This tree has moved from its place.

language threatens to fail, that there is an unbridgeable gulf between experience and expression, and that the word inevitably falls short of the thing.[17] The many indirect descriptions, according to this view, are only a substitute made necessary by the lack of a direct description. Another theory is that the phenomenon is not the result of the inability to take possession of the thing by the word, but of a 'flight from the thing' into the word (Karl Vossler), *i.e.*, an evasion of reality, a disguising, transforming, and distancing of things by insubstantial words. In fact, however, we have here something different from and deeper than a mere renunciation or substitution of reality. The dominant mannerist feeling is of the magic power of words, as in this line by a surrealist like Robert Desnos:

Mots, êtes-vous des mythes, et pareils aux myrthes des morts? *[18]

The poet calls words myths because he feels them to be more real, more significant, more enduring than things, charged with more complex meaning and a voice more audible and significant than that of inarticulate objects.

For all its apparent virtuosity and wealth of vocabulary, mannerism is not eloquent; in comparison with the vigour and assurance with which the literary style of the succeeding period hits the mark, it seems rather to stammer. But, as T. S. Eliot remarks of Milton,[19] in spite of the magnificence and rhetorical facility or directness and naturalness of their way of expression, the baroque and neo-classical poets of the seventeenth and eighteenth centuries use a dead language. In comparison with it the language, not only of Shakespeare, but also of John Donne and Andrew Marvell, even of Góngora and Marino, for all its artificiality and affectation, is alive and close to that of spoken speech—it is not bookish. Its vividness, however, is not due solely to its approximation to everyday speech. The language of Shakespeare's characters would remain direct and natural even if they did not, like Troilus, interrupt a love scene with words such as 'You will catch cold and curse me'; and colloquialisms such as Donne's 'For God's sake hold your tongue and let me love' at the beginning of one of his most passionate love poems (*The Canonisation*) are by no means the only or the most important examples of the poet's unceremonious, mocking style, in which pathos is mingled with persiflage.

The distance between mannerist poetry and ordinary speech depends, not on its tone, but on its imagery. Metaphor more or less performs the function of irrational treatment of space, distorted proportions, and twisted forms in the visual arts. In so far as there is a similarity of formal

* Words, are you myths, and like the myrtles of the dead?

principles between the two, it is the outcome of the same propensity to indirectness and arbitrary and strained expression. The essence of the metaphor lies in the desire, not so much to describe something better, more vividly, more closely to the original experience and in that sense more truly, as to depart from a familiar picture by a daring flight of associations. The metaphorical way of expression is essentially elliptical, based on the mind's capacity to leap over the straightforward and obvious. It is part of the nature of mannerism to magnify the leap as much as possible, to focus attention on the mobility, range, and self-sufficiency of the leaping spirit rather than on the mere objectivity with which it is concerned; and, though metaphor is no more transferable to the visual arts than spatial forms are to literature, the situation in them is more or less the same. All kinds of mannerist representation are in a sense metaphorical.

True, even a simple simile involves a departure from sense experience and is an interpretation rather than a reproduction of reality, and it has long been known that its effect actually increases with the distance from the substratum of experience. Dr. Johnson, in spite of his completely neo-classical taste and his strongly anti-mannerist outlook, describes the simile as the crossing of two lines, and says that the greater the distance between the points of departure, the more successful it is. Basically this idea still survives in surrealism. 'The greater the distance between the things brought into connection with each other,' says one of its most authoritative representatives, 'the more powerful the image and the greater its effect'.[20]

The metaphor is said to have originated from the simile, and Quintilian describes it as an abbreviated simile; but at the same time it is its opposite and to an extent its dissolution. For the phenomena compared with each other in a metaphor lose all the autonomy that in a simile they still preserve. The emphasis is shifted from their respective properties and their original relation with each other to something new, something that differs from its component parts and is the consequence of their combination. The object is not to create a clearer picture or communicate a better understanding of something, but to turn worn coinage into brighter metal. In the course of time words fade and grow empty; the metaphor infuses them with new fire and colour and meaning. They can be linked together with the most unexpected and surprising results, for each contains a multitude of levels of meaning that can be brought to light and made vivid and effective; each contains innumerable overtones that remain unheard until a poet appears and gives them resonance. He does not so much rename things as make new discoveries. The general view is that the metaphor arises from the poet's search for the correct epithet, but the truth is rather that the poet is engaged in a search for new properties and

new phenomena; when he has discovered them, he has to give them new names.

In classical poetry the relationship between metaphor and simile is nevertheless by and large preserved and, though the similarity of the phenomena connected even in metaphors of the classical type is often questionable, it is never wholly absent; and incidentally it should not be forgotten that every comparison, even the most conservative, is lame. 'The moon is like the moon, that is all,' says Herodias in Wilde's *Salome*. It resembles neither a 'drunken woman' nor a 'pale maiden' nor a 'white rose'; and there is no real resemblance between lips and cheeks and roses and lilies. But in mannerist poetry even the semblance of truth contained in such images is lacking. The object is not to remind the reader of real experience, but to strike him by the contrast between the poet's words and the experience that he may have had.

T. S. Eliot touches on the difference between the two poetical styles in describing the imagery of Dante and Shakespeare. Dante compares the throng trying to make out him and his guide in the darkness of the underworld with the efforts of an aged tailor peering to thread his needle:

> e sì ver noi agguzzavan le ciglia
> come vecchio sartor fa nella cruna
> *(Inferno,* XV, 20/21.)

Compare Shakespeare's image:

> . . . she looks like sleep,
> As she would catch another Antony
> In her strong toil of grace.
> *(Antony and Cleopatra,* V. 2.)

Dante, as Eliot remarks, merely wishes vividly to illustrate an experience, while Shakespeare adds something new to it.[21] There is no question of resemblance in the Shakespearean metaphor; it has become creative, does not reproduce reality, but expands it. It is connected to reality as a blossom or fruit is to a tree.

With the departure from ordinary experience that takes place with the mannerist metaphor, there is indeed a kind of flight from reality which, with less justification, has been adduced as an explanation of the intoxication with words of the poets of the age. Ortega y Gasset says that metaphor always 'substitutes one thing by another, not so much to arrive at as to escape from it'.[22] The impulse can indeed be partly explained by a kind of fear of direct contact with things; they are given cover-names, that conceal by revealing. This theory transfers the origin of the metaphor to the unconscious, and takes into account the no doubt frequent desire to refer to certain things only in a veiled, allusive, and indirect way, but this removes the phenomenon from the sphere of aesthetics. Under Freud's

influence, attempts have been made to look to the world of primitive thought for the origin of the metaphor, and it has been suggested that this might lie in the taboo, that is to say, the ban on mentioning sacred names. According to this assumption, the metaphor originated in the use of substitute names in their place.[23] Ortega y Gasset was obviously greatly influenced in his observations by the psychoanalytical interpretation. His unusually high assessment of the creative value of the metaphor derives from quite different sources, however, and is completely mannerist in spirit. 'All other forms,' he writes, 'keep us in the real, in the already existent. All our activity is confined to adding and subtracting things. We owe our capacity to escape to the metaphor alone.'[24] Before the revival of interest in Góngora and his style in Spain, and the development of a modern literary movement which can be described as a new Góngorism, such a view would have been inconceivable, and it is obviously connected with the latter rather than with psychoanalysis.

However willing one may be to accept a psychological explanation of the origin of the metaphor, there are sociological factors that cannot be left out of account. The metaphorical way of expression is a sociological phenomenon; it became a conventional form, characteristic of social cultures, not of individual talents. In certain literary cultures, above all mannerism, it became a secret language, serving the purpose, not only of the complex expression of complex thoughts, but also that of ostentatiously marking off its users from the common herd; and the more far-fetched, abstruse, and difficult it was, the more completely was this objective attained, though at the expense of correspondingly greater hazards to artistic success. The gravest danger, however, involved in the mannerist use of metaphors lay, not in their daring, but in their accumulation, which often led to a weakening and discrediting of one poetical image by another. For, though a bold metaphor may be forbidding at first sight, in the long run its impact is generally greater and more lasting than that of a more cautious one. But, for all the intensity of the mannerist striving for originality that makes itself felt in the cult of the metaphor, the latter at the same time strikingly displays the mannerist trend to the conventional. It is sufficient to recall that certain types of metaphor appear almost simultaneously throughout western literature, and seem to have been equally popular everywhere. One of the commonest is the comparison of a bird to a feathered musical instrument. Marino (*Adone*, VII, 37) writes of *voce pennuta . . . suon volante . . . canto alato*, and Góngora (*Soledades*, I, 556, and II, 525) of *citeras de pluma* and *órganos de pluma*, and there is no lack of this image of winged song in the poets of other nations. Associating the impressions of different sense organs had a special appeal for the mannerists, as it had for the symbolists in modern times, and this no doubt played an important part in the development of

metaphors of the type quoted above. Wings suggested the fleeting nature of music, and at the same time brought it into an enigmatic, and to mannerism therefore attractive, contact with the tangible material world.

Metaphorical language has been described as the poetical language *par excellence*, which is true only to the extent that it is the pre-eminently artificial, unreal, indirect form of expression, 'poetical' in the original meaning of the word *poiein*. Metaphor plays a more important part in mannerist than in other kinds of poetry, but mannerism could be held to be the most suitable style for poetry only if there were a meaningful and indissoluble link between art and the artificial. In fact, however, it represents at most one of the two fundamental types of poetry, for, as Goethe says, there is also 'poetry without figures of speech (*Tropen*) that is itself one single figure of speech' (*Sprüche in Prosa*, No. 235). Eliot must have had this saying in mind when, in his discussion of the imagery of Dante and Shakespeare, he remarks: 'As the whole poem of Dante is, if you like, a vast metaphor, there is hardly any place for metaphors in detail of it'.[25] But the poetry of mannerism is irreconcilable with this concept of the metaphor, for it consists of a teeming multitude of images and associations, of which it can never have enough; its sense of life is of abundance, not of substance, it apprehends it, not as an integrated, but as an atomised entity.

What Proust says of metaphor is well known. 'La métaphore seule peut donner une sorte d'éternité au style,' he writes in an essay on Flaubert's language; though he adds that the use of metaphor does not constitute the whole art of style, and that the continual, even, persistent, irresistible flow of language that Flaubert pours on to the page represents another stylistic possibility, in his opinion an unprecedented one.[26] In his ambivalent attitude to Flaubert's style, Proust is something of a modern mannerist himself. He holds his own romanticism in check by classical discipline, and his romantic aspirations find satisfaction only in the classics. 'Seuls les romantiques savent lire les ouvrages classiques, parce qu'ils les lisent comme ils ont été écrits, romantiquement,' he writes.[27] In other words, all art originates in romantic feeling, and stylisation is therefore secondary. Thus for him the fundamental problem of style was most completely summed up in a writer who was a romantic in classical guise, to whom a classical style free of all imagery did not come naturally, but required an almost superhuman effort and a victory over all his instinctive inclinations.

So compulsive and dominant is the use of metaphorical language in mannerist poetry that it is possible to speak of the prevalence of a *metaphorism* in it. This passion for the metaphor derives from a sense of life that apprehends everything as being in a state of permanent change and interaction, and it is therefore also possible to speak of a *metamorphism*

underlying the metaphorism and assigning it its proper place and meaning in the history of ideas. This is the only way to overcome the first impression of being faced with something corresponding to mere ornamentalism in the visual arts, a mere swamping of matter in form, and to arrive at an understanding that the real reason for the never-ending accumulation of images lies in a sense of perpetual flux and transition, a sense of impermanence so strong that it is hardly possible to do more than establish the continually shifting relations between all things. Metaphorism, being directed, not to things themselves, but to the involved network of relations between them, is the only way of doing justice to the unstable, dynamic nature of a reality perpetually clothing itself in new forms. Emphasis on its dynamism, however, leads to misunderstanding and neglect of its permanent characteristics. Metaphorism is the product of relationism, a philosophy that regards everything as comparable to and replaceable by everything else; the principle of substitution provides the basis both for metaphorism and for the tendency to a general neutralisation. In physics quality is replaced by quantity; in social life individual differences disappear, man and his labour are reified and measured by the same standard, *i.e.*, working time, and in the standing army and the new bureaucracy individuals become interchangeable units.

The outlook underlying metaphorism implies a contempt of concrete reality, a devaluation of facts, and the undermining of objectivity in modern literature which socialist art criticism condemns with all the arguments that can be used in favour of 'social realism'.[28] It had earlier been pointed out that in a world in which 'every person, every thing, every relationship, can stand for every other . . . details do not matter very much',[29] but, while in the age of impressionism this was regarded as an 'annihilating but fair judgment', according to present-day 'progressive' social criticism such an outlook implies a devastating judgment on an age of which it is characteristic. General relationism implies general relativism, not just in the sense that everything is connected with everything else; it also implies that nothing is centred in itself and that there is no fixed centre anywhere. Everything can be partially explained by everything else, but nothing can ever be completely explained by anything. Everything is a cipher; but all the symbols in the secret code refer only to other symbols.

Metaphorism leads to the dissolution, not only of the solid, substantial, objective world, but to an extent also of language. As every description is replaceable by another, and the latter is not necessarily better or more accurate, the result is a feeling of being unfettered by the means of expression, a sense of the free and unhampered exchangeability of symbols, and finally of being on a slippery slope, guided by the affinities of words rather than of things. Such a condition virtually implies the end of

the dominance of reason, linguistic logic, and all external disciplines to which the poet might be prepared to submit. Hence classicism is fundamentally opposed to the metaphor; and it is not without significance that Goethe's saying about poetry without figures of speech dates from the strictly classical phase of his development. Goethe merely implies that the metaphor is anti-classical, but Hegel specifically describes it as such. He says that the modern style, in contrast to the ancient, is characterised by the 'predominance of metaphorical expression', and defines metaphor as 'an interruption of the perceptive process and a continual distraction, because it generates and accumulates images not strictly relevant to the object'.[30]

For theoretical purposes the metaphor is almost totally useless. If a statue is described as a poem in stone, for instance, not one iota is added to our knowledge of its nature; and the same questionable quality clings to it as soon as a work of literature is regarded as something more than a mere formal structure. All real art, if not a 'corrective of life', is a contribution to its interpretation. But in that respect what can it hope for from the metaphor?

It is sufficient to compare Marlowe and Shakespeare, or Shakespeare's earlier and later works, to see how unsatisfactory metaphor can be. In plays such as *Macbeth*, *King Lear*, and *Antony and Cleopatra*, metaphorism still prevails undisputedly, but the different metaphors combine into a poetic whole more or less corresponding to Goethe's 'single figure of speech'. One of the greatest triumphs of modern Shakespeare criticism has been the reduction of the imagery of each one of these plays to a single underlying vision, and the demonstration that, in spite of their apparently inexhaustible riches, each is simply the unfolding of that vision. On the other hand, it is usual to stress that with the development of Shakespeare's art his images become an ever more perfect instrument of dramatic effect and psychological characterisation. In reality, however, they do not so much assume a more comprehensive function as undergo a change of nature. They cease to be primarily decorative, and take on a more substantial role, not only in relation to the characters, but also as a more explicit expression of the poet's sense of life and creative impulse. Instead of serving merely to increase the beauty, music, and colour of the language, they keep alive the blaze of the vision from which the play originated.

The remarkable thing is that in the late works the metaphors proliferate as thickly as the hyperbolic similes in the early *Romeo and Juliet*, and that even the spiritualised, ecstatic language of *Antony and Cleopatra* not only contains such an abundance of metaphors that the listener's receptive capacities are severely tested, but that they are as intricate, arbitrary, and paradoxical as those in the poet's early works, though they

are no longer mere five-finger exercises, but are produced with the virtuosity of a master playing his obedient instrument. An essential change has taken place; metaphorism, without being discarded, has been superseded from within. Just as Tintoretto and El Greco cast off the excesses of mannerism without giving up its formal peculiarities, so Shakespeare preserves all the unruly luxuriance of metaphorism and at the same time passes beyond it. He develops the metaphor from a secondary into a primary form, transforms it from a superimposed ornament into a category in which things are originally apprehended and conceived. It has thus rightly been described as a constitutive mode of apprehension,[31] and, taking this idea a step further, it has been shown to be creative, capable of developing out of itself new elements of the poetical idea.[32] A frequently quoted example is this splendid passage from *Macbeth* (Act I, Scene VII):

> And pity, like a naked newborn babe,
> Riding the blast, or heaven's cherubim,
> Upon the sightless couriers of the air. . . .

The image of horse and rider is taken up again at the end of the monologue:

> I have no spur
> To prick the sides of my intent, but only
> Vaulting ambition, which o'erleaps itself
> And falls on the other.

The same image is inherent in Macbeth's failing resolution, and it is clear that the image of overweening ambition riding for a fall is due to an autogenesis of metaphors originating in that of horse and rider and leading on from there to a whole succession of images. One basic image has been perceived and taken full possession of; the various metaphors are nothing but aspects and refractions of a single vision. *Othello, Macbeth, King Lear,* like *Don Quixote* or *La Vida es Sueño,* in spite of their atomised structure, are all of a piece. They are elaborations, not merely of a coherent poetical conception, but also of a uniform sense of life that has become clear and manifest to itself.

The *concetto,* that quintessence of everything that is understood by point, wit, obscure and bizarre allusion, and above all paradoxical association of opposites, is almost as important a formal element of mannerist writing as is the metaphor. Concettism is a virtuoso play on words and ideas used to create a sense of distance from the banal and to make the commonplace seem rare and exquisite and the simple and readily intelligible complicated and sophisticated. The *concetto* is normally more abstract, less tangible and immediate to the senses, more naïve and artistically more restricted than the metaphor. The conventionalism of

mannerist literature is nowhere more manifest. Conceits of the type of Tasso's 'sweet poison', 'sweet martyrdom', 'sweet torment of love', or Marino's 'tired rest' and 'bold fear', or Góngora's 'burning ice' and 'frozen fire', proliferate in practically all the poets of the age, and oxymorons like 'warm snow of the bosom' or 'flowing pearls of tears' are commonplace. Plays on words reminiscent of music hall songs occur even among the most gifted poets. Théophile's couplet is notorious:

> Ha! voici le poignard qui du sang de son maître
> S'est souillé lâchement: il en rougit, le traitre.

The poetical appeal of this hackneyed device is increased in the most various ways, some of them very simple. Claudio Achillini, for instance, derives a pleasing conceit from the mere assonance of two words in the phrase *dalle stalle alle stelle* in connection with the birth of Christ; or a rather tired device such as the association of two apparently distinct phenomena is given new life by the opposite process, that is to say, by prolongation instead of condensation. Thus, after El Greco painted the portrait of his friend Hortensio Paravicino, the latter dedicated to him a sonnet of thanks that consists exclusively of the devious and complicated development of the idea that the likeness is so great that the poet cannot be sure whether it or he is his real self.

The *concetto* as a literary form also differs from the metaphor in that it is transferable, though not unrestrictedly, to the visual arts. Being a play on words, it is of course inseparable from language, but the wit and paradox, the piquancy and surprise, resulting from the association of the apparently irreconcilable, and the abstruseness and extravagance often given thereby to the simplest things, are formal peculiarities that have their equivalents in painting and sculpture, and even in architecture. Paintings such as Parmigianino's *Madonna del collo lungo*, Vasari's *Allegory of the Immaculate Conception*, or El Greco's *St. Maurice*, are full of complicated conceits; and Parmigianino's *Self-Portrait from a Convex Mirror* is itself a curious conceit of the type only to be found among the most extravagant virtuosi of words and similes.

Emanuele Tesauro, the writer of the most famous *Poetics* of the age, compares illusionism in architecture, the false perspective of the colonnade in the courtyard of the Palazzo Spada, for instance, with the illusionist effect produced by the accumulation of images in verse. In both cases, he says, the aim is deception, and the means by which it is produced are mere semblance, lulling the senses, mingling and confusing the various impressions.

Though the great majority of the *concetti* characteristic of mannerist poetry are of the most insipid and conventional kind, it is nevertheless by means of them that the poets of the age achieve their greatest successes.

When Marino calls the night *l'inchiostro del cielo,* the ink of the sky, it may seem very strained and artificial, but the conceit is undoubtedly original. Tasso's conceits largely take the conventional form of associating a noun with an adjective inconsistent with it, or using the same word in different connections with different meanings, as in *fera agli uomini parve, uomo alle belve* ('a wild beast to men and a man to wild beasts') (*Gerusalemme Liberata,* II, 40), but he often infuses real poetical life into the most tired formulas:

> . . . ti riveggio e non son vista:
> vista non son de te benchè presente,
> e trovando ti perdo eternamente
> Misera! non credea ch'a gli occhi miei
> potessi in alcun tempo esser noioso.
> Or cieca farmi volontier torrei
> per non vederti. . . .*
>
> (XIX, 105/106.)

With John Donne the conceit loses the Petrarchian form that it still so often preserves with Tasso and other poets of the age; or, in spite of certain survivals of that form, it assumes such an original, personal note that it really seems to be the sudden, happy inspiration that it purports to be. The subtlety, artificiality, and extravagance of his conceits do not in the least detract from their impact, which is actually deepened and prolonged by the fact that the meaning does not always leap to the eye. He finds striking images for the most well-worn ideas, comparing, for instance, the vanity of female charms after death to that of a sun-dial in a grave; or he produces an apocalyptic effect by the conceit of associating the Biblical idea of the four corners of the earth with the scientific idea of its roundness, as in the line

> At the round earth's imagined corners . . .
> (*Holy Sonnets,* VIII.)

Sometimes the conceit lies in a simple play of ideas that creates an impression of wit only because of the surprise produced by the naïve and unpretentious way in which it is stated, as, for instance, in the poet's words to his beloved with whom he lies in bed:

> Why should we rise? Because 'tis light?
> Did we lie down because 'twas night?

* I see you again and am unseen, unseen by you though in your presence, and finding you I lose you for ever. Oh, wretched me, I did not believe the sight of you would ever be painful to my eyes. Now I should gladly be blind in order not to see you.

The same play with the sun, daylight, and a pair of lovers that here produces this charming, though not very weighty, banter provides the content of one of his most successful and thoughtful poems. In *The Sun Rising* he reverses the idea of the lovers' arranging their day according to the sun, and makes it their servant instead of their master. The accent is shifted from the source of light and warmth to the fire that warms the lovers and makes their bed the centre of the universe:

> Thou sun art half as happy as we,
> In that the world's contracted thus;
> Thy age asks ease, and since thy duties be
> To warm the world, that's done in warming us.
> Shine here to us, and thou art everywhere;
> This bed thy centre is, these walls, thy sphere.

Here the conceit lies in the sun's being forced to take second place to love, and the idea must have had an enhanced piquancy in an age in which the heliocentric picture of the universe was new.

The French obtained extraordinary effects with the fireworks of the *concetto*, of which so early a mannerist as Maurice Scève was already an almost unsurpassable master. A line like

> Appuyé sur le plaisir de ma propre tristesse
>
> *(Délie*, 370.)

with that special, plastic, concrete quality, with which the French language informs even an abstract concept, or that fine couplet

> Tu me seras la Myrrh incorruptible
> Contre les vers de ma mortalité*
>
> *(Délie*, 378.)

have no parallels until Baudelaire, whose tone Scève anticipates.

What a gifted poet of the age was able to make even of such a stale conceit as that of his beloved's 'snow-like skin' is shown by this example from Tristan l'Hermite:

> Fais-moi boire au creux de tes mains
> Si l'eau n'en dissout point la neige . . .

The vividness of the image is far from suggesting that a hundred years' poetical practice and a tradition dating back to the troubadours went to its making.

The *concetto* is based on an antithesis, the association of two apparently irreconcilable ideas. Its prominence in mannerist poetry suggests the

* Thou shalt be the incorruptible myrrh
Against the worms of my mortality.

existence of a link between it and the dualism of the age, in the sense that antithesis in language and literature is a direct reflection of the cleavage within the individual and his alienation from the world. In reality, however, the contents of the mind never express themselves so simply and directly; there is no necessary connection between subjective dualism and antithetical formal expression. The latter may have a much more innocuous origin than the spiritual crisis of mannerism, and is capable of surviving longer than the impulses that give rise to it. Artistic forms are not always expressive; in the course of time they may grow more or less so than they were originally. The tendency that they share with all cultural phenomena of taking on a life of their own and developing autonomously leads sometimes to their survival long after they have become an empty shell, that is, have ceased to be expressive. The assumption of a close connection between antithesis in literature and dualism of the mind is based on equivocation rather than on a real identity. The transfer of the contents of the mind into artistic forms is never direct, consistent, and complete, or ages of harmony would produce no tragedy and ages of disharmony no idylls or pastoral poetry. The relation between states of mental crisis and extravagant, abstruse, or irregular artistic forms of expression is just as loose and incalculable as is that between art and illness, creativity and neurosis, medicine and aesthetics in general.[33]

IV

The Principal Representatives of Mannerism in Western Literature

I. ITALY

MANNERIST poetry maintained the strong link with Petrarchism. Most of its representatives were avowed followers of Petrarch, to whose tradition they adhered. They used his formulas and expressed themselves with the aid of his language, which had grown artificial and impersonal. A smaller but by no means inconsiderable group, to which John Donne and Andrew Marvell belonged, were under his shadow to the extent that, though their attitude was anti-Petrarchian, they imitated his style in the form of parody and seemed to have no objection to making an impression with the smooth forms of the original they made fun of. But Italian lyrical poetry remained Petrarchian in a thoroughly positive sense, and the feature that makes a poet like Marino often seem so monotonous and indigestible is his lack of any inner detachment from his model. Petrarchism, however, did not originate on Italian soil; Petrarch merely continued in Italy the tradition of the aristocratic social culture of feudal France as expressed in the poetry of the troubadours. Since the beginnings of the *dolce stil nuovo* and Dante, Italy had become the real guardian of the French literary tradition, and in the age of the Renaissance and mannerism France only took back its own cultural heritage from its foreign administrators, though in partially changed form.

In spite of the almost uninterrupted continuity of the Petrarchian tradi-

tion, French courtly poetry had its ups and downs even after its transplantation to Italy. It spread with the development of chivalrous forms of life and aristocratic ideals in the Middle Ages, declined again with the development of bourgeois society, and again entered a period of growth when the enriched upper bourgeoisie began adopting aristocratic and chivalrous manners. The age of mannerism, which bore the most distinct marks of a new process of aristocratisation since the feudal Middle Ages, and ended with a kind of catastrophe that can be described as the 'second defeat of chivalry,'[1] was also characterised by the resurgence of this courtly poetry. At all events, the new aristocratisation seems the most satisfactory explanation of the renewed strength of Petrarchism, which had never been more widespread or so dominant as now.

Petrarch took over the themes of courtly love casuistry from the troubadours. His own addition, in accordance with the circumstance that he was a generation younger than Dante and belonged to a predominantly bourgeois phase of Italian social history, consisted in a less cryptic and obscure way of expression than the *trobar clus* of the Provençal poets. Mannerism, with which the pendulum again swung in the opposite direction, led to a renewed complication of the dialectics of love and again obscured the language of the love poem, which with Petrarch had become relatively simple and direct.

Even Michelangelo, the greatest artistic, though not the greatest literary, personality of the Italian Cinquecento, is not entirely free of Petrarchism; he does not often use the familiar artistic means of the fashionable trend, but he cannot always resist the fascination exercised over his contemporaries by play with antitheses, parallelisms, and assonances. The following lines, for instance, besides including a number of Petrarchian contrasts, heightened in the mannerist fashion, end with a *concetto*-like surprise effect of the most conventional kind:

> Chi è quel che per forza a te mi mena . . .
> Legato e stretto, o son libero e sciolto?
> Se tu incateni altrui senza catena
> E senza mani o braccia m'ai raccolto,
> Che mi diffenderà dal tuo bel volto?*

The content of the following poem is nothing but a conceit, and a highly involved and abstract one:

* Who is it who by force leads me to you . . .
Tied and bound, or am I free and delivered?
If you enchain others without chains
And gather me up without hands or arms
What defence have I against your lovely face?

Si come per levar, Donna, si pone
in pietra alpestra e dura
una viva figura,
che là più cresce u' più la pietra scema;
tal alcun' opre buone,
per l'alma, che pur trema,
cela il soverchio della propria carne
con l'inculta sua cruda e dura scorza.
Tu pur dalle mie streme
parti può' sol levarne,
ch' in me non è di me voler nè forza.*

In spite of the broadly conventional pattern, Michelangelo here attains a condensation of expression that is unparalleled in the Italian poetry of his age, and to an extent anticipates Góngora.

The turning-point in Italian literary history that marks the end of the relatively happy, harmonious, and unproblematical Renaissance has always been regarded as the displacement of the poetry of Ariosto by the trend represented by Tasso (1554–95). Even Galileo contrasts the two poets on these lines in his *Considerazioni al Tasso*, and Wölfflin still saw them as the representatives of the classical and anti-classical stylistic principles.

'It seemed and still seems to me,' Galileo writes, 'that in his inventions this poet [Tasso] is beyond all measure shabby, poor, and pitiful, while Ariosto is magnificent, rich, and wonderful. When I consider Tasso's knights, their deeds, the events and other little episodes in the poem, I feel as if I were in the chamber of an eccentric who has taken pleasure in adorning it with all sorts of antiques, rarities, and curiosities, that is to say with bric-à-bac consisting of a fossilised crab, a dessicated chameleon, a fly or spider in amber, the little terracotta figures that are said to be found in ancient Egyptian tombs, and in painting, with a sketch by Baccio Bandinelli or Parmigianino and other things of that sort. On the other hand, when I enter *Orlando Furioso*, I see a great hall opening, an exhibition room, a royal gallery with a hundred ancient statues by the most celebrated sculptors, and an infinity of works by the hand of the most distinguished painters. . . .'[2]

The correctness of Galileo's perception of Tasso's place in the history of style is shown by the parallel he draws between his art and that of Baccio Bandinelli and Parmigianino; and the soundness of his judgment on the aberrations of taste of his age is evident from his description of the art and curio cabinets, the indiscriminating confusion of which, as is

* Just as a living figure is extracted from hard mountain stone and grows most where the stone diminishes most, so are good works of the trembling soul concealed by the barbarous, crude, and hard surplus of fleshly covering. You alone can free me from my external shell, for in me there is neither the will nor the strength.

known, extended even to the collections of the most sophisticated princes. His siding with the Renaissance poet Ariosto as against Tasso does not mean that he was too conservative to understand mannerism; on the contrary, his position in the matter was very far advanced, for in painting he was most attracted by the baroque artist Cigoli.[3] His partisanship for Ariosto shows only that he realised that the baroque had much more in common with the Renaissance than it had with mannerism. But when he finds so intolerable in Tasso the confusion of the frontiers between the different areas of sense experience, and protests against the meaningless-ness of a passage such as

> È un eco, un sogno, anzi del sogno un ombra
> ch'ad ogni vento si dilegua e sgombra
> (*Gerusalemme Liberata*, XIV, 63.)

he simply fails to appreciate the significance of the stylistic revolution re-presented by Tasso; he fails to see that Ariosto's plastic method of repre-sentation is yielding to a more fleeting, more impressionist, more emo-tional as well as more musical, more poetical, and more differentiated description of experiences. He objects to anything so insubstantial as an echo, dream, or shadow being scattered by the wind like smoke or mist, but underrates the poetical gain that lies in the increase of sensibility that allows the substantiality of sense impressions to evaporate, though with-out losing anything of their sharpness and wealth.[4]

Tasso is certainly not guiltless of the misuse of *concetti*, of the light-hearted play with antitheses and assonances, of the fabrication of technical difficulties for the sake of overcoming them with apparent vir-tuosity, which make a great part of the poetical production of the age un-readable and caused a man like Galileo to regard it with aversion. In view of his appreciation of the visual arts, however, the fact that he regards Tasso as no more than an empty and frivolous juggler with words is evidence of how clearly men of the time were able to distinguish between the competing styles and how definitely, though sometimes unfairly, they took sides.

Tasso's antithetical conceits, such as *dolci tormenti* (II, 36), *dura quiete* (III, 45), *molli avori* (XVI, 61) or *idolo crudele* (XVI, 47) are often com-bined with an assonance; in the following line there is actually a triple assonance:

> Ahi, tanto amò la non amante amata.

The rhythmic-musical effect the poet obtains in this manner is well illustrated by the following passage:

> Ecco, appar Gerusalem si vede,
> ecco additar Gerusalem si scorge;
> ecco da mille voci unitamente
> Gerusalemme salutar si sente. (III, 3.)

All this, however, still belongs to traditional practice, based on a long prehistory from which it hardly departs; meanwhile in many respects his poetry points to the future, and paves the way for later mannerist developments, notably Marinism. Marino's fundamental principle, that poetry must astonish and surprise, actually originates with Tasso, who announces that untruth is more poetical than truth,[5] and that the poet's real subject-matter is the marvellous, in the sense of the untrue. With this literature takes a decisive step towards mannerism.

Tasso's poem, which purports to be a heroic epic and to tell the story of the liberation of the holy city of Jerusalem, becomes in the poet's hands a love-poem in which there is little that is heroic, but a great deal that is sentimental and elegiac. The principal male figures, Rinaldo and Tancredi, are heroes of love rather than of war. With its melancholy mood, the work anticipates the kind of situation in which the protagonists of Racine's tragedies are usually involved. The hero is in love with a woman who is in love with someone else, who is in love with a woman who is in love with the hero. The poem also recalls the plays of Racine in being almost exclusively concerned with unrequited love. It is filled with the disconsolate spirit of the age, and has a paralysing effect, which is not characteristic of tragedy as a whole. Even the works of Racine, though full of pathological features that tinge passion with obsession, are free of the indefinable, morbid gloom that lies at the heart of the *Gerusalemme Liberata*.

No one suffered more severely than Tasso from the neurasthenia of his generation, or paid more dearly for the sensitivity and spiritual complexity of his age. Long before his mind became clouded he was liable to grave depressions, and his greatest poem was written in a state of unrelenting anxiety. The mood underlying his work is nowhere more terrifyingly expressed than in the poem *Incertezza nel timore*, which at the same time is characterised by all the essential features of mannerism:

> Io so che, non temendo,
> Non avrei che temere,
> Tanto valor in regio cor comprendo!
> Ma per lo mio volere
> Mosso, temo talvolta, e poi mi pento
> D'aver temuto; e sento
> In mezzo al mio timor nascer conforto;
> Così mezzo mi sto tra vivo e morto.*

* I know that, if I did not feel fear, I should have nothing to fear; such is the strength in my royal heart. But, moved by my will, I sometimes feel fear, and then I repent of having feared, and feel comfort rising in the midst of my fear; thus do I find myself half-way between life and death.

306

Only against the background of this pessimistic mood and continual anxiety can Tasso's eroticism be seen in its true light; it then becomes clear that, besides being a safety valve for the repressions imposed upon him by the discipline of the Counter-Reformation, the perverse form it assumes is a consequence of restriction to unspontaneous ways of expression. A good example is the passage in which he describes the hidden charms of Armida with the lewdness of a voyeur:

> Mostra il bel petto le sue nevi ignudi,
> onde il foco d'Amor si nutre e desta.
> Parte appar de le mamme acerbe e crude,
> parte altrui ne ricopre invida vesta:
> invida, ma s'a gli occhi il varco chiude,
> l'amoroso pensier già non arresta,
> chè non ben pago di bellezza esterna
> ne gli occhi occulti secreti anco s'interne.
>
> (IV, 31.)

Unsatisfied with what his eye really sees, he peeps beneath her clothing and in true mannerist fashion ascribes to occult powers what his imagination sees there.

Marino (1565–1625) is an incomparably lesser poet than Tasso but, as so often occurs in such instances, shows the marks of the predominant style more plainly than his greater contemporary. The origins of mannerist poetical forms in the poetry of the troubadours, the *dolce stil nuovo*, Dante, Petrarch, and Petrarchism are nowhere so evident, and no other poet so candidly admits the sources of his inspiration. The innocent air with which he confesses his plagiarisms and claims the right to present new things in old forms and old things in new is familiar.[6] With him poetry becomes completely playful; it cannot even be said that the form is more important than the content, because he toys with both, and both are relative to each other. He compensates for the plagiarisms in which he indulges by surprise; hence his principle:

> è del poeta il fin la meraviglia . . . •

Marino was one of those writers who enjoyed the greatest fame and widest influence during their life-time. He was the most prominent of the poets of his time, though he was one of the least significant. None of them used his stylistic means so externally, and none so seldom attained genuine artistic effects with them. Nevertheless, he gave its signature to the poetry of the whole age; and thus Marinism was more than a merely Italian literary movement, and more than a universal fashion. It was, indeed, the common denominator of the literary aspirations of the age, displaying their stylistic kinship in its most manifest form.

The question of the relationship between Marino and Góngora, which

is perhaps the most interesting problem connected with this phenomenon, is answered differently according to the nationality and outlook of the critic. It is generally assumed that Góngora was influenced by Marino but, as *Adone*, the work of Italian literature which is closest to the manner of Góngora, was written only in 1623, or twenty years after Góngora had developed his style and ten years after the publication of his *Soledades*, a vital influence on the development of Spanish mannerism can hardly be claimed for the Italian poet. On the other hand, the most superficial analysis of Góngora's poems is sufficient to convince one that there was no influence in the other direction either. Nevertheless, though Góngora developed his poetical language independently of Marino, Gongorism, like mannerism in literature as a whole, shows unmistakable evidence of Italian influence. In France the later mannerists, above all Saint-Amant and Théophile de Viau, show striking signs of Marinism. In England the metaphysical poets, just as in the case of Petrarchism, combined hostility to the fashion with good-humoured ridicule of it. In Germany, however, even poets as gifted as Harsdörfer, Hofmannswaldau, and Lohenstein adopted it unreservedly and often slavishly.

The most zealously imitated features of Marino were the weakest, most impersonal, and most mechanical—his metaphorism and concettism, and these lacked the life they sometimes have in *Adone*. Marino makes Venus mourning for Adonis 'weep the whole sea out of which she was born', and has the 'horses of Helios feed on supernatural fodder in the heavenly stables', but figures of speech as original as that were not followed; instead the patterns that were taken up were of the type of 'a golden meadow on an ivory hill' for a lock of fair hair on a white neck. In the endless jungle of Marino's metaphors and conceits there are lucky windfalls lacking in any special poetical value, like those quoted above, as well as some real pearls, such for example as the description of the death of Adonis, who turns into an anemone.

> Purpureo è il fiore, ed anemone è detto,
> breve, come fu breve il suo diletto.
>
> (*Adone*, XIX, 420.)

This is obviously based on Ovid (*Metamorphoses*, X, 728 *ff.*), but the repetition of the word *breve*, and the double reference to the shortness of life and to the brief pleasure the youth himself enjoyed and was able to give others, is the most charming feature of the passage, and is his own.

Like all the other mannerist stylistic elements, Tasso's eroticism appears in Marino in a cruder and more excessive, but also much more direct and uninhibited, and thus less pathological and perverted, form. Its exaggeration, however, which recalls the wishful fantasies of the age of puberty, is not completely normal. Marino's poems are so full of erotic themes and

references that they approach pornography. In *Adone* not only does all nature breathe love, but everything is turned into a sexual symbol, and both primary and secondary sexual characteristics become the substratum of a metaphorism in which, for instance, the phallus becomes the 'sweet arrow of love'. In an age in which even religious experience was tinged with eroticism, this obsession with sex may have contributed substantially to his popularity. At all events, he exploited it to the full, and his apology, *se oscena è la penna, è casto il core*, does not sound convincing, and his public cannot have expected it or taken it seriously.

2. SPAIN

The history of mannerism is Spanish literature can be divided into two periods, far apart in time and sharply differentiated in style. The first, of which the chief representatives are Cervantes (1547–1616) and Góngora (1561–1627), is that of pure mannerism, while the second, the most important figure in which is Calderón (1561–81), extends deeply into the baroque. The hybrid stylistic character of the latter is due to the survival of mannerism, that is to say, a number of its formal elements, in poets who belonged to the next stylistic period, but in Spain remained more loyal to the mannerist tradition than their contemporaries in other countries, France, for instance, where a poet like Racine, though traces of that tradition survive in him, can nevertheless be claimed unreservedly for the baroque. Further differences can be demonstrated within the two main periods, including that of true mannerism, and the manner of Cervantes can be contrasted with that of Góngora, as has indeed been done,[7] by pointing to the realism and extroversion of the one and the unrealistic disposition and introversion of the other, though it should not be forgotten that this contrast is inherent in mannerism and is more or less present in all its manifestations.

Góngora's art is often traced back to Italian or French sources, but its deepest roots really lie in the traditions of his own country. Marino and Góngora, the two representatives of lyric poetry of the age, obviously developed independently of each other and, apart from their own national literature, derived at most from the general Christian and western cultural tradition. If French medieval literature played a more important part in their development than that of other countries, it was a consequence of the special position of France in the Christian culture of the west. Spain may well have developed a form of Petrarchism even before the mannerist period; at all events, it developed the spiritual heritage of courtly and chivalrous poetry in its own fashion, and besides, even in Italy Petrarchism was less an Italian national than a general western

phenomenon, occupying the position previously held by Latin, Provençal, and French literature.

Góngora's major works, the *Soledades* and the *Polifemo*, to which, in spite of a large number of shorter poems, his fame is due, are characterised neither by an organically developed story nor any coherent train of thought or unity of mood. Almost exactly as in Marino, everything is a pretext for piling image on image, metaphor on metaphor, conceit on conceit. The impressionistic effects, the musical cadences of the language, the sound and colour of the words, the fireworks of wit and paradox, are momentary in impact, and the structure is always atomised. The poems consist of a hardly harmonisable mosaic of particles, and the longer they are, the more this is the case. But the components are more carefully thought out and more artistically executed than those in most of his contemporaries, and often have a spiritual and emotional intensity reminiscent of the best of modern poetry.

He uses the same fashionable formulas and strange oxymorons, and the same deliberate medley of forced and far-fetched metaphors as the other poets of the age; indeed, perhaps he uses them even more boldly, though side by side with such familiar antitheses as 'dumb eloquence' or 'burning ice' and purely mechanical metaphors of the type of 'coloured voice, winged song, feathered organ', there are innumerable examples that show his capacity to move freely within the general convention. When he refers to the 'woven snow' of a white table-cloth, it has a flavour not shared by images of the type of the 'red snow of the bosom' worked to death by other poets and, when he goes so far as to use such an unreal comparison as 'the earth is as blue as an orange', there is certainly no parallel to his daring in the poetry of modern times prior to the symbolists and surrealists. It is no accident that the rediscovery and revaluation of Góngora coincided with the appearance and influence of poets such as Mallarmé.[8] From examples of the type quoted above there was not far to go to completely capricious and illogical metaphors in which the most varied fields of experience were deliberately mingled, as in 'purple hours', or images that compelled attention because of their eccentricity, such as 'white-haired time combing out the days' as if they were lice.

The chief characteristic of Góngora's language, however, is the condensation and the obscurity that derives from the innumerable references, in which image follows on image practically without logical connection. The ideas developed are not difficult in themselves, and the metaphors are not inherently hard to follow, as they often are, for instance, in Rimbaud or Mallarmé. What makes this language so baffling is the avoidance of all direct description and the substitution for it of indirect and devious allusion; and, as this strained pursuit of indirectness is further complicated by the fact that the images follow on each other's heels without any

connecting links, thus obscuring the relationship both between them as well as between them and the things to which they refer, the resulting accumulation and incoherence of the single images makes a work like the *Soledades* practicably unreadable nowadays even to Spaniards. Hence Dámaso Alonso's edition, in which the text is accompanied by a prose transcription for the benefit of the modern reader, is absolutely essential. The fact that, as in the example below, the transcription is in places more than twice as long as the original best illustrates why Góngora is so difficult.

The *Soledades* begin with the following stanza:

> Era del año la estación florida
> en que el mentido robador de Europa
> —media luna las armas de su frente,
> y el Sol todos los rayos de su pelo—,
> luciente honor del cielo,
> en campos de zafiro pace estrellas;
> cuando el que ministrar podía la copa
> a Júpiter mejor que el garzon de Ida,
> —náufrago y desdeñado, sobre ausente—
> lagrimosas de amor dulces querellas
> da al mar; que condolido
> fué a las ondas, fué al viento
> el mísero gemido,
> segundo de Arïón dulce instrumento.

This is a translation of Dámaso Alonso's prose version:

> It was the burgeoning season when the sun enters the constellation of Taurus [the Bull] (the sign of the zodiac that recalls Jupiter's treacherously turning himself into a bull in order to abduct Europa). The sun enters the constellation in April, when the celestial bull (its brow armed with the crescent moon of its horns, shining and shone on by the sun and so penetrated by its light that the rays mingle with its hair) seems to be grazing in the sapphire pastures of heaven. Then a youth, who because of his beauty would have been more suitable than Ganymede to be Jupiter's cupbearer, shipwrecked at sea and moreover far from his beloved and scorned by her, raised his voice in sweet and tearful complaint, so that he moved Okeanos to pity and his desperate sighs calmed the wind and the waves, as if his lamentations would repeat the miracle of the sweet lyre of Arion.[9]

In searching for the roots of the obscurity, the far-fetched associations, the deliberate remoteness of image from object, or any other of the forms taken by hermeticism in mannerist poetry, social factors of the kind that may have played a decisive part in the origin of the *trobar clus* seem to provide a less satisfactory explanation of the preciosity of expression than they do with the troubadours, though they were still among the most

important influences that led to it. Mannerist poetry is obviously a secret language, the monopoly of a social and intellectual *élite*, a way of distinguishing and isolating oneself from the uninitiated multitude and thus, like the poetry of the troubadour Arnaut Daniel and his like, deliberately written for a select and discriminating audience.[10] But there was another factor, over and above regard for social distinction, that prompted the poets of the age of mannerism to wrap themselves in riddles and obscurity; and this, as has been pointed out in connection with Spanish poetry and Góngora in particular, lay in the impulse of lonely men to shield and entrench themselves against contact with others.[11] The alienation thus expressed was obviously a general characteristic of the age, not limited to Spain, or any one nation or even any particular level of society. Among the *élite* it took the form of a secret jargon, a cultural mask, a special way of thinking, a code baffling to the uninitiated. At other levels of society alienation assumed other forms of social and class differentiation more directly expressing ideological conflict and the class struggle.

There was yet another factor, however, that contributed to the obscurity of the mannerist poetical style, that is to say, fear of the commonplace and an often frantic desire to avoid banality and platitude. The same thing exercises a decisive influence on modern poetry, in which social discrimination has ceased to be the origin of stylistic change. Nowadays poets shun intelligibility just as they shun prettiness of form or any expression pleasing to the senses. Mannerists in their day similarly shunned intelligibility, though they did not shun beauty, or did so only very exceptionally.

In spite of all the difference of the artistic aims of Cervantes and Góngora, Lope de Vega and Calderón, they all abided by *conceptismo*, that is to say, the cult of lively, extravagant, bizarre metaphors and exaggerated, surprising, and paradoxical statement, as well as *culteranismo*, the cultivation of an artificial way of expression that was not content with being highly sophisticated, but had to be ostentatiously such. Góngora's enemies objected, not to his affectation, but to his complacent obscurity; they did not complain of his speaking in allusions, but only of his complexity. Quevedo, their leading spirit, regarded him primarily as the representative of *culteranismo* and condemned his self-important profundity while approving his bold and strange conceits. Góngora's real importance, however, lies neither in his fertility in metaphors, nor in the elasticity and boldness with which he associates images, nor even in the music of his language, which is what his most judicious admirers chiefly praise him for, but in the intensity with which he sometimes expresses the tragic inadequacy of thought and his doubts about his own poetical quality. One such passage in Part II of the *Soledades* (137–43) exceeds in power everything else written by that master of language:

Audaz mi pensamiento
el cenit escaló, plumas vestido,
cuyo vuelo atrevido
—si no ha dado su numbre a tus espumas—
de sus vestidas plumas
conservarán el desvanecimiento
los anales diáfanos del viento.*

The same doubt, coupled with an indefinable and therefore so much more terrible and incurable fear of himself, is the subject of the following poem which, with its expressionistically unsurpassable description of his disastrous mood, and because of the masterly technique with which the point is saved to the end, where it gains full effect, is one of the most brilliant in the poetry of modern times.

Cosas, Celalba mía, he visto extrañas:
casarse nubes, decobarse vientos,
altas torres besar sus fundamentos,
y vomitar la tierra sus entrañas;

duras puentes romper, cual tiernas cañas
arroyos prodigiosos, ríos violentos
mal vadeados de los pensamientos,
y enfrenados peor de las montañas;

los días de Noé, gentes subidas
en los más altos pinos levantados,
en las robustas hayas más crecidas.

Pastores, perros, chozas y ganados
sobre las aguas vi, sin forma y vidas,
y nada temí más que mi cuidados.†

(*Soneto* 261.)[12]

An idea of Góngora's 'modernity' can be derived from a poem such as the following, entitled 'The Deceptive Brevity of Life', which both in form and content recalls the works of another poet whose impact on modern literature has become momentous, Hölderlin:

* My audacious mind, clothed with wings, scaled the high point of heaven; if its daring flight did not give its name to the sea in which it plunged, the pride of the feathers it wore will be preserved by the diaphanous annals of the wind.

† I have seen strange things, my Celalba: clouds joined in wedlock, winds unleashed, high towers kissing their foundations, and the earth vomiting up its entrails; stone bridges smashed like reeds by raging torrents, great rivers in spate hardly to be crossed even in thought and those who sought refuge in the tops of the tallest pines and sturdiest beech-trees; I have seen shepherds, dogs, huts, and flocks floating lifeless and formless on the waters, but nothing did I fear more than my own thoughts.

Menos solicitó veloz saeta
destinada señal, que mordió aguda;
agonal carro por la arena muda
no coronó con más silencio meta,

que persurosa corre, que secreta,
a su fin nuestra edad. A quien lo duda,
fiera que sea de razón desnuda,
cada Sol repetido es un cometa.

¿Confiésalo Cartago, y tu lo ignoras?
Peligro corres, Licio, si porfias
en seguir sombras y abrazar engaños.

Mal te perdonerán a ti las horas;
las horas que limando están los días,
los días que royendo están los años.*

(*Soneto* 374.)[13]

Wilhelm Dilthey's posthumous writings include notes on the literature of the late Renaissance which, in contrast to that of earlier times, he calls a period of 'great works of fantasy'.[14] What he meant by this is not entirely clear, but he certainly intended to imply that a new period in western literature began at that time and produced works that were 'great' and at the same time 'fantastic'. His remarks need supplementing more or less on the following lines. The writings of Homer and of the Greek tragedians, Virgil and Dante, were great, but were not works of fantasy; on the contrary, they were the description and interpretation of a reality, that is to say, of a world that they felt to be real, often more real than that of direct experience. For all their difference in outlook, Homer and Dante shared the belief that they were relating or describing facts, either realities of sense experience or spiritual reality, but not fantasies, inventions, or fictions. Their works were not works of fantasy, and the imaginative writing of their time was not great, for both the fables and stories of antiquity and the love and adventure romances of the Middle Ages merely served the purpose of entertainment, were mere pastimes. The first literary works that are both great and fantastic are those of Shakespeare and Cervantes, Tasso and Calderón. These were the first poets who advanced consciously and deliberately into a fictitious world, not only to escape from ordinary reality, but also to look at it from a higher level and see it

* The swift arrow does not dally before its predestined target but strikes sharply home; and the funeral bier does not reach its goal in greater quiet over the silent sand than our life advancing swiftly and secretly towards its end. To him that doubts it every sunrise is a comet. Did Carthage have to confess this and do you ignore it? Licio, you are in peril if you persist in chasing shadows and embracing illusions. The hours will not forgive you, the hours wearing away the days, the days nibbling away at the hours.

in a wider context. Besides giving descriptions of the world and inventing images of the next, they simultaneously created magnifying symbols of the whole nexus in which they believed human life and destiny to be involved. They expressed themselves indirectly, obscurely, allusively, involving the general in the particular, but not in the fashion of the poets of the Middle Ages, to whom everything earthly and transient was no more than a simile, moreover a simile that was the direct opposite of a verifiable image of reality. They wished to create an intermediate realm between this world and the next, the two worlds of material and of spiritual being, in order to break down the boundaries of both. In their works man was heroically enlarged, but remained imprisoned in the human sphere, and expressed in a way that no heroic figure of earlier ages had done the tragic conflict between his natural limitations and his unlimited supernatural aspirations.

As Dilthey correctly perceived, a completely new period in literary history began with the end of the Renaissance. Instead of applying to it the rather cryptic phrase 'great literary fantasy', he might perhaps more appropriately have spoken of the birth of modern psychological literature, of the psychological novel, the tragedy of character and the moral drama. Nevertheless, the phrase is well chosen in so far as it makes it plain that the new literature, in spite of its psychological realism, is characterised by an unmistakable propensity to the fantastic, the imaginative, and the ambiguous quality of dreams. The real discovery of the age, however, was not the world of fantasy, but that of psychology. Moreover, this discovery was not limited to that of the narcissistic type, the invention of figures such as Don Quixote, Don Juan, Dr. Faustus, and Hamlet, to which there is nothing corresponding in earlier literature, or to the application of the new scientific method to psychological phenomena or the extension of psychological observation to new territories. It consisted rather in the adoption of a totally new approach to the phenomena of the mind. Shakespeare and Cervantes became the founders of the new psychology, not because of their more intimate knowledge of man, but because of their possession of a new key to the mechanism of the mind and their discovery of the ambivalence of mental attitudes. On the whole, in Shakespeare a villain is still a villain whichever way he is looked at,[15] but nevertheless his characters often go about in a kind of incognito, and still more often they are divided and ambiguous personalities, torn by contradictory impulses.

Don Quixote and Hamlet, Don Juan and Faustus, the most important embodiments of the moral problem of the age, are variations of the same complex character type, torn by internal contradictions, by the same conflict and the same ambivalence of feelings. Don Quixote, with the best will in the world, does nothing but harm. Don Juan, a libertine dedicated

to pleasure, becomes the pleasureless victim of his disastrous obsession; Faustus hesitates between contempt for life and desire for it; Hamlet, at any rate according to the psychoanalytical interpretation, suffers from the unresolved complex of not being far from committing the crime that he has to revenge, with the result that the unconscious motives of his affects and deeds differ so vastly from those that he professes.[16] In all these cases the tragic outcome is the consequence of incapacity to resolve an inner conflict and of despair that finds an outlet in a monomania. The idea that all one-sidedness is a betrayal of life, that Don Quixote's incurable isolation from reality, Don Juan's obsession with women, Hamlet's blinkered desire for revenge, as well as the aspect of the Faustus tragedy that already appears in Marlowe, namely that unalloyed, dryasdust knowledge leads astray, is not merely mistaken but charged with tragic guilt, is typically mannerist. Mental conflict is not overcome by one-sidedness of this kind but only repressed, and latent is turned into manifest tragedy.

Psychological interpretation of character in the modern sense begins in literature with the representation of mental conflict and the analysis of internal contradiction not exclusively based on moral conflict. Even Antigone is torn between her duty and her impulses; in Shakespeare, however, the dramatic theme and the source of the tragedy is not merely the conflict of obligations, but the hero's inability to choose between them. Moreover, inhibitions of the will do not arise merely from a moral impulse, as they do in Sophocles and still do in Corneille; they are also rooted in the nerves, that is to say, a region of the mind outside the range of conscious will and knowledge. The disintegration of the personality, however, such as takes place in modern man, the heroes of Stendhal, Dostoevsky, and Proust, has not yet begun. Conflicting impulses still appear separately from each other, but the characters' moral judgment on their own impulses and actions is clear and consistent; at most they hesitate between different impulses and decisions, but in their moral identification with one or the other they never hesitate. The crumbling of the personality, in which antagonism of impulses has gone so far that the individual is no longer clear about himself, and any unambiguous description of his character involves misrepresentation, has not yet taken place. Nevertheless there are premonitory signs of it in Shakespeare, in *Hamlet*, *Measure for Measure*, and *Antony and Cleopatra*; and with Don Quixote, who leads astray even such a sober, simple, and straightforward man as Sancho Panza, it has really set in.

Though the creation of types such as Don Quixote, Faustus, or Hamlet has not much to do with the exact observation and systematic study of mental life, it is noteworthy nevertheless that the age in which they were conceived also saw the beginnings of modern scientific psychology. True,

psychological typologies and classifications, accounts and interpretations of mental processes, existed in earlier times; there was a theory of temperaments and affects, there were descriptions and analyses of different character types, delineations of the passions and speculations about the forces that moved them, and there was a wide selection of self-observations and confessions. But there was no inductively based and methodically developed psychology. Even a master of self-analysis such as St. Augustine and a poet with as profound a knowledge of man as Dante founded their psychology on metaphysical and not empirical concepts. Instead of real observations and experiences, they started from speculatively established theoretical assumptions about the nature and inherent potentialities of the human mind. The psychology of the Renaissance, before the days of Montaigne, Cardano, and Machiavelli, was on the whole still speculative, and it first became empirically oriented as a consequence of discoveries such as that of hypocrisy as a motive force behind human attitudes and actions, and it was by the analysis of such impulses as self-deception and the study of mechanisms such as that of vanity, or of 'rationalisation', more or less in the sense later given to the word by psychoanalysis, or of ideology in Machiavelli's sense, though not in his terminology, that it came to discover its own field and methods.

With the autobiographical writings of Benvenuto Cellini and Cardano, and above all the self-analyses of Montaigne, the political–historical investigations of Machiavelli and the spiritual exercises of Ignatius of Loyola, the philosophical–speculative and moral–anthropological psychology of the Renaissance was given the practical stamp called for by the historical situation. In that age of growing capitalism, new political realism and radical religious propaganda, both economic and political success, indeed success in any sphere in a world based on competitive efficiency, called for psychological acuteness, knowledge, and understanding of human nature, and the capacity for empathy with the most varied types and frames of mind. The principle of a psychology of exposure discovered by Machiavelli, the methodical suspicion that men do not think and feel as they believe themselves or purport to think and feel, already contains the main theme of the whole of future psychological literature. His conception of mental processes as an instrument of the thinker's interests and of the ideological determination of moral standards, his analyses of selfishness and hypocrisy, provided generations of psychologists with a key to the understanding of the hidden motivations of thought and action. A series of successive steps led from the exposure of these mainsprings of mental activity to the discovery that the life of the mind consists of nothing but concealed aggressive and defensive manoeuvres, that we go about disguised and masked, not only from others, but also from ourselves, and that practically all our mental attitudes are capable of

simultaneously signifying both themselves and their opposites. The history of psychology in the modern sense had begun.

Don Quixote's tragedy is that of abstract idealism. The blind and uncompromising nature of what Ibsen calls the 'ideal demands', and the obstinacy with which he maintains his 'so much the worse for the facts' attitude even after his most severe defeats by reality, permit no hope of his conversion to understanding and tolerance. Who would expect of him as much moderation as he shows in his delightful conversation with his squire about fame, honour, and salvation? Sancho, about whom there is nothing of a hero and still less of a saint, is always in favour of the shortest and most comfortable route to his goal. As he says, he would like best to go straight to heaven. If salvation is so desirable, we should simply be saints, in his view. 'Yes,' replies Don Quixote, 'but we cannot all be monks, and there are many ways by which God leads His own to heaven.' (II, 8). That does not sound very quixotic, and it is hard to imagine that the intolerant disturber of the peace would have spoken so, at any rate before his end. Or is Cervantes here expressing his own moral judgment? Do his words point to the obverse side of his hero? Do they contain his absolution?

From the age of the German romantics to Unamuno the interpretation of Don Quixote's character was dominated by a moral relativism. He was said to be simultaneously saint and madman, his purity and innocence were emphasised, his fearless idealism and scorn for material things were admired, and his childish—the word used was 'childlike'—ignorance of the world was felt to be highly moving. Nothing but sympathy for the noble and unhappy knight was attributed to his author, though it had to be admitted that he never failed to see the madman in him. After recent historical events, which have demonstrated the havoc that can be wrought by idealism divorced from reality, the view of what Cervantes's attitude to his hero may have been has changed, and it began to be assumed that he might have taken a negative attitude to the crazy knight. If there is truth in this, the saying that there are many paths by which God leads His own to heaven may have been no more than empty talk in the mouth of that irresponsible chatterbox, and may not have been intended to apply to himself at all.

At all events, the original, classical interpretation of *Don Quixote* was anti-heroic. Until the beginning of the last century, all criticism was based on the view that it was a satire on the chivalrous romance. Doubt was first cast on the correctness of this assumption by the romantics, and since then it has been felt not to do justice to the full meaning of the work. The author's attitude to his hero was taken to consist exclusively of the deepest devotion, and critics only wondered whether he fully appreciated the

greatness of his knight, that paragon of idealism and Christianity and unparalleled symbol of the Spanish soul.[17] Salvador de Madariaga was one of the first to suggest a conflict between author and hero, and to suspect that Cervantes might not have approved of the latter's romantic eccentricities.[18] At the same time signs of the view that Cervantes was an advocate of commonsense and not of romantic recklessness grew constantly.[19] So much emphasis has recently been laid on the contrast between the author's sober rationalism and his hero's excesses that the former has been regarded as a prototype of circumspection and sound realism, while the latter has been held up as a frightening example of the dangers of prejudice and unscrupulous radicalism.[20]

No doubt Cervantes was a realist at heart, disinclined to romanticism and irrationalism; evidence of this is the mere fact of his having written this novel of social criticism, its basic idea, the mocking tone in which he speaks of chivalrous ideals, and the fact that it has come to symbolise the end of chivalry, whatever else may be seen in it. He knew what was involved in the process, and was certainly one of the few Spaniards of his time who had a foreboding of the fall that lay ahead.[21] But the anti-romantic interpretation of *Don Quixote* and emphasis on its author's rationalism goes too far if it is forgotten that Cervantes, in spite of his rationalism and realism, was far too deeply rooted in the spiritual world of mannerism, and was much too vitally influenced by the contradictions of his time, to have been able to take a completely negative attitude to his hero. Thus it cannot have been against his will and knowledge that Don Quixote turned into what he so often seems to be, that is, nothing but a dangerous visionary and madman; it seems much more reasonable to assume that Cervantes, working out his ideas in accordance with the ambivalence of his feelings and the inconsistency of his mannerist way of thought, before he completed the work, if he did not originally conceive him as such, made of him a figure in which light and shade were mixed.

If the tendency today is to regard Don Quixote almost as a criminal whose madness and irresponsibility threaten the lives and security of so many innocent people, there is perhaps not much more truth in it than there was in the earlier, romantically irrational interpretation. At all events it serves to demonstrate that the reinterpretation of *Don Quixote*, which, like that of all great works, never stops, has again taken a new turn and come up with a new picture of the hero. A view such as that 'taking the windmills for giants was not a mistake but a crime'[22] would have seemed simply unintelligible in the romantic age; experience of the events of the last fifty years was necessary to give it plausibility. But in Cervantes's text there may be just as much or as little justification for it as for the view of Don Quixote as a hero without fear or blemish.

Towards the end of the fifteenth century, as a symptom of the re-establishment of authoritarianism, the decay of bourgeois democracy, and the gradual permeation of western culture with aristocratic forms, a new admiration of the heroic life and a new fashion for chivalrous romances appeared, first in Flanders and Italy, and then also in France and Spain. Chivalrous ideas and ways of life were the idealised form in which the new nobility, partly risen from below, and the princes advancing towards absolutism clothed their ideology. Ignatius of Loyola still described himself as a knight of Christ and organised his order on the principles of chivalry, though he also had partially to adapt himself to what he saw to be the requirements of political realism, for the ideals of chivalry were manifestly no longer viable. Their irreconcilability with the rationalism of economic and social developments was becoming ever more obvious, and so, after a century of renewed enthusiasm for knights errant and their adventures, and of insatiable wallowing in chivalrous romances, chivalry suffered its second and final defeat. The great writers of the age, Shakespeare and Cervantes, are no more than the spokesmen of their generation; they announced only what was indeed evident, that chivalry had outlived its time and that its values had become fictitious.

In Spain, where the cult had reached its greatest heights, the reaction against it was sharpest. In seven hundred years of struggle against the infidel, religion and honour and the interests and prestige of the ruling class had fused into an indissoluble whole, and the wars of conquest in Italy, the victories over France, the fabulous colonisation of America and the exploitation of its riches, had automatically become powerful propaganda for the military caste. Consequently it was here that the resurrected spirit of chivalry shone most brightly and disappointment was most bitter when its virtues turned out in practice to be obsolete. Nowhere else was the conflict between ideal and reality so acute, and nowhere was the disillusionment so great. That was also one of the reasons why Spain believed it recognised its own language in mannerism, the art born of the spirit of this conflict.

In spite of their victories and their treasures, the Spaniards had ultimately to yield to the economically more progressive Dutch and the more realistically minded British pirates. Even the war-tried heroes of Spain were no longer able to support themselves, and the proud hidalgo was reduced to penury, or to the life of the rogue and vagabond. The chivalrous romance was indeed the least suitable preparation for the civil life that awaited the returning warrior. Cervantes's own career was typical of the time of transition from chivalrous romanticism to the new bourgeois-capitalist realism, and it shows the abyss that lay between them. Without knowing his life-story it is scarcely possible to appreciate the sociological significance of *Don Quixote*. Cervantes came of an im-

poverished noble family, and took part as a common soldier in Philip II's expeditions to Italy; he was severely wounded at the Battle of Lepanto, on his way home was captured by Algerian pirates, and was ransomed only after five years. When he returned home he found his family poverty-stricken and in debt. He had to content himself with the post of a minor tax official, was sent to prison, either innocently or for some trivial offence, and lived through the defeat of the Armada and the collapse of Spanish military power. The tragedy of the nation of chivalry *par excellence* was repeated in that of Cervantes and his knightly hero, and in both cases the cause lay in the historical anachronism of chivalry, the untimeliness of irrational romanticism in an age that was growing more and more unromantic. If Don Quixote attributes the discrepancy between his ideals and reality to bewitchment of the latter, and explains the conflict between the subjective and objective orders by outside intervention in the course of events, it means that he has slept through the world-historical transformation; his dream-world seems to him to be the only reality, while that of real experience is the world of magic. Cervantes himself had to awaken to reality from the disastrous illusion of dream—it is to this awakening that his masterpiece is due—and was forced to recognise for what it was the one-sided, undialectical nature of the outlook, lacking in tension and excluding all change and adaptation, that led to the downfall of his hero and his nation; he was forced to the realisation that its abstract idealism was as unassailable by reality as the latter was unaffected by the former, in other words that, with such lack of contact with the world, all action was doomed to ineffectiveness and failure.

It is perfectly possible, as has been pointed out,[23] that Cervantes was unconscious, at any rate at the beginning, of the 'deeper' meaning of his work to which the romantics drew attention. This is suggested by the fact that Sancho Panza was a later inspiration, which Cervantes did not think of at first; for without the contrast between Sancho and Don Quixote the idealist aspect of the latter would hardly appear. Cervantes's original purpose was indeed probably limited to parodying the fashionable chivalrous romances. In Italy the fashion for chivalry to a large extent prevailed in social classes of bourgeois origin and was not taken too seriously, and no doubt it was in that country, the home of liberal humanism, that the foundation was laid for Cervantes's critical attitude towards it; at any rate the first suggestion for his epoch-making joke came to him from Italian literature. His work was and remained a satire on the trashy literature of his age, a criticism of anachronistic chivalry; but at the same time it grew into an indictment of a sober, alienated reality from which an idealist, and not only a mad idealist, had no choice but to take refuge behind his *idée fixe*. The novelty of the work did not lie in the ironic treatment of chivalry or the mockery of the stereotyped chivalrous

romance. Its new, unprecedented, and epoch-making quality in the deep-est sense of the word lay in the confrontation of two realities, one trivial and the other sublimated, the partial acceptance and partial rejection of both, the paradoxical association of romantic idealism with rationalism and realism, the irresolvable dualism resulting from the impossibility of realising the idea and of reducing reality to the idea.

Cervantes's ambivalence towards chivalry is rooted in the inner con-tradiction of the mannerist outlook. This explains the hesitation between giving unqualified approval either to unworldly idealism or to worldly commonsense that underlies the whole conception of the figure of Don Quixote and the whole psychology of the novel. As a child of his time Cervantes can have been neither merely a realist and rationalist nor merely an idealist and irrationalist; and, though he was a bitterly disillusioned critic of the self-deception of his contemporaries, and though his work has become the prototype of the novel of disillusion, he remained a mannerist, thinking in unresolved and unresolvable paradoxes. The state of mind of an age which had lost its bearings cannot have been welcome to him, but he cannot have been unaffected by it. The conditions of the time even in that respect were not so very different from those of the present day. It may well, as has been suggested, be impossible for the art of our own time to present a true picture of our situation and be pro-gressive and creative without making one of its themes the 'anxiety' which fills men's minds today.[24] But between the observation and registration of this fact and acquiescence in it, between being affected by a crisis, disease, breakdown, or whatever one may care to call it, and its fatalistic accep-tance, there is a wide abyss.[25] Cervantes must have regarded Don Quixote as the great tragic symbol of his age, as well as of his own life, though from beginning to end the novel is a criticism of his time, his hero, and perhaps also of himself. He himself was filled with the dualism, the sense of alienation, and, if you like, the 'anxiety' of his contemporaries, but he was not fascinated by it.

Cervantes is the proper starting-point, not only for discussion of the fundamental outlook on life that lay behind mannerist literature, but also for an analysis of its form that attempts to go beyond establishing the characteristics of Marinism, Gongorism and related trends. For there is no writer in whom there appears more plainly the uncertainty about be-ing faced with reality or unreality, the misgivings about where truth ends and illusion begins, that are fundamental to mannerism. No other writer expresses the doubtful and ambiguous nature of things with such bewildering and at the same time fascinating power, clothing it in a play-fulness to which the reader can adopt no attitude other than that of 'conscious self-deception'. The tale is full of allusions to the effect that it is related to a world of pure fiction. The frontiers between fictional and

objective reality are continually crossed and re-crossed, and the characters pass with the greatest nonchalance from their own sphere of life into that of the reader. A characteristic example is the passage in Part II in which reference is made to the fame acquired by knight and squire as a result of the success of Part I, and the latter tells the duke and duchess at whose court he and his master are guests that he is 'Don Quixote's groom, who appears in the story too, and is named Sancho, if he was not changed in his cradle, that is, in the press'.

However, the most significant example of the problematic nature of the mannerist attitude to reality is the following:

> 'According to your life-story that has recently been published with such great success', the duchess says to Don Quixote, 'you have never seen the lady Dulcinea, if I recall correctly, and in reality no such lady exists in the world, except in your imagination.' 'A great deal could be said in answer to that,' the knight replies. 'God knows whether a Dulcinea exists in the world or not, or whether she is a mere figment of the imagination or something else. These are things that it is not so easy to be positive about' (II, 32).

When the extent to which Don Quixote's thoughts, plans, and speeches are occupied by the thought of Dulcinea is taken into account, this admission that the woman by whom his mind is dominated perhaps does not really exist after all, capped by the fact that he regards the question as relatively unimportant, the difference between the real and the unreal being not readily discernible in any case, gives one an inkling of the mannerist idea of reality.

In addition to the author's divided mind in relation to his hero, wavering between liking and aversion, and his uncertainty about how to give him his due, the alternation between comic and tragic treatment of him, in other words what has been called the 'mixture of styles' in this kind of writing, is an outcome of the same feeling of uncertainty in relation to reality. But *Don Quixote* has a large number of other mannerist stylistic traits apart from those derived from the antithetical and ambivalent nature of the mannerist sense of life. In the first place it is a novel, not only of disillusion, but also of alienation; indeed, it is the novel of alienation *par excellence*. As it proceeds, the complete alienation of its hero from his time and environment emerges more and more distinctly. He cannot and will not adapt himself to this world. Where others make themselves useful and fit in, he makes himself ridiculous, useless, actually harmful. Mannerist too is his obsession, the compulsion under which he lives and acts, making the whole plot like that of a puppet-play controlled by strings. The odd and capricious way in which the story is told is also mannerist, as are its formlessness and lack of proportion; the author's

insatiability in producing ever new episodes, digressions, and commentaries; the combination of details by a kind of cinematic montage technique, working with continual jumps, interpolations, flash-backs, and dissolves; the mixture of naturalism in detail with the fantastic quality of the whole; the adjustment of the features of the low picaresque novel to those of the idealistic chivalrous romance, and of the tones of everyday speech, which Cervantes was the first faithfully to reproduce, to the artificial rhythms and studied metaphors of *conceptismo* and *culteranismo*; and, finally, the extremely uneven execution, in parts accomplished and delicate, but elsewhere negligent and crude, because of which *Don Quixote* has been described as the most carelessly written of all literary masterpieces,[26] though certain works of Shakespeare emulate it in that respect too.

It has often been claimed that the history of the modern novel, or the novel itself in the true sense of the word, begins with *Don Quixote*. In reality, however, the work marks much more than the opening of a new chapter in literary history; it changed, not merely a literary form or literature itself, but the face of western man. It expressed for the first time in literature a problematic, relativist attitude to direct, concrete, practical reality, its partial acceptance and simultaneous rejection. Unquestioning acceptance or summary rejection of it had been frequent in the course of history, and had led to the production of innumerable works, including masterpieces, but no earlier product of literature moved with such ambivalent feelings and divided loyalties between the spiritual and the sensual, the practical and the ideal, between tangible reality and illusion, poetry and prose; none was so uncommitted to either. Whatever else this dualism might mean, for all the danger that might be concealed even in the partial reprieve of quixotic irrationalism and unrealism, it was of immeasurable importance in the history of the human spirit, for it was no less than the first statement in art of the dialectical nature of thought. Not only had the antinomical nature of being and the antithetical movement of thought been discovered for literature, not only had the dynamism behind all being and action been revealed, but also all unity had been dissolved into dualism, all being into becoming, all rest into movement. It became obvious that there was another side to everything, no one-sided view was acceptable without qualification, and true statements about the double face of things and the divided human mind could be made only in the form of antithesis, pros and cons, paradox.

The romantics called *Don Quixote* a philosophical novel, in a sense that today seems outmoded and not very significant; because of its dialectical nature it could still be called a philosophical novel, however. The whole work moves in contrasts, and every one of its aspects and viewpoints is balanced by an opposite aspect or viewpoint. Perhaps this dialectical pro-

cess appears nowhere more strikingly than in the relationship between Don Quixote and Sancho Panza. It has rightly been pointed out[27] that not only is Sancho affected by his master, but that the latter is also affected by him, and that, influenced though not convinced, he ends by showing signs of more sense of reality than one would have thought possible at the beginning.

The mannerist conception of life as a borderline state between being and illusion, semblance and reality, found no more revealing analogy than the dream, and no more important literary exponent of the analogy than Calderón. There is hardly a notable writer or thinker of the age who is not preoccupied and puzzled by the dream, and the minds of the greatest of them turned continually on the subject. 'We are awake in sleep and sleep while awake,' says Montaigne in the *Apologie de Raymond Sebonde*, and Shakespeare says: 'We are such stuff as dreams are made of.' For Tasso too life is only a dream—*un eco, un sogno, anzi del sogno un' ombra*. There is no end to the examples that could be quoted. Calderón alone wove three of his masterpieces round his conception of life as a dream— *La dama duende*, *El gran teatro del mundo*, and *La vida es sueño*; of the latter he also made an *auto sacramental* (Corpus Christi play).

The idea of the ontological insignificance of experience and the misleading nature of the conception of things derived from sense data obviously does not originate with mannerism, that is to say, with Calderón, Shakespeare, or Montaigne. It has Platonic and even Eleatic origins, and is contained in any philosophy that is opposed to realism or nominalism, *i.e.*, is based on ideas or universals. What is specifically mannerist is the emphasis laid on the insubstantiality and illusory nature of the whole of existence instead of on the mere fictitiousness of ordinary experience; and mannerist, above all, is the failure to discover a way of salvation from the insubstantiality and vanity of life in turning to such things as the ideas of Plato or the transcendental values of Christianity.

An alarming, painful, ineradicable tension prevails in the world in which one is confined, according to the mannerist view, subject to the inscrutable domination of mute and invisible forces hostile to the spontaneity of life. Men act like puppets moved by invisible strings; and even the realisation that they do not do what they would like to do or act as they would like to act comes to them too late to be of any advantage. True, Calderón is enough of a Christian not to forget that unqualified values and commandments nevertheless exist, but he is so much a child of his sceptical century that he doubts that these values can ever be put into practice. For the reality of this life itself is doubtful; it is like a dream, fleeting, illusory, and insubstantial. The awakening after its apparent fulfilments is associated with fearful disillusion, *desengaño*, which in

Spanish implies, not a unique experience isolated from the rest of life, but a sudden awakening to the truth after a life of self-deception that threatened the self with destruction, a penetration to the light from the dark depths of narcotising illusion that was bound to deprive existence of its meaning. The fundamental facts about life are the inevitability of illusion so long as it lasts and the fearful awakening that follows realisation of its true nature; and in that age of crisis, examination of conscience, and doubt, disillusion came to signify the very essence of self-knowledge.

But if there is no escaping from 'dreams', that is to say, from the web of illusion and fiction and play-acting in which one is caught up, what conclusion should be drawn from this situation, what can be done in the light of it? The answer cannot be perpetual wakefulness, because that is beyond human capacity, so perhaps it might be a state of mind which would enable one, so to speak, to dream consciously, that is to say, always remembering that all human status, authority, and dignity are mere roles that have to be cast aside again, borrowed masks and costumes that have to be returned to the property-man when the play is over.

Part of Calderón's final answer to all these problems is the idea of God as author, producer, and stage-manager of the great drama of the world, responsible for the whole illusory performance in which man is involved. Life may be not our own dream, perhaps we are merely someone else's dream. The idea of God as the impresario of this fearful spectacle is one of those paradoxes of faith the prototype of which is the 'injustice' attributed to God by Luther; and it is an early anticipation of Kafka's conception of the deity.

The *theatrum mundi*, like the dream, besides being one of mannerism's favourite images, is one of those that most succinctly express the spirit of the age. The link between the theatre and illusion, and thus also with dream, is obvious. The idea of the theatre as a symbol is, however, older than the symbolical or metaphorical use of the dream and illusion. Even Plato speaks of the tragedy and comedy of life, and of men being playthings of the gods.[28] This idea recurs throughout ancient philosophy, and in particular plays an important role in the literature of late antiquity. In the Middle Ages, with their dramatic conception of the Last Judgment, their representation of the Biblical stories, their enactment and setting, the idea of human life as a great spectacular drama acquired a new meaning. The Renaissance, which took such great pleasure in the theatre, paved the way for mannerism in that direction too. But it was not until the latter came into being that the image of the *theatrum mundi* acquired its new dimensions and its proper depth. The idea that all the world was a stage, that men were like players with their exits and their entrances, that they were never really what they seemed to be, was not the most important. Underlying the image was the shattering of the sense of identity, of the

self's harmony with itself, the problem of the homogeneity of character, and of how to reconcile all the things that lay hidden behind a person's mask. That is why phrases such as 'I am not what I am' and 'Nothing is what it seems' recur so frequently in Shakespeare in one form or another, and what the age was concerned with was, not so much the fictitiousness of phenomena, as with illusion, that gave happiness only so long as one was taken in by it. In the *Apologie de Raymond Sebonde* Montaigne tells the story of Lycas, who imagined himself to be continually at the theatre, where the most entertaining plays were produced for his pleasure. When the doctors cured him, he wanted to take action against them to make them restore the illusion which had made him so happy.

The great writers and thinkers of the age were severe critics of their generation; they were far from pleading the cause of a Lycas, or advocating the preservation of self-deception. Calderón was a less realistic thinker than Montaigne, Shakespeare, or Cervantes, but he was more remote from the morbid tendencies of the romantic movement, as well as from the romantic whims of the baroque, than he was from the self-critical spirit of mannerism, with the language of which he was still familiar. It was not for nothing that, as one of his illustrations of the modern metaphorical way of expression in contrast to the ancient style, Hegel picked a passage from one of Calderón's plays, *La Devoción de la Cruz*:

> . . . heridas y ojos
> son bocas que nunca mienten.
> (I, 811–12.) [29]

'Wounds and eyes are mouths that never lie.' Who has ever expressed himself more manneristically?

3. FRANCE

The most important representative of mannerism in French literature is Montaigne, who occupies a key position in the whole movement. Attempts to represent his philosophy as an expression of the Renaissance are vain. Even the usual classification of it as relativism and scepticism is not really reconcilable with its attribution to the Renaissance; the classification, though in itself not inaccurate, does not, however, say very much. The existentialist Maurice Merleau-Ponty points out correctly that there are two aspects of Montaigne's scepticism; that besides implying that nothing is true, it also implies that nothing is false; it robs us of the capacity to demonstrate the wrongness of the opinions, theories, or attitudes that we reject.[30] This not only throws light on a highly important aspect of Montaigne's thought, but also, though obviously without Merleau-Ponty's

realising it, most pertinently sums up the mannerist way of thinking in general. Montaigne, he says, sets out from the observation that every truth contradicts some other truth, and reaches the conclusion that truth itself is contradictory. The meaning of this basic contradiction is that rejection of a truth always involves discovery of a new kind of truth. The dynamism of this continual rejection of statements and formulations, and the dialectical process by means of which the denial of one truth always involves acceptance of another, constitute the very essence of the fundamentally undogmatic, uncommitted, and experimental mannerist way of thinking.

Pascal was still influenced by the dynamism and dialectics of mannerism, which directly associate that typical representative of baroque metaphysics, not only with Montaigne, whose optimistic acceptance of life he rejected, but also with the whole mannerist philosophy of life. His affinity with mannerism appears, not only in the fact that his whole style of thinking and writing is based on paradox, which with him attains a subtlety and complexity unprecedented in any previous writer, but also in his awareness, which fills his whole being and never leaves him, of the hazardous nature of all thought whatsoever. Even his argument for faith, the highest thing he knows, takes the form of a 'bet', that is to say, he conducts it in thoroughly dialectical fashion, with results unforeseen and unforeseeable in advance.

Montaigne, as Merleau-Ponty observes, was permanently fascinated by the paradox of consciousness, that is to say, the phenomenon of our having something objective as our spiritual property and our yet remaining distinct from it. He discovered the paradox of the unification of the subjective and objective, of the inalienable and at the same time self-alienating nature of all spiritual structures and values, and maintained to the end as an essential element of his thought the paradox, so characteristic of mannerism, that the self was open to external reality and at the same time shut off from it. Cartesian reason, which gained such authority over the French spirit in the century of classicism, took possession of reality and remained master of itself by mastering the outside world, but Pascal, unlike his contemporary Descartes, shared with the mannerist Montaigne the feeling of being involved in problems the key to which he did not for one moment believe to have at hand. His spiritual community with Montaigne and mannerism is based on his realisation that everything in the self throws us back on things and that all things throw us back on the self.[31] Awareness of this interdependence and continual drift from one pole to another underlies the whole of mannerism. In contrast to the shifting foundations on which this method of thinking is epistemologically based, Descartes believed firm ground was attainable by the formulation of clear concepts, just as Kant believed he had found it in the categories of

reason and German idealism relied on the creative self. Confidence of this kind provided common ground for the rationalism and realism of the age from the beginnings of the baroque to the end of impressionism, and contributed to giving it a uniform and essentially anti-mannerist character. Rationalism believes in the cognisability of things; reason is like a lens enabling them to be examined—to Descartes it was neutral, colourless, completely transparent, while to Kant it was coloured, lending its own hue to things, but still a lens. To mannerism, however, all things presented themselves in distorted forms, under a cloak of concealment that made their true nature impossible to ascertain. The mask was never laid aside, the cloak never thrown off. That is why the essay of Montaigne, circling round the essence of things, just as it circled round the author's own self, without ever being so pretentious as to claim to penetrate their essence, was such an appropriate form for dealing with a world of impenetrable disguises. He asks questions with no prospect of being able to give satisfactory answers; that is to say, he is concerned with things about which it seems more important to ask questions than to try to give answers.

The closest contemporary of Montaigne (1533–92) among the leading representatives of mannerism in France was the dramatist Robert Garnier (1534–90). A member of the same generation was Du Bartas (1544–90), who with his variety of *culteranismo* represented a much more decisive turn to mannerism than did Ronsard, for instance, whom in contemporary eyes he alone surpassed. About the middle of the century Ronsard and the poets of the Pléiade were still at the height of their fame; by about 1580 Desportes, an insipid imitator of Petrarch, and the intellectually rather more ambitious Du Bartas were the leading French poets. The two really important mannerist poets of the century were Maurice Scève (1510–64) and Jean de Sponde (1557–95). The former perhaps appeared too early, and his reputation was limited to Lyons, while the latter appeared too late, when Malherbe, in spite of his own roots in mannerism, was bringing that 'irregular' poetical style into disrepute and paving the way for the general acceptance of classicism. So lasting was Malherbe's influence that in most histories of literature until recently Maurice Scève was barely mentioned as a local celebrity side by side with Louise Labé, and Jean de Sponde was usually not mentioned at all.

Scève was nevertheless not only one of the greatest mannerist lyrical poets, but also one of the first and most original representatives of the style. At a time when western verse still moved almost exclusively within the limits of Petrarchism and confined itself to the stereotyped expression of the joys and troubles of love in the manner of the pedantic poets of the Renaissance, his work anticipated the essential features of mannerism, its

sensibility and complexity, its spiritualisation of the senses and its sensualisation of the spirit. *Délie*, his principal work, published as early as 1544, is a collection of about 500 *dizains*. These are still full of Petrarchian antitheses and conceits, but he is the only poet of his time who is able to give them a convincing originality. Who else could have devised a turn of phrase as delicate and piquant as *appuyé sur le plaisir de ma propre tristesse?* It is not for nothing that he has been called a sixteenth-century predecessor of Mallarmé. The affinity between the two poets is unmistakable:

> La blanche Aurore à peine finissait
> D'orner son chef d'or luisant, et de roses,
> Quand mon esprit, qui du tout périssait
> Au fond confus de tant diverses choses,
> Revint à moi sous les Custodes closes
> Pour plus me rendre envers Mort invincible.
> Mais toi, qui as—toi seule—le possible
> De donner heur à ma fatalité,
> Tu me seras la Myrrhe incorruptible
> Contre les vers de ma mortalité.*

In comparison with the poets of modern times, he has actually been rated above Baudelaire.[32] At all events, his poetical innovations were unheralded and came more surprisingly; the macabre tone that is one of Baudelaire's mannerisms never becomes tiresomely stereotyped with him, and he assumes none of the former's daemonic attitudes. He is one of the few French poets who never succumb to empty rhetoric, which is something that cannot be said even of the discoverer of directness and naturalness in modern verse. The following poem, which is perhaps the most fully representative of Scève's art, not only has Baudelaire's tempestuous *élan* and deep passion, not only combines pathos and directness in a fashion which has been described as a mixture of the tone of Racine with that of journalism, but also actually surpasses him in the power and simplicity of expression:

> Le jour passé de ta douce présence
> Fut un serein en hiver ténébreux,
> Qui fait prouver la nuit de ton absence
> A l'oeil de l'âme être un temps plus ombreux
> Que m'est au corps ce mien vivre encombreux,
> Qui maintenant me fait de soi refus.

* The white dawn had barely finished decking out its brow with shining gold and roses when my spirit returned from the valley of the shadow to give me more courage against death. But thou, who alone canst make my fate fortunate, shalt be the incorruptible myrrh against the worms of my mortality.

> Car dès le point que partie tu fus,
> Comme le lièvre accroupi en son gîte,
> Je tends l'oreille, oyant un bruit confus,
> Tout éperdu aux ténèbres d'Égypte.*

In comparison Ronsard seems stiff and rhetorical, for he never shakes off the ornamental imagery of the Renaissance or the old-fashioned mythological allusions and pedantic verbosity of humanism. He has no scruples about repeating himself, piles image on image without adding anything new, and appears to be concerned, not with intensity of expression, but only with correctness. He is essentially anti-mannerist in feeling, and is the most classically minded French Renaissance poet. In his anti-Petrarchism he goes so far as to admit practically no antitheses or conceits to his poems, and in that respect he and the other members of the Pléiade, above all Du Bellay, are exceptions to the rule of the time. It would be wrong, however, to assume that he has no links with mannerism. Mannerist aspirations play a part in his make-up, as they do with the masters of the Renaissance in Italy, and to the extent that he renounces harmony, regularity, and rationality his art gains in complexity and power. It has repeatedly been suggested that the Pléiade was a literary appendage of the school of Fontainebleau, but that is going too far. Both share a taste for learning, interest in mythological analogies and allegories, and aspire to an elegant, smooth, cultivated way of expression and, above all, there is a marked erotic undertone in both. Ronsard was a devotee of the cult of the female breast, which in the mannerist period in France amounted to a fetishism and, in the fashion of so many of his contemporaries, wrote a *Blason du sein*:

> Ma Dame se levait un beau matin d'été. . . .
> Quand le Soleil attache à ses cheveux la bride. . . .
> J'entrevis dans son sein deux pommes de beauté
> Telles qu'on ne voit point au verger Hespérides. . . .

He uses this favourite theme of the artists of Fontainebleau with obvious pleasure elsewhere as well:

> Marie, levez-vous, ma jeune paresseuse. . . .
> Je vais baiser vos yeux et votre beau tétin
> Cent fois pour vous apprendre à vous lever matin.

Nevertheless, he remains remote from the anti-classical outlook and precious formal language of the school of Fontainebleau, which took over and further developed the attainments of the first generation of Italian

* Each day spent with you was a halcyon day in a dark winter, making the night of your absence the gloomier, more troublesome than the life which now rejects me is to my body. For since you left, like a hare squatting in its hole, I stretch my ears, pricking up my ears at every strange sound, lost in Egyptian darkness.

mannerists. In comparison with the true mannerists, he creates the impression of a not particularly subtle, almost pedantic mind, who seldom succeeds in expressing an idea in a form as complex as that, for instance, in which he uses the metamorphosis of the silkworm as an allegory of the poet's art:

> C'était un oeuf qui en ver s'est changé;
> Après avoir voué toute sa soie,
> Que l'artisan par mainte étroite voie
> Doit joindre à l'or pour les habits d'un Roi.
> Ce ver après, comme ennuyé de soi,
> Soudain se change, et vole par les prés,
> Fait papillon aux ailes diaprées
> De rouge, vert, azur et vermillon.
> Puis, se fâchant d'être tant papillon,
> Devient chenille, et pond des oeufs, pour faire
> Que par sa mort il se puisse refaire.

In contrast to this, he sometimes writes lines of striking simplicity and strikes a note reminiscent of folk-song:

> Mignon, allons voir si la rose
> Qui ce matin avait déclose
> Sa robe de pourpre au soleil,
> A point perdu cette vêprée
> Les plis de sa robe pourprée
> Et son teint au vôtre pareil.*

Even this apparently simple tone originates in the sophisticated courtly pastoral and recalls the mannerism of Pontormo's frescoes in the villa at Poggio a Cajano. A mannerist propensity also appears in his lively interest in the Narcissus theme, which he uses in one of his finest poems:

> . . . ce qui plus me deut, c'est qu'une dure porte,
> Qu'un roc, qu'une forêt, qu'une muraille forte
> Ne nous sépare point, seulement un peu d'eau
> Me garde de jouir d'un visage si beau.†

After the rather premature and isolated phenomenon of Maurice Scève, and the episodic traces of mannerism that appear in Ronsard, who remains loyal at heart to the Renaissance, the first real mannerist generation in French literature is represented by Montaigne and Garnier. With Garnier the world is dominated by the dark powers heralded by Scève, without which mannerist poetry is conceivable, but not mannerist drama.

* Darling, come and see if the rose that this morning opened its purple dress to the sun has kept until this evening its purple folds and its complexion equal to yours.

† What grieves me most is that no grim gateway, rock, forest, or strong wall keeps us apart, but that only a little water keeps me from enjoying such a beautiful face.

French literature has no examples of the horror and perversity which in other countries, particularly England and Germany, formed part of the attraction of the theatre; France produced nothing comparable to the sadistic brutality of a Ford or Webster or the perverse characters of a Lohenstein. That made the transition from mannerism to classicism in the theatre much easier in France than elsewhere, and for the same reason the classical theatre in France was able without difficulty to identify itself with the baroque.

Garnier is the only French dramatist in whom there lives something of the spirit of Shakespeare. There is therefore some justification for the view that he was a kind of French Elizabethan and combined Shakespearean with the Racinian features of his style.[33] His Racinian passages, such as:

> Moi, j'ai toujours l'amour cousu dans mes entrailles

or

> Mieux eût valu pour toi, délaissée au rivage,
> Comme fut Ariane en une île sauvage,
> Ariane ta soeur, errer seule en danger . . .

are certainly more convincing than those in his Shakespearean manner, but the stylistic link between him and the Elizabethans is unmistakable. All the later French dramatists seem tame, polished, and innocuous in comparison; he makes all of them, including Corneille and Racine, seem precious, and in most cases it is only the preciosity in their work that recalls mannerism. Conceits such as

> Dans mon ennemi je trouve mon amant

or

> La moitié de ma vie a mis l'autre au tombeau

in Corneille's *Le Cid*, or

> Brûlé de plus de feu que je n'en allumai

in Racine's *Andromaque*, or

> Présente je vous fuis, absente je vous trouve

in his *Phèdre*, are still fundamentally exercises in that fashionable style, and even in Molière, who makes such fun of the *précieuses*, there are examples of this artificial way of expression.

> Belle Philis, on désespère
> Alors qu'on espère toujours . . .

from *Le Misanthrope* is perhaps the most famous example.

Though Montaigne as a thinker far surpasses all his contemporaries,

none of whom approaches him in historical importance, as a stylist he remains within the limits of the general convention, and he expresses himself just as piquantly, antithetically, and paradoxically as the others, except that the structure of his prose is much more complex and he succeeds in giving his phrases more colour and variety than any writer of the age until Pascal. The following passage from the first book of his *Essays* in which he develops the idea of the inseparability of life and death, is almost without parallel as a stylistic *tour de force*:

> Le premier jour de votre naissance vous achemine à mourir comme à vivre. . . . Tout ce que vous vivez, vous le dérobez à la vie; c'est à ses dépens. Le continuel ouvrage de votre vie c'est bâtir la mort. Vous êtes en la mort pendant que vous êtes en vie. Car vous êtes après la mort quand vous n'êtes plus en vie.
>
> Ou, si vous aimez mieux ainsi, vous êtes mort après la vie; mais pendant la vie vous êtes mourant, et la mort touche bien plus rudement le mourant que le mort, et plus vivement et essentiellement.
>
> Si vous avez fait votre profit de la vie, vous en êtes repu, allez vous en satisfait. Si vous n'en avez su user, si elle était inutile, que chaut-il de l'avoir perdu, à quoi faire la voulez-vous encore?
>
> La vie n'est de soi ni bien ni mal: c'est la place du bien et du mal selon que vous la leur faites.
>
> Et si vous avez vécu un jour, vous avez tout vu. Un jour est égal à tous jours. Il n'y a point d'autre lumière, ni d'autre nuit.[34]

The idea is inherently complicated enough, but the unusual resources of language at Montaigne's command give it a special depth and breadth. Life and death are inseparably linked; one can have no part in one without the other. They are relative to each other; death presupposes life, and throughout one's life one is dying; and when it is over there is no more death. However long or short life may be, one day is like all other days, and so long as it lasts life is no different from what it is on any single day.

A passage like this not only recalls how mannerist even Pascal's way of expression is, but also shows the extent of Montaigne's influence on him. 'L'homme connaît qu'il est misérable, puisqu'il l'est; mais il est bien grand, puisqu'il le connaît.'[35] The idea that man is great because of his awareness of his wretchedness in form and content spans the distance of a century that separates the two thinkers. Pascal develops the same idea and illustrates it from a new angle:

> L'homme n'est qu'un roseau, le plus faible de la nature; mais c'est un roseau pensant. Il ne faut pas que l'univers s'arme pour l'écraser: une vapeur, une goutte d'eau, suffit pour le tuer. Mais, quand l'univers l'écraserait, l'homme serait encore plus noble que ce qui le tue, puisqu'il sait qu'il meurt, et l'avantage que l'univers a sur lui; l'univers n'en sait rien.[36]

Here the superiority of mind over matter and mortality is given the stamp of tragedy.

From the point of view of the history of style, if not from that of pure artistic achievement, the most important representative of mannerism in French literature was Jean de Sponde (1557–95), with whom anti-classicism attained undisputed supremacy in France. Renaissance classicism had been superseded, and that of the baroque was not yet in sight. His verse is dominated by the dark tones of night, unhappy love, the ever-present thought of death, and his gloom and pessimism remained the fundamental mood of the poetry of his most gifted contemporaries and successors, Agrippa d'Aubigné (1551–1630), Théophile de Viau (1590–1626) and Tristan l'Hermite (1601–55). As soon as the mood lightened, opposition to mannerism and the beginnings of the new classicism became manifest.

The most solid and homogeneous production in French mannerist literature came from Jean de Sponde, but the peak was reached, not by him, but by Agrippa d'Aubigné, whose *Printemps* contains lines that are among the best in French verse:

> Si quelquefois poussé d'une âme impatiente
> Je vais précipitant mes fureurs dans les bois,
> M'échauffant sur la mort d'une bête innocente,
> Ou effrayant les eaux et les monts de ma voix.
>
> Mille oiseaux de nuit, mille chansons mortelles
> M'environnent, volant par ordre sur mon front:
> Que l'air en contrepoids fâché de mes querelles
> Soit noirci de hiboux et de corbeaux en rond.
>
> Les herbes sècheront sous mes pas, à la vue
> Des misérables yeux dont les tristes regards
> Feront tomber des fleurs et cacher dans la nue
> La lune et le soleil et les astres épars.
>
> Ma présence fera dessécher les fontaines
> Et les oiseaux passants tomber morts à mes pieds,
> Étouffés de l'odeur et du vent de mes peines:
> Ma peine, étouffe-moi, comme ils sont étouffés!*

* If, driven by the impatience of my soul, I sometimes give vent to my fury in the woods, growing heated over the death of an innocent beast, or frightening the waters and mountains with my voice, a thousand night birds, a thousand mortal songs surround me, flying by order across my brow. Let the air, angered by my complaints, be darkened by owls and circling crows. The grass will dry under my feet at the sight of the wretched eyes whose sad looks make flowers droop and the sun and moon and scattered stars hide in cloud. My presence will dry up the fountains and make the passing birds drop dead at my feet, suffocated by the smell and the breath of my griefs. My grief, suffocate me as they are suffocated.

Tristan l'Hermite has nothing comparable to this remarkable poem, but he has lines, such as the opening of the sonnet *Les agréables pensées*, that have a startling delicacy and directness:

> Mon plus secret conseil et mon cher entretien,
> Pensées, chers confidents d'un amour si fidèle,
> Tenez-moi compagnie et parlons d'Isabelle. . . .

And Théophile de Viau, apart from the 'surrealist' tendency to which we have referred in another context, in poems such as *La Maison de Sylvie* shows a similar tendency to the uncomplicated and apparently unsophisticated:

> Diane quitte son berger
> Et s'en va là dedans nager
> Avec ses étoiles nues. . . .

Lafontaine himself did not write many lines of a more shining, controlled, and relaxed beauty.

The grace and melody that form part of the artistic means of Agrippa d'Aubigné and Théophile de Viau are completely lacking in Jean de Sponde. His earnestness makes him the French poet who comes closest to the English metaphysical poets, irrespective of the justice of his description as a 'Donne *manqué*.[37] Of the qualities of the English poets of the age, he chiefly lacks their sense of humour, however bitter-sweet this may have been, and the corresponding detachment from the conventional means of expression that they used. As a poet of death, however, he is completely the equal of his English counterparts, particularly John Donne, and nobody has ever invented more moving images in describing it than he in his *Sonnets de la mort*:

> Tout s'enfle contre moi, tout m'assaut, tout me tente,
> Et le Monde, et la Chaire, et l'Ange révolté,
> Dont l'onde, dont l'effort, dont le charme inventé
> Et m'abîme, Seigneur, et m'ébranle, et m'enchante. . . .*

Malherbe, born in 1555, was a contemporary of Jean de Sponde and, though he survived him by a generation, this only partially explains his turning away from mannerism. His poetry contained classical elements from the beginning and preserved mannerist traits until the end. His early work *Les Larmes de saint Pierre* is full of the conceits and playful stylistic devices that he later so violently condemned, but it is a fact, though perhaps a less striking one, that traces of mannerist influence never totally disappear from his style. His mannerist origins are betrayed in the piquant method of expression of lines such as the celebrated:

* Everything rises against me, assaults me, tempts me, the world and the flesh and the Angel of Revolt alike, whose depths, attack, and invented charms both shatter and shake and enchant me, oh Lord. . . .

> Beauté, mon beau souci, de qui l'âme incertaine
> A comme l'océan son flux et son reflux . . .

the tone of which seems like an echo of time past, or the perhaps even more characteristically mannerist line:

> Et rose, elle a vécu ce que vivent les roses . . .

but there are reminiscences of it even in the completely classical poems, as, for instance, the *Prière pour le Roi Henri le Grand:*

> La moisson de nos champs lassera les faucilles,
> Et les fruits passeront le promesse des fleurs.

As a consequence of the dictatorship of Versailles, French seventeenth-century classicism was predominantly courtly and aristocratic in character. It was a magnificent, imposing royal style, following rigid conventions and speaking above all to the aristocracy in the language of the aristocracy. Nevertheless, it would be superficial and misleading to ignore the very notable part played by the bourgeoisie, both in its production and consumption. In discussing cultural matters, and particularly the theatre, the representatives of the age, including such an orthodox classicist and obdurate upholder of *convenance* as Boileau, always speak of the court *and* Paris, *la Cour et la Ville,* that is to say, the King and his entourage on the one hand, and the bourgeoisie on the other. The famous classical writers of the age, Corneille, Racine, Lafontaine, Boileau, etc., were all simple bourgeois; Corneille, one of the creators of the class conception of seventeenth-century French aristocracy, was a Rouen lawyer, a typical representative of the provincial middle class, and the strolling player Molière actually belonged to the lower level of that social stratum. There were numerous points of contact between the outlook and artistic taste of the court and the bourgeoisie. At this stage of development the representatives of both thought and felt in a rationalist and anti-mannerist fashion. Both the new courtly public and the new bourgeoisie were sober, matter-of-fact, and conventionally minded, and both shunned the fantastic, the bizarre, the arbitrary, and the intellectually too ambitious and complicated. They wanted poets to use a clear, correct, easily intelligible language, free of artifice and mystery.

In the eyes both of the court and of the bourgeoisie the quintessence of correct, 'classical' form was discipline; they wanted order, proportion, and moderation to protect them from the extravagances both of the barbarous Middle Ages and of morbid mannerism. Thus their requirements were fully met by the dramatic unities, that characteristic principle of the artistic taste of the new France, so strongly opposed to the formlessness and immoderation of mannerism and medievalism alike. Reason ruled supreme, and this made it impossible to uphold the tradition either of the

medieval popular theatre or of the Elizabethan drama on the French literary stage.

In spite of the work of poets such as Racine and Lafontaine, French literature suffered an immeasurable loss as a consequence of this purification and rationalisation. If one does not regard it as compensated for by the gain, the final outcome was the more deplorable in that it was only the positive values of mannerism that went overboard. Those that are covered by the term 'precious' survived for a long time, so long, in fact, that it could rightly be maintained that the seventeenth century in France was as precious as it was classical, if not more. The whole French intelligentsia was precious, both the stiff Corneille and the emotional Racine, both Molière, who made such fun of the fashionable disease, and Boileau, who so severely and humourlessly condemned its aberrations.

Racine is the classicist who makes richest use of the stylistic resources of mannerism, and it is with him that their power, intensity, complexity, and sonority survive longest, though he sometimes uses them almost as extravagantly as the most unruly of his predecessors. After the resounding line:

> Une femme mourante et qui cherche à mourir

at the very beginning of *Phèdre*, which is one of the finest in French classical literature but is written in a way of which the most discriminating mannerist would have been proud, in a single scene of Act I he produces a firework display of piquancies, assonances, antitheses, one after the other:

> Tout m'afflige et me *fui*t, et conspire a me *nui*re (161)

> Quand tu sauras mon crime, et le sort qui m'accable,
> Je n'en mourrais pas moins, j'en mourrais plus coupable (241/2)

> Ariane ma soeur, de quel amour blessée
> Vous mour*û*tes aux bords où vous *fû*tes laissée (253/4)

> Je le vis, je rougis, je pâlis à sa vue (273)

> . . . dérober au jour une flamme si noir (310).

Moreover, in Racine, as in Malherbe, there are lines such as the following that are among the purest examples of classicism but betray their mannerist origin, though no trace survives in them of mannerist subtlety:

> Mais tout dort, et l'armée, et les vents, et Neptune . . .

or

> C'est Vénus toute entière à sa proie attachée . . .

If the poet had not passed through the school of sixteenth-century literature, such power and music would have been inconceivable.

4. ENGLAND

Mannerism survived longest in English literature. It began with Marlowe (1564–93) and ended only with the last of the metaphysical poets, Richard Crashaw (1612–49), Abraham Cowley (1518–67), and Andrew Marvell (1621–78), that is to say, in the second half of the seventeenth century, when the other national literatures of the west at most had stragglers to offer, but no more real representatives of the style. The metaphysical poets, the Elizabethan dramatists, and Shakespeare in particular, assure English literature a special position in the history of mannerism. Only Cervantes can be put on a par with Shakespeare, and in comparison with him Montaigne can at most be recalled. Góngora is too eccentric and uneven to compete with the English poets of the age, and the French too isolated and their most successful achievements restricted to individual poems. It therefore seems the more remarkable that in the visual arts the English produced nothing comparable with the works of mannerists even of the second rank in other countries. In England, however, the Palladian manner survived longer and was in a way more faithfully adhered to than elsewhere; to an extent it developed into a national style, with the result that it has been possible with a certain amount of justification to speak of the English 'affinity to mannerism as a national constant'.[38]

In England euphuism, like the preciosity that corresponded to it in France, was not confined to literature, but extended to the way of expression of the higher classes of society in general. It spread beyond the boundaries dividing the Renaissance, mannerism, and the baroque, but on the whole it was a Renaissance phenomenon rather than one deriving from mannerism. As a poetical style, with its predilection for contrasts, parallelisms, and assonances, it had a great deal in common with Petrarchism and obstinately preserved the Renaissance sonnet form. By the nature of their art Sidney, Spencer, and Lyly are still Renaissance poets, though they were born in the middle of the century. Their relatively late appearance and not completely contemporary character are among the circumstances that obscure the concept of the Renaissance in English literature and blur the dividing lines between it and mannerism, and even between it and the baroque, which in this instance are not very sharp in any case. These poets, in spite of their Renaissance roots, anticipated some features of Shakespeare's early works, and even played a certain part in Shakespeare's classification with the Renaissance.

Marlowe's mannerist mentality appears most clearly in his spiritual kinship with Machiavelli. Machiavellism, which in later English dramatists always presents itself in modified and qualified form, appears in him in its original purity. His closeness to Machiavelli, the Machiavelli of the

Prince, though his relationship to him changes, remains the unshakable foundation of all his work. None of his gigantic, over-life-size heroes, neither Tamburlaine, the conqueror, nor Dr. Faustus, the rebel against God, nor the fiendish Barabas is conceivable without this ideological foundation. Marlowe seems actually to have read the *Prince*, not to have known about it merely by hearsay, like most of the dramatists of the age whom it influenced. He knew exactly what Machiavelli was about, but interpreted the doctrine of political realism in the light of his own spiritual interests and applied them to his own purposes, developing them into a moral philosophy for supermen and a psychology of hubris. It was from the idea of the superman and his hubris that the concept of modern tragedy arose.

So far as the development of Marlowe's Machiavellism is concerned, the type embodied by Tamburlaine and Dr. Faustus in the *Jew of Malta* represents a more orthodox rather than a more liberal interpretation of the original doctrine. From a rebel against the divine and natural order the hero develops into a ruthless fighter who as a Jew claims rights for himself that he denies to non-Jews. But, whatever changes may take place in the protagonist's character, the same overweening presumption, and its justification, the 'dual morality', remain the same.

> It's no sin to deceive a Christian;
> For they themselves hold it a principle,
> Faith is not to be held with heretics:
> But all are heretics that are not Jews.

Barabas believes himself justified in treating Christians with the inhumanity that Tamburlaine deals out to his enemies:

> . . . with such infidels,
> In whom no faith nor true religion rests,
> We are not bound to those accomplishments
> The holy laws of Christendom enjoin.

Marlowe's Titanism also hardly changes, but remains essentially true to its Machiavellian origin. A tyrant's power is exalted in words such as Tamburlaine's

> A god is not so glorious as a King. . . .

Dr. Faustus indulges in soaring fantasies such as:

> I'll leap up to God . . .

and the dying Jew Barabas assumes superhuman dimensions in exclaiming:

> Die, life! fly, soul! tongue, curse thy fill and die!

340

Marlowe's imagery is dominated by wild fantasy and violence, as befits the violence and passions of his characters. His images are sombre and intemperate, like the confessions wrung from the tormented souls of his heroes in their paroxysms of self-destructive megalomania. He seldom strikes the musical note of Shakespeare's lyricism, though he is not incapable of it, as is shown by the celebrated couplet from *Dr. Faustus*:

> Oh! thou art fairer than the evening air,
> Clad in the beauty of a thousand stars!

With the transition from Marlowe to Shakespeare, the change in intellectual climate appears, among other things, in the changed attitude to Machiavelli. Shakespeare, like all his contemporaries, was deeply influenced by the *Prince*. His characters include a whole gallery of Machiavellian men of violence, amoral tyrants, mouthpieces of the 'dual morality', double-tongued intriguers, and heartless traitors. Marlowe himself could not have painted Richard III or Iago blacker. But what puts the two poets skies apart is the fact that Shakespeare is no longer fascinated by such types; in his eyes they have ceased to be the subject for admiration that they were for Marlowe. Not only does he become more and more critical in his attitude to the Machiavellian superman, but perhaps he ultimately comes to appreciate that Machiavelli's realism implies adaptation to facts, but not worship of brutal reality.

Shakespeare moves within the boundaries of the literary and theatrical conventions of his time in that he shares both the virtues and vices of the prevailing style. He succumbs to all the infantile diseases of his generation—the artificial way of expression of the sonneteers, the affectations of euphuism, the naïveté of the popular theatre, and the undiscriminating forms of the latter that survive on the Elizabethan stage. He was born in the same year as Marlowe, and so far-reaching was his adaptability to the style of the age that it has been suggested that if he had died in the same year as he, he would nowadays seem to be the less individual and creative poet of the two.[39] No one can say, of course, how Marlowe would have developed if he had lived, but Shakespeare survived the 'infantile diseases' without his art suffering any ill effects, though traces of them never completely vanish.

In an early work such as *Romeo and Juliet* he still expresses himself with the aid of the conventional stylistic means of international Petrarchism and native euphuism, and accumulates the most outworn antitheses and figures of speech:

> . . . O brawling love! O loving hate!
> O anything of nothing first create!
> O heavy lightness! serious vanity!
> Mis-shapen chaos of well-seeming forms!

> Feather of lead, bright smoke, cold fire, sick health!
> Still-waking sleep, that is not what it is!
> This love feel I, that feel no love in this.
> (Act I, Scene 1.)

Stale stuff of this kind is salted with the most banal play on words, even in the tensest dramatic situations. Shakespeare, true to the histrionic streak in his temperament, never completely abandons play on words, but with the increasing refinement of his taste uses it less and less. A number of factors favoured its retention. Apart from its immediate dramatic effect, it was the form in which the playwrights of the age were perhaps most vividly aware of the potentialities inherent in language as one of their tools. The flexibility of language of the Elizabethan period, its elasticity of associations, the wide range of liberties that it permitted, nowhere appeared more plainly. Play on words, besides enabling a writer to shine by exploiting double meanings and creating the impression of eloquence and wit, often helped to spark off and sustain the flow of dialogue. It also served a psychological purpose, first revealed by Freud's explanation of the mind's methods of camouflage, notably in the form of wit, though Shakespeare and his contemporaries cannot have been aware of it. Nevertheless, they used it partly for this purpose. It helped their characters to abreact repressed or hidden impulses, lent greater tension to dramatic events, and added a new dimension to the field of psychological processes.

Just as in his later works Shakespeare still sometimes plays with words in a rather naïve and complacent manner, so does he retain an often excessively ornate, flowery, hyperbolical way of expression. Othello, not content with using phrases such as 'whiter than snow' and 'monumental alabaster', at the height of the tragedy resorts to diction as studied and artificial as

> . . . drops tears as fast as the Arabian trees
> Their medicinable gum. . . .

That the author of *Romeo and Juliet*, as well as of *Hamlet*, *Measure for Measure*, and *Troilus and Cressida*, and even of *Othello*, was a mannerist will be readily admitted, but when he wrote *Antony and Cleopatra* he was a mannerist still. In this late work, which is his finest and most mature, the faults of his earlier style have disappeared—the simple play on words, the inorganically composed, purely ornamental metaphors and the rest of his playful artistic means. Nevertheless, this too is an extravagantly virtuoso performance, superabundant in imagery and expending itself in images, a work of fantasy born of the spirit of metaphor. Not only the language, the complex way of expression, the overloaded metaphorism,

the predilection for indirect, enigmatic, paradoxical statement are manner-
ist, but so also is the sustained propensity to the strange and the bizarre.
Cleopatra is an exotic figure, like most of Shakespeare's heroes of the
period of the great tragedies, like the Moor Othello, the suspicious,
epileptic Caesar, the aged and foolish Lear, the manic, melancholic
Hamlet. She is a strumpet, like Cressida, and 'coloured', like Othello.

Another mannerist characteristic is that for the sake of dissonance and
paradox Shakespeare never fails to draw attention to the realistic and
prosaic as well as to the fascinating features in her portrait. He does not
try to make her more beautiful or younger than the plot requires. With
almost Proustian masochism, he emphasises her age, her wrinkles, her
dark colour; Antony seems almost on the point of saying of her, as Swann
does of Odette, that she is not his 'type'. But Enobarbus calls her a
'wonderful piece of work' and Caesar says of her in death:

> . . . she looks like sleep
> As she would catch another Antony
> In her strong toil of grace.

The poet idealises neither Cleopatra nor Antony, or does so in an
indirect, obscure, mannerist fashion. They are no longer young, they are
by no means inexperienced, and their love has nothing in common with
that of Romeo and Juliet, or even of Troilus. Theirs is a passion of two
disillusioned, self-seeking, narcissistically self-centred characters; a
typically mannerist love affair, the tyranny of which, like that of the
Proustian, is not in the least mitigated by the equivocal nature of their
feelings and the absurdity of the situation to which they lead. Cleopatra
is the prototype of the *femme fatale*, who brings disaster to her lover, not
only by the passion that she kindles and keeps aflame in him, but also by
her uprooting him. Antony, one of the pillars on which world order
rests, is reduced to helpless bondage under her spell. Under the female
domination in her house, which is filled with the odour of women, where
she walks about naked at night among her serving girls, he turns into a
'strumpet's fool'.

The work is the most sexual of all Shakespeare's plays. Though it is
not the most indecent, it is the sultriest and, at any rate in that sense, the
most mannerist. To Cleopatra even death is a lover with whom she goes
to bed. This extreme eroticism and the ambivalent character of love,
which in Antony is associated with continual inner conflict and in Cleo-
patra leads ultimately to a complete transfiguration, is basically at one with
the attitude to love of the metaphysical poets. In it the spiritual and the
physical are indissolubly combined, as are happiness and misery, strength
and weakness, domination and servitude. All this, above all its everlast-
ingly doubtful nature, and the alternating adulation and scorn with

343

which it is treated, are typically mannerist, though in the lyric poets the turn to tragedy that it takes with Shakespeare is lacking.

Antony and Cleopatra, with the additive method of its composition, its scenes the number of which could evidently be increased or reduced at will, its flexible structure, the individual components of which could be displaced or altered to taste, its completely loose organisation, following neither the principle of unity nor that of proportion or balance of constituent elements, is 'anti-classical' *par excellence*, less in harmony than almost any other important work of art or literature with the principle of necessity and finality. With its forty-odd scenes, its structure is completely 'cinematic' and atomised, a stylistic characteristic that appears, not only in its freely extensible or reducible length, but also in its freedom from all regard for temporal or spatial unity and in the arbitrariness with which the scenes are combined. This method calls for the use of the term 'montage' rather than that of composition working up to a dramatic climax. A film-like freedom with space and time, discontinuity in both mediums, dissolves and interpolations, are characteristic of the whole. Also cinematic is the length of the cast, most of whom have nothing to do with the real drama, as well as the lack of action during long stretches of the play which, like a film, consists in part of building up settings. The tragedy itself begins only in Act III, and continues with broad and frequent digressions in scenes some of which are large-scale while others are intimate, lyrical, and introverted. That the lyrical and intimate moments are so effective and in fact make the deepest impact is the more remarkable in that the two lovers are never alone in the midst of all this film-like bustle, never without escorts and witnesses.

It is not, however, only its formlessness and the chance and arbitrary boundaries that the poet sets himself in the selection of his material that make *Antony and Cleopatra* a totally unclassical work. The inconsistent psychology of the principal characters is also completely unclassical. This inconsistency of characterological description is a consequence, not only of the atomised structure of the play, in which each scene to an extent produces its own independent effect, but also of the fact that no special value is attributed to psychological uniformity of character. The Cleopatra of the last act is not the Cleopatra of the beginning of the play, and this is a consequence, not of her divided nature, as it is in the case of Antony, Brutus, Macbeth, and so many other characters of Shakespeare, but of an inconsistency in her portrait that the poet neglected or disdained to eliminate. In this too she is not alone among Shakespeare's characters; Ophelia, Gertrude, Lear, Falstaff, and Ariel have different personalities in different parts of the plays in which they appear, and the difference is not justified by any psychological development or change of heart, or any particular dramatic or scenic effect. Ob-

viously complete carelessness prevails here concerning the principles of unity followed by classical drama. In mannerism unity of structure is either a matter of indifference or, as we have seen, is obtained by different, less striking, and often more complicated means than in classical art.

With *Antony and Cleopatra* Shakespeare reaches perfection as a poet, a master of language, imagery, and verbal music. The last scenes, with Cleopatra's frenzied exclamations of grief and ecstasy, are unparalleled in power and beauty, and unsurpassed even by Shakespeare himself. With it his work attains its climax, and the boundless wealth and irresistible flow of images make it at the same time the final and most complete justification of mannerism.

Everything is here, from the great complex of metaphors at the end of Act IV, with the wonderful lines

> . . . there is nothing left remarkable
> Beneath the visiting moon . . .

to the end of the drama, infused with the magic of an overwhelming imagery, saturated and glowing with cosmic ideas:

> His face was as the heavens, and therein stuck
> A sun and moon, which kept their course, and lighted
> The little O, the earth. . . .
> His legs bestrid the ocean; his rear'd arm
> Crested the world; his voice was propertied
> As all the tuned spheres, and that to friends;
> But when he meant to quail and shake the orb,
> He was as rattling thunder. For his bounty,
> There was no winter in't, an autumn t'was
> That grew the more by reaping; his delights
> Were dolphin-like, they show'd his back above
> The element they liv'd in: in his livery
> Walk'd crowns and crownets, realms and islands were
> As plates dropp'd from his pocket.

Then, shortly before the end, there come the rapturous words:

> . . . I have
> Immortal longings in me. . . .
> . . . Husband, I come.

And finally there is the last, unforgettable image:

> . . . Peace, peace!
> Dost thou not see my baby at my breast,
> That sucks the nurse asleep?

The whole great stream of images and visions, carried along by the ecstasy of love and grief, the irresistible and inexhaustible flow of verbal invention, begins with the line:

> Our strength is all gone into heaviness. . . .

For all its power and intensity, in view of the prominence of the position it occupies, it is one of the most unambitious in all the great tragedies. Simple though it may be, however, it is rich in overtones that quicken the pulse and prepare the audience for what follows. The word 'heaviness' hints, not only at the burden of the body, but also at the sinister presence of death; the weight of a dead body is the very essence of alienation and soullessness. There is a naïve popular belief that a body is heavier after death, as if the departed soul had lent it a buoyancy that counteracted the force of gravity. Heaviness, however, also expresses the sadness of the unalterable. While life lasted everything might yet have been made good, but now it has gone, leaving behind a thing that is deaf and dumb and heavy—heavy, too, with the grief it suffered in life.

The lament over the weight of the body also expresses Cleopatra's childish impotence—she suddenly feels weak and helpless in her grief. Her transformation from helplessness to tenderness, anticipating the final image of the nurse sucked asleep, is one of the finest features of the episode.

Characteristic of the tone and mood of the passage is the use of the plural. Apart from identifying Cleopatra with the dead Antony for what is to come as well as for what has gone before, it echoes the affectionate tone used in talking to small children, as if she were saying: 'We're tired, aren't we? Let's go to sleep.'

An essential element in the poetical effectiveness of the word 'heaviness' in a line of such spiritual delicacy is the play made with its abstract and concrete meanings. This was rooted in the special nature of the language of the Elizabethans which was lost with so many other components of their poetry.

In spite of the uninterrupted development of poetical language from Marlowe to Shakespeare and from the Elizabethans to the last of the metaphysical poets, the type of imagery used in English literature remains essentially unchanged throughout the whole long period that can be described as mannerist. In spite of all the differences of artistic purpose, the tone common to all the characteristic poets of the age marks them as contemporaries. The metaphysical poets, who bring the whole period of development to an end and represent the stylistic climax of one of its trends, are often regarded, not only as the real representatives of mannerism in English literature, but also as typical representatives of the movement in general, and they are quoted as epitomising the poetry of the age.

With their complexity of character, their antithetical interests, alternating between the sensual and the spiritual, their capacity as poets to 'devour any kind of experience' (T. S. Eliot), their both emotionally and intellectually developed sensibility, they play a vital part in the phase of English literature that extends from the sonneteers to Milton. Their work more completely represents the essence of the literary production of the age than does that of the greatest poets, and bridges the gulf between English literature and that of the rest of Europe that is plainly discernible even in that age of western spiritual community.

Any discussion of their role and significance must begin with a reminder that the name by which they are known is valid only with reservations. They were certainly more deeply interested in scientific and philosophical problems, and better equipped to tackle them, than most contemporary poets of other nationalities, though mannerism everywhere had a distinctly intellectual stamp and tension between sensualism and spiritualism was undoubtedly one of its essential features. The most important of them, Donne, Herbert, Crashaw, and Marvell, were certainly passionate thinkers and meditators, but whether they can be described as philosophers is doubtful. They were not philosophical poets, either in the deeper meaning of the word, implying that they had worked out for themselves a clear and uniform philosophy and vision of life, like Dante, for instance, or in the more superficial and pedantic sense, like Lucretius. There is even less justification for describing them as metaphysical, a term which was applied to them by the hostile critics of a later age, and was thus derogatory, like the names by which many other styles are known. Even Donne, speculatively the most gifted of the group, is not really original or especially subtle as a philosopher. The philosophical problems that concerned him were those that exercised the minds of the educated and half-educated intelligentsia of the day, turning on the meaning of time, transience, and death; eternity and immortality; the relationship between mind and matter, body and soul; the bond that united lovers, and the abyss that nevertheless divided them; the nature of faith and knowledge, the value of the old order bolstered by religion and the church, and the consequences of its break-up by science and the throwing back of the human mind on its own resources. Donne was undoubtedly a livelier and more sensitive thinker than most lyrical poets, but his importance as a speculative mind is based on his importance as a poet, and not the reverse. It has therefore been argued with good reason, not only that he was not a deep thinker, but also that his play with ideas should not be taken too seriously, as the latter really represent no more than fictitious intellectual attitudes, simulated problems and their solutions chosen for the sake of their paradoxical formulation.[40] As for his learning, he followed scientific progress with passionate

interest, but read indiscriminately everything he laid his hands on; in fact, he was a dilettante.

The importance of Donne and the metaphysical poets lies above all in the power and wealth of their imagery, their imaginative use of language, their artistry in words; and, though they remained loyal to the tradition to which mannerism adhered from the outset, that is to say, the old technique of play with conceits, metaphors, antitheses, and similar stylistic means, not only did they use these with more taste and variety than their predecessors, but also, even when they used the most well-worn formulas, their irony enabled them to preserve a healthy detachment from them. They managed to play with Petrarchian forms without compromising themselves. This too is only an aspect of one of their most striking characteristics, their perpetual readiness to mingle seriousness and jest, gravity and frivolity, worldliness and spirituality, asceticism and eroticism. Homogeneity of constituent elements is never and nowhere a characteristic of mannerism; if it had ever achieved such a thing, it would have ceased to be what it was. Now one, now another element predominates. In Marino it is levity, in Góngora melancholy. The wavering of the metaphysical poets between these two extremes is perhaps even greater than is to be found elsewhere; they perpetually hesitate between hem, and often in a mood in which playful high spirits are mingled with tormenting doubts.

Donne in particular expresses any kind of pleasure in life either in a suspiciously loud, overstrained, or uncertain and forced tone; even in his most light-hearted poems he mingles jest and earnest, and intersperses a light, commonplace, conversational tone with elevated and resonant poetical language, that is to say, ironically depreciates the emotions and at the same time engages in ecstatic flights of the imagination. Thus, in *The Sun Rising*, one of his most characteristic poems in this connection, the pert, mocking, actually cynical tone of the opening lines:

> Busy old fool, unruly sun,
> Why dost thou thus
> Through windows and through curtains call on us?

is followed almost without transition by a magnificent image with an almost Shakespearean cadence:

> Love, all alike, no season knows, nor clime,
> Nor hours, days, months, which are the rags of time.

The dialectical nature of Donne's thought, his antithetical world of ideas, also explains why the casuistry of love is the Petrarchian feature that he most willingly preserves. Wherever he can, he uses paradox, irreconcilable antithesis, explosive tension, and he turns even the ap-

parently most harmless idyll into a dramatic situation with an internal and external conflict. As a consequence of this propensity, as well as his predilection for direct speech and the dialogue form, there is a direct link between his verse and the most fertile literary genre of the age, the drama. His poems are small plays. Often they are whole scenes, or sometimes dramatic monologues, generally delivered with someone else present, though the latter may be silent. Mostly they have a dramatically developed moral plot, with a conflict, a crisis, and a tragic or reconciliatory ending.

In his youth Donne was a passionate epicurean, but he ended by leaving behind a most moving testimonial to human suffering. At a relatively early age the sense of his sinfulness and frailty became his constant companion. He was continually haunted by the thought of death, and the older and iller he became, the greater was his obsession with it. Shortly before his death, he had his portrait painted wrapped in his shroud like a mummy, and he kept the picture by his sickbed and gazed at it constantly until he died. It was at about this time, and perhaps in the presence of this picture, that he wrote his *Hymn to God my God, in my Sickness* in which he uses the image, subsequently used by others, of man's entering the Kingdom of God and becoming an instrument for the divine music:

> Since I am coming to that holy room,
> Where, with the choir of saints for evermore,
> I shall be made thy music; as I come
> I tune the instrument here at the door,
> And what I must do then, think here before.

Donne is unquestionably the most important representative of the metaphysical school, but its finest poem, and perhaps the most beautiful in the English language, is Andrew Marvell's *To his Coy Mistress*— whose presence is no less tangible for her silence. This small masterpiece, besides containing all the complexity and subtlety, nervous sensibility and intellectual vividness, of mannerist poetry, is perfectly constructed, a paragon of composition of which there is hardly a second example in mannerism. It consists of three parts, and if one wished, it could be called a playlet in three acts. Act I is an idyll, a wishful dream, a fantasy of the happiness of two lovers in a life beyond time and space. Act II brings the crux of the drama, the awakening to the passage of time and the inevitable end; and Act III consists of a vision of transfiguration in the blaze of love as redemption from the irresistible march of life-consuming time.

The poem begins in a gay, light-hearted, bantering manner:

> Had we but world enough, and time,
> This coyness, lady, were no crime. . . .

Not only is the use of the word 'world' in the first line more striking and original than the colourless 'space' would have been; it serves also as a hint at the cosmic background; in such a prominent position 'world' sticks in the reader's mind. On the heels of this there follows praise of the lady's graces, spirited and playful, passionate in places, but more ironic than the traditional pseudo-Petrarchian declaration of love; and this mood prevails for some time. In spite of its irony, however, it remains a wishful dream, a fantasy tinged with affect, the dreamlike nature of the imagined love idyll and its unreality appearing most plainly in the playful treatment of the idea of time:

> . . . I would
> Love you ten years before the Flood;
> And you should, if you please, refuse
> Till the conversion of the Jews. . . .
> A hundred years should go to praise
> Thine eyes. . . .
> Two hundred to adore each breast;
> But thirty thousand to the rest. . . .

Time is the real theme of the poem, the contrast between the apparent timelessness of love and the passage of time that brings all human happiness to an end. Love and happiness lie on this side of time; beyond it there lies the superhuman—and inhuman—'deserts of vast eternity'. When once the sense of time's ineluctable domination has dawned, the only choice is to be slowly consumed by it or

> . . . tear our pleasures with rough strife
> Through the iron gates of life . . .

and make an end intoxicated by them.

There is an obvious parallel here with the *carpe diem* of Catullus.[41] But using the argument of human transience as an invitation to the pleasures of love is a commonplace of Renaissance poetry, and Marvell had no need of Catullus to suggest the theme. Directly or indirectly, however, his remarkable love arithmetic must have been suggested by the latter, and he evidently only turns Catullus's fantastic number of kisses into an even more fantastic number of years. He satirises the fashionable sonneteers by associating his enumeration of the fantastic ages to be spent in wooing with that of his lady's physical charms, to dismiss both impatiently with the highly allusive and not further specified 'rest'.

The next section begins with two lines which are among the most unforgettable in literature:

> But at my back I always hear
> Time's winged chariot hurrying near.

T. S. Eliot [42] is of the opinion that this lacks the rhetorical echo of Catullus's

> Nobis cum semel occidit brevis lux
> Nox est perpetua una dormienda.

They are, however, more musical and more dramatic than the Latin couplet. Shakespeare's cadence is unmistakable, and the tragic sense of life of the age opens up a perspective that was still invisible to Catullus. No Roman, and indeed no writer of any age preceding his own, could have suggested to Marvell the image that follows, because before the crisis of the Renaissance, the development of the language of mannerism, and the appearance of Shakespeare and his contemporaries, an image such as 'deserts of vast eternity' would have been inconceivable.

After this passage of deep earnest and supreme poetical power, there again follows a section in a lighter vein and with a more ambiguous meaning. The poet's words are partly bitter and pungent, as in the phrase, reminiscent of Donne:

> . . . worms shall try
> That long preserved virginity. . . .

and partly cool and detached, almost cynical, with an empty smoothness reminiscent of the hollow rhymes of a music hall song:

> The grave's a fine and private place,
> But none, I think, do there embrace.

The third section again begins in a thoroughly conventional tone, with an admonishment to enjoy youth while you can, familiar to the point of satiety from Latin, Provençal, and contemporary international verse. A few lines later the poet produces, however, one of his most ravishing images, when, to preserve himself and his mistress from the ravages of time, he says:

> Now let us . . .
> . . . like amorous birds of prey,
> Rather at once our time devour,
> Than languish in his slow-chapt power.

Finally there is the incomparable climax and conclusion, which parallels and outstrips the first climax that foreshadowed it with its image of 'time's winged chariot'. The choice is between being crushed by its wheels or taking up the challenge and competing with it in its career:

> Let us roll our strength, and all
> Our sweetness, up into one ball;
> And tear our pleasures, with rough strife,
> Through the iron gates of life.

> Thus, though we cannot make our sun
> Stand still, yet we will make him run.

The poem is one of the last statements of mannerism, and one of its greatest triumphs. No example could better illustrate the loss suffered by literature with the disappearance of this tradition. For it shows more strikingly than any other work of its kind that all its distinguishing features are due only to an extent to the author's talent, and that the debt it owes to the prevailing style, its vivid language, its sensual directness, and its lack of concern for commonplace probability and sober rationality, is no less considerable.

PART THREE

Modern

I. INTRODUCTORY

THE present revival of interest in mannerism does certainly not imply that the art of our own day is a repetition or continuation of it. Artistic styles, achievements, and personalities are, like historical phenomena in general, unique. The features that remain unchanged or are merely repeated in them are historically among the least interesting and relevant. Typologically similar constellations recur in history, but identical constellations do not, and consequently only more or less rough generalisations, that fail to do justice to the subtle ramifications of the real development, can be made about types of artistic phenomena; in any case, assuming a periodicity of stylistic sequences would pass beyond the framework of a typology that remained even partially based on facts. The repetition, or even the straightforward, undeviating continuation, of a style would assume the presence of completely static historical circumstances and could take place only in the same historical and social environment. As soon as the continuity of a cultural whole is broken, not only is a repetition or straightforward continuation of the art belonging to it excluded, but also complete understanding of it ceases to be possible, and any attempt at its interpretation necessarily involves a certain amount of misinterpretation. Nevertheless, even misunderstanding of the original artistic purpose creates a bridge between present and past. Every generation is capable of building such bridges in a limited number of directions, while in others no reaction takes place at all.

Mannerism, however, though there was no recurrence or direct continuation of it after its end in the seventeenth century, survived as an undercurrent in the history of western art, sometimes more apparent and sometimes less. Mannerist trends have repeatedly appeared since the baroque and the rococo, and particularly since the end of international classicism, and they are most manifest in times of stylistic revolution associated with spiritual crises as acute as that of the transition from classicism to romanticism or from naturalism to post-impressionism. The circumstance that mannerism and the baroque are so often confused, and that the boundaries between them in the history of art, and of literature in particular, are ill-defined, is partly explained by the fact that, though mannerism by and large came to an end, individual mannerist stylistic features obstinately survived and did not cease to make their influence felt after the beginnings of the baroque. They seem to have exercised

355

least influence on artistic development in the eighteenth century, when the rationalism of the enlightenment and academic classicism prevailed. During this period, in spite of isolated contrary phenomena, such as the art of Fuseli or Blake, which moved on the borderline between classicism and romanticism, there can be said to have been a practically complete break with the mannerist tradition. The break began at different times in different countries, lasted for different periods, and took place in different forms. In Italian painting it took place at the turn of the sixteenth century, in French literature during the *grand siècle* within the boundaries of baroque classicism, in England it was the result of the poetical aims of Milton, Dryden, and Pope, and in Germany it came about only with the development of eighteenth-century classical literature; the new, rationalist, and realist outlook of the west was the outcome of a development protracted over two centuries. The anti-mannerist forces appeared at different times and in varying strength, depending on local conditions, but the outcome was everywhere the same, the elimination from art of extravagance and irrationalism.

With nineteenth-century romanticism the mannerist trends that had been leading a subterranean life since the end of the Cinquecento re-emerged and grew strong enough to make the whole romantic movement seem a revolt against the tyranny of anti-mannerism and a struggle for the artistic liberty that had been lost under the absolute régime of reason. With the late romantics Baudelaire, Gérard de Nerval, and Lautréamont, and in particular with the symbolists Rimbaud, Mallarmé, and Paul Valéry, the mannerist undercurrent again rose to the surface. But even here it would be wrong to speak of a revival of mannerism because, however numerous may be the features common to the crisis of modern naturalism and that of the Renaissance, and however appropriate it may be to call Maurice Scève the Mallarmé of the sixteenth century and Mallarmé the Góngora of the nineteenth, in spite of these parallelisms we are confronted with completely different historical, though with similar typological, phenomena. It is the differences between the poets of the two periods that give importance both to their historical and their artistic personalities. Nothing is more unhistorical and more alien to the spirit of art than the idea of perpetual recurrence. Periodicity of style can be said to exist only in the sense that styles that succeed each other are always antagonistic, but the duration of a style is not limited in advance, and there is no such thing as a minimum of tension that must be present before one style can succeed another. Their mutual relations always differ. Romanticism appeared in the form of a revolt against classicism, while the rococo still partly followed the line of the baroque, and mannerism partly continued the course of the High Renaissance, partly repudiated it; and, finally, the baroque preserved elements both of

the Renaissance and of mannerism, and was at the same time opposed to both.

The symptoms of the crisis that shook the sixteenth century appear in intensified form at the present day; economic and social disintegration, the mechanisation of life, the reification of culture, the alienation of the individual, the institutionalisation of human relations, the atomisation of functions, and the feeling of general insecurity prevail in our own outlook, and the same sense of life leads to similar artistic forms. Life is represented on different planes of reality, moves simultaneously in different spheres, and is expressed now in natural, now in anti-natural, form. The dream as a messenger from the unconscious, as a symbol of our life that extends into two different worlds, as an indication of our ignorance of the real nature of the being in which we are involved, plays just as important a part in the art and literature of our time as it did then. The phenomenon of the dream not only dominates the whole of surrealist art in the narrowest sense of the word, and the whole of the modern novel from Proust and Kafka to Joyce, but to an extent also prevails in modern dramatists as different as Maeterlinck and Strindberg, who wrote 'dream plays', like Shakespeare and Calderón. In poetry the metaphor has entered on a new period of undisputed sway; phenomena are transformed into a kaleidoscopic world of imagery, a succession of continually shifting analogies. The rule of metaphorism and metamorphism prevails again everywhere, and everything lives and moves but is threatened with collapse, for there are no firm foundations. Art expresses itself in riddles and paradoxes more mysterious than ever; once more the object is to say everything in as difficult, allusive, and devious a way as possible, in order to avoid banality of expression and to make its appreciation more dynamic by increasing the tension present in all artistic experience. All these features of modern art recall mannerism. But there are no works that can be compared with those of Shakespeare and Cervantes or Tintoretto and El Greco, either in artistic quality or stylistically. Nor is there anything corresponding, say, to the works of Rosso or Parmigianino, or that of any of the representative poets of the age. The connection between Rosso and a modern surrealist, or between Maurice Scève and Baudelaire, or Góngora and Mallarmé, is not only much looser, but also completely different in kind from that between representatives of the same style, however wide the ramifications of the latter may be. What they have in common is of the nature of what there is in common between the works of Bernini and the Laocoon group. Modern art, as art tends to be in such conditions, is certainly mannered in many respects, and it displays a large number of quasi-mannerist characteristics. But, though it shares a number of themes with the Cinquecento, it also has others which in the age of mannerism did not yet exist. Also it makes no

use of artistic means which were important in that period (for instance, the language of the Elizabethans and of the French lyric poets of the century subsequently emasculated and made colourless by classicism), and puts nothing equivalent in their place.

2. BAUDELAIRE AND AESTHETICISM

Baudelaire is the modern poet *par excellence*, the first modern poet and the first modern artist, indeed the first modern man, in the sense of up-rooted intellectual, alienated city-dweller, and disillusioned romantic; the first to whom romanticism and materialism, rapture and reason, emotion and reflection, became inseparable, as they are to us. This dualism, which made possible an integration as well as a differentiation of intellectual and emotional forces, that is to say, led the way back to that unity of sensibility that was the secret of the Elizabethans and thus produced an increased complexity of intellectual attitudes, represented the first vital step towards the creation of a quasi-mannerist way of literary expression as opposed to classicism and romanticism alike.

By restoring honour and importance to the poetical image, the meta-phor, the startling or paradoxical statement and emphasis and exuberance for their own sake, Baudelaire continued romanticism completely in the mannerist spirit. His rejection of sentimentality and uninhibited emotion-alism, as well as of the pretty and pleasing was, however, definitely unromantic. True, he is not lacking in notes of unadulterated inwardness, and some of the finest passages in the *Fleurs du Mal* are infused with pure romantic feeling, as the lines in which death is said to make the bed of the poor:

> . . . qui refait le lit des gens pauvres et nus
> (*La Mort des pauvres*)

or the lament about the vanishing summer of life:

> Bientôt nous plongerons dans les froides ténèbres
> Adieu, vive clarté de nos étés trop courts!
> (*Chant d'automne*)

There are whole poems, including one of his most incomparable, *Le Cygne*, which have this pure emotional quality. The theme is the fate of the outcasts of life, those who have irretrievably lost something dear to them . . .

> . . . quiconque a perdu ce qui ne se retrouve
> Jamais . . .

358

the tragedy of Andromache mourning over an empty grave, the consumptive Negress tramping the streets of Paris and dreaming about her native coconut palms, or the sailor washed up on a lonely island, 'defeated and captive, like so many others'. It is a totally unmannerist poem, or at all events one which has passed beyond mannerism, consisting as it does of a single trope instead of a whole number. The image of the swan trailing its white wing in the dry dusty gutter

. . . le coeur plein de son beau lac natal . . .

dominates the whole poem, absorbs and assimilates all the other images. So barely does the poet evade the danger of mere allegory by immobilising the stream of metaphor in this way that it is hard to say whether his success is due to luck, daring, or genius.

Examples of such perhaps lucky, though by no means blind, bull's eyes are rare with Baudelaire, however. Normally he achieves his triumph by means of an uneven, manneristically broken, self-conscious and self-critical method, which is above all characterised by a coquettish piquancy and a grimacing, distorting expressionism. It is mainly to this that Proust refers in his comments on the poet; [1] and he could scarcely have described Baudelaire's manner better than by the word *grimaçant*, that so precisely hits off the self-consciousness and strain that his way of expression shares with mannerism, as well as the often grotesque impression created by the self-reflecting and self-dramatising pleasure in suffering with which he anticipates the later expressionists.

Proust's deep understanding of Baudelaire is due to the affinity of his own conception of time with that of the poet. In the *Fleurs du Mal* he discovers the first signs of a new sense of time, a feeling of the passage of the days, the erosion of life, the irretrievability of the past, that has hardly anything in common with the classical poetical concept of the brevity of life, the numbering of our days and the transience of human things, but represents rather the first step towards the concept of time implicit in *À la Recherche du Temps perdu* and present-day literature in general. What matters is the experience of time as such, not the sense of its being measured; an active relationship with the past, living and revivifying memory, and not mere knowledge of the past. Proust recognised his spiritual heritage in Baudelaire's efforts to reconstruct in his memory the treasures scattered in the débris of the past. In the last part of his novel, where he mentions the role of reminiscence, the fruit of the 'involuntary memory' discovered by him in earlier writers, he speaks of Baudelaire and discloses a basic difference between him and others. He quotes examples from the *Fleurs du Mal* that remind him of his momentous experience with the *petite madeleine*, the little sponge-cake, the taste of which set in motion the long stream of memories of which his whole huge

work, due to the *mémoire involontaire*, is composed. In Baudelaire, he says, these are 'more numerous, less arbitrary than in others, and therefore decisive'.[2] The poet sought more discriminately and more relaxedly in a woman's odour, for instance, or in that of her hair or breast, for the *correspondances* that suggested to him 'the blue of the huge vault of heaven' or 'a harbour full of flames and masts'.

Baudelaire is undoubtedly one of the most original poets in history. He discovered for poetry such novel themes of emotional life and the world of ideas, and made such unusual and, from the poetical point of view, such neglected aspects of experience the subject of his art, that in comparison the romantic movement, in spite of all its revolutionary innovations, seems no more than an unimportant sequel to classicism. This, however, does not mean that his themes are as numerous as they are novel. His poetry is limited to relatively few. Apart from woman, love and its perversions, sexual fetishes and the so-called artificial paradises, they are almost exclusively restricted to Paris and its swarming multitudes, to poverty and death, nostalgia for antiquity and the east, dreams about travel, distant harbours, the familiar lamp of a longed-for but never discovered home. The stereotyped nature of his subjects also recalls mannerism; it is disturbing, however, only when the theme is one, such as his perpetually lurking satanism, that has lost its point.

The real link between mannerist and modern poetry is not, however, represented by Baudelaire's failings, but by those features of his art which make him the greatest poet of modern times, and the only one who stands comparison with Maurice Scève, Góngora, John Donne, and Marvell, and actually far surpasses them in poems such as:

> Sois sage, ô ma Douleur, et tiens-toi plus tranquille.
> Tu réclamais le Soir; il descend; le voici:
> Une atmosphère obscure enveloppe la ville,
> Aux uns portant la paix, aux autres le souci.
>
> Pendant que des mortels la multitude vile,
> Sous le fouet du Plaisir, ce bourreau sans merci,
> Va cueillir des remords dans la fête servile,
> Ma Douleur, donne-moi la main; viens par ici,
>
> Loin d'eux. Vois se pencher les défuntes Années
> Sur les balcons du ciel, en robes surannées;
> Surgir du fond des eaux le Regret souriant;
>
> Le Soleil moribond s'endormir sous une arche,
> Et, comme un long linceuil traînant à l'Occident,
> Entends, ma chère, entends la douce Nuit qui marche.

The opening, in which the poet apostrophises his grief, and tells it, like a child, to behave, has, apart from the directness given to an otherwise not very original device, an emotional undertone; the intimacy between the poet and his grief become the measure of his alienation from the world, which is the real subject of this, as it is of all Baudelaire's poems.

His grief asked for evening, from which it expected some relief. Here it is, the poet says, and the familiar, almost commonplace, features of Paris by night appear, with its multitude 'under the lash of pleasure', and only after the first half of the poem has been expended in this way does he produce the striking conceit: Grief, give me your hand; come with me, away from them all. This, like similar instances in mannerism, becomes the source of a flood of images that have no rational link with each other or with the theme that was their point of departure, but follow only the poetical logic of their own language. Look, says the poet—and one wonders whether he is still apostrophising his grief—look at the dead years on the balconies of the sky in old-fashioned dress; see smiling remorse rising out of the waters; see the dying sun lying down to rest under an archway, and listen, my dear one—yes, he is still addressing his grief—listen to the sweet night approaching, dragging a long shroud westwards.

Le Coucher du soleil romantique is also completely mannerist in character, not only because night and death are again the principal theme and these so vividly recall Jean de Sponde, John Donne, and other poets of their generation, but also because the vision of the setting sun opens up metaphysical–religious perspectives which had been closed to poetry since the beginning of rationalism.

> Que le Soleil est beau quand tout frais il se lève,
> Comme une explosion nous lançant son bonjour!
> —Bienheureux celui-là qui peut avec amour
> Saluer son coucher plus glorieux qu'un rêve!
>
> Je me souviens! . . . j'ai vu tout, fleur, source, sillon,
> Se pâmer sous son oeil comme un coeur qui palpite. . . .
> —Courons vers l'horizon, il est tard, courons vite,
> Pour attraper au moins un oblique rayon!
>
> Mais je poursuis en vain le Dieu qui se retire;
> L'irrésistible Nuit établit son empire,
> Noire, humide, funeste et pleine de frissons;
>
> Une odeur de tombeau dans les ténèbres nage
> Et mon pied peureux froisse, au bord du marécage,
> Des crapauds imprévus et de froids limaçons.

Happy are those who greet the setting of the sun as gladly as its rising. Such is the simple and unsophisticated note struck at the beginning of this

poem. The characteristic Baudelairean and, in a way, mannerist twist occurs only in the seventh line when, with a concetto-like jump in the train of thought, without explaining why the speaker is not among the fortunate for whom the evening is as magnificent as the morning, he says: Let us chase the setting sun to catch one last, departing ray; and then, without transition, there follows the shift to the first person singular: 'In vain I pursue the retreating god; irresistible night establishes its empire.' The twilight of evening is also the twilight of the world. 'A grave-like odour floats in the shadows, and I tread shudderingly on unsuspected toads and cold snails.'

Baudelaire, however, is only a remote ancestor of modern literature with its quasi-mannerist stylistic features. Before these could prevail, not only the romanticism with which he had many ties, but also the impressionism for which he merely paved the way had to be superseded. The breach that followed did not prevent the impressionist outlook from surviving to a certain extent among the younger generation. At all events, Mallarmé and Proust still adhered to the aestheticism which was predominant in the outlook of the impressionists and inherent even in mannerism. Their aestheticism, however, does not so much mean that they adopted a passive and essentially contemplative attitude, or even that they regarded art as an end in itself, a self-sufficient exercise, or as the only real compensation for the disappointments of life; rather did they regard it as the only way of achieving a life of fulfilment that without it would have been inarticulate and incomplete. They did not merely believe that life in the form of art was better and more acceptable than it was in reality but, as Proust, the last great impressionist, claimed, they also held that it prospered and grew meaningful only in the form of memory, vision, artistic creation, which rescued experience from the ravages of time. According to this view, it is not when we first come across men and things that we are most fully taken up with them, but when we have ceased to be directly involved and look at them only as spectators, when we create or appreciate works of art, when we remember. Art does not copy things we already know and possess, but reveals something unknown and creates an otherwise non-existent objective world for our experience. Looked at in this way, the arbitrary treatment of reality, the capriciousness of form, and the artificiality of expression peculiar to mannerism acquire a new meaning, and the result is a better understanding of why its creations were inherently artifacts and always retained something of their artificiality.

At all events, it was in impressionism and through the doctrine of art for art's sake that aestheticism became fully aware of itself, and the complete inbreeding of modern art began. The revolution was not confined to the fact that henceforward artists worked primarily for other

artists and that art itself—that is to say, the world as the medium of artistic experience and artistic effort—became the object of art, but lay rather in the fact that raw, unformed nature untouched by artistic form lost its aesthetic appeal, and the ideal of naturalness gave way to that of the artificial. Life in the big city, its pleasures and vices, the *vie factice* and the *paradis artificiels*, in spite of or because of their dangers, were not only incomparably more attractive, but were also more meaningful, and therefore more human, than life in the 'realms of nature'. Nature in itself was ugly, formless, and devoid of purpose; only through art did it become intelligible and enjoyable. The words *la femme est naturelle, c'est à dire abominable* express a variety of very different impulses, some of them not even emotionally quite unambiguous, but at all events they make it plain that Baudelaire, while he loathed nature in general, loathed woman only in so far as she was a creature of nature and instinct. Almost like the Goncourts, he regarded nature as an enemy, to be spoken of only in tones of irony and contempt. This was the end of the pastoral, of Rousseau's idealisation of the state of nature, and of romantic nature worship. Everything simple and direct, instinctual and spontaneous, lost its charm; self-consciousness, the mastery of the instincts, and the fundamental unnaturalness of civilisation were valued instead. The phenomenon of artistic appreciation as such was discovered, and the significance of the conscious, critical functions in the process of artistic creation. This discovery, as indeed the whole philosophy of the *vie factice*, originated with Baudelaire, who wanted to turn his 'enjoyment into knowledge' and desired the critic to speak through the poet.[3] Nothing more strikingly illustrates Baudelaire's revulsion against the natural and the extent of his enthusiasm for the artificial than his belief that nature was actually morally inferior. Evil was effortless, in other words natural, he claimed, while good was an artifact, that is to say, artificial and unnatural.[4]

But even this enthusiasm for the artificiality of civilisation was only a form of the romantic flight from the world. Modern art, unromantic as it fundamentally is, nevertheless remains linked to romanticism by this feature. The difference is that, instead of taking flight from social reality into nature, as the romantics did, refuge is sought in a more sublimated, spiritual, meaningful world. In Villiers de l'Isle-Adam's *Axel* (1890, published posthumously), one of the most authoritative statements of the new outlook, imaginary, purely spiritual forms of life are invariably preferred to practical reality, and unrealised desires and illusions always seem more perfect and satisfactory than the possibilities of ordinary, trivial life. Axel and Sara are in love, but renounce the happiness of their first and what they also wish to be their last night together because the hero fears that afterwards he will no longer have the courage to commit suicide; if they survive it, however, their love, like all dreams

that come true, will not stand the test of time. He values perfect illusion more highly than imperfect reality. 'Life?' he says. 'That is what our servants see to for us.'

In Huysman's *À Rebours* (1884), another important document of *fin de siècle* aestheticism, self-entrenchment behind fictions and illusions, substitution of the life of the mind for real life, is actually carried a stage further. Des Esseintes so completely seals himself off from the world that he ends by no longer risking a journey because he fears being disappointed by any realised possibility. This kind of introverted passivity and hostility to life and the revulsion from nature as expressed in the aestheticism of the period represents basically the same attitude. When Des Esseintes says that 'the age of nature is over', he means that its place must be taken by the rule of the mind, and that fiction must be substituted for reality in general. He believes that everything straight must be made crooked, and that all natural instincts and inclinations must be bent into their opposite. He lives in his house as in a monastery, sees no one, writes and receives no letters, sleeps by day, and reads, imagines, speculates at night. He creates his own 'artificial paradises', renounces everything that gives pleasure to others, and devises for himself a private universe of symphonies, colours, scents, drinks, artificial flowers, and rare gems.

The dreamer and epicurean Des Esseintes is the prototype of the spoilt and sickly decadent who makes a cult of his sickness. The concept of decadence, however, which began to take the place of aesthetic hedonism in the eighties, included features that were not necessarily present in aestheticism, above all a sense of crisis and doom, of living at the end of a period and in a disintegrating civilisation. This is one of the basic features that modern art and the modern outlook share with mannerism. To be sure, the representatives and spokesmen of decadence were completely unaware of mannerism, but they had a much deeper sense of living in a period of late culture than any previous generation; hence their unprecedented sympathy with old, tired, over-refined civilisations, Hellenism, the late Roman period, the rococo, and the late style of the great masters. Appreciation of the spiritual atmosphere of such phases and their achievements, which, if not superhuman, were humanly the more accessible for that reason, was part of the essence of the decadent sense of life. The feeling of decadence that afflicted men may not have been completely new in all its components, but its influence was more exclusive and more unalloyed than similar feelings in earlier times. Its connection with Rousseauism, Byronic tiredness of life and the romantic sense of doom is, in spite of the differences and contrasts, unmistakable. Romantics and decadents felt drawn to the same abyss, were similarly fascinated by destruction and self-destruction. But for the decadents, as for Baudelaire,

the abyss was everywhere, and everything was pervaded with anxiety and a sense of vanity . . .

> . . . plein de vague horreur, menant on ne sait où . . .

The abyss that faced the Christian in the form of sin, the knight of the age of chivalry in the form of loss of honour, and the bourgeois in the form of illegality, yawned deepest to the decadents in connection with things for which they had no names or formulations. Hence their often desperate struggle to achieve form, their insuperable revulsion from everything unformed, untamed, and crudely natural. Hence also their predilection for cultures that possessed the greatest number of formulations, though not always the deepest and most allusive, and had a word for everything, even if sometimes it was only a weak one. The affinity between the decadent attitude to art and that of mannerism appeared in the pleasure taken in fluency and suppleness of statement and the cult of form and articulated expression for its own sake, and created the conditions for a quasi-mannerist artistic practice, though its practitioners had not the slightest suspicion of the existence of mannerism.

Verlaine's *Je suis l'empire à la fin de la décadence* became the signature of the age and, though as an apologist of the period of Roman decline he had his forerunners in Gérard de Nerval, Baudelaire, and Gautier, he launched the slogan at the right moment, and made a cultural programme of what had hitherto been no more than a passing whim. However much or little sixteenth-century mannerism may have had to do with the art and literature of the late Roman period, whether it was aware of any connection with it or not, it chose its patterns wherever it found them, never for the sake of their second-rank quality. Here lies the most striking difference between the decadent attitude to art and that of true mannerism, which turned against the High Renaissance, that is to say, against what, in spite of reservations, must have seemed to it the golden age, but played up no other style in its place. Actually, no generation before that of the nineteenth-century decadents, however non-conformist and revolutionary-minded it may have been, had ever opted for a silver as against a golden age.

3. MALLARMÉ AND SYMBOLISM

Symbolism, like mannerism, was an intellectualist movement in art. Jean Moréas, who introduced the term, described its objective as the substitution of reality in literature by the 'idea'. The change of style it brought about meant the victory of Mallarmé over Verlaine, that is to say, a shift of emphasis from sensuous impressionism to spiritualism and idealism.

A hard and fast dividing line between symbolism and impressionism cannot always be drawn, however, because they are only partly antithetical, partly they overlap. The optical and acoustic effects of symbolism are impressionist in nature, as are the mingling of different sense data, the interaction of artistic forms, and above all what Mallarmé meant by the reconquest from music of the inalienable property of poetry. The spiritual and irrational outlook of symbolism is, however, sharply opposed to the naturalism and materialism of impressionism. To the latter sense impressions are final and irreducible, while to symbolism all immediate experience is merely a feeble substitute for the ineffable and the intangible, a totality it believes to have been lost, or the distortion of an intelligible world of ideas, a hidden absolute. The crucial breach with the centuries-old naturalist outlook lay here.

Thus symbolism was far from being merely the outcome of a development that began with the romantic movement and consisted in the rehabilitation of metaphors and linguistic subtleties that classicism had banned; that is to say, it did not represent merely the climax of a process that had already scored decisive victories with the imagery and verbal painting of impressionist verse. Its essence was rather the rejection of impressionism because of its materialism, of the Parnasse because of its formalism and rationalism, and of romanticism itself because of its emotionalism and the conventionality of its imagery. Symbolism can thus to an extent be regarded as a reaction against the whole of earlier poetry.[5] The poets known as symbolists discovered a hitherto unknown phenomenon, at any rate one that had been ignored since the time of mannerism, that is to say, the *poésie pure, i.e.,* poetry originating from the inherent spirit of language independently of logical content or reason.

They included in the category 'symbol' all the functions of language conveyed by terms such as name, image, simile, or metaphor, everything, in fact, except its logical or conceptual meaning. This had nothing whatever to do with allegory, which departs from the individual instance, or with the kind of symbolism that preserves objective concreteness but conveys a general truth. They had in mind something much more in the nature of a mathematical or rather musical symbol, or 'sign', which, as against the vocabulary of ordinary speech, has the advantage of being uncorrupted and having poetical, though not logical or conceptual, clarity. Instead of the latter the symbol was intended to fix the lyrical-musical mood associated with things, and thus also the musical overtones of experience. The mannerists, and more particularly poets of the type of Góngora, must have wanted such signs to express their sensual experiences, but instead of a specific, autonomous symbol language they achieved only an accumulation of metaphors. Language is not a collection of abstract signs, and cannot be turned into one; words and

combinations of words, apart from their musical and emotional values, have a primary logical meaning that can shift and grow blunted with time, but can never be made to disappear completely, and by being overlaid only loses in sharpness and clarity.

To the symbolists, with their conception of a sign language, any idea of the type of the *mot juste* was utterly remote. In trying to convey the tone and colour and emotional quality of an experience more adequately than by ordinary language, they had no faith in the possibility or desirability of finding the 'one right word' for every object. On the contrary, they can be assumed, unlike Flaubert, for instance, to have doubted the existence of such a thing. Instead they seem to have adhered to Verlaine's admonition:

> Il faut aussi que tu n'ailles point
> Choisir tes mots sans quelque mépris.

With their inexhaustible vocabulary, they intoxicated themselves with language without attaching too much importance to the individual word; indeed, one word often seemed to them as good as another, and they always regarded a rich selection as preferable to a single word, however telling it might be. In apparently sharing Verlaine's view and following his advice, they anticipated the surrealist theory of the automatic creativity of language and reconciled themselves to the fact that words are not always bull's eyes, but often miss the target, indeed to some extent necessarily do so. Meanwhile they had such unlimited confidence in language in general that they firmly believed that, if left to its own irrational impulses and its own formal laws, it could not go astray completely.

With its linguistic mysticism and its *alchimie du verbe*, the affinity of this irrational theory of art to mannerism is obvious. The form it took in symbolism, and the whole hallucinatory theory of poetic creation, derives from Rimbaud. It was he who proclaimed that the poet must be a seer; by weaning his senses from their normal functions, denaturalising and dehumanising them, he must turn himself into an esoteric visionary. The method that he advocated and practised not only accorded with the ideal of artificiality that had prevailed since Baudelaire, but also contained a new element, of which there are merely premonitions in Baudelaire, namely that of the deformation and distortion of phenomena as an artistic means of the expressionism that was now beginning to appear. The new theory and practice were based on the assumption that normal, spontaneous attitudes were artistically unproductive, and that the poet must overcome the natural, normal, rational man in himself before he could discover the real, hidden meaning of things.

Flaubert in his time had had the idea of writing a book without a

subject, which would be pure form, pure style, nothing but verbal music; thus the basic idea of *poésie pure* really dates back to him. So far did he carry the idea that his saying that a beautiful line without meaning was more valuable than a less beautiful one with meaning would hardly have been accepted without reservation even by Mallarmé, for the idea of renouncing intelligible content even for the sake of the most beautiful form was not consistent with the symbolist view in the matter. Nevertheless, Mallarmé believed in an autonomous poetical sense which could and should be independent of reason. Since the success of the movement he initiated, the idea that a poem can be partly and sometimes almost fully appreciated without complete understanding of the meaning of individual words and phrases has become a commonplace of poetical theory and the point of departure of a new attitude towards mannerism in literature. Mallarmé wrote without knowing where the first word or line would lead; the poem grew, like those of Góngora or Donne, in the form of a crystallisation of images and image-like ideas developing out of and modifying each other. This principle of arbitrariness, by which the creative process was apparently left to itself, opened up the possibility of a similar approach to the reading and appreciation of poetry. For, just as it was unnecessary to follow a preconceived plan in writing a poem, so did its adequate appreciation not necessarily require understanding of its rational meaning; it was not even necessary that it should have such a meaning.[6]

Poésie pure was a side-shoot of symbolism; its 'purity' indicated that it was a product of poetical language, *i.e.*, the specific medium of poetry, and its renunciation of the portrayal of ideas and feelings that did not arise from the sensual effect of linguistic means gave it an un-sentimental and irrational, though by no means unintellectual, stamp. One of the most strikingly 'mannerist' features of the new trend lay in this kind of intellectualism. In his rejection of emotion, inspiration, and passion as the source of poetry Mallarmé went farther than any representative of *culteranismo*. 'I found it, and still find it, unworthy to write out of pure enthusiasm,' he said to Paul Valéry. 'Enthusiasm is not the mental attitude of a writer.' The answer he gave Degas when the latter complained that, though he had plenty of good ideas for poems, he could not write them, is well known. 'My dear Degas,' he said, 'poems are written, not with ideas, but with words.' Valéry's comment in his account of this conversation[7] is characteristic both of symbolism and of the *poésie pure* movement of which he was a spokesman. 'C'est le secret,' he writes, and indeed it is the secret of mannerism as a whole, and of all quasi-mannerist literature. To mannerists the secret of poetry truly lies in words, and not merely in the sense that their mastery is the condition of success and that ideas for which no poetically relevant expression is

found lack poetical life and substance. More important, from the manner-ist viewpoint, is that a much greater impact, and even a deeper intellectual stimulus, results from the sound of words, their evocative power, the associations deriving from their sensuous quality, than is obtainable from their logical content. Hence form, the specific means of expression, the particular medium of the artist and his art, is of primary importance, and abstract ideas, that is to say, ideas capable of being formulated otherwise than in the manner in which one finds them, are the outcome, not the source, of the emotional content inherent in the formal language. This theory was developed by Baudelaire, who was himself indebted for it to Edgar Allan Poe.[8]

In addition to the formalism of the *poésie pure*, symbolism has a whole series of other features that recall mannerism. In the first place there is its method of expression, with its emphasis on what Baudelaire called *corre-spondances*, or analogies between parallel phenomena or areas of sense experience; also there is its highly elliptical character, that leaves un-mentioned everything obvious, and often a great deal that is not so obvious, and is consequently sometimes uncommonly allusive, in-herently difficult, and complacently obscure. Difficulty of theme hardly arises, but great importance is attached to increasing the tension, and thus the impact of the statement, by brevity, compression, and incomplete ex-pression. The symbolists discovered something that the mannerists must have felt, perhaps without realising it, namely that if a poem is cryptic and obscure, its appeal to an appropriate public is not in the least dimin-ished; on the contrary, the smaller the demands made on him, the more likely the reader is to shrug his shoulders and pass by. The most important factor, at any rate to Mallarmé, with his predilection for allusiveness and indirectness, must have been the sense that all great art has its secret which it never yields, that it remains inaccessible to theory and analysis and irreducible to any simple idea; and that where the impact is greatest and most irresistible the secret is most impenetrable, with the result that success always seems to be the fruit of lucky and inscrutable chance rather than of understood or understandable intentions.

In the poem *Toast funèbre*, Mallarmé refers to the 'mystery of the name' the poet gives things by finding words for them:

> Le Maître, par un oeil profond, a, sur ses pas,
> Apaisé de l'éden l'inquiète merveille
> Dont le frisson final, dans sa voix seule, éveille
> Pour la Rose et le Lys le mystère d'un nom. . . .

This is one of his most revealing statements about the nature of poetry and poetical language, that is to say, the detachment from and cloaking of things achieved by poetical expression. The purpose of words, according

369

to the general view, is to indicate things, and the special purpose of a poetical image is to substitute a livelier, more striking, less easily disregarded term for one that has been worked to death and no longer attracts attention. Mallarmé's 'mystery of the name', however, serves an opposite purpose. In naming things a poet veils them, wraps them in mystery, for if he did the opposite, if he made them plain, he would deprive them of the qualities they possess in immediate, uncontaminated experience. For he would eliminate, not only the complexity they have in concrete, still undifferentiated experience, but also those individual and unique features they possess by reason of the relationship between them and the particular self experiencing them.

The doctrine of poetical diction with veiled contours expresses an outlook just as opposed to the ideal of the *mot juste* as was Verlaine's, with his rejection of precise language, though the latter did not share the linguistic mysticism of the symbolists and their blind confidence in the first word they might hit on. If Mallarmé had summed up his philosophy of language by saying that one word was just as good as another, Verlaine might perhaps have replied that one word was as bad, vague, and indefinite as another. In his *Art poétique* he comes out against wit, eloquence, rhyme, in short, against all unspontaneous devices, and when he declares music to be the real element of poetry, he is not thinking of the poetical territory to be regained from music that Mallarmé had in mind. The difference between the approach to art of the two poets is neither accidental nor superficial. Verlaine is still an impressionist and, in accordance with the romantic trend of his art, he makes ample use of the metaphor, but he is far from allowing his language to be dominated by it. The effect of his verse depends on melody and rhythmical flow, that is to say, on musical effects, and not on profusion, rarity, or eccentricity of images.

It was with Mallarmé that metaphor was first restored to the rights that it had enjoyed under mannerism. It again became a vehicle for pure play of imagination and ideas, and shook off the laws of logic, experience, and physical causality as well as the principle of artistic economy, uniformity, and continuity in developing images. It was not for nothing that Jean Cocteau called Mallarmé a *professeur de billard*. He plays with his billiard balls, caring for nothing except the patterns they make and their possible evolutions; if they collide and the click is loud enough, he is satisfied.

He uses very few balls, however; Baudelaire used few themes in his poetry, but Mallarmé uses fewer. The stereotyped features characteristic of mannerist and quasi-mannerist art are even more striking with him than they are usually. Not only does he restrict himself to a more limited field than his predecessors, but in his best and maturest poems he has one

topic only. The subject and object of his verse is not the living, thinking, feeling self in general, but specifically the poetical self, and his poetry is merely a statement of the problems and conflicts arising from the profession of poetry, a picture of the labyrinth of artistic creation and the poet's wrestling with the spectre of inadequacy and sterility. The bugbear of sterility and impotence becomes its principal theme, and anxiety about this so dominates his mind that it even creeps into poems of such a different mood as *L'Après-midi d'un Faune*. Because of obscure failings on his part (*par de vagues trépas*) the two nymphs whom the faun at last gets into his power elude him just when he is on the point of enjoying the sweet fruit of all his efforts.

The narcissism that prevails in his verse appears both in its subject and its object. The growing importance of the novel of character-formation (*Bildungsroman*) and the progressive identification of authors with their heroes, their concentration of interest on persons of their own kind, plainly reveal this trend even in Balzac, Stendhal, and Flaubert; it is sufficient to recall Lucien de Rubempré, Julien Sorel, and Flaubert's saying: 'Mais, Madame Bovary, c'est moi!' It was the continuation of this trend that led to the prevalence in literature of the narcissistic self, culminating on the one hand in the passivity of the heroes of Villiers de l'Isle-Adam, Huysmans, and Jacobsen, and on the other in Mallarmé's sterility complex, which represents the last stage in alienation from the world and the self. The betrayal of others involved in trying to propagate oneself without attachment to anybody, that is to say, writing for writing's sake, was felt to be completely vain. The true symbol of the poet was discovered in the sterile prostitute, and the sadistic-masochistic fixation on this image remained as strong as ever.

4. SURREALISM

The quasi-mannerist trends of modern art appear in their purest form in surrealism. The basic feature that the latter shares with mannerism is dualism of fundamental outlook. In both reality is split into two different spheres, and an incurable split runs through all things. Their continuity has been shattered, and the meaning of everything is fused with its opposite—the real with the unreal, the rational with the irrational, the worldly with the other-worldly. The strongest link between mannerism and the artistic outlook of the present day is this dualism, the sense of having one foot in each of two worlds, in one of immediate experience, which is naturalistically representable, and at the same time in another, which is visionary, and therefore capable at most of being hinted at by sensual means. Art is consequently simultaneously realist and more than

realist, *i.e.*, 'surrealist'. This principle seems to prevail in varying degrees in all the progressive artistic tendencies of the present day.

The features of surrealism described as mannerist appear plainly only when the whole influence of this dualism is taken into account—the difference in the levels of reality on which various parts of the same composition move, the mingling of immediately visible phenomena with the hallucinatory forms that they may assume, the indivisibility of sensation and vision, perception and intuition, and the rational and irrational components of the artistic experience. When these things are fully appreciated, many characteristics of surrealism which are generally considered relevant lose importance. Both the unconscious origin of artistic inspiration and the dream as the source of artistic material undergo a substantial devaluation, and 'automatic writing' becomes a purely practical device that can be followed or not, but no longer seems a basic ingredient of the style. The division of the mind into conscious and unconscious attitudes, or states of wakefulness and dream, seems to be merely a symptom or reflection of the contradictory nature of things. In the unconscious and in dreams the surrealist, like the mannerist, sees messengers from a world that differs from the ordinary world and opens up a new dimension of mental life. He looks to the unconscious and to dreams, not for an explanation of the mental processes that take place in a state of wakefulness and consciousness, but for an aspect of life that will show both dream and wakefulness, consciousness and unconsciousness, from a new and unknown angle and display their enigmatic nature. His interest in these phenomena is therefore very different from that of the psychoanalyst and, though it is no accident that surrealism and psychoanalysis were contemporaneous in origin, and the former cannot have been uninfluenced by the latter, it would be premature, however tempting, to regard surrealism as no more than a transference of the psychoanalytic method to art. For what was there corresponding to psychoanalysis in the Cinquecento? And if, as is obvious, there was no equivalent, how is the mannerist obsession with the dream, and the insatiable mannerist interest in the dark and shadowy side of the mind, to be explained? As so often in the history of ideas, we are obviously confronted here with a case, not of direct derivation, of straightforward causality, but of interdependence and synchronism of meaningfully connected phenomena.

Surrealism was born of the untruth and ultimate sterility of the aesthetic culture of impressionism, just as in its time mannerism was born of dissatisfaction with Renaissance hedonism. Gloom, anxiety, and torment, however, prevail more exclusively in modern art than they did in the art of any earlier time. Revulsion against the pleasing and complacent nature of the manifestations of romanticism and impressionism developed into such a violent *anti-espressivo* and *anti-grazioso* that a complete breach

seemed to have been made with the art of the last century. Efforts were actually made to invent new symbols, merely for the sake of demonstrating complete rejection of the expressive and sensual appeal of the art of earlier times. Rimbaud thought of inventing his own artistic language, Schönberg devised a new tone system, and it has been rightly said of Picasso that he paints every one of his pictures as if he were discovering the art of painting all over again.

The whole dadaist movement from which surrealism sprang originated in a resistance to the allurements of ready-made forms and comfortable but worthless, because exhausted, clichés which prevented all spontaneity of expression. The theory of art both of dadaism and surrealism was based on a contradiction in terms, for their fundamental principle was total rejection of the current means of expression because of the danger of their becoming outworn. But how is communication—which at any rate the surrealists do not reject—to take place if all means of communication are questioned and if possible done away with?

The critic Jean Paulhan distinguishes two types of writers according to their attitude to language.[9] In the first, that of the destroyers of language, he includes the romantics with the surrealists and symbolists, because they initiated the movement against conventional forms, commonplaces, and clichés in favour of directness of expression, and represented a process of linguistic innovation, as the whole history of literature has done ever since. The 'terrorists', as he calls them all, take refuge from the perils of language in pure, spontaneous, virginal inspiration, and are opposed to all consolidation and immobilisation of the living, spontaneous and creative life of the spirit, and all externalisation and conventionalisation of its forms; they are, in short, opposed to all objective 'culture'. He connects the surrealist doctrine of the nature of language and poetry with the philosophy of Bergson, and sees in the struggle to preserve spiritual directness and spontaneity the influence of intuitionism and the doctrine of the *élan vital*, which indeed provide the philosophical background of the irrationalism and existentialism of the literary *avant-garde*. The opposite camp, that is, the writers who are aware that the price of understanding is, among other things, commonplaces and clichés, and that literature is essentially communication, language, convention, and thus is to an extent outworn, but for that very reason unenigmatic and immediately intelligible form, he calls the camp of the 'rhetoricians', the oratorical artists. Believing that consistent pursuit of the policy of 'terror' must ultimately lead to silence, *i.e.*, spiritual suicide, he takes his stand unreservedly by the 'rhetoricians'.

Mallarmé and the symbolists believed that all the ideas that occurred to them were an expression of their nature. It was not poetical genius that made their words expressive; they were poets by reason of their faith in

'the magic of words'. The dadaists and surrealists doubted whether any-
thing objective, external, formal was capable of expressing man at all,
and they doubted the value of all such expression. They claimed that it
was 'inadmissible for a man to leave a trace behind him'.[10] Their negation
of aesthetic culture developed into a general nihilism, that questioned not
only art, but the whole of the human condition and the value of all
intellectual achievement.

Symbolism in poetry did not come to an end with Mallarmé. The later
'rhetoricians', as Paulhan would call André Gide, Paul Valéry, T. S.
Eliot and, perhaps, Rilke, continued the Mallarmé tradition, used words
discriminately, believed in the 'magic of the word', and wrote poetry out
of the spirit of language and literature as an institution, though at the
same time they all had more or less close connections with surrealism.
Incidentally, the artistic and literary importance of the latter depends,
not on the works of its official representatives, which are mostly so
insipid, monotonous, and mannered in the worst sense of the word
that they hardly deserve mention in a survey as cursory as this, but on its
symptomatic role in modern art and literature as a whole. If, however, the
secondary stylistic characteristics of surrealism are disregarded, and the
criterion of the style is held to be a divided outlook that permits of no
homogeneity whatever in the artistic description of reality, writers such
as Proust, Kafka, Joyce, and Eliot are seen to be, not only like-minded
contemporaries linked by the same spiritual crisis and similarity of artistic
purposes, but also surrealists of the same type.

Valéry and Kafka are contemporaries, and so are Joyce and Eliot. The
first two produced more or less rhapsodically and published irregularly;
that gives the more significance to the dates of publication of the other two.
Both Joyce's *Ulysses* and Eliot's *The Waste Land* appeared in 1922, and
represent the two principal directions taken by the new literature. The
former sets out unmistakably on the path of expressionism and surrealism,
while the latter still to an extent remains within the borders of symbolism
and formalism. Common to both, however, is an intellectual outlook
reminiscent of mannerism, and their anti-naturalism and irrationalism,
their pointed and paradoxical method of expression, their tormented and
tormenting sense of life, their problem-ridden minds that question all
established things and, above all, their unhesitating mixing of various
levels of being, give their work an essentially surrealist stamp. With
Valéry and Eliot the starting-point is always an idea, a speculative
problem, while with Kafka and Joyce it is an irrational experience, a
vision, a metaphysical–mythological image. Both pairs represent a
dichotomy that runs through the whole field of modern art and literature.
Strictly formal and violently anti-formal, natural and anti-natural,
rational and irrational tendencies that have never been so closely associ-

ated, except in mannerism, appear in them side by side and often com-
pletely fused; and the conflicting styles result in mixed formations so
remarkable that they sometimes produce the impression of split-minded-
ness or of deliberate play with two different possibilities of expression
rather than of competing stylistic trends.

Picasso, in whom the conflicting formal tendencies in painting are most
strikingly combined, is also the most representative artist of the age. He
has been called an eclectic, a 'master of the pastiche', and it has been
claimed that in revolting against the rules and modifying them he wishes
merely to demonstrate his mastery of them. His continual tergiversations
and abrupt changes of manner remind others of Stravinsky, who has
been described as his truest contemporary. But that is far from telling the
whole story. Picasso's eclecticism is primarily a negation of the uni-
formity and consistency of the personality, or at all events of its unity and
consistency as an ideal; his imitations of different prototypes are protests
against the cult of originality and individualism. His deformation of
reality, which appears in endlessly new variations in order the more im-
pressively to demonstrate their arbitrariness, is above all intended to
show that 'nature and art are two totally different things'. Picasso turns
himself into conjuror, juggler, and parodist out of opposition to the
romantics, with their 'inner voice', their 'being able to act so and not
otherwise', their self-adulation and self-adoration. But in repudiating
romanticism he also to an extent repudiates the Renaissance, in which the
artistic and stylistic unity that he disrupts and the individualism and sub-
jectivism that he rejects originated. Thus he completes the breach that
mannerism began. The mannerists, however far-reaching their in-
dividualism, remained true to the Renaissance conception of personality,
which Picasso totally abjures by making problematic, not only the
identity of the objects represented, but also that of the artist himself.

The spiritual world of the present is torn by such deep contradictions,
its coherence is so undermined, that the principal, if not the only real,
theme of art has become the concurrence of the most mutually remote and
apparently irreconcilable themes. Surrealism became the representative
artistic trend of the age by taking as its starting-point the paradox of all
form and the absurdity of all human experience. Dadaism, out of despair
at the inadequacy of all cultural forms, stood for the abolition of art
and a return to chaos; it constituted, in other words, the most extreme
form of romantic Rousseauism. Surrealism, which had not much more
confidence in human reason and conscious mental attitudes, set its hopes
on 'automatic writing' as a method of artistic creation, and believed that
new knowledge, new truth, and a more revealing art, could be attained
out of chaos, dream, the unconscious, that is to say, the uncontrolled

and unprepared manifestations of the mind. But by taking over from psychoanalysis the principle of turning to the unconscious and the pre-rational and the method of free, uncensored association, thus providing something in the nature of a substitute for the good old inspiration of the romantics, it nevertheless brought about a certain rationalisation of the irrational and a certain organisation of the chaotic and spontaneous. Its method, however, is incomparably more pedantic, dogmatic, and inflexible than that in which the irrational and intuitive is controlled by the artist's sensibility, taste, and self-criticism and the guiding principle is reflection and choice between various possibilities instead of an alleged unselectivity and anarchy—that wish-dream of romantic aesthetics which consists in granting free rein to uninhibited creativity.

The vital factor in the form and content of the new art is a sense of a second reality, inseparably connected with that of ordinary experience, but nevertheless so different from it that only negative statements can be made about it and its existence can be indicated only by gaps and deficiencies in the context of ordinary experience. The primary factor in the artistic and philosophical outlook of the age is unquestionably the discovery of this second reality. The unconscious and the dream, free and uninhibited association, and letting oneself be carried along by the autonomous means of expression, that is to say, by language left to itself, are only intermediaries that pass on this message from the depths of the mind. The interpretation of the message may owe a great deal to psychoanalysis, but without the discovery of the second reality the technique of psychoanalysis would hardly have been applied to art.

The dualism of life is certainly no new idea; indeed, as a theme of art or fundamental attitude behind it, it is very ancient, and appears in innumerable variations. But the dualism and ambiguity, the pitfalls and traps, that lie hidden from human understanding in every phenomenon, every fact, were never felt so intensely, so tormentingly and menacingly as at the present day. The only parallel is to be found in the age of mannerism, when there was a similar sense of a cleavage running right through life. In most of the more or less popular representatives of surrealism, Salvador Dali, for instance, the place of the stylistic means by which mannerist painting expressed this dualism, that is to say, the different methods of composition and the inconsistent dimensions and spatial relations, is taken by a much more mechanical process, the creation of mere contrast between the photographically true reproduction of detail and the extravagance, the ostentatious absurdity, of its selection and combination. On the other hand, no such difference of level exists between the style of a Kafka, whose natural, factual, and often deliberately dry and sober prose is at the same time a most sensitive instrument for the expression of ideas, and the style of the greatest mannerist writers. But,

however widely the degree of artistic success may differ from case to case, and however broad or narrow one's conception of surrealism may be, its theme is the same—the absurdity of life, which is the more striking the more realistic are the single features of the unrealistic, vision-like image which the work as a whole assumes.

The dead donkey on a piano in a surrealist film, or Dali's naked woman's body that opens like a chest-of-drawers, or his watches that bend and stretch like pancakes, the queer way in which the most heterogenous objects are linked and matched, obviously only express the wish to bring coherence and continuity into this divided and atomised world, though in a very bizarre fashion. A totalitarian obsession prevails; frantic efforts are made to connect everything with everything else; and everything that surpasses the individual and points to something else, if possible a totality, seems more important than any individual case; everything is fitted into a series of endless and apparently indiscriminate associations.

With this relationism and striving for universalism there goes hand in hand a devaluation of man, and the so-called dehumanisation of art. In a world in which everything can be important or may be equally important, man loses his pre-eminence, and psychology the special role it had in nineteenth-century literature. The works of Kafka and Joyce are not psychological novels in the sense that the great novels of the last century were. In Kafka the place of psychology is taken by a kind of mythology, and in Joyce the psychological description of the characters is perfectly accurate in detail, just as the individual elements in a surrealist painting can be naturalistically unobjectionable, but there is no longer any psychological focal point of the argument, which now moves in a far wider sphere than in the older novel. The depsychologising process began with Proust, who on the one hand reached the summit of the psychological novel with his analyses of thought and feeling, but on the other marked the beginning of a development that led to the disruption of the individual as a self-contained entity identical with himself. For, since the whole of existence becomes the content of consciousness and is otherwise of a thoroughly problematic nature, and things have a meaning solely through the spiritual medium that perceives them and change with the latter, psychology can hardly be said to survive in the sense in which the term is used in connection with Stendhal, Balzac, Flaubert, Tolstoy, or Dostoevsky. In the latter the mind is the opposite pole of the objective world, the complement of external, material reality, and psychology *par excellence* the interaction between subject and object, self and non-self, world within and world without. But when objective reality is completely subjectivised and becomes a projection of the self, psychology loses its real meaning; it becomes a vehicle for metaphysics.

Proust, for all his mastery as a portraitist and caricaturist, is much less concerned with the characterisation of individuals than with the description of the mechanism of the mind in general. His work is no portrait gallery, in the sense that Balzac's 'repertoire' of characters is, though he has been compared to him in this connection; it is much more a *summa* of modern psychology, a comprehensive picture of the impulses, emotions, and inclinations, the sensitivity and occasional obtuseness, the kindness and cruelty, the rational and irrational motivations, the subtlety and sophistication, the complex spiritual promptings and primitive instinctual urges of modern man. Like Joyce's *Ulysses*, *À la Recherche du Temps perdu* is really a novel without a hero; both are memoirs, chronicles, autobiographies, moral philosophies, reminiscences with commentaries and anecdotes. Broadly speaking, they are encyclopaedias of the modern world with a more or less artificial, arbitrary focal point that is to an extent subsequently introduced. With the flight from the plot, a phenomenon the premonitory signs of which had been perceptible for a long time, there was now associated a flight from the hero. Instead of a progressive sequence of events, the effort to recapture the past results in the pouring forth of a flood of memories, or of ideas and associations; or a stream of consciousness, an unending, uninterrupted inner monologue takes the place of a plot with a beginning, a middle, and an end. The emphasis is always on unbroken continuity, total flow of movement, the kaleidoscopic, perpetually changing picture of a disintegrating world. Proust's endless, interlocking sentences, his page-long, breath-taking paragraphs, and his remark that his subject would have been best served if he had written the whole of his novel in one single unbroken paragraph, are as indicative of this conception of the world as a heterogeneous continuum as are the last forty pages of *Ulysses*, in which there is no punctuation.

The next most important characteristic of surrealism after this multiform view of reality is its film-like structure, which is associated with the abandonment of the space and time of ordinary experience and of most artistic styles. The cinematic technique of representation not only implies its own laws of spatial and temporal connection, but also involves a blending of the two categories that seems to ignore the autonomy they assume elsewhere. In the film the boundaries between space and time are fluid, and there are forms of perception in which space assumes a quasi-temporal and time a more or less spatial character. In general, and in the visual arts in particular, space is a stationary, unchanging medium, without goal or direction; while time, in general and so in literature, particularly in the drama, has a well defined direction, a trend of development, and represents a rectilinear order of events. Such was the state of affairs before the advent of the modern, post-impressionist, cinematic

concept of time. Before the influence of the film made itself felt, the arts were sharply differentiated by the predominance of one or other of these categories, either static space or dynamic time. But then space lost its passivity and finality, and acquired its own dynamism, even in painting; it became fluid and, so to speak, changed before the spectator's eyes, just as in a film, in which its formation takes place before one's eyes in stages that are neither homogeneous nor equivalent. Some represent a more primitive, others a more advanced stage in the development and experience of space. Thus, for example, the use of the close-up represents a phase in the temporal development of the film that has to be prepared and requires a certain time to fade away and disappear; and, just as space is dynamised in this fashion and assumes features characteristic of time, so time to an extent assumes a spatial quality, the most striking feature of which consists in the far-reaching liberties that may be taken with the succession of events.

In a film we move about in time with the same freedom with which we walk from one room to another and back again and spend a longer or shorter time in each. Thus time loses, not only its constant standard, but also its uninterrupted continuity and irreversible direction. Sometimes it stands still, or it jumps backwards or forwards, according to whether close-ups, flash-backs, or dissolves are being used. Simultaneous events can be shown in succession, or events widely separated in time simultaneously by double-exposure or alternation of shots. The technical possibility of interrupting the continuity of a shot and changing the camera angle at will contains in principle the method of the discontinuous treatment of time, and hence one of the most fruitful and original devices of the film—the parallel and intermittent representation of concurrent plots. The crossing and the intersection of two different lines of the plot, the simultaneity of representation of opposing actions, conflicting moods, and contrasting optical effects, provide the basis of the cinematic idiom, and the whole of modern art seems cinematic because it is permeated by the idea of simultaneity.

This idea exercises a fascination over our age. Awareness of the moment in which we find ourselves is an essential element of our time experience. To the man of today everything topical, contemporary, occurring at the present moment, has a special meaning and value, and this keen sense of the actual gives the fact of simultaneity its extraordinary significance. Modern man is as absorbed in his contemporary world as medieval man was in the world beyond, and men of the age of enlightenment in a Utopian expectancy. The discovery that one and the same man experiences so many different and irreconcilable things at one and the same moment, and that the same things are happening at the same time in so many places—the universalism of which modern technics

have made us conscious—is perhaps the real source of the new conception of time and the abruptness with which modern art describes life. At all events, the simultaneity of the contents of the mind, Bergson's *simultanéité des états d'âme*, is the fundamental experience that connects the various trends of modern art. Beneath practically all its manifestations there lies the counterpoint of mental processes discovered by Bergson and the symphonic structure of their unity. Just as, when we listen properly to a piece of music, we are aware of the connection of each new note with all those that have preceded it, so do our deepest and most important experiences contain everything important that we have experienced and made our own. If we understand ourselves properly, we read our own minds like a score; we resolve the chaos of the entangled sounds and transform them into a meaningful pattern of horizontal and vertical relations. Modern art never tires of the fascination of the maze of ideas simultaneously present in the mind and inseparable from one another.

The endeavour to represent events or impressions separated in space and time emerging simultaneously in vision is the—film-like—common denominator of the various trends in the art, and particularly the painting, of the present day. The futurism of the Italians, the expressionism of Chagall, the cubism of Picasso, and surrealism in all its varieties, have at least this one characteristic in common. The practice of representing in one picture two different aspects of the same object, combining, for example, profile and full face in a portrait, or the method used by Picasso in his earliest cubist paintings, and still used by him in many of his latest works, namely that of showing one eye from the side and the other from the front, involves the introduction of a time factor, that is to say, simultaneity, into a spatial structure the components of which in reality are never seen simultaneously. We are faced here both with a rejection of Lessing's 'pregnant moment', the introduction of which into the visual arts meant the representation of movement without involving time, and with something in the nature of a return to Wickhoff's 'continuous' method of representation,[11] by means of which it was possible to show two episodes within the framework of one scene in an almost cinematic way. In painting simultaneity means rejection of the naturalist–impressionist method, which tries to restrict the description of reality to the rendering of a momentary impression. From the beginning of the Renaissance to the end of impressionism, the aim of pictorial representation was the reduction of sensual experience to its visual elements, the rendering of purely optical impressions and of nothing more than what the eye could take in at a single moment and at a single glance; in other words, the exclusion from the picture of everything merely known but not seen, or seen at a different moment of time from that represented. Manner-

ism was the only phase of development in which the continuity of this process was interrupted. In our time this episode is being repeated, unless the episode on this occasion turns out to be a real turning-point. Hitherto time had to be translated into terms of space (a momentary situation, in Lessing's meaning of the word) in order to find a legitimate place in the visual arts. Now, however, time is assuming a form in painting that can be described as the fourth dimension of space. If a painter shows the two eyes in a portrait from two different aspects, the time taken by the spectator to move from one position to the other is represented too. Instead of being eliminated, as it was in Lessing's 'pregnant moment', it is added to space as a new dimension.

The special concepts of space and time peculiar to the film, the fluidity of the boundaries between the two categories, and more particularly the impression of simultaneity, are the consequence of montage, that is to say, the breaking up of the continuity of the action by the interpolation of extraneous factors and the organisation of the single shots in a way that deviates from the logic, chronology, or causal nexus of the theme. The essence of montage lies in the immediate combination of heterogeneous elements, and in this sense its technique embodies the formal principle of the whole of surrealism, and indeed the whole of modern art.[12] Apart from the film, however, it is in surrealist painting that the principle of montage appears most strikingly, as a consequence of the apparent fortuity of the objects represented. Besides expressing the heterogeneous nature of reality, the various levels of reality at which life unfolds itself in its different aspects, its irrationality and the mind's inability to master its contradictions, it strikingly illustrates the playful nature of the whole style. Also it creates a stronger impression than does surrealism in other fields that all the manifestations of life are equally important or unimportant, and that it is more or less a matter of chance what the themes of our experience may be, and that consequently even the most carefully chosen subject may be no more than an *objet trouvé*.

Picasso's surrealism is reflected, among other things, in his method of work, of which he once said that he never knew in advance what would finally appear on the canvas; whenever he began painting, he felt as if he were taking a plunge into the unconscious. This method is unmistakably related to that of 'automatic writing', in which the artist claims that he uncritically and uninhibitedly gives free rein to his impulses. But it is also, and more closely, related to the mannerist attitude, the peculiarity of which was blind confidence in the autonomous activity of the means of expression, that is to say, of language, and in the autogenesis of images. Picasso lets himself be guided by his brush, just as mannerist, symbolist, or surrealist poets let themselves be guided by the metaphor-producing power of language, and he accepts any gift of chance he comes across while

painting as a constitutive element of the work in progress. 'If I have no blue, I take red,' he says, obviously believing that in the last resort the choice of means and themes is a matter of indifference; all that matters is the intensity of the experience, the liveliness of the vision, the sharpness with which it is seen. The artist's self is changing and variable, and outside the work of art itself no criterion of any kind exists for assessing its quality. The different works of an artist need have as little to do with one another as with nature. They are notes and comments on the experience of reality rather than renderings of its manifestations, and they have no claim, either individually or in combination, to be anything in the nature of a picture of the world, that is to say, a synthesis or epitome of life. The paintings an artist leaves behind him are scattered signs of himself, and he expends himself without expressing himself or the world completely.

Picasso closely approaches mannerism by reason, not only of the character of his whole art and the stylistic differences of his various phases, but also of the heterogeneous composition of his individual works. Besides passing in succession through cubist–formalist and naturalist–expressionist periods, as well as others in which he pursues classical beauty of line or anarchical anti-formalism, he goes so far in his eclecticism as repeatedly to change the stylistic criteria within one and the same work. Thus a painting as important in his artistic development as *Les Demoiselles d'Avignon*, for instance, besides exploiting the results of the art of the last decades of the nineteenth century from Cézanne to Gauguin, includes clearly distinguishable elements of Negro sculpture, cubism, and expressionism, and instead of trying to make a synthesis of these elements, the artist seems rather to be eager to preserve their differences.

5. PROUST AND KAFKA

The two most important writers of the present age, Marcel Proust and Franz Kafka, are also those who have most in common with mannerism, though they can no more be said to be mannerists in the full sense of the word than can the symbolists or surrealists. Kafka, because of the themes and the problems that concern him, above all the alienation and bureaucratisation of human relations, has a deeper affinity with the world of mannerism than Proust, whose links with it are more manifold, but more superficial. The critical situation in which both find themselves is less catastrophic with Proust, but is manifested by a larger number of symptoms. The sense of shattered identity, the role in life of misleading semblance, the continually shifting aspects of things, the changes wrought by time, the secret activity of dream and the unconscious, and the

theme that looms largest in his work, namely the varying aspects of love and the ever-present narcissism that underlies everything and most immediately and unmistakably expresses his alienation from the world and mankind, are all mannerist features that clearly indicate his place in the history of literature and of ideas.

Proust, particularly in his early period, makes rich use of preciosities of language, artificial, piquant methods of expression, unusual and unexpected associations of ideas and words, and far-fetched and carefully elaborated analogies and metaphors. His stylistic means, especially his metaphorical statements, which are with him, as they were in mannerism, the expression of an unstable world—of a metamorphism—attain in the course of time a subtlety that allows us to forget how strained they remain. But he never develops his musically or visually conceived metaphors so elaborately and long-windedly for the sake of their beauty, but, like the mannerists, or his favourite poet Baudelaire, or the symbolists, does so because of the inexhaustible associations—*correspondances*—between the things that he discovers or tries to establish. His metaphorical way of expression is fraught with a relationism and perspectivism that is much more disturbing than the relativism and metamorphism of his predecessors. With him everything is continually shifting and changing from one level to another, not only because life and man are continually changing, but also, and mainly, because they seem perpetually to change according to the observer and his specific viewpoint and the momentary circumstances of his relationship to them. There are as many realities as there are aspects of reality, and as many characters as there are relationships in which human beings are involved; and everyone sees and judges them according to the situation in which they become significant to him. Every reality dissolves into a series of pictures, *imagines*, but the question of the substance behind them remains unanswered. Even recapturing the past means no more than digging up a buried picture that becomes the point of departure for a series of other pictures. Artistic success lies in the discovery of one first memory picture. There is no question in Proust of art's having an *intelligible* quality. All that could be interpreted in this sense are suggestions in the last part of *À la Recherche du Temps perdu* that perhaps nature herself establishes metaphor-like relations between things:

> An hour [Proust writes] is not merely an hour, it is a vase filled with perfumes, with sounds, with projects, with climates. What we call reality is a relation between those sensations and those memories which simultaneously encircle us—a relation which a cinematographic vision destroys because its form separates it from the truth to which it pretends to limit itself—that unique relation which the writer must discover in order that he may link two different states of being together for ever in a phrase.

In describing objects one can make those which figure in a particular place succeed each other indefinitely; the truth will only begin to emerge from the moment that the writer takes two different objects, posits their relationship. . . . In this, as in life, he fuses a quality common to two sensations, extracts their essence and, in order to withdraw them from the contingencies of time, unites them in a metaphor, thus chaining them together with the indefinable bond of a verbal alliance. Was not nature herself, from this point of view, on the track of art, was she not the beginning of art, she who often only permitted me to realise the beauty of an object long afterwards in another, midday at Combray only through the sound of its bells, mornings at Doncières only through the groans of our heating apparatus?[13]

Elsewhere in the novel Proust says of the works of the painter Elstir that

the charm of each of them lay in a sort of metamorphosis of the things represented in it, analogous to what in poetry we call metaphor, and that, if God the Father had created things by naming them, it was by taking away their names or giving them other names that Elstir created them anew.[14]

This, in complete harmony with the aesthetics of mannerism, means that the artist does not imitate nature, and that his works are not the result of a God-inspired talent, but are rather creations that compete with those of God. What Proust may have had in mind when he said that metaphor was the only thing that could give style a kind of eternity can be inferred from examples in his own work, such as the almost untranslatable description of the flower-strewn banks of the Vivonne:

Çà et là, à la surface, rougissait comme une fraise une fleur de nymphéa au coeur écarlate, blanc sur les bords. Plus loin, les fleurs plus nombreuses étaient plus pâles, moins lisses, plus grenues, plus plissées, et disposées par le hasard en enroulements si gracieux qu'on croyait voir flotter à la dérive, comme après l'effeuillement mélancholique d'une fête galante, des roses mousseuses en guirlandes dénouées. Ailleurs un coin semblait réservé aux espèces communes qui montraient le blanc et rose proprets de la julienne, lavés comme de la porcelaine avec soin domestique, tandis qu'un peu plus loin, pressées les uns contre les autres en une véritable platebande flottante, on eût dit des pensées des jardins qui étaient venues poser comme des papillons leurs ailes bleuâtres et glacées, sur l'obliquité transparente de ce parterre céleste aussi: car il donnait aux fleurs un sol d'une couleur plus précieuse, plus émouvante que la couleur des fleurs elles mêmes. . . .[15]

By and large this is still impressionistic, as is the description of the lilac in the first part of the novel analysed by E. R. Curtius,[16] but not only has the flood of imagery an urgency and condensation unknown to impressionism, not only does it combine the poetical with the common-

place, as in the 'flowers that seem to have been freshly washed, like porce-
lain treated with housewifely care', not only does it involve, that is to
say, a blurring of the boundaries that is post-impressionist and to an
extent mannerist, but it also leads up to a sublimation of the scene that
has nothing whatever to do with impressionism. The colourful sky com-
bines with the flowery meadow and, first with the beneficent afternoon
sun and then with the melancholy of its setting, opens up perspectives
that are yet another reminder of Baudelaire.

Besides its more serious elements, Proust's imagery has a playful
aspect and he preserves it to the end. Among many similar examples,
there is the page-long series of metaphors in *Du Côté de Guermantes* in
which he describes a brightly lit, crowded theatre auditorium; the way in
which the *tour de force* of this accumulation of images is sustained yields
nothing to Góngora or Marino. The focal point is the box of the Princesse
de Guermantes, sitting like a 'great goddess' in the semi-darkness of her
grotto, and from this Proust develops one image after another, turning
the crowded auditorium with its dazzling lights and pompous decoration
into a seascape with marine vegetation, nymphs, and natural deities.[17]

Proust's treatment of the problem of time illustrates the mannerist
quality of his art in an incomparably deeper fashion than does his meta-
phorical way of expression. Death and transience and the ravages of time
figure prominently in the works of practically all the mannerist poets.
They are a major theme in Shakespeare, and in a work such as *Troilus and
Cressida* are seen as the major problem of human existence. Time appears
as an element of disruption, undermining all the values of life, above all
love and loyalty. This attitude forestalls certain features of Flaubert's
disillusionism, and even of Proust's conception of time. Other elements
in the latter stem from Bergson's philosophy. Flaubert, who anticipated
the idea, though not the clear conception, of an 'inner' time measurable
by no mechanical means or quantitative criterion, differed from Bergson
in that for him time remained an element of destruction, while Bergson
found in it the very medium of active spirituality and inwardness. This
new, internalised, spiritualised, destructive, but simultaneously creative
conception of time was first given artistic form by Proust. The time in
which we perish—for it is we who perish and not time—is the only
source from which we can recapture something of what we were and
what we had. Past time does not preserve our being complete and un-
altered, but contains traces of it, and these, with luck and persistence, we
can recapture. In any case, when we have recaptured the past, we shall
look at it with changed eyes. For, just as any particular moment of the
present is partly composed of fragments of the past, so does the present
in turn invade the past; with each new moment that passes it acquires a
new aspect and new meaning.

From the revival of the past Proust derives, not only new hope for living, but also the real justification of art, which in the last resort he sees as the only defence against the ravages of time and the only possible redemption from its curse. Memory, by which we regain possession of past time and our former life and self, is also the organ of the artistic vision; the work of art is its product. The artist owes everything to memory, and it is the artist alone who enjoys this privilege; no one but he is capable of deciphering the faded writing of the past. The restriction of this prerogative to the artist links Proust with nineteenth-century aestheticism. His escape from alienation by way of the memory is a flight through a back door, not a complete break-out. The fact of alienation remains unchanged; the way of escape, he believes, exists only for the elect.

The entirely modern, 'film-like' quality of Proust's conception of time appears in the supersession of the impressionist view of it as well as in its complete relativisation. Not only does he emphasise the convergence and confluence of different periods of time, but also he abolishes the limits between the space and time factors in experience. He calls attention to simultaneity by making different memories concurrently topical, and obscures the boundaries between space and time to such an extent that it is often impossible to say in which medium one is moving. He says, not only that past and present are mingled and form an indivisible whole, and that the length and significance of different periods of experience are relative and not to be measured by the same standard, but also that time is relative to space. Certain places and times are as closely linked in our memory as are the different times when we have had the same experience, with the result that we are unable to disentangle them. A place we remember also means a point of time in our life, and has no reality for us other than that. Again, memory of a certain period of our life can be so closely associated with a particular place that the latter often has a more definitely chronological quality for us than the date of the events there or their duration.

This relativism of space and time is obviously only one aspect of Proust's general relationism. The different phases of time are each other's measuring-rod, the chronological and spatial circumstances of their occurrence are inseparable from one another and are merely different dimensions of the same medium, just as everything that has ever been important to us can be connected with everything else and acquires special significance according to what it is connected with. Everyone who has played a part in our life assumes many faces. Not only does he mean something different to everyone he meets; he also means many different things to us, depending on the events in which he takes part and the state of mind in which we think of him. Marcel says that, to console him-

386

self after Albertine's death, he had to forget not one, but innumerable Albertines; and at the beginning of the novel, on Swann's first appearance, there is a passage that says that, even in relation to the most trivial events of everyday life, we are not a uniform entity that is the same to everyone, but that our social personality is a creation of others.[18]

The alienation manifest in this relativism and perspectivism, which makes men and things lose their substance and vanish into mere relationships, is most vividly expressed in narcissism, the pathological form in which Proust invariably clothes love, or alternatively flees from it. There is scarcely a hero in the whole of literature who has so much love for his own love as Swann or Marcel, and so little for the woman to whom he is emotionally tied. At all events, there is none so thoroughly aware as is Swann of not liking the woman from whom he is incapable of freeing himself, realising as he does that she is not even the type of woman who appeals to him. Lovelessness, and cruelty to oneself and one's partner, are the characteristics of the Proustian erotic relationship. Instead of the more usual claim, that the greater the love the greater the suffering, he says that love *is* suffering, and that, if suffering ceases, it is certain that love has ceased too, and now it is the other party's turn to suffer. Love is again what it was to the Latin poet, an affliction that strikes like an illness. You are 'in love' with the woman from whom you catch fire, but at the same time you hate her, because you have become dependent on her. The qualities in her with which you believe yourself to be in love are the creations of your imagination, and in reality do not exist.

The only real, permanent, and incurable love is of the self; a love partner is needed at most for the objectification of what is always a subjectively determined and subjectively limited emotion. Characteristic of all Marcel's later relationships is his description of that between him and his first friend Saint-Loup:

> It was promptly settled between us that he and I were to be great friends for ever, and he would say 'our friendship' as though he were speaking of some important and delightful thing which had an existence independent of ourselves, and which he soon called—not counting his love for his mistress—the great joy of his life. These words made me rather uncomfortable and I was at a loss for an answer, for I did not feel when I was with him and talked to him—and no doubt it would have been the same with everyone else—any of that happiness which it was, on the other hand, possible for me to experience when I was by myself. For alone, at times, I felt surging from the depths of my being one or other of those impressions which gave me a delicious sense of comfort. But as soon as I was with someone else, when I began to talk to a friend, my mind at once 'turned about', it was towards the listener and not myself that it directed its thoughts, and when they followed this outward course they brought me no pleasure.[19]

In Proust's view, there is no happy love because there is no real choice; only unrequited love exists. 'Love,' he writes, 'in the painful anxiety as in the blissful desire, is the insistence upon a whole. It is born, it survives, only if some part remains for it to conquer. We love only what we do not wholly possess.'[20] To the narcissist love and jealousy are interchangeable terms; he is in love only when he is jealous and because he is jealous. His prototype is Othello. It is jealousy that ties Swann to Odette and Marcel to Albertine, and they are jealous because they are unsure, not only of the women, but also of themselves.

The sense of alienation is the strongest link between Kafka and Proust, and also the most important factor in their affinity to mannerism. In Proust, apart from his narcissism, his jealousy, his imperialism in love, alienation appears most noticeably in his concept of time, his flight into the past, that is to say, in everything that he means by *le temps perdu*, his 'search' for it and for his own self. But its most striking manifestation is in the consequences of his permanent sense of guilt. There may be a hundred reasons for the latter—his Oedipus complex, his homosexuality, his incapacity for regular work, his introversion, his indifference to the world, his lovelessness, his unhappy disposition, which made him believe that he must destroy all the happiness around and in him, though it is only after his grandmother's death and the disappearance of Albertine that he begins to have an inkling of his detachment from others, and begins gradually to realise that his only real interest in life is the exploration of his own 'heart', the description and fathoming of his own feelings, his gratuitous experimentation with critical human situations, his conception of life as a laboratory or training-ground for mental acrobatics, in short, that all he cares about is using life as the raw material for his work.

Numerous though the causes of Proust's sense of guilt and alienation may be, generally they are repressed into the unconscious, and hence emerge deviously, in pathological forms, in symptoms that can be interpreted only analytically. On the surface they are reconcilable with beliefs as apparently optimistic as that in redemption by memory, recapturing the past and the self, and the rewarding and satisfying process of artistic creation. Proust's world is hung with dark veils, but is not filled with the irredeemable hopelessness of Kafka's. In an often-quoted conversation with Max Brod, Kafka said: 'Our world is only a bad mood of God's, a bad day.' 'So outside this world which we know there might be hope?' Brod replied, and Kafka answered with a smile: 'Oh, hope enough, any amount of hope, but not for us.' Not only is this one of the grimmest of all the grim things that have been said about the human lot, it is also one of the most profoundly and senselessly defeatist, the darkness

of doom being made the grimmer by the idea of an invisible, intangible light existent only in the eyes of blind faith.

Both Proust and Kafka were atheists, for neither believed in a personal God in whom he could take refuge. But, while to Kafka the forsakenness of a godless world meant that life was meaningless and led to a sense of utter hopelessness as well as to a kind of religious 'yearning for consolation and redemption',[21] Proust, in spite of the dark depths in which he was sometimes plunged, remained within the traditional boundaries of French rationalism, and preserved the untroubled, almost cheerful spirit of the enlightenment. Kafka, however, even without God or religion, was and remained a mystic; while proclaiming the bankruptcy of reason, he took refuge in a mystical belief in an irrational and absurd absolute. Proust regarded religion as a part of the historical culture of which he felt himself to be an heir; he never spoke of it disrespectfully, or created more mystification about it than he did about any other part of the national heritage—at most he aestheticised it. If it is true that in his last hours he asked that prayers should be said for him after his death, no more importance should be attributed to his doing so than, say, to his remark that the performance of a Wagner opera at Bayreuth was not less significant than the celebration of a high mass in Chartres cathedral.

The absurd picture that Kafka paints of the higher or divine power in which men believe makes it hard to say whether the implication is that there is and can be nothing corresponding to it in transcendental reality, or whether he admits the possibility, but believes that such a divine power must be so completely irrational and inconceivable by human standards that the only true statements that can be made about it are negative and apparently meaningless. If there is indeed a God with qualities as superhuman and humanly inconceivable as those with which He is endowed by faith, the conventional picture of heaven with its choirs of angels is no less absurd than the idea of His holding court in an attic.

According to Kafka's philosophy of life, the divine power and its ways can hardly be conceived of in an age of the most extreme alienation and reification of human relations such as the present except in the form of a flawlessly functioning bureaucratic machine. But attributing to God a task measurable by human standards, and expecting Him to act justly, considerately, and reliably by those standards, and to carry out His task punctually and conscientiously, is as fantastic and nonsensical as, say, the idea that the instrument through which He exercises His power functions as humanly—all too humanly—as the hierarchy of officials in the *Castle* and the *Trial*.

Kafka's picture of bureaucracy, however, is not so much the indirect expression of his idea of God as a description of his God-forsaken

environment; in it he expresses his revulsion and alienation from the present. Bureaucratic institutionalisation has reached its cruellest and most repulsive form. No longer does it merely function impersonally and inhumanly, it has become actually a monster, a Moloch. The officials are corrupt, depraved, and dirty—dirt is their element. They are parasites, living in and on refuse, like vermin, and they combine the two most revolting human vices, servility and abuse of power. The minor official hides behind lack of information and responsibility, and his senior behind unapproachability. By this Kafka obviously intends, not to create an image of the divine order, but to make the remoteness of the God of the Old Testament a characteristic of the alienated nature of reality.

The principal feature expressing alienation that Kafka shares with mannerism is the chaotic, incomplete, and incompletable portrayal of life. With unprecedented boldness he mingles the various kinds of reality the juxtaposition of which always represents the chaotic and fragmentary nature of things in mannerist and quasi-mannerist art. Never were details observed with such weird sharpness and described with such dry exactness brought into such hallucinatory connections, and never were such trivial episodes combined into such an airy and ethereal, visionary and dreamlike whole. Once more we are inevitably reminded of the dream, which in the age of mannerism presented itself as the closest analogy to the heterogeneous nature of human life. The dream is indeed a useful aid to the understanding of the works of Kafka, though it would be unsatisfactory and misleading to dismiss these as odd and puzzling dreams. Kafka describes no dreams; on the contrary, his aim is to give an account of life as it is lived in full wakefulness, however inscrutable, inexplicable, and unreasonable it may be. Shakespeare and Calderón say expressly that life is like a dream; Kafka says nothing of the sort. Unfortunately, he would say, for all its incomprehensible and fantastic nature, life is no dream. There is nothing imaginary about it. It is the clear, cold, pitiless, unchangeable reality we face when we awaken from sleep, as many of Kafka's principal characters do at the beginning of their story.

Kafka's tales are neither the symbols they are called by Max Brod,[22] nor are they allegories, as Georg Lukács would have them,[23] nor parables, as Walter Benjamin makes them out to be.[24] Common to symbols, allegories, and parables is that they make statements about life and the nature of men and things, leaving their meaning to be inferred. The latter does not coincide with the features that can be directly experienced, but rather lies hidden behind the facts of experience. Symbol, allegory, and parable have a meaning that has to be discovered or established; they are interpretation, or explanation, or embody a lesson, but are not really description or representation. They are concerned with the solu-

tion of a puzzle or problem, that is to say, not with what things are, but with what they mean.

To be sure, Kafka himself says, in an indirect manner, different from the usual, what he has to say about his characters and the events in which they are involved. But the origin of his indirect and unusual tone is quite unlike, and to an extent is the opposite of, that of the forms mentioned above. The indirect and unusual effect of the latter is the result of their emphatic allusiveness, and the way they are linked with some truth or principle of wider implication than the special case given. In Kafka, on the other hand, the impression of transference from ordinary reality to a special plane of experience derives from the complete lack of any interpretation or explanation; the facts are presented in all their nudity, without gloss or comment. In symbol, allegory, and parable things are given a plainer, more allusive, deeper or more general meaning than they normally have, while in Kafka they are stripped even of the meaning they have in the simplest, most factual, most unpretentious tale. Even the latter contains some key, some hint of its wider implications, but Kafka adds nothing to his account, neither explanations nor conclusions; his stories and sketches, with all their episodes, digressions, and speculations, remain as dark, inscrutable, and unintelligible at the end as they were at the beginning. The lack of all attempt at interpretation is the more remarkable in that the events and characters he describes are so strange. They are, however, exactly what they appear to be; their strangeness is not a sign of any hidden meaning. No interpretation could modify their strangeness, no analysis reveal the law that moves them.

Kafka's style and the vision of life that he develops in his works are directly connected with his metaphorical way of expression; it is on the latter that the simultaneous directness and indirectness of his statements are based. A metaphor is indirect, figurative speech that, instead of a familiar and usual expression, applies another that is less usual and is as surprising as possible; in comparison with the symbol, the allegory, or the parable, it is direct speech, however, because though it results in a devious instead of a straightforward and obvious description, it does not in the least modify the original meaning of the thing described, and adds nothing to what would have been said by the familiar expression. The content of Kafka's novels and stories, the endless trial for no specified crime, in which there is no indictment and no possibility of any defence, the unapproachable castle with its innumerable offices, its closed doors and its door-keepers who have no authority to do anything whatever, the young man who turns into an insect and is ignored and exploited by his family, the subterranean building with its yawning emptiness and deathly quiet, are all metaphors of isolation and hopeless alienation, and of the eternal and unbridgable remoteness of all meaning that could

satisfy the mind or remove doubt. It is certainly tempting to regard them as symbols, because they possess an intensity of expression characteristic of the latter and, like them, seem to need interpretation, in that they point to an unexpressed meaning and, like all symbolic forms, retain the concreteness of the individual case. But the vital difference is their lack of all reference to anything general or typical. The fate of Kafka's characters, the trial of the bank official Josef K., the efforts of the land surveyor to penetrate into the interior of the seigniorial castle, the metamorphosis of Georg Samsa, the conviction hanging over the head of Georg Bendemann, or whatever it may be, always and invariably concerns one single and unique individual, and has nothing to do with human fate in general or with the super-personal, abstract meaning of life.

The images in which Kafka clothes his experiences and ideas, the never-ending trial without a charge, the inaccessible seat of the higher authorities, the man who is changed into an insect, the subterranean structure sealed off from life, have even less in common with allegory, because the author did not first have an abstract idea and then choose a suitable image for it, as he would have had to do to abide by Goethe's distinction between symbol and allegory. On the contrary, idea and image, thought and metaphor, undoubtedly presented themselves to his mind simultaneously and inseparably. Nor do Kafka's stories present us with examples, as parables or fables do. They resemble neither Menenius Agrippa's story, quoted by Livy, of the stomach's anger with the other parts of the body, nor Tolstoy's of the simple old man who could not learn the Lord's prayer but did not need to, nor Dostoevsky's of the Grand Inquisitor who would have been prepared to crucify Christ a second time. These are real parables, intended to teach something. Where, as in Kafka, there is no moral and no intention to teach, there is no parable.

But Kafka's novels and stories, though they are all based on a metaphor and consist of the development and exploitation of a metaphorical idea, are written in a prose that is almost totally unadorned and free of imagery. Each of his works is, in Goethe's sense, one long figure of speech, and yet it contains no figures of speech. Kafka's style is at its purest in the *Metamorphosis*, in which a single image is even more luxuriantly developed than in the *Burrow* and extends over the whole length of the story. 'To them I am no more than a bed-bug—just as alien and annoying.' That is what Georg Samsa thinks of himself in relation to his family. This idea, which is so thoroughly and pitilessly carried through, may have originated in the dream from which the narrator awakens at the beginning of the story; that is to say, he is not describing a mere dream, but the metamorphosis may have taken place while he was asleep. The story consists merely of the ordinary, trivial events in the life of a lower middle class

family whose grown-up, bread-winning son leads the life of a bug, and on top of it has to endure his father's hatred. He reacts to the lovelessness and contempt he meets with a sense of guilt, which is magnified and made more unintelligible by the fact that he is not aware of having incurred any guilt, and therefore cannot help feeling the mere fact of his existence to be guilty. There is nothing against him except his claim to human status, and his metamorphosis is obviously the result of his renunciation of the latter. As in the *Trial*, the theme is again a sense of guilt so great that any specific charge would only diminish it and change its nature.

In spite of the continual recurrence of certain themes and problems, as above all this sense of guilt and the strange, nightmarish paralysis that hamstrings those afflicted by it, Kafka never goes beyond the single instance and the concrete picture. No attempt is made to go beyond them, because nowhere would anything be essentially different or more revealing.

At the base of all mannerist and quasi-mannerist art there lies the sense that the ultimate and vital things, the whole complexity of life, the insoluble contradictions and irrational motivations of human existence, the link between truth and illusion, mind and body, instinct and reason, are ineffable and unrepresentable. Its special nature, its weaknesses and to an extent also its strength, are connected with the sense of being faced with an impassable boundary, a sense of inadequacy in the face of tasks that would unhesitatingly be tackled by artists with more naïve assumptions. Its shortcomings are so striking, and its depths so obscure, that sufficient arguments can always be found for rejecting it, and both classicism and naturalism, with their self-sufficiency and assurance, their unbroken image and unproblematic idea of reality, readily reveal its deficiencies. But classicism and naturalism do not always satisfy either, and it was from this that mannerism and the quasi-mannerist trends of the present day arose. These forms of style permit the expression of complex experiences and problems for which neither classicism nor naturalism provide an outlet. Many of these experiences may be incommunicable, and many of the questions asked may remain unanswered, but the gain lies in the hints and the questions. Proust's and Kafka's answers are not always satisfactory either, but the manner in which they state their questions, and the things that they question, place them among the most important representatives of the art of their time, and among those who bring us closest to an understanding of mannerism.

Notes

PART ONE: GENERAL

I: THE CONCEPT OF MANNERISM

1. Heinrich Wölfflin, *Renaissance und Barock*, 1926, p. 3.

2. Leo Spitzer, 'Linguistic Perspectivism in the Don Quijote', *Linguistic and Literary History*, 1948, pp. 51/52.

3. G. Galilei, *Considerazioni al Tasso*. Ed. Mestica, 1906.

4. Max Dvořák, *Kunstgeschichte als Geistesgeschichte*, 1924, p. 270.

5. Walter Friedländer, 'Die Entstehung des antiklassischen Stils in der italienischen Malerei um 1520', *Repertorium für Kunstwissenschaft*, Vol. 46, 1925.

6. Kierkegaard, *Gesammelte Werke*, 1910 ff. VI, p. 276.

7. The idea is due to Georg Lukács.

8. Cf. Wilhelm Pinder, 'Zur Physiognomik des Manierismus', *Ludwig Klages-Festschrift*, 1932.

9. Rudolf Kautzsch, 'Kunstgeschichte als Geistesgeschichte', *Belvedere* (Forum), 1925, Vol. VII, No. 1, pp. 10–12.

10. Wilhelm Pinder, *Das Problem der Generation*, 1926, p. 140; Wilhelm Pinder, *Die deutsche Plastik vom ausgehenden Mittelalter bis zum Ende der Renaissance*, 1928, I, p. 252.

11. This untenable theory occurs in W. Weisbach, 'Der Manierismus', *Zeitschrift für bildende Kunst*, 1918–19, Vol. 54, p. 162, and in Margarete Hoerner, 'Der Manierismus als künstlerische Anschaungsform', *Zeitschrift für Ästhetik und allgemeine Kunstwissenschaft*, 1926, Vol. XXII, p. 200.

II: THE DISINTEGRATION OF THE RENAISSANCE

1. The idea comes from Konrad Lange, *Das Wesen der Kunst*, 1901, who may have been influenced by Coleridge's 'willing suspension of disbelief'. Coleridge must in turn have been influenced by the German romantics' idea of irony.

2. Paul Valéry, 'Hommage à Marcel Proust', *Les Cahiers de Marcel Proust*, No. 1, 1927, p. 108.

3. T. S. Eliot, *What is a Classic?*, 1945.

4. Cf. my *Philosophy of Art History*, 1959, pp. 385 f.

5. Heinrich Wölfflin, *Kunstgeschichtliche Grundbegriffe*, 1929, p. 243.

6. André Malraux, *Les Voix du silence*, 1951, p. 276.

7. According to Francesco Flora, *Storia della letteratura italiana*, Vol. II, 2, 1948, p. 656.

8. As for example by Henri Hauser, *La Modernité du XVIᵉ siècle*, 1930.

9. First pointed out by Marcelino Menendez y Pelayo, *Expediente Academico*, 1874.

10. W. Sypher, *Four Stages of Renaissance Style*, 1955, p. 9.

11. E. R. Curtius, *Europäische Literatur und lateinisches Mittelalter*, 1948, p. 256; G. R. Hocke, *Die Welt als Labyrinth*, 1927, p. 226.

12. Richard Zürcher, *Stilprobleme der italienischen Baukunst des Cinquecento*, 1957, p. 12.

13. Niels von Holst, *Die deutsche Bildnismalerei zur Zeit des Manierismus*, 1930, p. 3.

14. E. R. Curtius, *op. cit.*

15. Cf. the discussion of the problem of periodicity in the history of art in my *Philosophy of Art History*, Ch. IV.

16. E. R. Curtius, *op. cit.*, pp. 275–303.

17. M. Dvořák, *op. cit.*

18. See my *Philosophy of Art History*, Ch. VI.

19. Heinrich Wölfflin, *Die klassische Kunst*, 1948, p. 206.

20. Friedrich Schlegel, 'Über die Unverständlichkeit', *Kritische Schriften*, ed. W. Rasch, 1956, p. 349.

21. C. S. Lewis, 'Donne and Love Poetry', *Seventeenth-Century Studies presented to Sir Herbert Grierson*, 1938, p. 80.

III: THE ORIGIN OF THE SCIENTIFIC OUTLOOK

1. Wilhelm Windelband, *Lehrbuch der Geschichte der Philosophie*, 1910, p. 293.

2. Wilhelm Dilthey, *Weltanschauung und Analyse des Menschen seit Renaissance und Reformation. Gesammelte Schriften*, II, 1914, pp. 343 ff.

3. Cf. my *Social History of Art*, 1951, I, p. 333.

4. Montaigne, *Essais*, III, 2. Bibliothèque de la Pléiade, p. 899.

5. *Ibid.*, I, 1, p. 29.

6. *Ibid.*, II, 12, p. 679.

IV: THE ECONOMIC AND SOCIAL REVOLUTION

1. Cf. Richard Ehrenberg, *Das Zeitalter der Fugger*, 1896, pp. 404 f.

2. Federico Zeri, *Pittura e Controriforma*, 1957, p. 27.

V: THE RELIGIOUS MOVEMENT

1. Hubert Jedin, *Das Konzil von Trent*, 1926, p. 9.

2. Cf. Joseph Lortz, *Die Reformation in Deutschland*, Vol. I, 1939, p. 388.

3. In contrast among others to W. Dilthey, 'Die Glaubenslehre der Reformatoren', *Preussische Jahrbücher*, Vol. 75.

4. Ernst Troeltsch, *Die Soziallehren der christlichen Kirchen und Gruppen*, 1912, p. 434, footnote.

5. The doctrine of predestination first took this radical form in Calvinism. See Troeltsch, *op. cit.*, p. 615.

6. Luther, *Vom freien Willen*.

7. Karsten Klaehn, *Luthers sozialethische Haltung im Bauernkrieg*, 1940, p. 117.

8. Friedrich Heer, *Europäische Geistesgeschichte*, 1953, p. 258.

9. Cf. J. W. Allen, *Political Thought in the Sixteenth Century*, 1928, pp. 25–26.

10. P. Pietsch, *Luther und die hochdeutsche Schriftsprache*, 1883. This quotation and the figures that follow are taken from K. Klaehn's book mentioned above, pp. 46–48.

11. E. Belfort Bax, *The Social Side of the German Reformation*, Vol. II. *The Peasant War in Germany 1525–26*, 1899, pp. 275 ff.

12. As for instance by Ernst Troeltsch.

13. Wilhelm Pinder, 'Zur Physiognomie des Manierismus', in *Die Wissenschaft am Scheidewege, Ludwig Klages-Festschrift*, 1932.

14. Hans Rose, Kommentar zu Wölfflins *Renaissance und Barock*, 1926, p. 182.

15. The most extreme standpoint in this sense is taken by Nikolaus Pevsner, 'Gegenreformation und Manierismus', in *Repertorium für Kunstwissenschaft*, 1925, Vol. 46; and in 'Die italienische Malerei vom Ende der Renaissance', in *Barockmalerei in den romanischen Ländern*, Handbuch der Kunstwissenschaft, 1928.

16. Werner Weisbach, 'Gegenreformation, Manierismus, Barock', *Repertorium für Kunstwissenschaft*, 1928, Vol. 49, p. 22.

17. *Ibid.*, p. 24.

18. Hubert Jedin, 'Entstehung und Tragweite des Trientiner Dekrets über die Bilderverehrung', *Theologische Quartalschrift*, 1935, p. 116.

19. Cf. Federico Zeri, *Pittura e Controriforma*, 1957, p. 24.

20. K. G. Fellerer, 'Das Tridentinum und die Kirchenmusik', in *Das Weltkonzil von Trient*, 1951, I, pp. 447 ff.

21. Federico Zeri, *op. cit.*, pp. 25–26.

22. Cf. H. K. M. Schnell, *Der bayrische Barock*, 1936, p. 12.

23. Giovanni Paolo Lomazzo, *Idea del tempio della pittura*, 1590, Ch. VIII, 1884, p. 263.

24. P. Brezzi, *Le riforme cattoliche dei secoli XV e XVI*, 1945, pp. 96–97.

VI: THE AUTONOMY OF POLITICS

1. Machiavelli, *The Prince*, translated by L. Ricci, revised by E. A. P. Vincent, Oxford, 1957, Ch. XV. The last sentence reads in the original: *Onde è necessario ad un principe, volendosi mantenere, imparare a potere essere non buono, ed usarlo e non usarlo secondo la necessità.*

2. *Ibid.*, Ch. XVIII.

3. Cf. E. Troeltsch, *op. cit.*, p. 532.

4. Montaigne, *Essais*, III, Ch. 1, Bibliothèque de la Pléiade, p. 894.

5. Friedrich Meinecke, *Die Idee der Staatsräson*, 1929, p. 49.

6. *Ibid.*, p. 15.

7. Eduard Meyer, *Machiavelli and the Elizabethan Drama*, 1907.

8. Francis Bacon, *The Advancement of Learning*, 1605.

9. Machiavelli, *The Prince*, Ch. XXV.

10. Machiavelli, *Discorsi sopra la prima decade di Tito Livio*, II, 47.

11. *Ibid.*, I, 2. Cf. J. W. Allen, *A History of Political Thought in the Sixteenth Century*, 1928, pp. 452 ff.

12. Giovanni Paolo Lomazzo, *Trattato dell' arte della pittura, scultura et architettura*, 1584; *Idea del tempio della pittura*, 1590.

13. Federico Zuccari, *L'idea de' pittori, scultori ed architetti*, 1607.

14. Erwin Panofsky, *Idea*, 1924, p. 45.

15. F. Meinecke, *op. cit.*, p. 51.

VII: ALIENATION AS THE KEY TO MANNERISM

1. Hegel, *Phänomenlogie des Geistes*, Ch.VI, B. 'Der entfremdete Geist. Die Bildung'.
2. Campanella, *Metaphysica*, Pars I, Lib. 1, Ch. 1, Para. 9.
3. Marx, *Das Kapital*, I, 1, 4. 'Der Fetischcharakter der Ware und sein Geheimnis'.
4. Marx, *Ökonomisch-philosophische Manuskripte vom Jahre 1844*. MEGA, I. Vol. 3, pp. 85–86.
5. Cf. Henryk Grossmann, 'Mechanistische Philosophie und Manufaktur', *Zeitschrift für Sozialforschung*, 1935, IV, 2.
6. Marx, *Das Elend der Philosophie*, 1885, p. 29. Cf. Georg Lukács, *Geschichte und Klassenbewusstsein*, 1923, pp. 94–101.
7. E. Troeltsch, *Soziallehren*, pp. 448–55.
8. Karl Holl, *Gesammelte Aufsätze zur Kirchengeschichte*. I, 1927, p. 321.
9. *Ibid.*, p. 502.

VIII. NARCISSISM AS THE PSYCHOLOGY OF ALIENATION

1. Freud, *Zur Einführung des Narzissmus*, Gesammelte Werke, X, 1946, p. 138.
2. Paul Valéry, *Fragments du Narcisse*.
3. Cf. Albert Thibaudet, *Paul Valéry*, 1923, pp. 96 ff.
4. Marino, *Adone*, V; *Narciso di Bernardo Castello*; *Eco di Ventura Salimbeni*.
5. Góngora, *Soledad* I.
6. Oscar A. H. Schmitz, *Casanova*, 1918, pp. 23–24.
7. Armand Hayem, *Le Don Juanisme*, 1886, p. 86.
8. Georges Gendarme de Bévotte, *Le Légende de Don Juan*, 1911, I, p. 32.
9. Tirso de Molina, *El Burlador de Sevilla*, II, 270–73.
10. Hans Heckel, *Das Don Juan Problem in der neueren Dichtung*, Breslauer Dissertation, 1915.
11. Goethe, *Wilhelm Meisters Lehrjahre*, Book IV, Ch. 13.
12. W. H. Auden, 'The Alienated City', *Encounter*, August 1961. Vol. XVII, No. 2, p. 11.
13. Freud, *Gesammelte Werke*, X, 1946, p. 155.
14. Freud, *Über libidinöse Typen*, Gesammelte Werke, XIV, 1948, pp. 510–11.
15. Otto Fenichel, *The Psychoanalytical Theory of Neurosis*, 1946, p. 526.
16. Freud, *Gesammelte Werke*, XIV, p. 512.
17. On the idea of the 'negative hero' cf. Hans Heckel, *op. cit.*, p. 24; and Otto Rank, *Die Don Juan-Gestalt*, 1924, p. 16.
18. Freud, *Gesammelte Werke*, X.

IX: TRAGEDY AND HUMOUR

1. Cf. Georg Lukács, *Die Theorie des Romans*, 1920, p. 29.
2. Franz Rosenzweig, *Der Stern der Erlösung*, 1930.
3. Kierkegaard, 'Reflex des antik Tragischen im modern Tragischen', *Entweder Oder*, Vol. I.
4. Georg Lukács, 'Die Metaphysik der Tragödie', *Die Seele und die Formen*, 1911.
5. Karl Jaspers, *Von der Wahrheit*, 1947, p. 924.
6. See Note No. 6. Part One, Ch. V.
7. Schopenhauer, *Die Welt als Wille und Vorstellung*, II, Ch. 8.
8. Freud, *Der Humor*, Gesammelte Werke, XIV, 1948, p. 385.
9. Julius Bahnsen, *Das Tragische und der Humor*, 1931, p. 102.
10. Jean Paul, *Vorschule der Aesthetik*, Ch. 76.

PART TWO: HISTORICAL

I: OUTLINE OF THE HISTORY OF MANNERISM IN ITALY

1. Theodor Hetzer, *Die sixtinische Madonna*, 1947, p. 40.
2. Walter Friedländer, 'Die Entstehung des klassischen Stils in der italienischen Malerei um 1520', *Repertorium für Kunstwissenschaft*, Vol. 46, 1925.
3. Hermann Voss, *Die Malerei der Spätrenaissance in Rom und Florenz*, 1920, p. 153.
4. Max Dvořák, *Geschichte der italienischen Kunst*, II, 1929, p. 127.
5. *Ibid.*, p. 127.
6. Wilhelm Pinder, *Das Problem der Generation*, 1926, p. 140; and *Die deutsche Plastik vom ausgehenden Mittelalter bis zum Ende der Renaissance*, 1928, II, p. 252.
7. Galileo, *Considerazioni al Tasso*, Opere, IX, p. 69. Cf. E. Panofsky, *Galileo as a Critic of the Arts*, 1954, pp. 19–20.
8. Theodor Hetzer, *op. cit.*, p. 51.
9. M. Dvořák (*op. cit.*, II, p. 62) emphasises Giulio Romano's share in the original designs, while Oskar Fischel (*Raphael, 1948, I, p. 286*) emphasises that of Francesco Penni.
10. M. Dvořák, *op. cit.*, II, pp. 62–63.
11. Heinrich Wölfflin, *Die klassische Kunst*, pp. 149 f.
12. Cf. Hans Luetgens, *Raffaels Transfiguration in der Kunstliteratur der letzten vier Jahrhunderte*, 1929.
13. Frederick Hartt, 'Raphael and Giulio Romano', *The Art Bulletin*, 1944, XXVI, No. 2, p. 86.
14. Rudolf Sobotta, *Michelangelo und der Barockstil*, 1953, p. 36.
15. Wilhelm Pinder, *Das Problem der Generation*, p. 55.
16. Attention to the concentration of masses in Michelangelo has been drawn in particular by Rudolf Sobotta, *op. cit.*, pp. 35–37, who contrasts this feature, however, both with the 'baroque decoration' and baroque 'spreading of the masses over broad surfaces', on the one hand, and with the slender and elongated forms of mannerism on the other; recognising the latter only in the *Pietà Rondanini*. The weight and burden of the human frame in Michelangelo was emphasised by Hans Sedlmayr, *Michelangelo*, 1940, pp. 10–23. C. de Tolnay, *Michelangelo*, V, p. 31, claims the organic and substantial nature of the human body in Michelangelo's art as an anti-mannerist feature, having previously stated his view of the artist's relationship to mannerism in earlier volumes of the same work and in his article on Michelangelo in Thieme–Becker, *Künstlerlexikon*, 1930.
17. E. Panofsky, *Städel Jahrbuch*, VI, 1930.
18. Rudolf Sobotta, *op. cit.*, p. 35, in his analysis makes this one of the most important features of Michelangelo's art; it had previously been pointed to by Wilhelm Pinder.
19. Lomazzo, *Trattato dell'arte della pittura*, 1585, pp. 22–23.
20. Heinrich Wölfflin, *op cit.*, pp. 194–98.
21. W. Friedländer, *op. cit.*, p. 55.
22. Cf. C. de Tolnay, *Michelangelo*, Vol. V, 1960, p. 10.
23. Cf. Adolf Schinnerer, *Michelangelos Weltgericht*, 1958, p. 10.
24. Heinrich Wölfflin, *op. cit.*, pp. 204 ff.
25. *Ibid.*, pp. 167–80.
26. F. M. Clapp, *Jacopo Carucci da Pontormo*, 1916, p. 7.
27. Roberto Longhi, 'Comparj spagnoli della maniera italiana', *Paragone*, IV, 1953, No. 43, pp. 3–8. Giuliano Briganti, *Der italienische Manierismus*, 1961, pp. 24–25.

28. Cf. I. Fraenckel, *Andrea del Sarto*, 1935, pp. 38, 53. Hugo Wagner, *Andrea del Sarto. Seine Stellung zur Renaissance und Manierismus*, 1951, pp. 20 f, 45 f.

29. S. J. Freedberg, *Painting of the High Renaissance in Rome and Florence*, 1961, I, p. 501.

30. M. Dvořák, *Italienische Kunst*, II, p. 167.

31. *Ibid.*, pp. 166–67

32. H. Voss, *op. cit.*, I, pp. 209 f.

33. N. Pevsner, 'Die italienische Malerei vom Ende der Renaissance', in *Barockmalerei in den romanischen Ländern*, 1928, p. 43.

34. Wilhelm Pinder, Physiognomik des Manierismus, *Ludwig Klages-Festschrift*, 1932.

35. Niels von Holst, *Die deutsche Bildnismalerei zur Zeit des Manierismus*, 1930, p. 47.

36. Julius Schlosser, *Die Kunstliteratur*, 1924, p. 383.

37. This is the position taken by L. Fröhlich-Bum, *Parmigianino und der Manierismus*, 1911, pp. 117 ff., and P. Barocchi, *Il Rosso Fiorentino*, 1950.

38. S. J. Freedberg, *Parmigianino*, 1950, p. 126.

39. G. Fiocco, *Giovanni Antonio Pordenone*, 1939, pp. 82–83. O. Gamba, 'Il Parmigianino', *Emporium*, p. 109. S. J. Freedberg, *Parmigianino*, pp. 47, 48.

40. H. Voss, *op. cit.*, I, p. 142.

41. Giuliano Briganti, *Der italienische Manierismus*, p. 55.

42. Charles Dejob, *De l'Influence du Concile de Trente*, 1884, p. 263.

43. N. Pevsner, *Academies of Art*, 1940, p. 13.

44. *Ibid.*, pp. 46 ff.

45. Cf. F. Antal, 'Zum Problem des niederländischen Manierismus', *Berichte zur kunstgeschichtlichen Literatur*, 1928–29, p. 218.

46. For this attribution cf. L. Dimier, *Le Primatice*, 1928, p. 45; H. Vollmer in Thieme–Becker, *Künstlerlexikon*, XXVII, 1933, p. 403; F. Bologna and R. Causa, Catalogue of the 'Fontainebleau e la maniera italiana' Exhibition, Naples 1952; R. O. Parks and W. Friedländer, Catalogue of the 'Triumph of Mannerism' Exhibition, Amsterdam, 1955.

47. S. J. Freedberg, *Parmigianino*, p. 76.

48. Cf. R. Longhi, *Arte Veneta*, 1948, pp. 43–45; Catalogue of the Bassano exhibition in Venice, 1957, p. 82.

49. Cf. R. Pallucchini, *La giovinezza del Tintoretto*, 1950, p. 25.

50. W. Arslan, *I Bassano*, 1931.

51. R. Pallucchini, *op. cit.*, p. 23.

52. Theodor Hetzer, 'Studien über Tizians Stil', *Jahrbuch für Kunstwissenschaft*, 1923.

53. Hans Tietze, *Titian*, 1950, p. 382.

54. G.N. Fasola, 'Il manierismo e l'arte veneziana del cinquecento', *Venezia e l'Europa*, XVIII Congresso Internazionale dell'Arte (1955), 1956, p. 293.

55. Taine, *Voyage en Italie*, II, 1874.

56. Dvořák, *Italienische Kunst*, II, p. 145.

57. *Ibid.*, p. 156.

58. The painting may, as has been assumed (M. Pittaluga, *Tintoretto*, 1925, p. 272), be a product of his workshop, but can certainly not be an early work dating from the fifties.

59. Dvořák, *Italienische Kunst*, II, p. 160.

60. E. von Bercken, *Tintoretto*, 1942, p. 19.

61. D. von Hadeln, *Jahrbuch der Königlich Preussischen Kunstsammlungen*, XXXIV, 1914.

62. R. Longhi, 'Suggerimenti per Jacopo Bassano', *Arte Veneta*, 1948.

63. Cf. W. Friedländer, *Caravaggio Studies*, 1955, p. 63.

64. Fritz Baumgart, 'Zusammenhänge der niederländischen mit der italienischen Malerei in der zweiten Hälfte des 16. Jahrhundert', *Marburger Jahrbuch der Kunstwissenschaft*, 1944, XIII, pp. 205–6.

65. Friedrich Antal in his otherwise remarkable essay, 'Zum Problem des niederländischen Manierismus', *passim.* certainly exaggerates the importance of the Tuscan influence. Also it is doubtful whether the influence of the style developed in the Zuccari circle was sufficient, as Antal believes (p. 231), to explain the art of the maturer El Greco.

II. MANNERISM OUTSIDE ITALY

1. Hans Kaufmann, in 'Der Manierismus in Holland und die Schule von Fontainebleau', *Jahrbuch der Königlich Preussischen Kunstsammlungen*, 1923, No. 4, vigorously maintains that a decisive role was played by the school of Fontainebleau; the case against this is stated by Friedrich Antal, Roberto Longhi Review, *Kritische Berichte zur kunstgeschichtlichen Literatur*, 1928–29, pp. 148–49.

2. Cf. Max J. Friedländer, 'Die Antwerper Manieristen von 1520', *Jahrbuch der Königlich Preussischen Kunstsammlungen*, Vol. 31, 1915.

3. Max J. Friedländer, *Die niederländischen Manieristen*, 1931, p. 3.

4. These arguments against regarding Bruegel as a mannerist are firmly stated by Hans Sedlmayr, *Verlust der Mitte*, p. 189.

5. Dvořák, *Kunstgeschichte als Geistesgeschichte*, 1928, p. 234.

6. Hans Sedlmayr, in his 'Die *macchia* Bruegels', *Jahrbuch der kunsthistorischen Sammlungen in Wien*, New Series, Vol. VIII, 1934, correctly observes and describes the process by which form becomes devoid of meaning and significance without fully stating, however, the implications of the phenomenon or of the idea of alienation in his context, though he mentions the latter.

7. G. Glück, 'Bruegel und der Ursprung seiner Kunst', in *Aus drei Jahrhunderten europäischer Malerei*, 1933, p. 154.

8. Ch. de Tolnay, *P. Bruegel l'Ancien*, 1935, p. 42.

9. Hans Kaufmann, *op. cit.*

10. F. Antal, *op. cit.*, p. 208.

11. Hubertus Lossow, 'Zum Stilproblem des Manierismus in der italienischen und der deutschen Malerei', in *Deutschland–Italien*, *W. Waetzoldt-Festschrift*, 1941, pp. 201 ff.

12. The only surviving contemporary account of El Greco's stay in Rome (other than a letter by the painter Giulio Clovio) is that of Giulio Cesare Mancini, written a few years after the artist's death. He writes that, when Pope Pius V ordered certain figures in Michelangelo's *Last Judgment* to be painted over on the ground of indecency, El Greco said that if he had his way he would destroy the whole picture and paint another, which would be just as good and more decent. At the time of his stay in Rome El Greco may have had certain reservations about Michelangelo, but his connection with him is so close and the influence of the *Last Judgment* in particular on his later style is so great, that the whole story seems to be of doubtful credibility.

13. Cf. J. F. Willumsen, *La Jeunesse du peintre Greco*, 1927; F. Antal, *op. cit.*, pp. 231–33.

14. G. Marañon, *Elogio y nostalgia de Toledo*, 1958, p. 115 and *passim*; and the same author's, *Greco y Toledo*, 1958, pp. 91 ff.

15. Francisco Pacheco, *El arte de la pintura*, 1649.

16. 1950 edition, pp. 270–71.

17. Hugo Kehrer, *Greco als Gestalt des Manierismus*, 1939, p. 35.

18. Manuel B. Cossio, in *El Greco*, 1908, p. 239, regards the *Burial of the Count of Orgaz* as a counterpart to the roughly contemporary *Don Quixote* and an idealisation of the spirit of chivalry. He argues that to El Greco vulgar mannerism was just as grave a distortion of the spirit of chivalry as the chivalrous romances of his time were to Cervantes.

19. Catalogue of the exhibition of the Collection in the London National Gallery, 1961, pp. 30–31.

20. Harold E. Wethey, *El Greco and His School*, 1962, II, p. 56.

III. MANNERISM IN ART AND LITERATURE

1. Among others by Oskar Walzel, Fritz Strich, and L. L. Schücking.

2. As is often the case with Leo Spitzer and Helmut Hatzfeld.

3. As for example Mario Praz, Ezio Raimondi, and Georg Weise.

4. As notably by Thierry Maulnier in his *Introduction à la poésie française*, 1939, and his paper, 'Les derniers Renaissants', in *Langages*, 1946.

5. Cf. among others R. Bray, *La Préciosité et les précieux*, 1948.

6. M. M. Mahood, *Poetry and Humanism*, 1950.

7. Cf. O. de Mourgues, *Metaphysical, Baroque and Précieux Poetry*, 1953, p. 104.

8. Cf. W. Sypher, *Four Stages of Renaissance Style*, 1955, pp. 33–34.

9. *Ibid.*, p. 20.

10. *Ibid.*, pp. 19, 20.

11. For the definition of thrust and recession in depth cf. Hans Hoffmann, *Hochrenaissance, Manierismus, Frühbarock*, 1938; Richard Zürcher, *Stilproblem der italienischen Baukunst des Cinquecento*, 1957; Werner Hager, 'Zur Raumstruktur des Manierismus in der italienischen Architektur', *Wackernagel-Festschrift*, 1958.

12. N. Pevsner, 'The Architecture of Mannerism', *The Mint*, 1946, p. 121.

13. *Ibid.*

14. Cf. R. Zürcher, *op. cit.*, p. 44.

15. W. Hager, *op. cit.*, p. 139.

16. *Ibid.*, p. 134.

17. Cf. Leo Spitzer, *Die Literarisierung des Lebens in Lopes Dorotea*, 1932.

18. Quoted by Wallace Fowlie, *The Age of Surrealism*, 1960.

19. T. S. Eliot, *Note on the Verse of John Milton*, 1936.

20. Pierre Reverdy, according to André Breton, *Manifeste du Surrealisme*, 1929, p. 38.

21. T. S. Eliot, *Selected Essays*, 1932, pp. 243–44.

22. José Ortega y Gasset, *El Tema de nuestro tiempo*, 1923.

23. Heinz Werner, *Ursprünge der Metapher*, 1919; *Ursprünge der Lyrik*, 1924.

24. *Ibid.*

25. T. S. Eliot, *Selected Essays*, p. 244.

26. Proust, 'À propos du "style" de Flaubert', *Chroniques*, 1927, pp. 193–94.

27. Proust, *Pastiches et mélanges*, 1919, p. 267.

28. Cf. among others Georg Lukács, *Wider den missverstandenen Realismus*, *passim*, particularly pp. 39 ff.

29. Walter Benjamin, 'Ursprung des deutschen Trauerspiels' (1929), in *Schriften*, 1955, I, pp. 141 ff.

30. Hegel, *Aesthetik*, ed. Friedrich Bassange, 1955, p. 400.

31. J. Middleton Murry, *The Problem of Style*, 1922, p. 13.

32. First in Caroline F. E. Spurgeon, *Shakespeare's Imagery*, 1935, p. 334, and then in W. H. Clemen, *The Development of Shakespeare's Imagery*, 1951, pp. 98–99.

33. See my *Philosophy of Art History*, pp. 97 f.

IV. THE PRINCIPAL REPRESENTATIVES OF MANNERISM IN WESTERN
LITERATURE

1. See my *Social History of Art*, I, pp. 396 ff.

2. Galileo, *Considerazioni al Tasso*, Ed. Mestica, 1906, p. 57.

3. Erwin Panofsky, *Galileo as a Critic of the Arts*, 1954, p. 16.

4. Galileo, *op. cit.*, p. 148.

5. Cf. Ulrich Leo, Torquato Tasso, *Studien zur Vorgeschichte des Secentismo*, 1951.

6. See Note 7. Part One, Ch. II.

7. H. Hatzfeld, 'The Baroque of Cervantes and Góngora,' *Anales cervantinos*, III, 1953.

8. Albert Thibaudet, 'Le phénomène gongorin', *Les Nouvelles Littéraires*, May 28, 1927.

9. Luis de Góngora, *Las Soledades*. Edited by Dámaso Alonso, 3rd edit. 1956, p. 117.

10. See my *Social History of Art*, I, p. 225.

11. Karl Vossler, 'Poesie der Einsamkeit in Spanien', *Sitzungs-Berichte der Bayrischen Akademie der Wissenschaft*, 1935, Vol. VII, p. 148.

12. Góngora, *Obras completas*. Ed. Mille y Gímenez, pp. 463–64.

13. Góngora, *Obras*, pp. 525–26.

14. W. Dilthey, *Die grosse Phantasiedichtung*, 1954.

15. L. L. Schücking, *Die Charakterprobleme bei Shakespeare*, 1932.

16. Ernest Jones, 'The Oedipus Complex as an explanation of Hamlet's mystery', *The American Journal of Psychology*, 1910.

17. Miguel de Unamuno, *Vida de Don Quijote y Sancho*, 1914.

18. Salvador de Madariaga, *Don Quijote*, 1926.

19. Cf. Cesare de Lollis, *Cervantes reazionario*, Bari, 1924.

20. Leopoldo Eulogio Palacios, 'La significación doctrinal del Quijote', *Acta de la Asemblea Cervantina*, 1948, p. 311.

21. Américo Castro, Incarnation in 'Don Quijote', *Cervantes across the Centuries*, 1947.

22. Alberto Navarro Donzaléz, 'La locura quijotesca', *Anales cervantinos* I, 1951, p. 279.

23. Unamuno, *op. cit.*

24. Theodor W. Adorno, 'Das Altern der neuen Musik', *Dissonazen*, 1956, pp. 102 ff.

25. Cf. Georg Lukács, *Wider den missverstandenen Realismus*, pp. 80 ff.

26. W. P. Ker, *Collected Essays*, 1925, II, p. 38.

27. Salvador de Madariaga, *op. cit.*

28. E. R. Curtius, *Europäische Literatur und lateinisches Mittelalter*, 1948, p. 146.

29. Hegel, *Aesthetik*, 1955, p. 399.

30. Maurice Merleau-Ponty, 'Lecture de Montaigne', *Signes*, 1960, p. 250.

31. *Ibid.*, p. 251.

32. Valéry Larbaud, 'Ce vice impuni, la lecture', *Domaine française*, 1941, p. 59.

33. Thierry Maulnier, *Introduction à la poésie française*, 1939, pp. 82–86; *Langages*, 1946, pp. 18–21.

34. Montaigne, *Essais*, I, p. 20. Bibliothèque de la Pléiade, 1950, p. 118.

35. Pascal, *Oeuvres Complètes*, Ed. F. Strowski, 1931, III. *Les Pensées*. 161, p. 62.
36. *Ibid*.
37. Alan Boase, 'Jean de Sponde—Un poète inconnu', *Mesures*, October 15, 1939, p. 130.
38. Werner Hager, *Zur Raumkonstruktion des Manierismus*, p. 114.
39. Patrick Cruttwell, *The Shakespearean Moment*, 1954, p. 56.
40. C. S. Lewis, 'Donne and love poetry in the 17th century', *Seventeenth-Century Studies, presented to Sir Herbert Grierson*, pp. 69 f., 80.
41. Cf. T. S. Eliot, *Selected Essays*, p. 295.
42. *Ibid*.

PART THREE: MODERN

1. Marcel Proust, 'À propos de Baudelaire', *Chroniques*, 1927, pp. 212 ff.
2. Marcel Proust, *À la Recherche du Temps perdu*, Pléiade, III, p. 920.
3. Baudelaire, *Richard Wagner et Tannhäuser à Paris*, 1861.
4. Baudelaire, *Le Peintre et la vie moderne*, 1863.
5. Albert Thibaudet, *Histoire de la littérature française de 1789 à nos jours*, 1936, p. 485.
6. Henri Bremond, *La Poésie pure*, 1926, pp. 16–20.
7. Paul Valéry, 'Degas, Danse, Dessin', *Oeuvres*, II, p. 1208, Bibliothèque de la Pléiade.
8. Edgar Allan Poe, *A Philosophy of Composition*, 1846; *The Poetic Principle*, 1848.
9. Jean Paulhan, *Les Fleurs de Tarbes*, 1941.
10. André Breton, *Les Pas perdus*, 1924.
11. Franz Wickhoff, 'Römische Kunst', *Schriften*, III, 1912, pp. 14–16.
12. For a discussion of the problem of form in the cinema, its conception of time and montage technique in connection with modern art in general, cf. my *Social History of Art*, II, pp. 940–48.
13. Marcel Proust, *À la Recherche du Temps perdu*, XII. English translation *Remembrance of Things Past*, XII, *Time Regained*, by Stephen Hudson, London, Chatto & Windus.
14. Marcel Proust, IV, *À l'Ombre des jeunes filles en fleur*. English translation *Within a Budding Grove*, by C. K. Scott-Moncrieff, Part II, p. 186, London, Chatto & Windus.
15. Marcel Proust, *Du côté de chez Swann*, Bibliothèque de la Pléiade, I, pp. 169–70.
16. E. R. Curtius, 'Marcel Proust', in *Der französische Geist im 20. Jahrhundert*, 1952, pp. 303 ff.
17. Marcel Proust, V. *Le Côté de Guermantes*. Pléiade, II, pp. 40 ff. English translation (as above) *The Guermantes Way*, Part I, pp. 44–47.
18. Marcel Proust, *Du Côté de chez Swann*, Pléiade, I, p. 19. English translation *Swann's Way*, Part I, pp. 22 f.
19. Marcel Proust, *À l'Ombre des jeunes filles en fleur*, Pléiade, II, p. 735. English translation as above, IV, p. 46.
20. Marcel Proust, *La Prisonnière*, Pléiade, III, p. 106. English translation as above, *The Captive*, pp. 134–38.
21. Georg Lukács, *Wider den missverstandenen Realismus*, 1958, p. 46.
22. Max Brod, *Franz Kafka*, 1946, pp. 236–37.
23. Georg Lukács, *op. cit.*, pp. 44 f.
24. Walter Benjamin, *Schriften*, 1955, pp. 208 ff.

Index of Subjects

Index of Names